CARAVAGGIO

OTHER BOOKS BY HOWARD HIBBARD

The Architecture of the Palazzo Borghese

Bernini

Bernini e il barocco

Florentine Baroque Art from American Collections
(with Joan Nissman)

Carlo Maderno and Roman Architecture, 1580–1630

Poussin: The Holy Family on the Steps

Michelangelo

Masterpieces of Western Sculpture

The Metropolitan Museum of Art

CARAVAGGIO

Howard Hibbard

THAMES AND HUDSON

To Shirley

First published in Great Britain in 1983
by Thames and Hudson Ltd, London

Copyright © 1983 by Howard Hibbard

Printed and bound in the U.S.A.

Contents

CONTENTS

Color photographs follow page 148.

Preface

Caravaggio is the most arresting European painter of the years around 1600. Although he died in 1610, in his thirty-ninth year, he is often considered the most important Italian painter of the entire seventeenth century. He is also notorious as a painter-assassin: he killed a man in 1606, and a similar crime was rumored in his youth. We would not be fascinated by his personality and his crimes had he not been a great painter; but the extent and even the nature of his artistic contribution is still in question, and his paintings will always be controversial. For contemporaries like Giulio Mancini, Caravaggio was famous as a realistic genre painter, his best picture the *Gypsy Fortuneteller* [12]. More recently, especially since Walter Friedlaender's *Caravaggio Studies* of 1955, he has been hailed as an original and personal interpreter of scripture. An Italian writer has recently compared his achievement to that of Giotto and Masaccio; another actually likened his exploration of nature to Galileo's.

Caravaggio's paintings speak to us more personally and more poignantly than any others of the time. We meet him over the gulf of centuries, not as a commanding and admirable historical figure like Annibale Carracci, but as an artist who somehow cut through the artistic conventions of his time right down to the universal blood and bone of life. Looking back almost four hundred years, we see him as the first Western artist to express a number of attitudes that we identify, for better or worse, as our own. Ambivalent sexuality, violent death, and blind faith in divine salvation are some of the contradictory messages and images that pervade his works. If one were to try to reduce Caravaggio's contribution to the history of art to a single sentence, it might be said that he was the only Italian painter of his time to rely more on his own feelings than on artistic tradition, while somehow managing to remain within the great mainstream of the Renaissance. From this point of view he is an important precursor of Rembrandt and even of modern art.

I have tried to evaluate Caravaggio in the light of his contemporaries and

predecessors and to come to terms with his unique qualities. But, as Ellis Waterhouse wrote some twenty years ago in a passage that has become famous:

> So much fancy ink has been spilled about Caravaggio during the last thirty-five years, and he has been credited with roles of such extravagant importance in the history of art (not all of them mutually compatible), that his true quality is very hard to discern and the innocent reader of art-historical literature could be forgiven for supposing that his place in the history of civilization lies somewhere in importance between Aristotle and Lenin.[1]

If I dare to write a book on such a subject, it is in large part thanks to recent discoveries of both paintings and documents, as well as to new interpretations of individual pictures and even of periods in his career. The chronology of Caravaggio's early works was essentially settled after the great *Mostra* of 1951 by the acute observations of Denis Mahon, supplemented by his own archival discoveries. Essential knowledge of Caravaggio's work for his two most important patrons has come from the publication of the artistic inventories of Marchese Vincenzo Giustiniani by Luigi Salerno in 1960 and of Cardinal Del Monte by Christoph Frommel in 1971. Among the recent studies that have changed our views about Caravaggio, the contributions of Herwarth Röttgen—at first chiefly archival, then embracing connoisseurship, iconography, and even psycho-history—stand out as the most significant as well as the most controversial of the last fifteen years. Most of this material was published after the excellent monograph by Roger Hinks (1953), which has a good chapter on Caravaggio's life. Like Friedlaender's wonderful *Studies,* it is now factually antiquated. I have therefore tried to write a reliable book that examines Caravaggio's life and work together, so far as that is possible.

The text is almost exclusively concerned with paintings by Caravaggio himself or with those that obviously reflect lost works by him, leaving aside the penumbra of questionable attributions and the quantity of peripheral works that tend to blur his artistic personality and to confuse our perception of his achievement. My aim has been to illuminate Caravaggio's unique qualities. Since I hope that this book will be useful as well as interesting, the more important attributed works are illustrated and discussed in Appendix I.

Most of the basic bibliography for the individual paintings will be found in the Notes to the Illustrations, beginning on page 268. These notes, despite my desires, often approach catalog entries. I do not try to compete with the compendia by Marini

[1] E. Waterhouse, *Italian Baroque Painting* (London, 1962, p. 21).

and Cinotti, however, and they must be consulted by scholars who want complete documentation.

I am indebted to a number of people and institutions for help over the years. My appointment as Slade Professor at Oxford for 1976–1977 forced me to put together such inchoate thoughts as I had about Caravaggio. The audience sat through the eight lectures with tolerance and occasionally enthusiasm, but there is only a vague similarity between those talks and this book. For me, Oxford was an unalloyed pleasure; I am particularly grateful to Francis and Larissa Haskell for hospitality and friendship, and I also thank Jaynie Anderson, who cheered me on and contributed to my education as well.

In the spring of 1977 I was helped to see most of the works of Caravaggio by a travel grant from the Penrose Fund of the American Philosophical Society. The experience of seeing the paintings in London, Malta, Messina, Naples, Rome, Florence, and London again, all within three weeks, followed closely by visits to Cleveland and Detroit, was both sobering and enlightening; (after such a singleminded trip, one feels that it must be immediately repeated, so as to finally get things straight). Much of the illumination of these and other expeditions to see Caravaggio's paintings came from the sharp eyes of my wife Shirley, who has been the most important and constant influence on this book. She has done more for it (and for me) than I can readily express; she also typed innumerable drafts of the text. All of my books should have been dedicated to her; this one finally is.

I have often benefited from students who worked on Caravaggio, not only in graduate seminars at Columbia University or in independent papers, but also in two summer seminars for college teachers sponsored by the National Endowment for the Humanities. I have tried to acknowledge their contributions in the proper places, but I owe a generic debt to Donald King and William A. McIntosh for enlarging my horizons. My friend Robert S. Liebert, M.D., gave me the benefit of his psychoanalytic speculations and insights; I have profited from the ideas of David Kahn and John Markowitz. Joseph Forte gave me useful information and help on various occasions. The archival discoveries that allow us to date the *Entombment* and its chapel are indebted to the guidance of Joseph Connors. David Rosand was my learned adviser on Venetian and musical topics.

When the paintings of the Contarelli Chapel were undergoing conservation and restoration at the Istituto Centrale del Restauro in Rome in the mid 1960s I was given the priceless opportunity of seeing the canvases at close range under lights. Phoebe Dent Weil, then working at the Istituto, was responsible for those visits. I am grateful to the director, Giovanni Urbani, for many kindnesses. A number of people at the Istituto helped me to see the *Burial of St. Lucy* over the years, including

the conservator, Paolo Mora, and most recently Michele Cordaro. Various institutions and their members have allowed me to see paintings that were not on public display, or to see them in better light: the Fondazione Roberto Longhi; Carlo Sestieri; David Carritt; Kent Ahrens and Jean Cadogan; Renato Brandolini; and the staff of the Laboratorio de' Restauri at the Fortezza da Basso in Florence. My study at the Louvre was aided by the enthusiasm and knowledge of Pierre Rosenberg.

Research on Caravaggio over the last thirty years has been greatly indebted to the publications of Denis Mahon; I am also pleased to acknowledge his friendly conversations on the subject—one might better call them private lessons—as well as a correspondence that began, on other subjects, over a quarter-century ago.

My greatest professional debt is to Richard Spear. He read two versions of the text and much other material, giving me corrections, suggestions, and advice for which I am particularly grateful. Both the form and the content of the book have profited from his criticism, but he must not be blamed for its faults—they are mine, not his. Charles Dempsey, whose vision of Caravaggio is less conventional than mine, gave me the benefit of wise counsel. Creighton Gilbert made useful corrections.

When this book was nearing completion I was blessed with the help of Michael Young, a graduate student at Columbia University, who did much more than an assistant needed to do. Laura Gilbert, Kristin Kelly, Laura Camins, and many others have also helped me over the years. Robert Baldwin kept me informed of bibliographical news in the field of gesture. Maurizio Marini not only gave me permission to use photographs and information but was also encouraging and helpful in other ways, as were Maurizio Fagiolo, Luigi Spezzaferro, and Kathleen Weil-Garris. Vincenzo Pacelli kindly furnished photographs of the most recent Caravaggio discovery, the *Martyrdom of St. Ursula* of 1610. For photographs I am also indebted to Geneviève Creuset, Christoph Frommel, Irene Geismeier, Francis Haskell, N.G. Lutzkevich, J. Patrice Marandel, Mary Myers, Vincenzo Oddi, Alfonso E. Pérez Sánchez, Herwarth Röttgen, Erich Schleier, Charles Scribner III, Herman Shickman, Richard Spear, S. Vsevolozhskaja, Angelo Walther, Georgia Wright. Karin Einaudi of the Fototeca Unione at the American Academy in Rome furnished many photographs.

During a sabbatical leave in 1979–1980 I profited from a fellowship from the National Endowment for the Humanities—awarded (I regret to say) for another project. Much of that free time was spent on this book, which steadfastly refused to be finished. I have relied on the library of Columbia University and its helpful personnel, particularly Christina G. Huemer, the Fine Arts Librarian. I am also indebted to the Biblioteca Vaticana, the Archivio Segreto Vaticano, and the Archivio di Stato in Rome. I am especially grateful to the staff and Library of the American Academy in Rome, where I spent many happy years. No book on Roman art could

hope to be complete without the Bibliotheca Hertziana, but my thanks are mingled with regret that Wolfgang Lotz, the former Director, is no longer there to greet us with his charming, understated erudition.

Finally, if the reader will grant me a short recollection, I should like to say a word about Oskar Hagen. He taught the first course I ever took in art history, "Representative Painters of the Seventeenth Century." When Hagen wrote the words "Michelangelo Merisi da Caravaggio" on the blackboard that day in 1947, I remember thinking, "So, that's what Michelangelo's name was." Dr. Hagen, as we all called him, had been the pupil and assistant of Heinrich Wölfflin, and like his teacher he taught by the comparative method: two slides on two screens made his visual points. Hagen's thesis (all of his courses had one) made Caravaggio the wellspring of Baroque art. Caravaggio's influence was the common quality shared by Rubens, Rembrandt, Velázquez, even Poussin—and Hagen pushed the tenuous links about as hard as human ingenuity could manage. But for a beginner his approach was perfect.

Stout, ruddy, even apoplectic in appearance, Hagen punctuated his verbal and visual assault on the audience with bangs of the pointer and the chirp of a metal cricket, which he employed to signal for new lantern slides. Hagen's lectures were meticulously planned; their martial organization spilled out onto mimeographed sheets that listed the pairings of the day along with dates and succinct commentary. His sense of drama made the rapid and accurate change of images imperative and if some dreamy apprentice ruined the climax of a lecture by inserting the wrong slide, Hagen's roars could be heard down the corridors of Bascom Hall. Puffed and red as he usually was, on those occasions it seemed possible that he would explode. Nevertheless Hagen and his exotic subject quickly captured my imagination: art history seemed to be the key to universal culture. Over the next few years I slowly reconciled myself to the idea of studying the history of art as a profession—a daunting career for the son of a man who had started life as an Iowa farmer. Before leaving the University of Wisconsin I also discovered, as so many others had, that under Hagen's ferocious crust there beat a generous heart. He was so remarkable that I want to remember him here, for he seems to have been all but forgotten.

Oskar Frank Leonard Hagen (1888–1957) was born in Wiesbaden, his mother British, his father German-American. As a youth he had studied musical composition with Humperdinck, and during much of his life he composed music—I remember a murky *Concerto Grosso* of which he was extremely proud. In 1921 Hagen revived the operas of Handel at Göttingen in versions that now cause pain or laughter among cognoscenti, but Hagen did them first (he was eventually made a Fellow of the Royal Society of Arts). I have referred to Hagen's theatrical bent, which he came by

honestly; at one time he had worked with Max Reinhardt. Hagen's famous daughter Uta was named after his favorite Gothic portrait, in Naumburg Cathedral. After his first wife died, Hagen courted by mail, and in 1940 married the founder of the Bentz quartet, the first female string ensemble in Europe. Beatrice Hagen's charming Swiss equanimity was a perfect foil to her husband's choleric temperament.

Hagen first came to Wisconsin as Carl Schurz memorial professor in 1924 and, for reasons that are not clear to me, left Germany for good in 1925. It is true that his doctoral thesis on Correggio is now pronounced worthless and that his popular book on Grünewald was flawed and controversial. The scholarly community in Germany was probably hostile to Hagen's emotional style. Perhaps too the unsettled economic conditions made emigration more attractive than it would have been otherwise, for as *professor extraordinarius* he had no regular salary.

When Hagen founded the Department of the History and Criticism of Art at Wisconsin and set out to educate the youth of the Midwest, the university was one of the most progressive and intellectually exciting in the country. Luring a famous young German professor of art probably seemed only appropriate. When Hagen found no suitable text in English to give his classes, he wrote a spirited one, *Art Epochs and Their Leaders,* which was widely read. He taught courses in Medieval and Renaissance art. Soon he must have begun lecturing on American art and wrote a book on painting before the American Revolution that was hated by specialists. (Later, John Steuart Curry, Madison's captive Regionalist, painted his portrait in shocking orange.) Hagen also taught Spanish art, and Fred Licht (in his *Goya*) has reminded us of the value of Hagen's approach. It is embodied in a little book entitled *Patterns and Principles of Spanish Art,* his most obviously Wölfflinian production. Like his teacher, Hagen was a believer in the ideal of an art history without artists—in Germany he had written a book called *Deutsches Sehen.* But he failed to be a real force in his adopted country: Wisconsin was not a center of art-historical study and by the end of his career he had long since lost contact with the scholarly establishment. Hagen was a unique figure at Wisconsin, educated in the old school and cultured as few men are. Late in life, going on summer vacation, he announced that the only book he would take along was the New Testament in Greek.

Scarsdale, New York

Introduction:
Early Years in Milan and Rome

Caravaggio's name was Michelangelo Merisi; in Rome, where he first established himself as an artist, he was called "Caravaggio" because the farming community of that name, east of Milan, was the family home. His father, Fermo di Bernardino Merisi, had probably been born there and was named after a locally revered saint. Fermo was a man of repute, *mastro di casa* (which is to say, steward or majordomo), and perhaps even architect to the young Francesco Sforza, the Marchese di Caravaggio (circa 1551–1583). Although Fermo is called *mastro* or *magister* in contemporary documents, we can probably say that he belonged to a rising class of dignified people that approached the status of what we call the gentry in England, below the nobility but above peasants and mere workers. From later documents we learn that Fermo owned land in and around Caravaggio. In 1563 he married and was already living in Milan. A daughter, Margherita, was born in 1565, another daughter died in 1567, and their mother must have died soon after as well. On 14 January 1571 Fermo married Lucia Aratori, Caravaggio's future mother. Since Marchese Francesco Sforza lived chiefly in his Milanese palace, the Merisi family was also in Milan during most of this time, living in the parish of Santa Maria della Passarella.

We can be reasonably certain that Michelangelo was born near Milan between September and December 1571. On 25 September 1589 he swore to be eighteen, but presumably he was anticipating a bit. We know as a documentary fact that his younger brother, Giovan Battista, was born in Milan on 21 November 1572. Michelangelo's birth must have been close to the date of the Battle of Lepanto (7 October 1571), in which a papal league decisively set back the Ottoman Turks in the Gulf of Corinth. He was seven years younger than Shakespeare but surely never heard of him. Shakespeare's exact contemporary, the revolutionary Tuscan scientist Galileo (1564–1642), was a friend of some of Caravaggio's Roman patrons. The greatest artistic genius of this generation was, arguably, Claudio Monteverdi (1567–1643), a

north Italian like Caravaggio, whose brilliantly innovative musical career unfolded in Mantua and Venice.

The plague raged terribly in Milan throughout 1576, and at some time Fermo Merisi must have moved back to the family home in Caravaggio, where he died intestate on 20 October 1577. His father, Bernardino, died the same day, and Fermo's brother Pietro also succumbed, all presumably victims of plague. Michelangelo's mother was left with four children, the eldest barely six. They stayed on in Caravaggio, where her third son, Giovan Pietro, died in 1588. The other child was a daughter, Caterina.[1]

Milan

Michelangelo Merisi, described as living in Milan, was apprenticed on 6 April 1584, aged about twelve and a half, to the Milanese painter Simone Peterzano, who was then living in the parish of San Giorgio al Pozzo Bianco. The notarial document stipulated four years' service in Peterzano's home and shop together with payment by Caravaggio of 24 gold *scudi*.[2]

Milan at this time was nominally ruled by Philip II of Spain through a governor, but it was dominated by the spirit of Archbishop Charles Borromeo (1538–1584). He had been a force in the last sessions of the Council of Trent and was canonized in 1610, the first of a great succession of Counter Reformation saints that included Ignatius Loyola and Teresa of Avila. Charles was the first resident archbishop in a century, which points up the decay of the Italian Renaissance Church. He literally wore himself out trying to repair the damage and threatened to excommunicate the Spanish rulers when they interfered, citing the example of his great Early Christian predecessor, St. Ambrose. By example and reform, Charles harried Milan into the Catholic Reformation era almost in spite of itself. Perhaps some splinter of his zealous spirit embedded itself in Caravaggio.[3]

Caravaggio's master, Simone Peterzano, worked chiefly in Milan from 1573

[1]Caravaggio's probable birthdate and other information on his early career began to come to light during preparations for his supposed quatercentenary in 1973. See Cinotti (1975, pp. 192 ff.). Much of the data had already been printed by Cinotti (1973). Caravaggio's father may have been from a family of architects: a Giulio Merisi da Caravaggio had been architect of the Palazzo Capodiferro-Spada in Rome, c. 1550: Frommel (1973, II, p. 78 and *passim*). Cf. Bertolotti (1881, I, p. 53).

[2]This and all other documents known c. 1970 are printed in Cinotti (1971, pp. 146 ff.), sometimes with new transcriptions. Summaries in Cinotti (1973), with newly discovered material about Caravaggio's birth, and a few errors, corrected and amplified by Cinotti (1975). Marini (1974) also prints the documents.

[3]See Gregori (1973, pp. 19 ff.) and, in general, *Storia di Milano* (1957). For St. Charles, see M. de Certeau in *Dizionario biografico degli italiani* (XX, 1977, pp. 260 ff.). The Counter Reformation is surveyed by O'Connell (1974), which lacks theological discussions; see the *Enciclopedia cattolica* and the *New Catholic Encyclopedia*. Evennett (1970) is the best short introduction. Cf. Cochrane (1970) for essays on the general period.

until 1596. He came from nearby Bergamo, which was Venetian territory, and had evidently studied with the aged Titian in Venice since he signed one painting "student of Titian" [114]. Venetian art was so clearly dominant in north Italy during the Cinquecento that most Lombard artists were at least touched by its light and color, its fluid and sometimes dynamic rendering of forms in space, its lyrical themes. One of Titian's greatest altarpieces, a *Christ Crowned with Thorns,* was in a Milanese church, but its presence did not suffice to inspire the local school. By the end of the century there must have been a strong sense even in Venice that the golden age was over; talented younger artists like Palma Giovane (circa 1548–1628) failed to approach the incandescence of their masters. The single exception was El Greco (1541–1614), who had moved from Crete to Venice to Rome and finally to Spain in 1577. His art, essentially unknown to Italians, was predicated on the achievement of Venice and particularly that of Tintoretto. Perhaps Peterzano was in Titian's studio together with El Greco in the 1560s.

By comparison with Titian, Tintoretto, and Veronese, Milanese painters were rigidly academic. Giovan Paolo Lomazzo (1538–1600), the chief theoretician of Milanese art, went blind early in his career; his successors were mediocrities like Peterzano. Despite his Venetian training, Peterzano's art is thoroughly Lombard, with weighty classicizing forms, hard outlines, and realistic details only occasionally enlivened by a flicker of Titianesque color and atmosphere [88, 114]. A stronger, more popular art was practiced by members of the Campi family from Cremona, and some of them were painting in Milan in Caravaggio's time [142, 157]. Perhaps as a consequence, the next generation of Lombard painters was more vigorous than its counterpart in Venice although only Caravaggio attained international stature.[4]

No paintings from Caravaggio's Lombard years have been identified. Since north-Italian reminiscences crop up in his later pictures, it will be more useful to discuss these memories when they are appropriate than to try to recreate what Caravaggio may have seen and remembered from his earlier years. Surely he knew works by all the local masters, past and present, not only of Milan but of nearby Lodi [16, 152] and Cremona [14]. Brescia and Bergamo, not far away, had strong local schools of painting that were frequently renewed by contact with Venice. Savoldo, Romanino, and Moretto in Brescia [79] were probably direct influences on Caravaggio's art. There were also a variety of Giorgionesque painters active in Lombardy whose works Caravaggio would have known, such as Giovanni Cariani [39], who worked in Bergamo, and Bartolommeo Veneto [19], who spent his last years in Milan.

[4]For Lombard painting, see Dell'Acqua (1957); Ciardi (1968, pp. 23–31); Freedberg (1975); Begni Redona (1963); Bossaglia (1964); and Zampetti (1975–). Peterzano is discussed by Baccheschi (1978).

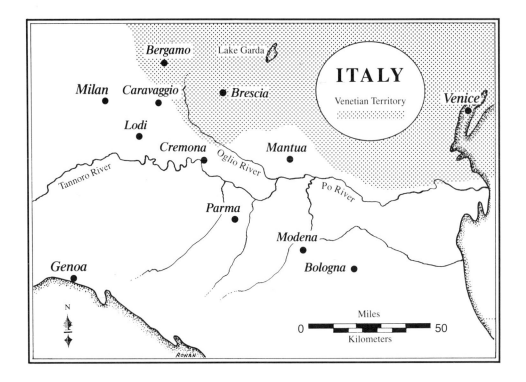

Lorenzo Lotto (died 1556) painted poetic visions during a long stay in Bergamo, where G. B. Moroni (died 1578), Moretto's pupil, carried on a literal version of his teacher's style [123] that can still be identified in an early portrait by Caravaggio [27].[5]

Caravaggio should have learned from Peterzano the fundamentals of painting, the grinding of colors, the preparation of walls for fresco, and the basic principles of drawing and applying paint to wall and canvas. He learned those things, that is, if he actually completed his apprenticeship. In view of his later resistance to authority, his impatience and unusual belligerence, we may wonder. Moreover, there are fundamental aspects of Renaissance painting, mastered by Peterzano, that Caravaggio did not learn or refused to practice. He never painted frescoes. He was presumably not much of a draftsman since not one drawing has survived. His ability to paint figures in a believably receding space was deficient. Peterzano's name is absent from Milanese documents during 1586–1589; part of that time he may have spent in Rome. If he did not take the young Caravaggio along, his education may have been interrupted or terminated in ways that we do not know. Nevertheless, Giulio Mancini, our earliest

[5]The most important early proponent of Caravaggio's Lombard origins was Roberto Longhi (1929); cf. Gregori (1973). Friedlaender (chapter 2) gives a good survey.

Roman source of information, was of the opinion that Caravaggio had served a normal apprenticeship.

There was a rumor, much later, that Caravaggio killed someone and had to flee Milan—Giovan Pietro Bellori, a reliable Roman scholar, scratched this in the margin of Giovanni Baglione's *Lives of the Painters.* The story may have come from Mancini, who heard that Caravaggio had committed a crime and spent a year in a Milanese jail.[6] True or not, it must have sounded probable in the light of his later escapades. Perhaps, however, Caravaggio's character was not wholly unusual. The painter and theoretician G. B. Armenini remembered a visit to Milan, perhaps in the late 1550s, when he "took up with some young Milanese whom I found much more dedicated to adorning themselves with clothes [Milan was the home of millinery] and fine shining arms than to handling pens or brushes"—which at least in part describes the Caravaggio we know in Rome.[7]

On 25 September 1589, Michelangelo Merisi, *"Habitans Caravagii,"* swore that he was eighteen years of age; the document was for the sale of property. Various notices place him in Caravaggio during the following months; his mother died there on 29 November 1590. The family was evidently in debt, and in 1590–1591 they sold more land, with Michelangelo keeping the money and perhaps spending some of it unwisely. On 11 May 1592 there was a final and surprising division of property between Michelangelo, his brother Giovan Battista, and his sister Caterina. It left Michelangelo an inheritance of 393 Imperial pounds, which might have been enough to support him for a few years if he had been careful. The settlement mentions an uncle, Ludovico, a priest "formerly of Milan now living in Rome." Presumably Michelangelo then set off for Rome. Michelangelo and his younger brother, who was destined for the priesthood, could have gone to Rome together. Giovan Battista was studying moral theology with the Jesuits in Rome in October 1596 and was there again (or still) early in 1599.[8]

Bellori supposed that Caravaggio went to Venice before coming to Rome and thought that he discovered there the art of Giorgione, to whom he attributed

[6]Mancini wrote that Caravaggio was apprenticed in Milan and worked diligently, "although now and again he would do some outrageous thing" (p. 223; see Appendix II, p. 346). In a later note filled with a confusing jumble of ideas, Mancini says that he committed a crime, wounded a police agent, and was thrown into a Milanese jail for a year (p. 227, n.). Bellori, in a marginal note to his copy of Baglione's *Lives,* wrote that Caravaggio killed a companion and had to flee the territory (margin, p. 136; see p. 351 below). Baglione himself seems to have known none of this; when Bellori came to write his life of Caravaggio he merely said that after he had painted portraits for some time, being quarrelsome and contentious, he got into trouble and fled Milan for Venice. No records of these Milanese difficulties have yet been found (Cinotti, 1975, pp. 211–212).

[7]Armenini (1977, p. 290). For Mancini, Baglione, and Bellori, see Appendix II, pp. 346, 351, 360.

[8]See Cinotti (1975, pp. 206–211). He was ordained subdeacon by the Bishop of Bergamo on 18 December 1599 and presumably lived in Lombardy thereafter. Cf. p. 31, n. 17.

Caravaggio's early colorism. His theory has no basis in fact.[9] If Caravaggio did go to Venice (there is no evidence in his early works for such a visit), he would presumably have been more interested in contemporary masters. We assume that he arrived in Rome in the latter months of 1592 or early in 1593.[10]

Rome

In Caravaggio's day the pope was not only head of the Catholic Church but also a worldly prince with extensive lands and considerable power. The Catholic Reformation, the predominant cultural phenomenon in Rome between 1550 and 1600, produced a great and deep spiritual revival with new missions, charity, and a tendency toward mysticism. But these changes were accompanied by a strengthened bureaucracy that made the pope an increasingly secular monarch in close political alliance with other states. Hugh Trevor-Roper pointed out that

> in the late sixteenth and seventeenth centuries the Catholic Church was not only, in politics, the Church of the princely system, and, in society, the Church of a "feudal," official system: it was also exclusively tied to these systems. Its old elasticity had gone, intellectually and spiritually as well as politically. While the Protestant Churches (or some of them) contained within them a wide range of ideas and attitudes—liberal Calvinism for their merchants and entrepreneurs, Anabaptism and Mennonism for their industrial workers—the Catholic Church no longer had anything similar.[11]

Clement VIII Aldobrandini (reigned 1592–1605) had to accommodate the papacy to a number of crises. Catholic Spain was fighting France, England, and the Netherlands. The assassination of King Henry III of France in 1589, and worries over his Protestant successor, Henry of Navarre, had Catholic Europe in alarm. Pope Clement, who had been elected with Spanish support, solved the French problem in 1593 by embracing Henry and his political decision to convert to Catholicism (he supposedly capitulated by saying cynically, "Paris is worth a Mass"). The pope and indeed all of Europe had graver worries in the East, where the Sultan of the Ottoman Empire, temporarily free from Persian aggression, again threatened the Imperial lands of Austria. In a war lasting from 1593 to 1606 the emperor had to give up his

[9]Bellori's ideas of Giorgione's color were not based on first-hand knowledge of the paintings but derived from books (Ridolfi, 1648; ed. Hadeln, 1914–1924, I, p. 107, and perhaps also from Boschini: see Friedlaender, p. 14, and Borea in Bellori, 1976, p. 212, n. 6, for Boschini).

[10]The documents show that Caravaggio was at liberty to leave home in May 1592, and the nature of the division of property indicates that he did.

[11]Trevor-Roper (1969, pp. 41–42). On the papacy, see Pastor. Pecchiai (1948), Petrocchi (1970), and Paschini (1958) are local histories. Partner (1976) is a good introduction to the earlier Cinquecento. See also the economic survey by Delumeau (1957–1959) and the generally sound remarks in Evennett (1970).

Hungarian crown to a Turkish puppet, and the Muslim threat remained until late in the seventeenth century. In 1593 a Turkish fleet looted the Calabrian coast and sacked Reggio, thereby beginning an undeclared war between the Turks and Spain that simmered for years. Throughout this period the Mediterranean was overrun with pirates, chiefly Muslims based in North Africa; their fiercest antagonists were the Catholic Knights of Malta, who were themselves pirates. At home, Romans suffered from extreme famine during the years 1590–1593. Every year also seemed to witness some new repression of thought. Late in 1594 Tommaso Campanella was transferred to the prisons of the Roman Inquisition and in 1600 Giordano Bruno was burned alive in the Campo dei Fiori.

Since Caravaggio's first documented works date from 1599–1600, we are forced to rely on later biographers for our knowledge of the period 1593–1599, when he grew to maturity as an artist. None of these writers is wholly reliable or complete, and because Caravaggio's style and subject matter changed and fluctuated during the 1590s it is impossible to be sure of the dates or even the authenticity of some of the early works.

The earliest of the basic sources for Caravaggio's life and art are the manuscripts of the unscrupulous dilettante-collector Giulio Mancini (1558–1630), who became personal physician to Pope Urban VIII in the 1620s. Mancini compiled a "Treatise on Painting" between 1617 and 1621 and also tried to catalogue the paintings in Roman churches. Apparently he did not actually know Caravaggio, but he had been a friend of Monsignor Melchiorre Crescenzi, whose portrait Caravaggio supposedly painted. Mancini's brief report on Caravaggio's early life is supplemented by that of Giovanni Baglione (circa 1566–1643). Baglione's pages on Caravaggio form a short but reliable record of his Roman career, written by a contemporary painter who was also a sworn enemy. Giovan Pietro Bellori (1615–1696) generally followed Baglione and Mancini, with some changes and new information. His *Life* (1672) embodies a judicious assessment of the artist, who is seen and criticized from the point of view of a learned seventeenth-century classicist whose ideas had been tempered by a long friendship with Poussin.[12]

We learn from Mancini, who was well informed about the family in Milan, that Caravaggio's father, Fermo Merisi, was *mastro di casa* and architect to the Marchese di Caravaggio, and that after an apprenticeship of some four years Cara-

[12]Mancini was thoroughly discussed by Salerno (1957; cf. Mahon, 1947, pp. 32 ff. and appendix 2). On Mancini as a "dealer," see Haskell (1980, pp. 123–124). He was characterized by Hess as a dilettante who wrote for noble gentlemen who wanted to know "just enough" about painting to seem informed (1968, esp. pp. 116–117).
For Baglione, see Appendix II, p. 351 and Notes to illustrations 10 and 96. For Bellori, see p. 360 and below.

vaggio came to Rome, aged about twenty. Numerous additions to Mancini's manuscripts show that he and other annotators made efforts to get further news. One such note mentions that Caravaggio first stayed with a certain Tarquinio (Ligustri?) and then for a few months with a Monsignor Pandolfo Pucci from Recanati. Pucci is a historical figure, steward to the sister of Pope Sixtus V Peretti and later Archpriest of Loreto.[13] Caravaggio had to do demeaning work; he claimed to have been fed nothing but greens, which led him to call Pucci *"Monsignor Insalata."* According to Mancini, Caravaggio painted a few pictures at this time and then became ill and had to go to the Hospital of Santa Maria della Consolazione, where he continued to paint during a lengthy recovery. In a later note Mancini inserted a stay with the Cavalier d'Arpino before Caravaggio's illness, which seems to be correct. Later, according to Mancini, he had a room in the Palazzo Santacroce-Petrignani.[14] Other aspects of Mancini's *Life* show him to have been only partially informed; like other writers, he was chiefly engaged by Caravaggio's early works.

Baglione, whose *Lives* were published in 1642, gives slightly different information, and since he was himself a painter in Rome during this entire period, we have to take all his statements seriously. He wrote that after Caravaggio came to Rome he worked for a Sicilian. (Bellori wrote in the margin of his copy of Baglione that the painter's name was Lorenzo and added that Caravaggio was extremely poor, without clothing, and painted three heads a day for almost nothing.) A much later biographer reported that at this time Caravaggio fell in with an apprentice from Syracuse, Mario Minniti (1577–1640), and that they became friends in hardship.[15]

When we read about Renaissance painting we usually study the great commis-

[13]For supposed connections between the Peretti and the Sforza da Caravaggio, see Calvesi (1975, p. 78). For Pucci and other early patrons, Cinotti (1971, p. 173, n. 14, and *passim*). Caravaggio's many changes of residence are cited in ibid. (pp. 62 ff.).

[14]This and other early contacts are discussed in Cinotti (1971, notes, pp. 172 ff.). Caravaggio's stay in the Palazzo Petrignani is mentioned only by Mancini, who did not know Caravaggio; it has been supposed to date from 1595 at the earliest because Petrignani was resident in Forlì during 1594 (Hess, 1967, p. 230, n. 3; Cinotti, 1971, p. 174, n. 25; cf. Frommel, 1971, pp. 7–8 and n. 21). The Easter Census *(Stato d'anime)* of 1595 lists only six people in the "Palazzo di Monsignor Fantino" and neither Caravaggio nor Petrignani (Archivio del Vicariato di Roma, *San Salvatore in Campo, 1595–1632,* 1595, fol. 21, no. 129). That of 1596 again lacks either Caravaggio or Petrignani (1596, fol. 23; Fantino's brother Settimio was not listed in either year; the family seems to have been away). The other years from the 1590's are missing. Since we can probably assume that Caravaggio was taken up by Cardinal Del Monte c. 1595 or at the latest in 1596, Caravaggio may already have moved out when the census for 1595 was taken.

[15]Our information comes from Susinno's life, dated 1724 (1960, pp. 116 ff.; cf. Appendix II, p. 380). He wrote that Minnitti arrived in Rome young, where he met Caravaggio in the shop of a gross Sicilian painter; they then determined to strike out on their own and lived together for some time. How one reconciles this with Caravaggio's residence with Cardinal Del Monte, I do not know; further, see Frommel (1971, pp. 7, 25; 1971a, pp. 30 ff.). In the trial of September 1603, Caravaggio stated that he knew a *"Mario pittore"*: "this Mario once lived with me and left three years ago, and I have not spoken to him since." (Cinotti, 1971, p. 155, F. 52; cf. her p. 176, n. 71.) Further, see p. 161 and nn. 16, 18.

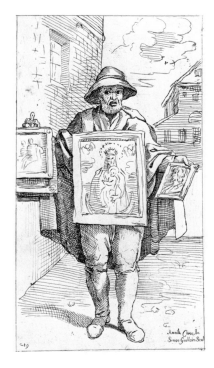

1. After Annibale Carracci, *Vende Quadri (Picture Seller)*. Engraving, 1646.

sions, forgetting the hordes of minor artists who sold or tried to sell their wares on the open market—some were even hawked on the street like apples or brushes [1]. In the beginning Caravaggio worked for painters in this category. Bellori at one time believed that Caravaggio next turned out quantities of half-figures for Antiveduto Grammatica (circa 1570–1626), who was at first known chiefly as a portrait painter. This connection may be significant since Caravaggio's first patron, Cardinal Del Monte, owned many pictures by Antiveduto.[16]

All the writers agree that Caravaggio soon went to work for Giuseppe Cesari, later the Cavalier d'Arpino, which is our first useful piece of Roman information. Cesari (1568–1640) was a precocious participant in the papal fresco commissions of the late 1580s and then attained fame and position as the favored painter of Pope Clement VIII.[17] Baglione claims that Caravaggio stayed in Cesari's house for some

[16]In the marginal note to Baglione (see p. 351) Bellori went on to say that Caravaggio came to Rome, painted three heads a day for Lorenzo Siciliano, and then, being very poor, worked in Antiveduto's house knocking out half-figures. Del Monte's collection of paintings by Antiveduto (see Frommel, 1971) could well have been gathered afterward; but since he habitually patronized younger, promising artists, it is possible that he was in contact with him by this time. (Baglione's *Life of Antiveduto*, c. 1570–1626, is on his pp. 292 ff.)

[17]Röttgen (1973) is the basic study. Mancini's later notes on Caravaggio's stay (p. 226, n. to line 22) are confusing because he seems to say that Caravaggio lived with Bernardino (Cesari) at their house *alla Torretta*, but it is difficult to make sense of the passage (cf. Marini, 1974, pp. 12–13). Bernardino was out of Rome until June 1593 (Röttgen, p. 28), which may help the early chronology. Zeri (1976) has attributed still-life paintings to Caravaggio from this early period that are almost certainly not by him and that have nothing to do with his known style of painting still life; cf. Sterling (1981, p. 17 and pl. 55).

months after working for the man Bellori called Lorenzo Siciliano. Presumably this residence took place in 1593. Mancini indicates a stay of eight months, terminated by Caravaggio's illness (a later note tells us that he was kicked in the knee by a horse) and a lengthy stay in the Ospedale della Consolazione.[18] Bellori says that Cesari employed Caravaggio to paint flowers and fruits, "which he imitated so well that from then on they began to attain that greater beauty that we love today." In other words, Bellori seems to credit Caravaggio with turning still life painting into art [cf. 47]. The example he gave, a *Vase of Flowers* long since lost, was probably painted later for Cardinal Del Monte. We do know that Caravaggio painted a portrait of Giuseppe Cesari's brother Bernardino, for it was listed in an inventory drawn up by Giuseppe himself.[19]

We can only speculate on the possibility that Caravaggio helped Giuseppe Cesari in his fresco commissions, which were numerous in this period. Not only was he finishing the vault of the Contarelli Chapel [49] but he was also being urged to complete the decorations of the Olgiati Chapel in Santa Prassede [176], which were presumably done in 1593–1595. There we see rich swags that could just possibly have been drawn and even painted by Caravaggio, together with graceful figures deriving from Raphael and Michelangelo that are unlike Caravaggio's early work.[20] Cesari's smaller pictures would have been more important for Caravaggio's youthful style, since he began to paint mural-sized paintings only around 1600. One of Giuseppe's most attractive mythological pictures, a *Perseus Rescuing Andromeda* [8], probably dates from 1592–1593 and hence might well have been seen by Caravaggio when it was under way. Its stylish representation of figures in difficult poses, like the flying Perseus together with the nude Andromeda in a landscape, conjure up a dream world that is very far from Caravaggio's own first essays in mythology [cf. 9]. Cesari's picture belongs to the sophisticated world of the late Renaissance and represents a style that we sometimes call Mannerism. Caravaggio's paintings represent a break with that style—but whether he was a conscious "anti-Mannerist" is debatable.[21]

[18]Mancini (p. 224 and n.) reported that while in the hospital, Caravaggio made many paintings for the prior, who took them home to Seville (note: Sicily). Although Mancini is not always correct, his information about the very early years is more particular than any other source. Frommel (1971, p. 7 and n. 19) has surmised that the most probable time for Caravaggio's stay would have been under Prior Giovanni Buttari, who served from 27 April 1592 until 24 January 1594. He could have been Sicilian.

[19]Listed in the inventory of Costanzo Patrizi's collection, dated 27 February 1624 (Rome, Archivio di Stato, *Archivio dei 30 Notari Capitolini,* Leonardus Bonannus, Busta 92, fols. 355 ff.). Caravaggio's painting is cited on fol. 388, valued at 25 *scudi,* a modest sum. Another version of the inventory is in Archivio Storico Capitolino (Not. A. Richetto, Busta 592). Cf. Cinotti (1971, p. 163, F 99) and my Note to illustration 137.

[20]Röttgen (1973, pp. 29–30 and p. 177, Doc. 2). The decoration of the vault followed soon after that of the Contarelli Chapel [49]; see Notes to illustrations 49 and 71 below.

[21]The idea was the logical outcome of the concept of Mannerism as an anticlassic style; both derive from Walter Friedlaender (reprinted 1957) and date to the early decades of the century. See also Shearman (1967).

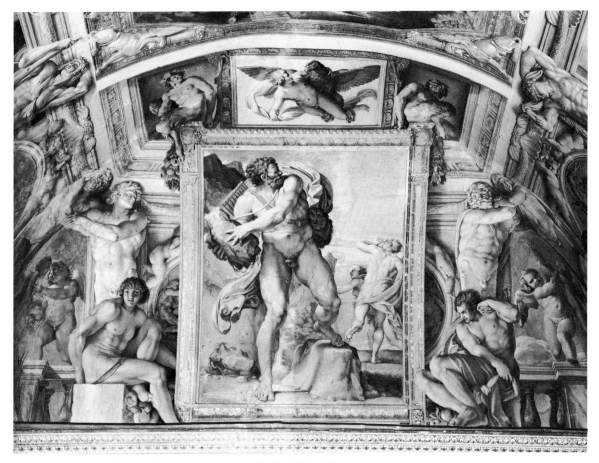

2. Annibale Carracci, Galleria Farnese, vault frescoes (detail). 1597–1600.

The art that Caravaggio saw being practiced and praised in Rome was chiefly large-scale fresco decoration. It had been produced by the yard under Sixtus V, who reigned vigorously from 1585 to 1590. He transformed Rome by laying out new streets, re-erecting ancient obelisks, and building palaces, an aqueduct, and fountains —a flurry of construction that was crowned by the great dome of St. Peter's. The frescoes he commissioned, of small artistic worth but often of topographical interest, decorate the new Vatican Library and other buildings thrown up with great hurry and little thought by the impetuous pope. During Caravaggio's years in Rome these fresco commissions continued and indeed increased as the Jubilee year of 1600 drew near. The transept of the Cathedral of Rome, San Giovanni in Laterano, was completely redecorated, an enormous work of many hands under the supervision of Giuseppe Cesari d'Arpino. The most grandiose of these fresco decorations is in the

11

Sala Clementina of the Vatican; the best of them is the smaller but artistically imposing Galleria Farnese, a private commission from a young cardinal [2].[22]

The intelligent and gifted Annibale Carracci (1560–1609) frescoed the vault of the Galleria in the years before 1600, just when Caravaggio was rising in accomplishment and prominence. But if we juxtapose one of his small paintings of the early years [9] against Annibale's superb frescoes in the Galleria, we may well wonder just how much Caravaggio could have hoped to achieve in papal Rome and how he might have set about doing it.

Caravaggio never painted in fresco. He always worked within a relatively narrow foreground space, but his pictorial scope and accomplishment grew dramatically in the ensuing decade. His art is also compulsively personal, with direct or indirect self-references, as in [9], where he probably represented himself as Bacchus. All of this is very different from the assimilated High Renaissance sophistication of Annibale's great frescoes.

[22]See Wittkower (1980). For Annibale Carracci, see Posner (1971). A chronology of painting done under Pope Clement VIII is in Abromson (1981). Röttgen's essay on Cesari (1973) gives a good sense of his rise under Clement VIII. Cf. Kirwin (1972) and Strinati (1980). Patronage is discussed more broadly by Haskell (1980), but he is concerned chiefly with the period after c. 1621.

I
FINDING THE WAY

I

Early Secular Paintings

Mancini, our earliest informant, lists a *Boy Bitten by a Lizard* and then a *Boy Peeling a Pear* as Caravaggio's first paintings, but we cannot be sure that either of them has survived [cf. 25, 3].[1] For stylistic reasons the *Boy Bitten* can hardly be among Caravaggio's first works. But many copies of a painting showing a boy peeling a small green citrus fruit presumably reflect a primitive original that may be shown in [3]. The half-length figure with an open white shirt, seated behind a table, performs his mundane task. The fruits, which include bergamots, red and yellow peaches, nectarines, and red cherries as well as grain, are all painted with a precision that exceeds the competence of the stylized figure, which is carefully modeled in light and dark. A ray of light cuts into the upper right-hand corner; in the *Luteplayer* [18] and in the *Boy Bitten,* which were probably painted several years later, the effect has increased. We cannot be sure that the simple scene has any significance other than as proof that the young artist had mastered some aspects of still-life painting, a genre that was then associated with north Italy and even more with France, Germany, and the Netherlands. A number of these northern artists were in Rome at this time. Northern still life is often without people, and Caravaggio seems from the beginning to have combined something of the northern tradition with the old Italian predilection for humankind as the principal subject of art.

The two earliest paintings usually attributed to Caravaggio, apart from the *Boy Peeling,* were taken from the Cavalier d'Arpino by the greedy new cardinal-nephew, Scipione Borghese, in 1607 [4, 9]. We may even imagine that they had been produced when Caravaggio was painting fruits and flowers for Cesari d'Arpino,

[1]Information on the paintings is gathered in the Notes to the Illustrations, beginning on p. 268. References to these notes have a capital N: e.g., Note 3. In another context Mancini seems to indicate that the *Boy Bitten* was not one of the very earliest paintings: see Note 25.

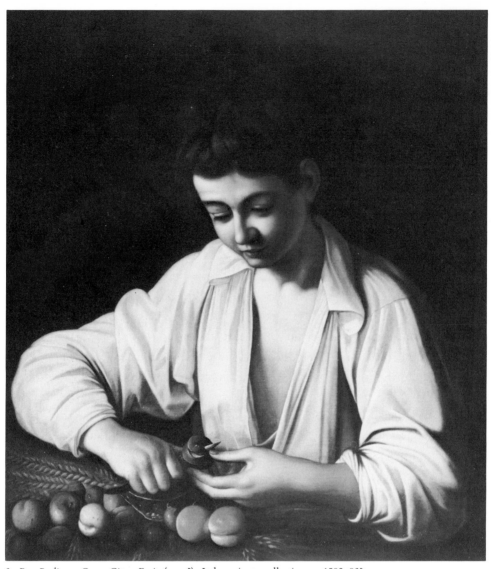

3. *Boy Peeling a Green Citrus Fruit* (copy?). Italy, private collection. c. 1592–93?

which is what Baglione wrote in 1642. Caravaggio was supposedly in the Hospital of Santa Maria della Consolazione for a considerable time after his stay with the Cesari and painted many pictures there. Nevertheless we cannot insist on very early dates for most of the surviving works. It is possible that only the *Boy Peeling* dates from before 1594. We assume that sometime around 1594–1595 Caravaggio was on his own, possibly living some of the time in the Palazzo Petrignani. The Bolognese biographer Carlo Cesare Malvasia reported in 1678 that Caravaggio at first had to show his pictures in public—presumably in outdoor exhibitions, which was the

lowest category of art merchandising then as now.[2] Mancini tells us that Caravaggio's early pictures were painted to sell, which is to say that he had no commissions. One of the many problems surrounding Caravaggio's early works is the small number that remains from the time before his first recorded commission in mid 1599. Only about a dozen smallish paintings survive from that period of six or seven years. The earliest are roughly two or three *palmi* (45 × 65 cm) in size.

A BOY WITH A BASKET OF FRUIT

The *Boy with a Basket of Fruit* [4] stands as a kind of prop for a still life. The luxuriant produce, vaguely autumnal with three kinds of grapes, is not precisely a seasonal display since it also includes fruits that mature earlier. Certainly the fruits and leaves in their succulence and vivacity far outstrip the callow youth, whose anatomy seems to have caused the painter so much trouble that some writers have tried to take the boy away from Caravaggio, leaving him only the fruit. The boy's strained shoulder and neck betray a crude technique and fumbling knowledge of the body that are nevertheless superior to the bland forms of the *Boy Peeling* [3]. The face of the boy with the basket, its ruddy complexion brushed in rather coarsely, conveys no clear message other than a vague wish to please, which might be appropriate for a vendor. His open mouth, which seems to reveal the tongue, gives the spuriously momentary air of just passing by—quite different from the natural effect of the long pose that must have been required. There is a soliciting aspect to this picture, and since some of Caravaggio's other paintings of the 1590s are apparently homosexual in implication, we may read at least unconscious elements of this kind into the *Boy with a Basket,* whose fruits have various potentially symbolic meanings.

This kind of painting was not particularly fashionable in Rome—famous painters were not producing such works—but the inventory of pictures seized from the Cavalier d'Arpino in 1607 included both this and the *Self-Portrait as Bacchus* [9]. The inventory also lists a number of still-life subjects, some of which could have been by Caravaggio. Such pictures were famous in antiquity: Pliny the Elder, for example, described a painting by Zeuxis of a boy carrying grapes that was so realistic that the fruit fooled birds into trying to eat it.[3] Still-life painting is often mentioned in his

[2]Malvasia (II, p. 9; 1980, p. 43) wrote that before Cardinal Del Monte discovered Caravaggio, his paintings, "because they were not seen in good places but rather depreciated by the artist's need . . . went begging in all the public exhibitions." For exhibitions, cf. Haskell (1961), which is chiefly concerned with a later period; see also Note 98 below.

[3]For Zeuxis, see Pollitt (1965, pp. 155–156; cf. *idem,* 1966, p. 223, for *xenia,* paintings of food). The subject is discussed by Sterling (1981); see also pp. 80–84 below. For art as a copy of reality, see Kris & Kurz (1979, chapter 3).

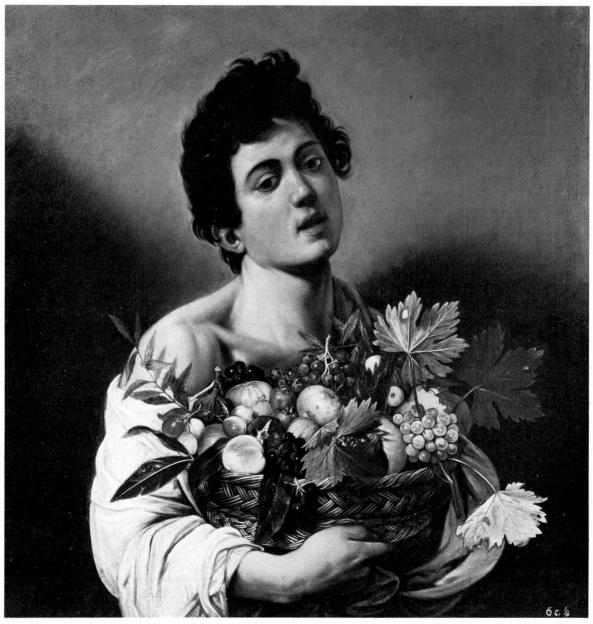

4. *Boy with a Basket of Fruit.* Galleria Borghese. c. 1594?

pages and elsewhere in ancient writing on art. Men of the Renaissance combed Pliny for clues to the nature of the lost art of antiquity, and it was natural for still life to be revived in Italy. Even more to the point for Caravaggio, perhaps, was a new vogue for still life and genre in sixteenth-century Lombardy. One example is Vincenzo Campi's *Fruitseller* [5]. Caravaggio's picture is far more focused and the fruit is more naturalistically painted, but it has Milanese parallels that go back to the circle of

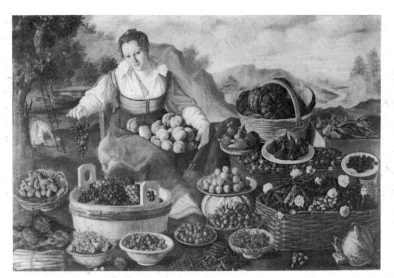

5. Vincenzo Campi, *Fruitseller*. Milan, Brera. c. 1580?

6. Ambrogio de Predis, *Girl with Cherries*. New York, Metropolitan Museum. c. 1494?

Leonardo da Vinci [6]. Since we have reason to believe that Caravaggio remembered Leonardesque pictures later on, this antecedent has some significance.

In the *Boy with a Basket* we notice a strong diagonal shadow cast by light apparently entering the room from above, the beginning of Caravaggio's famous "cellar light." This light, and the strong modeling of the forms in the foreground, make his early pictures strikingly different from those of another great northern innovator, Annibale Carracci. Annibale's *Bean Eater* [7], painted in Bologna some ten years earlier, presents a broadly painted, realistic still life that is indebted to Flanders and Holland. Annibale's picture uses graded tones that give a sense of finite space and atmosphere that is far more sophisticated than Caravaggio's. It is also a true genre scene showing the figure in a setting.

SELF-PORTRAIT AS BACCHUS ("BACCHINO MALATO")

One of Caravaggio's earliest surviving paintings is a little *Bacchus* with peaches and grapes [9], which Roberto Longhi called the *Bacchino Malato* because of its sickly complexion. It seems to accord with Baglione's assertion that after Caravaggio's stay with Cesari d'Arpino he tried to get along by himself and painted small pictures from his own reflection. According to Baglione, the first of these pictures painted from the mirror was "a Bacchus with bunches of various kinds of grapes painted with great care, but a little dry." Bacchus, in pseudoclassical garb, with a green-and-yellow

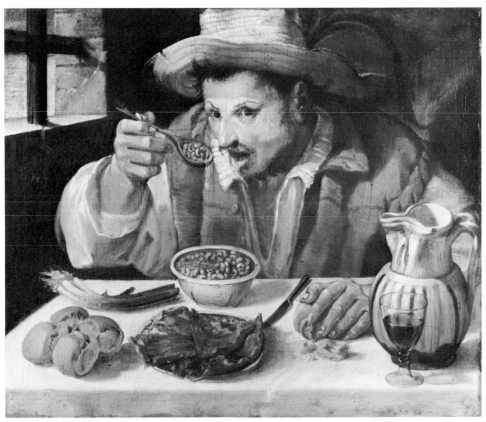

7. Annibale Carracci, *Bean Eater*. Galleria
Colonna. c. 1583–84.

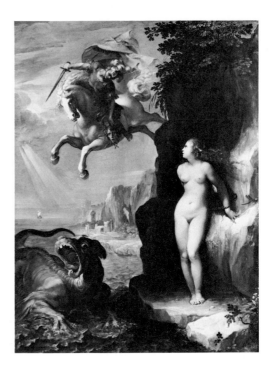

8. Giuseppe Cesari, *Perseus Rescuing Andromeda*.
Providence, Museum of Art, Rhode Island School
of Design. 1592–93.

melancholy complexion, sits hunched, faunlike and provocative, behind a simple table. He holds a bunch of white grapes in both hands and turns his head toward the viewer, forcing an unconvincing little grimace of a smile. Ivy leaves circle his head, purple grapes with their leaves and two peaches rest near us at the corner of the table. In the back there is only a generalized brown smudge. This again is a kind of still-life painting, but with a more assured treatment of anatomy than that in the *Boy Peeling* [3]. Bacchus has been consciously posed, but the composition is cut off oddly at the top and right by the frame. In addition, the ivy, the "antique" costume, and perhaps even the man's yellowish complexion give the picture mythological pretensions.

Andrea Alciati's *Emblemata,* a learned emblem book, proclaimed that the Elegaic Poet is pale and crowned with ivy, but Caravaggio's figure was more probably meant as a melancholy Bacchus. Milton, echoing ancient writers, speaks of "ivy-crowned Bacchus" without implying more, and we may want to leave it at that. Modern commentators have outdone themselves in interpretation; but when we realize that this was a self-portrait of the artist at least in part because his own face was the most constantly available, it may not be necessary to consider it a piece of profound self-analysis by a narcissistic twenty-three-year-old. Caravaggio's chief interest at this time may have been in creating something that would attract enough attention to sell. Yet this painting, like many of Caravaggio's early works, can be considered the product of a contemporary fashion for pagan subjects, with possibilities of allegorical, symbolic, or emblematic interpretation.[4] Cesari d'Arpino owned it in 1607 and may have bought it or got it from Caravaggio at the time it was painted, presumably about 1594. Although Caravaggio's pictures do look different from others of the period [cf. 24], to some extent he accepted current tastes. But he was unable or unwilling to produce a finished and facile picture in the fashionable style [cf. 8; 147 is an elaborate example in fresco by Federico Zuccaro].

In addition to the paintings discussed here, Caravaggio began to paint religious pictures—at first, perhaps, rather tentatively. A *Repentant Magdalen* and the *Rest on the Flight into Egypt* [28, 29] may have been the earliest (see Chapter 2). All the sources state that at first he did poorly but that he was befriended by men of the profession: Caravaggio's talent was manifest almost from the beginning. One such admirer was Prospero Orsi ("Prosperino delle Grottesche"), a Roman of status who was also a

[4]Beginning with Salerno (1966) and continuing in studies by Calvesi (1971), Posner (1971a), and Röttgen (1974), scholars have tried to show that Caravaggio's secular paintings are emblematic, or disguised Christian symbols, or homoerotic charades, or disguised autobiography—to mention only the dominant theses (cf. also Frommel, 1971a). Praz (1975, pp. 274–275) tried to distinguish between possible and impossible kinds of meaning for the period, but no one would now be satisfied with the old idea of Caravaggio as a simple painter of the model.

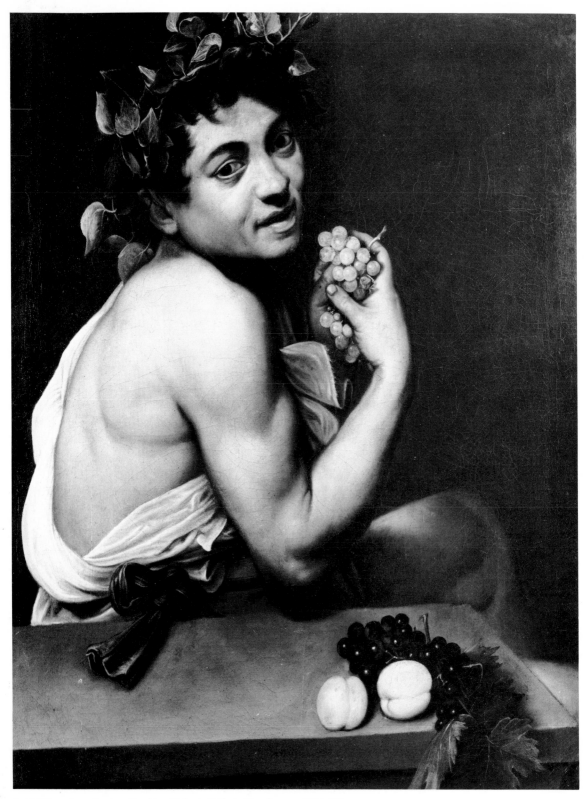

9. *Self-Portrait as Bacchus (Bacchino Malato)*. Galleria Borghese. c. 1593–94?

22

minor painter of grotesques. We do not know just when they became friends. Baglione tells us that a French dealer called Maestro Valentino, with a shop near San Luigi, finally took some of Caravaggio's pictures, and that through him Caravaggio came to the attention of his first significant patron, Cardinal Francesco Maria Del Monte.

PSEUDO GENRE: *THE CARDSHARPS* AND *THE GYPSY FORTUNETELLER*

Bellori reports that Del Monte first purchased a painting of cardplayers, not mentioned by the earlier writers, and Del Monte's inventory records it [10]. It was an unusual theme in Italy; Caravaggio never did another, although a dozen painted copies were made in the following decades. Pictures of cardplayers are now so familiar that the novelty of Caravaggio's work may easily be missed. The subject became commonplace thanks to his imitators, who played infinite variations on the theme of a dupe in the hands of cheaters [11].

Caravaggio's picture has been lost since 1899. It was organized by a table placed roughly parallel to the plane of the canvas. At the left behind the table a seated innocent consults his cards, as does a bearded, bug-eyed conspirator behind him, possibly a Gypsy, who signals to the young cardsharp in the foreground. The latter in turn reaches behind his back, where we see a five of hearts.

These plumed dandies, with their striped brocades and velvets somewhat the worse for wear, reappear in various guises in paintings by Caravaggio done as late as 1606 [140]. We must beware of datings based wholly on the repetition of a face or a costume, however, since Caravaggio surely had ways of recording them for later use and may even have owned some of the clothes. (Bellori wrote that Caravaggio "wore only the finest materials and princely velvets; but once he had put on a suit of clothes he changed only when it had fallen into rags.") We would understand Caravaggio's paintings better if we knew more about the history of costume.[5]

[5]Caravaggio's costumes have often been considered to be echoes of paintings from the earlier Cinquecento in Lombardy by Romanino, Callisto Piazza [16, 152], and others. Pearce (1953) tried to show that the costumes in the *Calling of St. Matthew* [52] were contemporary livery. The evidence may never be adequate since experts on historical costume rely on paintings and prints. Still, it would seem logical for the clothes of the boy in the *Fortuneteller* [12] and those in the *Cardsharps* [10] to be contemporary rather than historical. If they are, the similar ones in the *Calling of St. Matthew* are also contemporary. By contrast, the Bacchuses, musicians, and angels in [9, 15, 18, 22, 29, and 30] were presumably meant to evoke another time and place, antique or otherworldly. (The lutenist in [18], like the musicians in the *Concert* [15], may wear a "poetic" costume.) The clothes of the *Boy with a Basket* [4] and the *Boy Bitten* [25] may be contemporary, but they are also deliberately pushed off the shoulder, perhaps as an erotic tease. See Cinotti (1971, p. 181, n. 151).

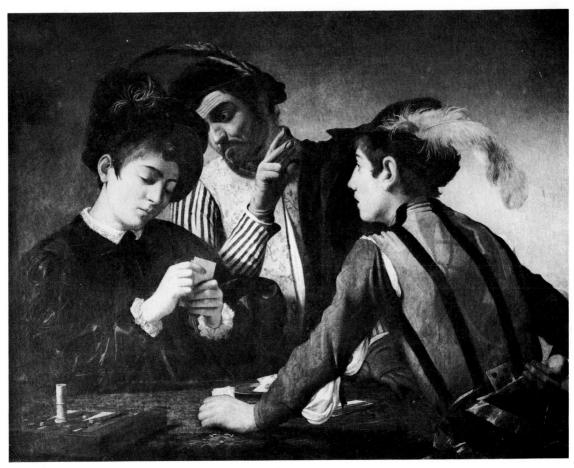

10. *Cardsharps (I Bari).* Lost. c. 1594–95?

The *Cardsharps,* which seems to be purely anecdotal, is an advance on the earliest works in the placement of figures in space. The pictures we have considered heretofore were half-length studies of boys who look out of the picture at us; in the *Cardsharps,* which was about twice the size of the earliest paintings, three distinct personalities are engaged in a scene of genre-like pantomime, carefully staged for our amusement. There had been scenes of card playing in art before Caravaggio, especially in the North, but there are no models for his large and focused treatment of a scene of cheating. Consequently the picture was sometimes interpreted later as an allegory or parable.

The *Cardsharps* is related in size and subject to another picture of duplicity,

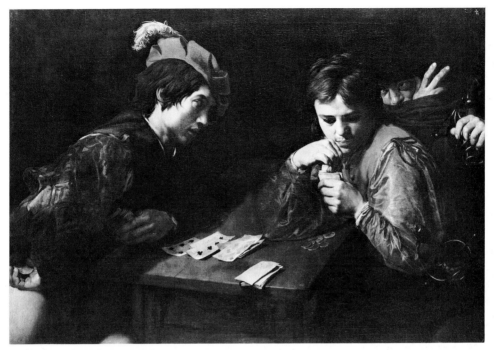

11. Valentin, *Cardsharps*. Dresden, Gemäldegalerie. c. 1615–18?

the *Gypsy Fortuneteller* [12], which Mancini said was sold for the small sum of 8 *scudi*. [6] It is also an anecdotal half-length, without background and without even the modest spatial conquests of the *Cardsharps*, which could have been painted later. Once again the sources of the subject are from the North, but no artist before Caravaggio had painted a Gypsy fortuneteller as exclusive subject. Thus he isolated a detail of northern genre and made it an independent work of art.

The *Fortuneteller* is a portrait of two youthful figures. The half-length format implied portraiture both in antiquity and in the Renaissance, and Bellori interpreted the picture in that way. Caravaggio shows the woman in the traditional costume that Gypsy women continued to wear long after the men had abandoned theirs. She looks into the eyes of a foppish boy who falls rather sweetly in love as she points to the girdle of Venus on his palm while slipping the gold ring off his finger. Gypsy women were assumed to be thieves, and while Caravaggio takes this for granted, he does not exaggerate the evil as he did in the *Cardsharps*.

[6]Cardinal Del Monte owned a contemporary variant of the *Fortuneteller* [177] that is sometimes attributed to Caravaggio: see Note 12, pp. 276–277.

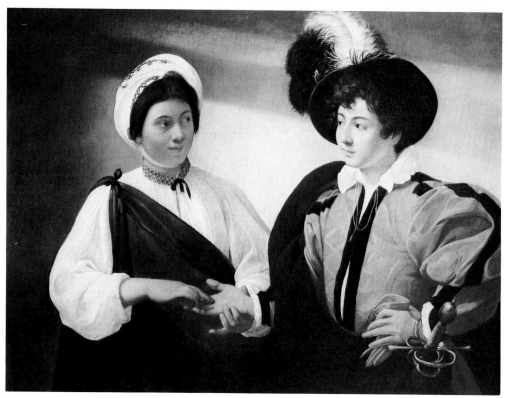

12. *Gypsy Fortuneteller.* Paris, Louvre. c. 1594–95?

The novelty of Caravaggio's *Fortuneteller* has been dimmed by imitations and variations that are often coarsely humorous. Even in Manfredi's relatively restrained and melancholy version [13], the participants have doubled in number, as have the thefts. Some of these pictures demonstrate the sour and evil associations that Gypsies had provoked in northern Europe. Caravaggio's Gypsy is almost a sympathetic figure, reflecting a somewhat different tradition in Cinquecento Italy, where the Catholic Gypsies, supposedly from Egypt, were associated with the Egyptian sojourn of the Holy Family. Gypsies had been known in western Europe since the early fifteenth century, and Boccaccino, a Cremonese artist born a century before Caravaggio, had painted one with gray-blue eyes [14]. Titian even painted the Madonna dressed something like a Gypsy, and a mysterious *"Zingarella"* by Correggio is actually a Madonna and Child.[7]

The *Cardsharps* and the *Fortuneteller,* though often imitated, are unique in

[7]The *Gypsy Madonna* is in Wethey (I, 1969, p. 98, no. 97). For the Correggio, see Gould (1976, pp. 44, 229–230). Cardinal Federico Borromeo specifically criticized Correggio for painting the Madonna as a Gypsy (*Mvsaevm,* 1625, p. 15; trans. Diamond, 1974, p. 235).

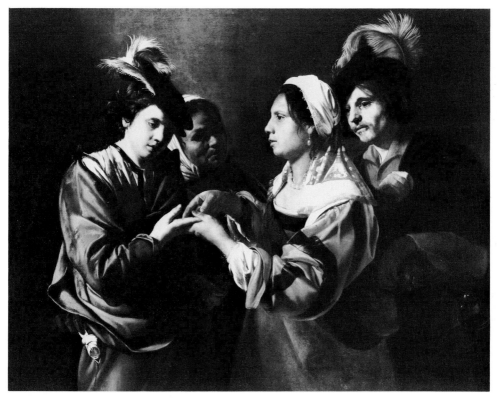

13. Bartolomeo Manfredi, *Gypsy Fortuneteller*. Detroit Institute of Arts. c. 1610–15?

Caravaggio's *oeuvre* in their depiction of people taken, as it were, off the street or out of the tavern. Even so, we do not see the street or the tavern, and his other "genre" pictures are far from representing real lowlife. It was left to Caravaggio's followers to portray the bohemians of the street, and it is they who later gave Caravaggio that misleading image.

The strip at the top of the *Fortuneteller* is a later addition or replacement. Caravaggio's picture lacked the white feather and perhaps also the space that now gives the scene some room to breathe. When it arrived in France in 1665, badly damaged by seawater, it was described as *"un pauvre tableau, sans esprit ni invention,"* an opinion shared by the great Gianlorenzo Bernini, who was then in Paris.[8] Bellori, who knew the painting well before it left Rome, praised the realism of the figures, which even Baglione had called "beautifully painted." For Mancini, writing around 1620, the painting represented the summit of Caravaggio's art.

The simple composition suggests a relatively early date, but the obvious

[8]Chantelou (1885, p. 190). See Note 12 for further references.

resemblance to a boy in the *Calling of St. Matthew* of 1600 [54] has tempted some art historians to put the picture later. We see Caravaggio's meticulously detailed attention to strings, bows, eyelashes, cast shadows, and other details, including a particularly intricate sword hilt of the kind that he himself carried and that often reappears. He sometimes applies a thick impasto without much inner differentiation, as in the black areas; but the picture is so poorly preserved that conclusions are risky, even though it still seems to show characteristic changes *(pentimenti)* in outline.

Caravaggio apparently did not plan his pictures in drawings. By 1600 he had begun to work up his compositions directly on the canvas in oil, *alla prima,* without much preparation; sometimes wholly different compositions underneath appear in X-ray photographs [59]. Such a technique is typical of Venice, particularly of Titian, and Caravaggio's teacher Peterzano could have handed down a version of this kind of oil painting to his pupils. Nevertheless, X-rays of Caravaggio's earlier works do not show extensive changes in composition, and this makes us think that he began as a more traditional, if limited painter who planned his pictures in more conventional

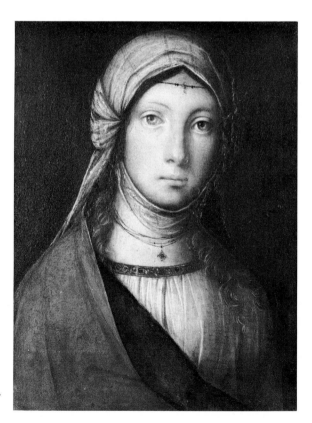

14. Boccaccino, *Gypsy Girl.* Florence, Uffizi. c. 1516–18.

ways. One characteristic of Caravaggio's early compositions is a simplicity that may indicate little need for planning.[9]

Caravaggio's application of paint in this period is not Venetian: the clear edges of color areas, the colors themselves, and the relatively opaque surfaces are different from the loose freedom of Titian's more transparent, coloristic technique. By comparison with Venetian brushwork of the later Cinquecento, Caravaggio's early paintings are distinctly Lombard, rather hard and almost primitive. But in Rome his northern art may have seemed distinctively coloristic from the first, novel and beautiful in comparison with the dry, linear works by Federico Zuccaro or Giuseppe Cesari. Even the great champion of Annibale Carracci's ideal style, Monsignor Giovan Battista Agucchi, thought that Caravaggio was *"eccellentissimo nel colorire"* despite a deep antagonism toward both the painter and his rowdy imitators, who followed nature rather than Art.[10]

It seems reasonable to suppose that Cardinal Francesco Maria Del Monte (1549–1626) was attracted to Caravaggio by pictures such as those we have been discussing. Bellori thought that the *Cardsharps* [10] got Del Monte interested.

Caravaggio and Cardinal Del Monte

Del Monte's noble family, which was connected to the Bourbons, came from the Marches in eastern Italy. He was born in Venice, where Titian, Sansovino, and Aretino witnessed his baptism. Until he was twenty-five, Del Monte served the Della Rovere court; when Urbino was conquered by the Sforza, Del Monte followed a Sforza cardinal to Rome. Nevertheless, Del Monte's long Roman career was achieved largely through ties with Florence. When Cardinal Ferdinando de'Medici found it necessary to hang up his cardinal's hat in order to become Grand Duke of Tuscany, marry, and father an heir, Del Monte was promoted to cardinal in his place. For almost four

[9]Caravaggio must have made drawings as an apprentice and at the beginning of his independence, but none survive. His paintings are also full of "drawn" edges in paint (Moir, 1969). But his mature paintings are not based on detailed drawings. Cesare Brandi wrote: "He did not draw, because the X-rays have shown that there is no compositional preparation underneath, but ra ..er new beginnings, simultaneous and overlapping, with heads that almost always begin with an ear and that are then abandoned and covered up" (1974, p. 10). The grooves in the underpainting or priming of these paintings may indicate that he posed the model anew each day, using the marks as guides. Nevertheless the X-rays that show these underpaintings, like the grooves, are of paintings of c. 1600 and later, not the earliest works.

[10]Agucchi may have written this c. 1610 (Mahon, 1947, pp. 65, 257); he went on to compare Caravaggio to Demetrios. See Mahon for a full discussion of the *disegno-colore* controversy in the 1590s; Sutherland Harris (1977, pp. 28–29) has a good summary.

decades he served the Medici cause in Rome, living at first in their palace at San Luigi near the Piazza Navona, the Palazzo Madama [51, no. 3].[11]

A sophisticated diplomat, Del Monte was a lover of music and art. He was also a serious practitioner of the pseudo-science of alchemy, which was not then in real disrepute; one of his medicines killed a man.[12] He was friendly with Galileo, and his brother Guidubaldo, a scientist, published treatises on mathematics, mechanics, and perspective.[13] Del Monte also lived, at least in part, for the pleasure of plays, parties, and other less public amusements. Supposedly he had dallied with women of ill repute early in his career, but his later tastes seem to have veered toward boys, although we have this information from only one hostile source. He was discreet and his reputation was quite good, even in strict Counter Reformation Rome.[14] For most of his acquaintances, Del Monte seems to have been a man of "delightful bearing and conversation," a worldly presence of a kind that has always been possible at the papal court.

Less sybaritic cardinals than Del Monte—notably Cardinal Federico Borromeo —favored and even harbored artists, and Del Monte's interest in art of all kinds was broad and deep. Indeed, he succeeded Cardinal Borromeo as the cardinal-protector of the artists' organization in Rome, the Accademia di San Luca, at about the time he met Caravaggio.[15] Del Monte had an extensive collection of paintings and ancient statuary, including the Portland Vase. Thus we should not be surprised to learn that he soon gave Caravaggio a room in his commodious palace, an allotment of bread

[11]Spezzaferro (1971) is the basic study; further: Frommel (1971) and Röttgen (1974, pp. 188 ff., 195 ff. and *passim*). The Palazzo Madama [51, no. 3] was near San Luigi dei Francesi, hence Caravaggio's introduction to Del Monte through a picture dealer "at San Luigi" [51, no. 1]. For the palace, see Orbaan (1920, pp. 163, 168). Del Monte purchased a palace in Campo Marzo in 1615 (Archivio di Stato, Rome, Notary D. Buccamatius, 21).

[12]See Spezzaferro (1971); for the story of a death of a "patient," see Baglione (p. 153). We tend to forget that eminent scientists, like Newton a century later, also practiced alchemy.

[13]Spezzaferro (1971); for Galileo, cf. p. 84 below.

[14]A Hispanophile biographer, Dirck Amayden (Vincenzo Giustiniani's great friend) wrote slyly of Del Monte that "he loved the company of youths, I do not think out of evil instincts but from natural friendliness. And one must add that before the assumption of Urban [VIII, 1623–1644], he gave no cause for censure, wisely keeping everything private. After Urban's election he . . . dedicated himself openly to his tendencies. Even old and blind . . . and impotent in the face of attractions, he left money to a young boy" (quoted in Latin by Spezzaferro, 1971, p. 60; references to earlier affairs with females, p. 68). Further to his homosexuality: Frommel (1971, p. 10 and *passim*). Röttgen (1974, pp. 196 ff.) saw Caravaggio's "homoerotic" art as only a phase dominated by Del Monte. For the *avviso* reporting a ballet attended by Del Monte and other cardinals, at which boys were dressed as women, see Orbaan (1920, p. 139, n. 1). In 1617 the Venetian ambassador described Del Monte as "a living corpse . . . given up entirely to spiritual matters, perhaps so as to make up for the license of his younger days" (quoted by Haskell, 1980, pp. 28–29 and n. 1; cf. p. 397).

[15]Del Monte at first shared the position with Gabriele Paleotti of Bologna (cardinal 1565–1597), author of the famous *Discorso intorno alle imagini sacre* (cf. p. 51, n. 1).

and wine, and an allowance.[16]

The papal court of Clement VIII was hostile toward Del Monte's protector, Grand Duke Ferdinand. Thus when Caravaggio obtained the cardinal's favor he automatically lost all possibility of patronage from the Aldobrandini family. At first the problem could hardly have occurred to him, but by 1600 he may have set his sights on other patrons in order to break out of what perhaps seemed to be a restrictive situation. Nevertheless he had to wait until the election of Paul V Borghese in mid 1605 in order to achieve papal favor.

The biographer Mancini, oddly enough, tells us nothing whatever about either Del Monte's patronage or his collection. When Mancini was writing, around 1620, the Cardinal's treasures may have been difficult to visit.[17] We must therefore rely on Baglione and Bellori, both of whom suggest that Caravaggio's first painting done expressly for the cardinal was a *Concert of Youths* [15].

A CONCERT OF YOUTHS

Caravaggio crowded four male figures into an uncomfortably narrow foreground space and partially clothed them in drapery *all'antica;* the sashes with their ragged ends appear in other early works [18, 25]. Although the picture is open to various interpretations, Caravaggio's ambition was obviously to rival his Renaissance predecessors by showing an imaginary, quasi-mythological scene with figures loosely swathed in garments that were meant to summon up ideas of the antique past.

The *Concert* has been extensively damaged, cut down, and repainted; a pair of large wings that once grew from the shoulders of the boy at the left has been obliterated. Originally the painting was allegorical, with winged Eros holding grapes

[16]The vase was seen in Del Monte's collection in the winter of 1600–1601 by Nicolas-Claude Fabri de Peiresc, who later hoped to publish it with illustrations by Rubens (Möbius, 1967–1968, pp. 25–27). It seems probable that many of Del Monte's antiquities were obtained from the Della Porta family (cf. Baglione, pp. 152–153). The vase was sold to the Barberini after Del Monte's death and was illustrated in Cassiano dal Pozzo's "paper museum."

The *"parte e provisione"* that Baglione mentions was the usual allowance plus food and wine that was given to members of a household. We do not know whether Caravaggio was obliged to paint for Del Monte in return. The pictures that Caravaggio painted for Del Monte all date before 1600, though he seems to have stayed on in the palace until 1604 or 1605 (cf. p. 88, n. 28).

[17]Mancini did not mention Caravaggio's stay with Del Monte in connection with paintings and he cites none of Del Monte's paintings in his text. He does tell a story about a visit from Caravaggio's brother to Del Monte that seems very damaging on the surface (see pp. 348–349 below). The report can hardly be literally true (cf. Cinotti, 1975, p. 210 and *passim*, and Röttgen, 1974, pp. 165 ff.). Nevertheless there must be a kernel of fact in it since Mancini has the brother mention their sister. For Baglione and Del Monte's collection, see p. 55, n. 4. As the chart on p. 273 shows, Mancini and Baglione knew different artists named Caravaggio in the 1590s: the only paintings they list in common are the *Bacchino Malato* [9] and the *Boy Bitten* [25].

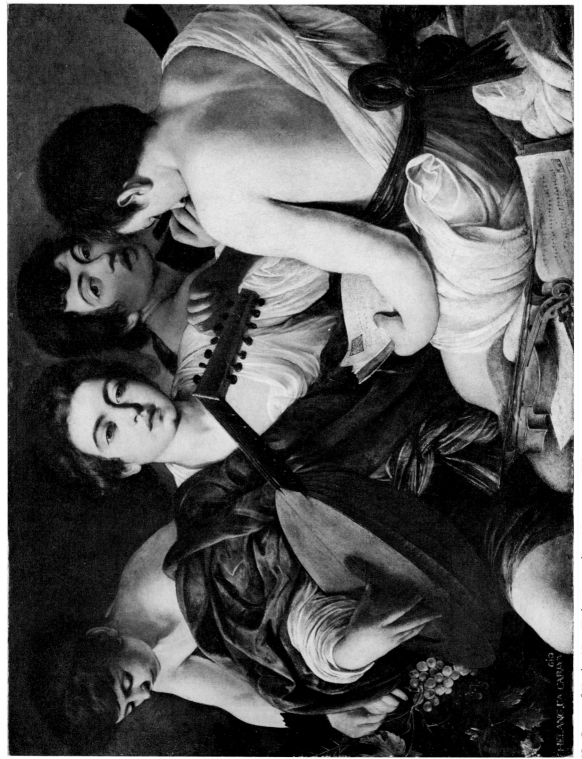

15. *Concert of Youths.* New York, Metropolitan Museum. c. 1595.

and three semi-nude youths engaged in preparations to play and sing the music that had long been thought to be (as Orsino was to say in *Twelfth Night*) "the food of love."

The musical party is a familiar theme in Venetian and north-Italian art, where artists produced similarly crowded pictures that Caravaggio must have known [16]. Unlike them, Caravaggio's painting is neither portraiture nor genre. The costumes, the nudity, and Cupid all point to an erotic, pseudoclassical ambition; there is an obvious connection between Cupid with his grapes, the Bacchic wine that they imply, and the sensual musicians. A number of Renaissance paintings symbolize Music by showing three female musicians in the company of Cupid. Giorgio Vasari, describing such a painting by Paolo Veronese, explained that "Love is always in the company of Music." Caravaggio has rung changes on this theme that show sophistication and even perversity, for the generic females of tradition are now boys, dressed (or undressed) in antique garb. Nevertheless the connections of this *Concert* to traditional paintings of Music would have been evident to any sophisticated observer—as would Caravaggio's deviation from the norm.

Cardinal Del Monte must have been particularly important for the production of the first picture he commissioned from Caravaggio: his inventory lists several other paintings of concerts as well as a number of musical instruments, including lutes, guitars, and a chest of viols. Del Monte himself boasted of singing *"alla spagnuola"* and playing a little guitar.[18] Caravaggio's picture, which shows a lute being tuned, could illustrate or imply harmony, which was defined in antiquity and the Renaissance as the resolution of discord, *discordia concors*. Since the eyes of the lutenist seem to be filling with tears, perhaps the music is meant as an antidote to disappointed love. John Fletcher wrote, "In sweet music is such art/Killing care and grief of heart"; and Shakespeare, "music oft hath such a charm/To make bad good, and good provoke to harm."[19] These and similar lines illustrate a growing tendency to relate the sounds of music to the human passions, and Caravaggio's painting is in this tradition.

The waiting violin and musical part in the foreground of the *Concert* probably belong to the studious musician at the right. They have also been seen as a mock solicitation of the viewer to join in, an impression that is reinforced by a somewhat later painting, the *Luteplayer* [18]. The sensual nudity of the male figures, accom-

[18]Spezzaferro (1971, p. 68) quotes Del Monte as writing to a friend: *"Sappiate che io suono di chitarriglia et canto alla spagnuola"*

[19]*King Henry VIII* (III.i.12); *Measure for Measure* (IV.i.14). When I quote Shakespeare or Milton I do not imply a connection with Caravaggio but rather with the world of the later Italian Renaissance that had spread to England: see Brooke (1977). Gregori (1972, pp. 44–45) found parallels between Caravaggio's "mute poetry" and Shakespeare's autobiographical sophistication in the *Sonnets*.

16. Callisto Piazza, *Concert*. Philadelphia Museum, Johnson
Collection. 1520s?

17. Studio of Titian, *Venus and a Luteplayer*. New York, Metropolitan Museum. 1560s or 1570s.

panied by Cupid with his grapes and arrows, suggests that this play will not be wholly musical.[20] We find similar implications in the very different paintings by Titian of Venus with a musician [17]. Here Venus holds a suggestive recorder (considered to be a "low" instrument), and a viola da gamba stands waiting to be played at the right. Although the sexual solicitation in the *Concert* and other pictures painted by Cara-vaggio for Del Monte is muted and overtly symbolic, the contrast with Titian's heterosexual theme is obvious.

It is possible that the lutenist, who is very much the queen of this gathering, is Caravaggio's friend Mario Minnitti; Caravaggio himself seems to look out at us from behind as the horn player. All of these boys are similar; he seems to have varied and reused the same types, not only in this single picture but also over several years. Caravaggio's portrait-like depiction of the boys makes the interpretation of this and other early pictures problematic. His efforts may have been directed at poetic allegory, but his instincts (or limitations) as an artist led him to paint people that seem disconcertingly contemporary. This ambiguous tension between subject and rendering makes Caravaggio unique; it soon made him famous as well.

A LUTEPLAYER

The form and to some extent the content of the *Concert* are matured and concentrated in a masterpiece of Caravaggio's early period, the *Luteplayer,* which was probably painted about 1596 [18]. It is a fully realized Del Montean production. The lutenist sits behind a table, which affords a realistic space that Caravaggio had not achieved in the *Concert.* Moreover, we seem to see the corner of a room, perhaps for the first time in his paintings. The lutenist represents a considerable technical advance in figure painting over the earliest works [cf. 3, 4, 9]. The light from above, visible on the wall at the upper right, strikes both the figure and the flowers, which are thus set in believable relief against the dark background.

The gender of the figure is more ambiguous than in the *Concert.* Baglione called him a boy, as did Del Monte's inventory; Bellori (describing a copy) thought it a girl. The equivocation is surely significant, for in the Renaissance androgyny was equated with homosexuality. The musician now plays, and again a violin, bow, and music are waiting, as if for someone, perhaps the viewer, to take them up and join in.

[20]Einstein (1949, II, p. 743) reports that the aim of music in the Cinquecento "is not emotion, not edification, uplift, or self-improvement, but to serve as entertainment at best, and often enough a prelude to Venus, an accompaniment to eating and drinking, or a mere pastime." Others have pointed to the essentially private amusement that most such secular musical performance provided: the performers were often their own audience.

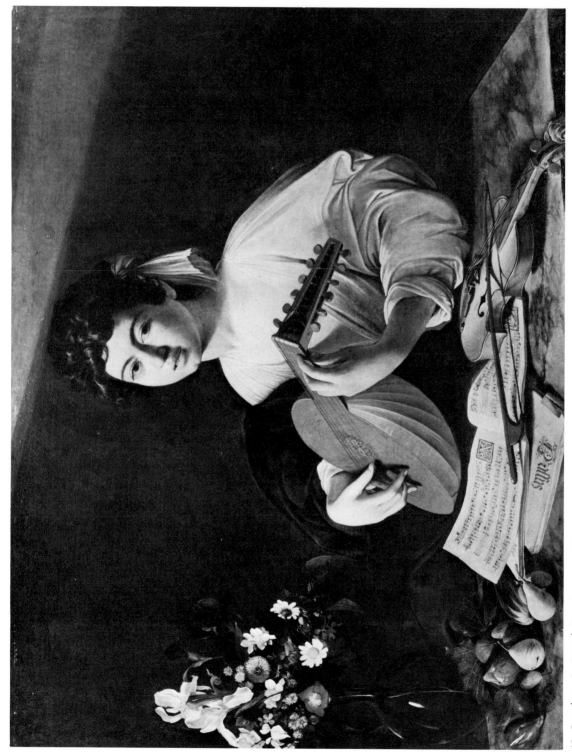

18. *Luteplayer.* Leningrad, Hermitage. c. 1596?

The *Luteplayer* is in the tradition of earlier north-Italian paintings. One of 1520 [19] also implies players or singers outside the picture: the music, turned toward us, is labeled for tenor and bass. It was evidently painted in Milan (another version is still there), and the single half-figure seen against the dark background seems to be a source for Caravaggio's painting, despite the obvious differences in costume and handling.

The closed score in Caravaggio's picture is inscribed *Bassus;* all of Caravaggio's music seems to be in the form of separate parts for ensemble playing [cf. 15, 29, 98]. The music being sung in Caravaggio's painting appears to be a madrigal by Arcadelt that was specifically amorous: *"Voi sapete ch'[io v' amo]"* (You know that I love you). Lutes were associated particularly with erotic music, and many amorous songs for lute survive from this period. Shakespeare wrote of the "lover's lute" and of the "lascivious pleasing of a lute."[21] The erotic message is expressed in the languid imagery of the Del Montean Caravaggio, but the mock solicitation of the viewer is far more blatant than it was in the *Concert,* reinforced as it is here by figs and cucumbers on the table. The vegetables seem overtly sexual, but they are only a gross footnote to the flowers, which have always been symbols or messengers of love. Nevertheless, it is also possible to interpret the picture as a visual double entendre, and again the image may illustrate harmony.

The beautiful sounds of music are based on Pythagorean geometry, which defined harmonious sound according to the length of the vibrating strings. The androgynous lutenist is an attractive mixture of the sexes—again a kind of *discordia concors*—and, just as flowers produce fruit, so the lutenist, the musical scores, and the violin on the table are sources of harmonious music. The picture could have been read in this way as well as the other. It could also be taken as an illustration of the five senses, since the flowers imply the sense of smell, the vegetables taste and touch, and the music touch and hearing. The whole painting is of course an appeal to our sense of sight and exists only because of it.

Caravaggio's *Luteplayer* develops the symbolism of the *Concert* with a new spatial freedom in which each element has ample room, yet the figure is dominant and sensual, with parted lips that might even be called lascivious [26]. The textures, skin, and still life are painted with mastery, though there is now some discoloration on the face. According to Baglione, Caravaggio once called this the most beautiful picture he ever painted.

The vase of flowers may be indebted to a Netherlandish vogue that began about this time [cf. 20]. Flower painting was established as a genre in the Netherlands before

[21]*I Henry IV* (I.ii.75); *Richard III* (I.i.13).

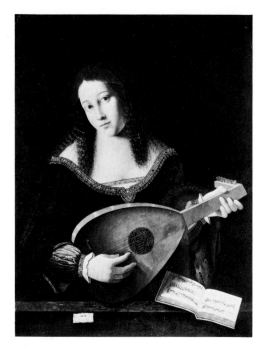

19. Bartolommeo Veneto, *Luteplayer.*
Boston, Gardner Museum. 1520.

1600, and Carel van Mander, the early biographer of Dutch artists, records that one was painted by Cornelis van Haarlem, probably about 1580.[22] Van Mander himself is said to have painted them, and his Roman informant, Floris van Dyck, was an early exponent of still-life painting. Del Monte, an admirer of Northern painting, also had a small picture by Caravaggio, now lost, that is listed in the inventory of his gallery as *"una Caraffa."* It was presumably the picture of flowers that Bellori so admired that he described it first among Caravaggio's paintings. He wrote that Caravaggio "painted a vase of flowers with the transparencies of the water and glass and reflections of a window of the room, rendering flowers sprinkled with the freshest dewdrops." This work is lost, but a painting wrongly ascribed to Jan Bruegel in the Galleria Borghese [20] may be similar. It shows a bouquet, painted with Northern particularity, in a carafe that is probably Italian. Comparison with Caravaggio's flowers [18, 25] reveals the differences but the Borghese painting, apparently acquired along with others of the same sort in 1613, could be an echo or conceivably a source for Caravaggio's lost picture.

Even the hostile Baglione admired the realism of the flowers in the *Luteplayer,*

[22]For Van Mander and Cornelis van Haarlem, see Vey (1969, p. 336). Jan Bruegel, who was in Rome from 1592 to 1594/95, was an important flower painter but his earliest flower piece, for Cardinal Borromeo, dates from 1606 (Ertz, 1979, p. 252). Cardinal Del Monte, who owned eleven paintings by Bruegel, had no *Still Life* (see Note 47).

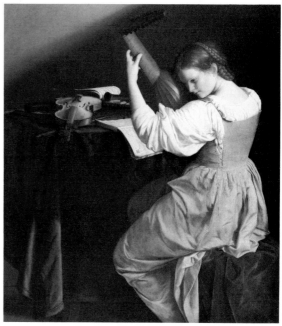

20. Anonymous, *Vase of Flowers.* Galleria Borghese.

21. Orazio Gentileschi, *Luteplayer.* Washington, National Gallery. c. 1615?

writing that "on the flowers is fresh dew that is rendered with exquisite accuracy." Caravaggio's realism and above all his color attracted the attention and admiration even of his detractors.

It is instructive to compare Caravaggio's *Luteplayer* with a beautiful painting by a sometime follower, Orazio Gentileschi [21], which also alludes to other players by showing various instruments. Gentileschi (1563–1639) was a selective realist, a lover of fine clothes and female faces, an exquisite technician. His Caravaggism was superficial and attractive.

BACCHUS

The somewhat mysterious *Bacchus* in the Uffizi [22] is probably later than the *Concert.* Now one of Caravaggio's most famous early works, it was unknown until 1913 and is not mentioned by any of the early writers. It was not in Del Monte's collection at the time of his death, was never copied or imitated, and may have been a gift from Del Monte to the Grand Duke in Florence, where it languished in storage for centuries.

Once again Caravaggio organized the picture by interposing a table between us and the figure, who sits on a bed or triclinium heaped with pillows. The young, fleshy Bacchus has an Oriental cast, his black, wiglike hair all but covered with leaves

and grapes. An "antique" sheet falls over his left shoulder and he holds out a large, precarious goblet, as if to demonstrate his role as "giver of joy" (*Aeneid* I. 734). The surface of the wine in the decanter at the left is slightly off-horizontal, giving the impression that it has just been set down and is still swinging, with beaded bubbles at the rim. In the foreground there is a luxuriant, overripe still life of fruits and leaves [23].

Here, more than in his previous pictures, we meet the peculiarly ambivalent nature of Caravaggio's realism. Caravaggio's attempt at a classical figure has often summoned up thoughts of Ingres; Berenson even toyed with the possibility that an Oriental print might have been a source. Caravaggio is attempting—unsuccessfully —to evoke an ancient and poetic world wholly outside his own. His pagan nude has the red face and hands of a man who is customarily clothed. Caravaggio paints the model more faithfully than he imagines the subject, which seems to be a mere pretext. (Is it seemly to show an antique god with dirty fingernails?) Since Caravaggio is so meticulous in painting details, including cast shadows and vegetal decay, we may wonder why he did not show the distortion that should be caused by the carafe when we look through the glass. All these questions point to a level of naiveté, or perversity, that may indicate a relatively early date. Perhaps no other painting records so blatantly Caravaggio's early dependence on the model and his insistence on painting what he saw—up to a point. That point is the figure itself, which seems unreal and lacking in human presence. As in the very earliest paintings, there is also no larger context, background, or atmosphere.

The relatively flat and airless quality of this *Bacchus,* coupled with its absence from the early biographies, makes it particularly hard to place in Caravaggio's career; the boys in the ruined *Concert* probably shared his pinkish white flesh. Because of insecurities in the anatomy and the relative lack of atmosphere it should be dated before 1597. By then Caravaggio was presumably a more accomplished painter whose figures showed increased and more believable relief, thanks to heightened chiaroscuro and a dark background, beginning perhaps with the *Luteplayer* [18]. The Bacchus resembles the lutenist in the *Concert* [15] and the *Boy Bitten by a Lizard* [25]. All three have at times been supposed to be self-portraits, but what we know of Caravaggio's features hardly supports this claim [cf. 9, 66, 67].

The prominent still life of ripe and partially decaying fruits and leaves is a gorgeous, even decadent showpiece [23].[23] Bacchus, the god of vegetation and fruits, offers us wine and, as in some other Del Montean pictures, may also imply an offer

[23]Caravaggio's renditions of fruits and leaves in this period can be compared to the illuminations in herbals and botanical treatises (cf. Blunt & Raphael. The comparison was made by Battisti [1962], p. 276).

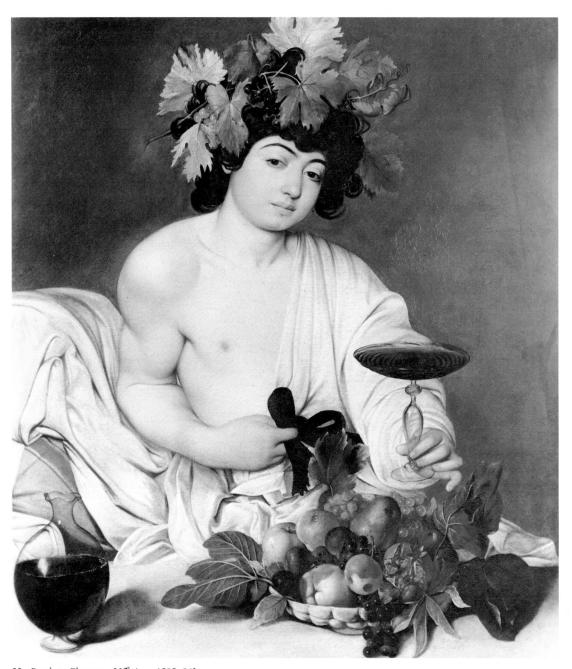

22. *Bacchus.* Florence, Uffizi. c. 1595–96?

23. Detail of [22].

of himself as he toys with his velvet bow. The kind of dishabille seen here was normally found in images of wanton women such as the lascivious goddess Flora. Caravaggio's transfer of that tradition to a male may have been too blatant for any patron to display, and the picture seems to have been suppressed from the beginning. Still, it could have been painted as an odd but intelligible version of Bacchus as a symbol of androgynous divinity.

Giulio Cartari, in his popular book on the antique gods, says that Bacchus was sometimes shown in female dress. And Giovan Paolo Lomazzo, the Milanese theoretician and friend of Peterzano's, whose books Caravaggio could have read, states that the ancients showed Bacchus as bisexual, with a garland on his head and his eyes half closed, and that he should be a beautiful youth but empty-headed. Cesare Ripa, whose *Iconologia* first appeared in 1593, also calls Bacchus androgynous but sees him as a symbol of the divine. The idea that Bacchus was both male and female came from

24. Annibale Carracci, *Bacchus*. Naples, Capodi-monte. 1590–91.

the *Bacchae* of Euripides and from Vitruvius—though we can hardly presume that Caravaggio had read them. The sense of a personal or even Hermetic meaning is reinforced when we compare Caravaggio's airless and insinuating image with a straightforward *Bacchus* painted a few years earlier by Annibale Carracci [24]. Annibale too shows a nude figure holding a glass of wine, but this is the pagan outdoor god of antiquity and the Renaissance. Caravaggio's closet *Bacchus* is a different breed.

A BOY BITTEN BY A LIZARD

The *Boy Bitten by a Lizard* [25] was listed by Mancini first among Caravaggio's paintings; elsewhere he coupled it with the *Fortuneteller* [12], as having been sold for a pittance. Baglione, the biographer closest to Caravaggio, also mentions the *Boy Bitten* as one of his earliest works. None of the versions that we know is surely autograph; all are fairly small, like the earliest paintings. An effeminate boy, seen from the side in sharp foreshortening with an awkwardly protruding shoulder, is being

bitten on the middle finger of his right hand by a small lizard. The subject was not entirely new; a follower of Bernardo Campi's had drawn a baby bitten by a crab, and anecdotal pictures from Caravaggio's time show boys bitten by a crab or a rat. The picture is a fascinating record of Caravaggio's great ability as a still-life painter, combined for the first time with a startling momentary action. Much of its interest lies in the illusionistic depiction of the flowers and fruit and of the carafe with its reflections.

The dramatic foreshortening and the exaggerated light-dark seem to prove that this picture is not one of Caravaggio's first; some writers date it as late as 1597 because of its advanced chiaroscuro. It is one of an experimental series that shows Caravaggio trying various kinds of subject matter, lighting, and expressive effects. The pictures that we date during the period 1594–1597 are so disparate that it is impossible to construct a chronology on rational evolutionary principles without further evidence.

The boy's alarmed reaction, his hand flung out and his mouth open, seems to develop aspects of *The Cardsharps* [10]. The jasmine and roses were a hiding place for the lizard, but they can also be interpreted symbolically. Here, far more than with the first *Bacchus* [9], we seem to need an interpretation of the image, perhaps as a *vanitas* allegory, although the picture, like others, has probably been overinterpreted. Its meaning may be no deeper than Shakespeare's rhyme:

> Roses have thorns, and silver fountains mud . . .
> And loathsome canker lives in sweetest bud.
> (Sonnet 35)

Roses are usually associated with Venus and things venereal, and a rose worn behind the ear was considered an amorous come-on even in antiquity. Cherries too can have sexual meanings. The lizard was sometimes thought to have a deadly bite, which may be its meaning here; but perhaps owing to the Greek word, which is similar to *phallos,* lizards also carried that connotation, which was well known from an epigram by Martial. Even the particular finger being bitten has a sexual association.

Donald Posner pointed out that this and similar pictures are "contrived to be aggressively provocative, they involve conceits and display a degree of wit that were obviously 'programmed.'" Presumably these elements point to a time after Caravaggio had been drawn into the circle of Cardinal Del Monte. But whether we choose to read the picture as a private, even campy homosexual reference or as a more general warning against the evils of life, there is no avoiding the need to interpret. And once again there is at least a possibility that this picture could contain a private double entendre. Since jasmine was sometimes considered to be a symbol of Prudence, the

25. *Boy Bitten by a Lizard*. London, Korda Collection. c. 1596–97?

little bouquet made up of a rose surrounded by jasmine may reinforce the picture's meaning: love with prudence or pain will follow.

A few of these paintings were given moralizing, symbolic, or emblematic interpretations by poets. The earliest are by Gaspare Murtola, in a book published in 1603; the Cavalier d'Arpino also wrote such poetry.[24] But these glosses need not imply that Caravaggio had the same thoughts when he painted the pictures in the 1590s. Caravaggio's association with erudite poets like Giovan Battista Marino probably dates from 1601 or even later, some years after these paintings had been produced.[25]

CARAVAGGIO'S REALISM AND RENAISSANCE THEORY

The differences between Caravaggio's realism and the pictures of his contemporaries are sharpest in his almost tangible, portrait-like rendering, which seems naive in its direct intensity and lack of idealization or atmosphere [cf. 22, 26, 27]. Nevertheless Mancini seems to say that Caravaggio was not good at portraiture because of a failure to get a likeness.[26] If he was not, this could give us a clue to the relationship between somewhat similar figures in different paintings—for instance, the supposed self-portraits in the *Bacchino Malato* [9] and the *Concert* [15].

Caravaggio was an iconoclast in the eyes of his contemporaries because he refused to subscribe to the idealistic theories of the Renaissance. These theories were predicated on the story of Zeuxis' picture of Helen (or Venus), which was formed from a combination of the most beautiful features of many models. Men of the Renaissance believed that antique artists had already made this selection, and this is why they thought that ancient art was more worthy of emulation than nature itself.[27]

[24]Salerno (1966). Most of his evidence dates from the early Seicento and may not be relevant to Caravaggio's paintings of the 1590s.

[25]Marino arrived in Rome only late in 1600 and he was frequently away thereafter (see Mahon, 1951, p. 225, and my p. 118, n. 2). See Mirollo (1963) and Viola (1978) for Marino.

[26]Mancini (p. 136) wrote that some excellent artists like Caravaggio did not get good likenesses because they lacked natural color. He went on to say that for drawn likenesses Annibale Carracci was excellent (cf. Spezzaferro, 1971, pp. 80–81, n. 118).

[27]Renaissance artistic theory was surveyed by Blunt (1956); Summers (1981, pp. 279 ff., 380 ff., and *passim*). Cf. Panofsky (1968, esp. pp. 104 ff.) and Kris & Kurz (1979, pp. 43 ff., 47–48, 64, and *passim*). Baxendall (1974, part III) gives examples from the Quattrocento. For Zeuxis and Helen, Pollitt (1965, p. 156, quoting Cicero, *De Inventione*). For Renaissance texts on imitation, see Barocchi (*Scritti,* II, section IX); cf. Lee (1967, pp. 9–16), Mahon (1947, parts II and III), and Battisti (1960, pp. 175–215). Further, I. Lavin (1980, I, pp. 10–11 and n. 21).

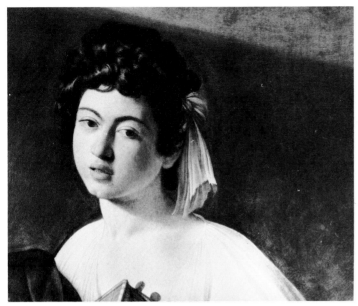

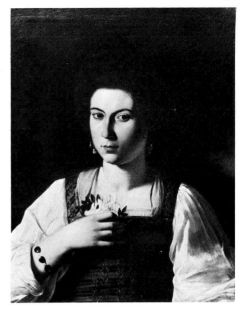

26. Detail of [18].

27. *Portrait of Phyllis.* Destroyed. c. 1597?

Bellori, writing a century after Caravaggio's birth, criticized him in these terms, saying that he

> recognized no other master than the model, without selecting from the best forms of nature—and what is incredible, it seems that he imitated art without art [*pare che senz'arte emulasse l'arte*]. . . . despising the superb statuary of antiquity and the famous paintings of Raphael, he considered nature to be the only subject fit for his brush. As a result, when he was shown the most famous statues of Phidias and Glykon in order that he might use them as models, his only answer was to point toward a crowd of people, saying that nature had given him an abundance of masters.[28]

Bellori summoned up the example of an ancient painter, Demetrios, who was criticized by his contemporaries because he was more devoted to nature than to beauty. Monsignor Giovan Battista Agucchi, an art theorist, adviser to the Aldobrandini, and close friend of Annibale Carracci's, compared Caravaggio to Demetrios in a manu-

[28]Bellori (pp. 201–202), followed by a description of how he came to paint the *Fortuneteller* [12]. Cf. Bellori's similar statements (pp. 212 ff.), where Caravaggio is found wanting in comparison with Annibale Carracci. The *Herakles Farnese,* signed by Glykon, was displayed in the courtyard of the Palazzo Farnese. Various sculptures, including one of the *Horsetamers* on the Quirinal, were attributed to Phidias; Bernini thought that the *Mastro Pasquino* was by Phidias or Praxiteles (Chantelou, 1885, p. 26). Cf. Haskell & Penny (1981).

script that he may have begun before Caravaggio's death. Caravaggio could have had a worthier ancient model (or excuse) than Demetrios, for Pliny relates that the Greek painter Eupompos, when "asked which of his predecessors he followed, pointed to a crowd of men, and said that one ought to imitate nature itself, and not another artist."[29] These are the very sentiments that Bellori attributed to Caravaggio. Thus the reputation that Caravaggio brings down to our own time and even his supposed utterances are based on an accretion of stories and attitudes that may have more to do with later theorists and their desire to categorize painters than with Caravaggio's actual words and practice. Nevertheless he must have made loose remarks about freedom from the shackles of the past, since Carel van Mander already reports them in 1604.

Van Mander, in a book published in Holland, was well aware of Caravaggio's fame even though he had no knowledge of his pictures. Van Mander wrote that Caravaggio

> is one who thinks little of the works of other masters, but will not openly praise his own. His belief is that all art is nothing but a bagatelle or children's work, whatever it is and whoever it is by, unless it is done after life, and that we can do no better than to follow Nature. Therefore he will not make a single brushstroke without the close study of life, which he copies and paints.[30]

This early report is very close to Bellori's characterization; and because the information that Van Mander printed was almost surely sent from Rome around 1600 by a Dutch compatriot, it is authentic and contemporary.

Caravaggio's rebelliousness may have been based on his somewhat mysterious but ultimately fortunate inability to paint in the style of successful Roman contemporaries like the Cavalier d'Arpino [cf. 8]. As Denis Mahon pointed out, there was

> an ironic vein in Caravaggio's art which can very well reflect the master's reactions to criticisms based on Cinquecento preconceptions as to the business of a painter. . . . Caravaggio was quite plainly incompetent by those standards;

[29]For Agucchi, see Mahon (1947, part II). Bellori's *Lives* has as its introductory essay a lecture given at the Accademia di San Luca in 1664, "The Idea of the Painter, Sculptor, and Architect. Selection of Natural Beauties Superior to Nature." (Cf. Panofsky, 1968, p. 48.) The citation of Demetrios and Eupompos was a cliché in the Renaissance: Demetrios was invoked by Leon Battista Alberti as a bad example. Cf. Pollitt (1965, pp. 134–135). Quintilian *(Institutio Oratoria)* wrote: "Demetrios, however, is criticized because he was too realistic and was hence more fond of truth than of beauty" (Pollitt, p. 221; Kris & Kurz, 1979, pp. 40, 82). Bellori's *Life of Caravaggio* (p. 201) begins with an invocation of Demetrios. For Eupompos: Pollitt (pp. 154–155, quoting Pliny, *Natural History*); Kris & Kurz (pp. 14–19).

[30]See below, p. 344. Van Mander's information may antedate the Contarelli Chapel paintings of mid 1600, which he did not mention.

his greatness is intimately bound up with the fact that this is so, and that he nevertheless set about creating standards of his own.[31]

There was also good Renaissance precedent for breaking away from hallowed models; a series of great painters had observed this process in their outstanding predecessors. Leonardo da Vinci praised Masaccio for using no model but nature, "mistress of all masters," saying that those who do otherwise toil in vain.[32] Caravaggio is thus another representative of the successive waves of realism that have periodically refreshed tired styles and reawakened interest in an art that had strayed too far from life in the pursuit of an ideal.

Although similar statements can be found throughout the entire history of art, the dominant trend of the Cinquecento, in both art and theory, was to exalt "perfected nature" rather than the mere imitation of what the eye sees. Thus for Michelangelo's friend Benedetto Varchi, the goal of art was ostensibly "the artful imitation of nature" —but his emphasis was on "artful." For him as for the others, painting and sculpture began not with nature but with *disegno,* which is to say, art.[33]

Caravaggio is at least partially in this tradition: his realism is highly selective. In the early works, however, his combination of realism (a more or less slavish reproduction of the model) with allegory or symbolism is uneasy or unresolved. Sometimes the conflict between the two is so great as to make us think that he is satirizing Renaissance art.[34]

[31]Mahon (1953, p. 216), a review of Longhi's *Caravaggio* (Milan, 1952).

[32]Barocchi, *Scritti* (II, pp. 1281–1282; cf. Beck, 1978, p. 7). Cristoforo Landino, a Quattrocento commentator on Dante, had praised Masaccio in a similar way (Beck, pp. 29–30). For Landino, and for *"imitatore"* and other terms used in these contexts, see Baxandall (1974, pp. 115–151). For some of these same qualities as goals of the pietistic period of the 1590s, see Röttgen (1968, pp. 71 ff., esp. p. 77). For "nature" in Renaissance theory, Bialostocki (1963, pp. 19 ff.).

[33]Barocchi, *Scritti* (I, p. 535): "Everyone now realizes that the artful imitation of nature is not only the end, but the beginning of *disegno*" See also *Scritti* (II, p. 1899 and *passim*). Bernini told Chantelou that Veronese and Titian sometimes took their brushes and did "things they hadn't thought about at all, letting themselves be carried away with a kind of fury of painting . . ." (1885, p. 222; he went on to say that not all their paintings were of that sort). On another occasion, Bernini quoted Annibale Carracci as having said that he who had not painted in fresco could not be called a painter (p. 256); his comment demonstrates the same basic prejudice against paintings that are not firmly grounded in drawing.

[34]Dempsey (1970, p. 326). Further to ambiguity, see D. Freedberg (1982).

2
The First Religious Paintings

We cannot trace Caravaggio's development as a religious artist in the way that we have followed his early secular works, beginning with half-length single figures and developing into more complex, multifigured compositions. Two of his earliest religious pictures show whole figures in landscapes [29, 30]. Moreover, the stylistic relationships between these paintings and fairly early secular pictures such as the *Cardsharps* [10] and the *Fortuneteller* [12] are not at all clear. Nevertheless three religious paintings are obviously earlier than the others.

THE REPENTANT MAGDALEN

It is quite possible that the *Repentant Magdalen* [28], which may be Caravaggio's first attempt at a religious theme to have survived, began as a simple painting of a seated model—an idea that was revolutionary at this time. It is one of two related pictures that have been together since their first mention by Mancini [28, 29], who thought they were very early works painted in the Palazzo Petrignani. Baglione mentions neither and they were not in Del Monte's collection.

The Magdalen sits alone on a low chair in her bare room, her sparse finery set onto the floor, shedding a tear for sins that are hardly imaginable in so young a creature. This painting gave Bellori an opportunity for a set piece in which he conjured up a Caravaggio who painted pure genre from life and who then added a minimal iconographic flourish in order to turn a "meaningless" portrait-study into a religious picture:

> Since Caravaggio aspired only to the glory of color, so that the complexion, skin, blood, and natural surfaces might appear real, he directed his eye and

work solely to that end, leaving aside the other aspects of art. Therefore ... when he came upon someone in town who pleased him he made no attempt to improve upon the creation of nature. He painted a girl drying her hair, seated on a little chair with her hands in her lap. He portrayed her in a room, adding a small ointment jar, jewels, and gems on the floor, pretending that she is the Magdalen. She holds her head a little to one side, and her cheek, neck, and breast are rendered in pure, simple, and true colors, enhanced by the simplicity of the whole figure, with her arms covered by a blouse and her yellow gown drawn up to her knees over a white underskirt of flowered damask. We have described this figure in detail in order to show his naturalistic style and the way in which he imitates truthful coloration by using only a few hues.

The foregoing passage follows a similar, briefer discussion of the *Gypsy Fortuneteller* [12], which Bellori put in the same category. Caravaggio seems to have painted over part of the Magdalen's skirt in order to insert the still life, and therefore Bellori's assumption that the picture began as genre may be correct. If so, the painting documents a significant early moment in Caravaggio's career.

The repentant Magdalen is a characteristic theme of the Counter Reformation: melancholy humility after conversion from a life of sin. Mary Magdalen was a supreme example of Penance, the sacrament of greatest importance after Baptism and the Eucharist and one that was particularly emphasized in this period, when the Church wanted to welcome back those who had gone astray into Protestantism. In the Middle Ages the Magdalen was already celebrated as the "blessed bride of God," the prototype of those who are drawn from heathen paganism to the source of grace. Since Caravaggio painted other converted Magdalens [33, 136], this first picture may already indicate a personal interest in the subject. He may also have been aware of a tendency to discount the Magdalen's harlotry: in the Italian translation of the first books of Cesare Baronius's *Annals of the Church,* published in 1590, we read that the Magdalen had probably not been a public whore but only impure and vain *("incontinente, e vana")*—and these are indeed the worst sins that we should impute to Caravaggio's young woman.[1]

The theme had been treated in a very different way by Titian, who painted a nude Magdalen clad only in her flowing tresses and amply displaying the charms

[1]Bologna (1974, pp. 155 ff.) argued that all of Caravaggio's iconographic choices ultimately conflict with standards of religious decorum, suggesting that he read Cardinal Paleotti's treatise of 1582 in order to apply his precepts in reverse (see p. 30 and n. 15 above). But Paleotti is himself contradictory and ill-suited as a guide for painters: see Prodi (1965). Paleotti's text is in Barocchi, *Trattati* (II, pp. 117 ff.). Further, see Boschloo (1974, chapter 7), and Spalding (1976, chapter 2). Many of Caravaggio's paintings seem iconographically unexceptionable from an ecclesiastical or theological viewpoint; it was often what was perceived as a breach of artistic decorum, or what we would now call good taste, that made the paintings unacceptable.

28. *Repentant Magdalen.* Galleria Doria-Pamphilj. c. 1594–95?

that had led her into sin.[2] Caravaggio's avoidance of female nudity is notable, here and elsewhere. His image, however secular, is a chaste one, worthy of the Counter Reformation and in sharp contrast to the nude displays that remained popular throughout the period [cf. 183]. Caravaggio's religious iconoclasm was not always out of step with Tridentine theory.

Although the *Magdalen* is in poor condition, we still see in her face the lovely flesh tones that Bellori described. But her flatness, the rubbery hands, the sparse interior environment, and the less than perfect painting of certain details all point to a fairly early moment in Caravaggio's career, probably before the Uffizi *Bacchus* [22], and quite possibly before Caravaggio met Cardinal Del Monte.

THE REST ON THE FLIGHT INTO EGYPT

The *Rest on the Flight into Egypt* [29] probably dates from the same early period, when Caravaggio was on his own. It seems to have been with the *Magdalen* from early times, and the two pictures, with the *Fortuneteller* [12], were in the Pamphilj collection by 1657. Hence all three may have been together much earlier.[3] They all seem to have been painted before Caravaggio's meeting with Cardinal Del Monte, since the *Cardsharps* [10], which is in some sense the pendant to [12], was supposedly the first picture by Caravaggio that Del Monte purchased. (Presumably the *Fortuneteller* had already been sold to someone else, since Del Monte apparently took the trouble to have a version made for himself [177].) The paintings of this period are difficult to compare, but on the basis of stylistic maturity the *Magdalen* may be earlier than either the *Cardsharps* or the *Fortuneteller*.

The *Rest on the Flight* [29] shows a sleepy baby cradled in his loving mother's arms at the right, set before a misty landscape. Mary is painted from the same model

[2]Wethey (I, 1969, pp. 143–144, no. 120). Both Vasari and Cardinal Federico Borromeo agreed that such *Magdalens* were without reproach (cf. *Mvsaevm*, 1625, p. 24), and Borromeo owned one. D. Freedberg (1982) discusses related problems. Further, cf. Notes 136 and 183 below.

[3]Mancini (p. 303), writing of Caravaggio's school, cites "many pictures in private hands, and in particular in the houses of Marchese Giustiniani and signor Alessandro Vittrice," meaning by Caravaggio as well as by followers. On p. 109 he specifically discussed Vittrici's *Gypsy Fortuneteller* (my Note 12), and on p. 140 he mentioned that Caravaggio had sold it for a pittance, less than he had received on other occasions (cf. Note 25). Mancini also listed [28 and 29] as having been painted at this time, which he identified with Caravaggio's stay in the Palazzo Petrignani (see p. 8, n. 14). Baglione records none of them (see chart, p. 273). All three paintings later turned up in the Pamphilj collection, so Vittrici's "many pictures" could have included not only the *Fortuneteller* but also the *Magdalen* and the *Rest on the Flight:* they may all stem from the same general period before Caravaggio went to live with Del Monte. If so, it would explain why the cardinal had only a version of the *Fortuneteller,* which was widely admired. Spear (1971, p. 4) noted a relationship between the Vittrici *Fortuneteller* [12] and the *Rest on the Flight* [29]; others have found similarities between the *Fortuneteller* and the *Magdalen* [28].

29. *Rest on the Flight into Egypt.* Galleria Doria-Pamphilj. c. 1594–95?

who posed for the *Magdalen* [28]. The center left of the composition is occupied by the back of an angel, semi-nude, who serenades the Holy Family on a violin. This group is Caravaggio's peculiar contribution, as is the Eyckian idea that angels need a score in order to play their heavenly music. (Here it is a little lullaby in C major that can still be transcribed.) Caravaggio insists on the excess violin string that dangles in kinks from the pegs of the instrument.

Among his early works, the *Rest on the Flight* is unusual in its landscape, which recalls Tintoretto. It could also depend on memories of Savoldo and Moretto, great Brescian painters of the early Cinquecento whom Caravaggio had surely studied. The affectionate position of Mary's head has sources in Lotto and Correggio. The fore-ground moves from the sterile rubble in front of Joseph to lush verdure around the Madonna, dividing the picture into a barren, secular left half and an idealized right half with its crepuscular vista. The lyrical tone, autumnal hues, and prominent still

life make the painting one of the most charming works of Caravaggio's youth despite the erotic angel and the disjunctive composition.

In this painting there is not the imaginative or profound response to the subject that is apparent in the *St. Francis* [30], the third religious painting of this early period. The *Rest on the Flight* is simply an idyllic moment, without much theological significance. It departs from customary depictions of the legend by showing an oak tree instead of the palm that supposedly furnished food for the Holy Family. Caravaggio has thrust his vision of a provocative angel into this charming scene. We also see for the first time a juxtaposition of alluring youth and fumbling age that will be a leitmotiv in several of Caravaggio's paintings [cf. 36, 87, 102]. Joseph is a simple elderly man, awkwardly barefoot, who holds up a part-book for the angel to follow. Maliciously or accidentally, Joseph's head is juxtaposed with that of the ass, whose large eye intrudes between the foreground figures. Gradually we realize that the whole picture is imperfectly resolved as a vision of forms set into space: details jump forward or fall back, giving an impression of naiveté.

The graceful angel, balanced on his left leg in a pose derived from the *maniera* painters, receives our continuous attention. His presumed frontal nudity, like the violin and score, could be Del Montean, but the picture is so tied to north Italy in its charming lyricism that it is probably earlier. It is also related to compositions by the two Cesari, with whom Caravaggio probably worked in 1593 or 1594, and thus may date to about 1594. If this is so, it follows that many of the qualities that we find in Caravaggio's paintings for Del Monte may simply be characteristic of the youthful Caravaggio himself.

THE ECSTASY OF ST. FRANCIS

The *Ecstasy of St. Francis* [30] could have been painted specifically for Cardinal Del Monte; his Christian name was Francis, and a *St. Francis* by Caravaggio is recorded in his inventory.[4] It is similar in size to Del Monte's *Concert* [15] and related to it in the style of the figures.

Francis reclines on a hillside that slopes away from us to the left, tenderly

[4]The painting may have had a complicated history since Ottavio Costa could have owned either the original or a copy (see Note 30). It is the one painting in Del Monte's inventory that is not mentioned by any of the old writers (see chart, p. 273). Nevertheless its absence merely points up the difficulties in dealing with these sources. Mancini, writing about 1620, did not mention Del Monte's paintings; it is not usually understood that Baglione also omitted most of them: the *St. John* [96] is cited in the Mattei collection (which it left around 1624 for Del Monte's). The only other paintings in the inventory that Baglione knew are the *Concert* [15] and the *Luteplayer* (see Note 18).

supported by an angel who resembles the Eros in the *Concert* and who is almost equally nude. Brother Leo sits in the dark middleground at the left; farther back, small figures around a fire point excitedly up to our left and beyond the picture frame. Evidently they see the divine source of the light that falls on Francis and the angel and which has presumably just imprinted the stigmata on the saint's hands, feet, and chest.

Traditional representations of the Stigmatization show Francis kneeling on Mount Alverna, where he maintained a vigil through the night and toward morning

> in a vision saw a crucified seraph above him who marked the signs of his wounds so visibly upon him that he himself seemed to have been crucified. His hands and feet were signed with the character of the cross . . .

according to the shortened version of St. Bonaventure's Life in the *Golden Legend*. [5] This is the scene that Giotto and unnumbered artists after him had shown. Caravaggio's St. Francis is also found in that setting, but he has not emphasized the actual stigmatization and the traditional seraphic vision is missing. The image seems to record a religious ecstasy, conveyed through light and manifested by the collapse of Francis into the arms of a comforting angel, a materialization of the divine love that made Francis into a new Christ.

Caravaggio's picture is powerfully physical, despite some vegetal detail and intimations of landscape. Two large human forms dominate the foreground, with a relatively empty space at the left in which the distant figures are unusually small and dark. There are typical confusions or distortions: Francis's right arm seems to emerge from that of the angel, and we seek a long time before finding the angel's left hand. He, for all his boyishness, is bigger than the saint, whose lower body trails off ambiguously. Its crudities and awkward passages indicate that this must be one of the earlier paintings. Nevertheless, Caravaggio's outstanding importance as an innovator in religious imagery is already evident and the picture was quickly copied and imitated [32].

The *St. Francis* shows a personal response to mystical events that we value in Caravaggio's later and finer religious paintings. The landscape, which was a delight to Francis as well as to most of the artists who portrayed this scene, is reduced to a darkling shimmer as tiny lights penetrate the gloom: fire and distant clouds that reflect the early dawn. The brilliant light that floods onto Francis and the angel is something quite different, the heavenly light of God. In this respect Caravaggio's picture may be closest to Giovanni Bellini's in the Frick Collection, which arguably

[5]*Golden Legend* (pp. 602–603). See also the *Little Flowers of St. Francis,* "Five Considerations on the Holy Stigmata of St. Francis."

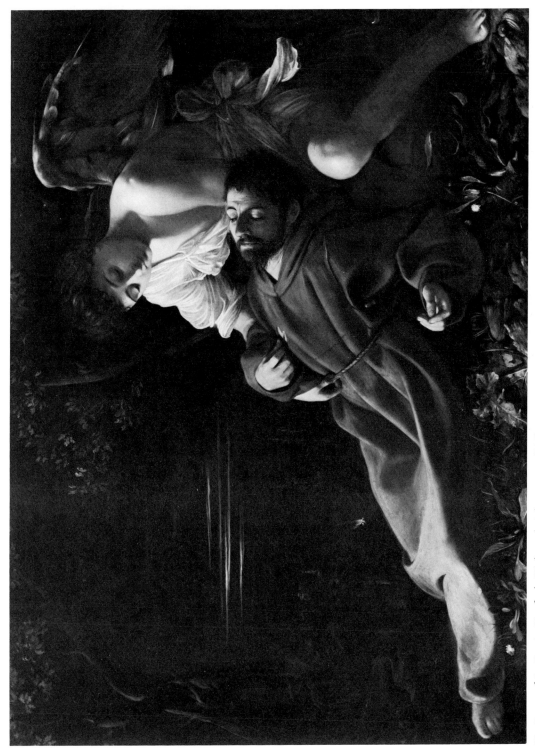

30. *Ecstasy of St. Francis*. Hartford, Wadsworth Atheneum. c. 1595?

57

shows a nocturnal Stigmatization, without a seraph, in which the entire landscape is miraculously illuminated, as described in the early sources. Artists gradually reduced the size of the seraph even in conventional pictures as time went on; yet Caravaggio, who probably did not know Bellini's painting, has seemingly reinvented the theme as an effect of God's power expressed through light. He emphasizes the force of this heavenly light by contrasting it with the darkness of the surrounding landscape, one of the very few he ever painted [cf. 29, 74, 102].

A second innovation in Caravaggio's picture is the passive, indeed unconscious form of the saint, who in conventional Stigmatizations actively welcomes his divine affliction. Francis swoons with one eye shut and the other open but unseeing in mystic ecstasy. Caravaggio was influenced by two relatively novel pictorial themes that he probably learned from Giuseppe Cesari d'Arpino. One was the Vision of Francis, a subject that Giuseppe Cesari had painted about 1593, perhaps when Caravaggio was working with him. In this new iconography Francis reclines, sometimes even in bed; or he sits up in his woodland retreat and has a vision of an angel, who often serenades him. Such paintings depict a vision that was necessarily private and internal. Caravaggio's *St. Francis* is more precisely another new subject, his Ecstasy, in which the swooning, ascetic saint is supported by angels. Cesari drew a Stigmatization in this way around 1590. But Caravaggio's recumbent Francis derives more obviously from the dead Christ mourned and supported by angels, which was itself a fairly recent invention. Thus we see that in his early religious works Caravaggio has connections with the progressive art he found in Rome, and particularly with that of Cesari d'Arpino, whose paintings served him on other occasions as well.

Giovanni Baglione painted a variant of Caravaggio's picture in 1601 [32]. In it a second angel holds the instruments of the Passion, making the parallel with Christ even clearer: we witness an ecstasy following a meditation on the Passion. Such imitations of his manner irritated Caravaggio enormously, and they seem to have caused the enmity that sprang up between him and Baglione afterward.

The theological background of these pictures is often overlooked. The historical Francis (1181–1226) was a happy, childlike saint who loved everything. His transformation into a suffering mystic was the result of gradual evolution. The influence of harsh Spanish asceticism was one source of this change, but the Spanish themselves had been influenced by a Franciscan movement epitomized by Harphius (Henry de Herp, died 1477), a Dutchman who incorporated speculative Germanic mysticism into Franciscan thought. The central idea of these mystics was expressed in a doctrine called "the super-eminent way" that recommended denial of the world and its creatures in favor of direct union with the divine by internalizing everything:

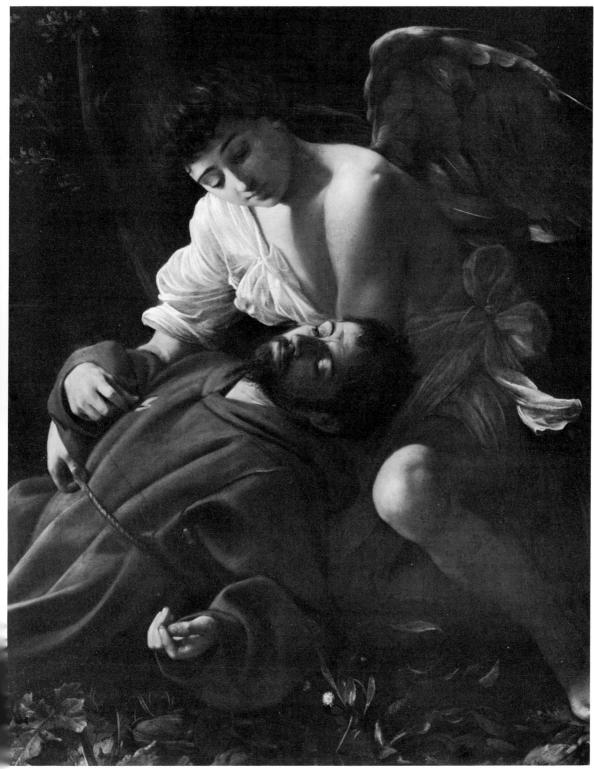

1. Detail of [30].

32. Giovanni Baglione, *St. Francis in Ecstasy.*
Santa Barbara, Davidson Collection. 1601.

the bypassing *(dépassment)* of every created thing, even the humanity of Christ. The desolation and bitterness that we associate with such austere Spanish mystics as St. John of the Cross (1542–1591) is already present in this early Franciscan thought, and indeed the idea of the "dark night of the soul," or mystic death, which Caravaggio's picture may represent, is found in the writings of Francis's official biographer, St. Bonaventure (died 1274), as well as in Suso, Eckhart, and countless others.

Caravaggio, like most artists of the period, shows Francis as a Capuchin, a reformed order of zealous Franciscans founded in 1529. The Capuchins taught St. Bonaventure's threefold way to God based on mystical ascent through purgation, illumination, and union. So many Capuchins followed this mystical tendency that in 1593 a general chapter of the order was forced to condemn "extreme tendencies towards the mystical, so-called super-eminent way under the influence of Harphius" and others. This criticism took place in Rome just before Caravaggio's picture was painted. His picture is visual proof of the late-Renaissance perversion of the historical thought and character of St. Francis, a distortion that continued unabated, despite official condemnation, in the art of contemporary Lombard artists like Morazzone (1573–1626), with whom Caravaggio had a kind of subliminal affinity. This mysticism flowered above all in Spain.[6]

Franciscan iconography of the Counter Reformation tended to assimilate

[6]For generic relationships between mysticism and the prevalence of plague, see McNeill (1976, pp. 184–185). Further, see Note 30.

scenes from the story of Christ into that of Francis: Christ's Agony in the Garden of Gethsemene was appropriated for the Ecstasy of Francis. Caravaggio's picture is also a kind of Pietà, with the Virgin's place taken by an angel [31; cf. 116]. Iconographically, Francis is a new Christ experiencing the equivalent of Christ's martyrdom and Mary's subsequent compassion simultaneously, a metaphorical death and rebirth through the ecstasy of the love of God. In a painting that has no exact precedent, Caravaggio seems to have combined the Stigmatization and the Ecstasy in a scene that is not outwardly a vision but an actual physical manifestation, a mystic Stigmatization in which light alone carries the full force of God's recognition and love.

Caravaggio's *St. Francis* seems newly felt and imagined, as if he had experienced the subject before he painted it. The picture gives the impression that he began with no preconceptions, no tradition whatever, and simply relied on his own thought and feeling. Caravaggio did not bring this intense response to every religious theme, but throughout his life he showed unusual interest in conversion and in submission to the divine will. It is what I take to be this autobiographical element that makes the *St. Francis* so original and so moving. It is also typically ambiguous; Caravaggio was not able to complete his vision of God's wonderful love without an intermediary from his own (or Del Monte's) world of androgynous adolescence.

THE CONVERSION OF THE MAGDALEN

Caravaggio apparently took up a theme related to the *Repentant Magdalen* [28] several years later, in a painting showing Martha chastising Mary, the *Conversion of the Magdalen* [33]. It seems to reflect a more mature moment in his evolution, around 1597–1598, when he was elaborating his compositions and beginning to work up his pictures from a dark background.

The idea and the rudiments of the composition are Leonardesque, and they may derive from a painting attributed to Leonardo that Caravaggio probably knew in Rome. Caravaggio's increasing use of darkness as a shroud of night from which only a few highlights emerge may also derive from a study of Leonardo's *sfumato,* although its unifying mist is different from the achievement of Caravaggio, who failed to reproduce Leonardo's enveloping atmosphere. Nevertheless it was Leonardo who had reformed Italian art, in pictures such as his *Last Supper,* by rejecting hieratic formulas in favor of human drama. Caravaggio is in that tradition. In subject matter too we find Leonardesque themes: Caravaggio's lost *Caraffa* may be connected with Vasari's

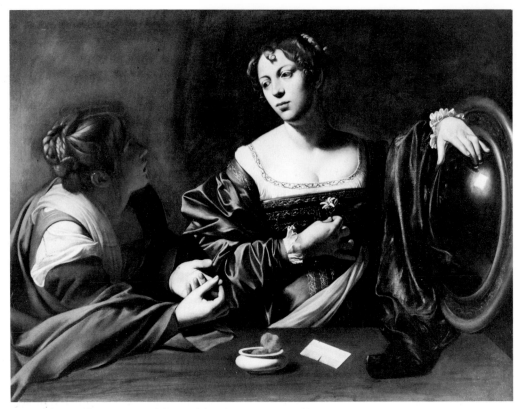

33. Caravaggio (?), *Conversion of the Magdalen*. Detroit Institute of Arts. c. 1598.

description of a similar picture by Leonardo; the *Medusa* [37] may rival a painting by Leonardo, which Vasari said was never finished.[7]

In this picture, Mary, still resplendent in her finery, is shown at the moment of divine revelation and conversion, an inner transformation that contrasts with Martha's pose and gesture. In the surviving canvases, however, it is Martha, with her turned profile and shadowed features, who seems worthy of Caravaggio. The Magdalen, coarse and blatant in shiny colors that we can easily name (unusual in a painting by Caravaggio), is in hue and texture unlike anything else he ever painted. Perhaps the Detroit picture was begun by Caravaggio but only blocked out at the right and then partially finished by another hand, as Donald Posner once suggested. The theme of conversion, however, fits in well with what we know of Caravaggio's larger interests. The problematic *Magdalen* falls in with a group of relatively advanced pictures that includes two unquestionably authentic works, *Judith Beheading Holofernes* [36] and *St. Catherine* [34].

[7]Cited in Note 37; cf. p. 84, n. 22, and pp. 150, 152.

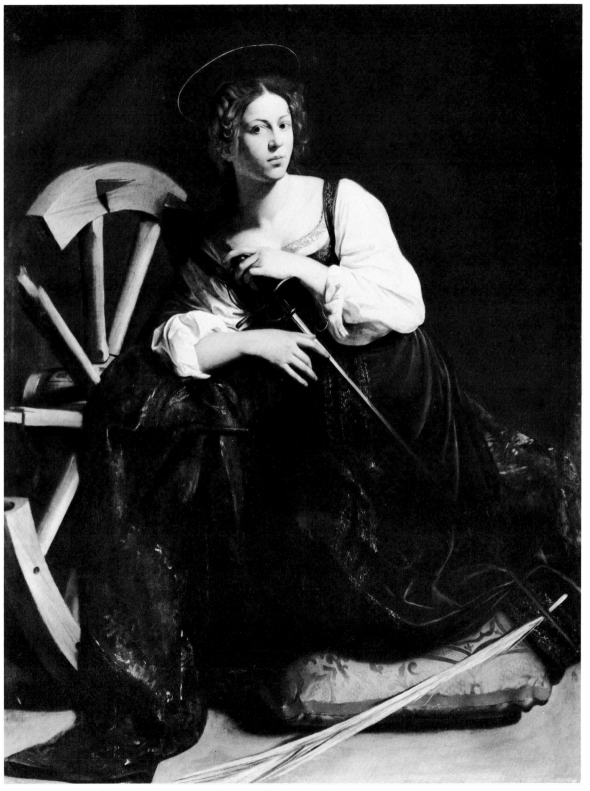

34. *St. Catherine of Alexandria.* Lugano (vic.), Thyssen Collection. c. 1598.

35. Annibale Carracci and Lucio Massari, *St. Margaret*. S. Caterina dei Funari. c. 1598.

ST. CATHERINE OF ALEXANDRIA

The monumental *St. Catherine* was surely painted for Del Monte, probably in 1598–1599. Caravaggio's only sister was named Catherine, but the choice was probably Del Monte's since he had other pictures of the subject, including one by Annibale Carracci. The model and to some extent the costume is that of the *Conversion of the Magdalen* [33], here obviously painted by Caravaggio himself, and the contrast in quality is striking.

The light falls (unusually) from the right. *St. Catherine* is untouched by Caravaggio's deeper imagination, and the figure is subordinated to her magnificent drapery and crimson cushion, though the striking face is rendered with portrait-like fidelity [cf. 27]. The jutting axle and prominent rapier not only allude to her martyrdom but also belong to a growing repertory of thrusting, cutting weaponry [cf. 36, 59].[8] Compared to his dramatic pictures, the *St. Catherine* is cool and formal. Yet we learn a great deal about Caravaggio when we compare it with contemporary saints by Annibale Carracci [35] and Giuseppe Cesari d'Arpino [91]. By 1597 Cesari had achieved a *maniera* sinuosity with a relatively lush surface, a softening of his style

[8]Macrae (1964) and my p. 196, n. 19. Macrae noted that Caravaggio's swords show "a consistent tendency toward simplification of form . . . in each succeeding painting he showed an earlier example in the development of proto-rapiers, so that, unwittingly, he has illustrated their historical development almost exactly in reverse." Further, cf. Norman (1980).

in oils toward the end of the decade. The image also displays some of that prurience that artists tended to infuse into pictures of female saints, but which Caravaggio avoided. Annibale's Venetianizing *St. Margaret* of about 1598 [35] supposedly prompted Caravaggio to exclaim: "At last I see a real painter."[9] Pictures such as these are the precursors of more emphatic devotional icons that were soon to be produced by Rubens, Reni, and Bernini. Caravaggio's *St. Catherine* is unlike its contemporaries in its tendency toward portraiture untempered by idealization. The female saints by Cesari and Annibale, different though they are, share a tradition that Caravaggio rejected.

The realism of the *St. Catherine* is evident—a lack of atmosphere, an almost coarse depiction of the alert face and the common hands, an insistence on harsh shadows, reflections, and details. Perhaps the most striking feature is a bravura treatment of the clothing, which ranges from seamstresslike embroidery on the blouse through realistic but more liberated golden arabesques on the black skirt to amazingly free and light brushstrokes creating brocade on the blue drapery. This embroidered fabric, which falls over the wheel and reappears at the right, makes us think of the mature Velázquez. Such mastery in a large, life-size painting points to a date close to the Contarelli Chapel (1599–1600), a maturity that is also seen in the powerful highlighting and dark background.

JUDITH BEHEADING HOLOFERNES AND THE *MEDUSA*

Judith Beheading Holofernes [36] was probably also painted in 1598–1599, when Caravaggio began to darken the darks in his paintings. The German painter Joachim von Sandrart explained that Caravaggio

> was determined never to make a brushstroke that was not from life, and to that end he placed the model before him in his room in order to copy it as well as he could. And in order to bring out better those effects of relief and natural roundness, he used dark vaults or other shadowed rooms with one small light above, so that the light falling on the model made strong shadows in the darkness and so emphasized the effect of relief.

At this time too he began to be more concerned with drama and cruelty; violent death and mutilation replace some of his earlier themes.

[9]Bellori (p. 32, *Life of Annibale*) wrote: *"Collocato il quadro su l'altare, per la novità vi concorsero li pittori; e fra li varii discorsi loro, Michel Angelo da Caravaggio, dopo essersi fermato lungamente a riguardarlo, si rivolse e disse: 'Mi rallegro che al mio tempo veggo pure un pittore,' intendendo egli della buona maniera naturale, che in Roma e nell'altre parti ancora affato era mancata."*

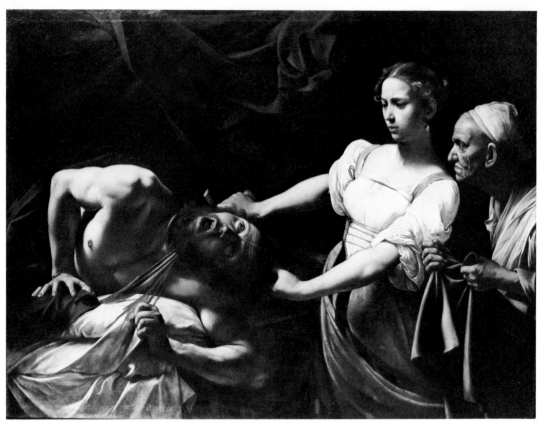

36. *Judith Beheading Holofernes.* Galleria Nazionale. 1598–99.

Jews and Protestants alike put the Book of Judith among the Old Testament Apocrypha, but in Jerome's Latin Bible, Tobias, Judith, and Esther follow the historical books. According to the tale (which is wildly unhistorical), Judith, a Jewish widow, saved her homeland during an Assyrian invasion. In the Renaissance she became a symbol of Fortitude. For Catholics she is also an antetype of the Virgin Mary; part of Judith's prayer is included in the earliest Roman Breviary, and she is still invoked on the feast day of Mary's Immaculate Conception as the savior of her people, as Mary was of hers.

Caravaggio's composition is fairly simple. The figures, slightly over life size, are spread across the front plane; the dark red drapery hanging unexplained at the left is probably based on Venetian models. There is no created space for the two women, which recalls problems that Caravaggio repeatedly failed to solve [cf. 15]. Judith comes up to the surface of the canvas to dispatch her enemy with slightly awkward determination. The turtle-like old woman may have northern ancestors, and she will reappear in transformed, Caravaggesque state in countless genre-like pictures of the Utrecht school. Richard Spear pointed out to me that she is most probably

based on a Roman Republican portrait bust—which seems obvious once it has been mentioned. The female type seen in Judith is new for Caravaggio; sexual and attractive, she is quite different from his early female figures [cf. 12, 28]. The contrast between the old hag and the nubile Judith may show Caravaggio's awareness of a late Renaissance extension of the idea of *contrapposto,* which pointed up contrasts of position or, as here, of age and condition.[10] We see impasto in the highlights on Judith's right breast and on the shoulder of Holofernes. Caravaggio again displays his love of details: icy blue lacing on Judith's blouse, gold design on the sword handle, gold-on-gold brocade on Judith, and ribboned earrings like the little *Magdalen* [28].

Annibale Carracci, with whom Caravaggio was evidently on fairly good terms, called Caravaggio's art here *"troppo naturale"*—too natural. In another context we learn that he disapproved of spotlight effects that left most of a picture in gloom: Caravaggio's darkness covered the difficulties of art with the shadows of night (Annibale supposedly went on to say), whereas Annibale preferred open and clear light, seen straight on, in order to reveal what he considered the most complex achievements of the painter's craft [cf. 81].[11]

The horrifying decapitation, with jets of blood and screaming face, has a counterpart in a painted shield bearing the Medusa of about the same time [37]. It is not properly a picture at all but a decorated piece of parade armor that exhibits the interest in extreme expression that Caravaggio began to show in the *Boy Bitten* [25]. I have mentioned that Caravaggio may have read in Vasari's *Lives* that Leonardo had also painted a shield with the decapitated Medusa. Traditionally, metal shields had relief Medusa heads with snakes for hair that served the apotropaic purpose of scaring the enemy, which is just how Giovan Battista Marino described Caravaggio's picture in a poem. But unlike the stylized frontal heads of traditional shields, Caravaggio's *Medusa* looks alive: her mouth screams and blood spurts from her severed neck. According to Baglione, the shield was a gift from Del Monte to Grand Duke Ferdinand of Tuscany and it is still in Florence.

[10]Summers (1977, p. 356) quotes Comanini's *Il Figino* of 1591: "And as the poet plays with antitheses, or with *contrapposti,* so the painter counterposes in one painting figures of women and men, infants and old . . . next to a man a woman . . . or next to a beautiful girl an ugly old woman." It seems possible that this principle was already consciously in operation in Caravaggio's *Rest on the Flight* [29], and since *Il Figino* is a Milanese treatise, Caravaggio may have read it (Barocchi, *Trattati,* III, has the text).

[11]Malvasia (I, p. 344) reports that Annibale, "Forced to give his opinion of a *Judith* by Caravaggio, said: 'I do not know what to say, except that it is too natural.'" In the *Life of Guido Reni* (II, p. 9; 1980, pp. 43–44) an unnamed painting by Caravaggio in the Palazzo Lambertini aroused Ludovico Carracci's interest (perhaps a copy of [104]: cf. Malvasia, II, p. 217). He was supposedly "struck dumb by seeing only a great contrast of light and dark, with too close an imitation of nature, without decorum, with little grace and less intelligence." The remarks then attributed to Annibale, quoted above, are not generally believed to be authentic. Reni (Malvasia, II, p. 56) was also made to say that Caravaggio's art was *"troppo naturale."* Cf. Mahon (1947, pp. 37–38, n. 39), and Dempsey (1977, pp. 23–24, 85–86). Bellori (p. 5: *L'Idea*) said the same thing, citing Demetrios and calling Caravaggio his modern equivalent.

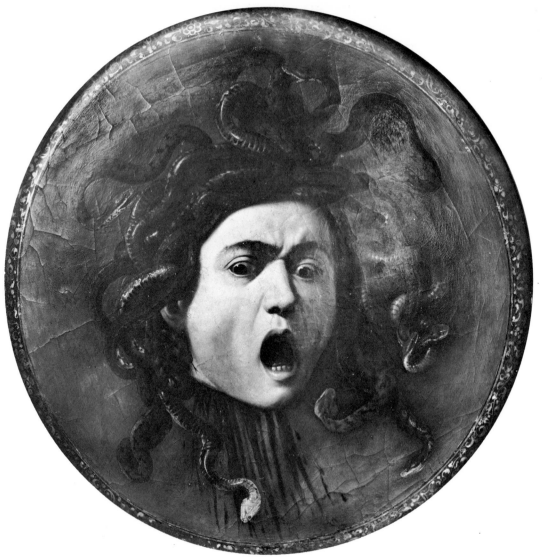

37. *Medusa*. Florence, Uffizi. c. 1597?

Both Judith and Medusa had moralizing identifications: Judith quickly became a proto-Marian figure; Medusa symbolized the victory of reason or virtue over sensuality because she turns warm male flesh to cold stone. Mantegna painted *Philosophia* with a Medusa shield, and Milton could write:

> What was that snaky-headed Gorgon shield
> That wise Minerva wore, unconquer'd Virgin,
> Wherewith she freez'd her foes to congeal'd stone,
> But rigid looks of Chaste austerity
> And noble grace . . .
>
> (*Comus,* 446–450)

These two decapitated heads with their streaming blood and horror-stricken faces also belong to Caravaggio's private world of fears and fantasies, or so we may suppose from the series of images that he eventually produced [102, 156, 173].[12] Freud, in "The Medusa's Head," pointed out the unconscious symbolic relationship between decapitation and castration; from all that we know of Caravaggio's later life and art, he was obsessed, far more than most men, with such fears. The toothy mouth of the youthful Medusa must also remind us of that psychoanalytic favorite, the *vagina dentata;* the concept may even furnish a clue to Caravaggio's relative comfort in the male world of Cardinal Del Monte.

Following Caravaggio's meeting and friendship with Del Monte, the next important event, the most decisive of his Roman career, was his commission in July 1599 to paint two large pictures for a chapel in the church of San Luigi dei Francesi across the street from Del Monte's palace (see Chapter 3). The paintings themselves reveal Caravaggio's successful struggle to attain a monumental style commensurate with the expectations for this semi-public site [52, 56]. In order to have been considered for the Contarelli commission, Caravaggio may have painted more ambitious paintings that are now unknown. But most of the pictures that have since been assigned to this period are probably contemporary with the Contarelli Chapel or later.

THE BETRAYAL OF CHRIST AND CHRIST CROWNED WITH THORNS

One candidate for a missing picture is a composition representing the capture of Christ [38]. The figures, seen at night with special lighting effects from a lantern and reflections in armor, are crowded into a frontal plane and could reflect a stage in Caravaggio's development around 1598–1599—but we are peering back through what seems to be a copy that may distort the presumed original, and all proposals of this kind must be treated with caution. A *Betrayal of Christ* was recorded in the Mattei collection by 1623; Marchese Ciriaco Mattei was one of the new patrons who began to recognize Caravaggio's unique qualities in the years around 1600. The composition, more ambitious than anything we have discussed so far, shows a confusion of actions and gestures. It seems to depend in part on prototypes from Lombardy such as Cariani's *Road to Calvary* [39], painted almost a century earlier, where the

[12]For actual decapitations in the Cinquecento (which were reserved for high-class criminals), see Edgerton (1972). These horrors came to a climax with the bloody executions of the Cenci on 11 September 1599. Caravaggio must have been fascinated.

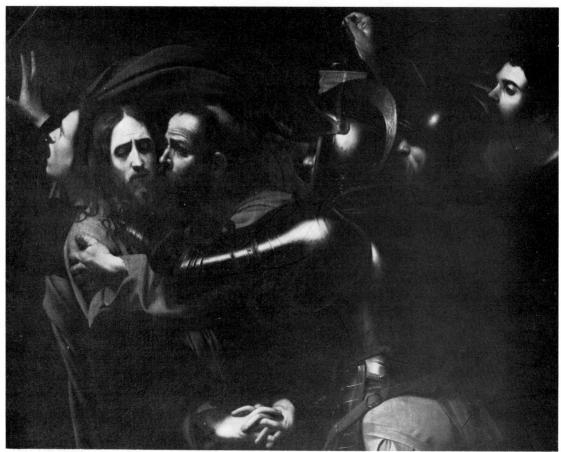

38. After Caravaggio (?), *Betrayal of Christ*. Odessa, Museum of Western and Eastern Art.

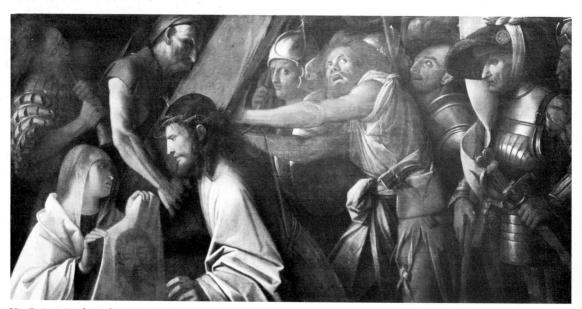

39. Cariani, *Road to Calvary*. Brescia, Pinacoteca. c. 1510–17.

70

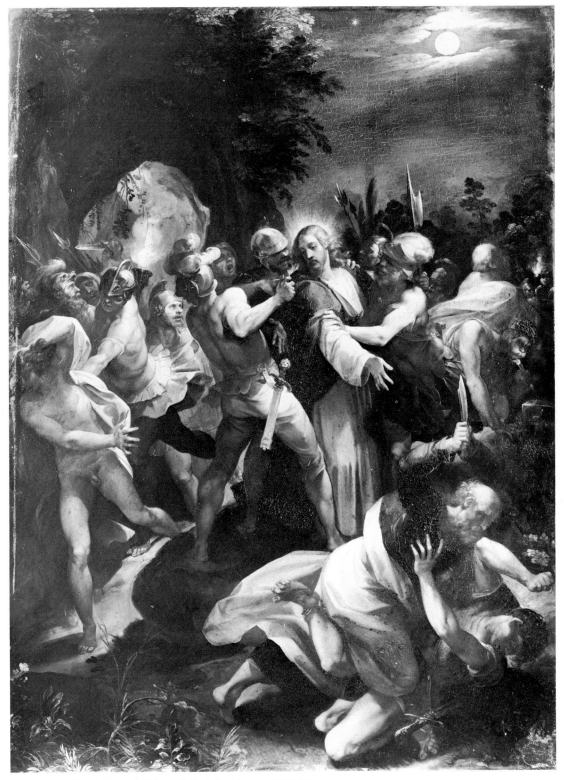

40. Giuseppe Cesari, *Betrayal of Christ*. Galleria Borghese. c. 1596–97.

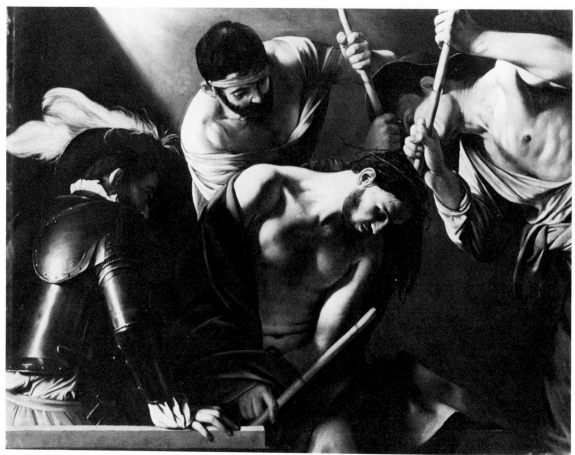

41. After Caravaggio (?), *Christ Crowned with Thorns*. Vienna, Kunsthistorisches Museum.

crowding, costumes, highlighted armor, and juxtaposed heads are all something like Caravaggio's. Missing in Cariani's picture is Caravaggio's concentration and above all his exaggerated light-dark, which is accentuated in the *Betrayal of Christ* because the scene takes place at night [cf. 30].

Caravaggio must have known a small painting by Giuseppe Cesari, probably to be dated 1596–1597 [40], which is notable for its light-dark contrasts. There the same motifs appear in a more conventional space and acted out with *maniera* exaggeration. Caravaggio's picture shows his growing interest in the horrific in the depiction of a figure running away at the left, mouth open and apparently screaming. The open mouth of the *Boy Bitten* is a prelude to this kind of empathetic expression, which finds a more grisly outlet in the pictures we have just discussed [36, 37]. In the *Martyrdom of St. Matthew* of 1600 a similar screaming figure runs out at the right [56,

68]. These figures seem to derive from Titian [cf. 61], and they may reflect Ludovico Dolce's observation that in Titian's painting "one seems to hear the scream."[13]

As it comes down to us, Caravaggio's *Betrayal of Christ* is similar in size and theme to a well-known *Christ Crowned with Thorns* [41], possibly from the Giustiniani collection. Although still often attributed to Caravaggio, it is more probably a copy or a version of a painting now lost. The picture has dramatic lighting and a mature, almost violently compact composition that point to a later moment in his development.

THE SUPPER AT EMMAUS (LONDON)

We are on more secure ground when we turn to the large and dramatic *Supper at Emmaus* now in London [42, 46, 48]. Baglione says that Caravaggio painted an *Emmaus* for Ciriaco Mattei, which is probably this one, later acquired by Cardinal Scipione Borghese. In Caravaggio's picture we see the moment in which Christ reveals himself to two disciples on the day of his Resurrection, Easter Sunday. The event is unbearably poignant because the gospel writers say that after Christ's arrest, the disciples "all deserted him and ran away" (Matthew 26:56; Mark 14:50). The story of the supper at Emmaus is told only in Luke (24:13–32).

> That same day two of them were on their way to a village called Emmaus, which lay about seven miles from Jerusalem, and they were talking together about all these happenings. As they talked and discussed it with one another, Jesus himself came up and walked along with them; but something kept them from seeing who it was. He asked them, "What is it you are debating as you walk?" They halted, their faces full of gloom, and one, called Cleopas, answered, "Are you the only person staying in Jerusalem not to know what has happened there in the last few days?" "What do you mean?" he said. "All this about Jesus of Nazareth," they replied, "a prophet powerful in speech and action before God and the whole people; how our chief priests and rulers handed him over to be sentenced to death, and crucified him. But we had been hoping that he was the man to liberate Israel. What is more, this is the third day since it happened, and now some women of our company have astounded us: they went early to the tomb, but failed to find his body, and returned with a story that they had seen a vision of angels who told them he was alive. So

[13]Baglione (p. 136) uses the same cliché to animate the *Boy Bitten: "e parea questa testa veramente stridere."* For Dolce, see Barocchi, *Trattati* (I, p. 204; also ed. Roskill, 1968, pp. 190–191, with translation and comments, pp. 221, 329). Further, cf. Rosand (1980, p. 91 and *passim*).

42. *Supper at Emmaus*. London, National Gallery. c. 1600–1601.

some of our people went to the tomb and found things just as the women had said; but him they did not see."

"How dull you are!" he answered. "How slow to believe all that the prophets said! Was the Messiah not bound to suffer thus before entering upon his glory?" Then he began with Moses and all the prophets, and explained to them the passages which referred to himself in every part of the scriptures.

By this time they had reached the village to which they were going, and he made as if to continue his journey, but they pressed him: "Stay with us, for evening draws on, and the day is almost over." So he went in to stay with them. And when he had sat down with them at table, he took bread and said the blessing; he broke the bread, and offered it to them. Then their eyes were opened, and they recognized him; and he vanished from their sight. They said to one another, "Did we not feel our hearts on fire as he talked with us on the road and explained the scriptures to us?"

In Caravaggio's picture Christ presides over a table laden with grapes, wine, water, bread, and a cooked fowl. Here he is still representing still life for its own sake, and this is one of the last such pictures he painted.

The *Supper at Emmaus* is traditional in composition. But the lighting, the close-up view of dramatically posed, half-length figures set against an impenetrably dark background, and the beardless Christ (who may purposely be shown as Semitic) are all novel. Painters typically chose the moment when the eyes of the disciples are opened: Titian showed Christ with his left hand on the symbolic bread, blessing rather than breaking it, a Venetian tradition that was varied in a picture by Veronese that may have been in Rome in Caravaggio's day [43]. There Christ blesses and looks heavenward. Despite differences, the dramatic gestures of the right-hand disciples by Veronese and Caravaggio may indicate a connection. But the Venetian pictures seem secular and mundane with their servants, dogs, and gracious vistas.

The Christ in Caravaggio's painting gestures dramatically as the two disciples recognize him; the turbaned servant merely stands, neither seeing nor comprehending. Caravaggio's decision to show Christ beardless may reflect a brief reference to his apparition after death in the Gospel of Mark, which says that Christ "appeared in a different guise to two of them as they were walking, on their way into the country" (Mark 16:12; the Vulgate translates the Greek for "in a different guise" as *in alia effigie*). Yet the beardless Christ has other, simpler explanations. Early Christian images of Christ, such as those on the sarcophagus of Junius Bassus, unearthed in 1595, often showed him without a beard. There was new interest in Early Christian art and ritual at precisely this time, reflected and abetted by the famous *Annals of the Church* (1588–1607) by Cesare Baronius, who tried to support the eternal verity of Roman

43. Studio of Paolo Veronese, *Supper at Emmaus*. Dresden, Gemäldegalerie. c. 1560?

44. Marco d'Oggiono, *Salvator Mundi*. Galleria Borghese.

45. Michelangelo, *Last Judgment* (detail). 1534–41.

Christianity by a credulous appeal to early Church tradition.[14] Moreover, a beardless Christ is found in paintings by two artists in whom Caravaggio had particular interest. A *Salvator Mundi* long attributed to Leonardo, which was presumably then as now in Rome, shows him beardless [44]; (another such picture, now in the Ambrosiana in Milan, was owned by Cardinal Borromeo). These are only the most obvious and available of a number of similar pictures that presumably depend on a lost prototype by Leonardo himself. Michelangelo chose to show a beardless, Apollonian Redeemer and Judge in his *Last Judgment* in the Sistine Chapel [45], and Caravaggio seems to have been particularly drawn to Michelangelo at this time (see Chapter 6). There is even an iconographic connection between the scenes, for Christ's first appearance to the disciples at Emmaus may be thought of as a prefiguration of his final appearance on the Last Day.

Caravaggio's *Supper at Emmaus* demonstrates a new mastery of half-figure composition. As in some earlier works, he relies on a table to arrange the scene [cf. 9, 10, 18]. The table is set close to us, parallel to the plane of the canvas, but far enough removed for a disciple to be shown before it. At the moment of dramatic revelation this disciple pushes back his chair in astonished disbelief. In doing so, he seems to thrust it into our own space before the canvas, revealing Christ to us as well. We see this disciple only from the side and back, in the darkness; the focus of our attention is on the illuminated Christ. The astonished disciple at the right, an unforgettable figure, throws out his arms in a dramatic gesture of amazement so that his left hand seems to cut through the picture plane. Caravaggio's new interest in gesture may have been stirred by a study of Raphael as well as by memories of Leonardo's *Last Supper* in Milan; the almost caricatured face of the disciple also has Leonardesque precedents. The idea that interior thought and feeling must be depicted in art through outward gesture was stated by Leon Battista Alberti, who wrote that the movements of the body reflect those of the soul.[15] In this painting Caravaggio reveals his new study of the masters of the High Renaissance. The picture, then, does not belong with the relatively naive dramas of the 1590s; rather, it shows a new sophistication born of the Contarelli Chapel (see Chapter 3).

The left arm of the gesticulating disciple unites the painted actors with us, the living viewers, in a manner that signals a new age of participatory art. The spectator is almost forced to take part in the painted religious drama. Mannerist artists had long been toying with the illusion of continuity between spectator and painted scene [cf. 147], but in general these were tours de force that called attention to themselves as illusions rather than to the subjects and their meaning—indeed, the manner tends to

[14]Pullapilly (1975) gives a thorough treatment.
[15]*"hi motus animi ex motibus corporis cognoscuntur"* (*De Pictura*, II, 41; 1972, p. 81; trans. p. 82).

become the meaning, the subject merely a motif. Caravaggio adapts Mannerist tradition only to the extent that he again seems to penetrate the picture plane, not as an exhibitionist but as a dramatist who seizes our attention in order to illuminate the meaning of the story within the frame.

Caravaggio's setting is appropriately obscure for an evening supper at an inn, but these are now the typical darks that he will use in almost every picture.[16] The colors are deep and warm: a green undergarment on the disciple with the shell and a greenish brown background contrast with variants of dull red on the other three figures. The only blues in the picture are on the beautiful faience pitcher and bowl [46]. Bellori wrote, perceptively:

> Without doubt Caravaggio advanced the art of painting, because he lived at a time when realism was not much in vogue and figures were made according to convention and *maniera,* satisfying more a taste for beauty than for truth. Thus by avoiding all prettiness and falsity in his color, he strengthened his hues, giving them blood and flesh again, thus reminding painters to work from nature. Consequently, Caravaggio did not use cinnabar reds and azure blues in his figures; and if he occasionally did use them, he toned them down, saying that they were poisonous colors. He never used clear blue atmosphere in his pictures; indeed, he always used a black ground, and black in his flesh tones, limiting the highlights to a few areas. Moreover, he claimed that he imitated his models so closely that he never made a single brushstroke that he called his own, but said rather that it was nature's. . . .[17]

Despite the still life and other details that are suppressed in Caravaggio's later version of this theme [137], the painting is dramatically effective through the forced contrast of deep darks and brilliant highlights, the extraordinary combination of gestures, and the focus on Christ. All of this may well date the picture just after the side paintings for the Contarelli Chapel [52, 56], but it could be exactly contemporary (1600). There are "errors" in the *Supper at Emmaus* that might place it earlier rather than later: the extended hands of the disciple at the right are of about the same size, even though one is thrust toward us and the other, if anything the larger of the two, is as far from us as possible. The innkeeper's hands are also unusually large [46]. These anomalies, even if they serve a dramatic purpose, confirm the opinions of the old writers that Caravaggio was poor at diminution and perspective effects. Nevertheless, with the *Supper at Emmaus* we have arrived at a moment when Caravaggio was making extraordinary leaps in his artistic growth—an evolution so extreme and so

[16]The exaggerated darkness used to heighten the effects of brightness is also, in certain contexts, an example of the extended sense of the *contrapposti* so dear to the High Renaissance and later: see Summers (1977) and my p. 67, n. 10.

[17]Bellori (p. 212). A scientific study of Caravaggio's colors would be most useful (cf. Note 33).

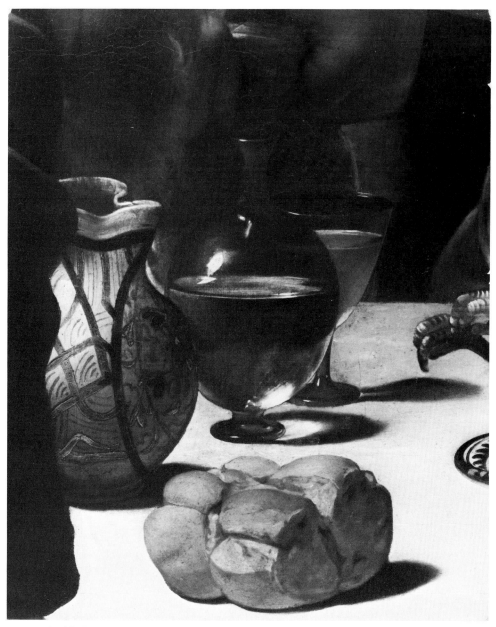

46. Detail of [42].

rapid that only the fairly recent discovery of documents has allowed us to begin to understand it.

One of the disciples, Cleopas, is named in the Bible; the other is anonymous but might be Peter. This may have been the opinion of Cesare Baronius, who wrote that Peter was surely the first disciple to see Christ after his Resurrection. The striking figure at the right, wearing the shell, might however be James the Great, elder brother

of John and companion of Peter, whose shrine at Santiago de Compostela was the chief Western goal of pilgrims. Such pilgrims were identified by a scallop shell, which then became the artistic attribute of St. James himself. On the road, Cleopas said to the unknown traveler, "Are you only a stranger in Jerusalem?" In the Vulgate, "stranger" is rendered as *peregrinus*. The idea of pilgrimage (symbolized by the shell, whoever the disciple may be), whose object is salvation, is reinforced by the living presence of the *Salvator Mundi*.

In Jerome Nadal's *Evangelicae Historiae Imagines* of 1593, which was widely consulted, we are told that the Supper at Emmaus prefigures the Mass. The resurrected Christ in Caravaggio's painting presides over wine and bread that become his blood and body in the sacrament. Christ's gesture parallels the priest's consecration of the wafer. The underlying message of Caravaggio's *Supper at Emmaus* seems to be that Christ reveals himself to the faithful, physically and spiritually, only through the Eucharist, symbolized by the bread, wine, and grapes. The outstretched arms of the disciple, which may also allude to the Crucifixion, join us to the pilgrim: we are all on pilgrimage in search of salvation. Even those who do not acknowledge Christ are on this journey; the innkeeper, who sees and understands nothing, represents the world of pagans and heretics who do not recognize Christ and his Church. Nevertheless the innkeeper casts a shadow that seems to form a negative halo around the brilliant head of Christ, as if to indicate that we honor the Savior even while ignoring or denying him.

STILL LIFE

The meaning of the *Supper at Emmaus* is reinforced by the still life: eucharistic grapes, and pomegranates that allude to the Resurrection. The prominent basket of fruit on the edge of the table can thus be explained, if not wholly excused, by its symbolic meaning. Caravaggio's preoccupation with this still life is therefore appropriate for a Christian supper even if, as Bellori complained, it is out of season for Easter.[18] The luxurious basket of overripe fruit is a tour de force of realism that intrudes upon our attention by projecting beyond the table [48]. It lacks the emphatic precision and clarity of the still life in the Uffizi *Bacchus* [23], which is to say that Caravaggio has now assimilated it into the overall tonality of the dark painting. It also calls to mind Caravaggio's only independent *Still Life,* in which we see some of the same qualities [47].

[18]Bellori (p. 213). Apart from the obvious symbolic significance of the grapes and pomegranates, which Bellori ignored (see Note 42), autumn sometimes signified martyrdom (Bosio, 1632, p. 639 D), and hence autumnal fruits might be appropriate.

The picture belonged to Cardinal Federico Borromeo (1564–1631), Archbishop of Milan, who gave his paintings to the library he founded there, the Biblioteca Ambrosiana. In Rome, Borromeo lived near Del Monte, was a friend of the Giustiniani, and formed part of the Oratorian circle frequented by some of Caravaggio's patrons, including the Giustiniani and Crescenzi, all of whom were neighbors [cf. 51].[19] This *Still Life* was once wrongly associated with a gift from Cardinal Del Monte to Borromeo in 1596, but it is undated and can be left to find its place on the basis of style, which puts it somewhere between the still life in the *Bacchus* [23] and that of the *Supper at Emmaus* [48]. The relative clarity and precision of the *Still Life* might indicate a date closer to the airless still life in the *Bacchus;* but by 1600, when he was presumably painting the *Supper at Emmaus,* Caravaggio was surely aware of the difference in focus desired in an autonomous still life as opposed to a still life detail in a large painting.[20] The baskets are similar in the two paintings, and so is the viewpoint. Thus these pictures could be fairly close in date. The cardinal may have commissioned the painting in Rome or purchased it directly from Caravaggio; Borromeo was in Rome from 1596 to mid 1601 and earlier as well.

The Ambrosiana *Still Life* is seen straight on, the basket resting on a strip of color that we read as a horizontal surface touching the picture plane. The basket projects beyond that strip, which is to say that it seems to break through the surface on which the picture was painted. This *trompe l'oeil* effect was abetted by a painted frame, of which only a part remains. Although the creamy background was added after the still life itself had been painted, it is not necessarily (as was once supposed) by someone who later tried to convert a detail of a larger picture into an independent composition. Caravaggio may have painted the picture more or less as we see it, and it is the sole survivor of his early interest in independent still-life painting.

Still life is often found in Lombard paintings [cf. 5], and a few Lombard pictures of independent still life may be contemporary, but Caravaggio's small *Still Life* is unique in its grandeur and compositional power. The eloquent and uncanny balance between subject and ground, the stylish relationship to the frame that cuts off the mysterious tendril coming in at the right, all make it an outstanding contribution to a genre that was then in its infancy.

Still-life details are described by the critics of antiquity and can be found in

[19]From April 1599 until his departure in mid 1601, Borromeo lived near Caravaggio in various palaces. For the Roman period, see Gabrieli (1933–1934). For connections with the Oratory, Ponnelle & Bordet (1929, p. 445 and *passim*). Cf. Pastor (XI, p. 745); the biography by Prodi in *Dizionario biografico degli italiani* (XIII, 1971, pp. 33 ff.); Calvesi (1975, pp. 83 ff.); and Prodi in Evennett (1970, p. 138). For Borromeo's collection and his theory of art, see Diamond (1974), Coppa (1970), and my Note 47, pp. 294–295.

[20]See pp. 40–41 above.

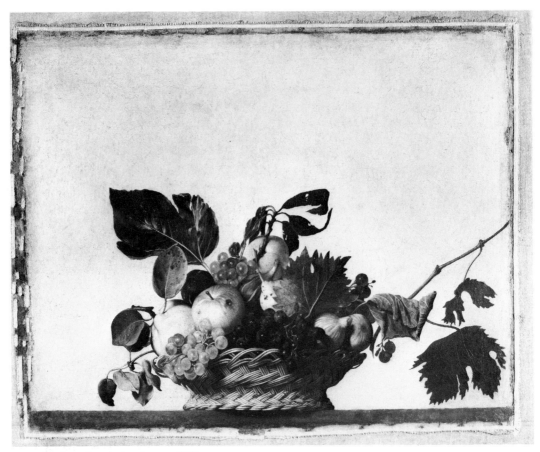

47. *Still Life*. Milan, Ambrosiana. c. 1598?

surviving fragments of painting and mosaic, but still life as a distinct genre seems to have been a creation of the Renaissance. Only then were the minds of viewers ready to accept independent still life, detached from a larger context, as art. Such pictures are also indebted to medieval tradition, and in the Renaissance every plant, flower, and animal still had the possibility of offering an ulterior meaning, usually one derived from older commentaries. Often such meanings were knotted into a single emblem; the *Boy Bitten by a Lizard* [25] may illustrate this tendency.

The fruits in Caravaggio's *Still Life* are basically those of late summer: four kinds of grapes, two of figs, and apple, pear, and peach. Everything verges on decay —which may simply be a function of elapsed painting time, Caravaggio's realism. There are also overtones in any display of maturing fruits that make them paradigmatic of the endless cycle of the seasons and that of life itself. Such pictures can symbolize the vanity of earthly things, not merely by showing the inevitable maturation and decay of all life but also, as Ernst Gombrich put it, because

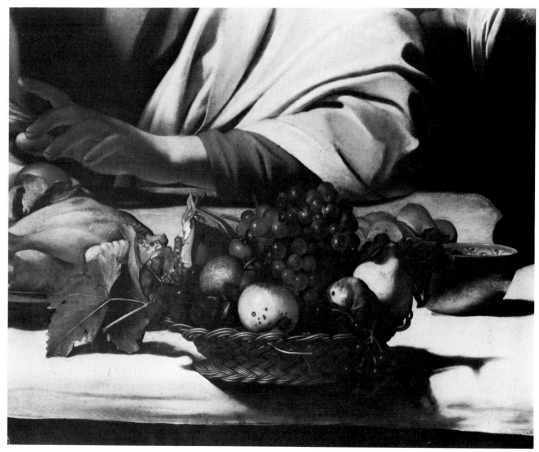

48. Detail of [42].

every painted still life has the *vanitas* motif "built in" as it were, for those who want to look for it. The pleasures it stimulates are not real, they are mere illusion. Try and grasp the luscious fruit or the tempting beaker and you will hit against a hard cold panel. The more cunning the illusion the more impressive, in a way, is this sermon on semblance and reality. Any painted still life is *ipso facto* also a *vanitas*.[21]

Vincenzo Giustiniani once quoted Caravaggio as having said that it was as much work for him to make a painting of flowers as one of figures (*"il Caravaggio disse, che tanta manifattura gli era a fare un quadro buono di fiori, come di figure"*). Perhaps Caravaggio was referring to the painting in Del Monte's collection that is listed in the inventory of 1627 as *"una Caraffa"*—or whatever picture it was that Bellori admired for its flowers and the reflections on the glass [cf. 18, 25]. The surviving *Still Life* [47], Bellori's description of the vase of flowers, and Caravaggio's remark

[21]Gombrich (1963, p. 104).

have led some writers to assume that he believed still life to be not only as difficult as traditional figure painting but also as good.[22]

Caravaggio's practice was quite different from his supposed theory. He all but abandoned still life and, in 1599, launched a successful attempt to rival the greatest painters of religious scenes on a grand scale—but not altogether on their own ground. Nevertheless, his explicit and implicit rejection of Renaissance idealism was correctly perceived by many contemporaries as a new and dangerous point of view.

Caravaggio has even been found (rather extravagantly) to be an artistic parallel to Galileo and others of the time who, in one way or another, broke through the traditional Aristotelian hierarchies of fixed belief. According to his critics, Caravaggio's basic and prevailing sin was his vaunted dependence on the object or model, which he treated very much as he did fruit or flowers, even when it was a young woman posing as Mary Magdalen [28]. His supposed statements about artistic method and subject matter, which seem to foreshadow the nineteenth century, made Caravaggio the *bête noire* of the critical minds of the seventeenth century because he seemed to deny the traditional hierarchy of subjects. (This convention, which placed history painting at the top and landscape, genre, and still life at the bottom, was based on antique theory reinforced by more than one thousand years of Christian tradition.) So too Galileo soon produced telescopic proof of the Copernican theory that there was nothing special about the earth, that all celestial bodies obey the same impartial laws. Aristotelian-Ptolomaic thinkers had to become defensive, and they were bolstered by a worried Church.[23] Caravaggio's boldness in the face of established theories and methods of art may remind us of pioneers like Galileo, but a comparison must also point out that while the author of the *Dialogo dei massimi sistemi* was observing the universe with new curiosity and new instruments, formulating principles of observation and experiment that are basic to modern science, Caravaggio traveled in the opposite direction. His interest in the visual world was small; his entire *oeuvre*

[22]Bologna (1974, pp. 177–178) makes much of this passage, as others have, but Caravaggio (in the context in which Giustiniani quoted him) was simply commenting on the relative difficulty of flower painting from a technical point of view, without making any implication of relative worth. His own practice proves that he did not consider them equal. (For the text, see p. 346 below.) For still life in the art of Caravaggio, cf. Argan (1956, pp. 35 ff.) and my pp. 17–18, 37–38. The *Caraffa* is listed in Del Monte's inventory (Frommel, 1971, p. 31). Bellori described a *Carafe with Flowers* (p. 202), which he placed in Caravaggio's earliest Roman period and praised highly (see pp. 10, 38 above). The *Caraffa,* like the *Medusa* [37], may have been inspired at least in part by Vasari's description of a painting by Leonardo da Vinci (Vasari-Barocchi, IV, pp. 21–22; Vasari-Milanesi, IV, pp. 23 ff.; cf. Gregori, 1972, pp. 31–32, and my pp. 61–62, 152). Reflections and other imitations of nature were also a specialty of Giorgione's (Vasari-Barocchi, IV, p. 46; Vasari-Milanesi, IV, p. 98).

[23]Cf. Bologna (1974, p. 176). The scientific activities of Cardinal Del Monte and his brother Guidubaldo are discussed by Spezzaferro (1971); further, Salerno (1975, pp. 21 ff.). Spezzaferro (pp. 89–90) pointed out that Guidubaldo placed particular emphasis on the importance of shade and shadow in his treatise, published in 1600 but presumably known during its preparation. Cf. Parronchi (1976).

contains not a single independent landscape. He was essentially a painter of figures without background, and as time went on he stopped looking very carefully: he seems to have done without models in later years. Thus observation and experiment are not his claim to importance as an artist. His achievement was based on looking inward, on imagination coupled with a special sense of humanity in the service of traditional religious scenes. Caravaggio's novelty was poetic, for all his "realism."

CARAVAGGIO'S PERSONALITY AND ART

Here we should take stock of what we know about Caravaggio, as we shall need to do again from time to time. He painted very few secular pictures after 1599, but those he painted are revealing [98, 172]. His interpretation of religious scenes was unusual and often the result of independent thought—a personal concern with the subject that far transcended the norm. Almost every picture is exceptional in one way or another, and some of them are poignantly moving. What then should we make of the early paintings and their creator?

The secular pictures have been interpreted at one extreme as straightforward still-life or genre painting, which seems to be about all that Mancini, Baglione, and Bellori got out of the subjects. Roberto Longhi, the greatest modern connoisseur and entrepreneur of Caravaggio and Caravaggism, found little more. Recent interpreters, led by Luigi Salerno, have discussed the same paintings as by-products of a sophisticated circle of erudite *précieux,* and have proposed learned and complex interpretations. The truth probably lies between the two extremes.

No one ever wrote that Caravaggio was a learned man or a great reader. Although he must have had an elementary education and could certainly read and write, we have no letters by his hand and we hear of none; we may suspect that he was not a master of literary or even conversational skills. His predilection for gambling and fighting conjures up a physical, even feral man and an unattractive one: Bellori wrote that Caravaggio was short and ugly *("fu di statura piccola et brutto di volta").* [24] When we learn that he loudly denounced the artistic models and goals of the past, the picture of an ignorant lout seems complete. Obviously, however, it is not.

Almost from the beginning, Caravaggio was a marked man of talent. Merely to serve successfully in Arpino's studio was a kind of recognition; Caravaggio also

[24]Bellori wrote this in the margin of his copy of Baglione (p. 137); see p. 5, n. 6, and p. 9, n. 16 above. A close contemporary of Caravaggio's, Giulio Cesare Gigli, described the painter in a poem published in 1615 as "pale of visage, with abundant hair, and with sparkling eyes set deep in his face" (Cinotti, 1971, p. 164, F 113), but he was perhaps basing this on a portrait since he was a Venetian and probably never saw Caravaggio.

made cultivated friends and kept them even though friendship with him was admittedly precarious. Prospero Orsi, his well-born friend and promoter, was the brother of a learned poet, Aurelio; the boisterous companion of Caravaggio's sometimes criminal outings between 1600 and 1606, Onorio Longhi, had a university degree. Baglione, who knew him, called Caravaggio "satirical and proud" *(Satirico, et altiero)*, which is quite another side of his personality from that of a boisterous ruffian. Caravaggio was obviously a difficult person; but it seems that both Annibale Carracci and Caravaggio found it necessary to detach themselves from received opinion, and even from those who expressed it, in order to create a newly vital art. Or perhaps it is the other way around (as we suspect in the case of Caravaggio): only a personality utterly divorced from convention could succeed in cutting through it. Although historians now cherish Annibale's art, his wide range, his uninhibited eye, and his exploration of new genres and modes, he still seems like a historical figure. Caravaggio, who was far more limited, was also less able to conform for psychological reasons; it was he who broke through to new artistic ground that a "normal" person could not have discovered.

Even so, we have not fully defined Caravaggio and perhaps never can. When we realize that the refined Cardinal Del Monte harbored and protected him for years, that men of the taste and state of Marchese Vincenzo Giustiniani and Cardinal Ferdinando Gonzaga valued his work enough to try to make him happy and safe despite his excesses, and that Murtola, Marino, and others eulogized his paintings in poetry, we begin to grasp the outline of a different, more complex, and perhaps split personality.

The experimental, even trial-and-error nature of Caravaggio's earlier paintings makes us think that he probed various genres, foreign [10] or exotic [12], to see where his talent lay or to show his versatility. These efforts include the *Boy Bitten* [25], which may have a literary or epigrammatic core; but Caravaggio's main interest here may have been physiognomical experiment, a search for momentary expression of face and gesture. There will always be debate on these issues, and the ambiguity of some of the paintings may be part of the artist's intention.

Since Caravaggio was in close contact with cultivated, literary people, his paintings may to some extent reflect their expectations. Without creating a morbidly poetic or a deeply learned Caravaggio, we can at least presume that his relationship with literary and artistic men led him to produce pictures that were deliberate essays in a particular mode or genre and that were recognized as such, however unusual they may have been in other respects. Pictures such as the Uffizi *Bacchus* [22] are in the antique spirit, perhaps in part dependent on ideas Caravaggio gleaned from Del Monte's own collection. We have also seen that there is a Venetian quality to some

of the paintings, though the lack of landscape background at first disguises their source. Giorgione's accomplishment was even more vaguely understood in the seventeenth century than it is now, but his name was invoked more than once in comments on Caravaggio's color. In subject matter as well, certain paintings by the young Caravaggio were the result of a conscious return to a more or less archaic mode of the past, a poetic moment in Venetian art around 1510. The *Concert* [15] and the *Luteplayer* [18] are overtly Venetian, even Giorgionesque pictures in subject, though far from the bucolic poetry of Giorgione's imagery. It is difficult to be certain today, but it is possible that Caravaggio's paintings of music making, and in other pictures the costumes with their stripes and plumes, seemed retrospective and poetic in the eyes of his contemporaries.[25]

Caravaggio's art is less traditional, more a product of his own idiosyncrasies, than that of Annibale or Cesari d'Arpino. What we see in his pictures must reflect some aspect of his own sensibility and this personal content would still be present even if some of the secular paintings were proved to be satires. Nevertheless, the androgynous figures in the *Concert, Luteplayer, Bacchus,* and *Boy Bitten,* as well as the ambiguous angels of the early religious paintings [29, 31], may be the realization of a poetic mode as perceived by the artist, a reflection of Del Montean taste and atmosphere rather than evidence of homoerotically autobiographical content.

Whether Caravaggio was essentially or exclusively homosexual is far from certain. Minnitti, with whom he supposedly lived for years, and who may have been the model for the lutenist in the *Concert* [15], eventually tired of Caravaggio, married a Roman, and was later a family man in Syracuse.[26] Onorio Longhi was married and a father by 1602; Caravaggio painted portraits of both man and wife.[27] Mancini heard that the model for the Virgin in *The Death of the Virgin* [133] was Caravaggio's mistress—not a rumor that would circulate about a known homosexual. None of this proves anything at all, and the sex lives of Renaissance artists were probably often much like that of Benvenuto Cellini—a bit of both sexes, as was convenient. Although we do not need to presume that Caravaggio's pictures with homoerotic content are necessarily more confessional than others, there is a notable absence of the traditional erotic females—no Venuses, Danaës, or Europas. In his entire career he did not paint a single female nude, which was wholly unlike the great Venetians but also unlike Cesari d'Arpino, Annibale, and even that notorious celibate, Guido Reni.

[25]But see p. 23, n. 5.

[26]See p. 8, n. 15.

[27]The inventory of effects owned by Onorio's son, the architect Martino Longhi il Giovane, listed portraits of Onorio, of his wife Caterina Campana, and a *St. John the Baptist in the Desert,* all by Caravaggio, as well as a few other paintings with attributions to Raphael, Titian, and others (Bertolotti, 1881, II, p. 26).

Nevertheless (and unlike Annibale or Reni) Caravaggio had an emotionally charged relationship with at least one woman in Rome.[28] Around 1599 he also began to paint women who are desirable in our eyes and who were, at least arguably, desired [36; cf. 131–132].

At this time too the violence of Caravaggio's personality begins to erupt into his art: beheadings and martyrdoms take up an alarming share of his output. And Caravaggio seems to have become more belligerent in these years; his extensive criminal record begins late in 1600. The new subjects and problems seem to express his own concerns more accurately than the Del Montean paintings, whose musical themes and languidly erotic spirit never return.

[28]For Lena, see p. 191 and Note 120. Cinotti (1971, p. 179, n. 135) cited the *"Menicuccia"* mentioned in a criminal record of October 1604 as a possible girl friend (her pp. 157–158, F 61). (From this suit it appears that if Caravaggio was not living in the Palazzo Madama, he was still dependent on Del Monte, for the first thing he did on getting into trouble was to send word to the cardinal.) A third possibility concerns a suit to keep Caravaggio from bothering a girl and her mother (July 1605; Cinotti, p. 176, n. 67; the document is now lost). The evidence for Caravaggio's homosexuality is also scarce: see Röttgen (1974, pp. 196–197), Posner (1971a), and my p. 247, n. 7, and Note 96.

II
EGREGIUS IN URBE PICTOR

3
The Contarelli Chapel (I)

Caravaggio's first public commission was for two paintings in a chapel belonging to the heirs of a French cardinal, Matteu Cointrel (Contarelli in Italian), in San Luigi dei Francesi [52, 56], the French national church in Rome. It is the fifth and last chapel on the left, just across the via del Salvatore from Cardinal Del Monte's palace, Caravaggio's home [51].

Cointrel had been made cardinal in December 1583 and died less than two years later, in 1585. He left money for the façade and high altar of the church and for the decoration of the chapel, which had been built in 1565. Girolamo Muziano (1532–1592) had contracted with Cointrel in September 1565 to paint the chapel with the story of Matthew in six parts, including the Calling of Matthew and his Martyrdom (the stories that Caravaggio began to paint thirty-four years later) on the lower walls and an altarpiece showing Matthew writing the gospel with the angel (the subject of Caravaggio's eventual altarpiece). These works were never painted by Muziano. Cointrel's will stipulated that the chapel be finished under the direction of Virgilio Crescenzi (died 1592), who lived in a palace down a neighboring street that still carries the family's distinguished name [see 51].

Today the decorations of the chapel correspond almost exactly to the subjects described in the contract of 1565. In 1587, however, Crescenzi commissioned a Flemish sculptor named Jacob Cobaert to do a statuary group for the altar niche instead of a painted altarpiece. The group was still to represent St. Matthew, Cointrel's name-saint, writing his gospel with the assistance of an angel, his symbol and inspiration combined. A white, three-dimensional altarpiece may have been chosen because the chapel is very dark and the altarpiece has to be seen against a lunette above, facing south. A painted altarpiece does not show up well in these circumstances, as we can verify today. The Crescenzi seem to have been fond of Cobaert, who was experienced in bronze casting but not in marble sculpture. In 1591 Giuseppe Cesari d'Arpino was commissioned to paint the rest of the chapel in fresco. He began with the vault, which

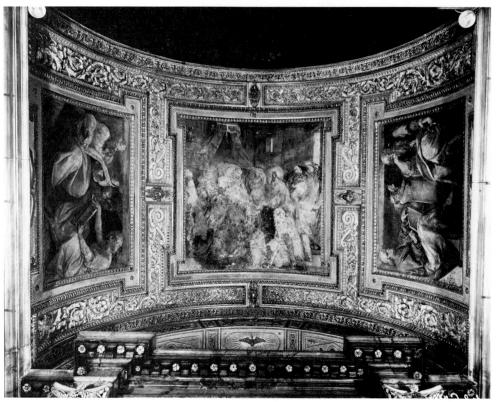

49. Vault of Contarelli Chapel, S. Luigi dei Francesi, frescoes by Giuseppe Cesari: *Prophets; St. Matthew Resurrects the Daughter of the King of Ethiopia.* 1591–93.

50. Giuseppe Cesari, *Calling of St. Matthew* (drawing). Vienna, Albertina. c. 1593?

he decorated with *trompe l'oeil* Prophets in the lower compartments [49] and a scene from Matthew's legendary apostolate in Ethiopia at the top [71]. These paintings were finished by June 1593. Caravaggio may even have worked on them since he had assisted Cesari early in his career. Cesari failed to continue the frescoes although he began to plan them [50]; Cobaert, having accomplished very little, signed a new contract in 1596 but never completed his statuary group [cf. 86].

The priests of San Luigi, after waiting more than thirty years for the chapel to be decorated, were understandably impatient. In 1597 the Crescenzi were called to account. They claimed to have spent the large sum of 4000 *scudi* on the chapel and said that it was the fault of Giuseppe Cesari that the walls were still unpainted. Pope Clement VIII temporarily took the responsibility for the chapel away from the Crescenzi and vested it in the governing body of the Works of St. Peter's, the *Fabbrica di San Pietro,* with which Del Monte was associated. They in turn promised Cesari 400 *scudi* for painting the side walls. But Cesari had been working in Naples and then increasingly for Clement VIII. In 1597–1598 he was painting frescoes in the Palazzo dei Conservatori; in April 1598 he accompanied the pope on his expedition to Ferrara and then went on to Venice. Early in 1599 he began a major renovation of the transept of San Giovanni in Laterano.[1] Cesari's important commissions left him no time for San Luigi, and when the Contarelli Chapel (as it is always called) was opened for services in May 1599 it must have been essentially bare of figural adornment, apart from the frescoes in the vault. (It has been suggested that Caravaggio's first altarpiece [87, 92] might have been produced as a temporary picture for this occasion, but in style it fits better into the period of his documented commission for an altarpiece, 1602—see Chapter 5.)

These circumstances led to Caravaggio's contract of 23 July 1599, in which he agreed to paint the side pictures for the same 400 *scudi* that had been promised to Giuseppe Cesari. The description and size of the pictures were those of the contract of 1591. Caravaggio was to finish his work by the end of the year; presumably the French priests of San Luigi wanted their church to make the best possible appearance during the Papal Jubilee of 1600 with its expected hordes of pilgrims, including many from France. However, the pictures were unveiled only in July 1600. Baglione tells us that Caravaggio got the commission through Del Monte: *"Per opera del suo Cardinale hebbe in s. Luigi de'Francesi la cappella de' Contarelli"* (through his cardinal he got the Contarelli Chapel commission). Since Del Monte had been one of the executors of Virgilio Crescenzi's estate in 1592, we must imagine that he was close to the family and that the substitution of Caravaggio for Giuseppe Cesari was made

[1]Röttgen (1973). In addition to the works mentioned, the *St. Barbara* [91] was first exhibited on 29 August 1597; the *Betrayal of Christ* [40] dates from the same period.

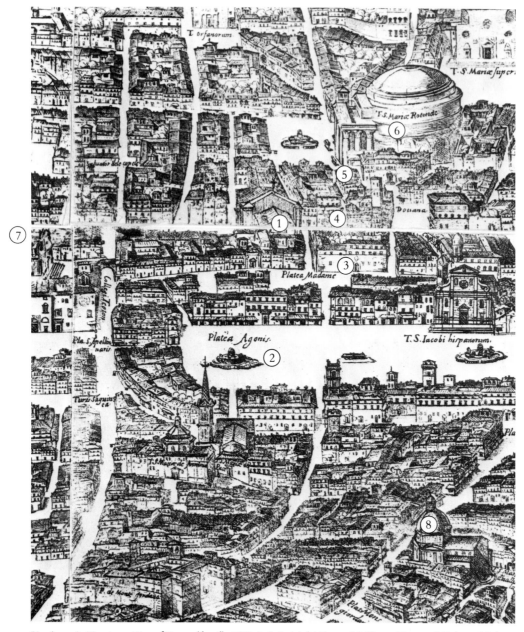

51. Antonio Tempesta, Map of Rome (detail). 1593. 1. S. Luigi dei Francesi 2. Piazza Navona 3. Palazzo Madama 4. Palazzo Giustiniani 5. Palazzo Crescenzi 6. Pantheon 7. S. Agostino 8. S. M. in Vallicella (Chiesa Nuova).

with the full consent of the Crescenzi and of Francesco Contarelli, the cardinal's nephew, a priest at San Luigi. Del Monte evidently continued to be closely associated with San Luigi, for his funeral was celebrated there in 1626 with considerable pomp.

We should probably imagine that Caravaggio made studies of some kind during the spring or summer of 1599 for the satisfaction of the authorities—not just before he began the actual painting but even before the contract was signed. After all, he was inexperienced as a large-scale painter. Perhaps he even traveled to Bologna and Venice to study contemporary works; we do not know.[2] The painted areas on the walls of San Luigi are close to three and one-half meters wide and almost as high, which is to say, some ten feet square. Thus the full-length figures in them could be life-size [cf. 64]. To our knowledge Caravaggio had never painted a picture that was even two meters in either dimension; nor had he ever painted a picture with more than a few figures, whereas his pictures for San Luigi have, respectively, seven and thirteen figures. Moreover, the contract required that the *Martyrdom* take place in a church of considerable width and depth, with a view up several steps toward the altar and with many people. These requirements must have caused Caravaggio to think and work harder than ever. Perhaps at first he thought of painting on the wall in fresco, as custom dictated and as Muziano and Cesari might have done. The man who supplied Caravaggio's canvas was paid only in December 1599, and the contract does not specify a medium.

In 1953 Denis Mahon examined the X-ray photographs of the *Martyrdom of St. Matthew* [cf. 59] and came to the conclusion that because the original figures were considerably under the size of those in the *Calling of St. Matthew* [52] (which was evidently painted without much change), Caravaggio must have begun the *Martyrdom* first. Then, finding himself in trouble, he tried to enlarge the figures. Eventually he gave up entirely and painted a new picture on top of the old [56], to the scale of the *Calling*, which he had presumably begun in the meantime. The *Calling of St. Matthew* is closer in style to his previous paintings, although comparison with the *Judith* [36] shows how much more complex this commission was than his works of only a short time before.

Both Contarelli paintings show an extreme and unnatural use of light-dark. The darks are so dark as to seem black, and thus the forms touched by light stand out with exaggerated effect against the darkness. We have seen that Caravaggio already tended toward this forced chiaroscuro in some of his recent pictures [34, 36, 38]. There are a number of historical explanations, but two practical ones stand out:

[2]What could be quotations from Annibale Carracci's *Resurrection* (now Louvre) and Tintoretto's *St. Mark Rescuing a Slave*, pointed out to me by Michelle Murray, might be explained by a trip north around 1599 (cf. Note 56).

in the darkness of the chapel, where we look up at paintings well above our heads, only brilliant highlights could carry; and by masking awkward junctures and gaps with darkness, Caravaggio could disguise his limitations as a painter of traditional Renaissance scenes in perspective. The pictures are both novel and dramatic. In his very first public works Caravaggio produced a revolution in religious painting.

THE CALLING OF ST. MATTHEW

The *Calling of St. Matthew* has its scriptural origin in a brief passage in the gospel of Matthew (9:9): "Jesus saw a man called Matthew at his seat in the custom-house, and said to him, 'Follow me'; and Matthew rose and followed him." That is the entire story; Matthew's immediate acceptance of Christ's call was the significant act of faith. In Caravaggio's painting the tax collector (called Levi by Mark and Luke) and his worldly companions are seated around a table, shown in a raking light [52, 53]. Although this light falls from the right, Caravaggio did not coordinate it with the daylight coming down from the lunette in the chapel. In the gloom at the right, spottily illuminated, Christ and a disciple (presumably Peter) seem to advance toward the group, although Christ's feet point forward [54]. His outstretched hand catches the light as he gestures to Matthew to follow him; Matthew responds with an identifiable "Who, me?" gesture that we can all but read on his lips. The two figures closest to the picture plane—Peter and the sharp *bravo* ("Spada")—have their backs to us. Before them is a frieze of men seen against the wall and the dark. At the far left a vertical strip of even darker background seems to indicate the corner of the building behind the figures; that is, they seem to be shown outside a Roman palace rather than within it. The *Calling of St. Matthew* is larger and more complex than Caravaggio's earlier works, subtle and shrouded in deeper shadow. It is also strikingly different from the narrative scenes of his contemporaries.

Cesari d'Arpino's drawing must record his project for the same painting [50]. It may well have been developed while Caravaggio was in his shop, for the vault had been finished in the spring of 1593 and only the walls remained. The drawing follows the contract, which stipulates that Christ and his companions are to be shown walking down a street where they encounter the shop of the tax collector; in the drawing it is seen at the rear as an opening in a palace with men walking in. Instead, Caravaggio used his old trick of placing figures around a table, quite like the *Cardsharps* [10] and obviously expanded from it. Spada is almost the reverse of the seated cheater; the boy behind is from the *Fortuneteller* [12]. They have merely

52. *Calling of St. Matthew*. Contarelli Chapel, S. Luigi dei Francesi. 1599–1600.

changed their clothes. Caravaggio seems to have deliberately quoted from these popular early works. Such fellows are typical hangers-on, familiar in literature from Shakespeare to Manzoni and Dickens. Since Caravaggio was now painting full-length figures, he used the opportunity to make a moral contrast between the secular, almost dancing legs and feet of the mundane people around the table and the sober stance and garb of the barefoot Christians [cf. 53, 54]. The costumes of the figures reflect Caravaggio's desire to show the worldly men as modern, whereas the robes of Christ and the Apostle, red and dark green, are vaguely holy and antique.

The shrouded gesture of Christ, the most noteworthy single motif in Cara-

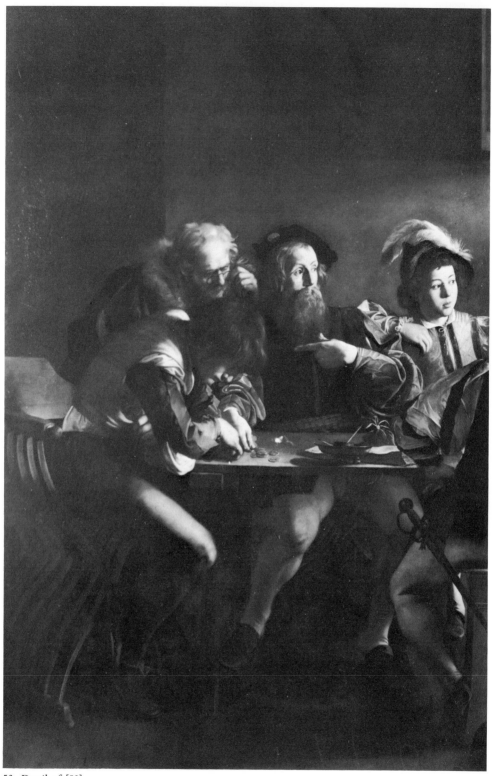

53. Detail of [52].

54. Detail of [52].

vaggio's picture, is a studied quotation from Michelangelo's most famous image, the *Creation of Adam* on the Sistine ceiling. Christ's oddly limp right hand, seen as if stopped by the camera, mirrors that of Michelangelo's inert Adam, who is about to be invested with life by God. Christ is the New Adam, and "as in Adam all men die, so in Christ all will be brought to life" (I Corinthians 15:22). Caravaggio was no Michelangelo, yet we may see here a kind of identification, perhaps the first that Michelangelo Merisi made with his great predecessor and namesake (see Chapter 5).

Possibly someone told Caravaggio that St. Augustine had referred to the Holy Spirit as the Finger of God, an idea familiar from the hymn *"Veni Creator Spiritus,"* which was sung on special occasions such as papal conclaves in the Sistine Chapel. This connection may have inspired Michelangelo. Caravaggio transforms Adam's hand into that of Christ, who in turn invests Matthew with Divine Grace. Luke (11:20) quotes Christ as saying, "if it is by the finger of God that I drive out the devils, then be sure the kingdom of God has already come upon you." The whole mission of Jesus was uniquely directed by the "finger of God," which is here equated with Christ's finger. Peter's hand echoes that of Christ, while Christ's other hand opens out toward us. This part of the canvas was worked over from an earlier idea, visible in X-ray photographs, that showed Christ alone in the foreground with a more colloquial beckoning gesture. The removal of Christ to the secondary plane, like the Michelangelesque quotation, were afterthoughts that make the picture more perverse, with the protagonist half-hidden at the far side of the canvas.

The gospel, following the description of Matthew's call, mentions many bad characters, tax gatherers and others, seated at table with Jesus and his disciples, and this scene has been assimilated into our view of Matthew's character: "The Pharisees noticed this, and said to his disciples, 'Why is it that your master eats with tax-gatherers and sinners?' Jesus heard it and said, 'It is not the healthy that need a doctor, but the sick.'" The sickness Christ refers to was interpreted as avarice.

Moneylenders or tax collectors could amass riches in the Renaissance only through usury, which was prohibited by the Church. Such men, according to Christian doctrine, are blinded by money and self-deceit. Caravaggio's Matthew even has a coin stuck in his hat brim [53]. Below we see a confusing play of hands and money on the table. Matthew fingers one of the many coins with his right hand, an indication of his sin, while his left points incredulously in response to Christ's command, "Follow me." The shortsightedness of those blinded by money is often represented in northern paintings by eyeglasses, worn by usurers or misers. So too in the *Calling of St. Matthew* a man peers through his spectacles at the money, unaware of Christ's call.

The artists of Antwerp loved to show Matthew among petty scribes and

55. Marinus van Reymerswaele, *Calling of St. Matthew*. Lugano (vic.), Thyssen Collection.

moneylenders, combining the familiar northern theme of the goldsmith or usurer with aspects of the Prodigal Son, another sinner who was forgiven through love and faith. The shelves in Marinus van Reymerswaele's picture [55] could be interpreted as being heaped with papal indulgences that allowed usury to continue for a fee—directly linking the Catholic Church with Sin. Thus Matthew became a potentially Protestant symbol, a sinner, even a Prodigal, who was saved through Faith without the Sacraments of the Church. The story of Matthew also reassured merchants and bankers in commercial centers like Antwerp that even a greedy sinner could be saved.

In Caravaggio's painting, as in the northern versions, Matthew is called by Christ; yet we are told by theologians that he was saved through his own faith. These were matters of great concern at precisely this moment in Rome, where the theology of the Jesuit Luis de Molina was hotly debated. The issue was the role of human free will in man's salvation, as opposed to Augustinian (and Protestant) predestination. In

1598 the pope was forced to set up a Congregation to investigate this dispute over "efficacious Grace."[3]

Everything about Caravaggio's *Calling of St. Matthew* seems to emphasize the haphazard, apodictic nature of God's Divine Grace, and to that extent it is close to the anti-Molinist position, as we might expect in a French church. Perhaps the original version was thought to be too conciliatory toward Protestants, in the spirit of the Edict of Nantes of 1598. The change made at the right, where an Apostle is interposed between Christ and us, could have been made to symbolize the Church (Peter) that is necessary for our salvation.[4] Or perhaps he was simply added to give Jesus some company, in accordance with the contract.

THE MARTYRDOM OF ST. MATTHEW

Caravaggio's other painting, on the right-hand wall of the chapel, posed different problems and was for him the greater accomplishment [56, 64]. It reminds us of more traditional compositions than does the *Calling,* and it is perhaps less important as a document in the career of Caravaggio the revolutionary.

According to the *Golden Legend,* Matthew preached and perished in Ethiopia; a story of Matthew and the King of Ethiopia appears on the vault above [71]. (The ployglot press of the Vatican had printed a New Testament in Ethiopic in 1548–1549, and Ethiopia was a contemporary concern of the Church.[5]) After clearing out two magicians, Matthew raised money to build a great church, which was somehow erected in thirty days. Matthew's martyrdom came as a result of thwarting the king's lust for a virgin named Ephigenia, who was, in the words of the *Golden Legend,* "espoused to the eternal King."

> When he heard these words, the Ethiopian king was consumed with rage, and went out of the church, while the apostle, intrepid and unmoved, exhorted all to patience and constancy . . . after Mass the king sent a swordsman, who came behind Matthew as he stood at the altar with his hands raised to Heaven in prayer, drove his sword into his back, and so consummated the apostle's martyrdom.[6]

[3]See Parker (1968, pp. 67 ff.).

[4]Calvesi (1971, pp. 117 ff.).

[5]Jesuit missionaries went to Ethiopia in 1555, but their most notable successes came after 1589 and chiefly after Arpino's fresco was painted; hence no direct connection seems possible (Pastor, V, pp. 497–498; VI, pp. 230–231; XI, pp. 491–492). After 1559 the printing and even the reading of the Bible in vernacular was prohibited by the Church: see Greenslade (1963, pp. 112 and 202 ff.). On the subject of printed scripture, see Eisenstein (1980, esp. chapter 4).

[6]*Golden Legend* (pp. 563–564).

56. *Martyrdom of St. Matthew* (companion to [52]).

Caravaggio followed recent Roman precedent by showing the story in a different way. Girolamo Muziano, some ten years before, had painted a similar scene in oils for a Mattei Chapel in Santa Maria in Aracoeli; there too we see that the idea of stabbing the saint in the back had been abandoned in favor of a narrative tableau [57]. Caravaggio's painting allows a clear space in the center for the act of Martyrdom: the recumbent saint, already wounded and with blood spattered on his alb, awaits the final blow from the athletic executioner as onlookers flee to left and right.

At this time there was a focus on the cult of martyrs in Rome that was part of new Catholic attention to the early Church in the face of Protestant criticism. John Foxe's illustrated *Book of Martyrs* of 1563, which described Protestant martyrs in plain English, may have spurred on Catholic martyrologies. Depictions of martyrdom became commonplace in Jesuit churches during the 1570s and 1580s [58]. The Jesuits encouraged actual martyrdom for their missionaries and painted grisly scenes of

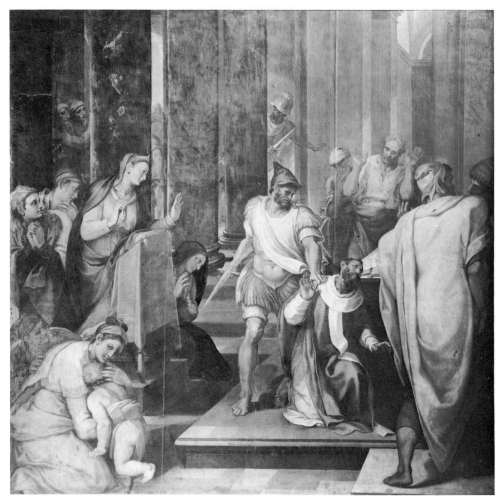

57. Girolamo Muziano, *Martyrdom of St. Matthew*. Mattei Chapel, S. M. in Aracoeli. 1586–89.

martyrs, old and modern, on the walls of their churches. In SS. Nereo ed Achilleo, newly decorated by Cardinal Baronius, we find similar horrors, crudely painted.[7] Thus martyrdoms were in vogue, and they had meaning in the Catholic fight against Protestant heresy, for they summoned up visions of the heroic defenders of the early Church while reminding Christians that dying for the faith was a contemporary reality.

Caravaggio was faced with painting a public picture that would be more than twice the size of his earlier works and show many figures engaged in complex activity throughout a deep space. He turned to the past for help. His earliest composition is

[7]Baronius had already produced a new, corrected edition of the Roman Martyrology. For Jesuit martyr cycles, see Buser (1976) and Monssen (1981). SS. Nereo ed Achilleo was an old church refurbished to look as much like an Early Christian *titulus* as the knowledge and purse of the scholarly Cardinal Baronius would allow (see pp. 75–77). Cf. Krautheimer (1967).

58. After N. Circignani, *Martyrdom of Blessed Edmund Campion and Others in 1583.* Engraving, 1584.

59. *Martyrdom of St. Matthew* [cf. 56], Outline of earlier versions as seen in X-rays.

in part recoverable from X-ray photographs, and we can also see *pentimenti*—for example, through the leg of the figure sprawling at lower left. The general design of the earlier version is shown in outline in [59]. We see a smaller figure than the final executioner, striding into church with sword drawn. He is similar to the central warrior in Raphael's *Battle of Ostia* in the Vatican Stanze, and Raphael's frescoes were the logical school for an artist who had never essayed a large-scale tableau. Caravaggio, or his patron, was evidently dissatisfied with the relatively small scale of the figures and perhaps with other aspects of the painting in progress. So, characteristically, he started over, creating a new composition that is in some ways close to the one by Muziano [56, 57].

In Caravaggio's final version the executioner appears in pagan nudity in the midst of the worshippers; his position still recalls Raphael and Raphaelesque echoes like Circignani's *Massacre of the Innocents* [60], which shows the debased Raphaelism of Caravaggio's Roman predecessors. But much of Caravaggio's drama came from the consultation of Titian, probably through the woodcut of his painting of the *Death of St. Peter Martyr* [61]. The recumbent Peter, his arm raised as if to receive heaven's grace, and the running figure with arms outstretched are both echoed with significant differences in Caravaggio's picture. The fleeing boy at the right of the *Martyrdom* screams with a cry that reminds us of the openmouthed *Medusa* [37] or of Holofernes [36], and is particularly close to the left-hand figure in the *Betrayal* [38].

Caravaggio took advantage of the steps called for in the contract to raise the main scene to the center of the canvas. In the lower corners he put nude *repoussoir* figures (dressed essentially like the executioner) in unusual poses that may derive in part from frescoes by Cesari d'Arpino, now lost but recorded in oil sketches. It has even been suggested that Caravaggio imagined Matthew in the act of baptizing these nudes in a pool that is presumed to be below the lower frame of the picture. The nudes reclining on steps going down on three sides toward us do suggest such an idea, although a pool never existed in the nave of a basilica. The contract calls for benches (*banchi*); perhaps that is what Caravaggio meant to show. The foreground figures reveal a dependence on Mannerist precedents in his first truly elaborate painting. The entire composition is ingenious, knit together by Caravaggio's tenebrism and by the isolation of Matthew and the executioner at the center of an anonymous crowd.

Arpino's frescoes and others like them would have guided Caravaggio in trying to place figures in space. But he did not set his scene in a believably large church, as described in the contract. Cardinal Cointrel might have visualized something like Sicciolante's fresco of the *Baptism of Clovis* in one of the opposite chapels [62], which depicts a vast Renaissance interior of a kind that Caravaggio would never attempt. He masked his deficiency, here and elsewhere, with chiaroscuro, which was aided by

60. N. Circignani, *Massacre of the Innocents*. Il Gesù. Late 1580s?

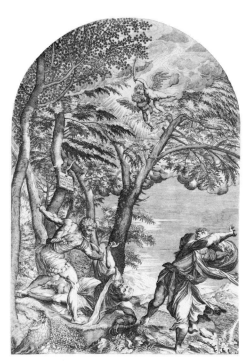

61. Titian, *Death of St. Peter Martyr*. Engraving (reversed) after lost painting of 1530.

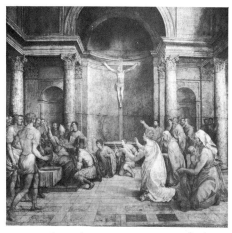

62. Sicciolante da Sermoneta, *Baptism of Clovis*. S. Luigi dei Francesi. c. 1548–49.

the chapel's gloom so that only the parts of figures illuminated by the brightest painted highlights could have been seen. Even with every benefit of restoration and electric light, the background remains obscure.

Unlike most of its predecessors, Caravaggio's painting is wholly figural. The naked swordsman in the center acts as the axle of a flattened, wheel-like composition of great centrifugal energy. The act of martyrdom is framed by the reclining figures in the foreground and by those at the sides who recoil or flee in horror (the contract specifies: "a multitude of men and women . . . most of whom are frightened by the event, others abhorrent, others compassionate"). Caravaggio particularly illuminated the lower right quarter of the picture, which is the part nearest the spectator at the chapel railing [63]. The large figures at the lower right and the screaming boy running away [68] were perhaps calculated to catch the attention of visitors in the nave and to draw them to a distant chapel that might otherwise be overlooked.

The two nude figures in the foreground almost merge, like a double exposure or Siamese twins, inseparably confused. As our eyes get accustomed to the darkness we begin to see a mass of bodies fleeing at the left, again in pairs [64, 65]. Seen at an angle from the aisle, the executioner moves toward us while the confusing crowd at the left recedes into darkness [cf. 64]. Some look back, among them a figure with a plumed hat, clutching his sword, who is like a refugee from the *Cardsharps*—or from the *Calling of Matthew* across the chapel. The play of swords and hands in this obscure area is uniquely Caravaggio's. The raised hands of the man in the left foreground, a rhetorical gesture of surprise and horror, are related to the gesticulation in the *Supper at Emmaus* [42]. The group also includes to the rear a bearded, saturnine villain who is none other than Caravaggio himself [66].

Caravaggio's face looks precisely like Ottavio Leoni's portrait of him [67]. We recognize the arched eyebrows, flaring nostrils, and somewhat hostile expression of the mouth. (Bellori said Caravaggio was *"brutto di volta"*—he had an ugly face.) The emotions of this witness to the martyrdom are hard to read; is he angry or horrified? The most plausible explanation would make him King Hirtacus, who ordered the slaying of Matthew. The concerned glance back would thus be explained, as would the fierce but perhaps ambivalent expression on his face. We sense here a beginning of the fatalistic or tragic self-image that can be deduced from some of Caravaggio's later works, his identification with violence and evil, which seems to have increased with time. He must have expected to be recognized here, and his presence is a form of signature that was well known in Italian Renaissance art.

The figure of Matthew is of particular interest in our attempt to understand Caravaggio. Within a year he would paint St. Paul's conversion in an analogous way, the disciple flat on his back with his whole body exposed and vulnerable [75]. Both

63. Detail of [56].

64. Contarelli Chapel, S. Luigi dei Francesi, showing parts of [56] and [93].

Matthew and Paul are essentially alone, abandoned in mortal crisis. The fear of being helplessly open to attack, like Matthew or Holofernes or Paul, seems to have aroused anxieties in Caravaggio that led him to invent increasingly novel pictorial treatments.

The angel here is somewhat like the angel in the early *St. Francis* [30], a survivor from the world of Del Monte's pretty boys. In particular, he may remind us of the suggestive angel in the *Rest on the Flight into Egypt* [29]. The whole picture of Matthew's martyrdom seems to resolve itself in the contrast between the violence of the nude executioner and the delicate, curved palm frond that is being carefully lowered into the martyr's hand [69]. Carefully, because Caravaggio's angel has not yet learned to fly; he rests on his cloudy support as best he can and leans down gingerly so as not to fall. This part of the painting is still the work of the "realist" Caravaggio, who seems to say with Courbet, "Show me an angel and I will paint one."

65. Detail of [56].

IV

66. Detail of [56].

67. Ottavio Leoni, *Portrait of Caravaggio*
(drawing). Florence, Biblioteca Marucelliana.

Having finished these unusual pictures, Caravaggio must have been both proud
and worried in the face of what was bound to be a mixed critical reaction. And the
new paintings caused a great stir—according to Baglione, so much so that even
Federico Zuccaro, *"maravigliandosi di tanto rumore,"* came to see the chapel. Sup-
posedly he said that there was nothing new in the *Calling of St. Matthew* to make
such a fuss about, only the ideas of Giorgione. Perhaps this was a defensive criticism
by an outmoded Mannerist in the face of a new style; it may also have been a pointed
reference to Caravaggio's deep chiaroscuro. Vasari claimed that Giorgione had imi-
tated Leonardo: "Having seen and greatly admired some things of Leonardo's, which
were smoky and distant, and very dark [*terribilmente di scuro*], Giorgione made them
his model and imitated them carefully in oils." The pedantic Zuccaro would probably
have believed this erroneous account, with its typical Tuscan bias, and thought of
Giorgione as a very dark painter.[8] By and large, Giorgione was poorly understood
at this time, his works essentially unknown or confused with those of his followers,
and his reputation in Rome was poor. Zuccaro's comment was disparaging. It may

[8]Vasari-Barocchi (IV, p. 42; Vasari-Milanesi, IV, p. 92). Sutherland Harris (1977, p. 43, n. 19) observed that
"Giorgione described by Vasari sounds remarkably like Caravaggio described by Baglione and even Bellori."
Bernini quoted Annibale Carracci as having said, when shown ambitious paintings that were ill-formed: *"Pare
che siano di Giorgione"* (Chantelou, 1885, p. 163). Nevertheless, Cardinal Borromeo (*Mvsaevm,* 1625, p. 10, trans.
Diamond, 1974, p. 213) wrote of one of his paintings: "If one looks at the excellence of the design, one would
think it a work by Giorgione, not of Titian; if at the power of color, of Titian, not by Giorgione." (It is now
ascribed to Bonifazio.) Further to Zuccaro's criticism of Caravaggio and to ideas about Giorgione in the
Cinquecento, see Mahon (1947, pp. 177–178); but cf. Longhi in *Paragone* (17, 1951, p. 9).

68. Detail of [56].

also have been part of a pejorative Roman tendency to lump all north-Italian painters together—Bernini actually called Veronese and Titian "Lombards," and he was probably as sophisticated as Zuccaro.[9] On the whole, however, Caravaggio's debut as a public painter was a great success.[10]

Both the *Calling of St. Matthew* and the *Martyrdom* reveal Caravaggio's tendency to interpret remote historical events in an ambiguous way that is pseudocontemporary—and not merely because of the mixture of costumes or the setting of the *Calling* by a Roman palace. He had an intuitive ability to think himself into a scene

[9]Chantelou (1885, p. 190) wrote: "*Se levant pour aller diner, il a jeté les yeux sur un Bassan, et a dit . . . que le costume n'y était nullement gardé. Je lui ai dit que ce costume avait aussi été mal observé par le Titien et par Paul Véronèse. Il a ajouté: 'Par tous les Lombards.'* " Bernini included Correggio among the Lombards (p. 222) and said that all of their art was disproportioned (p. 155). In Rome and Florence the Venetian painters were admired with reservations. Three different times in Paris, Bernini quoted Michelangelo as having said, when looking at Titian's *Danaë*: "If those painters knew how to draw . . . they would be angels and not men" (Chantelou, pp. 88, 222, and 249). The quotation comes from Vasari's *Life of Titian* (Milanesi, VII, p. 447).

[10]Baglione (p. 137) wrote that the paintings made Caravaggio accidentally famous and that they were highly praised by nasty people. His inordinate bias was so outrageous here that Bellori scribbled *"Baglione Bestia"* in the margin of his copy (see p. 5, n. 6; 9, n. 16; 85, n. 24 above). Scannelli thought the paintings to be Caravaggio's best; for his and other criticisms, see Notes 52 and 56.

69. Detail of [56].

without much attempt at historical clothing or scenery. This peculiarity has been called ahistorical and even antihistorical. Caravaggio cannot have been fully aware of the theological significance of these religious stories, or at least he does not present it clearly. Caravaggio's subjects live for us today because of the immediacy with which they are painted. The sense of actuality derives from treating events of great import as if they were genre scenes.[11] He also had an unusual empathy with certain aspects of the subject matter, and this makes his pictures seem semi-autobiographical.

Caravaggio's attention to detail is strong and focused, as we see when we look at the parchment or fabric window of the palace in the *Calling of St. Matthew* [70]. He painted the crossed strings or wires outside; one is broken and dangles just as it must have in the window he copied. (A similar window, seen from inside, appears in Cesari d'Arpino's fresco above [71].) This detail illustrates the literal, factual aspect

[11]The problem has often been discussed; see, for example, Argan (1956, esp. pp. 28, 31–32); Röttgen (1974, pp. 227–236 and *passim*); and Bologna (1974, p. 154 and *passim*). Argan summed up his impressively rhetorical statement by writing (pp. 36–37) that Caravaggio's realism "is nothing other than a vision of the world from the point of view of death rather than of life: because it is unnatural, antihistorical, anticlassic, and instead profoundly, desperately religious."

70. Detail of [52].

71. Giuseppe Cesari, *St. Matthew Resurrects the Daughter of the King of Ethiopia*. Contarelli Chapel, S. Luigi dei Francesi [detail of 49].

of Caravaggio's earlier realism that singles him out from all other painters, and here as elsewhere it is somewhat perverse: it can never have been visible *in situ*. In contrast to the realism of the window, Caravaggio painted nearby a perfect circle of light in perspective, one of his first haloes [70; cf. 34]. There is much more than genre in these pictures. In the Contarelli Chapel, Caravaggio set the stage for significant drama through the forced highlighting of thoughtful compositions enacted in the dark. Details are realistic; the whole is theatre.

The immanence of God in all of us is demonstrated at the left of the chapel in the *Calling,* where Matthew is arrested in his worldly life by the finger of God, made manifest by Caravaggio's highlighting. It is the light that makes the strongest impression amid the darkness in the Contarelli Chapel; we are aware of its supernatural force. Its divine power is symbolic in the *Calling,* but it is strong enough to convert a sinful man. The brutal human force in the *Martyrdom* kills a saint.

A unique example of Caravaggio's influence on a great contemporary artist is found in Ludovico Carracci's *Calling of St. Matthew* [72]. It is the delayed result of

72. Ludovico Carracci, *Calling of St. Matthew.* Bologna, Pinacoteca. c. 1610.

116

Ludovico's one visit to Rome from Bologna in 1602, and obviously he hoped to improve on the model. The painting, famous in its day, was praised by the Bolognese critic Carlo Cesare Malvasia. We see many of the details of Caravaggio's canvas transported to a grandiose setting—Christ's gesture, even the eyeglasses. Ludovico (1555–1619), Annibale's cousin, was a dynamically emotional painter who had been one of the great pioneers of the early Baroque. Although his own art is full of chiaroscuro contrasts, we see that he was unable (and unwilling) to assimilate Caravaggio's innovations; the painting looks more like the work of a flabby Mannerist. But the followers or imitators of Caravaggio (who had no students) were also unable to match his style.

Caravaggio's achievement in the Contarelli Chapel was to adapt his emphatic, realistic figural style to the demands of large-scale wall painting. He produced paintings with vague but definable settings and included an actual wall with a window [52, 70]. Although the *Calling* is ostensibly an exterior scene, it seems like an interior. Indeed, apart from the paintings with landscapes or foliage [29, 30, 74, 96, 102], the Contarelli paintings are the only early pictures with backgrounds—and that of the *Martyrdom* is vague and disappears into darkness. This more defined space is a temporary, even un-Caravaggesque phenomenon that continues into his next work, the first *Conversion of St. Paul* [74].

Caravaggio's consultation of Raphaelesque models in the composition of both works in the Contarelli Chapel may have been due to his acquaintance with Cristofano Roncalli (1551/52–1626), the favorite of the Crescenzi family, who was entrusted by contract to adjudicate the value of blue and ultramarine used by Caravaggio in the Contarelli paintings. Possibly Roncalli also advised Caravaggio in this period, giving him the benefit of his experienced *maniera* style [181] and his study of Raphael's school and the artists in their train.[12] Nevertheless Caravaggio's achievement, here as elsewhere, was to focus on the time-honored figural drama that had been the central theme of Italian art since Giotto—and to do so more dramatically than any other painter of his time.

[12]Röttgen (1974, pp. 103 ff.); Kirwin (1972, pp. 180 ff.). In 1603 Caravaggio called Roncalli one of the best painters in Rome (see p. 161).

4
The Cerasi Chapel

We have seen that Carel van Mander was informed of Caravaggio's fame by 1604 and knew something of his personality (see page 48). Van Mander wrote that Caravaggio is "doing extraordinary things in Rome, . . . he has climbed up from poverty through hard work . . . [to] earn reputation, a good name, and honor with his works." This published report from far-off Holland reminds us that soon after 1600 Caravaggio was an international figure. He was also known to a wide Italian public even before the Contarelli pictures were installed in July 1600. In April 1600 he had signed a contract with a Sienese patron for a large picture, almost three meters high. It was to be painted, the contract stipulated, "according to the sketch already done" *(conforme allo sbozzo fatto),* and he was paid 60 *scudi* on account toward a total of 200 *scudi*—an amount equal to his payment for each painting in the Contarelli Chapel. Since he was given a final payment on 20 November 1600, the picture must have been finished, but we have no idea what or where it is.[1] Caravaggio was on his way, and soon he got more commissions.

When the poet Giambattista Marino was in Rome Caravaggio apparently painted his portrait, and Marino owned other paintings by Caravaggio.[2] By mid 1601 Cardinal Federico Borromeo had presumably taken Caravaggio's *Still Life* [47] back to Milan. Even before that time, Rome's most perspicacious patron, the wealthy

[1]Masetti Zannini (1971) published the documents. The painting was to measure 12 × 7 or 8 *palmi* (268 × 156/179 cm) and was to be finished at the end of June 1600. The patron, Fabio de Sartis of Siena, is otherwise unknown. The *saldo* was paid in Del Monte's Palazzo Madama. Caravaggio still lived there, and may have even as late as 1604 (see p. 88, n. 28).

[2]See Cinotti (1971, pp. 68–69 and 175, nn. 54–56). He was in Rome on and off from 1600 until late in 1605; the portrait may well date from one of the later visits. A *Susanna* mentioned in a letter of Marino's has been connected with a painting that has no relationship to Caravaggio (Marini, 1974, no. 43; cf. Nicolson, 1979, p. 34). Marino's *Portrait* (Cinotti, 1971, p. 163, F 103) was at one time in Naples (Hess, 1967, p. 231, n. 7). See also my p. 46, n. 25.

Marchese Vincenzo Giustiniani (1564–1637), seems to have become Caravaggio's ardent supporter, superseding Cardinal Del Monte.[3]

After the Contarelli pictures were installed on the side walls of the chapel in July 1600, Caravaggio got a new commission, again for two side pictures in a private chapel [73, 80]. Monsignor Tiberio Cerasi, treasurer general under Pope Clement VIII, had just acquired a chapel in Santa Maria del Popolo. Cerasi was rich; the position of treasurer, which he was allowed to purchase, cost a fortune. Once the chapel had been acquired, Cerasi set out to have it decorated by Annibale Carracci. The altarpiece of the *Assumption of the Virgin* [81] is by him, and the vault frescoes are by a follower who worked from Annibale's designs. The precise dates of these works are not known; since no records of payment to Annibale have come to light, scholars have assumed that he finished the work and had been paid before Cerasi died in May 1601.

In 1600 Annibale Carracci was completing the vault of the Galleria Farnese [2]. He had worked for Cardinal Odoardo Farnese since 1595, and as a member of the Farnese household, painting almost exclusively for the cardinal, he occupied a position in the Roman art world that was wholly different from Caravaggio's, or for that matter of any other painter. Although he was the most intelligent and versatile artist in Rome, he had painted few public works and was probably not well known. Supposedly Caravaggio admired his *St. Margaret* [35]. Late in 1600, when Caravaggio's side paintings for the Contarelli Chapel were visible and the vault of the Galleria Farnese had been unveiled, it must have seemed obvious to Cerasi's adviser that an ideal chapel decoration would combine the talents of the two painters. This adviser was presumably none other than Marchese Vincenzo Giustiniani, for it was he who delivered the first payment from Cerasi to Caravaggio in September 1600. Perhaps the dual commission was not regarded precisely as a competition, although the painters surely found it a challenge. Annibale, the experienced fresco painter, got the vault decoration. His altarpiece has been interpreted as a polemical statement of his idealist position [81].

On 24 September 1600, Caravaggio, called *"egregius in Urbe Pictor,"* signed a contract to paint two cypress panels measuring 10 × 8 *palmi* (over two meters high). They were to represent the conversion of St. Paul and the crucifixion of St. Peter. The contract specifies that Caravaggio will show the patron figural drawings or *bozzetti* before proceeding *("specimina et designationes figurarum et aliorum . . . ex*

[3]Discussed further on pp. 160–163 and, nn. 14, 19, and 22; see also Note 98. The family was originally Genoese, with vast fortunes from banking. Giustiniani is placed in the Roman scene by Haskell (1980, pp. 29–30); cf. also Salerno (1960).

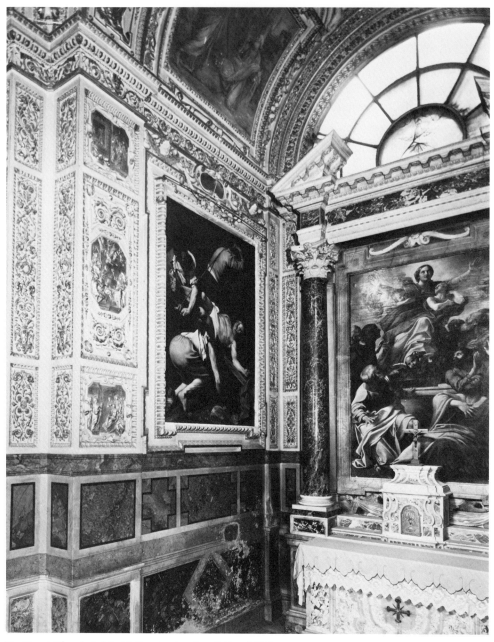

73. Cerasi Chapel, S. M. del Popolo, showing [81] and [82].

sui inventione et ingenio"). Caravaggio was to finish the two paintings in eight months, but Cerasi died first, on 3 May 1601. At that time the correspondent from Urbino reported that the chapel was being "beautifully painted by Caravaggio." Nevertheless it seems unlikely that he produced his paintings ahead of schedule, and the final payment was made more than half a year later, on 10 November. Possibly the writer heard that the chapel was being decorated by Carracci and Caravaggio and then

confused their names in his report just as he did the name of the church, which he called Santa Maria della Consolazione.[4] The frescoes were probably finished, and the altarpiece, which is on cypress wood, may have been in place. Possibly the first versions of Caravaggio's pictures were also there.

THE CONVERSION OF ST. PAUL

Baglione, who should have known what was happening in these days, says that Caravaggio's first paintings for the chapel were done in another style *("lavorato da lui in un'altra maniera"),* that they did not please the patron and were then acquired by Cardinal Sannesio. This report may not be strictly true, however, since Mancini (circa 1620) thought that Sannesio's pictures were only retouched copies, and Bellori does not mention them at all. Nevertheless one such picture does exist, close in size to the dimensions of the contract, and painted on cypress wood [74]. It is certainly *in un'altra maniera* from those in the chapel, and one's first impulse is to attribute it to someone else—as Roberto Longhi and Denis Mahon did at first, and as a few others still do. Because it is painted on wood, the only such support in Caravaggio's entire *oeuvre,* its surface is hard and shiny. But it has a characteristic technical feature, grooves scored in the priming (evidently as guidelines), that is also found in the Contarelli paintings.

All the figures are crowded into the foreground. Saul, half naked, reels back at the left while Christ and an angel emerge explosively at the upper right as the physical agents of conversion, divine apparitions that are almost unprecedented in Caravaggio's art [cf. 56]. Saul (who became Paul after his conversion) falls back but has not reached the ground; the bewhiskered soldier reels behind his buckler displaying the crescent moon; a branch cracks off the poplar tree behind—everything is caught at a split second of crisis that we actually seem to hear. The details are overpowering: gestures, ribbons, leaves, plumes. (There is still another cringing, Leonardesque figure back at the left, partially hidden from view and difficult to make out.) The basic composition seems to derive from Raphael's tapestry [77], but in color and in complication the painting follows the style of the left half of the *Martyrdom of St. Matthew,* which was finished by July 1600 [56]. If we take into account the relatively poor condition of the Contarelli picture, together with the unusual wooden support of the Odescalchi *Paul* and its consequent brilliance of surface, the two paintings can be understood as essentially contemporary. But when we compare the

[4]Cinotti (1971, p. 151, F 35). The *avviso,* dated 5 May 1601, states that Cerasi was buried *"nella sua bellissima Capella, che faceva fare nella Madonna della Consolatione, per mano del famosissimo pittore Michel Angelo da Caravaggio."* The *lapsus* is explained by the continuation of the notice, which states that Cerasi's heirs were the Fathers of the Madonna della Consolazione, who were obliged to finish the chapel, as they did, paying Caravaggio in November.

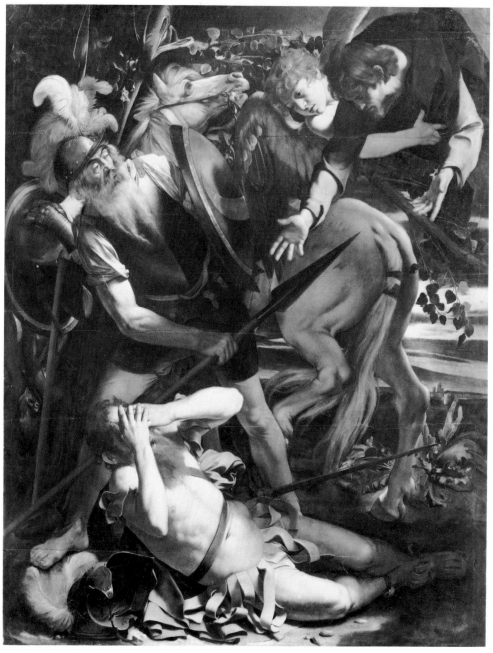

74. *Conversion of St. Paul.* Principe Guido Odescalchi. 1600.

Odescalchi *Paul* [74] with the painting in the Cerasi Chapel [75], which is powerfully simplified, chary of detail, and without divine personification, there seems to be no point of contact. It might be argued that Caravaggio's most dramatic growth and change as an artist occurred during the year following the Cerasi commission.

In the Odescalchi picture Paul covers his eyes as Jesus holds out both arms in supplication while the bearded and bedecked old soldier tries to ward off the divine assault with his shield. It seems almost inconceivable that Caravaggio could first have imagined this composition and then put it aside to produce one so fundamentally different. In the final version, Paul has a completely different reaction to his experience. Only his costume and the huge hindquarters of the horse remain. The many *pentimenti,* major and minor, such as the double fingers of Paul's left hand and the streak running through the ground at his left, remind us that Caravaggio also modified his final design in the course of painting. Nevertheless it could be maintained that the second picture is still not wholly successful. No old painted copies survive (in contrast to the popularity of the *Crucifixion of St. Peter*) and it seems to have exerted only occasional influence on later painters. The *Conversion of St. Paul* was probably too radical to have made much impression. A hostile viewer—and surely there were many—would see chiefly the rear end of a horse: one wag has likened it to an accident in a blacksmith's shop.

The contrast between the Cerasi *Paul* and the Contarelli paintings [52, 56] is immense. Whatever esthetic distance Caravaggio had achieved in the earlier pictures with their foreground *repoussoir* figures is deliberately abrogated in the Cerasi paintings in favor of an abrupt confrontation that is shocking and immediate. The size of the figures in relation to the whole is greater, as they are only half as wide as those in the Contarelli Chapel. The Cerasi Chapel itself is narrow, and Caravaggio's forms seem to be pushed out of the frames toward us; the figures are bigger and fewer [cf. 73]. In a sense, Caravaggio returned to his old close relationship between viewer and subject, although the Cerasi pictures are well above our heads in the narrow chapel. But now there is a difference, a foreground space in which the action takes place, which marks a change from half-length pictures like the *Judith* [36]. The isolation of the recumbent Paul in this narrow strip makes his conversion more poignant. Caravaggio simplified the composition and clarified the meaning at the same time.

The Book of the Acts of the Apostles, a continuation of the gospel of Luke, tells the story of Paul's conversion three times in almost identical words:

> I was given letters . . . to our fellow-Jews at Damascus, and had started out
> to bring the Christians there to Jerusalem as prisoners for punishment; and this

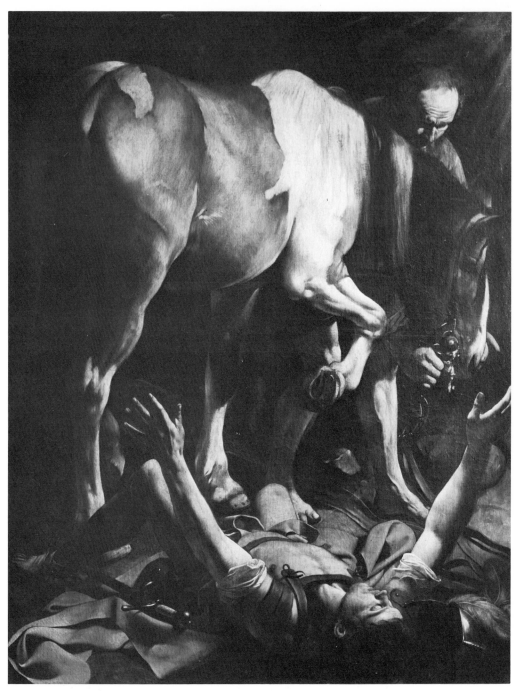

75. *Conversion of St. Paul*. Cerasi Chapel, S. M. del Popolo. 1600–1601.

is what happened. I was on the road and nearing Damascus, when suddenly about midday a great light flashed from the sky all around me, and I fell to the ground. Then I heard a voice saying to me "Saul, Saul, why do you persecute me?" I answered "Tell me, Lord, who you are." "I am Jesus of Nazareth," he said, "whom you are persecuting." My companions saw the light, but did not hear the voice that spoke to me. "What shall I do, Lord?" I said, and the Lord replied "Get up and continue your journey to Damascus; there you will be told of all the tasks that are laid upon you." As I had been blinded by the brilliance of the light, my companions led me by the hand, and so I came to Damascus. (Acts 22:5–11)

The significance of this conversion was spelled out carefully in the *Golden Legend*. Although that medieval compilation was officially frowned on by Tridentine authority, it continued to be published and reprinted in Caravaggio's day, and the theme of conversion was even more timely in 1600 than it was in 1300. The *Golden Legend* tells us that

> Three reasons explain why the Church celebrates this conversion, and not that of the other saints. In the first place, the conversion of St. Paul is a greater example than the others, to prove to us that there is no sinner who may not hope for the grace which he needs. Further, this conversion is the subject of a greater joy, for the Church rejoiced the more over the conversion of Saint Paul, that she had been the more afflicted by his persecutions. Finally, this conversion was more of a miracle than the others, since God showed by it that He could convert His cruellest persecutor, and make of him His most loyal apostle The conversion was also miraculous in the manner in which it was accomplished, namely, the light which prepared him for conversion. This light was sudden, immeasurable, and divine.[5]

Michelangelo had painted both the *Conversion* [179] and the *Crucifixion of St. Peter* [83] on the side walls of the Pauline Chapel in the Vatican Palace. The Cerasi paintings, which are relatively small, deliberately invoke comparison with these great frescoes. Michelangelo's *Conversion of St. Paul* is notable for its host of heavenly creatures around Christ, complementing the earthlings below, a tradition that Caravaggio had varied in the Odescalchi picture [74] after consultation with Raphael's tapestry [77]. Michelangelo's follower Taddeo Zuccaro had also compressed and concentrated the scene in his altarpiece: stricken rider, bolting horse, heavenly agents [78]. In order to leave this tradition behind, Caravaggio could have been helped by the memory of Moretto's painting in Milan [79]. Moretto shows a big horse above Paul and only a slim ray of light to indicate the divine power—which seems particularly relevant for Caravaggio's picture. We have observed that toward the

[5]*Golden Legend* (p. 126).

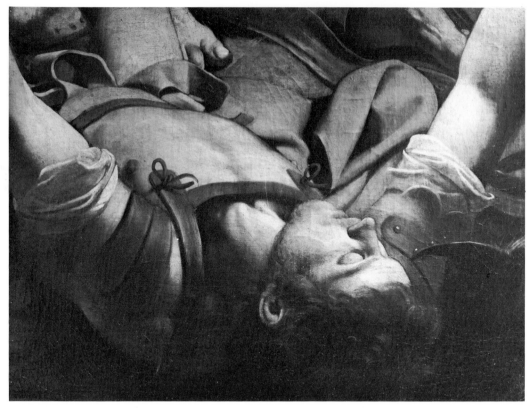

76. Detail of [75].

beginning of his career Caravaggio had employed light in a novel and symbolic way in a similar context [30].

Caravaggio's *Conversion of St. Paul* would seem to be a psychological study of unparalleled modernity. Saul, the Jewish persecutor of Christians, is knocked flat before our eyes and almost into our space [76]. He receives the literal enlightenment of conversion through the penetrating rays of God's light, "brighter than the sun" (Acts 26:13), which seem to occupy his body; his arms open wide as if to welcome the Divine force that has temporarily blinded him. Caravaggio painted what the text reports: brilliant light but no apparition. Thus Caravaggio's revolution was based on a return to orthodoxy, somewhat in the spirit of the Protestant return to scripture.

Nevertheless Caravaggio retained what he wanted from tradition, most obviously the horse. Although Acts does not mention a horse, it had become iconographically indispensable in the Renaissance, and Caravaggio, among other things, needed it to fill up the picture. The ordinary piebald animal seems to step gingerly over Paul's vulnerable body. It is led by an old man, now merely a groom, who is lighted but unenlightened by the divine efflorescence [148]. Paul's position is based not only on earlier *Conversions* but also on soldiers in scenes of Christ's Resurrection. Caravaggio

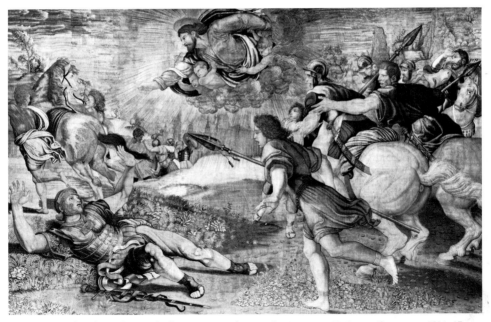

77. Tapestry after design by Raphael, *Conversion of St. Paul*. Pinacoteca Vaticana. Cartoon c. 1514–17.

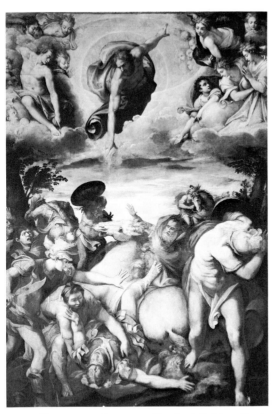

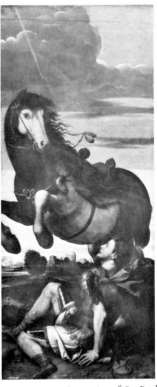

79. Moretto, *Conversion of St. Paul*.
Milan, S. M. presso S. Celso.
c. 1529–30.

78. Taddeo Zuccaro, *Conversion of St. Paul*. S. Marcello al
Corso. c. 1563.

remembered Raphael's tapestry [77] when he planned Saul's position, but he turned the body around so that the head comes down and out toward us. In most of these representations Saul is shown in Roman armor (he was *civis romanus,* he tells us). Caravaggio makes him young, as Raphael had done, but also common, as no artist had done before. The confusion of arms and legs makes us realize that Caravaggio still has not mastered the art of *digradazione:* there is simply not enough room for the three actors in this scene. It is cramped, even claustrophobic, and in that sense it is more experimental than the Odescalchi picture with its more conventional treatment of figures and space [74].

In the *Conversion of St. Paul* Caravaggio's innovations more than compensate for his weaknesses. In contrast to Roman tradition, the number of figures is reduced to a minimum. The servant or groom is essential, not merely to control the horse, but to provide a foil to Paul. Like the waiter in the *Supper at Emmaus* [42], the groom illustrates the arbitrariness of God's Grace. Caravaggio omitted a personified God and substituted symbolic light coming in at the upper right, whose force is felt exclusively through its sledgehammer impact on Paul. His helplessness before the will of God is expressed by Paul's recumbent body, head thrown down toward us. Paul is vulnerable to God even as Francis was [30], wounded by a physical blindness that symbolizes his former spiritual blindness.

All three of the paintings in oil on the lower level of the Cerasi Chapel are related to frescoed scenes above: the *Crucifixion of St. Peter* to a *Domine Quo Vadis?;* the *Assumption* to a *Coronation of the Virgin;* and the *Conversion of St. Paul* to another confrontation between Paul and God, the scene of the saint transported to the third heaven (II Corinthians 12:2–4) [cf. 73, 80]. Paul was the one Apostle on earth who had been caught up to experience a vision of heaven and heavenly love. The third heaven, for Dante and others, was specifically the abode of Love, which ruled the universe: *"l'amor che move il sole e l'altre stelle"* (*Paradiso,* **XXXIII**, 145). Dante, like others before him, equated God chiefly with light—the *gloria* with which the *Paradiso* begins is primarily light, increasing canto by canto—and every Italian schoolboy knew Dante.

Paul's blindness on earth is thus contrasted with his illumination in heaven. Caravaggio has shown closed eyes in the head of a common, rather youthful fellow of no distinction [76]; the contrast with the conventional bearded sage in the fresco above typifies the gulf between Caravaggio and Annibale's more traditional art. The light that blinds Paul in the painting is joined in the afternoon by real sunlight from the transept window. When we visit the chapel at that time and look up at the source of this light, we see first the vault of the entrance vestibule, where the dove of the

80. View into Cerasi Chapel, showing [75].

Holy Spirit is painted in the center of a burst of heavenly light. The Holy Spirit was the particular repository of Love, according to St. Augustine, and Santa Maria del Popolo is an Augustinian church. The evil Saul was blinded and converted by the light of God, to become the Paul who later defined Love as the chief Virtue, greater even than Faith or Hope (I Corinthians 13:13).

With hindsight, we may imagine that Caravaggio skewed the sense of the painting in his own psychological direction; some of his other pictures seem to show a longing for an overwhelming, undeserved Grace. In this sense, Paul was a much more comfortable subject for Caravaggio than St. Francis, a Christlike man. Saul, like Matthew, was a sinner—like Caravaggio himself, who begins to appear on the

129

81. Annibale Carracci, *Assumption of the Virgin*. Cerasi Chapel, S. M. del Popolo. 1600?

Roman police blotter in October and November 1600 in what would soon become a crescendo of antisocial behavior.[6]

I am convinced that Caravaggio needed to believe in the grace of God even more than most of his contemporaries; but he was also in a Pauline or Augustinian tradition that had been particularly strong in the earlier sixteenth century. This point of view stressed man's total dependence on divine grace and mercy, a passive theology

[6]It may not be a coincidence that Caravaggio's first brush with the law occurred at this time: see Cinotti (1971, p. 151, F 30–31, etc.). On 25 October 1600 he was too ill to carry his sword and had a servant follow him with it; on 19 November Caravaggio was charged with attacking one Girolamo Stampa, giving him several *bastonate* (F 31). See the summary of his criminal activities in Wittkower (1969, pp. 192 ff. and 196 ff.), and my pp. 168–170 and n. 7.

that tended to ignore the significance of good works and to stress the role of faith in the process of salvation. Faith had been the key aspect of Michelangelo's belief, as Caravaggio may have known; and although we now think of trust in Faith alone as Protestant, it was not heretical before the Council of Trent. This "Evangelism" had flourished in the 1530s and 1540s, and the ideas had never entirely died out. Versions of the controversy had recently erupted in Rome around the teachings of Luis de Molina (see pp. 101–102), and Evangelism survived in Venice into the early seventeenth century. Any depiction of the conversion of Paul represents the triumph of the power of God over earthly matters and hence, perhaps, of Faith over Works. Caravaggio's picture seems to stress that aspect, and we shall see further instances of his hope for conversion and salvation.

Donald Posner has suggested that Caravaggio revised his first pictures when he saw Annibale Carracci's altarpiece. This is possible if the *Assumption* was finished by spring of 1601 and if Caravaggio's final paintings were finished only in the following summer. The final payment, of 10 November 1601, does not precisely indicate the date that the paintings were finished, and such payments were usually somewhat late; still, Caravaggio's pictures may not have been completed before September or October 1601.

Whether or not he saw the altarpiece, Caravaggio must have realized that Annibale would paint a clear and relatively bright picture, even if he could not have imagined so schematic a composition as the one actually produced, with large figures forced onto the picture plane [81]. Annibale had the obvious advantage of painting a larger picture placed at the end of the main axis of the long chapel [cf. 73]. Caravaggio's achievement was to make his side pictures more dramatic and arresting than the altarpiece. Posner wrote of Annibale's altarpiece:

> By its nature the situation demanded that the altarpiece (the ceiling frescoes were considered of secondary importance) make an irrefutable demonstration of the power of those of his ideas whose validity he knew Caravaggio's paintings would implicitly deny. This meant commitment to *disegno,* and insisting on his debt to Raphael and to the ancients. Conversely, it meant a severe curtailment of the naturalistic and coloristic components of his style. The result, the *Assumption of the Virgin,* is a bold, but doctrinaire, statement of the ideal style.[7]

Charles Dempsey believes that Caravaggio's mature achievement was based on a study of Annibale's art, and indeed that he was the first painter (aside from Ludovico Carracci) to have understood Annibale's reform and to have gone on to create a

[7]Posner (1971, I, p. 138).

personal style based on that understanding. Dempsey wrote of the confrontation in the Cerasi Chapel:

> Caravaggio painted two masterpieces in his new style, based on the *colore* he had learnt from Annibale combined with his own innovations in *chiaroscuro*. Annibale, on the other hand, for the only time in his life, painted a picture on panel, gave it a light ground, and banished all *scuro* from the painting, working only in the *chiaro* range of the palette. At the same time, even as Caravaggio painted figures which were more "natural" than Annibale's norm, so again did Annibale exaggerate the differences between them by painting his figures in a more classically idealized style than he had ever before attempted.[8]

Perhaps Caravaggio's increased darkness—his rejection of the *chiaro* end of the range of color values and his insistence on *scuro*—had a theoretical motivation. Possibly he equated naturalism with *scuro* in contradistinction to the Mannerists' use of a lighter palette. But these issues were formulated in print only a generation later and we cannot be sure that he entertained such theoretical positions. Annibale, who also reacted against Mannerism, gradually lightened his palette after coming to Rome, in an effort to move from a "Venetian" darkness to a Raphaelesque clarity. Thus Annibale's paintings became blonder as Caravaggio's were becoming darker.

In 1601 a visitor to the Cerasi Chapel was perhaps expected or allowed to go only as far inside as did the cameraman who took the photographs [73] and [80]. From that point we see Caravaggio's paintings from the side, and evidently he adjusted his compositions accordingly: both pictures have powerful diagonals. But whereas the spiritual focus of the *Conversion of St. Paul* is toward the viewer—that is, at the right of the canvas—the focus of the *Crucifixion of St. Peter* [82] is away from us, again at the right side of the canvas. Nevertheless the diagonals and the intense contrast of light against darkness make the pictures seem strong, clear, and simple when compared with Annibale's crowded and coloristically high-keyed composition. Moreover, Caravaggio's pictures are above our heads, and even when seen straight on there is a dramatic foreshortening.

THE CRUCIFIXION OF ST. PETER

In contrast to the stillness and intimacy of the *Conversion,* the *Crucifixion* is all physical action, straining and groaning [82]. Sweaty workers struggle to raise the cross, although Caravaggio can only freeze them in their poses, spotlighted against the dark.

[8]Dempsey (1977, p. 86, n. 59).

82. *Crucifixion of St. Peter* (companion to [75]). 1600–1601.

83. Michelangelo, *Crucifixion of St. Peter* (detail). Vatican, Cappella Paolina.

Peter raises his head to look—not at us, as in Michelangelo's fresco [83]—but past the mighty spike piercing his left hand toward the altar in the chapel, which represents the only path to salvation for ordinary mortals [84]. Michelangelo's painting broke with tradition by showing the cross in the act of being raised, and by emphasizing Peter's almost accusatory rebellion at a form of martyrdom that he himself had chosen. After Michelangelo, paintings showing Peter's cross being raised became commonplace; a mediocre picture in the Gesù, which was probably painted just before Caravaggio came to Rome, would have been known to everybody. Ultimately Rubens borrowed the idea for his great triptych of the *Raising of the Cross of Christ*

134

84. Detail of [82].

85. Pieter Bruegel, *Conversion of St. Paul.* Vienna, Kunsthistorisches Museum.

in Antwerp, which was painted shortly after his long stay in Italy.

Caravaggio's concentration is novel and gripping; the event is presented with unexpected physical immediacy. Like its opposite, the scene is reduced to essentials, to the process of crucifixion, but with Caravaggio's familiar emphasis on mundane or irrelevant surface details. The hind-quarters of the lower workman, brilliantly illuminated, are thrust prominently at us when we enter the chapel [73]. We may imagine that Caravaggio was in a sense thumbing his nose at Annibale's ideal style —as if to say, this is how things really happen. Such an attitude seems to be originally northern, almost Bruegelian in its revision of the heroic ideal of Mediterranean art, but with one great difference. Caravaggio, for all his iconoclasm, remains in the figural tradition of Italy. Pieter Bruegel (circa 1525/30–1569) would reduce the size of his protagonists and sometimes hide the subjects of his pictures, perhaps in an attempt to show that great events are significant only in retrospect [85].

Caravaggio, by contrast, is Michelangelesque. He is at his most powerfully sculptural in the *Crucifixion of St. Peter,* where he concentrates on figures of heroic size, set out like reliefs against a dark background. And then, having insisted on physical grandeur and on the traditional Italian focus, he gives an antiheroic, pseudo-realistic, reductionist version of the story and concentrates on cruel or mundane details. Caravaggio's greatness is rooted in perversity.

136

The extreme combination of naturalistic surface and classic composition found in the *Crucifixion of St. Peter* can be found again in pictures of the succeeding years [104, 107]. The powerful physicality of Peter and the plebeian types of all of Caravaggio's figures in the Cerasi Chapel lead directly to the first *St. Matthew* for the Contarelli Chapel, which was commissioned early in 1602.

5
The Contarelli Chapel (II)

The altarpiece of the Contarelli Chapel was to have been the marble group of St. Matthew and the angel by Cobaert, which was installed in the niche above the altar in January 1602. Actually, only the *Matthew* was set up; the angel remained uncarved. How the finished group might have looked in the chapel is shown in [86]. Once installed and viewed, the statue was rejected by the rector of the Congregation of San Luigi, who was the nephew of Cardinal Contarelli. Eventually it was finished by another hand and placed in a chapel of SS. Trinità dei Pellegrini.

Contarelli and his friends the Crescenzi were at last free to commission a different altarpiece. The money was surely available; Cobaert was to have received 500 *scudi* for each of his figures, and only one was ever finished. Caravaggio signed a contract on 7 February 1602 with Abbot Giacomo Crescenzi, who was "acting for Francesco Contarelli." Caravaggio agreed to paint a picture for 150 *scudi,* "in place of the statue of white marble," showing Matthew writing his gospel with an angel at the right in the act of dictating to him. The painting, with two full-length figures, was to be finished by Pentecost Sunday, which in 1602 fell on May 26. Caravaggio produced a picture that in its sculptural presence was very much a substitute for statuary [87]. This famous work was destroyed in Berlin in 1945.

The picture was powerful and odd: an old, bald Matthew with wrinkled brow and crossed legs sits on a Savonarola chair, writing. His hand is guided by a luscious angel who poses in curvilinear elegance, mouthing the words. This angel approximates a Mannerist *figura serpentinata,* and Caravaggio may have composed it to demonstrate his competence in this traditional exercise as well as to present a contrast to the stocky, naturalistic saint [cf. 29]. Matthew's foot seems to project out of the picture; the photomontage in [92] shows how it might have appeared in the frame, which would have demanded a larger painting than the one that was in Berlin. Presumably it was soon cut down, for there can be little doubt that the Berlin picture was painted to go into that place.

86. Contarelli Chapel, S. Luigi dei Francesi, with photomontage of statuary group by Jacob Cobaert and Pompeo Ferrucci.

Matthew's ecclesiastical symbol is a man, or a man with wings, which is to say, an angel. There was also an old tradition that Matthew's text was dictated directly by God. Since Matthew's gospel was thought to be the first, and the source of the others, it had to have been divinely inspired—hence the dictating angel—and it had to have been written in Hebrew, God's language. This argument worried Erasmus in particular because no Hebrew or Aramaic text had been found, and that lack was regarded by some Catholics as a threat to the very foundation of their faith. Then, during the sixteenth century, Hebrew texts were discovered and printed. Caravaggio's *Matthew* therefore writes in Hebrew, thanks to a learned adviser and in conformity with the opinion of Cardinal Baronius that Matthew composed his gospel *"in lingua pure Ebrea,"* as his Italian translator put it.

There were numerous Hebraists at the papal court; Cardinal Valier reported in 1600 that Cardinal Borromeo was "expert in Latin, Greek, and Hebrew." Borromeo had been a neighbor and a friend of Caravaggio's patrons but had left Rome for good in mid 1601. Caravaggio's adviser may have been Monsignor Melchiorre Crescenzi, and perhaps at about this time Caravaggio also painted a portrait of this neighbor, whom Bellori called a *dottissimo prelato*. [1] The Hebrew letters are revealing because they reproduce one of two texts that had been printed by this time. Before

[1] Bellori (p. 205); the suggestion was made by Hess (1967, p. 234).

139

87. *Inspiration of St. Matthew.* Destroyed. 1602.

88. Simone Peterzano, *Inspiration of St. Matthew*.
Milan, Certosa di Garegnano. c. 1578–82.

it was copied out (perhaps traced for Caravaggio's use) it was given a scholarly grammatical emendation. Translated, it reads, "The book of the generations of Jesus Christ son of David . . . ," which corresponds to St. Jerome's Vulgate. Thus Matthew is shown writing his gospel in a Hebrew that was in perfect accord with the Latin version used by the Church. Caravaggio's painting illustrates the direct verbal inspiration that Roman churchmen desired, and Matthew writes in Hebrew the very words that St. Jerome had translated from the Greek.

Bellori and other late writers took it for granted that the altarpiece was Caravaggio's first work in the chapel; consequently it used to be dated to the 1590s. This assumption had the merit of explaining the different appearance of the Apostle in the pictures on the side walls, which were presumed to have been painted only after this first altarpiece had been rejected by the priests of San Luigi—as it apparently was, almost immediately. More than one writer has tried to connect the appearance of the head of Matthew in the first altarpiece with that of another wise simpleton, Socrates, who was much discussed and admired in this period. Such a suggestion would help to explain his physiognomy and would also accord with the abstruse learning underlying the Hebrew inscription, both of which were far beyond Caravaggio's intellectual realm. It is just possible that Caravaggio's painting was a kind of trial run, produced as a temporary altarpiece for the celebration of the first Mass in the chapel, which took place in May 1599. But the powerful physicality of the painting seems to align it with those of the Cerasi Chapel and later, and it is much

89. Raphael, *Jupiter and Cupid.* Engraving by C. Alberti reversing the original. 1602.

90. Agostino Veneziano after Raphael, *Inspiration of St. Matthew.* 1518.

more probable that the painting was first produced as a result of the contract of 1602.

Caravaggio's angel recalls Del Montean or earlier works and may help to prove that the ambiguous, androgynous figures of the early paintings were meant to be primarily poetic or ethereal. The *serpentinata* pose, derived from Mannerist sources (and related to the angel in the *Rest on the Flight* [29]), may be more specifically derived from a painting by Giuseppe Cesari that was unveiled in 1597 [91].

Caravaggio's composition has several prototypes. A fresco by his first master, Simone Peterzano [88], exhibits similarities, and Caravaggio must have known it. The subject was a favorite among Lombards, who sometimes showed Matthew as a fairly rustic type; these memories probably influenced Caravaggio's conception. In other respects his most obvious sources are Roman, by Raphael. The position of the angel nestling up to a cross-legged older man is paralleled in Raphael's *Jupiter and Cupid* in the Farnesina. The composition had been engraved in reverse by Cherubino Alberti, a friend of Caravaggio's; the print was reissued in 1602 [89]. In addition, versions of a famous figure from the *School of Athens,* including an engraving called *St. Matthew* [90], use a pose that is almost identical with Caravaggio's. (The cross-legged pose, traditionally an attribute of scholars, is often found in Renaissance images of St. Jerome.) Finally, Raphael showed St. Matthew with his gospel book as a foreground witness to Christ's Transfiguration in his last painting, where the surprised

figure reacts dramatically by thrusting his bare foot out at us, threatening the picture plane [cf. 81].

When installed, Caravaggio's picture would probably have looked something like the photomontage in [92], very much a substitute for sculpture in its relief effect and in the projection of the saint's bare foot. That foot and the unlearned aspect of Matthew apparently led to the work's rejection by the church authorities. Baglione wrote maliciously that it pleased nobody *("non era a veruno piacciuto"),* but he is contradicted by his own text, which says that the painting was snapped up by Marchese Vincenzo Giustiniani, who lived just around the corner [51]. As we have seen, Giustiniani was involved with Caravaggio even before this; he owned pictures that are demonstrably earlier in date, such as the *Phyllis* [27], and he had probably instigated Caravaggio's commission to paint for the Cerasi Chapel in mid 1600. Giustiniani's learned friends, or associates of his brother, Cardinal Benedetto Giustiniani, may have been advising Caravaggio on the problematic image of Matthew all along.

91. Giuseppe Cesari, *St. Barbara.* S. M. in Traspontina. 1594–97.

92. Contarelli Chapel, S. Luigi dei Francesi, with photomontage of [87] inserted into altar frame.

143

Caravaggio's altarpiece was commissioned, as we have seen, on 7 February 1602; when he got the final payment on 22 September it was already in place. No other painting is mentioned in the documents, but another picture by Caravaggio is now on the altar [93]. The second altarpiece was most probably painted between September 1602 and February 1603. Bellori wrote:

> After he had finished the central picture of St. Matthew and installed it on the altar, the priests took it down, saying that the figure with its legs crossed and its feet rudely exposed to the public had neither decorum nor the appearance of a saint. Caravaggio was in despair ... when Marchese Vincenzo Giustiniani acted in his favor and freed him from this predicament. So, intervening with the priests, he took the painting for himself and had Caravaggio do a different one, which is now to be seen above the altar. And to honor the first painting more he took it to his house

This passage seems to show that there was one commission and one payment from San Luigi, as the documents record, and that Giustiniani paid Caravaggio for his second picture while taking the first for himself. Abbot Giacomo Crescenzi, the new executor of Cardinal Contarelli's testamentary desire to complete the chapel, had commissioned Caravaggio's painting; the rector of San Luigi, Francesco Contarelli (Cardinal Contarelli's nephew), paid Caravaggio on Crescenzi's account when his picture was completed and installed in September 1602. The painting was then rejected by the priests of San Luigi.

This sequence of events may at first seem inconceivable, but it was a normal one. Both of Caravaggio's other rejected altarpieces were paid for by patrons and subsequently refused by church officials (see pages 197 and 202–204). The difference between the later rejections and the first one at San Luigi was Giustiniani's intervention. He commissioned a second altarpiece from Caravaggio for San Luigi and took the rejected picture. Thus the second *St. Matthew* [93] should date from late 1602 to early 1603, which is where it belongs stylistically. This theory would also account for the payment in February 1603 to a carpenter who provided a new wooden framing for the altarpiece.

The first *St. Matthew* was refused and—thanks to Giustiniani—a new one substituted that was more decorous, that does not thrust a foot toward the priest at the altar, and that does not insist on Matthew's illiteracy. After all, transcribing the gospel from the word of the Lord is one thing; having one's hand guided like a child (or worse, like an illiterate peasant) is quite another. But Caravaggio's second picture does not wholly forsake the sculptural physicality of the first version. Matthew's footstool, familiar from the *Calling* [53], juts out beyond the painted floor on which it rests; apparently it drops down into our space, breaking through the picture plane

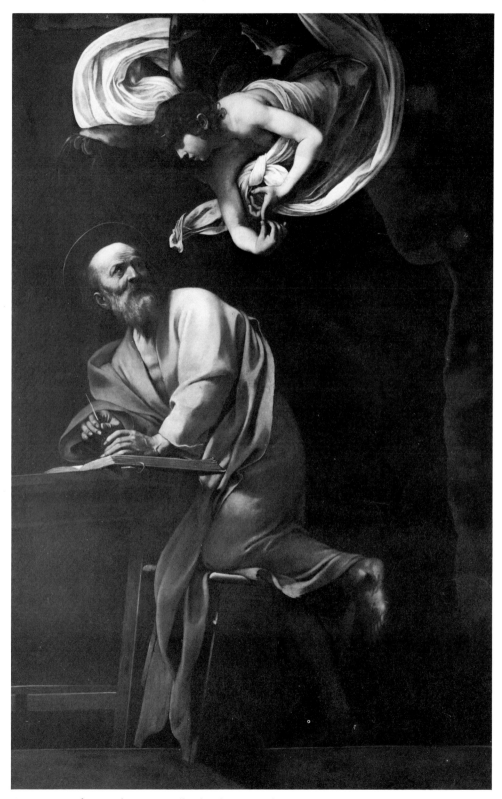

93. *Inspiration of St. Matthew*. Contarelli Chapel, S. Luigi dei Francesi. 1602–03.

with some of the *trompe l'oeil* verisimilitude of the rejected *St. Matthew*. The intention is the same, to join our space with his and to create an illusion out of the ordinary. But the sculptural insistence of the first picture is replaced by a softer, more coloristic manner that Caravaggio continues in his only documented painting of 1603 [102].

Caravaggio's second altarpiece follows an age-old formula whereby Matthew writes what the angel dictates. The angel no longer snuggles up to the old man but hovers decorously in the air, for the first time in Caravaggio's art, ticking off the generations. Matthew, in an odd, transitory pose, looks up, startled by the angel. And Matthew now appears to be the same man who was Called and Martyred on the side walls [52, 56]. He writes and even looks like a scholar; indeed, this picture may have been influenced by paintings of St. Jerome, and it led to a number of others.

REJECTION AND REVISION

I should say a word here about the rejection of Caravaggio's first Contarelli altarpiece since it must seem odd that the priests of San Luigi had no idea what it would look like until it was installed. The rejected altarpiece was painted in place of a rejected statue, which is doubly strange. (Baglione recounts in his *Life of Cobaert* that the priests had waited fifteen years for the statue of Matthew in hopes that it would be divine or miraculous and then, finding it dry and dull, did not want it.[2]) One would have supposed that during the Counter Reformation it was routine to inspect works of art commissioned for the Church—first as projects, and again before completion. The contracts often call for samples or sketches. Supervision rarely took place, however, and artists were traditionally secretive about work in progress. Since decorations for chapels were almost always commissioned by individual patrons, the paintings had at the very most to conform to a general iconographic scheme, as at the Gesù or the Chiesa Nuova. In other churches there may have been no supervision at all, the income from the chapel owner being enough to satisfy the priests.

Even the Jesuits, whose artistic concerns were limited to subject matter, rejected an altarpiece by Scipione Pulzone only after it had been finished and installed in a prominent chapel in the Gesù. Pulzone had shown the seven archangels as portraits of living people and had given all of them names, but the Council of Trent had ruled

[2]Baglione (p. 100) reported that the Contarelli commissioned Cobaert to make a marble group for the chapel: "He spent his life on it, never letting anyone see it, and not knowing how to carve the hands since he had no experience in sculpturing marble, but would not get advice or help of any kind. He worked on it until he was almost eighty, and when old could not finish it."

that only three were named, and that angels and saints should not be portraits. Such errors seem inconceivable around the year 1590, yet they were committed by an artist who had had experience and friendship with the Jesuits.[3] There are other examples: Pietro Bernini's first relief for the tomb of Pope Paul V was rejected in 1611 and replaced with another by the same artist in 1613.[4] Baglione, the biographer of Roman artists between 1572 and 1642, reported none of this; thus we cannot be sure, simply by consulting him, how many works were rejected or sent back for revision. We do learn of paintings being replaced after a time, presumably because the originals were unsatisfactory.

Sometimes, after installation, a painting did not look well because of the light; thus artists customarily touched up their works *in situ*. [5] Rubens, having painted the high altarpiece for the Chiesa Nuova in 1606–1607, found it unsatisfactory even after retouching and replaced his single painting with a drastically redesigned triptych. Reflections, such as those that bothered Rubens and his patrons, could have been one reason for Caravaggio's replacement of the first *Conversion of St. Paul,* which was on wood, with a painting on a canvas support; but this does not explain the radical revision he made in design. In general, commissioned paintings were not often refused, although they were constantly criticized for defects of one sort or another. Economy dictated keeping what was there. Thus Barocci's altarpiece for the Aldobrandini Chapel in Santa Maria sopra Minerva, which was sent to Rome from Urbino in 1609, was considered small and dark, but it is still in place.[6] Caravaggio is unique in having as many Roman altarpieces refused as were accepted.

And so we come back to the problem of Caravaggio's character and personality, which was extraordinary then and which dumbfounds us still. He was so very rebellious and uncontrolled in his private life, yet he produced thoughtful and innovative paintings such as could not have been predicted even from an intellectual artist. Moreover, he continually produced his work close to the time specified, regularly meeting his contractual obligations with only minimal delay—in contrast with the endless procrastination that was common among successful artists such as

[3]Hibbard (1972, pp. 38, 46–47).

[4]Documents published by Dorati (1967, pp. 235 and 252, nos. 128–136).

[5]Rubens, writing from Rome in 1607 about his first altarpiece for the Chiesa Nuova, mentioned that "it will be necessary for me to retouch my picture in its place before the unveiling; this is usually done in order to avoid mistakes." (Magurn, 1955, p. 16: 9 June 1607). Cesari d'Arpino did considerable retouching on his *Coronation of the Virgin* in the same church after it was first set up (Röttgen, 1973, p. 125, no. 44); the practice was common.

[6]An *avviso* of 12 March 1611, after the unveiling of the Aldobrandini Chapel, reports that "the picture on the altar, even though beautiful, being by Barocci . . . is not very successful, and it is reported that Cardinal Aldobrandini wants to replace it" (Orbaan, 1920, p. 187). See Emiliani (1975, pp. 221 ff., no. 272) and Note 107, p. 315 below.

Barocci, Cesari, and Reni.[7] But Caravaggio's innovative style, even at its most classic, was also difficult for the public to assimilate and was even deliberately rude. His disregard for traditional decorum led some churchmen to reject his works.[8]

[7]Cesari d'Arpino's *Coronation of the Virgin,* commissioned on 2 December 1592, was finished and installed only in 1615, after a span of some twenty-two years, and it seems not to have been satisfactory even then (see n. 5 above). Barocci's *Presentation of Mary in the Temple* [182] seems to have been ordered by 1590 and delivered only in 1603 (Emiliani, 1975, pp. 206 ff., no. 255). Cesari's *Presentation of Christ in the Temple* for the same church was commissioned in 1617 and delivered in 1627 (Hess, 1967, pp. 363–364). Reni's procrastination was proverbial, and it increased as he got older.

[8] There was little systematic control of art by the papacy even though an edict was issued by the Cardinal Vicar of Rome on 13 November 1603 stating that all altarpieces and other public works of painting in churches had to be licensed by his office. Although the edict was renewed and expanded by Urban VIII, little actual censorship seems to have occurred (Orbaan, 1915, pp. 34–35, n. 47).

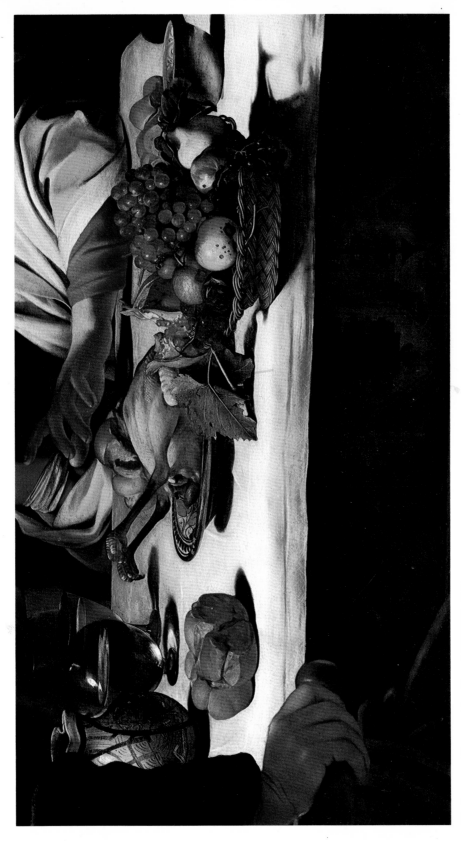

The Supper at Emmaus (detail). c. 1600/1601. [42]
London, National Gallery

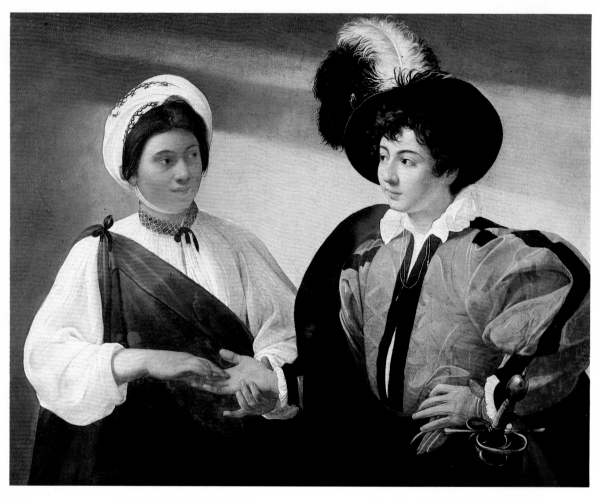

The Gypsy Fortuneteller. c. 1594/1595. [12]
Paris, Louvre
(Scala/Editorial Photocolor Archives, Inc.)

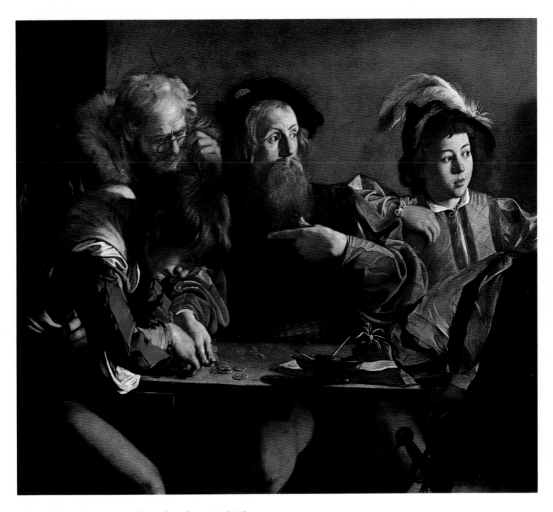

The Calling of Saint Matthew (detail). 1600. [52]
Rome, S. Luigi dei Francesi
(Scala/Editorial Photocolor Archives, Inc.)

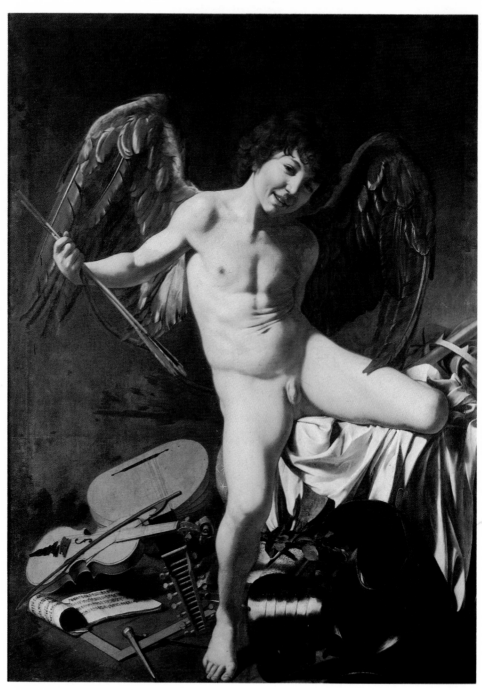

Amor Vincit Omnia. 1601/1602. [98]
Berlin (West), Gemäldegalerie Staatliche Museen Preussischer Kulturbesitz

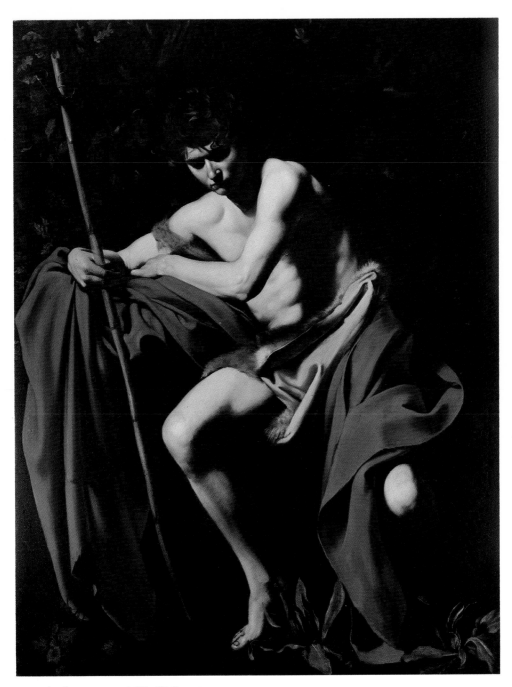

St. John the Baptist. c. 1605. [126]
Kansas City, Missouri, Nelson Gallery–Atkins Museum (Nelson Fund)

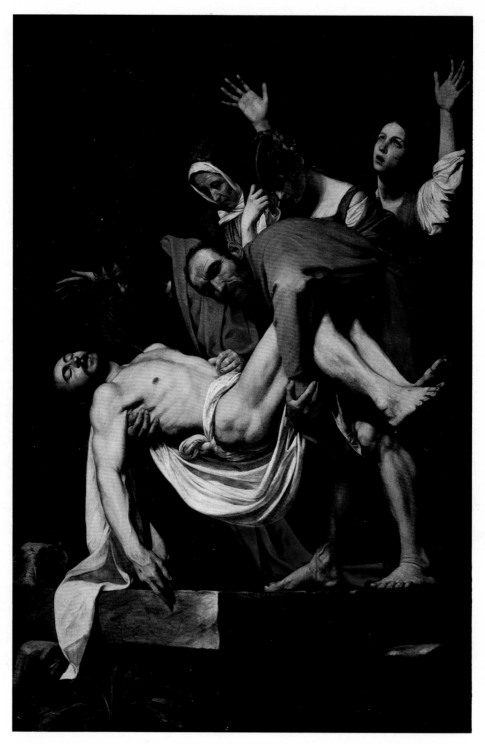

The Entombment of Christ. 1603–04. [107]
Vatican Museum
(Scala/Editorial Photocolor Archives, Inc.)

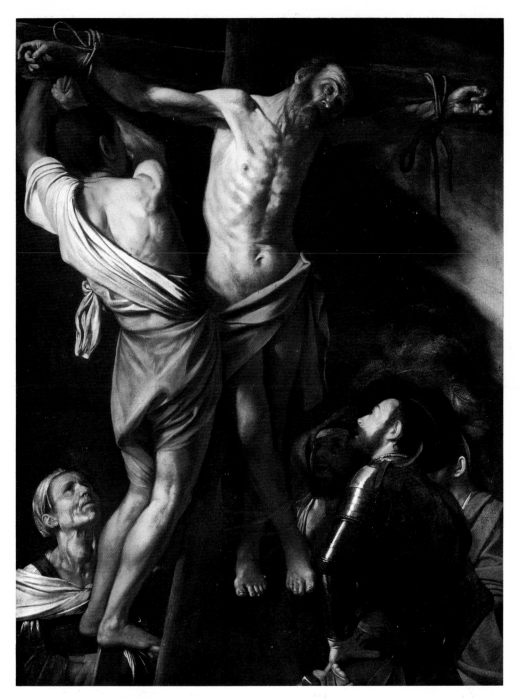

The Crucifixion of St. Andrew. 1607. [144]
Cleveland Museum of Art, Purchase, Leonard C. Hanna, Jr. Bequest

The Resurrection of Lazarus (detail). 1609. [163]
Messina, Museo Nazionale
(Scala/Editorial Photocolor Archives, Inc.)

6
Michelangelo Merisi
and Michelangelo Buonarroti

Giulio Mancini, attempting to categorize the schools of Roman painting around 1620, distinguished four: that of Caravaggio, that of the Carracci, that of the Cavalier d'Arpino, and then (giving up) everybody else. In characterizing the *Caravaggisti* [cf. 11, 13] he of course emphasized their darks and heightened lights, which he called unnatural and without good precedent, qualities that to him were of equal importance. Such painters, he continued, are dependent on reality and keep the model before them while they paint, which is all very well for single figures. But Mancini made fun of these painters when he imagined them trying to paint an elaborate composition, with a room full of a "multitude of people acting out the story, with that light coming in from a single window, having to laugh or cry or pretending to walk while having to stay still in order to be copied." As a result, he said, figures painted by the members of this school have strength but lack movement, emotion, and grace, and he blamed this on the realistic technique itself. He then wrote that as far as he was concerned the best of these works was Caravaggio's *Gypsy Fortune*

We can now see that this view of Caravaggio's achievement, by prejudice against his followers, took hold and resulted in the notion of vaggio who never went beyond the accidental grouping of a few genre-like figures. I have tried to show that the progression from the first Contarelli paintings to the Cerasi Chapel and the first *St. Matthew,* all produced in the span of three years, belies this traditional view. Between 1599, when he began thinking about the Contarelli histories, and 1602, when he had painted the first *St. Matthew,* Caravaggio consis

[1] Mancini (pp. 108–109). Bellori (pp. 20–21, in *Idea*) believed that art in Rome of the later Cinque being carried to two contrary extremes, one wholly natural, the other imaginary, the camps led respe Caravaggio and by the Cavalier d'Arpino: "The first simply copies bodies as they appear to the eye, selection; the second does not pay attention to nature at all, following the freedom of instinct it pleased God that in Bologna . . . there grew up an elect artist [*elevatissimo ingegno*] and with him art, whi had fallen and almost died, was resurrected. He was Annibale Carracci" Thus, for Bellori, Annibale arrived just in time to save art from flying off in two bad directions, one realistic, the other Manneristic.

used forms and formulas borrowed from illustrious artists of the past; from them he learned to clarify and simplify his monumental compositions.

Caravaggio differed greatly from most of his predecessors in the exaggerated darkness of his backgrounds and shadows and in the brilliant contrast of highlights seen against this obscurity. Here he could have cited the practice of Leonardo and Giorgione, both of whom were famous as dark painters. We have seen that Caravaggio's tenebrism is related to Leonardo's *sfumato:* both artists used darkness to unify their compositions. Leonardo may even have tried to emulate the dark glazes or varnishes that Pliny thought had been used by Apelles.[2]

Caravaggio not only quoted Michelangelo's *Creation of Adam* in the *Calling of St. Matthew* [52] but also turned first to Raphael and then to Titian in order to work out his composition for the multifigured and for him unprecedented *Martyrdom* [56]. Caravaggio's interest in Raphael perhaps came to a peak in 1601 or 1602, but he must have looked hard at his works on many occasions after 1599. Raphael in particular provided sources for the first *St. Paul* and the first *St. Matthew* [cf. 74, 77, 87, 89, 90].[3] The second *St. Matthew* [93] is related to compositions by Michelangelo, and the flying angel, Caravaggio's first, may derive indirectly from Annibale. The two Cerasi pictures of 1601 were in their very subjects Michelangelesque. In the *Crucifixion of St. Peter* Caravaggio used a version of Michelangelo's central group while reducing his own composition to its bare and brutal core [82, 83]. The sculptural presence of the figures in some of these pictures is overwhelmingly Michelangelesque. After the Odescalchi *St. Paul* [74], Caravaggio's compositions are increasingly spare and concentrated, with the bare minimum of figures. It is almost as if he had tried to emulate Cristoforo Landino's famous characterization of Masaccio: *"buono componitore et puro sanza ornato"* (a good composer and pure, without ornament).[4]

On the other hand, Van Mander and Bellori say that Caravaggio rejected antique and Renaissance art alike. And when we compare Caravaggio with his great predecessors we see that he insists on a surface realism of cloth and skin and hair that consistently denies the ideality of artistic forms, which makes them seem radically unlike Raphael or Michelangelo even though they are also very far from genre. Given his personality and temperament, Caravaggio must have been heartily sick of hearing the praise of dead artists whose styles he could not emulate. His teacher Peterzano apparently revered Titian and may often have invoked his name. If Caravaggio ever

[2]Weil Garris Posner (1974, pp. 17 ff. and *passim*). In addition to Raphael and Giulio, who began to paint in a darker manner by c. 1520, we should also mention Polidoro da Caravaggio. Further to Caravaggio and Leonardo, see pp. 61–62; 84, n. 22; and Notes 33, 37, and 96.

[3]Argan's discussion (1974) is not adequate.

[4]See p. 49, n. 32.

consulted the old lives of the artists, or other books on art, he would soon have tired of reading about the surpassing excellence of Michelangelo in Vasari, the ultimate superiority of the nudes of the *Last Judgment* in Armenini, and the perfection of Raphael and the antique in Dolce.[5]

All this worshipful retrospection culminated in Lomazzo's ideal painting of Adam and Eve: Adam drawn by Michelangelo after the proportions of Raphael and colored by Titian, Eve drawn by Raphael and painted by Correggio.[6] (Annibale Carracci actually achieved a synthesis of this kind in his art.) These pressures no doubt fueled Caravaggio's rebellion. Perhaps doubting that he could ever paint like Raphael or his followers, Caravaggio must have resented the honor that was customarily paid to the great masters of the past; hence his ambivalence about what he had to borrow from them. Realizing this, we may understand better the naturalistic, indecorous aspects of paintings like the *Crucifixion of St. Peter,* even though its composition is a marvel of calculated art [82].

These ruminations seem useful as an introduction to two paintings that Caravaggio produced during the period of naturalistic classicism I have just been describing, but which are quite different from the others. They were painted for two famous patrons, yet they also seem to reflect a struggle with his own worldly ambitions, his ambivalent sexuality, and his paranoid outlook on life. The pictures are also specifically Michelangelesque, and they still puzzle, shock, and amuse.

ST. JOHN THE BAPTIST (?)

The youthful St. John in the wilderness was a familiar theme in the Renaissance. Caravaggio's perversion of the norm, in a picture that he probably painted for Ciriaco Mattei in 1601 or 1602, is so extreme that we are not sure that he meant to paint a St. John at all [96]. The identification is confused by the presence of a ram rather than the familiar lamb, and there is no cross or banderole. Caravaggio painted the model more devotedly than he was interpreting scripture, and in a provocatively exhibitionistic pose. Copyists tended to add a cross and other attributes in order to clarify the image, but a later painting by Caravaggio, now in bad condition, which also shows a semi-nude youth with a ram, was already identified as a *St. John* in 1613 [95]. Although both the Mattei and the Del Monte inventories called [96] a *St. John,*

[5]Vasari's belief that Michelangelo represented the culmination of all art is too well known to need comment; for Armenini, see p. 5, n. 7; for Dolce, p. 73, n. 13. For Cinquecento theory in general, see Blunt (1956) and Summers (1981).

[6]Lomazzo (1590, chapter 17). See Blunt (1956, esp. p. 157).

94. Cesare da Sesto, *St. John the Baptist in the Wilderness*. Edinburgh, National Gallery (loan).

95. *St. John the Baptist in the Wilderness*. Galleria Borghese. 1605–06/1610?

Gaspare Celio called it a *"Pastor friso"* (Phrixos?), and the painting when sold from Del Monte's estate in 1628 was perhaps called a "Corydon." Thus two different contemporary sources took it to be a pagan, or at least a classical figure, and its appearance is strikingly erotic and secular. Since the picture was owned by Ciriaco Mattei's son Giovan Battista (John the Baptist) it may have been painted for him. Perhaps the enigmatic, secular features of the painting are references to Giovan Battista's zodiacal symbol or something even more arcane.[7]

The perversity of Caravaggio's treatment is matched by the exalted source of the figure. The *St. John* is a version of a nude, even of various nudes, from Michelangelo's Sistine ceiling [97]. And such a *St. John*—nude, provocative, and highlighted in a tenebrous setting—is also very Leonardesque. Leonardo's last painting was a nude, androgynous *St. John*. There are also quantities of Lombard pictures of the Baptist, all of which go back to studies by Leonardo [cf. 94]. (One of them, with only minor changes, was turned into a *Bacchus* by a later artist, probably because it seemed too sensual for a saint.) Caravaggio, despite his name, grew up in Milan and was trained there; and the founder of modern painting in Milan was of course Leonardo. We have seen that Caravaggio, for all his rebelliousness, seems to have gone through a Leonardesque phase in the late 1590s: the *Caraffa,* the *Conversion of the Magdalen,* and the *Medusa* [33, 37] were all versions of pictures attributed to Leonardo.

[7]Caravaggio's many *Baptists* [95, 126, 153, 168, 170] suggest a personal significance—at this time, possibly, an infatuation with someone of that name (see Note 96). But Creighton Gilbert, in an article that will appear in the *American Journal of Semiotics* (III, 1983), proposes that Celio's *Pastor friso* is the Phrygian shepherd, Paris, which would resolve some of the problems found in [96].

152

96. *St. John the Baptist in the Wilderness* (?). Pinacoteca Capitolina. c. 1601–02.

97. Michelangelo, *Ignudo* from Sistine Ceiling. c. 1509–10.

The pose of Caravaggio's *St. John* recalls more specifically the nudes in Michelangelo's Sistine ceiling, most precisely one that is inadvertently shown near a ram's head in the neighboring scene of sacrifice [97]. The resemblance is so striking that Walter Friedlaender called Caravaggio's picture a persiflage directed against Michelangelo. Other critics have taken the relationship even more seriously. Caravaggio undoubtedly felt keenly what Harold Bloom has called the anxiety of influence; he, of all artists, rebelled at the need to study and emulate the Old Masters.

Caravaggio may have felt this anxious ambivalence all the more keenly because he was himself named Michelangelo. Michelangelo was not a usual Christian name in his family, and there can be little doubt that Caravaggio, as a painter, felt the pressure of the appellation, perhaps even the prediction of his parents.[8] The Michelangelism of Caravaggio's *St. John,* which is flagrant and obvious, is also perverse and personal. Perhaps he took the sublimated homoeroticism of the Sistine *ignudi* as a challenge to produce a more exhibitionistic expression of the same thing: he was Michelangelo's namesake, emulator, and antagonist all at once.

Michelangelo Buonarroti (1475–1564) was the great, one might say the archetypal artist of the Renaissance, apotheosized in his own lifetime, studied, emulated,

[8]Cinotti (1975, p. 201) lists the common names in Caravaggio's family and remarks on the new popularity of Michelangelo Buonarroti in Milan as the result of his patronage by Pope Pius IV (1559–1564), a Milanese. Perhaps the same association underlies Lomazzo's preference for Michelangelo: he cites him as the first of seven Governors of the Temple of Painting (1590, chapter 19). The name Michelangelo must represent the ambition of Caravaggio's father, who came from a line of artisan-builders (see p. 2, n. 1).

and plagiarized by some of his successors, criticized or rejected by others, but ignored by no artist in Italy. Imitators of the master's monumental, ideal style were the norm in the period of sophisticated *maniera* of the mid Cinquecento [cf. 78]. Caravaggio, like every Roman artist, was caught up in Michelangelism. His early works, in their seeming artlessness and naturalism, could have been regarded as a deliberate attack on the establishment, an assault on everything held precious by Federico Zuccaro, who had refounded the Roman Academy of Art in the early 1590s.[9] We should not be surprised to learn that Caravaggio had nothing to do with this Academy, although they hung his portrait after he died.

Pictures like the *St. John* naturally worried churchmen of the Counter Reformation. Cardinal Ottavio Paravicino, who had been tutored by the pious Oratorian Cesare Baronius, wrote pointedly to a friend in 1603 of Caravaggio's tendency to paint pictures that were neither sacred nor profane, but somewhere in between: *"tra il devoto, et profano."*[10]

AMOR VINCIT OMNIA

The exhibitionistic *St. John* is related to an even more blatant picture, *Amor Vincit Omnia* or *Victorious Cupid,* which was painted soon after the *St. John* for Marchese Vincenzo Giustiniani [98]. The frontally nude urchin grins as he plays Cupid with his huge bird's wings. Half sitting, clutching his bow and arrows, he is oblivious of the objects below. Presumably they symbolize geometry and architecture, music and astronomy; literary and martial glory are represented by a book, laurels, and armor. The scepter and crown of worldly power are as casually disdained as the poet's bays. A violin and lute are portrayed with special care [100], but two instruments were hardly necessary to symbolize music and harmony; Caravaggio evidently enjoyed painting them. Since Giustiniani wrote treatises on music, architecture, sculpture, and other subjects, it seems obvious that the picture refers to his interests in some oblique way, but the perversity of the image as a whole has never been satisfactorily explained. On the surface, it subordinates authority, reason, and even the senses to the power of heedless Love. Giustiniani hung it in a place of honor and considered it priceless.

The *Amor* is Caravaggio's last significant secular picture, and it most clearly exhibits his confrontation with Michelangelo's achievement, a compound of admiration and almost childish rebellion. Michelangelo had carved a famous *Cupid* in his youth, but Caravaggio's Cupid is again related to nudes from the Sistine ceiling [cf.

[9]Mahon (1947, part III). See p. 30 and n. 15 above.
[10]Letter published with commentary by Cozzi (1961). Cf. Bologna (1974, pp. 158 ff.).

98. *Amor Vincit Omnia (Victorious Cupid).* Berlin, Staatliche Museen. c. 1601–02.

99. Michelangelo, *Victory*. Florence, Palazzo della Signoria. c. 1527–30?

97] and especially to Michelangelo's *Victory,* carved for an abandoned project for the tomb of Julius II [99]. The *Victory* is perhaps his most outspoken homage to a beautiful male ideal.

In contrast to Michelangelo's exalted figure, Caravaggio made naked Love a preadolescent boy triumphing over the learned arts and sciences of Giustiniani and his kind [100], posing naughtily and exhibiting himself. The image is infinitely removed from Michelangelo's own sublime sexual metaphors, such as his *Ganymede* [180], which is similar in pose, and of which Del Monte owned a version.[11] Michelangelo sublimated the erotic story into a divine, quasi-Platonic metaphor of the aspiration of the soul to God. Caravaggio turned a pagan, heterosexual symbol that had become a cliché into a boy of the streets and an object of pederastic interest. Charles Dempsey summarized Caravaggio's achievement:

[11]See Note 98. Recorded in the inventory of 1627 (Frommel, 1971, p. 37): *"Un Ganimede di mano di Michelangelo Buonarota con Cornici d'Ebano alto palmi doi, et largo palmi uno ¼"* (50.3 × 28 cm).

157

100. Detail of [98].

The painting is pointedly and conventionally programmed: *Omnia vincit amor*. But where Annibale in the Farnese Gallery sustained the classical and literary fiction required to express the same subject, Caravaggio maintained only the literary apparatus, and by adopting a contrary style for its expression showed us the worm in the bud, the coarse reality masked by the conceit. Fiction and reality are poised as delicately in the painting as the feather against the boy's leg, and it is this balance that gives the painting still its extraordinary power to shock.

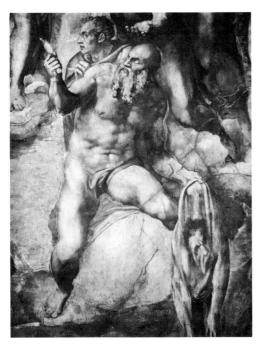

101. Michelangelo, *St. Bartholomew* (detail of *Last Judgment*). Sistine Chapel. 1534–41.

There may well have been more than rivalry or rebellion moiling in Caravaggio's mind when he created these Michelangelesque images. We also seem to see a profound identification (even if it is momentary and perverse) with a great artist of the past whom Caravaggio must have believed to have been homosexual. Michelangelo had infinitely complex feelings about himself and the conflicts between his physical desires and his religious beliefs. His pitiful, flayed image is held in the *Last Judgment* by the almost brutal Bartholomew [101], whose pose is again almost precisely that of Caravaggio's Cupid. Caravaggio's Michelangelesque identifications and parodies are also full of contradictions and conflicts. The one clear reference in these two pictures is to Michelangelo's homosexual imagery, as if Caravaggio were driven to tear away the idealizing mask in order to expose the true source of the Master's single-minded devotion to the male nude. Yet Caravaggio was at the same time strongly attracted to his great exemplar and namesake.[12]

The *St. John* and the *Amor* [96, 98] seem to reflect Caravaggio's ambivalent reaction to the artistic tradition he was forced to study. Some of the peculiarities of

[12]I find more pattern and meaning in Caravaggio's borrowings of c. 1598–1603 than others have. See Friedlaender (p. 21), Argan (1956, p. 35), Pepper (1971, esp. p. 343, n. 43), and Gregori (1972, esp. pp. 39 ff.). Röttgen (1974, pp. 103 ff. and 122, n. 92) and Kirwin (1972, pp. 180 ff.) have suggested that Caravaggio was guided to some extent by Roncalli c. 1599–1602 (see p. 117 and Notes 52, 56, and 75).

these pictures may be connected with his need to evolve very quickly from small-scale genre into a painter of large religious pictures; they could even be considered a kind of neurotic by-product or symptom that is paralleled by his increasingly outrageous behavior. Perhaps, however, we are too caught up in the modern emergence of acceptable homosexuality when we discuss these paintings. Surely one of Caravaggio's chief interests was to paint the nude more realistically—more carnally, in the literal sense of the word—than his predecessors. Possibly these two paintings are rather special versions of what later came to be known as "Academies," careful studies of the male model.

Observing the perverse sophistication of the *St. John* and the *Amor,* we are tempted to attribute many of their qualities to a patron. But it is difficult to learn much about Ciriaco Mattei, who seems to have been the first owner of the *St. John*. His father employed Federico Zuccaro to paint in his palace, and it is possible that Ciriaco's son, Giovan Battista, was the one who was interested in Caravaggio; we simply do not know.[13] We do know a great deal about Giustiniani, who seems to have been no "libertine," but rather conventionally religious.[14] Nevertheless he had a consuming interest in classical antiquities, and the allusions to the arts and sciences, or the Muses, or worldly virtues and accomplishments, that we see scattered at Cupid's feet must be there because Giustiniani desired them.

THE TESTIMONY OF THE TRIAL OF 1603

Caravaggio's art is complex, his life largely unknown. We not only have no drawings, we have no letters, no inventory of his library, no laundry lists. Our information comes largely from what others had to say about him, and more often than not the others were critics or rivals. Still, we do have one precious opinion directly from Caravaggio's own lips, the record of his testimony at a trial in September 1603.

Caravaggio had hoped to get the commission for a painting of the Resurrection of Christ that was to be placed in the right transept of the Jesuit church in Rome, Il Gesù. In 1602 (the date of the first *St. Matthew*) the commission went instead to the mediocre Giovanni Baglione, who had recently tried to imitate Caravaggio's

[13]Ciriaco had collections of antiquities; his Villa Celimontana was famous. Cf. Panofsky-Soergel (1967–1968, pp. 111–112, with bibliography); also Orbaan (1920, p. 147, n. 2). For the villa, see MacDougall (1970).

[14]See the travel diary kept by Bernardo Bizoni in 1606, published by Banti (1942); Giustiniani attended Mass regularly, almost overconscientiously, wherever he went. His brother was a cardinal, and the family was closely tied to the Oratorians (see Note 107). His writings (cf. Note 98) show him to have been pedantic but wide-ranging in his interests.

manner [32] and whom Caravaggio despised in consequence.[15] When Baglione's painting was unveiled on Easter Sunday 1603, scurrilous verses about his character and art suddenly appeared. Baglione's suspicions settled on Orazio Gentileschi, Caravaggio, and his friend Onorio Longhi (1569–1609), whose roots were also Lombard. Longhi was the educated but peculiar son of an architect, an architect himself, and the father of an architect. (Onorio was called "a queer duck" by Baglione, who considered him "very odd.") By this time, we should recall, Caravaggio had already figured more than once in criminal proceedings.

Baglione brought suit for libel in August 1603, and Caravaggio was imprisoned in the Tor di Nona on 11 September. In the course of his interrogation in court Caravaggio gave a rough idea of his simple theory of painting (a trial is not the occasion for extended esthetic commentary). "A good painter knows his art," he said, with whatever sarcasm or irony may have been implied, "that is, how to paint well and to imitate natural things well" *(depinger bene et imitar bene le cose naturali)*.[16] The concept of "imitation" has a long history; suffice it to say that it did not mean the mindless reproduction of visual phenomena, as we might at first assume.[17]

When Caravaggio was asked which Roman painters fitted this description of excellence, his list made a strange group. Among the *"valentuomini"* he first named his old employer the Cavalier d'Arpino, then the philosophical Mannerist Federico Zuccaro, and then in turn Cristofano Roncalli, Annibale Carracci, and finally a Florentine painter of battle pieces and hunting scenes, Antonio Tempesta, who is now all but forgotten.[18] Some years later the perceptive Marchese Vincenzo Giustiniani

[15]Baglione's claim that Caravaggio wanted the commission for himself is not contradicted in the testimony. The Jesuits' refusal to employ him may have been for the same reasons that Paravicino alluded to in 1603 (see p. 155). For the Jesuits as patrons in this period, see Hibbard (1972).

[16]Transcribed in Cinotti (1971, pp. 154 ff., FF 49–56), which supersedes previous versions. Caravaggio, having said that he knew almost all the painters in Rome, began with what he called the *valentuomini*. When asked what the word meant, he replied as quoted above (Cinotti, F 52, 13 September 1603).

[17]See pp. 46–49 and nn. 27–34 above, and Röttgen (1974, p. 248, n. 101).

[18]"I think that I know almost all of the painters of Rome, and beginning with the good ones, I know Gioseffe [Cesari d'Arpino], il Caraccio, il Zucchero, il Pomarancio [Cristofano Roncalli], il Gentileschi, Prospero [Orsi], Gio[van] Andrea [Donducci, il Mastelletta], Gio[vanni] Baglione, Gismondo [Laire], and Giorgio [Hoefnagel] Todesco, il Tempesta, and others" (Cinotti, 1971, F52). Caravaggio answered, in response to the next question: "Almost all of those that I have named are my friends, but not all are good painters [*valentuomini*]." There followed the definition of *valentuomo* quoted above. Then: "Of those that I have named above, those not my friends are: Gioseffe [Cesari], Baglione, Gentileschi, Giorgio Todesco, because they do not speak to me; the others all speak and converse with me." Then, in response to a question concerning which of them were good: "Of the painters that I named, those who are good are Cesari, Zuccaro, Roncalli, Annibale Carracci, and the others are not." (Including, evidently, his great friend Prospero Orsi.) Dilating on this: "The *valentuomini* are those who understand painting and judge as good painters those whom I consider to be good or bad; but the bad and ignorant painters consider the ignorant ones like themselves to be good." Then (contradicting himself): "I do not know any painter who praises and values as a good painter any one of those that I consider no good." Finally, he added: "I forgot to say that Antonio Tempesta is also a *valentuomo*." The general tone of these responses situates him in the mainstream of opinion. Just how ironic or perverse all this was on his lips is of course impossible to say. (He then went on to discuss Baglione.) Further, see p. 8, n. 15, and Note 98.

discussed the same painters but he put them in different stylistic categories, as we do today.[19]

What, we may ask, was Caravaggio thinking about when he made his list? The answer seems obvious: the painters he named were the best. Moreover, the Cavalier d'Arpino was first painter to the pope with official state commissions; he had just finished decorating the transept of the Lateran and was embarking on the figural decoration of the immense dome of St. Peter's. Federico Zuccaro, at the end of his career, represented tradition and authority despite his criticism of Caravaggio. We know from another source that Caravaggio admired Annibale Carracci. Roncalli, a more traditional painter, was the favorite of the Oratorian group, the Crescenzi and Cardinal Baronius, and had an altarpiece underway in St. Peter's. Tempesta painted fresco decorations in the Palazzo Giustiniani and also produced the map in [51]. What these men had in common was in no sense an artistic style; it was popular success and critical acclaim. Success and acclaim were what Caravaggio had wanted in 1600 when he was struggling with the Contarelli Chapel, and they were what he had truly achieved in 1603 when the trial took place. In that year poems were published on some of his early paintings, and as early as 1600 he had been described as *"egregius in Urbe Pictor."*

Giustiniani, in his letter about Roman painting, put the Carracci and Caravaggio together in the rarest and most difficult category: those who painted *di maniera* but also from life—in other words, with both realism and style.[20] "Realism coupled with style" precisely defines the artistic goal that Caravaggio pursued. His realism was shocking, however, cruder than other people's ideas of what art should be and increasingly unlike what was left of visual reality in Annibale's idealizing paintings [81, 117]. (Bellori, at least in part recognizing that Caravaggio had performed a service to art, wrote that "painters who strayed too far from nature needed someone to set them on the right path again" but then added, "how easy it is to fall into one extreme while fleeing from another."[21]) Still, Caravaggio's *maniera* was highly refined, clarified and simplified in the critical fire of the great art of the past that he claimed to despise. His combination of conscious crudity and hidden sophistication makes him unique in Italian art.

[19]See Appendix II, p. 346. Mancini and Bellori tended to follow a scheme that has survived until our own day: that between extreme *maniera* and extreme naturalism there was a *juste milieu* occupied by Annibale Carracci, who was not only a mediator between these tendencies but also a superior artist (see p. 149, n. 1). Argan (1956, p. 27) began by discussing this phenomenon, speaking of the "Caravaggio-Carracci antithesis, which escaped Giustiniani." I suspect that Giustiniani was well aware of that antithesis and purposely slipped Caravaggio into his last and highest category precisely because he believed him to be, in his way, Annibale's equal. Indeed, he named Caravaggio first.

[20]". . . *dipignere di maniera, e con l'esempio avanti del naturale* . . ." (see p. 346).

[21]Bellori (pp. 213–214).

The trial seems to have produced no final outcome; Caravaggio was released from prison on 25 September, thanks to intervention by the French ambassador. Before the trial Caravaggio was painting a picture for the future Pope Urban VIII, Monsignor Maffeo Barberini [102]. The Marchese Giustiniani preferred Caravaggio's paintings to all others, and by 1600 other rich and noble patrons had begun to vie for his services. At the same time, the strain of his rapid development, his forced combination of hyperrealism and hyperclassicism, began to show. I have tried to identify outcroppings of rebellion and protest in the *St. John* and the *Cupid* [96, 98]. Late in 1602 the first *St. Matthew* altarpiece [87] seems to have been rejected as vulgar, which must have caused Caravaggio considerable anguish.

Perhaps Vincenzo Giustiniani, with his inquiring mind and flexible taste, was guiding Caravaggio to some extent in these years; we simply cannot know. No less than fifteen pictures attributed to Caravaggio are listed in the Giustiniani inventory of 1638.[22] There were also dozens of others, many of them naturalistic and some of them notable for their luminous effects: Caravaggio may have been influenced by the collection as well as by the collector. Among the paintings by Caravaggio in the Giustiniani palace were the first Contarelli *St. Matthew*, presumably acquired in 1602 or 1603; the *Victorious Cupid*, surely painted by that time; and the *Doubting Thomas* [104].

Caravaggio's life also began to change and the easy, sybaritic existence that he must have enjoyed in Del Monte's palace eventually gave way to a rougher independence.[23] Beginning in 1603 we seem to observe a change in style, tending toward a more painterly manner. The pictures of this later Roman period are perhaps the greatest of his career.

[22]See p. 119, n. 3. The inventory of 1638, published by Salerno (1960, pp. 135 ff.), lists thirteen paintings by Caravaggio *"nella stanza grande de quadri antichi"*: *St. Matthew and the Angel* [87]; *Christ in the Garden* [188]; *Christ Crowned with Thorns* [cf. 41]; *St. Augustine* (lost); *St. Jerome* [129?]; *Portrait of Sigismond Laire* (not by Caravaggio: Salerno, 1960, p. 23, Fig. 30); *Mary Magdalen* (lost); *Luteplayer* [18]; *Victorious Cupid* [98]; *Doubting Thomas* [104]; *Portrait of a Famous Courtesan*, unfinished (lost); *"Phyllis"* [27]; *Portrait of Cardinal Benedetto Giustiniani* (lost). In addition, two more pictures were ascribed to Caravaggio elsewhere: a portrait of Marsilio Sicca (Salerno, p. 138, no. 74), and a portrait of "Farinaccio Criminalista" (p. 141, no. 89), both lost. (For a portrait of the latter by Cesari d'Arpino, see Röttgen, 1973, no. 39.)

Just as we have seen that the early writers were ignorant of Del Monte's collection (Note 47, and chart, p. 273), so too they seem not to have known Giustiniani's. Mancini (pp. 225, 303) merely mentioned *"molti quadri"* by Caravaggio; Celio (p. 140; 1967, p. 43) named no pictures there by anyone. Baglione discussed the rejection of the first *St. Matthew* (see my Note 87) and Giustiniani's great love of Caravaggio's *Cupid* (see Chapter 5 and Note 98). But the *Luteplayer* that Baglione mentioned (p. 136) was Del Monte's (cf. Note 18). The only other Giustiniani painting that Baglione cited was the *Doubting Thomas* (see Note 104), which he thought had been commissioned by Ciriaco Mattei. Evidently he did not know these collections. Scannelli (p. 199) mistakenly cited the *Doubting Thomas* in the Ludovisi collection; the only Giustiniani painting he mentioned was the *Cupid*. Even Sandrart, who had lived in the palace and worked for the Marchese, mentioned only *St. Matthew, Cupid,* and the *Doubting Thomas*. Bellori must have known the collection first-hand but mentioned only those three plus the *Christ Crowned with Thorns* (pp. 206–207; cf. my Note 41). He discussed the *Luteplayer* in the Barberini collection (cf. Note 18). All in all, the impression is of ignorance, repetition from older writers, and hearsay.

[23]See p. 88, n. 28.

7
The Later Roman Paintings

It would be reassuring to believe that Caravaggio, who had raised genre painting and still life to the level of high art and then incorporated them into history painting of a very serious kind, had also been a novel and dramatic portrait painter. We have records of many portraits painted by Caravaggio; Giustiniani alone owned six, including one of Cardinal Benedetto Giustiniani. One portrait existed until 1945 [27]. Identified, perhaps mistakenly, as a courtesan named Phyllis, the sitter is shown in a manner that securely ties the picture to the 1590s [cf. 26, 34]. Caravaggio also painted portraits of members of the Crescenzi family and their friend the poet Marino, but these are all lost. Both Mancini and Bellori claim that Caravaggio painted portraits of the Barberini, and Bellori mentions one of Pope Paul V Borghese [cf. 193, 194]. The Borghese and Barberini portraits that have been published as Caravaggio's are not wholly convincing; and although a guidebook of 1650 mentions the Borghese portrait, no portrait by Caravaggio is listed in any of the Barberini inventories. Nevertheless Bellori wrote that "For Cardinal Maffeo Barberini . . . he painted, in addition to his portrait, a Sacrifice of Abraham."

THE SACRIFICE OF ABRAHAM

Since a *Sacrifice of Abraham* by Caravaggio is continuously recorded in the inventories, three payments to Caravaggio recorded by Maffeo Barberini's paymaster between 20 May and 12 July 1603 were no doubt made for it, not for a portrait. The final payment was dated 8 January 1604. The *Sacrifice of Abraham* [102] is one of Caravaggio's rare outdoor paintings; its understated landscape shows a church and tower set against hills in the right background. The juxtaposition of the head of Isaac and the sacrificial ram may recall the *St. John* [96], which he had probably painted a year or two before.

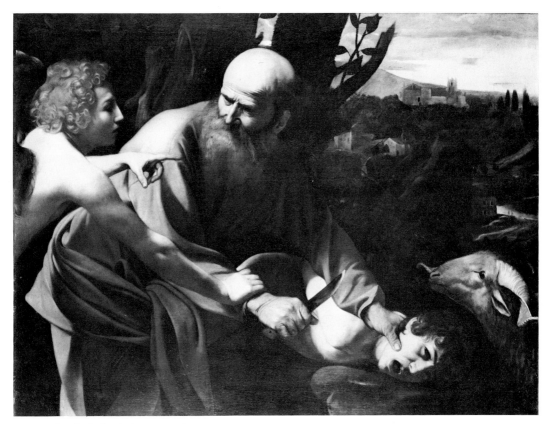

102. *Sacrifice of Abraham.* Florence, Uffizi. 1603.

Until recently the *Abraham* was dated only slightly later than the *Rest on the Flight into Egypt* [29], and certainly the *Abraham* is a more discursive, narrative painting than most of its contemporaries. Yet with the clearer vision that documents customarily give, we now see the work of a much more mature master in the angel who appears from the left to stay Abraham's hand. This angel is intimately related to the angel of the second *St. Matthew* [93], and Abraham is painted from the same model as Matthew himself [103]. The *Abraham* also shows a softer, more Venetian manner that begins with the second *St. Matthew*. The two paintings are as similar as possible in color and style, and it seems obvious that they were painted within a few months of each other.

The action takes place in the foreground in Caravaggio's familiar, frieze-like composition, but the figures are linked more intimately than in some of his earlier paintings. The *Judith* [36], for example, seems primitive and awkward by comparison, its figures strung out across the canvas as though Caravaggio did not dare to overlap them; and we know that he could not summon up much spatial realism in his early years.

165

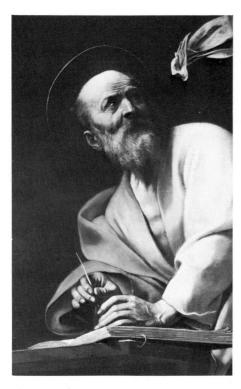

103. Detail of [93].

Like many of Caravaggio's paintings, the *Abraham* exemplifies Faith. St. Paul invokes the story:

> By faith Abraham, when the test came, offered up Isaac: he had received the promises, and yet he was on the point of offering his only son, of whom he had been told, "Through the line of Isaac your descendants shall be traced." For he reckoned that God had power even to raise from the dead—and from the dead, he did, in a sense, receive him back. (Hebrews 11:17–19)

Caravaggio may simply have been commissioned to paint this familiar subject from Genesis, but his interpretation seems unnecessarily cruel. Poor Isaac has become little more than an animal sacrifice, although his horror is plainly evident: Caravaggio was fascinated by the idea of a head cut off or a throat cut [cf. 36, 37]. Once again we also have a confrontation between a naked angel and a rather impassive, bald old man. The juxtaposition is different from that of Joseph and the angel in the *Rest on the Flight* [29], but the conjunction seems to have meant something special to the painter, as we see most pointedly in the first *St. Matthew* [87].[1]

The *Sacrifice of Abraham,* a devotional picture, was painted for a promising monsignor who was soon to be made cardinal and finally pope (Urban VIII, 1623–

[1]Argan (1974, p. 22) pointed out the "motif that recurs in Caravaggio's Roman paintings, with a frequency that is surely not accidental, of the contrast between old and young, where the youths and not the old do the teaching." See pp. 258–260 below.

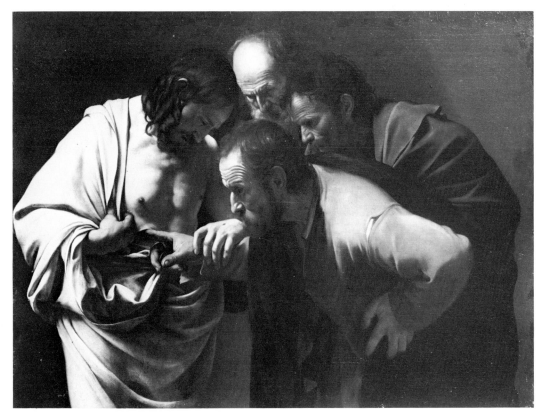

104. *Doubting Thomas.* Potsdam, Staatliche Schlösser und Gärten. c. 1602–03?

1644). Barberini's patronage was personal and esthetic rather than institutional, and his papacy opened a new artistic era. Only then can we speak of the true Roman Baroque, which is typified by the art of his young protégé, Gianlorenzo Bernini (1598–1680). Barberini's perspicacity as a patron is already seen in this commission of 1603.

THE DOUBTING THOMAS

The half-length *Doubting Thomas* [104], which was in the Giustiniani collection, must be close in date to the second Contarelli *St. Matthew* and the Barberini *Abraham*. The topmost, balding disciple seems to be none other than the man who posed for Matthew and Abraham [102, 103]. In place of the narrative of the *Sacrifice of Abraham* Caravaggio has returned to the concentration that he first achieved in the *Crucifixion of St. Peter* [82], but now with a centripetal focus.

The surgical detail of the picture is unbearable—or would be, were it not for

the counterbalancing composition. Caravaggio placed four heads in a concentrated diamond in the center of a canvas that is artfully planned and plotted, which is to say that it is unnatural. Thus the shockingly realistic *Doubting Thomas* could even be called classicizing in its composition.

This artful artlessness, with a similar concatenation of heads and hands, reappears in a different context in Hendrick Terbrugghen's wonderful *St. Sebastian* of 1625 [105]. It is almost the only picture by a "follower" of Caravaggio's that revives the intellectual and emotional qualities of this classicizing moment. Terbrugghen was apparently in Italy between 1604 and 1614 and perhaps again in 1620 or 1621. His belated assimilation of these powerful effects was the result of first-hand experience, not only of the *Thomas* but of the related *Entombment* [107].

Thomas was a scriptural example of lack of faith. Jesus said afterward, "Because you have seen me you have found faith. Happy are they who never saw me and yet have found faith" (John 20:24). Paradoxically, Caravaggio was himself a Thomas; more than any other Renaissance artist he professed to believe only in what he saw. Caravaggio's painting is also part of a continuing private series of works that depict conversion [33, 42, 74, 75].

The *Doubting Thomas* was one of Caravaggio's best known private pictures; Cardinal Del Monte owned a copy and there was a copy in Genoa by 1606. Caravaggio's painting epitomizes his mature Roman style in its fusion of the classic and the anticlassic. In a sense, he learned the lesson that Annibale Carracci had to teach; but while Annibale declined into a hopeless melancholy a few years after the Cerasi paintings were unveiled, Caravaggio went on to further accomplishments and deeper insights. He did so at least in part thanks to the dramatic confrontation in the Cerasi Chapel, where he was forced to simplify and clarify in a way that was hardly adumbrated in his earlier work.

After his trial for libel (see pages 161–163), Caravaggio was let out of prison but was confined to his house on pain of being made a galley slave, "unless he had written permission" to leave. In addition, he had to present himself in court a month later and to promise not to offend Baglione. These restrictions may explain why Onorio Longhi alone was arrested in November 1603 and accused by Baglione of insulting him and his friend Mao. Perhaps Caravaggio's discomfort in Rome led him to go to Tolentino in the Marches early in January, where he was supposed to paint an altarpiece for the Capuchin church, with no known result. The letter that informs us of this trip refers to Caravaggio as the best painter in Rome (*"anzi il primo che oggi sta in Roma"*).[2] Tolentino was a pilgrimage center not far from Loreto and it

[2]Cinotti (1971, p. 157, F 57).

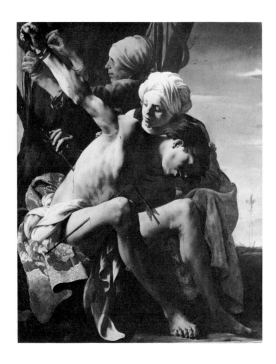

105. Hendrick Terbrugghen, *St. Sebastian Tended by Irene*. Oberlin, Ohio, Allen Art Museum. 1625.

is possible that Caravaggio visited the shrine of the Virgin's holy house before painting his *Madonna di Loreto* [120].

Caravaggio must have been hurt and offended that he had not been offered any of the new commissions for altarpieces that were being given out for St. Peter's. Ludovico Cigoli, a Florentine, got one in December 1603, and Cardinal Giustiniani promoted a mediocre Genoese, Bernardo Castello, for another one in August 1604. These commissions were the result of pressure from the provincial homelands of the individual cardinals who made up the Fabbrica di San Pietro; but since none of the painters was the equal of Caravaggio it must have caused him anguish. Even Baglione got a commission for St. Peter's in September 1604, and this was surely the last straw. Caravaggio's behavior, if anything, worsened in these years, although Van Mander had already heard about it earlier. He wrote that Caravaggio had "climbed up from poverty through his industry and by taking on everything with foresight and courage"—yet

> he does not study his art constantly, so that after two weeks of work he will sally forth for two months together with his rapier at his side and his servant-boy after him, going from one tennis court to another, always ready to argue or fight, so that he is impossible to get along with.[3]

[3]See p. 48, n. 30, and pp. 343–344 below.

Mancini called Caravaggio *"stravagantassimo"* and said that his excesses cut ten years off his life. Baglione wrote that Caravaggio was *"uomo satirico e superbo, . . . un poco discolo"* (satirical and haughty, and rather quarrelsome).[4] He always went about the streets with a sword and dagger at the ready; when he was ill he had a servant boy follow him with his sword. (We also hear that he had a black dog that did wonderful tricks.[5]) Baldinucci wrote that Cigoli occasionally joined Caravaggio in a tavern, "only to avoid the insults and persecution" that would result if he did not.[6] On one such occasion at the Osteria del Moro in April 1604, Caravaggio threw a plate of hot artichokes in a waiter's face and threatened him with a sword—and so was faced with another lawsuit. In October of that year he was seized by the authorities after throwing a stone. Del Monte sometimes rescued him from these scrapes. In November Caravaggio was arrested for insulting a corporal who had requested his license to carry a sword and dagger, and again he went to the prison of Tor di Nona, which was becoming a second home.[7] When the admiring Guido Reni (1575–1642) emulated his style in a *Crucifixion of St. Peter* painted in 1604–1605, Caravaggio supposedly challenged him to a duel, claiming that he had robbed him of his style.[8] Caravaggio's frustration at being excluded from St. Peter's apparently led him to rip open the enclosure protecting Domenico Passignano's *Crucifixion of St. Peter,* which was being completed. Caravaggio then went all over Rome, saying that it was terrible.[9] And so it went.

[4]Baglione (p. 138). The draft manuscript (Biblioteca Vaticana, *Chig. G. VIII,* 222, fol. 35) reads: *"fu huomo satirico e superbo* [*e superbo* crossed out, *et altiero* written above] *e dicea male de' Pittori e passati, e presenti . . . Fu Michelagnolo discolo et andava cercando occasione di* [*rompere il collo* crossed out]." (See p. 351 below.)

[5]The boy following Caravaggio with a sword was reported in 1600: see p. 130, n. 6. Baglione (p. 147, *Life of Carlo Saraceni*), wrote: "And because he claimed to imitate Caravaggio, who always had a shaggy black dog along with him, called Cornacchia [Raven], who did wonderful tricks, Carlo also went about with a black dog and called him Cornacchia." Susinno (1960, p. 114) repeats the story of Caravaggio's dog, perhaps simply based on Baglione (see below, p. 386).

[6]Baldinucci (III, p. 277; cf. VII, p. 56), following G. B. Ciardi, reported that Cigoli was obliging, "being willing on occasion when in Rome to go to an inn with Passignano and Caravaggio, simply so as not to condemn the actions of the first, and not to incur the insults and persecution of the deranged mind [*stranissimo cervello*] of the second." Cf. Note 189.

[7]Cinotti (1971, pp. 151 ff.) prints the documents retranscribed (see p. 130, n. 6 above). Her F 31 (19 November 1600) begins the criminal record, which in Rome ends only with the murder of 28 May 1606.

[8]Malvasia (II, p. 13) first retails the unlikely story of Caravaggio's desire to obtain the commission for frescoes in the dome of the basilica at Loreto (borrowed from Baglione, p. 291), then quotes Caravaggio as having said to Reni: "Why did you steal my style and manner of coloring in the picture of the Crucifixion of St. Peter at Tre Fontane?" (This was followed by abuse and threats that were surely twisted in the telling, which contains factual errors.) Reni's painting was presumably finished early in 1605, the period of the Loreto commission, when Caravaggio was in a crescendo of irregular behavior. Bellori (1976, p. 497) compared Caravaggio's *Crucifixion of St. Peter* [82] unfavorably to Reni's, which was notably Caravaggesque (cf. Pepper, 1971).

[9]Baldinucci (III, p. 447). For Passignano's painting and the other altarpieces for St. Peter's, see Chappell & Kirwin (1974, pp. 162–163, C, and *passim*). It was described as finished on 2 December 1605.

THE ENTOMBMENT OF CHRIST

Caravaggio's most admired altarpiece, *The Entombment of Christ,* was probably planned and begun in 1602–1603 [107]. It was painted for the second chapel on the right in the church of Santa Maria in Vallicella, the "Chiesa Nuova" of the Oratorian Fathers. The founder of the chapel, and indeed the first patron of any chapel, was a Pietro Vittrici, who had his chapel decorated before the church was enlarged and widened. In 1586–1588 the original chapels were converted into narrow aisles and new chapels were built out from them. Vittrici's chapel alone remained untouched and in its old place because the altar conferred a papal indulgence on those who heard Mass there, thanks to Pope Gregory XIII (1572–1585), who had been Vittrici's bosom friend. Vittrici's inadequate legacy of 300 *scudi* for the maintenance of the chapel became available at some time after his death in March 1600. On 9 January 1602, we

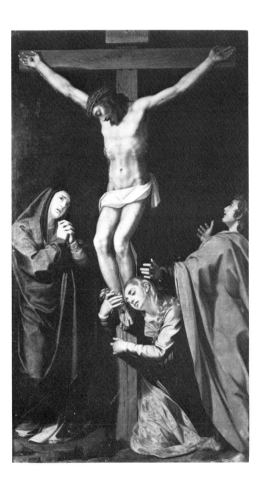

106. Scipione Pulzone, *Crucifixion with Saints.*
S. M. in Vallicella. c. 1588–90.

learn, the prized papal privilege was being temporarily transferred, *"sin che accomoda il privilegiato"* (until the privileged altar is rebuilt). No one has realized that the Oratorians built the present chapel only in 1602, after being assured by Pope Clement VIII that the privilege would not be lost. Thus Caravaggio's picture was not commissioned until then at the earliest. It was described as "new" on 1 September 1604, when the altarpiece from the old chapel was turned over to Pietro Vittrici's nephew, who had paid for Caravaggio's new painting.

The Chiesa Nuova has twelve altarpieces illustrating mysteries in which the Virgin appears. The chapel in which Caravaggio's painting hung, and where a copy can still be seen [108], was dedicated to the *Pietà*. Caravaggio's *Entombment* found its place between two chapels with altarpieces in an older style, a *Crucifixion* by Scipione Pulzone [106] and an *Ascension* by Girolamo Muziano, pietistic artists who died in the 1590s. Caravaggio seems to have wanted to continue the emphatic clarity of Pulzone's *Crucifixion* in his own painting, or perhaps he was asked to do so. The physiognomy of the St. John at the head of Christ, like his intense red cloak, seems to have been borrowed from Pulzone's picture.

Caravaggio's *Entombment* is his most meditated altarpiece, carefully and deliberately designed as a great diagonal that starts at the abandoned, outflung arms of one of the Marys at the upper right and descends to the horizontal of Christ's body and the slab whose corner seems to project into our space. The highlighted gestures, faces, and bodies correspond to the flow of light from the high right-hand window of the chapel, which was then the only window that functioned (because of adjacent buildings) and which is still the chief source of light.

The artful composition of the *Entombment* moves downward from the carefully placed hands at the upper right, down and left through the bending heads and bodies, down to the horizontal of the corpse and the stone, which is a symbol of the Church as well as a cover for the tomb. The altarpieces of the Chiesa Nuova are just above our heads [108], and the movement of the composition continues downward in the presumed lowering of Christ's body for burial in a tomb that we can imagine ourselves to be in, as though we were witnessing the event from the grave. Rubens, who saw it soon after it was first exhibited, understood the picture in this way. His corrected version dates from a later time, however, and it incorporates notable criticisms, particularly of the topmost figure and of the spacing as a whole [115]. But it would be an error to try to reconstruct just where Christ is to be buried in Caravaggio's picture, for its entire spirit is iconic rather than topographic. It is not a narrative; it ornaments a chapel dedicated to the *Pietà*. We are nevertheless reminded of St. Paul's Letter to the Romans (6:4): "By baptism we were buried with him, and

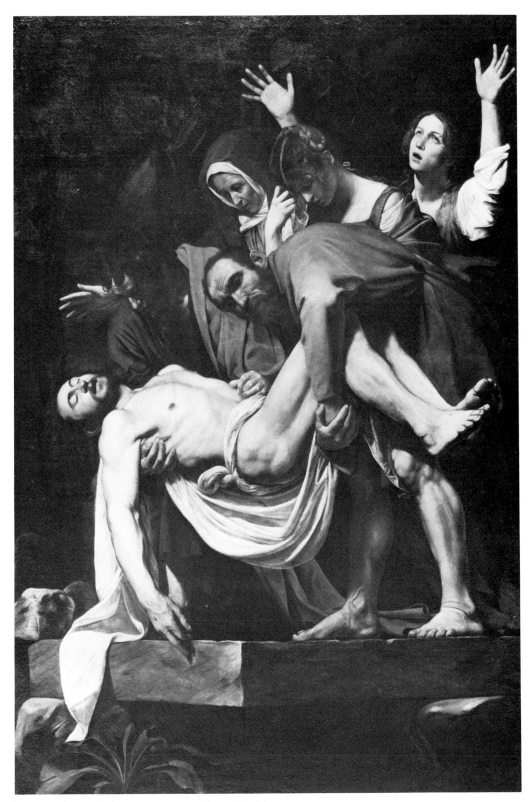

107. *Entombment of Christ.* Pinacoteca Vaticana. 1603–04.

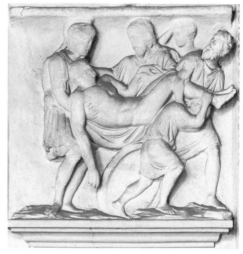

109. Fragment of Meleager Sarcophagus. Museo Capitolino. C. AD 150.

108. Vittrici Chapel, S. M. in Vallicella, with copy of [107].

lay dead, in order that, as Christ was raised from the dead . . . so also we might set our feet upon the new path of life."

Caravaggio's *Entombment* is a visual counterpart to the Mass that is best understood in the context of the chapel, with a priest at the altar raising the newly consecrated host for the adoration of the worshippers [108]. Since this was a privileged altar it would have been popular, and such a vision would have been a daily occurrence. This act perfectly juxtaposes the host with Christ's body in the picture above as the priest intones "This is my very body." The painting is in this sense related to Pontormo's famous *Deposition;* both display Christ's body elevated over the altar. The spectator-worshipper in turn receives the mystical body in the form of the host. Such pictures are essentially presentations of the *Corpus Domini* rather than enactments of the deposition or entombment of Jesus. Worship of the *Corpus Domini* grew spectacularly during the Cinquecento, and in 1539 a confraternity specifically dedicated to it had been founded in Rome, soon to be followed by many others.[10]

The origin of Caravaggio's composition is found in a number of Greco-Roman reliefs showing a hero carried from the battlefield. Such a relief is to be seen

[10]The first of these, and the most illustrious, was the Venerabile Compagnia del Sacratissimo Corpo di Cristo in Santa Maria sopra Minerva, founded in 1539; in the following forty-five years, fourteen more were established (Maroni Lumbroso & Martini, 1963, esp. pp. 357 ff.). The feast of Corpus Christi marks the institution and celebration of the Eucharist. For a related phenomenon, the exhibition and adoration of the Eucharist known as the Forty Hours Devotions *(Quarantore),* see Weil (1974).

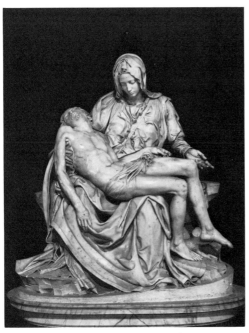

110. Michelangelo, *Pietà*. St. Peter's. 1497–1500.

in the Capitoline Museum [109] and all Renaissance artists were familiar with these formulas. Raphael's *Entombment* [111] seems directly inspired by them. Caravaggio's Christ is also related to Michelangelo's famous sculptured group in St. Peter's [110], but the hanging right arm reproduces a formula for pathos dating back to the reliefs of antiquity. Caravaggio's Virgin Mary is an old mother in blue nun's garb who mourns her son. Her outstretched right hand mirrors Michelangelo's resigned gesture; her left, which emerges from the darkness at our right, makes her seem to embrace the entire foreground group. Caravaggio's relationship to Michelangelo is never simple; he is insistently, even cruelly realistic in the face of Michelangelo's idealism and lyric beauty. Christ's body is relatively coarse and heavy; Nicodemus, the rough laborer in the foreground, does his work with effort. John inadvertently opens up the wound in Christ's side as he grips the heavy corpse, thereby recalling the *Doubting Thomas* [104] and pointing up a streak of cruelty or sadism that Caravaggio seems to have cultivated or was unable to suppress.

One source for the main group in the *Entombment* is Raphael's painting of the same subject [111]. By comparison, his swaying figures seem mannered and Caravaggio's figures as solid and sturdy as the tomb slab below. The comparison can also serve to contrast High Renaissance idealism with the naturalism of Caravaggio. Raphael wrote that he depended not on models but on his imagination: *"certa idea che mi viene in mente,"* which is quite different from copying one or even several

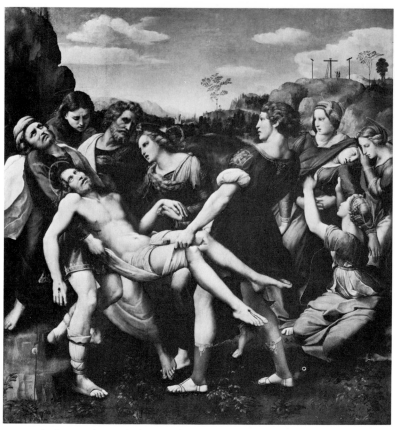

111. Raphael, *Entombment of Christ*. Galleria Borghese. 1507.

examples.[11] Caravaggio deliberately coarsened his Apostles and even Christ by choosing common people as models, thereby separating himself from idealizing precedents while turning to those same sources for compositional guidance. Caravaggio may have known a woodcut of the 1530s that shows Christ's body in a similar position as well as the familiar rhetorical expression of grief at the upper right [112].

Caravaggio's genre-like portraiture is found in all the figures, perhaps most strikingly in the topmost Mary with her individual features, arms flung upward [113]. Caravaggio has modified the traditional image into an individual who seems to invoke divine force from above. The gesture has a long pedigree, from Roman sarcophagi to Giotto to Titian (who is so much more poetic than Caravaggio could ever hope to be). Caravaggio has come a long way from the painful literalness of his Lombard predecessors, as seen in the *Pietà* by his teacher Peterzano [114]. But

[11]Panofsky (1960, p. 60) quotes the passage from Raphael's famous letter to Castiglione: "in order to paint a beautiful woman I should have to see many . . . but since there are so few . . . I make use of a certain idea that comes into my head. Whether it has any artistic value I am unable to say; I try very hard just to have it." (Printed in the original by Barocchi, *Scritti,* II, pp. 1529 ff.; cf. her p. 1530, n. 2.)

176

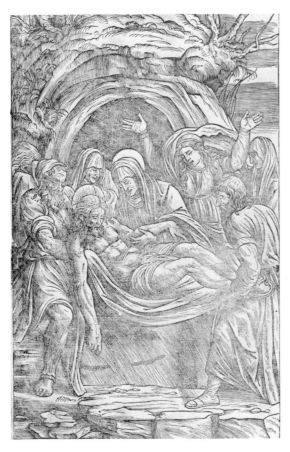

112. *Entombment of Christ.* Woodcut, 1533(?).

when we compare Caravaggio with Raphael or Michelangelo or Titian we see that the realism of Lombardy persisted in Caravaggio's art despite his new and stylish monumentality.

Herwarth Röttgen observed that the composition of the *Entombment,* though traditional, has been (as it were) rotated some twenty degrees away from the frontal norm, like a sculpture seen in the round [cf. 112 for the traditional orientation]. Thus, he claims, Caravaggio opened up an era in which new views of traditional scenes are possible—as Rubens quickly learned [cf. 115].

The assault on the picture plane made by the prominent corner of the tomb slab seems to link the *Entombment* with paintings such as the *Doubting Thomas* [104] and the first *St. Matthew* [87], although the *Entombment* was probably finished in 1604. It continues to show details of horrifying realism together with a studied, ideal composition, a combination that is first seen in the *Crucifixion of St. Peter* [82] and in the *St. Thomas.* In the years 1601–1604, Caravaggio combined painful realism, sculpturesque force, and sophisticated composition in a conscious effort to carve his niche in the pantheon of great Roman painters.

113. Detail of [107].

The *Entombment* has always been admired, probably because it shows Caravaggio accommodating his naturalistic forms and dark manner to a meditated and composed, if not precisely classic composition. The painting is stylish while remaining, above all, direct and moving. Its most obvious offspring is the *Death of the Virgin* [133], which may have been commissioned soon after the *Entombment* was finished.

The picture must have made a particularly striking contrast in the Chiesa Nuova with Federico Barocci's *Presentation of Mary in the Temple* [182]. It had just been delivered in April 1603; its traditional *maniera* composition with stereotyped *repoussoir* figures seems almost an act of historical recreation rather than a production of Caravaggio's time.[12]

Baglione, never a willing admirer, wrote that the *Entombment* was said to be Caravaggio's best work. Scannelli, writing in the 1650s, thought it equal to the

[12]See Note 107, p. 315.

114. Simone Peterzano, *Pietà*. Milan, San Fedele. 1583–84?

115. Peter Paul Rubens, *Entombment of Christ*. Ottawa, National Gallery. c. 1613–15?

paintings of the Contarelli Chapel, which for him were Caravaggio's best. Bellori was also a great admirer. Artists through the centuries have shown their esteem by copying—Rubens, Fragonard, Géricault, even Cézanne. This painting alone would put Caravaggio in the first rank of European painters.

The *Entombment* shows Caravaggio's ability to fuse realism and tradition; it took its place with Annibale's great *Pietà* as a modern classic [116]. Both pictures emphasize the tactile reality of Christ's suffering and death, and both pay conscious homage to the past. In the *Entombment,* Caravaggio came as close as he ever would to being an artist of the mainstream and his achievement is indebted to the guidance of Annibale, different though the two were in other respects. Perhaps Annibale in turn tried to recapture some of his old emotion in a later *Pietà,* the so-called *Three Marys* [117]. Here he seems to rival Caravaggio's painting, but with the more idealized corpse, beautiful Raphaelesque women, and bright light and color that he (and Renaissance theory) considered appropriate.

116. Annibale Carracci, *Pietà*. Naples, Capodimonte. c. 1599–1600.

THE MADONNA OF THE ROSARY

In the next year Caravaggio was painting a mysterious *Madonna* for a church in Modena at the behest of Duke Cesare d'Este. We know nothing about this picture, which was never delivered, but an extensive correspondence survives. (At the same time, beginning in June 1605, Este tried to get Annibale Carracci to paint a *Nativity of the Virgin,* again with no result.[13]) Some scholars have tried to connect Caravaggio's commission with a big painting now in Vienna [118]. It was first mentioned in letters of September 1607 as having been painted in Naples, but in style it best fits the period 1604–1605.

[13]Recorded in letters written from Rome to Modena between 6 August 1605 and 20 August 1607, when Caravaggio was reported to be in the process of being pardoned (Cinotti, 1971, pp. 158 ff., F 66, 70, 77, and 81). For Annibale's painting, which he seems to have worked on for almost two years, see Posner (1971, I, p. 147).

117. Annibale Carracci, *Pietà (The Three Marys)*. London, National Gallery. c. 1604–06.

The *Madonna of the Rosary* is the only painting by Caravaggio that could be called a standard Baroque altarpiece. The forms are clearly and firmly modeled, the lighting is strong and precise, the organization is the most conventional that we find in his work. It uses the graded levels of figures found in Venetian altarpieces and in Annibale's Bolognese paintings such as the *Madonna of St. Matthew* of the late 1580s —it even has much the same symbolic column [119]. Nature and the supernatural, however, are excluded from Caravaggio's painting. The stolid Madonna seems to be enthroned, although she is presumably an apparition. According to tradition, Mary should be handing a rosary to St. Dominic. Here, only Dominic and St. Peter Martyr of Verona (at the upper right) seem to see her, while Dominic distributes the ingenious aids to prayer to an eager group below. There we see Caravaggio's interest in silhouetting, and the bunching of outstretched hands near Dominic is characteristic and affecting [124]. A confusion of gesture and costume at the rear makes the painting

118. *Madonna of the Rosary*. Vienna, Kunsthistorisches Museum. 1605/1607.

119. Annibale Carracci, *Madonna and Child Enthroned with Saints (Madonna of St. Matthew)*. Dresden, Gemäldegalerie. 1588.

hard to read: there are actually three people to the right of Mary, before a vast apsidal space. Caravaggio filled the top part of this grandiose altarpiece with a rich red drapery attached to the fluted column. At its foot is a donor who invokes the protection of St. Dominic by sheltering himself under his cloak, which he clasps—we recall the old image of the Madonna della Misericordia, who protects humanity within her voluminous cape.

The hues in the *Madonna of the Rosary* are not as strong or as saturated as those of the *Supper at Emmaus* [42]; the painting is more tonal, with dull earth colors that

contrast with the green on the mother at the left. The belly of the Christ child was repainted to make him thinner, and he seems to float because his feet do not rest on the Madonna's lap but on an invisible seat below. Although this picture is not by any means as effective as the *Madonna di Loreto* [120], the eager, kneeling group reaching for the rosaries is novel and shows where Caravaggio's real interests lay [cf. 125]. Perhaps it was finished only after Caravaggio fled to Naples late in 1606; some of the passages in the lower section can be compared with the *Seven Works of Mercy* [138]. As a whole, however, the *Madonna* proclaims itself a Roman work. With its two Dominican saints and other clerical figures in the center, it is obviously Dominican. The theme is salvation through the Dominican priesthood, aided by the rosary, each of whose beads represents a prayer to the Virgin.

The *Madonna of the Rosary* is only just conceivably the picture that was first commissioned from Modena. That painting was to cost 50 or 60 *scudi,* and Caravaggio was getting much more than that for smaller paintings with fewer figures. (Baglione reported that Caravaggio was paid as much for portrait heads as other painters received for history paintings.) Nevertheless on 16 November 1605 Caravaggio promised to deliver the *Madonna* for Modena in a week; even though he did not, the date would fit rather well with the style of the picture in Vienna.

THE MADONNA DI LORETO

Another altarpiece remains in Rome, in the Cavalletti Chapel in Sant'Agostino [120, 122]. There may have been some connection between Caravaggio and the Augustinians, whose headquarters were in Lombardy: the Cerasi Chapel is in an Augustinian church and Sant'Agostino is another. We have seen that there are "Augustinian" elements in Caravaggio's approach to religious imagery and he even painted a *St. Augustine* for Giustiniani. The church of Sant'Agostino is in the heart of what an advertising man might call Caravaggio country, just off the Piazza Navona. He continued to live in this neighborhood even after he moved out of Del Monte's palace [51].[14]

Ermete Cavalletti died on 21 July 1602, aged forty-six, leaving a legacy of 500 *scudi* for a chapel to be decorated with a painting of the Madonna of Loreto, presumably to intercede for his soul in heaven. After some negotiation the family acquired the first chapel on the left in Sant'Agostino early in September 1603; it is

[14]Perhaps Caravaggio was still living with Del Monte in October 1604: see p. 88, n. 28 above.

120. *Madonna di Loreto*. Cavalletti Chapel, S. Agostino. 1604–05.

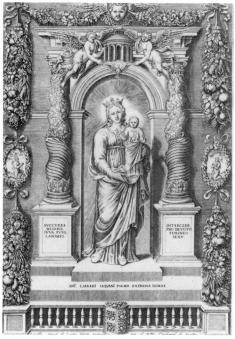

122. Cavalletti Chapel, S. Agostino, showing [120].

121. Engraving of the Madonna di Loreto. A. Lafreri.

even possible that Caravaggio was commissioned around that time, although it should be remembered that he was in jail in mid September in connection with Baglione's lawsuit. The *Madonna di Loreto* does not proclaim itself as a painting done immediately after the *Sacrifice of Abraham,* however. Its style gives every indication of dating from about 1605 rather than earlier.

The *Madonna di Loreto* is Caravaggio's most directly affecting painting. Like the *Entombment* [107], it is based on a spatial diagonal, one that resolves at eye level on the dirty feet of a kneeling male pilgrim. Also like the *Entombment,* this painting should be seen in place, and it is the only Roman altarpiece by Caravaggio, apart from the *St. Matthew* in the Contarelli Chapel, that still can be [122]. On entering the church and turning left, we are immediately struck by the brilliant light on the Madonna's face, the Christ child, and the feet and hindquarters of the pilgrim. This highlighting is set off by a greater darkness in the background than we have seen before [120]. Because the chapel is shallow, we approach the painting almost as the pilgrims approach the Madonna, and Caravaggio took advantage of the proximity to achieve a new intimacy.

The *Madonna di Loreto* (which was literally a statuary group at the Santa Casa) was shown in a popular print of the later sixteenth century, holding her child and

123. G. B. Moroni, *A Gentleman in Adoration Before the Madonna*. Washington, National Gallery. c. 1560.

standing in a niche. Some of these prints show pilgrims like Caravaggio's, inset at left and right [121]. The inscriptions beseech the Virgin to "succor the unfortunate and the meek, and to intercede for the devoted female sex." This dead icon was transformed into magic life by Caravaggio's brush. At the altar rail of the shallow chapel, close to the painting, we are invited to join the pilgrims, male and female, old and poor, who kneel humbly before the Madonna after their long pilgrimage. And the Madonna answers their prayer: she appears miraculously in an effulgence of light to allow the Christ child to bless them and save them. What we actually seem to see here is not a niche in the Casa Santa but a Roman doorway; Caravaggio still painted what he saw and the connection with Loreto is unclear.

The *Madonna di Loreto* is another painting that centers on Faith; it is also about Hope and Love, but it is especially about the faith of pilgrims. Caravaggio represented simple, blind Faith made substantial and tangible. At first we may think that a statue of the Madonna has come to life—like Pygmalion's statue, but through the force of divine rather than earthly love. Finally, we decide that we are witnessing a particularly tangible apparition. Other paintings of the Cinquecento sometimes waver between showing an apparition, which was common, and an actual transformation,

187

which was not.[15] The north Italian tradition from which this kind of picture seems to spring includes Moretto's depiction of the apparition of the Madonna to an impaired shepherd boy in the country and such paintings as G. B. Moroni's puzzling *Gentleman in Adoration Before the Madonna* [123], where the Madonna seems almost as "real" as the portrait. We do not know whether it is a donor with the Madonna, a vision, or a metaphor of devotion. The wealthy man who presumably commissioned that picture is portrayed in it, whereas Ermete Cavalletti's *Madonna* shows people of a very different class from his own—and we wonder how the family liked that innovation.

Caravaggio shows a miracle happening to simple, poor, contemporary people. Mary steps out rather balletically, on tiptoe; this is, after all, a vision and gravity is not wholly operative although the realistic child is plump and evidently heavy, as was the child in the sculptured group at Loreto [121]. Mary casts a shadow over the brightly lighted molding of the doorway that bisects the picture and disappears behind the man's head [120]. The kneeling woman looks old enough to be her companion's mother, and possibly she is. These people are pilgrims, on pilgrimage to a holy shrine of the Virgin—indeed, to her very home, which had been transported miraculously (to say the least) from the Holy Land. If the pilgrimage to Loreto was sometimes made barefoot, the infamous dirty feet of the kneeling pilgrims—which upset classicists like Bellori—would even be decorous in the iconographic sense. Removing one's shoes in a holy place was an ancient custom, and the dirt [125] emphasizes the pilgrims' humility (a word deriving from *humus,* soil). The miraculous appearance of Mary is the reward for humble faith.

Like the kneeling worshippers of the *Madonna di Loreto,* the disciple at the right in the *Supper at Emmaus* is also a pilgrim, identified by his shell [42]. He had been a blind pilgrim, one who did not recognize what he sought, and he acknowledges Christ with amazement as the scales fall from his eyes. Saul too was a kind of pilgrim, traveling to Damascus not to worship but to persecute, when his soul was enlightened by the blinding force of Jesus [75].

These pictures succeed so wonderfully and still appeal to us so strongly because

[15]Santi di Tito, a pietistic Florentine artist (1536–1603), produced a *Vision of St. Thomas Aquinas* in 1593 that shows the figures from a painting of the Crucifixion coming to physical life in front of the painted surface in response to Thomas's gift of his works (illus. Freedberg, 1975, p. 624, Fig. 281). They form a *tableau vivant* before the kneeling saint. Such a painting is the visual equivalent of the sensuous religious experience that St. Ignatius had prescribed in his *Spiritual Exercises.* Friedlaender and others supposed that Caravaggio was influenced by this Ignatian prescription for prayer, but I believe that the *Exercises* were specifically Jesuit in their application at this time. The idea of summoning up the sensuous presence of divine figures was widespread. Caravaggio might have remembered paintings such as Moretto's *Virgin and Child with Galeazzo Rovelli as St. Nicholas.* A study of such apparitions and transformations would be of great interest (cf. Arasse, 1972).

124. Detail of [118].

125. Detail of [120].

their credulity, which few of us share, is tempered by Caravaggio's factual approach. His was a commonsense interpretation of the miraculous. Yet it was more, a recreation of stories exemplifying Faith and Divine Grace, powerfully imagined and then painted from real models to create, as the King James version says, "the substance of things hoped for, the evidence of things not seen" (Hebrews 11:1). It was in *substantia rerum,* the substance of things, that Caravaggio the artist placed his ultimate faith. Painters of the Renaissance had learned to create real-looking spaces in which believable actions took place [cf. 62]. Caravaggio painted real-looking people who are seemingly thrust out into our own space and life by the darkness behind them. The artist who understood best what Caravaggio achieved in the Cerasi and Cavalletti chapels was Bernini, who translated the immediacy of Caravaggio's paintings into statuary and ultimately into visual and emotional experiences framed by a chapel or even a church. But he replaced Caravaggio's mundane people with idealized figures of white marble.[16]

In the *Madonna di Loreto* Caravaggio's forms emerge out of the gloom of the picture and the unlighted chapel: photographs show more than we normally see without artificial light [122]. The *Madonna di Loreto* is more pictorial, less belligerently sculptural than the Cerasi paintings [75, 82]. This stylistic change unfolds slowly after the obstreperous close-ups of 1601 and the succeeding years. We see it beginning in the softer contours and colors of the second *St. Matthew* and the *Abraham* [93, 102] and developing in a darker mode in the *Madonna of the Rosary* [118]. As time went on Caravaggio became a more canny painter as he became more monumental, simplifying the details of larger pictures rather than painting everything with the same care and emphasis [cf. 125, 131]. By the time of the *Madonna di Loreto* he painted in a quicker, surer way throughout; details are brushed in with regard for optical reality, and there are passages of virtuoso handling, with juxtapositions of related colors. Because the spotlighting chiaroscuro has become even more dramatic, the figures still look sculptural.

The picture caused quite a stir. Baglione, disapproving, said that *"da popolani ne fu fatto estremo schiamazzo,"* which can be translated as "the common people made a great cackle over it." Since he used the word *schiamazzo* on the same page to describe the propaganda that had led Giustiniani to overvalue Caravaggio's pictures, we may take the word to mean "unjustified praise." Thus Baglione may be reporting that the simple people who were portrayed in Caravaggio's picture saw it and approved of it. It must have been the talk of the town.[17]

[16]Connections have been noted in passing by many; cf. Hibbard (1983).

[17]Bologna (1974, pp. 185 ff.) tried to show that Baglione's passage indicates an interest on the part of the

The strikingly handsome model for the Madonna is new to Caravaggio's repertory; she reappears less sympathetically in his *Madonna with St. Anne,* painted for St. Peter's in the winter of 1605–1606 [130]; perhaps she is even remembered as the Madonna in the *Seven Works of Mercy* of late 1606 [139]. Possibly she was modeled on a young woman called Lena (Maddalena) whom Caravaggio liked; in July 1605 he wounded a notary named Pasqualone on the side of the head with a blow from his sword, evidently because the notary had had commerce with her. In the criminal complaint she was described as *"Lena che sta in piedi a piazza Navona . . . che è donna di Michelangelo"* (Lena, who is to be found standing in Piazza Navona, who is Caravaggio's woman). A female described as habitually standing in a public square might well have been a prostitute; since Caravaggio was fighting over her, perhaps she was not. A later biographer, G. B. Passeri, tells stories about a girl engaged to a notary who posed for Caravaggio; she could be the Lena of the documents, with the story somewhat changed in the telling. The idea that Caravaggio was a homosexual seems to be contradicted by these records, and his statuesque woman in the *Madonna di Loreto* is one of the most appealing in the art of the entire period. Indeed, one of the reasons given later for the rejection of the *Madonna with St. Anne* was the overly explicit womanliness of Mary, who is obviously painted from the same model [131, 132].

ST. JOHN THE BAPTIST AND ST. JEROME IN HIS STUDY

The altercation over Lena, and other legal difficulties caused by his behavior, got Caravaggio into so much trouble that in July or early August 1605 he found it expedient to leave Rome for Genoa,[18] where he may have painted the *St. John the Baptist* now in Kansas City [126]. A copy of this painting is still on the altar of a church near Genoa that was endowed by the banker Ottavio Costa, one of his Roman patrons. Presumably the *St. John* was painted for Costa at about this time, and it shares the stylistic traits of the *Madonna di Loreto.* John is no longer the insolent urchin that Caravaggio had painted a few years earlier [96]. The naughty scamp has grown into

common people in Caravaggio's art, in the context of a Marxist essay that is looking for such connections. But Baglione is critical and seems to suggest that the dirty feet and other breaches of decorum led to the *"estremo schiamazzo."* Nevertheless, as Mahon pointed out, Agucchi's plaintive reference to the meaningless opinions of the people (*"la vana voce del volgo"*), c. 1610, could be taken to mean that Caravaggio seemed to be more highly regarded than Annibale by the public (Mahon, 1947, pp. 182, 258 and n. 42; cf. Posner, 1971, I, chapter 11, for Annibale and Caravaggio).

[18]Documented in the letters to Modena (see n. 13 above).

126. *St. John the Baptist.* Kansas City, Nelson Gallery. c. 1605.

a brooding adolescent hermit, shown in the desert like a contemplative penitent. Penance was the first step to spiritual rebirth, emphasized as a virtue and a sacrament by Catholic reformers.

Something of the same spirit is found in Caravaggio's paintings of St. Jerome, who was even closer to the Catholic reform movement. Caravaggio may have painted two or three *St. Jeromes* within as many years. Giustiniani had a full-length one, conceivably the picture in Montserrat [129]. The *St. Jerome in His Study* is in the Galleria Borghese [127]. Perhaps it was painted soon after Scipione Borghese became a cardinal in July 1605, following the election of his uncle as Pope Paul V. A third dates from 1607–1608 [150].

In [127] the old scholar, bald and bearded, is seated at his crude desk. The books and writing materials refer to Jerome's translation of the Hebrew and Greek Bible into Latin, the so-called Vulgate, which was the sole Catholic Bible until recent times. This is not a painting of an inspired gospel writer like Matthew [87, 93] but an evocation of the intransigent Christian classicist who wrote spiritual directions that became fundamental for monastic organizations of the middle ages, and who had himself retired to a hermitage in the desert.

Jerome was a Doctor of the Latin Church whose popularity in Counter Reformation Italy rose in proportion to Protestant disrespect. Protestants were not keen on saints, and Jerome received special ridicule: Luther called him a sodomite and a heretic. We have seen that Jerome's translation of the gospel of Matthew was carefully vindicated in Caravaggio's first *St. Matthew*. Jerome had been baptised by a pope, Liberius, and it was Jerome who spoke of Peter as the first Bishop of Rome —which is to say, the first pope. Thus Jerome was essential to the papacy and three different *Lives* of the saint were published during the sixteenth century, when the Roman Church was battling Protestant heresy. Jerome was a great fighter against heresy and heretics, and almost single-handedly he invented what we call Mariolatry, which made him important in direct proportion to the occurrence of Protestant attacks on the cult of the Virgin.

Not only was Jerome the patron saint of scholars, he was also their model. Northern artists like Dürer loved to show him in his warm study, like a cozy Erasmus. Caravaggio, on the contrary, imagined a hermit in an invisible cell that should have been austere enough to please even St. Charles Borromeo, who wanted artists to eliminate all extraneous details and distracting figures from their paintings. Caravaggio's conception of Jerome ultimately depends on a long, essentially north-Italian development that resulted in a series of altarpieces and devotional works in Rome around 1600. Caravaggio is one of only a few post-Tridentine artists who still show Jerome indoors at his desk [127], probably because the lovingly painted northern

127. *St. Jerome in His Study.* Galleria Borghese. c. 1605.

examples, full of detail, had transformed the image into a symbol of Vanity. Although
St. Jerome was revered for his scholarship, which is clear enough in Caravaggio's
painting, the emphasis here is on asceticism, the impermanence of the flesh, the
imminence of death. Jerome's aged head forms a telling counterpart to the skull at
the left, a *memento mori,* which is the entire subject of the Montserrat version [129].

The model for Jerome resembles the *Abraham* and the second *St. Matthew* [102,
103]. The Borghese *Jerome* exhibits Caravaggio's interest in silhouetting, which may
also be seen in the *St. John* [126]. Jerome's arm nearest us stands out dark against the
light falling on the saint's body, then turns into the light at the hand [128]. The paint
is applied in dabs and flicks to form the hair and beard, a technique that became
common only later. This almost flashy virtuosity puts the picture in a special category,
and its authorship has sometimes been doubted for that reason.

While he was painting these devout images of ascetic saints whose example
was meant to guide and inspire, Caravaggio himself was behaving with less than
Christian restraint. He was arrested and jailed in May 1605, when the scribe at the
arraignment sketched the sword and dagger that Caravaggio had been carrying, as

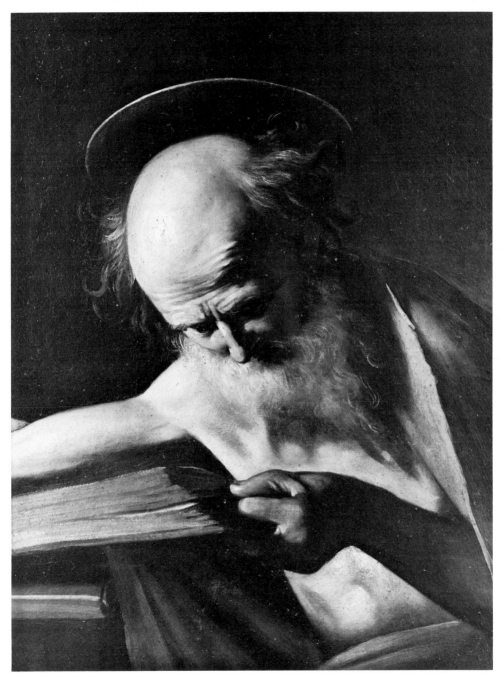

128. Detail of [127].

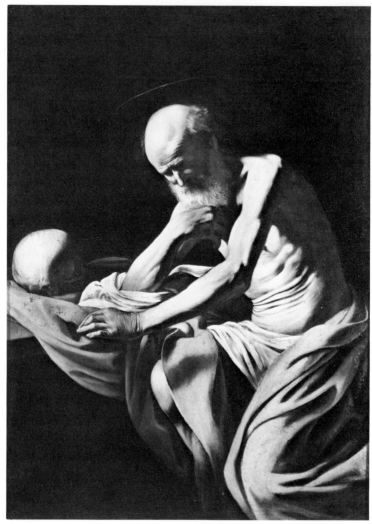

129. After Caravaggio (?), *St. Jerome*. Montserrat, Monastery Museum.

usual.[19] He was arrested twice in July (the second occasion was the "Lena" episode), whereupon he went to Genoa. On 24 August 1605 the agent of the Duke of Modena wrote that Caravaggio was back in Rome. The agent appealed to Cardinal Del Monte to help him extract the *Madonna* from Caravaggio for the duke. Del Monte explained that he should expect little from Caravaggio, that he was *"uno cervello stravagantis-*

[19]See Cinotti (1971, pp. 158–159, F 64 ff.). Here is the drawing of the sword and dagger that Caravaggio was carrying when he was arrested. The entire page is reproduced by Cinotti (1971, p. 75, Fig. 60). (See also p. 170, n. 8 above.)

simo" (very eccentric), and that he had turned down an offer of 6000 *scudi* from Prince Doria to fresco a loggia after more or less promising that he would do it.[20] Evidently Caravaggio was unwilling to paint in fresco for any money. By September he was in trouble again.

THE MADONNA AND CHILD WITH ST. ANNE (DEI PALAFRENIERI)

In October 1605 we hear that Caravaggio had been wounded mysteriously in the neck and ear and was recovering in the house of a friend. By this time he had presumably finished the *Madonna di Loreto* [120] and was supposedly finishing the *Madonna* for Modena. He also—finally—got a commission for St. Peter's, a *Madonna with St. Anne* [130] for an altar of the papal grooms *(palafrenieri)*. It was commissioned late in November 1605; payments made between December 1605 and 8 April 1606 totaled 75 *scudi*. Presumably the quasi-papal commission was possible because the hostile Aldobrandini pope, Clement VIII, had died early in 1605 and was soon succeeded by the friendly Paul V Borghese. Caravaggio's painting was exhibited on a new altar in the new part of St. Peter's for only a few days in April and was then removed to the nearby church of the Palafrenieri, Sant'Anna. By 16 June 1606 it had been sold to Cardinal Borghese for 100 *scudi*. By that time Caravaggio had left Rome for good.

The *Madonna dei Palafrenieri* is large, almost three meters high. By comparison with his greatest paintings, the *Entombment* [107] and the *Madonna di Loreto* [120], it is unsuccessful, but we see it now in the brilliance of the Villa Borghese loggia, not in the gloom of St. Peter's where, on a high and distant altar, it might have been striking. It shows St. Anne and the two generations of human divinities who issued from her, isolated in an immensely dark room. Mary and Jesus step on the serpent symbolic of original sin, thereby triumphing over Eve's fall in a manner approved by a papal bull of 1560. These ideas derived from the old concept of a sinless Virgin who bore the Savior, which then led to the idea of an immortal Mary who was herself conceived without sin, an "Immaculate Conception" that became Church dogma only in the last century. The emblematic imagery, typical of the Counter Reformation and certainly not of Caravaggio's choosing, also makes the serpent of Genesis a symbol of contemporary heresy. It is nevertheless possible that the painting was not kept in St. Peter's because of its iconography: perhaps, once they saw it, the cardinals of the *Fabbrica di San Pietro* decided that the subject was still too controversial, and that

[20]Letter of 24 August 1605 (Cinotti, 1971, p. 159, F 66). See also Note 126. Further to the loggia, see Pacelli (Pacelli-Bologna, 1980, pp. 26–27), who supposes that it was in the Casino Doria at Sampierdarena (Genoa), which was later painted by Caracciolo and then by Gentileschi (cf. Note 171 below).

Mary's full participation in the redemption of mankind should not be proclaimed so unequivocally in the central church of the Catholic world.

The image derives in part from a painting by Ambrogio Figino (1548–1608) in Milan that Caravaggio must have known, or recalled by means of a drawing or print, for the left side of his painting is an iconographic mirror image of Figino's. The iconic theological subject could hardly have had much appeal for Caravaggio, although the Virgin is ardent and more natural than in the *Madonna di Loreto* [131, 132]. The Christ child gave him an opportunity to paint another nude boy, which he relished, and perhaps he accentuated the nudity to the point of offense. The relegation of Anne to the side as an observing old crone may also have been displeasing, since the commission had come from a confraternity dedicated to her worship.

The lighting in the painting is unusual: we almost see the window from which it falls at the upper left, and Caravaggio shows a ceiling, perhaps for the first time. As usual, the figures are brilliantly lighted from another source outside the canvas, and the darks are very dark. The light reveals a red on the Virgin that becomes almost salmon on the sleeve, the only real color in the picture. It is painted on coarse canvas in a new technique that Caravaggio was evolving in 1605–1606; the dark reddish underpainting shows through as part of the finished coloration.

THE DEATH OF THE VIRGIN

The altarpiece for St. Peter's seems to be roughly contemporary with the completion of Caravaggio's *Death of the Virgin* [133], his largest Roman altarpiece, which was presumably commissioned in 1604 or 1605. It was painted for a learned papal lawyer, Laerzio Cherubini, whose chapel was in the Carmelite church of Santa Maria della Scala on the edge of Trastevere. The huge painting is now in the Louvre, covered with dirty varnish. Beneath the yellow grime is one of Caravaggio's greatest and most touching images.

The church of Santa Maria della Scala was begun in the 1590s, but only the nave with its three pairs of large open chapels had been completed in Caravaggio's time. The *Death of the Virgin* was painted for the middle chapel on the left, which was being decorated about 1605 by the architect Girolamo Rainaldi. Once again Caravaggio based his composition on a falling diagonal, this one coming to rest at the horizontal body of the dead Virgin. Entering the church and moving down the nave, we would first have seen her head with the mourners above and below, then the group of old men gathered around her simple cot. The red curtain may be a

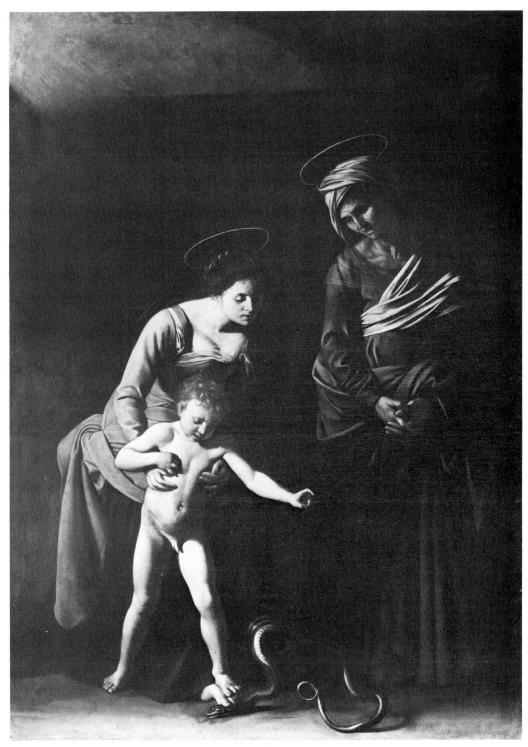

130. *Madonna and Child with St. Anne (Madonna dei Palafrenieri).* Galleria Borghese. 1605–06.

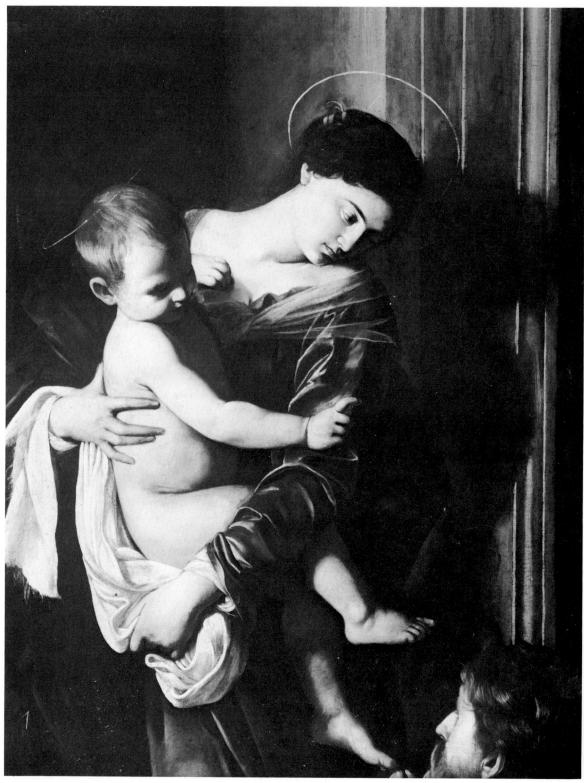

131. Detail of [120].

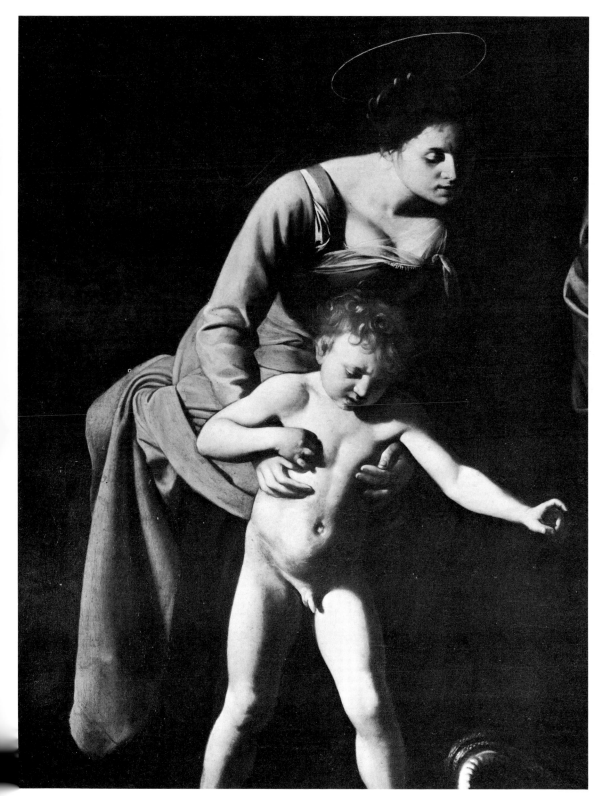

132. Detail of [130].

Venetian borrowing; it fills the otherwise empty space at the top of the picture and is ultimately to be understood as the bed hanging, pulled up to reveal the body [cf. 118]. A profound quiet seems to overcome the Apostles, who according to the apocryphal story were miraculously convened; they are shown in differing states of compassion and grief. Unlike the *Entombment* [107], the figures closest to the body are the most deeply affected, those farther away are arriving or moving about, and some of the heads at the back look unfinished [but cf. 148]. Caravaggio has banished the supernatural. There is an almost complete absence of rhetoric, gesture, and theatrics. Like late paintings by Rembrandt, the *Death of the Virgin* seems full of emotion conveyed by bulky, numbed bodies that are too overwhelmed by their feelings to express them.

In the front, seated in a simple chair, we recognize Mary Magdalen, her head down [135]. It seems likely that this is the same grieving young woman whom we see in the midst of the *Entombment,* wearing a similar dress [113]. There she stands next to a much older Mary, whereas the dead Virgin, laid out uncomfortably, is young. She is exhibited for the benefit of the gathering Apostles, who are barefoot, as might be appropriate for a chapel in a church of the Discalced Carmelites.

The representation of the Death of the Virgin is of Byzantine origin and it was called her Dormition. In the oldest images, Mary's soul was taken up by Christ and carried to heaven as her body dies. Nadal's pietistic book of 1593 still shows this scene [134]. The Death or Dormition had by then ceased to be common in the West since the Virgin's bodily assumption was an article of faith for Catholics even if its Dogma was not yet proclaimed [cf. 81]. Moreover, the Death of the Virgin (in Italian, the *Transito della Madonna,* emphasizing not her bodily death but her transition from earth to heaven) was not a proper subject for art according to the theological opinion of the Counter Reformation. Johannes Molanus wrote that the Virgin died without suffering and that representations of her death were irrelevant and even improper. Yet Cesare Baronius reaffirmed that she died a mortal death, and such writings as there were on the subject emphasize her joyful, painless death.[21]

Mancini thought that the model for Mary was a dirty whore from the Ortaccio, a disreputable quarter, and suggested that she was Caravaggio's mistress. Caravaggio's breach of decorum led to the rejection of the picture by the Fathers of Santa Maria della Scala and its replacement by a more conventional picture. The Virgin's bare legs and feet were specifically mentioned by Baglione as objectionable, as was her swollen form. Bellori thought the picture had been rejected because it showed a swollen corpse. By showing Mary dead rather than dying, Caravaggio not

[21]For Molanus on the Dormition, see Mâle (1932, p. 360). For Baronius, see pp. 75–77.

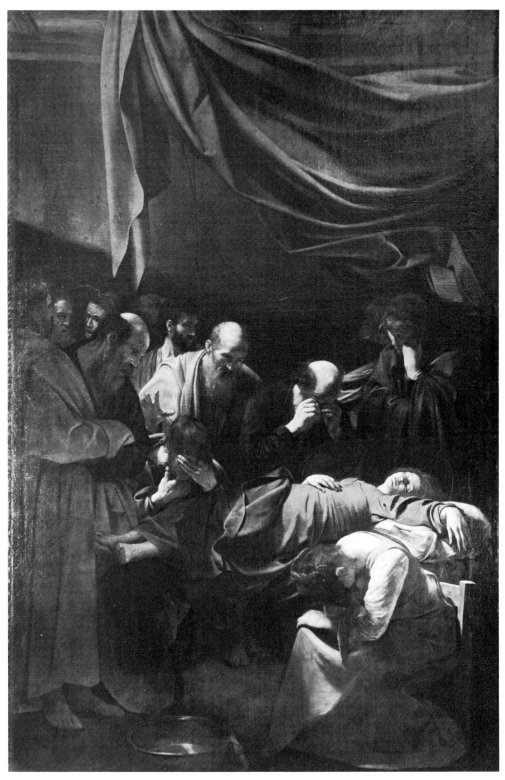

133. *Death of the Virgin*. Paris, Louvre. c. 1605–06.

A. *Apoſtoli, et alij ſancti Patres portantur ab Angelis Hieroſolymam, ve morti Dei Matris interſint, & aſumptioni.*
B. *Domus in monte Sion, vbi Maria Virgo Mater eſt mortua.*
C. *Componit ſe honeſtiſsime in lectulo,*

D. *circunſtantibus Apoſtolis & Patribus. Adeſt è cælo Chriſtus cum innumerabilibus Angelis.*
E. *Expirat ſuauiſsime ſanctiſsimam animam Mater Dei in manus Filij, excellenti cum Angelorum gaudio, & Patrum deuotione.*

134. *Death of the Virgin,* from Nadal, *Evangelicae Historiae Imagines,* 1593.

only flaunted decorum but also denied the spiritual content of the scene, reducing it to heartfelt mourning for a mere person. As such, it still moves us as few paintings do.

Bellori never saw the picture; Mancini and Baglione may have remembered it, but it was no longer in Rome when they were writing. Like Caravaggio's other rejected altarpieces, this one was taken by a great collector. Peter Paul Rubens (1577–1640) was in Rome from late 1606 until 1608, where he was painting the high altarpiece for Santa Maria in Vallicella. (He won the commission in the face of relatively weak competition, since Annibale Carracci was hopelessly depressed and incapable of painting and Caravaggio had fled to Naples.) Rubens recommended Caravaggio's painting to his protector, the Duke of Mantua. We learn from the correspondence that the *Death of the Virgin* was highly praised by other painters, and Rubens himself called it one of the best pictures Caravaggio ever painted. The purchase was finally made in March 1607, but in order to satisfy the Università delli Pittori in Rome the picture was exhibited publicly for a week, because almost no one had seen it.[22] Of all Caravaggio's paintings, the *Death of the Virgin* has had the

[22]Cinotti (1971, p. 160, F 79; also Bertolotti, 1885, pp. 34 ff.), where we learn that the painting was sold for what the owner paid, 280 *scudi*. The letters concerning the sale are translated in Friedlaender (pp. 307 ff.), who gives further bibliography.

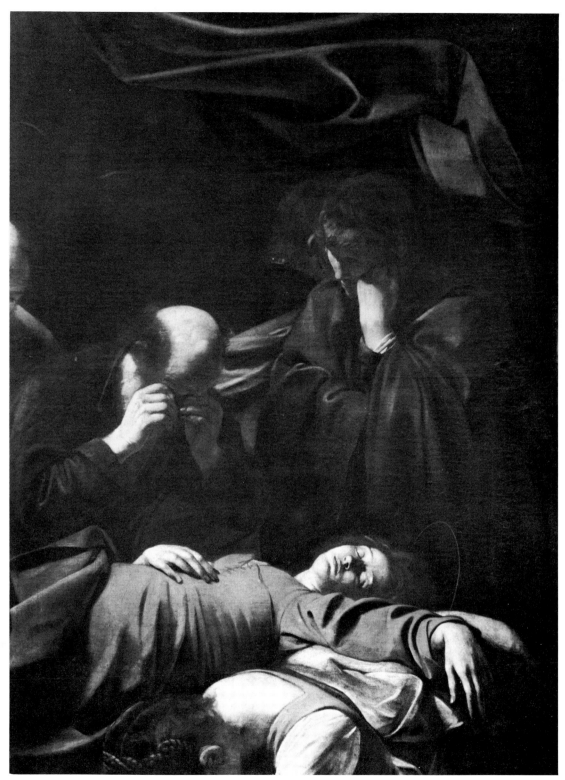

135. Detail of [133].

most illustrious history: from the Gonzaga collection in Mantua it entered that of Charles I of England and thence went indirectly to Louis XIV and so to the Louvre.

Caravaggio was not in Rome to enjoy the resale of his largest painting. On Sunday evening, 28 May 1606, on the via della Scrofa, he and some friends, among them Onorio Longhi, got into a prolonged fight over a wager of 10 *scudi* on a tennis match. Caravaggio was badly wounded in the head; his opponent, Ranuccio Tommasoni of Terni, died from Caravaggio's thrust. Caravaggio hid until Wednesday, when he was well enough to flee into the countryside, perhaps with some paintings. He never returned to Rome.[23]

[23]Marini (1978, pp. 31–32) showed that the fight took place near the Palazzo di Firenze on the via della Scrofa, and thus presumably near the courts still invoked by the nearby via della Pallacorda. The event is reported by a well-known *avviso* dated 31 May 1606 (Orbaan, 1920, p. 73; Cinotti, 1971, p. 160, F 76): "On that Sunday evening a serious fight took place in Campo Marzo, with four men on each side; the head of one was a Ranuccio da Terani [Terni], who died immediately after a long struggle; and of the other Michelangelo da Caravaggio, a painter of some fame these days, who is said to have been injured, but it is not known where he is. One of his companions, however, was badly wounded and imprisoned, who calls himself the Captain, from Bologna, who was a soldier of the Castel Sant'Angelo. They claim that the cause of the fight was a bet of 10 *scudi* on a game, which the dead man won from the painter." Cinotti mistakenly has "10,000 *scudi*," for 10; the original has "x" (Biblioteca Vaticana, *Urb. lat.* 1074, fol. 279v).

Another *avviso* of the same date, somewhat more discursive, has evidently not been published (Archivio Segreto Vaticano, *Avvisi*, 2, 1606, fol. 143v, 31 May 1606). The original is followed by a translation:

E tanto tempo che in Roma non è seguita questione fuor di qualche cacciamano che quella di domenica in Campomarzo, fra il Pittor Michelangelo da Caravaggio et un' tal Ranuccio Ranuccio [sic], che par cosa signalata raccontarsi, così la causa come l'istesso fatto diversamente. Et quanto alla causa, si dice che Ranuccio fusse creditore di X scudi del Pittore, quale sdegnato seco andava procrastinando di dargli sadisfattione, et che per vendicarsi di qualche ingiuria, havesse messo assieme 600 scudi per andarsi con Dio, mentre gli fusse venuto fatto qualche bel colpo. Onde passando quel giorno da casa del medesimo Ranuccio con comittiva, dal quale vedutolo si armò di dosso et lo andò [a] affrontare cacciando mano da solo a solo, restando ferito il Pittore, in aiuto del quale uscito il Capitan Petronio, et dall'altra il Capitan fratello di esso Ranuccio, con altri al numero di forsi 12 d'ambe le parti, finalmente Ranuccio inciampò dov'hebbe a cadere, nel qual tempo colto di stoccata cascò in terra morto, prima che'l fratello arivasse, sendo il Petronio restato priggione malamente ferito. (I am grateful to Gino Corti for revising my transcription.)

The text of this report is not altogether clear; the translation that follows is occasionally free and tentative: "Except for a few skirmishes, it has been a long time since we have had a dispute in Rome such as the one that took place on Sunday in Campomarzo between the painter Michelangelo da Caravaggio and a certain Ranuccio Ranuccio [sic], which seems worth recounting so that both the cause and the effect will correspond. As for the cause, it is said that Ranuccio was owed 10 *scudi* by the painter, who, indignant with him, was delaying to pay him off; and in order to protect himself from sudden injuries, [Caravaggio] had set aside 600 *scudi* for himself just in case it was needed [?], when fate overtook him. It happened that Caravaggio, passing by the house of Ranuccio on that day with a group of friends, was seen by Ranuccio, who armed himself and came out to confront him, fighting one on one. The painter was wounded, and a Captain Petronio came to his assistance. On the other side there was Ranuccio's brother, a captain, and others, perhaps 12 altogether on the two sides. Finally, Ranuccio tripped and in that moment, a swordthrust felled him dead before his brother could arrive. Captain Petronio has been imprisoned, badly wounded." (I am grateful to Darma Beck for aiding me in this translation.)

According to the representative from Modena, Caravaggio was also severely wounded (Cinotti, 1971, p. 160, F 77: letter of 31 May 1606; Friedlaender, p. 312, no. 63): "Caravaggio, the painter, left Rome badly wounded, having killed a man on Sunday night who had provoked him to a quarrel. I am told that he set out in the direction of Florence, and that possibly he may proceed to Modena." Onorio Longhi was exiled as a result of this escapade. Later he petitioned the pope from Milan to be allowed to return to Rome with his wife and five children, since he was innocent of the murder; the petition was granted in 1611 (Bertolotti, 1881, II, pp. 75–76; Cinotti, 1971, p. 162, F 96).

III
THE END OF THE ROAD

8
Naples and Malta

Sandrart, who should have been in a position to know, says that after the murder, Caravaggio "had to hide in the palace of Marchese Giustiniani, the protector of all virtuosi, who prized his works." Sandrart must have heard something about this from Giustiniani, who had housed the German painter in the 1630s. Nevertheless, Vincenzo Giustiniani was not in Rome at this time, having long since set out on an ambitious trip that took him to Germany, England, and France.[1] Hence he did not personally protect Caravaggio in his palace, but presumably someone allowed Caravaggio to recover in hiding for two days and then to escape. Perhaps it was Cardinal Del Monte's final kindness. Caravaggio's sympathizers may have included the papal family itself, for Cardinal Borghese purchased the *Madonna dei Palafrenieri* in mid June, when Caravaggio's crime and flight were still on everyone's mind.

There are conflicting reports about where Caravaggio went after his flight from Rome. Apparently he traveled first to the Sabine hills to the north; a letter of 15 July 1606 from Modena (concerning the mysterious *Madonna*) reports that he was on the run, and on 23 September he was reported to be in Paliano, east of Palestrina, which was owned by the Colonna family. Mancini and Bellori say that during this summer he painted a half-length *Magdalen* and an *Emmaus* at Zagarolo, another Colonna estate even nearer Rome but evidently safe from the papal authorities. The Colonna were connected by marriage with the Sforza family, one branch of which were the Marchesi di Caravaggio, the house Caravaggio's father had served.[2] The

[1]His travels in 1606 are recorded in Bizoni's diary (Banti, 1942). Sandrart (p. 276) did not connect the murder with Caravaggio's flight from Rome; see p. 377 below.

[2]Hess (1967, pp. 281, 285, 340, 425), following Bellori (p. 208), thought that Caravaggio's protector was Don Marzio Colonna, Duke of Zagarolo, who died in 1614 (cf. Note 118). Calvesi (1975, pp. 75 ff., followed by Borea in Bellori, 1976, p. 225, n. 1) seems to confuse the issue by changing the name to Don Muzio Sforza-Colonna, who was Marchese di Caravaggio and married to Orsina Damasceni Peretti. Although she was Principessa di Paliano, where Caravaggio supposedly stopped, they seem to have lived in Milan and would surely have been called "Sforza" and not "Colonna." (Muzio's mother, Costanza Colonna, may have been acquainted with Caravaggio; she seems to have been the ruler in charge of that town when the painter was living there, c. 1590.)

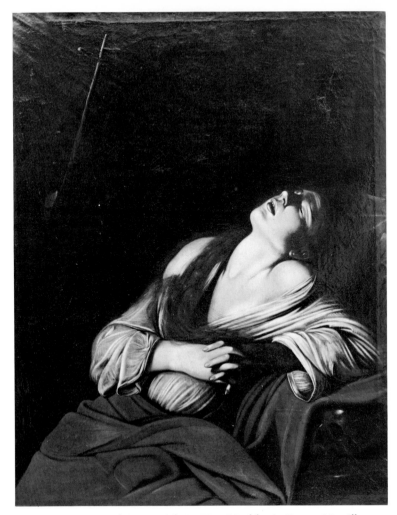

136. L. Finson, copy of Caravaggio's *St. Mary Magdalen in Ecstasy*. Marseilles, Musée Cantini. 1613?

Colonna connection led to the idea that the donor in the *Madonna of the Rosary* (or his precursor, since the head may have been repainted) is a Colonna with his symbolic column [118]. Moreover, Don Marzio Colonna's mother had instituted a confraternity dedicated to the Rosary at Zagarolo, so the picture might have been commissioned by the family.

ST. MARY MAGDALEN IN ECSTASY

The *St. Mary Magdalen in Ecstasy* may not have survived, but many copies point to a single source. Perhaps we get the best idea of the original from a signed copy by

Louis Finson, an admirer of Caravaggio who was in Naples by 1605 [136]. The saint is isolated in the darkness, her left elbow resting on a skull. Her attitude is one of utter emotional exhaustion, which may express Caravaggio's own desperation. Despite the potential sensuality of the pose, there is ambiguity in the treatment of the female figure. Certainly she is very different from the androgynous boys of his early days, but she is also unlike the later Roman pictures of "Lena." Perhaps he had to do without a model—and of course we are examining a copy and trying to peer back through it to the original. Compared with the luscious, often nude Magdalens painted by contemporary artists [cf. 183], Caravaggio's is sexless. Still, the distance he has traversed since the *Repentant Magdalen* [28] is immense. A tragic gulf separates the paintings: the later one seems to express that dark night of the soul that supposedly liberates the self from pride. Anguish is there, but liberation is not necessarily at hand. This is Caravaggio's first and perhaps only ecstatic figure after the early *St. Francis* [30]. Her abandoned pose, with her head back and mouth open as though gasping, may even have inspired Bernini's *St. Teresa,* and it reminds us especially of his *Death of the Beata Ludovica Albertoni.*

THE SUPPER AT EMMAUS

Two paintings of the *Supper at Emmaus* roughly span Caravaggio's Roman career as a monumental painter [42, 137]. The earlier one, as we have seen, was painted around 1600. The other, which was in the Patrizi collection by 1624, is probably the one painted in Zagarolo, though Mancini called it a *Christ Going to Emmaus,* which has caused confusion. The Patrizi picture, now in Milan, is to be dated no earlier than 1606.

The contrasts between the two works are obvious. The color is strong and local in the earlier one, shrouded and subdued in the later, where white has been all but banished and the light has been dimmed. Another contrast is in mood: the first painting is rhetorical, even theatrical, the second sober and hushed. Although the figure with his back to us gesticulates, his movement is abortive and masked by the dark. Unlike the earlier version, nothing threatens the picture plane. Christ looks like Christ; Caravaggio's early sensationalism is over. The blessing and the Eucharistic significance of bread and wine are the subject.

Even the technique has changed. Caravaggio's later pictures are sometimes painted very thinly: the weave of the canvas shows through, and such details as the wrinkled brow of the waiter are broadly painted. In some pictures these features are

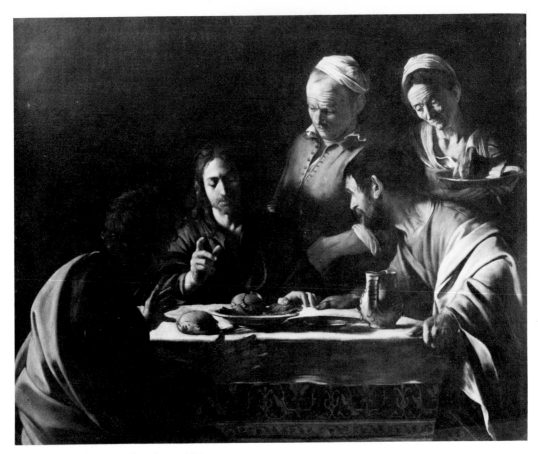

137. *Supper at Emmaus.* Milan, Brera. 1606.

repeated as stereotypes and the presence of an actual model becomes doubtful [cf. 161, 162]. We also notice the silhouetting of the disciple at left, continuing a trend in the later Roman paintings [cf. 128]. The earthy, brownish tonalities are hard to name: blue-green on Christ, greenish on the man at left, who wears a burnt-gold cloak. The picture is full of grays, and the drapery of the woman now shows through the roast. The image resolves itself when we are not too close; at a distance, lights show up and the scene becomes more gripping. We are in the somber world of the late Caravaggio.

Naples

A letter from Rome of 23 September 1606 reports Caravaggio to be in nearby Paliano and assumes that he is waiting for a reprieve in order to return. In fact he may already have headed for Naples. Like Sicily, Naples and the whole south of Italy had for centuries been a possession of Franco-Spanish rulers and since 1503 a dominion of the

Spanish king, who in Caravaggio's time was Philip III.[3] On 6 October 1606 a payment of 200 ducats was made to Caravaggio in Naples from the account of one Nicolò Radolovich for a large altarpiece of approximately 3 × 2 meters. It was to show the Madonna and Child above, encircled with angels, and four saints below—Dominic and Francis embracing between Vitus and Nicholas at the left and right.[4]

THE SEVEN WORKS OF MERCY

Nothing further is known of the Radolovich commission. Instead, on 9 January 1607, Caravaggio was paid the final installment of 400 ducats for a huge and complex painting representing the *Seven Works of Mercy* [138], which must have been painted in the last months of 1606. It is almost four meters high, larger even than the *Death of the Virgin,* but with smaller figures. Originally Caravaggio's painting was in a new church attached to a charitable institution, the Pio Monte della Madonna di Misericordia. It is now the high altarpiece in a still newer Baroque building of central plan, with seven subordinate altars dedicated to the individual works of mercy. Many of the other altarpieces are by Neapolitans like G. B. Caracciolo who were vitally affected by Caravaggio's innovative dark style.

The Seven Works of Mercy were usually shown in separate incidents, but the scene was rare in Italy. It derives from a passage in Matthew (25:35–36):

> For when I was hungry, you gave me food; when thirsty, you gave me drink;
> when I was a stranger you took me into your home, when naked you clothed
> me; when I was ill you came to my help, when in prison you visited me.

To this was added the pious act of burying the dead, making seven works. The passage concerns the Last Judgment. Matthew's parable is about salvation through good works, and Caravaggio's painting is a complex allegory of brotherly love in extreme situations. Theologically, it is the opposite of his Roman paintings, which almost always emphasize Faith.

Caravaggio's huge composition compresses the Seven Mercies into a crowded spasm of nocturnal activity that at first seems almost illegible. Above we see the Madonna [139]. We know from technical reports that she was a late addition to conform to the dedication of the church. Her face is a version of the recent "Lena" *Madonnas* [131, 132]. Below her, two marvelously linked angels swoop down, their

[3]*Storia di Napoli* (V, 1972), including Causa (1972); articles on the political and social situation are in V, 1.
[4]Pacelli (1977).

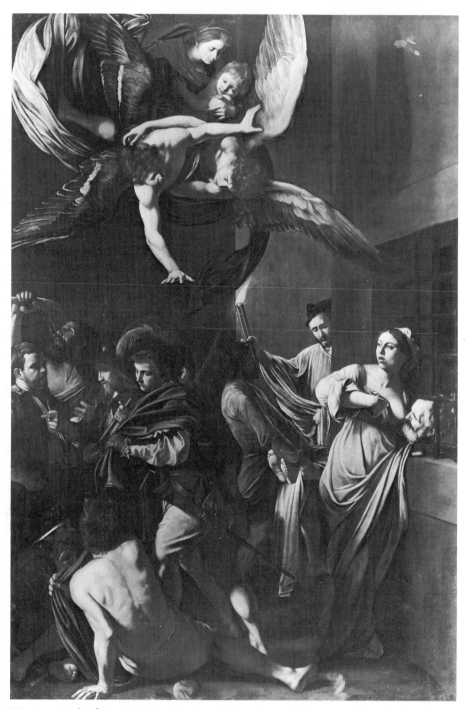

138. *Seven Works of Mercy*. Naples, Pio Monte della Madonna della Misericordia. 1606.

139. Detail of [138].

wings spread, as though scattering divine mercy; they effectively divide the crowded scene into two halves. Caravaggio has become, unexpectedly, the master of Baroque flight. Perhaps these angels were already conceived for the mysterious Radolovich commission.

The works of mercy are acted out by twelve figures, most of them seen only in part. To the left, a plump host welcomes the stranger [140]. Caravaggio identifies him as a pilgrim by the shell on his hat, and as Matthew implies, he is surely Christ, no doubt the resurrected Christ on his way to the inn at Emmaus with a companion. Drink for the thirsty is represented by Samson slaking his thirst in the desert from the jawbone of an ass: this is no ordinary Neapolitan street scene. At left center, St.

215

140. Detail of [138].

141. Detail of [138].

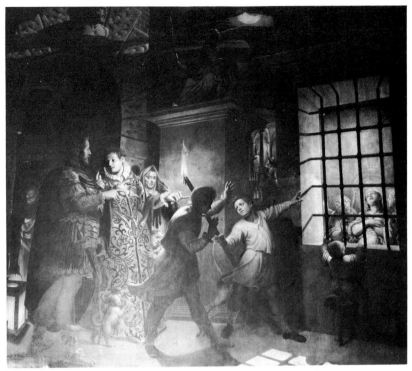

142. A. Campi, *Empress Visits St. Catherine in Prison.* Milan, S. Angelo. 1585.

Martin clothes the naked. He wears velvet and has a plumed hat, and with his sword and scabbard he marks the reappearance of Caravaggio's neo-Giorgionesque types from the earlier Roman years [cf. 12, 53]. Here, however, the sword is an instrument of healing rather than destruction, an ironic reversal that Caravaggio may have relished. Behind Martin we catch only a glimpse of Christ's companion, who is meaningless and unwanted in the larger composition, and whose legs become confused with Martin's below [141]. An almost invisible figure reclining at lower left represents the sick who are succored. We see the customary muddle of hand and gesture as Host, Christ, Martin, and the hidden traveler all seem to share extremities. An empty sheath cuts down across the pallbearer's leg, and the drawn sword glints across the face of the wretch at lower left as Martin divides his cloak. Caravaggio's fascination with swords and swordsmanship by no means ended with the death of Ranuccio Tommasoni.

To the right, divided from the other half by a dark wall, we see events concerned with last things: visiting the imprisoned and burying the dead [143]. The

143. Detail of [138].

visitor is also feeding the hungry. She represents Pero nursing her starving father Cimon—the famous (or infamous) *Caritas Romana* of Valerius Maximus, which soon inspired many prurient images. This section of the canvas contains pictorial elements that would have been familiar to Caravaggio from Lombard paintings such as Antonio Campi's *St. Catherine* [142]; the night scene, torches, and prison bars are all there [cf. also 157]. Removed from Rome, Caravaggio seems to have drawn increasingly on boyhood memories, and we shall discover these Lombard reminiscences even in Caravaggio's last works. He transformed their crude factuality and harsh illumination by filtering their memory through his experience of monumental, classic Roman art. As Freedberg pointed out, such stark, artificial light is also a metaphor that transfers the salience and depth of its contrasts to the emotions of the painted drama.[5]

Pero is Caravaggio's only female nude, if she can be called that—an incredible fact in view of the artistic conventions of the time. Unhappy with her chore, she has tucked her dress up under her father's chin and, covering her other breast, turns with crossed legs while uttering what we can only imagine as a groan from her coarse lips. Behind her, the feet of the cadaver disappear to the chant of a harshly illuminated priest. The candles that he holds aloft are one of Caravaggio's rare internal sources of light [cf. 38], but they had a great future in Caravaggesque paintings. The feet of the corpse remind us that the *Death of the Virgin* [133] had probably been finished earlier in the same year, 1606.

The *Seven Works of Mercy* is a tour de force, brilliantly composed in Caravaggio's crowded foreground manner, with imposing, even abandoned heavenly apparitions that are unique in his art and a far cry from the tentative angels of his early works [cf. 56]. The figures and draperies, fitfully illuminated, are striated with almost phosphorescent effects that are typical of his later paintings and quite different from the conventional modeling of the *Madonna of the Rosary* [118] or even that of the *Death of the Virgin*. Only a visit to the Monte della Misericordia (in the center of Naples, to one side of the Duomo) can convey the brilliance, grandeur, and pathos of this unique, and uniquely Neapolitan painting. Giulio Carlo Argan called it the most important religious picture of the Seicento.

THE CRUCIFIXION OF ST. ANDREW

The *Crucifixion of St. Andrew* [144], surely painted in Naples, may date from early 1607. It was the proud possession of Don Juan Alonso Pimentel y Herrera, Conde

[5]Freedberg (1975, p. 588).

144. *Crucifixion of St. Andrew.* Cleveland Museum of Art. 1607.

de Benavente, who was Viceroy of Naples from 1603 to 1610. When he returned home to Valladolid in July 1610 he took Caravaggio's *St. Andrew* with him. So Bellori states, and in 1658 the painting was recorded in an inventory of the Pimentel estate. Caravaggio's *St. Andrew* may thus be one of the sources of Spanish realism in the years immediately following 1610. There were also copies of paintings by Caravaggio in Spain at an early date. Francisco Pacheco, the teacher and father-in-law of Velázquez, called Caravaggio *"valiente imitador del natural."* [6] This picture may have been painted in the late winter or spring of 1607, before Caravaggio went to Malta, but it also has elements in common with later works.

The scene in Caravaggio's painting is not easily understood. It would seem that the man at the left is tying Andrew to the rude cross, but that is an error. (The so-called St. Andrew's cross was by no means standard and was even specifically rejected by some contemporary authorities; Caravaggio has it both ways by alluding to the traditional form through Andrew's crossed legs.) The legend depicted here was popular in Spain at just this time: the proconsul responsible for Andrew's martyrdom in Greece ordered that he be tied rather than nailed to the cross so that he would suffer longer (Andrew's sin was having converted the proconsul's wife). Andrew lived for two days, preaching to increasingly large crowds that demanded his release. The proconsul, seen in armor at the front of Caravaggio's painting, yielded and ordered Andrew untied, only to be thwarted by a supernatural act. The arms of Andrew's saviors were frozen by a divine paralysis in answer to his prayer to be allowed to die as a martyr. Heaven's response was a dazzling light; when it vanished, Andrew died. It is this scene that we witness in Caravaggio's painting, but the supernatural elements can be detected only by knowing the story.

The bodies in the foreground are brightly highlighted in Caravaggio's usual manner; the mysterious shaft of light at the right probably alludes to the heavenly effulgence of the legend. As in many of the later works, the colors are subdued and dark: dull red on Andrew, gold on the would-be savior, and a green accent on the woman are the only relief from the general brown and the sallow flesh tones.

The old woman has a prominent, realistically painted goiter. Goiters were common around Naples; it may be shown here to inspire compassion with the misery of the poor and sick—or possibly to signify the conversion of a sinful person. Originally she held her clasped hands in front of her disfigured throat, where a large

[6]Pacheco (1649; 1956, I, p. 144). Velázquez's rival at the Spanish court, Vicente Carducho, attacked his enemy under the guise of talking about Caravaggio (1633, p. 89), whom he accused of being an "evil genius, who worked naturally, almost without precepts, without doctrine, without study, but only with the strength of his talent, and nothing but nature before him, which he simply copied . . . ," comparing him with the Anti-Christ (trans. Brown; Enggass & Brown, 1970, pp. 173–174). The Spanish text is reprinted by Longhi (1951, p. 51).

145. *Flagellation of Christ*. Naples, Capodimonte. 1607.

222

pentimento can still be seen. She is the sole sympathizer in the painting—the men at the right seem to be ruffians connected with the proconsul—and she stands like a Greek chorus responding to the pitiful martyrdom of the emaciated old man.

THE FLAGELLATION OF CHRIST

The only other documented painting of the first Neapolitan period is a *Flagellation of Christ* [145], painted for a family named De Franchis and later placed in their chapel in San Domenico Maggiore (a Dominican connection like that of the *Madonna of the Rosary* [118]). The dramatic composition derives from Sebastiano del Piombo's great fresco in Rome, which was supposedly based on little sketches by Michelangelo [146]. Caravaggio once more reveals his Michelangelesque interests of several years before, and his return to what might be called a High Renaissance composition becomes obvious when we compare his picture with the elaborate Mannerist tableau by Federico Zuccaro, which he would also have known [147]. As he did in other pictures [82, 107], Caravaggio again participates in the return to High Renaissance art that we associate chiefly with Annibale Carracci. This revival, which unites a renewed

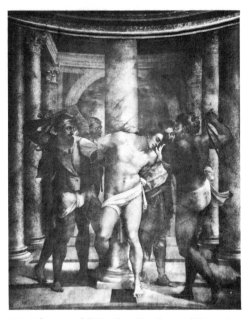

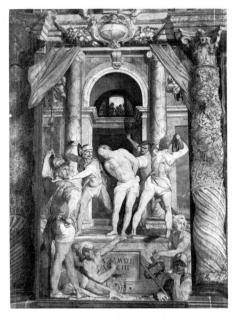

146. Sebastiano del Piombo, *Flagellation of Christ*. S. Pietro in Montorio. c. 1521.

147. F. Zuccaro, *Flagellation of Christ*. Oratorio del Gonfalone. 1573.

148. Detail of [75].

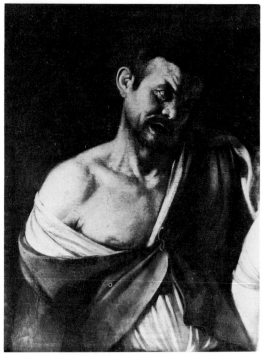

149. Detail of [145].

study of nature with inspiration from classic models, was the essential basis for the new Baroque styles of Rubens and Bernini.

Caravaggio concentrated the action, blotted out the background, reduced the space and the number of tormentors, and—perhaps most surprising—made the body of Christ elegantly curvilinear, almost like some Mannerist figures and recalling the *Madonna di Loreto* [120]. The painting has almost no color; golden browns predominate. A flickering light-dark illuminates the play of legs, feet, and hands. Above, there is only the column and the dark. As in the Cerasi Chapel, Caravaggio concentrates on process, with Christ being kicked and tied into place at the column. The man at the left pulls Christ's hair in his attempt to straighten him. The tormentor in front is still making his scourge as he looks up, his dark profile silhouetted against Christ's thigh. All this activity revolves around a central highlight that reveals Christ.

The canvas as a whole is very broadly painted—and quickly too, one would say—which is characteristic of Caravaggio's later works. They now approach a Venetian technique. Outlines are fuzzy, often created by a single broad brushstroke [149]. Wrinkles and other details border on caricature. The almost expressionistic strokes that compose the head in [149] are quite different from those of the *Madonna of the Rosary* [124]. Such free passages gave Roberto Longhi the idea that this picture could date from 1609–1610; but Caravaggio was capable of brilliantly summary treatment as early as 1601 [cf. 148].

The *Flagellation* is no doubt connected with payments made to Caravaggio in May 1607, totaling 250 ducats, from a member of the De Franchis family. Another De Franchis was an official of the Pio Monte della Misericordia, which probably explains the new commission. The *Flagellation* had still not been delivered on 29 May, when a last payment was made.

ST. JEROME WRITING

Caravaggio's last surviving *St. Jerome* was formerly in a chapel of the Cathedral of Malta [150]. As in the Borghese picture [127], the saint writes; but now he is seated on a bed behind a table that displays a macabre skull and a small crucifix. The Maltese picture is the more conventional in showing a room with furnishings, a cardinal's hat, and a door (if that is what we see at the right) inscribed with the arms of the patron, Ippolito Malaspina. The crucifix, resting precariously on the edge of the table nearest us, is reminiscent of earlier tricks [cf. 42]. The stone refers to Jerome's self-punishment,

150. *St. Jerome Writing.* Malta, Valletta, Cathedral Museum 1607–08.

a popular scene that Caravaggio never chose to depict, though numerous *Jeromes* by him are recorded in contemplative poses. An austere, thoughtful, pensive picture, the *St. Jerome Writing* was paired in the chapel with a *Magdalen:* the theme of penitence is clear. Malaspina was Prior of the Knights of Malta in Naples, but Caravaggio's painting may have been completed in Malta. In contrast to the larger, freer works of this period, it is highly finished. He seems to have kept a more precise style for his cabinet pictures while evolving a broad manner for grand public works.

Malta

Caravaggio arrived on the island of Malta on 13 July 1607.[7] His motive in visiting that dreary isle was the hope of becoming a Knight of St. John. His connections with Malta were various: relatives of the Giustiniani were Maltese Knights, and his Roman patron Ottavio Costa, who owned the *Judith* [36], was related to Ippolito Malaspina, for whom Caravaggio painted the *St. Jerome Writing* [150]. The Costa-Malaspina connection probably led him to go to Malta to paint the portrait of the grand master. There is no proof that Caravaggio was continuously on Malta until his departure in October 1608; since communication was constant between Malta and Naples, he may have made at least one voyage back.

The Knights Hospitaler of St. John are the oldest existing order of chivalry. They are the only group still surviving from the Crusades, tracing their origins back to a hospice for pilgrims in Jerusalem that was at first under Benedictine rule; eventually the Hospital of St. John had branches in many Mediterranean ports. After the fall of Acre in 1291 the Knights were expelled from their last toehold in Asia Minor; they settled on Cyprus and in 1309 on Rhodes, but they were besieged and driven from Rhodes in 1523. In 1530 Charles V gave the Knights a precarious home on the inhospitable island of Malta, where in 1565 they had to endure attacks of proverbial length and ferocity under the direction of Sultan Suleiman. Some seven thousand defenders lost their lives.[8] In the end Malta stood, and the famous siege proved to be the last great effort of the Ottoman Turks to conquer the western Mediterranean. Had they succeeded, Europe would have been all but encircled from the south.

[7]Ashford's hypothesis (1935) that Caravaggio was on Malta in the summer of 1607 was confirmed by a document of litigation in which Caravaggio was a witness (Azzopardi, 1978; cf. Spike, 1978). On 14 July 1607 Caravaggio was the guest of Fra Giacomo Marchese at his home in Valletta. At about this time (20 May 1607) the agent of the Duke of Modena wrote that "they are negotiating for his [Caravaggio's] release," and on 20 August: "Now they are negotiating peace for Caravaggio, who, as soon as it is concluded, will return [to Rome]." (Cinotti, 1971, p. 161, F 81; cf. p. 180 and n. 13 above).

[8]Bradford (1972) is a good popular history with bibliography.

151. *Portrait of Alof de Wignacourt with a Page.* Paris, Louvre. 1607–08.

PORTRAITS OF ALOF DE WIGNACOURT

During the siege the Grand Master of the Knights of St. John was Jean de la Valette-Parisot, after whom the capital city is named. A future grand master, Alof de Wignacourt, was also there, and it is he who is portrayed by Caravaggio [151]. He wears old armor that may well be La Valette's. This painting is in such poor condition that we can say little about it except that it shows Wignacourt's head much as it appears in other portraits. He stands in a stereotyped pose, probably dictated by the authorities, which ultimately goes back to Titian. Bellori reports that Wignacourt made Caravaggio an honorary knight *(per grazia)* in thanks for portraits, including a seated one that has disappeared. Caravaggio was made a knight of the *Ordine di Obbedienza,*[9] which may confirm that he was not of humble origin. The document of knighthood states grandly that "Malta would honor Caravaggio as the island of Cos had honored its Apelles." The reference to Apelles was canonical, but the allusion to Cos was also poignant, for the Knights had themselves been masters of Cos when they were stationed on Rhodes.

THE BEHEADING OF ST. JOHN THE BAPTIST

Caravaggio's largest painting, the *Beheading of St. John the Baptist* of 1608 [153], is the altarpiece of a large oratory off the right aisle of the Cathedral of St. John in Valletta. It was perhaps painted in thanks for his knighthood, as Bellori thought. The picture also honors Caravaggio, for an altarpiece for that chapel was probably the most important commission that the Knights of St. John could offer. Over five meters wide, this work far outstrips Caravaggio's other paintings in size. Since the Feast Day of the Decollation of the Baptist falls on 29 August, it is probable that the painting was finished by that date in 1608. And presumably it was completed after Caravaggio was knighted on 14 July.

The familiar story of the beheading of the Baptist is told by Mark and Matthew, but they say only that Herod "sent a soldier of the guard with orders to bring John's head. The soldier went off and beheaded him in the prison, brought the head on a dish, and gave it to the girl; and she gave it to her mother" (Mark 6:27–28). The scene that Caravaggio illustrated is not in the Bible but appears in the *Golden Legend,* which summarizes the extended medieval accounts.

Pictures of the subject were popular in north Italy [152, 157, 169], and

[9] A subdivision of the general class of the *Cavalieri di Grazia;* see Marini (1978, p. 78, n. 18).

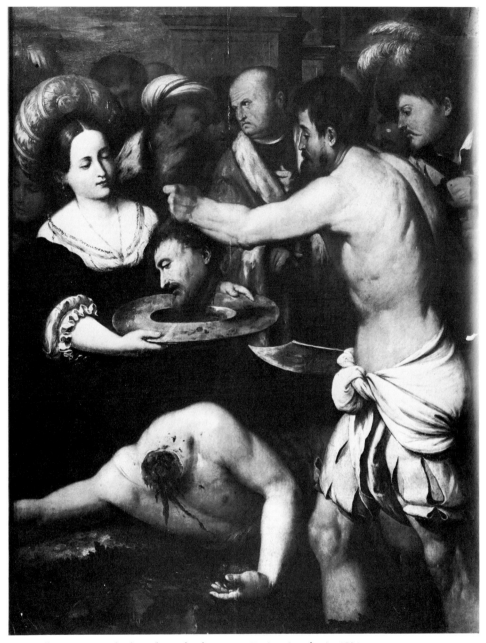

152. Callisto Piazza, *Beheading of St. John the Baptist*. Venice, Accademia. 1526.

Caravaggio himself painted the scene of the head being presented to Salome, perhaps more than once [168, 170]. In Callisto Piazza's picture of 1526 [152] we see the gory tradition from which Caravaggio sprang; but this painting explains more about early Caravaggio than late, for now he has eliminated flamboyant costumes and muted the horror.

Caravaggio's painting [153], neglected and damaged as it was, came into its

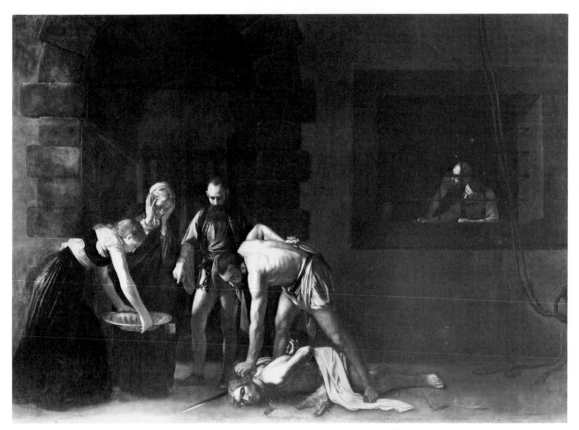

153. *Beheading of St. John the Baptist.* Malta, Cathedral. 1608.

own after it was restored and exhibited in Rome in 1955–1956 (an event that no one who was present will ever forget). It is painted surely and rapidly, with few *pentimenti,* little care for detail, and, as Bellori pointed out, with the priming left visible in the middle tones [cf. 161]. Because it is huge and relatively empty, it makes its best impression from the back of the long chapel. Caravaggio must have calculated this effect with some care. The hues are muted; the brilliant flame-red of John's garment is the only powerful spot of color.

As in most of Caravaggio's late paintings, the human figures are dwarfed by empty space and, here, by the architectural details of the palace behind. This is one of Caravaggio's few pictures in which the true Roman scale begins to emerge: the huge portal and other architectonic elements put man at a disadvantage. The action takes place in a piazza or court centered within the arch. Two men, perhaps prisoners, look out of the grillwork window at the execution [154]. The main group is posed in the most formal way, the old woman and the jailer erect, Salome and the executioner bending inward [155]. The jailer points to Salome's charger, lowered to

154. Detail of [153].

receive the severed head, while the executioner, holding John by his long hair, reaches for his knife to finish the job. All of this is gruesome, but it is fixed as art rather than life by abstract symmetry, an extension of the discovery that Caravaggio had made in painting the *Doubting Thomas* [104]: hyperclassic grouping mitigates horror.

John is dead. We are far from the theatrics of the early *Judith,* where horror was emphasized for its own sake as Holofernes screamed and blood gushed [36]. Blood runs in the Malta *Beheading* too, a relatively unobtrusive but unavoidable detail in the center foreground. Of course our eyes focus on just that spot, and if we could get close enough to the picture behind the altar, we would read in the blood Caravaggio's only and terrible signature: "F Michel A . . ." [156], the rest now obliterated by damage. Presumably the signature was to read "Fra Michel Angelo," meaning that he was already a Knight of Malta (or perhaps it was added to the finished picture after he had attained his knighthood). The signature is proof of Caravaggio's pride in attaining the honor he had sought so assiduously: its place and its nature are almost pathological, and they seem to confirm our suspicions of Caravaggio's identification with the Baptist and of his unusual preoccupation with beheading.

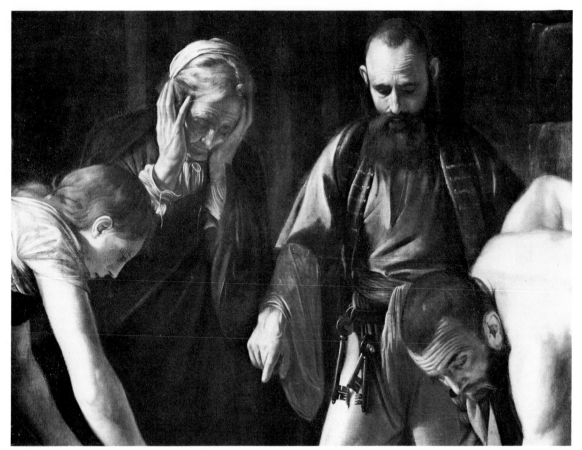

155. Detail of [153].

It was extraordinarily daring to leave three-quarters of the canvas essentially empty, as Caravaggio does in this painting. Probably he did so because of an unwillingness to paint figures very much over life size; the canvas is three and two-thirds meters high, and the foreground figures are at least as big as real people. I also suspect that Caravaggio chose this kind of composition because of a growing sense of man's essential isolation and tragic destiny. All the great altarpieces of the next year have something of this emptiness. Its roots are in the *Calling of St. Matthew* of 1600 [52], but the late pictures consistently show relatively small figures in a vast space.

Just how far he had come from his immediate predecessors in Lombardy can be gauged by comparing the *Beheading* with a similar subject by Antonio Campi, painted for San Paolo in Milan when Caravaggio was ten years old [157]. The grim

156. Detail of [153].

157. A. Campi, *St. John the Baptist Awaiting Execution*. Milan, S. Paolo. 1581.

interior with its wooden figures illuminated by torchlight looks "Caravaggesque," but we see how different Caravaggio actually is: spacious, almost noble in his grouping, and relatively idealizing in his figural types.

The only other picture that Caravaggio definitely painted on Malta is a *Sleeping Cupid* [172], which shows the dark, glowing style of his late works.

9
Sicily, Naples, Death

In addition to the Cross of Malta, Bellori tells us, the grand master gave Caravaggio a rich collar of gold, two slaves, and other marks of esteem. Nevertheless his nature did not allow him to remain a docile knight for long. Bellori, who visited Malta, reports that Caravaggio attacked a noble knight and was thrown into prison. He adds that Caravaggio was subjected to "misery, fear, and maltreatment." It has been suggested that the report of Caravaggio's Roman crime alone might have been the cause of his downfall, since men convicted of homicide were not allowed to become Knights of St. John.[1]

A document of 6 October 1608 reports that Caravaggio had been in prison and escaped by means of ropes; Baglione tells us that he did this at night. We must presume that Caravaggio was helped by someone in authority so as to get him out of the way and to avoid embarrassment. No one could possibly escape from a prison on Malta and over the sea to Sicily unaided.[2]

THE BURIAL OF ST. LUCY OF SYRACUSE

Caravaggio landed at Syracuse, which was the first stop for ships going north (see the map on page 236). There his Roman companion of some ten years, Mario Minnitti, lived and practiced.[3] We may assume, as his Sicilian biographer Susinno

[1]See Marini (1974, pp. 44–45) and Sammut (1978).

[2]Bellori (p. 210) has more detail than Baglione (p. 138). The date of the escape was published by Ashford (1935). In contrast to Bellori's account of Caravaggio's living a life of knightly decorum, cf. Susinno (1960, pp. 109–110; p. 381 below). Whether this report refers to Malta or to his later behavior in Sicily (Susinno's home territory) is not clear.

[3]Mack Smith (1968) is the best historical survey. For Minnitti, see Susinno (1960, pp. 110, 116 ff.)

stated in 1724, that Minnitti helped Caravaggio get a commission for a big altarpiece, the *Burial of St. Lucy of Syracuse* [158]. (Susinno wrote that Caravaggio was then *"in Italia il primo depintore."*) He painted it, probably late in 1608, for the Franciscan church of Santa Lucia al Sepolcro outside the city in the old Greek port, where St. Lucy's tomb was still venerated. St. Lucy is the patron saint of Syracuse, but depictions of her burial are all but unknown. The choice of subject was based on the fact that Lucy had been buried nearby, though her body had long since been removed. Thus Caravaggio's painting records the meaning of the site and the purpose of the old church. The picture, once in desperate condition, has been carefully restored. It shows signs of having been painted quickly, perhaps in order to have it ready for the feast day of St. Lucy on 13 December.

The *Burial of St. Lucy,* over four meters high, is again powerfully empty. The vast space above the figural group is occupied at the left by a huge arch or niche that is supposed to have been modeled on an ancient artificial grotto or prison. Caravaggio, who visited that famous tourist attraction with an archaeologist, said that it was

236

modeled on an ear, and it is still called *l'Orecchio di Dionigi*.[4] Actually, Caravaggio's arch in the painting is almost round whereas the *Orecchio* is pointed; inside the painted form we seem to see a vault, and it is possible that Caravaggio tried to invoke the sepulchral vastness of one of the rock-hewn catacombs that are a feature of Syracuse, which he must also have visited; Lucy herself had been buried in such a place.

Within the void of the painting the striking differences in scale between the huge diggers in the foreground and the crowd behind are somewhat reduced, but the composition may still show Caravaggio's relative inability to place figures accurately in space. Perhaps too he remembered Mannerist paintings from Lombardy, in which similar contrasts were common. The two gravediggers are exaggerations of the two bowing figures in the foreground of the *Beheading,* his most recent picture [155], and the seemingly forced perspective diminution of the spectators in the rear is also developed from a similar but less shocking reduction in scale in that painting. Compared to a Roman work like the *Entombment* [107], the void is immense and the figures relatively small—a characteristic of his late works.

The result is impressive and affecting. Lucy lies at the bottom left, the focus of attention, framed by the looming gravediggers and emphasized by the edge of the dark niche, which seems to descend precisely on the line of her exposed throat. Caravaggio had used architecture to similar effect in the *Beheading of the Baptist* [153], and even the *Madonna di Loreto* [120] might be compared. The heads of the other figures climb gradually to the contrasted pair of authorities at the right, the dark and sinister officer in armor directing the burial beside a brightly illuminated, benevolent bishop. There we see those tricks of gesture that Caravaggio seems to have loved— or to have been unable to avoid. The man in armor holds out his left arm horizontally, in shadow, to direct the gravediggers; the raised hand in the light, which seems to belong to him, is the right hand of the blessing bishop. (The hand near the bishop's face belongs to a bystander clutching a pike.) We might imagine that Caravaggio used these tricky manipulations as a subtle commentary on the difficulty of distinguishing good from evil.

The pitiful saint with her throat cut so discreetly [159] may owe something

[4]The archaeologist, writing in 1613, tells us: "I remember when I took Michelangelo da Caravaggio, that unique painter of our time, to see that prison. He, seeing its strength, and impressed by its uniquely ingenious imitation of nature, said: 'Don't you see how the Tyrant [Dionysius], in order to make a horn to hear things, took no other model than that which nature had produced for the same use? Therefore he made this prison like an ear' —which, having been overlooked before, henceforth became a commonplace" (V. Mirabella, *Dichiarazioni della pianta dell'antiche Siracuse,* Naples, 1613, p. 89, quoted from Marini, 1974, p. 76, n. 360; also Cinotti, 1971, p. 164, F 112). Dionysius the Elder (c. 430–367 BC) was Tyrant of Syracuse, as was his son until 344 or 343. The grotto, which seems to have been built out of an ancient aqueduct, produces great amplification of sound. I am grateful to Louise Rice for pointing out the discrepancies between the form of the "*Orecchio*" and Caravaggio's niche.

158. *Burial of St. Lucy*. Syracuse, S. Lucia al Sepolcro (temporarily? removed). 1608.

159. Detail of [158].

to Caravaggio's memory of the famous recovery of the body of St. Cecilia in Rome in 1599 and the commemorative statue by Stefano Maderno, produced in 1600, which is similar to Lucy in its simplicity [160]. Originally, however, Caravaggio showed Lucy's throat brutally slashed; his later modification of the wound now bears a revealing *pentimento.* The mourning woman bending over Lucy is almost a reverse copy of the old woman from the *Beheading of St. John,* which he had just finished [161, 162].

Few other details merit attention. (One head in the center is so different from Caravaggio's normal style that it may be by an assistant, even by Minnitti.) We note an increase in the use of stereotypical poses and gestures, which seems to have occurred from the time he left Rome: thus the ecclesiastical figure behind Lucy and the female figure at his right derive from the tradition of the dolorous John and Mary in Renaissance *Crucifixions.* We can assume that Caravaggio was less and less dependent on models in these years. The general tonality is golden, but much has been lost; at one time the painting may have been folded like a tablecloth; the entire bottom area is missing, including the workmen's shovels and big stones that can be seen in a copy. Unlike other depictions of saintly burials in this period, there is no heavenly chorus of angels to illustrate her place in paradise. As in the *Death of the Virgin* [133], Caravaggio shows only human aspects of divine drama. He eschewed the host of

160. S. Maderno, *St. Cecilia*. S. Cecilia in Trastevere. 1600.

angels that would normally swarm in the upper half of a saintly burial and so emphasized the emptiness of earthly death [cf. 133]. The essential hopelessness of the interpretation may well reflect Caravaggio's own doubtful attitude toward salvation. Set in place in the old rounded apse of Santa Lucia, behind the raised altar, the painting was impressive indeed, as old photographs show. It was an immediate success and was often copied.

Messina

We do not know when or why Caravaggio left Syracuse in the winter of 1608–1609, but there was probably no future for him there. (It was also the busy port of arrival and departure for Malta, which depended on Sicilian produce.) Caravaggio moved up the coast to Messina, even though it had an active Priory of Maltese Knights. Since he evidently traveled about as a celebrity, using the title Cavaliere di Malta, and since he lived in Messina for months, it seems obvious that his escape from Malta must have been achieved in collusion with the administration at Valletta. The Knights must have been willing to let him practice his profession in peace. Although the grand master, on 1 December 1608, expelled him from the order "like a foul or putrid limb," Caravaggio continued to pass as a Knight of Malta to the end of his days.[5] And, as his Sicilian biographer learned, knighthood, far from calming Caravaggio, made him even more impossible than he had been.[6]

THE RESURRECTION OF LAZARUS

On 6 December 1608 a resident of Messina named Giovanni Battista de Lazzari declared his intention of building a high-altar chapel in the church of the Padri Crociferi with an altarpiece showing the Madonna with his name saint, John the

[5]For the expulsion, see Sammut (1978).
[6]See p. 381 below (Susinno, 1960, pp. 109–110).

240

161. Detail of [153].

162. Detail of [158].

241

163. *Resurrection of Lazarus.* Messina, Museo. 1609.

164. Engraving after Giulio Romano, *Achilles Bearing the Body of Patroclus.*

Baptist, and others. By 10 June 1609 Caravaggio had finished a different painting altogether for the same patron, a *Resurrection of Lazarus* [163], which relates to the patron's name, Lazzari. The change may have been due to Caravaggio's own preference for a scene of activity rather than a traditional icon.

The picture Caravaggio painted is almost as large as the *St. Lucy,* and again it shows a frieze of figures against a dark, plain, but impressive architectural background. Jesus at the left holds out his hand in a commanding gesture recalling that of Christ in the *Calling of St. Matthew* [54]; other details show Caravaggio repeating even earlier works—the face at the left above Christ makes us think of the *Boy Bitten* [25]. The outstretched arms of Lazarus, stiff with death, are unusual, but they are paralleled in an impressive early painting by the Cavalier d'Arpino that Caravaggio may have remembered. The body held by a standing man behind could be based on an antique relief representing Achilles with the body of the dead Patroclus, a subject that had been painted by Giulio Romano and engraved [164]. The figures are swathed in the swiftly painted, striated drapery that was used in the *Burial of St. Lucy* and are lighted by almost phosphorescent effects. This painting too is in poor condition; its colors have changed, and those other than brown are found in only a few areas, such as the dark gold and green on Martha and a deep red on Christ, whose stolid head is probably not by Caravaggio at all but a later repainting. In general there is little color and the reddish ground shows through almost everywhere.

The unusual pose of Lazarus may be meant to foreshadow the crucifixion of the Christ who resurrects him, thereby encapsulating the Passion and the Resurrection in one miracle. It is also possible, as Röttgen has argued, that the right hand, which catches the light, is deliberately raised in an antique gesture of acclamation, whereas the left arm leads our eyes down to the skull (we think again of Golgotha) as if to show that Lazarus is in a struggle, both physical and psychological, between death and life. The Padri Crociferi were *"Ministri degli Infermi,"* hospitalers in charge of the sick; a struggle between life and death, aided by religion, was for them an

165. Detail of [163].

244

everyday matter. Susinno tells us that Caravaggio set up shop in the hospital and some of the models were presumably patients.

Above Lazarus we see his sisters Mary and Martha; the interlocking faces of Mary and Lazarus are almost Giottesque in their simplified power [165]. Here too we see the amazingly broad technique of the late Caravaggio, especially in the highlights. The detail gives an idea of his brushwork, of the rapidity and relative thinness of the painting: Caravaggio is actually drawing in paint.

Susinno, writing well over one hundred years later, says that when Caravaggio's first painting for Lazzari was criticized for a minor defect, the painter unsheathed his sword, cut the picture to shreds, and proceeded to paint a new one that he asserted would be just what they wanted. Susinno relates this episode to an apocryphal story about Cimabue; we need not give it much credence, but even if false, it is *ben trovato*.

THE ADORATION OF THE SHEPHERDS

Caravaggio's other surviving painting for Messina is an *Adoration of the Shepherds,* painted for a Capuchin church, perhaps on the order of the Senate [166]. More than three meters high, it was originally even larger and is now in poor condition. The powerfully diagonal composition focuses on Mary, dressed in red. (Messina is the "city of the Virgin.") She is related to the old theme of the Madonna of Humility, and as Longhi pointed out, the carpenter's tools in the foreground produce a still life of the poor. The figures are placed back within a believable interior space with a ceiling. Nevertheless, the shepherd in the center, next to Joseph, appears to have been crowded in as an afterthought, which often seems to have been Caravaggio's practice. The reverence is intent and silent. Details are now irrelevant to his purposes; compared to that of an early work [cf. 42], the still life here is vague and blurred. This is one of Caravaggio's most deeply felt and impressively simple works. Like other late pictures, it relies on a resonant space to accentuate the silent devotion of the figures.

Caravaggio received the incredible sum of 1000 *scudi* for this painting, by far the highest recorded payment to him. Susinno, the local biographer, called the work "unique, his most masterly painting." Caravaggio also got a private commission for stories of Christ's passion on four canvases, of which at least one was painted and is now lost.

He could have reflected on the irony of coincidence that led him to Messina, just as it had his great predecessor from Caravaggio, Polidoro, after the Sack of Rome.

166. *Adoration of the Shepherds.* Messina, Museo. 1609.

Polidoro too went first to Naples, then to Sicily, and finally to Messina, where he was murdered in 1543. His last work, also an *Adoration of the Shepherds,* has remained in Messina and must have attracted Caravaggio's attention, though there are no signs of its influence in his painting.[7]

THE ADORATION OF THE SHEPHERDS WITH STS. LAWRENCE AND FRANCIS

Caravaggio's last Sicilian altarpiece must have been painted in the summer of 1609. It is, or was, an *Adoration of the Shepherds with Sts. Lawrence and Francis* [167] for the Oratory of St. Lawrence in Palermo. The picture was stolen in 1969. It is somewhat more conventional than the other Sicilian paintings, but like them it is large —more than three and a half meters high. The subject is treated as genre, with figures crowded close to the picture plane; the standing figures with their bowed heads almost seem oppressed by the sloping roof. This picture contains the last of Caravaggio's angels, who flies down rather like those in the *Seven Works of Mercy* [138], one hand holding a traditional banderole bearing the words GLORIA IN ECCELSIS DEO, the other pointing upward to heaven. With the exception of the vigorous angel, the spirit of the painting lies somewhere between mourning and meditation. The naked Christ child lies pitifully on a tiny sheet in the straw as Mary looks down with a sorrow that shows that she understands his destiny. By this time the interconnections between the adoration of the infant Jesus and the lamentation over his corpse were so well known that either subject evoked the other. Caravaggio seems deliberately to have made reference to the *Pietà* here, and the helpless infant seems almost Flemish in its austerity.

Palermo must have been much less pleasant to visit than Messina: Spanish control was more evident, and life was dominated by the Inquisition.[8] Hence, perhaps, the relatively pietistic character of Caravaggio's painting.

[7]The parallel occurred to Mancini (p. 225, n. to lines 15–16) but in connection with Caravaggio's death, since (despite Vasari) he thought that Polidoro had been murdered *"in campagna."* Caravaggio's departure from Messina is explained by Susinno (see p. 386 below). This incident is one of two "homosexual" reports that have come down to us about Caravaggio; for the other, see p. 87 above, and Note 96.

Susinno also reports a story of Caravaggio's "impiety" that has been discussed as a symbol of his tragic view of himself, which concludes with Caravaggio's statement, "All my sins are mortal." Perhaps this story should be coupled with Sandrart's report (p. 379 below) that Caravaggio and his friends in Rome had as their motto *"nec spe, nec metu"* (no hope, no fear), an old Stoic device (cf. Röttgen, 1974, pp. 258–259, n. 250). Susinno (1960, p. 114) also repeats the rumor that Caravaggio was an atheist; but we must remember that he wrote in 1724.

[8]Marini (1974, p. 55); Mack Smith (1968).

167. *Adoration of the Shepherds with Sts. Lawrence and Francis.* Formerly Palermo, Oratorio di S. Lorenzo. 1609.

Naples Again

Caravaggio seems to have had the increasing sense of being pursued, and we may suppose that he had become somewhat paranoid. Perhaps, too, someone or some group was actually out to get him, possibly even the aggrieved *cavaliere* from Malta. At an unknown date Caravaggio left Sicily for Naples. The only notice we have is of 24 October 1609, when the Urbino correspondent in Rome reported that Caravaggio was in Naples and had been killed or wounded.[9] Later Baglione wrote that "his enemy finally caught up with him and he was so severely slashed in the face that he was almost unrecognizable." The attack occurred in the Locanda del Cerriglio, a notorious haunt of pleasure-seekers and worse that was recorded in Basile's *Muse napolitane* of 1635. The story inevitably conjures up the last act of *Rigoletto*.

Nevertheless, Caravaggio had more life and more pictures in him, although just what he may have painted during his last months is not clear. Two Neapolitan works, recorded in the literature, are apparently lost. A *Resurrection of Christ* and a *St. Francis Receiving the Stigmata* presumably date from this period. Both were painted for the Fenaroli Chapel in Sant' Anna dei Lombardi, which was destroyed by an earthquake in 1798.[10]

SALOME RECEIVING THE HEAD OF ST. JOHN THE BAPTIST

An old woman related to those found in [153 and 158] looks on with similar emotions in a late *Salome* [168]. In that painting the old woman's hands are clasped to her throat, as they had been at first in the *Crucifixion of St. Andrew* [144]. Bellori says that in Naples Caravaggio painted a *Salome with the Head of the Baptist* that he sent to Malta to placate Wignacourt. That canvas was presumably painted in 1609–1610. A picture of *St. John the Baptist* was also found among Caravaggio's effects when he died, and one of these paintings, if there really were two, could be the *Salome* in

[9]The *avviso* states: "We learn from Naples that Caravaggio, famous painter, was killed; others say wounded" (Orbaan, 1920, p. 157; cf. Baglione, p. 138). Baglione collapses the events of a year into his sentence on this moment in Caravaggio's life.

[10]The chapel was given to the Fenaroli only in December 1609, hence Caravaggio's paintings must be later still: see Pacelli (Pacelli-Bologna, 1980, p. 29, n. 3). The paintings were mentioned in an addition to Mancini's manuscripts (I, p. 340): *"In S. Anna, chiesa de' Lombardi, nella strada di Montoliveto, si trova una tavola d'un Christo resurgente bellissima.*
"In detta chiesa e cappella un S. Francesco in atto di ricever le stimate."
A description of the *Resurrection* is in Scaramuccia (1674, p. 75; see pp. 374–375 below). Moir (1976, pp. 148–149, n. 249) made an elaborate attempt at reconstructing the lost original from later pictures. Descriptions of the *Resurrection* mention that Christ had one foot out of the tomb; the supernatural was excluded (cf. Bologna, 1974, pp. 165–166).

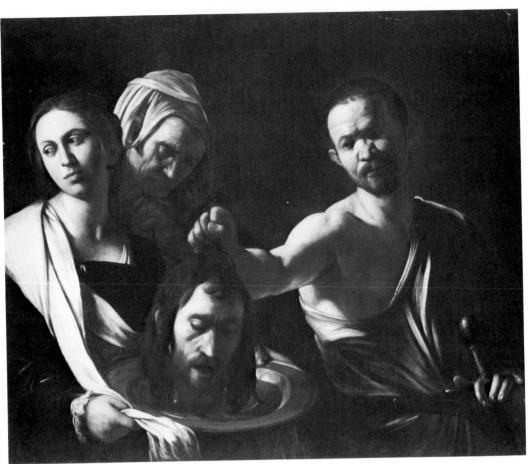

168. *Salome Receiving the Head of St. John the Baptist.* London, National Gallery. 1610?

169. B. Luini, *Salome Receiving the Head of St. John the Baptist.* Florence, Uffizi.

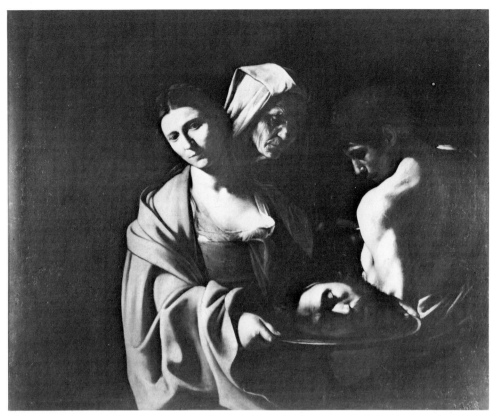

170. After Caravaggio (?), *Salome Receiving the Head of St. John the Baptist*. Madrid, Palacio Real.

London. It is so quickly painted that it seems unfinished, as it may well be, with thin, hastily applied paint and schematic drapery on the executioner. Salome looks away, as do the Leonardesque prototypes that lie behind the composition [169]. The entire surface shows signs of hurry; the color on Salome's face is applied like makeup, stopping crudely at the hairline.

Another *Salome,* which is certainly attractive, seems to be a pastiche [170]. The composition is similar to that in the London painting, with an almost identical old woman, but with an unusual emptiness at the left. Salome's décolletage is unlike Caravaggio, as is the rather poetic executioner, seen from the back and in profile like some of Caravaggio's *repoussoir* figures of around 1600 [cf. 63]. He is close to a number of figures by the Neapolitan painter Giovan Battista Caracciolo ("Battistello," 1578–1635), who was the nearest thing to a student that Caravaggio ever had.[11] This picture evidently suffered from a fire in the eighteenth century and must be considerably restored.

[11]Nicolson (1979, pp. 29 ff.).

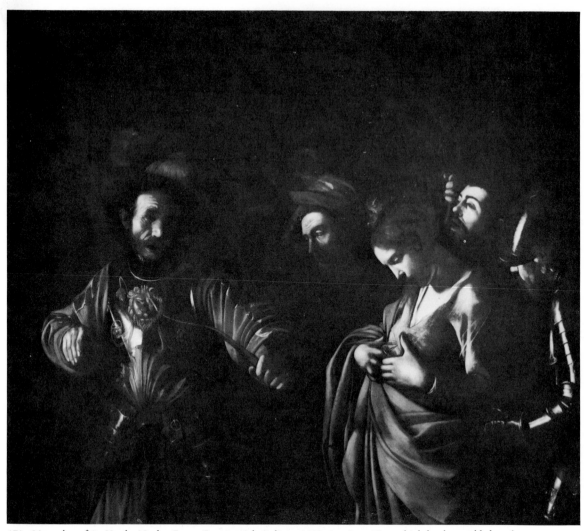

171. *Martyrdom of St. Ursula.* Naples, Banca Commerciale Italiana. 1610. A strip c. 15 cm. high has been added at the top.

THE MARTYRDOM OF ST. URSULA

A recently identified painting, *The Martyrdom of St. Ursula,* is documented as finished in May 1610 [171]. A letter from Naples to Prince Marcantonio Doria in Genoa, dated 11 May 1610, describes the varnish on the picture as still fresh and reports

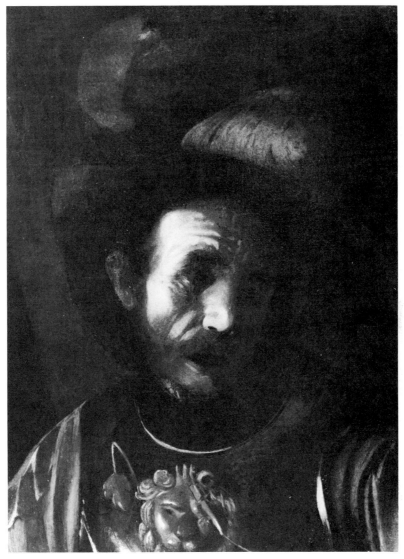

171a. Detail of [171].

consultations with Caravaggio. The subject is an unusual close-up of the martyrdom of a legendary virgin saint who was supposedly shot by the king of the Huns after refusing to be his wife. The *Golden Legend* reports that "he, seeing himself treated with contempt, aimed an arrow at her and pierced her through," which is what Caravaggio shows at horrifyingly close range, the string still throbbing on the bow. This last glimpse of Caravaggio's art proves that he continued to be a uniquely powerful painter up to the end, with an intensity and drama that no contemporary could match.

Ursula's face, shaded and bowed, is similar to that of Martha in the *Resurrection of Lazarus* [163]. More surprising, the bearded man at the right with his hand in the air looks like a later version of the supposed self-portrait in the *Betrayal of Christ* [38]. (The latter looks like a considerably earlier painting from the copies we know, but it may have to be dated later now that we have this evidence.) The *St. Ursula* has suffered, but the broadly painted head of the Hun [171a] leads us to believe that Caravaggio was entering a new phase, with increasingly free brushstrokes, that breaks new stylistic ground.

The letter to Genoa reveals that Caravaggio was a "friend" of Prince Marcantonio Doria, and presumably it was he who had commissioned a fresco of Caravaggio in 1605, with no result (see p. 197). It also transpires that Caracciolo was painting a *Martyrdom of St. Lawrence* for Doria at this time.[12] We may imagine that Caracciolo and Caravaggio were fairly close in 1609–1610, but Caravaggio's art may have had its greatest influence on the younger master at the time of Caravaggio's first visit to Naples.

Death on the Beach

Ferdinando Gonzaga of Mantua, who became cardinal in 1607 and arrived in Rome early in 1610, made the extraordinary gesture of soliciting a pardon for Caravaggio from Pope Paul V, and evidently it was forthcoming.[13] In hope of this reconciliation, Caravaggio set sail from Naples in the summer of 1610. To be safe, he landed at the Spanish bastion at Port' Ercole on the southern border of Tuscany, north of Civitavecchia. There the final scene of his tragedy was played out.

Upon landing, Caravaggio was mistaken for someone else, seized, and imprisoned. Baglione wrote:

> he was mistakenly captured and held for two days in prison and when he was released, his boat was no longer to be found. This made him furious, and in desperation he started out along the beach under the fierce heat of the July sun [*sol leone*], trying to catch sight of the vessel that had his belongings. Finally, he came to a place where he was put to bed with a raging fever; and so, without the aid of God or man, in a few days he died, as miserably as he had lived.[14]

[12]Pacelli-Bologna (1980, p. 26).

[13]Cf. Askew (1978). The Gonzaga, who had owned Caravaggio's *Death of the Virgin* [133] since 1607, may have been favorably disposed and perhaps hopeful of obtaining more pictures. High-placed people in Rome were already negotiating for Caravaggio's pardon in 1607 (see p. 180, n. 13 above).

[14]The text (pp. 138–139; see p. 356 below) is slightly different in the manuscript (see p. 170, n. 4 above), which I read: "*e senza aiuto* [words crossed out] *in pochi giorni morì male come appunto male havea vissuto.*" (cf. Röttgen, 1974, p. 154, for a somewhat different reading).

The correspondent from Urbino wrote on 28 July: "News has arrived of the death of Michel Angelo Caravaggio, famous painter and most excellent in coloring and imitation of nature, following his illness at Port'Ercole." Three days later another *avviso* reported that "Michel Angelo da Caravaggio, famous painter, is dead at Port'Ercole while traveling from Naples to Rome thanks to the grace of His Holiness in revoking the warrant for murder." In addition to Latin epitaphs by Marzio Milesi, Giovan Battista Marino wrote a memorial poem, *"In morte di Michelangelo da Caravaggio,"* published in 1619.[15]

Caravaggio died on 18 July 1610. We learn from the copy of a lost document, sent on 19 August from the office of the Viceroy of Naples to the Judge of Military Affairs at the Tuscan garrison, that a careful inventory had been made of Caravaggio's effects; the boat with his belongings had not gone far. Since Caravaggio still called himself *cavaliere,* and since the estate of a knight reverted to the order, the inventory was first sent to the Maltese authorities. They, rejecting Caravaggio's effects, sent it on to the new Neapolitan viceroy. He was Don Pedro Fernández de Castro, a collector of art, who wrote the Tuscan judge in no uncertain terms to send all Caravaggio's belongings back to him, and most particularly *"el quadro de St. Juan Bautista."*[16]

If indeed that work was sent, the puzzling painting now in Spain would be the best candidate for it geographically [170]. Perhaps it was unfinished and completed by Caracciolo in Naples before being taken to Spain when the viceroy returned home in 1616. Since the report does not mention the subject, apart from calling it a *St. John,* it is conceivable that it was the painting now in the Borghese Gallery, which is damaged beyond judgment [95]. The *Salome* in London [168], which looks to me like an authentic, flawed, and perhaps unfinished Caravaggio of the late period, seems to have come from Italy. Of course, the *"Juan"* may simply be lost. Of the other late, or supposedly later paintings, the *David with the Head of Goliath* [173] will be discussed in the next chapter. A *Denial of St. Peter* [192] must also be very late.

[15]The *avvisi* are in Orbaan (1920, pp. 175–176; also Cinotti, 1971, p. 162, FF 94–95). For the epitaphs and also a poem by Milesi, see Petrucci (1956); Cinotti (1971, p. 162, FF 92–93); epitaphs translated in Friedlaender (p. 293). Until the recent discoveries in the archives, Milesi's birthdate of 28 September 1573 was believed to be accurate. See also the articles on Milesi's poetry (Fulco, 1980) and on a painting by Caravaggio that he seems to have owned (Spezzaferro, 1980). Marino's poem was reprinted by Bellori (p. 371 below).

[16]Green-Mahon (1951, pp. 202–203) produced the date 18 July 1610 and the inventory, according to a copy of a lost document that has itself been lost. Green relied on notes and transcriptions made before World War II.

10
Afterthoughts

No other Italian painter of the seventeenth century has Caravaggio's power and conviction. His heirs were the younger, perhaps greater painters of other countries: Rubens, Rembrandt, and to some extent Velázquez (one cannot call Poussin an heir at all). When we invoke these names we realize that although Caravaggio was of interest to some of them for a while, most of their Italian debts lie elsewhere, with Titian and Raphael. Caravaggio's direct influence died out in the 1620s in most of the leading artistic centers; his so-called followers, most of whom he never met, were by and large a mediocre lot. To the extent that they were good they were individuals and not mere followers, which is of course true of all real artists [cf. 105].

I have remarked on the quality of Caravaggio's realism, which was both praised and damned by his contemporaries and by later writers. His naturalism was shocking in contrast to the art of the Mannerists, who often reproduced old formulas without much looking at life itself [cf. 8, 147, 176]. Caravaggio was unusually dependent on his models, especially before 1606, yet his compositions are not particularly lifelike. He was not a true genre painter, and he never painted what he actually saw in the street, piazza, or tavern. His settings are minimal, his anatomy is suspect, and the realistic surfaces of his figures often clothe attitudes and gestures derived from older, idealizing compositions that he was compelled to emulate. All too often he failed to reconcile the idea of ongoing life with the fixed pose that his method of painting relied on, and this defect separates him from his greatest successors, such as Rembrandt. Francesco Albani, a seventeenth-century Bolognese painter, complained of Caravaggio that "one sees imitations that resemble life, yet are not true; one finds no representation of character or liveliness of movement." In short, according to Albani, Caravaggio's art was not natural enough.[1] But the chief criticism of the seventeenth

[1] It is not always clear whether writers are criticizing Caravaggio's paintings or the results of "Caravaggism," which understandably upset even some of those who might have tolerated much of Caravaggio's own art. Malvasia (II, p. 163, *Life of Francesco Albani*) cited a letter from Albani describing his position: "He could never bear to have painters follow Caravaggio, seeing in his style the downfall and total ruin of the noble art of painting—

century was based on a contrary premise, that Caravaggio's figures, and thus his art, were not ennobled by a concept of beauty. This lack damned him in the eyes of Annibale Carracci and his theoretical followers, including Agucchi and Bellori.[2]

Most art, certainly all traditional Western art, is based on convention, and Caravaggio's painting is no exception. He came from a peripheral, artistically provincial area, and he arrived in Rome as an outsider, which was perhaps also his mental set. He was in many respects a loner.[3] As an artist he insisted at first on the importance of still life, seemed to approach artistic subjects of high seriousness as genre, and depended on the model in ways that were not acceptable to most of his contemporaries. They all used drawings as an intermediate step between the model and the finished work, but Caravaggio apparently did not—which is one explanation for his failure to do fresco painting. Nevertheless, when he came to paint his first large public pictures he fell back on what we usually think of as a Mannerist device, a quotation from a famous work of the High Renaissance [52]. He also indulged in self-quotation, using the idlers and dandies he had painted in the *Cardsharps* [10] or the *Fortuneteller* [12] as appropriate companions for Matthew, and he continued to use a blatantly unrealistic light-dark technique and a frieze-like arrangement of figures. But we could not have expected the successful mural art that he produced, especially on canvas, and almost at the first try [52, 56]. This is the kind of monumental painting that Italians had been trying to produce since Masaccio. Immediately following this success Caravaggio seems to have undergone a kind of High Renaissance crisis as he assimilated Leonardo and Raphael and Michelangelo while poking fun at their mystiques, as in the *Victorious Cupid* [98]. Then, in pictures such as the *Entombment of Christ* [107] and the *Death of the Virgin* [133], he showed his ability to synthesize the lessons of the past with his genre approach to the model, resulting in an art of unprecedented immediacy and power.

Caravaggio began his career in Rome as a painter of mythology and allegory who was also concerned with still life and genre, interests that seem to have been

because, although simple imitation is in some sense praiseworthy, it gave birth to all of what followed for forty years.

"'One sees an imitation of reality that is not believable, being without the liveliness of movement; and because it is necessary (like the Poet) to base one's art on an Idea, everything became corrupted because these artists did not represent ideas [*concetti*] or even . . . have an idea.'"

[2]See p. 46–49 above.

[3]Emphasized, perhaps overemphasized, by Röttgen (1974, pp. 164–168). Caravaggio was obviously difficult and strange; yet supposedly he got along with Minnitti for years and had faithful friends of many kinds—perhaps chiefly because they recognized his genius. The various criminal proceedings constantly mention others with whom he was passing the time. He may have had a great psychic loneliness, but he had a number of acquaintances despite his antisocial behavior and a personality that evidently verged on the psychotic. Of course these friends were themselves not entirely ordinary: Minnitti, on his way home to Sicily, "casually" committed a murder (Susinno, 1960, p. 117), and Onorio Longhi was what we might call an oddball—or worse (cf. p. 161).

encouraged by his first great patron, Cardinal Del Monte. The genre and still life of the 1590s persist in a few religious works but make their last real appearance in the London *Supper at Emmaus* [42]. And Caravaggio produced pure still life, of which one painting survives [47]. Most of the early pictures show half-length figures in a manner that would have been identified with works by Giorgione and Titian. Caravaggio may have attached himself consciously to this tradition—or tried to revive it—just as he produced pictures that were identified by everybody as belonging to the Venetian camp of *colore* (as opposed to Florentine *disegno*). He may even have considered himself the last representative of this great Renaissance tradition.[4]

The dominant themes of the paintings of the 1590s are often conveyed by effeminate boys who seem to be on sensuous display [15, 18, 22, 25]. Our interpretation of these pictures as harboring an overt or covert homosexuality is aided by what little we know of the patron, Cardinal Del Monte. Everyone sees the homoerotic quality of *Amor* [98], which was painted for the upstanding Marchese Vincenzo Giustiniani. Even in a later religious painting for St. Peter's, Caravaggio emphasized unnecessarily the nudity of the Christ child with all the power of his dramatic light-dark [132]. In his earliest religious pictures Caravaggio showed an independence from tradition, a personal approach that immediately made him unique [28]. But a deeply felt picture such as the *St. Francis* [30] also has the disconcerting presence of a boy angel who seems to have arrived from an erotic, mythological picture such as the *Concert* [15].

Here, at the beginning of his career, we also see the juxtaposition of youth and age that is at times charming and at times suggestive or aggressive [29, 30], a juxtaposition that reappears in the first *St. Matthew* [87]. Argan has suggested that these pictures in which youth teaches age typify Caravaggio's point of view toward older artists.[5] The first *St. Matthew* was ostensibly rejected because of the coarseness of the Apostle and his projecting bare foot. There may have been another focus of criticism, unvoiced and even unconscious, that is obvious to us: the alluring, seductive angel snuggling up to an old man. Their relationship is cozy but ambiguous. Many of these old men are in a sense fools. We may even see in them a commentary on one aspect of Caravaggio's relationship with his friendly patron, Cardinal Del Monte. Another side of the youth-age relationship is expressed in the *Sacrifice of Abraham* [102]. There the old man seems unnecessarily cruel, his left thumb presses into Isaac's cheek, and the knife held before his eyes makes Isaac scream—as do so many other horrified or horrific figures in Caravaggio's art [36, 37, 38, 68]. Abraham's arm is

[4] See Gregori (1972, p. 29).
[5] Argan (1974, p. 22); cf. pp. 55 and 166, n. 1 above.

stayed by another nude youth, an angel to be sure, but nevertheless one of Cara-vaggio's familiar urchins, like the devilish *Amor* [98]. Thus the combination of youth and age in the pictures of Caravaggio's first decade often seems sexually suggestive, sometimes is tinged with sadomasochism, and often implies ridicule toward older men.[6]

In the later Roman paintings the old men are increasingly bald and are constantly associated with ideas of death [102, 104, 107]. There are sound icono-graphic reasons for both the baldness and the skull in the *St. Jerome* of about 1605 [127], and the same is perhaps true for every other picture and for the disciples who mourn the death of the Virgin Mary [133]. Although Caravaggio's spotlighting keeps picking out these bald heads, they may well mean what they seem to represent: venerable age. Nevertheless they could also be an unconscious attempt to retrieve a father whom he lost when he was only six.

If we presume, as psychiatrists seem to have discovered, that artists are often abnormally sensitive as children, we may well imagine that Caravaggio was deeply upset by the sudden loss of his father (and at the same time his grandfather, his uncle, and perhaps others) and would have repressed anger at his father for abandoning him. We might then suppose that a father-memory—some magical attempt to recreate a lost parent—lies behind many of the images of old men; to a child of six a father seems venerably old even at thirty-five or forty. Having resurrected his father in some of these images, without realizing what he was doing, Caravaggio might then unconsciously punish him by showing an old man who is foolish, cruel, or bereft.[7]

If Caravaggio lost his father and other father figures early in life, he kept his mother until he was considerably older—yet she too died before he was of age. Caravaggio's representations of mother-son relationships in his Madonnas are particu-larly warm and cozy [29, 166]. The loving relationship seems to persist even when the child is well beyond babyhood [120, 130]. These older "babies" and their domi-nant, protective mothers may well be semiautobiographical. They could also represent Caravaggio's unconscious yearning for something he had lost and missed. We remem-ber Röttgen's idea that Caravaggio's Del Monte period can be understood as an unusually protracted adolescence, a failure to progress beyond a late-childhood stage that could have been influenced by his recent loss of maternal love. Even late in his brief life, Caravaggio continued to evoke these benevolent, protective maternal images [166]. One of his last paintings, however, shows an isolated baby on the ground [167], which may conceivably reflect his own final sense of abandonment. All

[6]For these and many other ideas I am indebted to conversations with Robert S. Liebert, M.D.
[7]If these speculations have any merit, we can presume that Fermo Merisi was bald, as Dr. Liebert pointed out.

such speculation is of course just that; yet Caravaggio's maternal images are strikingly different from those of Michelangelo, for example, who lost his mother when he was six and was reared in a predominantly male household. For Michelangelo, mothers are almost inevitably removed, cool, and detached from their sons, and only in death can the son be in some sense reunited with his mother in a loving relationship [174].

In his earlier paintings Caravaggio occasionally makes us imagine that he may have had the hope or fantasy of being chosen by God—despite (or even because of) his being a great sinner. The revolutionary *Conversion of St. Paul* [75] provides the most obvious example of this. The dream may well have dimmed in the later years of his wandering, but it is implicit in the *Calling of St. Matthew* [52] and is already manifest in the *St. Francis* [30]. It informs his treatment of the abandoned *Magdalen* [136]. All these were to some extent conventional themes that would not necessarily reflect Caravaggio's own hopes and fears had he not treated them so unusually, for such radical novelty can come only from the imagination. Thus the novel conception of the *Conversion of St. Paul,* the sense that Caravaggio gives of a body actually laid out by a blinding supernatural force, is reinforced by the vulnerable, open pose that gives his conversion the appearance of a sexual experience as well as a physical attack. The related spiritual agony in the recumbent, vulnerable body of the early *St. Francis* becomes overwhelming in the *Magdalen* [136].

Without too much exaggeration we can probably take the paintings he produced immediately after the murder of Ranuccio Tommasoni and his escape from papal Rome as an index of his mental state. They seem not to have been commissioned. One was a *Supper at Emmaus* [137], a story of the belated recognition of the Savior by followers who had deserted him. The other was an ecstatic, or better, repentant *Magdalen* [136], a reformed sinner in a state of agonized union with God. Error followed by enlightenment is a theme of both paintings—but knowing Caravaggio, we may wonder whether his grandiosity did not lead him to equate himself (unconsciously, of course) with the unrecognized Savior.

The darkness of Caravaggio's paintings, which becomes night-like by 1600, may have several causes. It helped him to hide problems of composition, and the highlighting of foreground figures increased the drama. But no one who loves Caravaggio believes that his use of chiaroscuro was merely a technical device. Like his other unusual qualities, it expresses an unusual personality. Darkness as such is not rare in Italian painting: night scenes were particularly popular in Caravaggio's native Lombardy, and he must have been inspired by their drama and poignance [cf. 142,

157]. But he went further, turning day into night, and showed events of all kinds in a gloomy setting. There is no sun in Caravaggio, little daylight and less sky. Perhaps his tendency to show a few figures highlighted against the darkness gives a rough profile of a man who tended to see human events in black and white ("those who are my friends speak to me, those who are not, do not," to paraphrase his testimony of 1603—see p. 161, n. 18). His egocentric behavior might indicate that his world was made up of a few friends set against a background of nameless "others." His paintings have a prevailingly somber mood that often edges into tragedy: his customary themes are martyrdoms, burials, or religious experiences that are like death in life —the ecstasy of St. Francis, the conversion of Saul, the repentant Magdalen. Even an allegory of good works becomes a purgatory of mysterious, ominous acts [138].

Toward the end of his life the paintings seem to change. These late pictures are still very dark with highlighted figures carrying the drama. Sometimes Caravaggio places his actors in a modest environment [166, 167]. Often however the action is set against a looming vastness, an oppressive void that tends to reduce the significance or effectiveness of the action, whether for good or evil [158, 163]. This new quality may derive from having to paint extremely large canvases, perhaps in a hurry. But it also seems to reflect a new pessimism, a jaundiced view of the circumstances of this world. Even the human figure, in which Caravaggio had invested all of his artistic capital, seems to become smaller and less heroic. His technique also changes, becoming broader and looser. Still, the Caravaggio of the *Martyrdom of St. Ursula* [171] is only an older version of the painter of *Judith Beheading Holofernes* [36]. Violence, mutilation, and murder are favorite subjects.

The obvious and indisputable streak of cruelty in Caravaggio's art is accompanied by swords and knives that played a leading role in the drama of his life. We have no reason to restrain ourselves when discussing their meaning for Caravaggio himself. Carrying arms was the privilege of a free man and the nobility was notoriously violent. Caravaggio's insistence on carrying a sword could have been bound up with a desire to appear to be in a higher class of society than his fellows. His eagerness to be a knight and the reports of increased turbulence in his behavior after his knighthood tend to support this idea.[8] Nevertheless his criminality seems to be rooted in deep-seated psychological problems that transcend purely social explanations.

Caravaggio habitually swaggered forth into the streets with sword and dagger; often he was severely wounded, and in time he killed a man. Psychiatrically, he may

[8] I am grateful to Joseph Connors for some of these ideas; he pointed to the violence of the "noble" fighting in Shakespeare's *Romeo and Juliet* as one example. War was indeed the occupation of aristocracy.

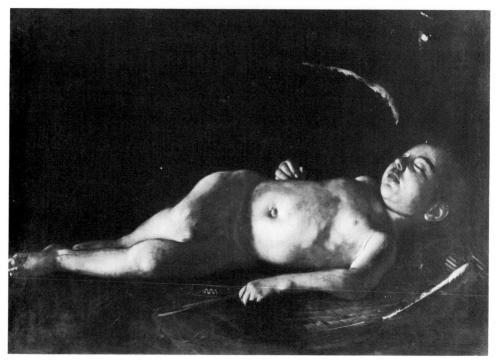

172. *Sleeping Cupid*. Florence, Pitti. 1608.

have been looking for punishment in order to atone for unconscious feelings of guilt, but we can never be sure of such analyses. Obviously he had well-founded fears of being hurt while at the same time he constantly provoked attacks. These private nightmares seem to be reflected in images such as the *St. Paul* and particularly in the bloody beheadings in his paintings [36, 153, 168, 170]. Since decapitation is, at least arguably, symbolic castration, perhaps Caravaggio unconsciously feared punishment for sexual thoughts or deeds on the order of an eye for an eye.[9] Certainly he produced an unusual number of severed or displayed heads, even when we reject all the debated attributions. The pervasiveness of death and dying seems to invade his last secular painting, a *Sleeping Cupid* [172] that looks like a dead baby. It may also be read as a sad footnote to the rambunctious and insinuating sexuality of the earlier *Amor* [98]. Such an image as the *David with the Head of Goliath* [173], whose severed head is supposedly a self-portrait, is an explicit self-identification with Evil—and with a wish for punishment. But it is also a brilliant *concetto* in an age of *concettismo;* the poet Marino, Caravaggio's friend, claimed that a work of art should astound.[10]

Let us review the self-image of Caravaggio in his pictures, his actual or reputed self-portraits. Many of the early ones have been thought to show his face: we are told that he painted himself while looking in a mirror. The sickly, possibly amorous

[9]See Freud (1955, pp. 273–274); cf. Schneider (1976).
[10]"*È del poeta il fin la meraviglia*" (from *La Murtoleide*, XXXIII; see Mirollo, 1963, p.25).

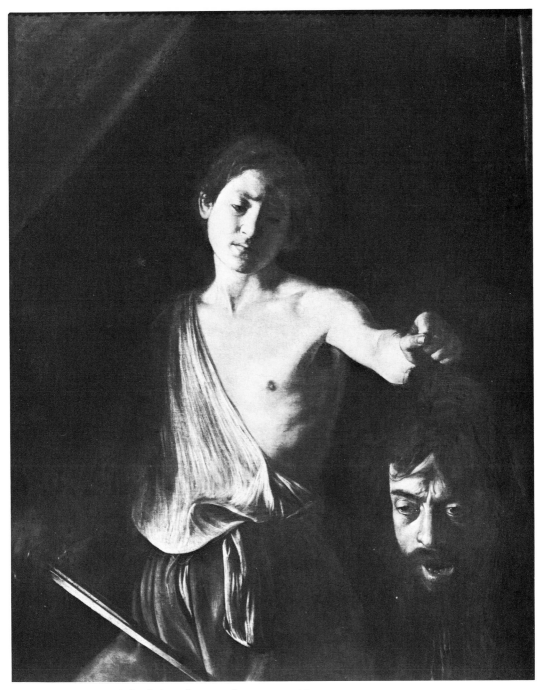

173. *David with the Head of Goliath.* Galleria Borghese. c. 1609–10?

Bacchus may well be Caravaggio [9]. The dark boy with the horn who looks out at us in the *Concert* also looks like Caravaggio [15]. There is a generic resemblance among many of these boys, all of whom have arched eyebrows, flared nostrils, thickly sensual lips. It has been proposed that the quite different figure at the right in the *Betrayal* may be Caravaggio [38], and the same head reappears in his last documented painting [171].

The self-portrait in the *Martyrdom of St. Matthew* is hardly debatable [66]. Ottavio Leoni's portrait of Caravaggio [67] is only a version of this image since he did not draw from the model. In the *Martyrdom* we find Caravaggio as a saturnine onlooker at a tragic scene—probably as the king who ordered the execution. If so, he is playing the part of a murderer; Caravaggio surely believed in murder more deeply than in martyrdom. But the villainous aspect that becomes prominent in the drawn and engraved portraits of Caravaggio may be tainted by a Platonic physiognomical theory.[11]

And so we return to the final "portrait," the horrifying head of Goliath, decapitated yet seemingly still alive [175]. It is a self-portrait on Bellori's authority, and it had already been described as such in a book on the Borghese collection published in 1650. The *David* takes its place with the *Beheading of the Baptist* and the late *Salome* in its overpowering suggestion of Caravaggio's fear, indeed expectation, of violent punishment—perhaps castration—and death [153, 168]. This worry is conveyed in a different way in the *Martyrdom of St. Matthew;* the *Conversion of St. Paul* [75] looks like punishment rather than divine enlightenment.

We should not deny the personal, even tragic quality of these images, particularly of the *David,* which in its implications is wholly different from those painted by Caravaggio's followers. We should also emphasize the essentially pessimistic quality of his self-image. Giorgione once painted himself as David with the head of Goliath, and of course he saw himself as the victor; so did Bernini more than a century later. Caravaggio, who was fascinated by beheading, seems to make his strongest identification with the beheaded: in the *Beheading of St. John* he wrote his own name, the only signature of his entire career, in the blood of a Baptist whose head is being severed [156]. "All my sins are mortal," he was quoted as saying soon after painting this picture, and we sense him moving toward a tragic, horrific end in his later art.

There are other aspects of this phenomenon to consider. It was recognized in Michelangelo's lifetime that the head of the old Nicodemus in his unfinished marble

[11]After discussing Caravaggio's failings as an artist, Bellori wrote about his physiognomy (p. 214), equating the two. The engraving of Caravaggio that precedes Bellori's *Life* seems to show a desperate man (1976, p. 210; cf. Cinotti, 1971, p. 86, Fig. 76, and her discussion).

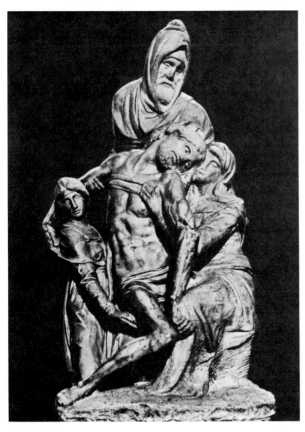

174. Michelangelo, *Pietà*. Florence, Cathedral. c. 1547–55.

Deposition, now in Florence, was a self-portrait [174]. Michelangelo tried to destroy this sculpture when he was eighty, although he had been working on it for years as a devotional group for his own tomb. Dr. Robert Liebert has proposed that we may interpret such self-images, and specifically this one, in the way a psychoanalyst sometimes interprets a dream in which the dreamer himself plays a part.[12] Such dreams may be a form of self-protection, allowing the dreamer to act out his hopes and fears in the guise of others, shielded from the painful recognition of what is on his mind by the self-delusion of being only a detached observer or minor participant. Liebert has argued that in the *Deposition* Michelangelo was (among other things) working out his own complex and repressed feelings of having been abandoned by his mother while a child of six, and his desire to be reunited with her in death. In other words, by identifying himself clearly to himself and to us as Nicodemus, he was free to act out his unconscious fantasy as Christ united in death with his loving mother, which was an altogether unacceptable idea to his conscious rational mind.

If we use this technique with the *David*—and I believe in this kind of interpretation when we have enough evidence—we find Caravaggio to be not only the beheaded Goliath, which is overtly his own image, but also the youthful beheader.

[12]Liebert (1977). Further to dreams, Rycroft (1979), who also has notes on dream research.

265

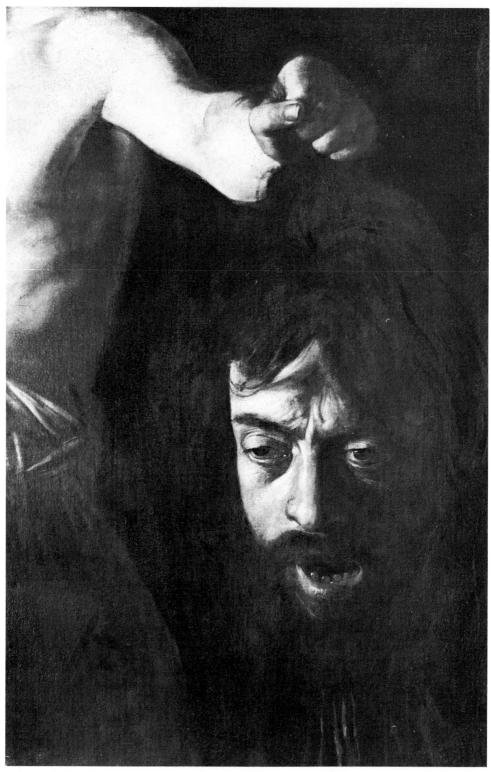

175. Detail of [173].

This identification would be the latent content of the painting as dream. We note the pensive, even sad expression of David as he holds the sword in its ambiguous position. Thus we have at least the possibility of reinterpreting these self-images in a manner that would accord, however superficially and roughly, with Caravaggio's own aggressive life. The self-portrait in the *Martyrdom of St. Matthew* and even the signature in the blood of the beheaded Baptist may reinforce this interpretation [66, 153]. Caravaggio's unconscious identification may have been as much with the killers as with the victims: he was in fact a murderer.

When we try to interpret the *David and Goliath* we should remember the traditional glosses of the Roman Church, which Caravaggio must have known, if only indirectly. St. Augustine wrote: "As David overcame Goliath, this is Christ who kills the Devil . . . Humility slays Pride."[13] Earlier in his life Caravaggio may have had dreams of being saved; later he was quite secure in damnation. But if he is to be identified with David, as I suspect he is, he may still, if only unconsciously, have been hoping for redemption; for David was a hero, a king, and the ancestor of Christ.

The enigma of Caravaggio and his art will remain forever, but we are coming closer to understanding him for our time and to seeing him more accurately in his own. He was far from being a universal artist, but however flawed and peculiar his paintings may be, they are the most fascinating of their era. From ambiguous essays in erotic, retrospective pseudo-genre he moved to grand displays of traditional Mediterranean figural art. Yet these religious pictures are also the most personal and affecting works by any artist between Michelangelo and Rembrandt. At his best, Caravaggio is an artist for everyone and for all time.

[13]*Enarrationes in Psalmos*, XXXIII.4 (Migne, P.L., XXXVI, 302): "*In figura Christi David, sicut Goliath in figura diaboli: et quod David prostavit Goliam, Christus est qui occidit diabolum. Quid est autem Christus qui diabolum occidit? Humilitas occidit superbiam. . . .*"

Notes to the Illustrations

Paintings are in oil on canvas and sculptures are of marble, unless otherwise described. The location, if unspecified, is Rome. Sizes are shown in centimeters, height before width. The unit of measurement found in the old inventories is the *palmo romano* (22.34 cm). I give extensive information only about paintings attributed to Caravaggio, and only as a supplement to catalog material already published by Cinotti (1971) and Marini (1974; cited here as "M" followed by catalog number and, when controversial, his date). Since Cinotti's compilation of 1971 is expensive and cumbersome, I often give her opinions as condensed in the handbook of 1973, which guides the reader back to the larger work. Books and articles often mentioned are cited by author and date; the complete reference appears in the Bibliography.

The *Lives* of Caravaggio by Mancini, Baglione, Bellori, and Sandrart, the pertinent parts of Susinno's, and notices by Van Mander and Scannelli appear in the original and in translation in Appendix II. Nothing speaks like the original text, and it is useful to read the *Lives* as such in addition to my entries. I cite these materials by their page numbers in the editions used; these numbers are found in the margins of the transcriptions.

Photograph Reference Abbreviations

GFN Gabinetto Fotografico Nazionale, Rome (now called Istituto Centrale per il Catalogo e la Documentazione).

ICR Archivio Fotografico, Istituto Centrale del Restauro, Rome.

When no reference is given the photograph comes from the Photographic Collection of the Department of Art History and Archaeology, Columbia University.

1. Simon Guillain after Annibale Carracci, *Vende Quadri (Picture Seller)*. Engraving, 27.2 × 16.7. From *Le Arti di Bologna*, engraved in 1646 after youthful drawings by Annibale, now lost. Posner (1971, I, p. 17).

2. Annibale Carracci, Galleria Farnese, vault

frescoes (detail). Palazzo Farnese. 1597–1600. Posner (1971, II, p. 49, no. 111, and I, chapter 8). (Photo: GFN E 37163)

3. Caravaggio (or old copy), *Boy Peeling a Green Citrus Fruit* (bergamot or *melangolo*?). Italy, private collection. 75.5 × 64.5. (M.2: c. 1593, showing other copies.) Mentioned by Marini (1978, p. 76). Mancini lists as the earliest paintings done "to sell" the *Boy Bitten* [25] "and afterward also a boy peeling a pear with a knife" (p. 224; another manuscript calls the fruit an apple: n. to line 12, *"una mela"*). These paintings are listed after a few copies of devotional pictures done for Monsignor Pandolfo Pucci and taken by him to Recanati.

The original is not surely known. This is the largest and evidently the best version yet discovered; it stems from an old Roman collection with papal ties. If the picture is to be identified with no. 89 in the list of paintings sequestered by the Borghese in 1607 from the Cavalier d'Arpino (De Rinaldis, 1936, p. 115: *"Un'putto in tavola con un pomo in mano"*), the original was on panel. The connection seems tenuous; if verified, it would date the picture to Caravaggio's early stay with Giuseppe Cesari, c. 1593 (see Notes 4 and 9). The surviving versions of this composition, whose popularity is mysterious, all show a small green fruit, whereas the description by Mancini and Arpino's inventory mention an apple or pear, which is puzzling.

The painting published by Nicolson (1979, plate 1) is smaller and slightly less impressive than this version, although I know [3] only from photographs. None of the paintings has convincing drapery. The long, rather boneless thumb is still found in relatively mature early pictures like the *Luteplayer* [18]. Cinotti (1973, no. 1) dates the conception to 1592/1593, which is the consensus; Frommel's date of 1595/1596 (1971, p. 51) seems too late, but all these early dates are built on hypotheses.

The small green citrus fruit shown in all the better copies may be related to the "Adam's Apple" (J. Snyder, *Art Bulletin*, LVIII, 1976, pp. 511–515, and letter from M. L. d'Ancona, ibid., LIX, 1977, pp. 658–659). Cf. D. Mahon in Nicolson (1979, p. 34) for an attempted interpretation. Calvesi (1971, p. 102) would see here an allegory of Christ purging humanity of sin. But despite the wheat, there are no grapes. Like most of his other iconographical sorties, it seems wildly unlikely.

Costello (1981), taking Mancini's pairing literally, interprets [3] as Taste and the *Boy Bitten* [25] as Touch, basing her theory on prints by Frans Floris (her figs. 3–4, 6–7). The hypothesis is attractive because Floris shows a woman with a knife and fruits; but she also bites into a fruit, which is the key element missing in Caravaggio's image. Moreover, despite Mancini, the *Boy Bitten* is so obviously different in style that a pairing seems unlikely. Although the versions of both paintings that we know may be only copies, they are so consistent among one another—all the versions of [3] are simple and even primitive; all the versions of [25] are dramatic in chiaroscuro and action—that the originals must also have been correspondingly different and hence produced at different times in Caravaggio's early career. (Photo: Courtesy M. Marini)

4. *A Boy with a Basket of Fruit (Fruitseller)*. Galleria Borghese, no. 136. 70 × 67. (M.5: 1593.) This work and [9] (*"Bacchino Malato"*) correspond to entries in the list of paintings seized by Pope Paul V from the Cavalier d'Arpino and given to Cardinal Scipione Borghese on 31 July 1607. This work is listed as *"un Quadro di un Giovane che tiene un Canestro di frutta in mano senza cornice"* (De Rinaldis, 1936, p. 114, no. 56; Cinotti, 1971, pp. 160–161, F 80, reprints the entries). None of the paintings were given attributions; this work was not given to Caravaggio by the old biographers, but the Borghese inventories of 1693 and 1790 attributed it to him (Della Pergola, II, 1959, pp. 75–76, no. 111; all the paintings attributed to Caravaggio in the inventory of 1693 are listed by Cinotti, 1971, pp. 163–164, F 108). Those who accept the painting, as modern critics almost invariably do, place it among the earliest works because of its Lombard ties, its relative crudity, and its origin in Arpino's collection, which makes it at least possible that it was painted while Caravaggio was working in

his shop, c. 1593 (but cf. Posner, 1971a, pp. 315–316, for a contrary opinion). Cinotti (1973, no. 3) lists the picture between the *Bacchino Malato* [9] and the *Boy Bitten* [25]. Röttgen (1973, p. 84, no. 14) believed that both [4] and [9] were influenced by Arpino's style, which seems more obvious in [9].

The connection of this painting with genre-like representations of fruitsellers in landscapes [cf. 5] was underlined by B. Wind (*Arte lombarda,* 42/43, 1975, pp. 70–73), who finds it related to images of Autumn. But [5] is not a *Season,* nor is Caravaggio's painting. Calvesi (1971, pp. 93–94, quoting an earlier article) pointed out that a child *(Amore)* with a basket of fruits and vegetables appears together with Bacchus and Ceres in a painting by Hans von Aachen, now in Vienna (his fig. 1). He then went on to see this work as an allegory of Christ as Love, bringing eternal life. This conclusion (and the citation in Note 3) may suffice to give an idea of his kind of iconology (cf. Praz, 1975, pp. 274–275).

For the seizure of Arpino's pictures, see Röttgen (1973, pp. 45–46). (Photo: GFN 54751)

5. Vincenzo Campi, *Fruitseller.* Milan, Pinacoteca di Brera, no. 333. 145 × 230. c. 1580? S. Zamboni (*Arte antica e moderna,* 30, 1965, p. 134) showed that it is related to other paintings, one of which is in the Brera, comprising two *Fruitsellers,* two *Fishsellers,* and two *Poultrysellers.* Hence the idea of a *Season* (see Note 4) is not probable. Campi, who was influenced by J. Beuckelaer, painted at least one independent still life (without human figures). Cf. Zamboni's biography in *Dizionario biografico degli italiani* (XVII, 1974, pp. 527 ff.). The Brera paintings came from the monastery of San Sigismondo in Cremona. (Photo: Museum)

6. Ambrogio de Predis, *Girl with Cherries.* New York, Metropolitan Museum of Art, Gift of Henry G. Marquand, 1890, no. 91.26.5. Oil on wood, 48.9 × 37.5. The·old catalog (Wehle, 1940, pp. 139–140) drew parallels with a painting dated 1494. (Photo: Museum)

7. Annibale Carracci, *Bean Eater.* Galleria Colonna. 57 × 68. c. 1583/1584. Posner (1971,

II, p. 5, no. 8; I, pp. 19–20). Posner (I, pp. 9 ff.) discusses "The Origins of Low-Life Painting in Italy" as a necessary preamble to his treatment of Annibale's works of genre and even portraiture. It is significant that Caravaggio's early paintings are not, in this sense, low-life and perhaps not even genre. (Photo: Villani 23688)

8. Giuseppe Cesari d'Arpino, *Perseus Rescuing Andromeda.* Providence, Museum of Art, Rhode Island School of Design, no. 57.167. Oil on slate, 68.6 × 51.5. See Röttgen (1973, pp. 78–79, no. 10), who dates it 1592/1593. The *Andromeda* is typical of Cesari's more attractive small panels; the same figural types are found in his frescoes, most obviously in the vault of the Olgiati Chapel [176], painted c. 1593–1595, just conceivably with the help of Caravaggio. (Photo: Museum)

9. *Self-Portrait as Bacchus ("Bacchino Malato").* Galleria Borghese, no. 534. 67 × 53. (M.4: 1593.) Cf. Note 4, the *Boy with a Basket,* which has the same origin. Listed in 1607 without attribution as *"Un altro quadretto con un giovinotto con la Ghirlanda d'hellera intorno, et rampaccio d'uva in mano senza cornice"* (De Rinaldis, 1936, p. 114, no. 54). Attributed to Caravaggio in the Borghese inventories of 1693 and 1790 (see Note 4). This painting is to be identified with Mancini's autograph note on the earliest pictures by Caravaggio, added to his text, in which he mentions *"un Bacco bellissimo et era sbarbato [?] lo tiene Borghese"* (p. 226, n. to line 22: a beautiful Bacchus, unshaven [?] owned by Borghese). The context of this note seems to put the painting in the period when Caravaggio was with the Cesari, c. 1593, and since the picture came from Giuseppe Cesari in 1607, the chances are greater that it was indeed painted at that time. Mancini then mentions a stay with Bernardino [Cesari?], which would have had to take place after June 1593, when Bernardino was allowed back into Rome (Röttgen, 1973, p. 28). We know that Caravaggio painted Bernardino's portrait (p. 10, n. 19). Baglione (p. 136) lists [9] first among Caravaggio's paintings. His citation was at one time taken to refer to the Uffizi *Bacchus* [22] (which seems not to be recorded in the old litera-

176. Giuseppe Cesari, Olgiati Chapel, S. Prassede, vault frescoes (detail). c. 1593–95.

ture at all) but its place in Baglione's *Life* accords better with this work, as does the description. Baglione is also more likely to have known it than [22], which seems to have disappeared soon after it was painted.

Unlike the *Boy with a Basket* [4], the *Self-portrait as Bacchus* was not recognized as Caravaggio's until 1927 (Longhi). Although it is now generally accepted, it was rejected by Posner (1971a), who considered it the work of an anonymous follower of Giuseppe Cesari's. Longhi thought that it was a self-portrait done while Caravaggio was recuperating from malaria in the Ospedale della Consolazione, hence the greenish complexion. Mancini's notes (p. 226, n. to line 22) indicate that Caravaggio was kicked by a horse; his information from this period is extensive, perhaps derived from Cesari d'Arpino himself, and hence Caravaggio probably did not have malaria, although his death in 1610 was supposedly the consequence of a fever. The color of the skin of the little Bacchus could be an attempt at showing a melancholic, saturnine image (cf. Röttgen, 1974, pp. 183 ff. and 249–250, n. 121). Frommel (1971a) suggested that Caravaggio here created a novel fusion of portrait and myth (cf. Frommel, 1971, pp. 22–23, and *passim*). The image is essentially of a Bacchus with ivy and grapes, and other meanings and interpretations should be treated with caution (see Brandi, 1974, p. 12, and the general remarks by Praz, 1975, pp. 412 ff., *contra* Calvesi, 1971). Ovid (*Fasti*, III.767) reported that ivy was most dear to Bacchus (*"hedera est gratissima Baccho"*).

10. *The Cardsharps (I Bari)*. Lost. The Barberini-Sciarra version (illustrated) measured 99 × 137. (M.11: 1594.) Sold to a Baron Rothschild in Paris in 1899, then disappeared. Bellori (p. 204) says that this picture was painted for Cardinal Del Monte. It was recorded in Del Monte's inventory of 1627: *"Un gioco di mano del Caravaggio con Cornice negra di palmi cinque"* (Frommel, 1971, p. 31). On 7 May 1628 Del Monte's heirs sold *"una S. Caterina* [34], *et un gioco di carte"* for 550 *scudi* (Kirwin, 1971, p. 55). These paintings then appear in an inventory of

the effects of Cardinal Antonio Barberini dated 1644 (M. A. Lavin, 1975, p. 167, nos. 261–262). Since the *Cardsharps* was not mentioned by Baglione, and since he did not mention the *St. Catherine* [34], their omission might give a clue to the date of Baglione's *Life*, but he knew very few of the paintings from Del Monte's collection. It was the only picture by Caravaggio mentioned by Scannelli as being in the Barberini collection (1657, p. 198). (Mancini knew none of Del Monte's paintings and did not mention this one.) The chart shows which early paintings were known to the early writers.

Both this work and the *Luteplayer* [18] were copied for the Barberini in 1642 by Carlo Mangone (Lavin, p. 9, doc. 78). Although subsequent writers have assumed that this was Del Monte's original, and that it entered the Barberini collection and later that of the Sciarra-Colonna, the Barberini inventories list both the *Cardsharps* and the *Luteplayer* as being by Caravaggio, whereas the latter can never have been anything but a copy (cf. Note 18). Thus there is at least the possibility that this was also a copy, as Moir pointed out (1976, p. 138, n. 232). Nevertheless Del Monte's *St. Catherine* [34] was sold together with the *Cardsharps*. Both entered the Barberini collection soon afterward, and the presumption must be that they owned the originals of both, as they surely did of [34]. Just why a copy was made of this when they owned the original is not clear, but copies, often made for gifts, were in demand. (See Cardinal Borromeo's defense of copies in *Mvsaevm*, 1625, pp. 12–13; Diamond, 1974, pp. 232–233.) That there was a copy of [18] is more comprehensible, for the original was in the Giustiniani collection (inventory of 1638) and remained there until its sale in 1808. Nevertheless the Barberini may have believed that their *Cardsharps* and their *Luteplayer* were both original works, as their inventories seem to indicate and as Bellori believed.

Bellori, who knew the Barberini collection well, writes about their Caravaggios after describing the Pamphilj pictures (pp. 203–204). He described the *Cardsharps* in detail, seeing in it Caravaggio's first attempts at Giorgionesque

CITATIONS IN OLD SOURCES OF THE EARLY PAINTINGS BY CARAVAGGIO

	MANCINI	BAGLIONE	SCANNELLI	BELLORI	OTHER
DEL MONTE INVENTORY					
Cardsharps [10]	no	no	yes	yes	(Both as Barberini collection)
Concert [15]	no	yes	no	yes	
St. Francis [30]	no	no	no	no	Costa testament, 1606
Fortuneteller [177] (copy?)	no	yes	no	no	
Caraffa (lost)	no	no	no	yes	
Luteplayer (copy?) [18] (?)	no	yes	no	yes (Barb.)	Giustiniani inventory, 1638
St. Catherine [34]	no	no	no	yes (Barb.)	
St. John (ex Mattei) [96]	no	yes (Mattei)	yes (Pio)	yes (Pio)	Celio: Mattei collection
OTHER DEL MONTE					
Bacchus [22]	no	no	no	no	Totally unrecorded
Medusa [37]	no	yes	no	yes	"Sent to Florence"
"Amor Divino" (lost?)	no	yes	no	no	(Baglione's error?)
OTHER EARLY PICTURES					
Boy Peeling [3]	yes	no	no	no	
Boy with Basket [4]	no	no	no	no	Arpino seizure, 1607
"Bacchino Malato" [9]	yes	yes	no	no	Arpino seizure, 1607
Fortuneteller [12]	yes	no	yes	yes	
Boy Bitten [25]	yes	yes	no	no	Sandrart
St. John Evangelist (lost?)	yes	no	no	no	(Mancini's error?)
Repentant Magdalen [28]	yes	no	yes	yes	
Rest on the Flight [29]	yes	no	yes	yes	
Conversion of Magdalen [33] (?)	no	no	no	no	Costa testament, 1606
Judith [36]	no	yes (Costa)	no	no	Costa testament, 1632 etc.

colorism (see p. 272, n. 9). Bellori then mentioned the *Concert* [15] as having been commissioned by Del Monte and discussed the *Luteplayer* [18] and *St. Catherine* [34], which he reported as being in the collection of Antonio Barberini ("*nelle medesime camere,*" p. 204, refers to "*le camere del cardinale Antonio Barberini*" on pp. 203–204). In the last two paintings Bellori perceived a later, darker style.

Although this work was in the same room in Del Monte's Ripetta palace with his version of the *Fortuneteller* (cf. Note 12), described as being of the same size and framed alike, they were not sold together (Kirwin, 1971, p. 55). Perhaps they were simply not considered to be a pair; more probably the suspicion or knowledge that Del Monte's *Fortuneteller* was not by Caravaggio was decisive—though it was sold earlier than the *Cardsharps*.

The dating has varied, only in part because the original is no longer known. Mahon (1952, pp. 9, 19) put both it and [12] before the *Concert* [15], dating them c. 1593/1594. "Of all Caravaggio's paintings," he wrote then (p. 9), "with the possible exception of the *Maddalena* [28], it has the least sense of volume; so striking, however, is the conception . . . that it requires a real effort to grasp the fact that—in relation, of course, to what Caravaggio was doing not so long afterwards—the protagonists are puppets

largely made of pasteboard. As with the *Buona Ventura* [12] and the *Maddalena*, the *Bari* must be very early." I have come to agree with these judgments even though we are relying on an old photograph for our opinion of [10] (see Note 28 for more of Mahon's thoughts). Mahon was the last writer to have seen these paintings together (after the *Mostra* in Milan of 1951), and thus we are all using our memories, notes, and photographs to compose a chronology that he was able to construct in front of all but a few of the paintings (this was of course not there and [18] was missing), which were there to be examined and arranged, as he describes in his articles of 1951–1952. Mahon's (and my) conclusions roughly parallel Bellori's sequence (pp. 203–204; see Appendix II): *Fortuneteller, Magdalen, Rest on the Flight, Cardsharps, Concert, Luteplayer.*

Some writers have taken the resemblance of the man to the right with the "Spada" in the *Calling of St. Matthew* of 1600 [52, 54] as an indication that it was painted in the Del Monte period: Frommel (1971, pp. 16, 51) put it after the *Concert* [15], c. 1595, and indeed the two cannot be far apart. There are also similarities with *St. Francis* [30]. But because the *Cardsharps* is lost and the *Concert* and *St. Francis* are in poor condition, comparisons are difficult. Röttgen also dated it fairly early in the Del Monte period, after the *Concert* and before the *Luteplayer* [18] (1974, p. 198; for him, however, the Del Monte years began in 1595/1596). Spezzaferro (1971, p. 86) put it after the *Luteplayer,* which seems too late. Cinotti (1973, nos. 6–10) listed the Del Monte paintings chronologically as: *Concert, Luteplayer, St. Francis, Cardsharps, Fortuneteller.* She then inserted the presumed original of the *Conversion of the Magdalen* [cf. 33], the Uffizi *Bacchus* [22], and the *Still Life* [47], an order that makes little sense to me and that does not account for the fact that Del Monte's *Fortuneteller* was not necessarily by Caravaggio.

I believe that [10] and [12] were painted as pendants of some kind in the same relatively early period; that Caravaggio sold the *Fortuneteller* (to a Vittrici? cf. Note 12) and managed to have the *Cardsharps* sold through

Valentino to Del Monte, who then commissioned the *Concert* [15] directly from Caravaggio. Bellori reports the sale of the *Cardsharps* (not known to Baglione); Baglione tells us of Del Monte's friendship and the commission of the *Concert.* Stylistically and iconographically, the sequence is convincing.

More than fifty copies of the *Cardsharps* are known, apart from variants such as [11], including some thirteen painted copies from the seventeenth century (Moir, 1976, pp. 104–105, no. 52, and fig. 8). Since Del Monte's painting was presumably the original, the version owned by Cardinal Giacomo Sannesio was probably a copy. It was reported stolen shortly after Sannesio's death in 1621 (Cinotti, 1971, pp. 66 and 162, F 98; for Sannesio and Caravaggio, see also Note 74). An inventory of the effects of Ottavio Costa in Rome, dated 1639, lists "*un . . . quadro delli tre giuocatori compagno d'uno che fece il Caravaggio*" (Spezzaferro, 1975, p. 118; *idem,* 1974, pp. 584, n. 36, and 585, n. 43). For [10] and [12] as pendants, see Note 12.

Although card playing was a favorite diversion of the upper classes in Italy during the Renaissance and is often mentioned in literature, it was rarely depicted in easel paintings. A drawing by Polidoro da Caravaggio shows an informal scene of outdoor card playing (A. Marabottini, *Polidoro da Caravaggio,* Rome, 1969, I, p. 303, no. 24; II, plate LXXIV, 2). Probably the best-known representation of card playing in Italian art is found in Niccolò dell'Abbate's frescoes in the Palazzo Poggi in Bologna (now University), showing courtly scenes, both amorous and familial, of singing, music making, and drinking (Venturi, *Storia,* IX, 6, pp. 600 ff., figs. 335–358). Musicians even set card playing to music, as in Alessandro Striggio's *Gioco di primiera* of 1569 (Einstein, 1949, II, p. 768). In art the subject was more common in the North, where it was used as an allegory of vice by Holbein (*Cardplayers,* from the *Dance of Death,* illus. Friedlaender, p. 109, fig. 73). B. Wind (*Storia dell'arte,* XX, 1974, pp. 31–34) tried to relate both the *Cardsharps* and the *Fortuneteller* to literary traditions of didactic, often comic genre and invoked ancient sources

(Juvenal, Martial). (Photo: Braun 43210, courtesy Richard Spear)

11. Valentin, *Cardsharps*. Dresden, Staatliche Kunstsammlungen, no. 408. 95 × 137. c. 1615/1618? See *Valentin et les caravagesques français* (Paris, Musées Nationaux, 1974, p. 106, and Cuzin, 1975, p. 57). (Photo: Museum)

12. *The Gypsy Fortuneteller*. Paris, Musée du Louvre. 99 × 131. (M.15: 1595.) There were two *Fortunetellers* from an early date: see J.-P. Cuzin, *La Diseuse de Bonne Aventure de Caravage* (Paris, 1977: Les Dossiers du Département des Peintures, 13). Cuzin's discussion (and the related exhibition at the Louvre) convinced almost everyone that the painting in the Louvre is the original, the Capitoline picture [177] a contemporary variant by another artist (see below). As a corollary, we may probably assume that Caravaggio never painted the same composition twice (*pace* Salerno, 1970; cf. Brandi, 1974, pp. 9–10).

The painting attributed to Caravaggio in Del Monte's inventory (*"Una Zingara del Caravaggio grande Palmi cinque con cornice negra"*; Frommel, 1971, p. 31) was almost surely the Capitoline picture and thus perhaps not by Caravaggio. Del Monte's *St. John* (see Note 96) and his *Fortuneteller* were presumably sold together on 5 May 1628 (Kirwin, 1971, p. 55; cf. Note 10). They stayed together, were subsequently in the collection of Cardinal Pio di Savoia, and eventually reached the Pinacoteca Capitolina, where they can still be seen. The Capitoline *Fortuneteller* is 116 cm high (the one in Paris, 99 cm). Nevertheless Del Monte's inventory listed both the *Cardsharps* [10] and the *Fortuneteller* as being five *palmi* high; as they were close together in the same room, it is odd that such a mistake was made. (The *St. Francis* [28] was the only other work listed as being five *palmi* in height; it now measures 92.5 cm (see the chart on p. 280).

Mancini (p. 224) thought that this work was early and listed it together with the *Rest on the Flight* [29] and the *Magdalen* [28]. He believed they were all painted when Caravaggio was living with Monsignor Fantino Petrignani (see p. 8, n. 14, and Note 28). He heard that [12] was one

of the pictures that Caravaggio had painted to sell on the open market and recorded that he got only 8 *scudi* for it (p. 140). When Mancini was writing his *Considerazioni*, c. 1620, the *Fortuneteller* he knew was in the house of an Alessandro Vittrici (cf. p. 53, n. 3, and Note 107), and it was Mancini's favorite among all Caravaggesque paintings (p. 109). He describes the theft of the ring seen in the Louvre version, which is not clearly shown in the other, presumably because of a misunderstanding. The Vittrici picture could be the Del Monte-Pio-Capitoline version only if it was sold to Del Monte between c. 1621 and his death in 1626, and all the presumptions are against this.

The painting now in Paris is presumably the one that sold for a pittance, was in the Vittrici collection c. 1620, and then passed to the Pamphilj, probably after the accession of Pope Innocent X in 1644. Scannelli had seen the painting in that collection by 1657 (p. 199), and Bellori (p. 203) described the *Fortuneteller*, *Magdalen* [28] and the *Rest on the Flight* [29] as being together in the same collection, though by the time he wrote (1672) the *Fortuneteller* had been sent to France. In 1665 Chantelou described the arrival of the painting, one of a group that was all but ruined by seawater (1885, p. 185: *"Ils se sont trouvés si gâtés, qu'on n'y connaissait presque plus rien."*). The paintings had been sent as a gift from Prince Camillo Pamphilj to Louis XIV. There seems to have been a contemporary understanding that the Pamphilj painting was the real one, for both Scannelli and Bellori, who describe Caravaggio's *St. John* [96] in the Pio collection, ignored Pio's *Fortuneteller* and discussed the Pamphilj picture.

For Bellori (p. 203) the *Fortuneteller* was one of the best examples of Caravaggio's programmatic use of realistic genre, as opposed to the idealizing combination of older models of which he approved. He continued by describing the *Magdalen*, another Pamphilj painting (see pp. 50–51 and Note 28).

Baglione (p. 136) listed the painting after Del Monte's *Concert* and *Luteplayer*, in a new paragraph. But the painting Baglione knew in the

Del Monte collection was not this but the one now in the Capitoline Museum [177]. He then mentioned the lost *Amor Divino* (supposedly Del Monte's but not in his inventory: see p. 273) and the *Medusa* [37], which Del Monte had given to the Medici. Then, in another new paragraph, Baglione discussed the Contarelli Chapel (Notes 52 ff.). This sequence, together with the similarity of the boy here to one in [52, 54], has induced some writers to date the *Fortuneteller* toward the time of the Contarelli Chapel (and thus to separate it from the *Cardsharps* [10] despite a similar resemblance between a figure in it and another in [54]: cf. Note 10). Thus Frommel (1971, pp. 18–19, 51) dated [12] to 1597/1598; Röttgen (1974, p. 198) implied the same date, placing it after the *Medusa* and just before the *Conversion of the Magdalen* and *St. Catherine*. Spezzaferro, however, placed it just after the *Cardsharps* (1971, p. 86).

If one is unwilling to date [10] and [12] to c. 1598/1599 on the basis of style, as I am, it should be manifest that when Caravaggio reused the two young boys from those paintings in the *Calling of St. Matthew* he was deliberately quoting from paintings that were already well known. Hence there is no virtue in supposing that these quotations were from his most recent pictures. Perhaps he was trying to establish a link between his old style and his new attempt to paint large religious scenes, which is also evident in the use of the figures around the table, as in the *Cardsharps*. The *Fortuneteller* has nothing to do with the paintings that most of us date to c. 1598/1599 [33, 34, 36, etc.].

Salerno (1974, p. 588, n. 10) put it in the very first phase of Caravaggio's activity, 1593/1594, and specifically rejected Frommel's late date. Cinotti (1973, no. 10) put it after the *Cardsharps* but before the Uffizi *Bacchus* [22]. Cuzin dated it to 1594/1595. All these writers essentially follow Mahon's idea that the *Fortuneteller* belongs in an early group, before Del Monte's *Concert* [15] (Mahon, 1952, pp. 4 ff. and 19), which still seems correct, whatever the actual dates may be (see the quotation in Note 10). Moreover, Spear (1971, p. 4) noted that "the *Fortune Teller*, para-doxically, is comparable with the *Rest on the Flight into Egypt*" [29] and spoke of Caravaggio's "remarkable poetic strain, which imbues the most roguish scenes with a lyrical beauty." I believe that the *Rest on the Flight* and the *Magdalen* [28] must be fairly close in date and that all these paintings are probably to be dated before Caravaggio moved into the Palazzo Madama with Del Monte, whenever that may have been. The *Cardsharps* and the *Fortuneteller* seem to have been separated from the beginning, probably because Caravaggio could not sell them both to the same person—an argument that helps to confirm their relatively early date. I assume that the *Fortuneteller* had already been sold for 8 *scudi* when Del Monte saw the *Cardsharps* and purchased it, beginning his patronage of the young artist.

For the subject, which was unprecedented in Italian art, see Cuzin. He shows that even in the North the theme had always been a detail in larger representations; thus the later paintings by Georges de la Tour and others are truly "Caravaggesque." For Gypsies, see E. J. Sullivan (*Art Bulletin*, LIX, 1977, pp. 217–221) and Note 13.

The *Fortuneteller* was used by Gaspare Murtola in a poem published in 1603 as a pretext for a commentary on the painter as illusionist. See Salerno (1966, p. 109; poem reprinted in Cinotti, 1973, p. 51; and 1971, p. 164, F 110). (Photo: Réunion des Musées Nationaux)

A *Fortuneteller* in the Pinacoteca Capitolina [177] has been attributed to Caravaggio by many writers, though it seems to fall into a secondary category (116 × 151.2; M.12: 1594). It has now been reattributed to Caravaggio by Cordaro (1980) as a very early work on the basis of new X-rays that show the canvas to have been painted first by Giuseppe Cesari d'Arpino, as Cuzin had thought. Cordaro's thesis ties the discarded canvas to a first attempt at the *Coronation of the Virgin* commissioned in 1592 but installed much later (see p. 148, n. 7). Had the canvas been discarded when Caravaggio was still in his shop, c. 1593, the argument would be fairly strong. The X-ray photograph of the Madonna by Cesari is so close to the painting finished in 1615

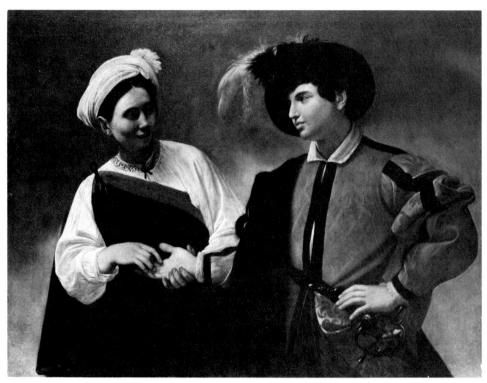

177. After Caravaggio (?), *Fortuneteller*. Pinacoteca Capitolina.

that the supposition of its having been painted c. 1593 is not wholly convincing.

This work has not been cleaned or conserved in any significant manner in modern times. The X-ray photographs show extensive losses and repaints, so an attribution must be tentative. Macrea (1964, p. 416) noted that the treatment of the sword is unlike Caravaggio's other versions and seems rather like "a weak imitation of the one in the *St. Catherine*" [34].

If this is a version of [12] we might suppose that the boy was modeled on the dupe in Del Monte's *Cardsharps* [10], possibly in order to produce a pair. Taken together, the two paintings could then have been interpreted as episodes from the life of the Prodigal Son (Luke 15:11 ff.), as later versions by Manfredi seem to imply (see the unpublished observations by C. Andersson in Cuzin, pp. 25–26 and n. 34, and my Note 13). But since the victims in Caravaggio's paintings [10 and 12] are not identical, a biblical interpretation seems impossible, and we may sup-

pose that it was not his idea. (The lost *Cardsharps* was of the same height that the Louvre *Fortuneteller* is now, but we do not know whether the former was changed during the centuries, as the latter surely was. And despite the additions to [12], the original may also have been of the same height.)

13. Bartolomeo Manfredi, *Gypsy Fortuneteller*. Detroit Institute of Arts, Founders Society Acquisitions Fund, no. 79.30. 121 × 152.5. Dated "c. 1610/15 (?)" by J.-P. Cuzin, "Manfredi's *Fortune Teller* and some problems of '*Manfrediana Methodus*'" (*Bulletin of the Detroit Institute of Arts*, LVIII, 1, 1980, pp. 14–25), an important contribution. Here we see the beginnings of the farcical treatment of Caravaggio's theme: the fortuneteller's accomplice robs the boy, but the fortuneteller herself is being robbed by the *bravo* at the right. The object being stolen is a hen (not visible in the reproduction). Gypsy women were notorious for hiding stolen goods, particularly

chickens, in their voluminous draperies, as Giacinto Gigli explained (*Diario romano,* ed. G. Ricciotti, Rome, 1958, pp. 124–125, October 1631; the passage concerns a recent edict forbidding Gypsy women to wear their traditional clothing).

Cuzin entertains the idea advanced by Alfred Moir that Manfredi might be the *Bartolomeo servitore* who was mentioned three times in the trial of September 1603 as having worked for Caravaggio (Cinotti, 1971, pp. 153 ff., F 47, 49, 52). According to Caravaggio, at that time Bartolomeo had been gone for two months. There is no indication in the records that he was a painter or an apprentice; the name was common. (Photo: Museum)

14. Il Boccaccino (d. 1525), *Gypsy Girl.* Florence, Galleria degli Uffizi, no. 8339. Tempera on wood, 24 × 19. A. Puerari, *Boccaccino* (Milan, 1957, pp. 168, 232) dated the painting c. 1516/1518. Cf. Berti (1979, P 216). (Photo: Soprintendenza alle Gallerie, 277974)

15. *A Concert of Youths.* New York, Metropolitan Museum of Art, Rogers Fund, 1952, no. 52.81. 92 × 118.4. (M.8: 1594.) First published by Mahon (1952, pp. 3–7; cf. *Metropolitan Museum of Art Bulletin,* XII, 2, 1953, pp. 33 ff.), who recognized this work as the original of the painting mentioned by Baglione, the first in his list of pictures done after Caravaggio was taken up by Cardinal Del Monte (p. 136). Bellori (p. 204) also mentions it first among Del Monte's pictures, though he believed that Caravaggio's introduction to Del Monte had been made through the purchase of the *Cardsharps* [10]. Röttgen (1974, p. 191) dates the picture c. 1596, but before the *Bacchus* [22] and the *Luteplayer* [18], because he dates the beginning of the Del Monte period to 1595/1596. Frommel (1971, pp. 15, 51) dates the picture 1594/1595 with the same intent.

The painting is listed in the inventory of Del Monte's effects, dated 21 February 1627: "*Una Musica di mano di Michelangelo da Caravaggio con cornice negra di palmi cinque in circa*" (Frommel, p. 35). (For the measurement, see the chart on p. 280.) Del Monte eventually owned some five

paintings described as *Una Musica,* one of which was by Antiveduto Grammatica, for whom Caravaggio had supposedly worked (see Spear, 1971, p. 106, no. 33, for a *Musica* by Grammatica; cf. my p. 9, n. 16, for the report). We do not know whether Del Monte's preference for this subject was spurred on by Caravaggio's picture or whether he already had paintings of the subject. Caravaggio's painting was sold together with the *Caraffa* on 8 May 1628 (Kirwin, 1971, p. 55; for the *Caraffa,* cf. my p. 84, n. 22.)

The *Concert* was evidently about the same size as the *Cardsharps* [10], and it may have been commissioned to make a secular pair. That idea was taken up by Bartolomeo Manfredi, whose pair of paintings depicting a concert and card-players (dating 1610/1615) is now in the Uffizi (Berti, 1979, nos. P 986 and P 988). Cf. my Notes 12 and 13.

The *Concert* has been cut down and is badly damaged; the head of Eros is largely modern, as is the music; the inscription is a later addition. Old copies show wings on Eros (Moir, 1976, pp. 84–85, no. 7). Spear (1971, pp. 70–71, no. 15) accepted Mahon's date of 1594/1595, called it "one of Caravaggio's earliest efforts at figural composition, if not his very first," and noted that tears seem to be welling in the lutenist's eyes. He agreed with Friedlaender that it must be an allegory of love. For the supposed musical allegory, see Scherliess (1973; cf. also *idem,* 1972). He pointed out (1973, pp. 147–148) that all of Caravaggio's representations of music show individual printed parts of ensemble compositions, but he did not believe that the notes play a role in the meaning of the paintings. Since he could not read the music in the *Luteplayer* [18], and because the music in this work is largely repainted, his observations may be subject to change (cf. Note 29).

Egan (1961, p. 193) saw this work as a late example of representations of *Musica,* which usually include three female players and Amor, as explained by Vasari (ed. Milanesi, VI, p. 373, *Life of Michele Sanmicheli*). Vasari described paintings by Veronese in the Libreria, where Music appears together with Honor and Arith-

metic and Geometry (see R. Marini, *L'Opera completa del Veronese,* Milan, 1968, p. 93, no. 40c). See also Note 18. For harmony in the Renaissance arts, see J. Hollander, *The Untuning of the Sky* ... (Princeton, 1961, p. 201 and *passim*), and R. Wittkower, *Architectural Principles in the Age of Humanism* (New York, 1971, part IV: "The Problem of Harmonic Proportion in Architecture"). Shakespeare, in an early comedy, wrote: "And when Love speaks, the voice of all the gods/Make heaven drowsy with the harmony" (*Love's Labour's Lost,* IV.iii.344–345) and, earlier in the same work, "music ... /Doth ravish like enchanting harmony" (I.i.167–168). Throughout Shakespeare we find references to "heavenly," "celestial," "sweet," and "delightful pleasing harmony."

For the high social position of the lute (as opposed to that of pipes), expressed in Castiglione's *Courtier* and exemplified in Renaissance art, cf. P. Egan (*Art Bulletin,* XLI, 1959, p. 307 and *passim*). See also Ripa's discussion in *Iconologia* (reprinted in Marini, 1974, p. 343). Further, E. Winternitz, *Musical Instruments and Their Symbolism* ... (New York, 1967). A rash of amorous lute songs was composed in the later sixteenth century, and *Richard III* opens with an image of York, who "capers nimbly in a lady's chamber/To the lascivious pleasing of a lute" (I.i.12–13).

Identifications of the figures in this work as Minnitti and Caravaggio have been disputed and are tentative: cf. Frommel (1971, 1971a). The presumably homosexual message was discussed by Posner (1971a), and by Röttgen (1974, pp. 189 ff.) as part of Del Monte's world.

The museum plans to restore the painting in the near future. (Photo: Museum)

16. Callisto Piazza, *A Concert.* John G. Johnson Collection, Philadelphia Museum of Art, no. 234. Oil on wood, 90.5 × 10.5. 1520s? The comparison of this painting with [15] was made by Salerno-Kinkead (1966). There are also many Venetian examples: see B. W. Meijer, "Harmony and Satire in the Work of Niccolò Frangipane ..." (*Simiolus,* VI, 2, 1972/1973, pp. 94–112), which differentiates between this tradition and

Caravaggio's. For Piazza, see M.-L. Ferrari (*Paragone,* 183, 1965, pp. 17–49). Cf. Note 152. (Photo: Museum)

17. Studio of Titian, *Venus and a Luteplayer.* New York, Metropolitan Museum of Art, Frank A. Munsey Fund, 1936, no. 36.29. 65 × 209.4. An unfinished studio replica of a painting now in Cambridge (Fitzwilliam Museum) that dates from the 1560s, which has more finished musical notation (cf. Zeri, *Catalogue,* 1973, pp. 77 ff.). The musical theme is discussed by D. Rosand in *Tiziano e Venezia* (*Convegno* [Venice, 1976], Vicenza, 1980, pp. 375–381, with previous bibliography). Rosand subordinates the Neoplatonic interpretations to the sensual images in these pictures, returning to their most obvious level while insisting on "contradictions and ambiguities." A simplistic solution is favored by C. Hope, *Titian* (New York, 1980, pp. 157–158; he mistakenly calls the instrument in the hands of Venus a flute; it is a recorder, which is played more directly and suggestively). Further, Wethey (III, 1975, pp. 195–196, no. 45, and *passim*).

This work was in Rome until c. 1718 and it may have been there in Caravaggio's day as well; later it was in the Pio collection together with at least one painting by Caravaggio (cf. Note 96). (Photo: Museum)

18. *A Luteplayer.* Leningrad, Hermitage. 94 × 119. (M.17: 1595.) Purchased from the Giustiniani sale of 1808 in Paris. In the inventory of 1638, drawn up after the death of Marchese Vincenzo Giustiniani, this is listed as *"Un quadro sopraporto con una mezza figura di un giovane che suona il Leuto con diversi frutti e fiori e libri di musica dipinto in tela alto palmi 4 largo palmi 5— con sua cornice negra profilata e rabescata d'oro di mano di Michelangelo da Caravaggio"* (Salerno, 1960, p. 135, no. 8). Although Baglione and Bellori describe a *Luteplayer* at some length, they both refer to one painted for Cardinal Del Monte and never speak of the Giustiniani painting. Nevertheless this work seems to represent Caravaggio's "Del Montean" style and should have been painted for him, as the *Concert* [15] surely was. Perhaps Del Monte's painting entered the Giustiniani collection following the cardi-

	Height in Del Monte's inventory			Measured height today
	palmi romani	=	*centimeters*	*centimeters*
St. Francis [30]	4		89	92.5
Cardsharps [10]	5		112	99
Fortuneteller [12]	5		112	99 (strip added?)
Concert [15]	5 *"in circa"*		112	92 (cut down)
Luteplayer [18]	6		134	94
St. Catherine [34]	7		156	173

nal's death in 1626 and the subsequent sale of his works in 1628, but it is not listed as having been sold (Kirwin, 1971). Baglione (p. 136) described the painting in Del Monte's collection at unusual length, immediately following the *Concert*.

Del Monte's inventory describes the picture as *"Un Quadro con un' huomo, che suona il leuto di Michel Angelo da Caravaggio con Cornice negra di palmi sei"* (Frommel, 1971, p. 36). But the measurements of Del Monte's *Luteplayer* in the inventory differ from those of the Giustiniani-Leningrad painting far more than the measurements of other pictures in the inventory differ from the surviving canvases.

Thus Del Monte's *Luteplayer,* at six *palmi,* was c. 134 cm high, while the painting in Leningrad is 94 cm, a difference of almost two *palmi.* (The manuscript transcribed by Frommel has a "6," but the scribe could have written the wrong number.)

The Giustiniani measurements given by Salerno (*palmi* 4 × 5— = 89 × 112 cm) work out well as approximations in *palmi* of the painting in Leningrad, which measures 94 × 119— indeed, the correspondence is about as close as we usually find for such measurements. Nevertheless I believe that Salerno read the figures incorrectly: what he transcribed as a dash, I read as "½." If so, the Giustiniani *Luteplayer* in the inventory measured *palmi* 4 × 5½, or 89 × 123 cm, and that is closer to the actual width of the painting (Archivio di Stato, Rome, *Casa Giustiniani,* Busta 16, *"Inventario de Quadri e Statue, 20, A. Parte IV, no. 8,"* under the heading *"Nella Stanza Grande de Quadri Antichi"*). This change does not affect the discrepancy in height between the work in Del Monte's inventory and the one in

Leningrad, which remains mysterious. (For other conflicts between Salerno's transcriptions and my own, see Notes 41, 87, 104, and 129.)

In 1642 Carlo Mangone was paid by the Barberini for copying the *Luteplayer* and the *Cardsharps* [10] (see M. A. Lavin, 1975, p. 9, doc. 78, and my Note 10). What seems almost surely to be Mangone's copy survives with the Barberini *Fidecommesso* number "13" painted at the bottom right (Lavin, p. 715; Moir, 1976, no. 8f and fig. 19; cf. his p. 123, n. 185). It has no flowers or fruit and shows several different musical instruments on the table.

Beginning in 1644 a *Luteplayer* ascribed to Caravaggio appears in the inventories of the Barberini collection, but the description matches the copy: it mentions other musical instruments and no flowers or fruit (Lavin, p. 167, no. 260). In 1671 it was listed as measuring five and one-half *palmi* in height rather than in width (Lavin, pp. 296–297, no. 111), but in subsequent inventories (1672, 1686) the error was rectified (Lavin, pp. 369, no. 149, and 397, no. 66). The inventory of 1671 continues to mention *"altri Stromenti Musicali,"* but the later inventories call the figure a woman playing an *arciliuto* and do not mention other instruments. In the inventory of 1671, Caravaggio's *St. Catherine* [34] and *Cardsharps* [10] were valued at 400 *scudi* each, the *Abraham* [102] at 450 *scudi,* and the *Luteplayer* at 250 *scudi* (Lavin, pp. 296–297, nos. 101, 111–113). These valuations assume that all the paintings were originals (Mangone had been paid 22 *scudi* for both copies). Thus the Barberini may have owned an old painting, perhaps even Del Monte's. (In the inventories of 1672 and 1686 the height is given as four *palmi* and four and one-

half *palmi* respectively, so the discrepancy with Del Monte's inventory is not resolved.) All we can say for certain is that the Giustiniani-Leningrad painting [18] was not one of those in the Barberini collection, for it was listed in the Giustiniani inventory of 1638 and remained there.

Nevertheless Bellori cited the *Luteplayer* in the Barberini collection (pp. 203–204) as having been painted for Del Monte, like the *Cardsharps* and *St. Catherine* in the same collection. He discussed them as a group, pointing out that the *Luteplayer* and *St. Catherine* showed the darkening of the shadows that characterized Caravaggio's maturing style. (Bellori, like the later Barberini inventories, calls the lutenist a woman.)

Although Mahon (1952, p. 19) paired the *Luteplayer* with the *Concert* [15] among works done in 1594/1595, most writers give it a somewhat later date in the Del Monte period, in part because of that darkening that Bellori observed in the copy but which is less evident in the original. Comparison is difficult because of the ruined condition of the *Concert*, but spatially the *Luteplayer* is more advanced. Spezzaferro (1971, pp. 85–86) put this work after the Uffizi *Bacchus* [22]; Frommel (1971, pp. 17–18, 51) dated it to 1597, followed in general by Röttgen (1974, p. 198). Cinotti, however, put it immediately after the *Concert* (1973, no. 7).

Pentimenti are visible to the naked eye and can be seen even in photographs. The model, often thought to be identical with that of the lutenist in the *Concert*, has also been identified with the boy in the Uffizi *Bacchus* and in the *Boy Bitten* [25]: see Frommel (1971a, 1971). For homoerotic interpretations, see Posner (1971a). Röttgen (1974, pp. 189 ff.) finds the homosexuality of these paintings to be a reflection of the Del Montean atmosphere and a symptom of what he analyzes as Caravaggio's prolonged adolescent phase. It has been suggested that the lutenist is a transvestite (Friedlaender, p. 156; Wagner, 1958, p. 20), but it seems more probable that he is simply meant to be beautiful—as beautiful as a girl (cf. Shakespeare, Sonnet 20). Like Bellori, both Berenson (1951, p. 14) and Bauch (*Kunst-*

geschichtliche Studien für Hans Kauffmann, Berlin, 1956, p. 254) thought the model to be a girl, but they were evidently relying on poor reproductions (Bauch mistakenly interpreted the clothing). Nevertheless there has always been equivocation about the sex of the figure.

Bauch linked the picture with the *vanitas* tradition of still-life painting and cited the similarity of a portrait of Monsignor Maffeo Barberini, attributed to Caravaggio, which also has a vase of flowers at the left. That painting is now universally rejected (Marini, 1974, p. 132, no. 29; cf. his C 15, p. 317, for the Bauch picture, and my Note 193). Baglione (p. 288) asserted that his friend Mao (Tommaso Salini) was the first to paint and arrange flowers with their leaves in vases—possibly as an attempt to discount Caravaggio's originality (cf. Note 20 and Bellori's comment on p. 10 above).

For the painting as Harmony, see Spezzaferro (1971, p. 87, n. 147) and my Note 15. For Pythagoreanism in the Renaissance, see S. K. Heninger, Jr., *Touches of Sweet Harmony* (San Marino, California, 1974). It is even possible, given Del Monte's alchemical interests, that the androgynous lutenist is a symbol of the alchemical hermaphrodite, around which the heavens were conceived as turning (Heninger, p. 157, reproduces the cosmic pattern from Bartholomaeus Anglicus, *De Proprietatibus Rerum,* Lyons, 1485, R5; also p. 312).

The reading *"Gallus"* for the closed score was suggested by G. DeLogu, *Caravaggio* (Milan, 1962, p. 140, no. 4); but I am assured by Gino Corti that *"Bassus"* is correct. Scherliess (1973, p. 147) read the title as *"Bassus"* but could not read the words on the lutenist's music, apart from the beginning "V" (cf. Note 15). The madrigal was a popular text, set by various composers including Arcadelt (*Opera Omnia Jacobi Arcadelt,* A. Seay, ed., American Institute of Musicology, II, 1970, book I, p. 58). The poem begins: *"Voi sapete ch'io v'amo anzi v'adoro/Ma non sapete già, che per voi moro"*

Flower symbolism is wittily discussed by Held (1961).For sexual significance of cucumbers, etc., see D'Ancona (1977, *passim*). (Photo: Museum)

281

19. Bartolommeo Veneto (d. 1531), *Lute-player*. Boston, Isabella Stewart Gardner Museum. Oil on wood, 66 × 50. 1520. F. Hendy, *Catalogue* (1931, pp. 27–30), lists ten versions and assumes that this was painted in Milan because three others were still there. An almost identical version (65 × 50), now in the Brera, is also dated 1520 (E. Modigliani, *Catalogo*, 1950, p. 56, no. 948). Cf. Scherliess (1972, pp. 41–42, 130 ff., no. XXVII), who illustrates five versions. The type seems to derive from Solario, as do other portraits by Bartolommeo. Both this and the Brera version show traces of a halo, as though they had originally been meant to show a saint (Cecilia?). Modigliani assumed that it was a portrait of a lady named Cecilia, but a portrait would never have had a halo. One could have been added, but it would be strange if haloes had been added and then effaced from both versions independently.

David Rosand pointed out to me that the music is not only turned toward the viewer but is also labeled for male voices ("Tenor," "Basus"). Thus the *concetto* of viewers joining in the music is already seen here.

For Bartolommeo, see C. Gilbert in *Bulletin, National Gallery of Canada* (XXII, 1973, pp. 2 ff.). He assumes that Bartolommeo had settled permanently in Milan by 1520, though he died in Turin. Despite his name, Bartolommeo was by his own description "half Venetian, half Cremonese," and worked in various parts of north Italy. Caravaggio must have known some of his paintings, including versions of this work. (Photo: Museum)

20. Anonymous. *Vase of Flowers*. Galleria Borghese, no. 362. Oil on copper, 28 × 21. Della Pergola (II, 1959, no. 221) connects this with a document of 1613 that records the purchase of twelve little paintings on copper of diverse fruits and flowers, but also suggests that it could have come from the paintings sequestered from Cesari d'Arpino in 1607 (see Note 4). One of them was a "*caraffa di fiori, et altri fiori non compito*" that, Della Pergola speculated, could have been a model for Caravaggio in Arpino's shop. Della Pergola attributed this and another

painting of the same kind to Jan Bruegel but the attributions are rejected soundly by Ertz (1979, p. 278), who does not even call the painter Netherlandish. I believe that it is by a Netherlandish painter working in Italy. (Photo: GFN E 32026)

21. Orazio Gentileschi, *Luteplayer*. Washington, National Gallery of Art, no. 1661. 144 × 129. Dated toward 1615 by Bissell (1981, no. 31). (Photo: Museum)

22. *Bacchus*. Florence, Galleria degli Uffizi, no. 5312. 93 × 85. (M.16: 1595.) Apparently not recorded in the old literature (cf. Note 9). Discovered in the Uffizi storerooms in 1913 and recognized by Longhi as an original (Marini, pp. 356–357). Mahon (1952, p. 19) put this at the beginning of his group to be dated 1595/1596, essentially where we still place it; Frommel (1971, pp. 17, 51) dated it 1596, before the *Lute-player* [18], which was also Spezzaferro's opinion (1971, pp. 85–86). Cinotti (1973, no. 12) and Röttgen (1974, p. 198) imply a slightly later date, c. 1597, after the *Luteplayer*, which to me seems wrong—but Mahon also put it after the *Luteplayer*. The paintings have never been seen together ([18] was not at the *Mostra* in 1951), and some confusion is understandable.

The face of Bacchus, like that of the lutenist in the *Concert* [15], appears rouged and lipsticked, a quality that had already emerged in the *Boy with a Basket* [4], and which I assume indicates a relatively early date. The red rubbery right hand is similar to the hands of the *Magdalen* [28], which I consider to be early. Thus I am inclined to date the painting early in the Del Monte period. For the still life, see also Notes 18 and 47.

Charles Dempsey (1970, p. 326) pointedly mentioned that some of these paintings might be satires, a word he derived from [*lanx*] *saturae*, a plate filled with fruits. A homoerotic interpretation was offered by Posner (1971a). For the equation with images of Flora, see A. Hollander, *Seeing Through Clothes* (New York, 1978, p. 209), with references to such paintings of Flora as Titian's (Uffizi) and Palma Vecchio's (London). See also Held (1961) for Flora. Cartari

(1571, pp. 412 ff.) discusses Bacchus as a transvestite (p. 422) and in other capacities. Bacchus's costume and semi-nudity derive indirectly from antique models, of which there were many in Rome, even in Del Monte's own collection. There is an obvious relationship to the fleshy Antinous types, including the *Antinous Farnese* (now Naples), then in Rome. Another (Vatican) shows Antinous as Bacchus. Shakespeare refers to "plumpy Bacchus" and "dainty Bacchus" (*Antony and Cleopatra,* II.vii.114; *Love's Labour's Lost,* IV.iii.336), which may reflect some of the overtones that we get from Caravaggio's painting. Since Bacchus was widely given credit for the "gift of wine," his offer of a goblet in the picture may be a reference to that tradition. Dempsey has recently suggested (letter) that paintings such as this portray "catamites—that is, young boys who sell themselves for immoral purposes. The word catamite comes from Greek and Latin corruptions of the word Ganymede, who is also a young boy corrupted by a high prince, viz Jupiter. Ganymede is also the cupbearer of the gods, who offers them wine." (Cf. Note 96.)

The condition of this work is poor; in 1978 it was again undergoing minor restoration. (I am grateful to the staff of the Laboratorio di Restauro at the Fortezza da Basso for allowing me to see the picture there, under lights.) The X-ray photograph, published by Berti (1979, pp. 64–65, figs. 12a–b), shows a coarser figure as Bacchus but does not bear out Nicolson's judgment that the picture is "ruined or drastically repainted" (1979, p. 34).

23. Detail of [22].

24. Annibale Carracci, *Bacchus.* Naples, Museo Nazionale di Capodimonte. 163 × 104. Posner (1971, II, p. 26, no. 59) dates it c. 1590/1591. In 1653 it was in the Farnese palace in Rome, attributed to Agostino Carracci. (Photo: Villani 23223)

25. *A Boy Bitten by a Lizard.* London, Vincent Korda Collection. 68 × 51.5. (M.7: 1594, accepts the Longhi version: 65.8 × 53.2.) A third painting of the subject, which I have not seen, is illustrated by Moir (1976, fig. 3). Mentioned by Mancini (p. 224), after Caravaggio's stay with Pandolfo Pucci, as the earliest named picture, followed by the *Boy Peeling* [3], both as done to sell. Earlier (p. 140), talking about prices, Mancini wrote that Caravaggio sold the *Boy Bitten* for 15 *giuli* and the *Gypsy* for 8 *scudi* (10 *giuli* equaled 1 *scudo*). Mancini specifically refers to these paintings as later than the earliest by saying that out of necessity they were sold for lower prices than he had been getting. This assertion would tend to militate against the very early date for the *Boy Bitten* that has occasionally been promulgated on the basis of Mancini's having mentioned it elsewhere together with the *Boy Peeling* (e.g., Costello, 1981; see Note 3). Baglione (p. 136) mentions this picture early, just after the *Bacchino Malato* [9], among the paintings done on his own and without great success. Sandrart, much later, also thought it early, perhaps done while Caravaggio was with Giuseppe Cesari (1925, p. 276). Probably by that time the painting was no longer to be seen; it is not mentioned by Bellori.

The choice between the cruder or more poorly preserved Longhi version and the more polished Korda picture—assuming that one of them is the original—depends on whether it is a very early work, or a more mature picture of c. 1596/1597. The shirt pulled off the shoulder makes us think of the early *Boy with a Basket* [4], as to a lesser extent does the shoulder itself. Mahon, "finding a certain direct and rather *farouche* uncouthness in the work of Caravaggio at a very early age" (1953, p. 214), accepted the Longhi picture and thought that the Korda version showed "the sort of contradiction which one expects when an original conception is reinterpreted to conform with a slightly later taste (in this case that of a later phase of Caravaggio himself)." Of course, both could be only copies. Since all the known versions employ dramatic chiaroscuro to highlight the action, the sensible solution may be to date the conception by style, which would favor a somewhat later date—and hence presumably the Korda picture.

No very early work by Caravaggio shows such dramatic chiaroscuro; vigorous action perhaps begins with the *Cardsharps* [10]. Between it

and [25] there seems little choice but to place the *Cardsharps* first, for all versions of the *Boy Bitten* exhibit a chiaroscuro that verges on what we see in the more mature pictures of the later 1590s. Without discussing the versions, Spezzaferro also put the picture into 1597/1598, after the *Lute-player* [18] (1971, pp. 86 ff.). Hess (1967, p. 283, n. 2), discussing the Longhi version, noted aspects of coloration that would indicate a later date. Even if the Longhi picture is the original, it can hardly be as early as Mancini and Baglione thought, and certainly it has nothing in common with the *Boy Peeling,* which Mancini once paired with it.

I believe that the Korda picture is an original of c. 1597, the Longhi version a good copy in only fair condition. This was also Nicolson's decision (1979, p. 34; endorsed by Spear, 1979, pp. 318–319). But Salerno (1970, p. 235) thought they were both originals (cf. Note 12), and Moir (1976, p. 104, no. 51) calls all the versions copies.

For the symbolism, which has been much discussed, see Salerno (1966), Posner (1971a), and Röttgen (1974, pp. 193 ff.). L. Slatkes (*Print Review,* 5, 1976, pp. 148–153) pointed out that since such reptiles were reported to have a deadly bite, the painting need not be a purely symbolic or allegorical illustration of danger or evil; we might add that Shakespeare mentioned "lizards' dreadful stings" (*III Henry VI,* III.ii.325). But Slatkes made some errors (he mistakenly mentions figs in the painting, p. 150). The nature of Caravaggio's animal has been clarified by D. Posner (*Art the Ape of Nature, Studies in Honor of H. W. Janson,* New York, 1981, pp. 387 ff.), who insisted on the difference between amphibious salamanders, which were sometimes thought to be poisonous, and lizards, which are reptiles and whose bite is not deadly. Indeed, they "don't generally bite people," as Posner stated, which makes it at least arguable that Caravaggio depicted the harmless "wall lizard" *(lucertola)* while having in mind anecdotes related to another, perhaps confusingly similar animal. Posner concluded that the homosexual boy "confronts not death but the powerful experience of rejection in love . . . the lizard's bite hurts, its marks remain

and ache for a long time, but it is not fatal."

Renaissance meanings for jasmine and other flowers are given by D'Ancona (1977, pp. 193 ff., no. 18, and *passim;* cf. my Note 3). Roses can also be simple metaphors of youthful beauty: "From fairest creatures we desire increase,/That thereby beauty's rose might never die" (Shakespeare, Sonnet 1). Shakespeare also alludes to the practice of putting a rose behind the ear (*King John,* I.i.141 ff.). The image of the thorn on the rose is a cliché in the language of all countries.

It seems possible that the picture is essentially an image of *vanitas,* and it could even refer to Lucretius: "a bitterness arose, a pang among the flowers" (*De Rerum Natura,* IV, 1134, and *passim;* trans. G. Highet, *Poets in a Landscape,* New York, 1957, p. 70). Costello (1981) insists on the pairing made by Mancini with the *Boy Peeling* (see Note 3) and interprets the two as Touch and Taste, invoking prints of the Five Senses by Frans Floris (his *Touch* is her fig. 3). For stylistic reasons I cannot accept the pairing, and many aspects of this work, like the rose behind the boy's ear, are left unexplained.

A poem by G. B. Lauri, *"De Puero, et Scorpio"* (1605), was tentatively (and incorrectly) connected with this painting by Battisti (1960, p. 214, n.; cf. Salerno, 1966, p. 108). (Photo: Courtesy David Carritt)

A related painting, *A Boy with a Carafe of Roses,* has been attributed to Giovanni Baglione by Röttgen (1974, p. 253, n. 157), I believe correctly. He dated it 1605/1606. (M.6: 1593, considers the Atlanta version the best copy of a lost Caravaggio.) I do not believe that the hypothetical original was by Caravaggio (cf. Nicolson, 1979, p. 34). It is a version of [25], to which it is too similar to be part of a series by Caravaggio.

26. Detail of [18]. (Photo: Museum)

27. *Portrait of a Courtesan named Phyllis (Fillide).* Formerly Berlin, Kaiser Friedrich Museum, no. 356 (destroyed 1945). 66 × 53. (M.20: 1596.) In the Giustiniani inventory as *"Un altro quadro con un ritratto di una Cortigiana chiamata Filide in tela da testa con sua cornice negra di mano*

di Michelangelo da Caravaggio" (Salerno, 1960, p. 136, no. 12). The preceding entry in the inventory lists "una Cortigiana famosa" by Caravaggio, "ancora imperfetto"; evidently he was believed to have painted more than one such picture, unless the unfinished one was a copy of this work, which is not what the inventory suggests. Frommel (1971, pp. 19, 51) dated Phyllis to 1598, with reference to the St. Catherine [34], an opinion shared by Cinotti (1973, no. 16), but the photographs of [27] make it seem cruder. The flowers have been variously identified as myrtle, orange, and—I think correctly—jasmine (Marini, 1974, p. 114; cf. my Note 25). (Photo: Museum)

28. The Repentant Magdalen. Galleria Doria-Pamphilj, no. 357. 123 × 98.3. (M.13: c. 1595.) Mentioned by Mancini (p. 224) together with the Rest on the Flight [29] as having been painted in the Palazzo Petrignani, which is to say, during the period after his stay with Giuseppe Cesari and before his commercial success. Not cited by Baglione. Scannelli (1657, p. 277) criticized the painting severely. Bellori discussed it at length (p. 203; quoted on pp. 50–51 above). See also Note 29; that work is in a sense the companion to this painting.

Dated by Frommel (1971, pp. 18, 51) and Röttgen (1974, p. 198) to c. 1597/1598; Cinotti dated it 1598/1599 (see Note 29), which seems too late. Mahon dated it earlier than [29], to 1593/1594 (1952, pp. 8–9): "There are two pictures which appear to me stylistically very close to the Louvre Buona Ventura [12], the Doria Maddalena and (judging from the photographs of the lost original) the Bari [10]. It is not unusual for art historians to be taken aback by the extraordinary flatness of the Maddalena, in particular in the treatment of her sleeves. . . . I had previously supposed that they have been rubbed down in a former cleaning . . . I have come to the conclusion that this is not the case, and that the explanation is to be sought in the dating. This is the typical ironed-out rendering of white drapery which we find in Caravaggio's earliest productions, and which accordingly marks the slight gap between it and the same gallery's Riposo [29]—hitherto always associated with it.

The sleeves of the gipsy in the Buona Ventura, though they have slightly more bulk, are treated in a very similar fashion to those in the Maddalena. The latter is, I feel sure, one of those pictures painted on Caravaggio's own account with a view to sale. It was started, it would appear, with no 'subject' . . . there is a pentimento whereby part of the dress was painted over to make way [for the accessories making it a Magdalen]—la finse per Madalena, as Bellori put it." I wholeheartedly endorse this analysis, although Mahon put the St. Francis [30] even earlier than the Magdalen. Whatever the sequence, all these paintings may well be earlier than the Bacchus [22] or the Concert [15], which was supposedly the first painting done expressly for Cardinal Del Monte. Thus all of them presumably represent Caravaggio's style in the years immediately before he met the cardinal through the sale of the Cardsharps [10], though I am tempted to believe that the St. Francis and Bacchus were painted for Del Monte (see Notes 22 and 30).

The model for this work is manifestly the same as that for the Madonna in the Rest on the Flight [29]; the two pictures may always have been together, and cannot be far apart in date (cf. Note 29). The lace around the neck of the Magdalen's blouse may be a later addition; it is not found in copies or in other costumes of the type by Caravaggio [cf. 27, 33, 34]; see Marini (1974, pp. 352–353, C and E, citing R. Bossaglia in Commentari, XII, 1961, pp. 195–202).

I. Toesca (Journal of the Warburg and Courtauld Institutes, XXIV, 1961, pp. 114–115) compared the pose of the Magdalen with a print of St. Thaïs by Parmigianino; she also cited the influence of images of Melancholy, of which Dürer's Melencolia I is the most obvious example. For the medieval Magdalen, see Pelikan (1978, pp. 126, 167). The quotation from Baronio is from p. 159 of the translation of 1590. See also Note 33. (Photo: GFN E 41615)

29. The Rest on the Flight into Egypt. Galleria Doria-Pamphilj, no. 241. 133.5 × 166.5. (M.14: 1595.) See also the discussion in Note 28. Mentioned by Mancini (p. 224) as being among the paintings done after Caravaggio left the Cesari

and went to stay with Fantino Petrignani (see p. 8, n. 14, and Note 12). These are paintings that some historians date in the Del Monte period; it has even been suggested that Mancini wrote "Petrignani" when he should have written "Del Monte" (Frommel, 1971, p. 8, n. 21)—but see the chart, p. 273. Neither this work nor [28] is recorded by Baglione. Bellori lists this after the *Fortuneteller* [12] and *Magdalen* [28] among the pictures in the Palazzo Pamphilj (p. 203). For the possibility that all three Pamphilj paintings were in the Vittrici collection earlier in the century, see p. 53, n. 3. For a discussion of the dates of these early paintings, see Note 12.

All writers insist on the Lombard memories that crop up in Caravaggio's rare outdoor paintings, including the roughly contemporary *St. Francis* [30]. For Cesari d'Arpino's compositions related to [29], see Röttgen (1973, nos. 88, 153). The angel has sometimes been supposed to reflect the figure of Vice in Annibale Carracci's *Hercules at the Crossroads* (c. 1596; Naples, Capodimonte), which was then in the Farnese palace in Rome; but Röttgen cited a similar figure, of 1594, in the Palazzo dei Conservatori (1974, fig. 58). Similarities in style with the *Fortuneteller* [12] were pointed out by Spear (1971, p. 4). The dates too are perhaps fairly close. Frommel (1971, pp. 17, 51) dated this to 1596, just before the Uffizi *Bacchus* [22]. Spezzaferro (1971, p. 86) put it after the *Cardsharps* [10] and *Fortuneteller*, which for him was also after the *Luteplayer* [18]. Röttgen (1974, p. 198) placed it after the *Cardsharps* and before the *Luteplayer*. Cinotti (1973, no. 14), however, dated it in what she called *"una fase di studio"* of 1598/1599, followed by the *Magdalen* [28], *Phyllis* [27], and *St. Catherine* [34], which for [28] and this work is too late.

The *Rest on the Flight* is one of Caravaggio's most descriptive paintings: the fiasco, the music, the wings, even the fungus on the oak tree are shown with considerable tactile realism. Although some details blur with distance, the spatial uncertainty, together with the north-Italian feeling of the landscape and the Madonna, make me want to date the picture quite early, before Del Monte's influence made itself felt. Neverthe-less the angel seems to belong to the Del Montean world of *St. Francis* [30] and the *Concert* [15], and the angel in the first *St. Matthew* is still related [87].

For the subject, see H. Voss (*Saggi e memorie di storia dell'arte*, I, 1957). For all the religious pictures, see also Mâle (1932). Caravaggio's painting omits the usual palm tree, from which the Holy Family was miraculously nourished, and substitutes an autumnal oak. We cannot be sure whether there is an iconographical significance here; the tree may simply be another example of Caravaggio's "realism": he may have painted the first attractive tree he saw. Nevertheless oaks had various meanings, and among them was the Tree of Life that became Christ's cross. The autumnal hues, which are not appropriate for the subject, might conceivably allude to the death of some pagan oak, that of Aeneas or of Romulus, for example (see the oak symbolism outlined in L. Partridge & R. Starn, *A Renaissance Likeness* . . . , Berkeley, 1980, pp. 142–143). For the music as a lullaby, see B. Disertori, *La musica nei quadri antichi* (Calliano [Trent], 1978, p. 51). I am grateful to Adrienne von Lates for pointing out the problem of the oak.

30. *The Ecstasy of St. Francis.* Hartford, Wadsworth Atheneum, no. 1943.222. 92.5 × 128.4. (M.9: 1594.) This painting is almost surely the one owned by Cardinal Del Monte at his death (Frommel, 1971, p. 34: *"Un S. Francesco in Estasi di Michel Agnolo da Caravaggio con Cornici negre di Palmi quattro"*), though it was not necessarily in his collection from the beginning. A *St. Francis* by Caravaggio, owned by Ottavio Costa in 1606, was recorded in testaments of Costa's friend Ruggero Tritonio in 1607 and 1612. Costa apparently gave the picture (a copy?) to Tritonio. Spezzaferro proposed that after Tritonio died in 1612 the *St. Francis* found its way to Del Monte, which is possible (1975, p. 114); more probably the Tritonio version is the copy now in Udine. Earlier confusions, caused by a misread date ("1597" for "1607"), were clarified by Spezzaferro (1974). In view of the fact that another of Costa's early Caravaggios was perhaps [33], which I consider to be less than a good

286

original, both works may have been only good contemporary copies. And Costa seems to have given them both away, unlike his beloved *Judith* [36], which he wanted preserved in the family forever. In 1639 Costa may have owned a different *St. Francis* (Spezzaferro, 1975, pp. 114–117; inventory of 1639, p. 118). Possibly his painting, if not this work, was M.89, the *St. Francis in Meditation,* of which two versions are now in Rome [cf. 191]. I consider them to be Caravaggesque rather than by Caravaggio; the one illustrated seems the better. (As for the *Penitent St. Francis* in Cremona, M.50, it is by a follower if it is connected with Caravaggio at all; it may be the product of an independent north-Italian development.)

This work is usually dated just before or after Caravaggio joined Del Monte, which is where I should put it as well. Röttgen (1974, p. 154, n. 168) decided that it was painted earlier because of the little "Arpinesque" figures in the middleground; further, cf. Röttgen (1973, p. 84, no. 14, and pp. 100–101, no. 24). Cinotti (1973, no. 8) dated it to 1596/1597, after the *Concert* [15] and *Luteplayer* [18], which seems late. The similarity of the angel here to the Eros in the *Concert* is unmistakable even though both heads have been repainted; the two paintings are also naive in conception and execution. Frommel (1971, pp. 15–16, 24) pointed out the similarities between the angel's face and that of the left-hand cardplayer in [10] and between Francis and the central figure in that painting. Thus the two works must be fairly close in time—though we have seen that facial resemblance alone is no guarantee of date (cf. Note 12). Since Del Monte supposedly purchased the *Cardsharps* and then commissioned the *Concert,* the *St. Francis* should be dated just then; Spezzaferro (1971, p. 85; 1974, p. 581) considered it a Del Montean production. The fact that Del Monte's Christian name was Francis can only strengthen the likelihood.

The theme was investigated by P. Askew (*Journal of the Warburg and Courtauld Institutes,* XXXII, 1969, pp. 280–306). Her attractive idea that Francis is depicted in the act of slowly receiving the stigmata seems to be refuted by evidence that the stigma on his right hand, rather than being a later addition, was original and then obscured by a restoration (cf. Spear, 1971, p. 69, n. 5). It is present in the copy at Udine and still another (Moir, 1976, fig. 14). Caravaggio's novelty lay in stressing the individual, inner experience of Francis in accordance with Franciscan doctrine, which made his stigmatization an internal, mystical experience rather than one superimposed from outside. For the theme, see F. G. Pariset (*Annales,* VII, 1, 1952, pp. 39–48). For mysticism in general, see E. Underhill, *Mysticism* . . . (New York, 1961; first published 1911). L. Cognet, *Post-Reformation Spirituality* (New York, 1959, pp. 14 ff.) briefly discusses Harphius and (pp. 51–55) Italian spirituality. I am indebted to an unpublished article on the subject of St. Francis in the later Renaissance by Felix Heap.

Spear (1971, pp. 5–6, no. 14) has a sensitive discussion of the painting. Marini (1974, pp. 19, 98) suggested that the angel is the Archangel Michael, who was "in close rapport with souls in ecstasy"; this would give the picture a self-referential significance if Caravaggio was aware of the belief. For Bellini's *"Stigmatization,"* see M. Meiss, *Giovanni Bellini's St. Francis in the Frick Collection* (Princeton, 1964).

The picture has suffered and was restored before its acquisition by the museum in 1943. It has not yet been X-rayed. Recently a top layer of varnish was removed, revealing *pentimenti* more clearly, including a lower position of the rope around the waist of St. Francis, which also had one end falling down in front. The left leg of the angel was at first behind its present position, and in many other places old outlines are visible. The painting is scheduled for further conservation, which will reveal the extent of the losses. They are now most evident in the head of the angel, which is chiefly restoration, although some original paint may be left in the facial area. I am grateful to Jean K. Cadogan, curator of paintings at the museum, for information and assistance. (Photo: Museum)

31. Detail of [30]. (Photo: Museum)

32. Giovanni Baglione, *St. Francis in Ecstasy.*

Santa Barbara, California, Davidson Collection. 155.6 × 116.8. 1601. Discussed by Spear (1971, p. 44, no. 3). See also J. T. Spike, *Italian Baroque Paintings from New York Private Collections* (Princeton, 1980, p. 22, no. 4).

33. Caravaggio (or after?), *The Conversion of the Magdalen.* Detroit Institute of Arts, no. 73.268. 100 × 134.5. (M.23: 1597; he did not know the painting in its present state; cf. *idem,* 1978, p. 16.) Published in 1974 with great fanfare (five articles) in the *Burlington Magazine* (CXVI, pp. 563–593), including technical observations of interest (pp. 563–572) that claim to show scoring (fig. 9) and record the use of tempera on wet oil in the flesh tones. Both characteristics might point to Caravaggio as the painter not long before c. 1600, when these features appear elsewhere. The scoring, however, is unproved and invisible, and Caravaggio's use of tempera has not been studied in relation to the general practice of the time. Hence the conclusions of the report are premature. I cannot accept the painting with any conviction, even after examining it on various occasions. Standing before the painting, I have the immediate and intense feeling that, attractive though it is in many ways, it is not by Caravaggio. (Cf. D. Posner, *Burlington Magazine,* CXVII, 1975, p. 302, for an inconvenient solution summarized on p. 62 above.) Nevertheless the model and part of the costume of the Magdalen are the same as those in the *St. Catherine* [34], and this person is presumably seen most attractively in the *Judith* [36]. The Martha is a wonderful invention with a considerable Caravaggesque pedigree. Perhaps the condition of the canvas is much worse than has been admitted. Moir (1976, pp. 107–108, no. 56) believes it to be a copy. The painting could have the same relationship to Caravaggio that the Capitoline *Fortuneteller* [177] has (see Note 12).

The work seems not to have been mentioned by the old writers. It would be difficult to maintain that *"la Madalena Convertita"* cited by Mancini (p. 224) is this work, for he mentions it immediately after [29], and those two paintings [28 and 29] were together then as now. This *Magdalen* may have been the painting listed in the inventory of Ottavio Costa's effects in 1639 (Spezzaferro, 1974, and 1975). Presumably it was the same painting that was offered to his friend Tritonio, who was given a choice between it and (a copy? of) [30] in 1606 and chose [30]. A painting of this subject, 4 × 6 *palmi*, was listed as a notable work in the Casa Mattei in an undated list of c. 1800 attributed to Caravaggio or Antonio Veronese (Biblioteca Angelica, Rome, ms. 2147, int. 8).

This work is painted in different styles: the green drapery by the mirror looks Venetian in its coarse impasto, while other parts are hard and shiny and still other parts (Martha) are vague and fuzzy. Nevertheless the work seems to represent a definable moment in Caravaggio's style around 1598; if he had only had a shop, I should attribute the painting to it without hesitation.

Cuzin (1975, pp. 55, 59, and figs. 7–8) identified two photographs from a mutilated version of this composition as by Valentin.

For the subject, see F. Cummings (*Burlington Magazine,* CXVI, 1974, pp. 572–578); see also Pelikan (1978, pp. 126, 167). (Photo: Museum)

34. *St. Catherine of Alexandria.* Villa Favorita, Castagnola (Lugano), Thyssen-Bornemisza Collection. 173 × 133. (M.22: 1597.) Not mentioned by Mancini or Baglione but listed in Cardinal Del Monte's inventory of 1627: *"Una S. Caterina della Ruota opera di Michel Agnolo da Caravaggio con Cornici d'oro rabescate di Palmi sette"* (Frommel, 1971, p. 34). Apparently acquired by the Barberini at the sale in 1628 (Kirwin, 1971, p. 55: 7 May); it, the *Cardsharps* [10], and a *St. Jerome* by Guercino were sold in one lot, and all appear in the Barberini inventory of 1644 (M. A. Lavin, 1975, p. 167, nos. 261–262; p. 169, no. 301). For the later Barberini history, see Notes 10 and 18 above. The "F 12" at the lower right in this painting is the Barberini *Fidecomesso* number of c. 1816: Lavin (p. 715). There are *pentimenti* in the missing part of the wheel, showing that it was at first round. What seem to be errors in perspective make the spokes irregular, and the metal axle thrusting out from the blue drapery seems off-center. The halo, per-

haps Caravaggio's first, seems to be drawn free-hand. The idea of showing her kneeling apparently derives from Titian's *St. Catherine* (Boston, Museum of Fine Arts).

Mahon (1952, p. 19) dated this just before the *Judith* [36]. Catalogued by Spear (1971, p. 72, no. 16) and dated c. 1597. Dated 1598 by Frommel (1971, pp. 19, 51), 1598/1599 by Cinotti (1973, no. 17), and 1599 by Röttgen (1974, p. 198). For Spezzaferro (1971, p. 88), the *St. Catherine* "could be understood as the summation of all his previous efforts, which had achieved consummation in the *Luteplayer,* the *Fortuneteller,* and the *Medusa*" [18, 12, 37]. This is the last painting done expressly for Cardinal Del Monte. From this time on, Caravaggio sought outside patronage, whether because of a change in their relationship, because of his higher prices, or simply because he wanted to become known to a wider circle. His commission for the paintings of the Contarelli Chapel in mid 1599 was a watershed in his career and, according to Baglione, it came through Del Monte (see p. 93 and Notes 52 and 56). (Photo: Museum)

35. Annibale Carracci and Lucio Massari, *St. Margaret.* Santa Caterina dei Funari. 239 × 134. Posner (1971, II, pp. 46–47, no. 106) dates the painting c. 1598. It is based on a figure of St. Catherine in an altarpiece of 1592 by Annibale (Posner, II, no. 67). *St. Margaret* was probably painted in Bologna by Massari and touched up or completed by Annibale in Rome. For Caravaggio's appreciation, see p. 65 and n. 9. (Photo: Villani 24362)

36. *Judith Beheading Holofernes.* Galleria Nazionale d'Arte Antica (Palazzo Barberini), no. 2533. 145 × 195. (M.32: 1599.) Presumably the *"quadro grande con l'imagine del Judit fatto da Michelangelo Caravaggio"* listed in the inventory of effects attached to the will of Ottavio Costa, dated 18 January 1639 (Spezzaferro, 1975, pp. 109–110, 118; cf. *idem,* 1974, pp. 584–585). It was recorded by Baglione, out of sequence, at the end of his list (p. 138) as being in the Costa collection. Although a *"Judith"* by Caravaggio was for sale in Naples in September 1607 (see Note 168), and although Costa had ties with Naples (see Note 118; Spezzaferro, 1974, 1975), the presumption is that Costa commissioned the painting in Rome and the Naples record refers to another picture, possibly a *Salome.* This is the one painting by Caravaggio that was especially dear to Costa: in 1632 he ordered that his collection not be sold, and particularly not the *Judith* and a few other choice items (Spezzaferro, 1975, pp. 109–110).

This work made a late appearance at the *Mostra* of 1951. Mahon (1953, p. 220) placed it near the first version of the *Martyrdom of St. Matthew* [56], which cannot have been begun before July 1599 (see Note 56). All writers now date it to c. 1598/1599. It was cataloged by E. Safarik, *Acquisti 1970–1972, Galleria Nazionale d'Arte Antica* (Rome, 1972, pp. 24–34). There are obvious *pentimenti* (e.g., along Judith's left arm). There also seems to be a groove above the lower outline of that arm, a feature that is prominent in the Contarelli paintings.

The positions of Judith and Holofernes are paralleled in a painting by or after Cerano, which may indicate a common Lombard source (*Mostra del Cerano,* Novara, 1964, fig. 69). Judith herself is a more attractive and appealing version of the model he used for *St. Catherine* [34] and for the unappetizing Magdalen in [33]. Judith's sword is a falchion (Macrae, 1964); like St. Catherine's rapier [34], it is to be distinguished from the swords carried or used by males in Caravaggio's paintings and by Caravaggio himself in life (see p. 196, n. 19). (Photo: GFN E 85608)

37. *Medusa.* Florence, Galleria degli Uffizi, no. 135. Canvas on wooden shield, diam. 55. (M.21: 1596.) Berti (1979, P 360). Given to the Medici by Del Monte, according to Baglione (p. 136; repeated by Bellori, p. 205). Del Monte was in Florence on 2 October 1602 (Calvesi, 1975, p. 81), and no doubt he made earlier visits as well as the later ones that are recorded. This work was discussed exhaustively by D. Heikamp (*Paragone,* 199, 1966, pp. 62–76), who cited the madrigal on the painting by Murtola (published 1603) as well as a poem in Marino's *Galeria* (Venice, 1619; both reprinted by Cinotti, 1973, pp. 51, 55; and 1971, p. 164). The shield was a part of the Medici

Armory and was not in the picture collection.

A lovely gold arabesque decorates the rim of the shield. The snakes are not lighted by the same source of illumination as the face, but both head and reptiles are shown as if alive. Wagner (1958, pp. 24–25) compared the bulging eyes to those of the possessed boy in Raphael's *Transfiguration* (his plates 8–9). Dated by Mahon just after the Uffizi *Bacchus* [22] and the *Rest on the Flight* [29], which seems a bit early (1952, p. 19: 1595/1596). Put after the *Luteplayer* [18] and just after the *Boy Bitten* [25] by Spezzaferro (1971, p. 88). Dated 1597 by Frommel (1971, pp. 18, 51), and put by Röttgen (1974, p. 198) in the same sequence, just after the *Boy Bitten* (but before the *Fortuneteller* [12]). Cinotti (1973, no. 20) dates the *Medusa* still later, c. 1599, after the *St. Catherine* [34] and the *Judith* [36], which seems unnecessarily late.

Vasari (Barocchi, IV, pp. 21–22; Milanesi, IV, pp. 23 ff.) wrote that Leonardo had the idea of painting a wooden shield with the Medusa's head but (typically) in his quest for perfection never finished it—a story that Caravaggio probably knew (cf. pp. 61–62 and 84, n. 22 above). If, as I suspect, the *Medusa* falls into a short period when Caravaggio was thinking specifically of Leonardo, it should probably be dated around 1597.

38. Copy (?) of Caravaggio, *The Betrayal of Christ*. Odessa, Museum of Western and Eastern Art. 133 × 171. (M.28: 1598.) A picture of this subject was seen by Gaspare Celio, presumably before 1620, in the Palazzo Mattei-Caetani, in the collection formed there by Marchese Ciriaco Mattei (died 1614) and then owned by his son Giovan Battista: *"Quella della presa di Christo mezze figure . . . di Michelangelo da Caravaggio"* (p. 134; 1967 ed., pp. 41 and 101, n. 391). Celio's book, published in 1638, bears a dedication dated 11 April 1620. Although it was brought up to date before being issued, apparently by the publisher (especially to account for the new works of art in St. Peter's), Celio's laconic indications of paintings in a few private collections presumably date from the original manuscript: thus he mentions Caravaggio's *"St. John"* [96] as being

in the Mattei collection, but it had been willed to Del Monte in 1624 and was sold by his estate in 1628. For our purposes Celio's citations are to be dated c. 1620, and for the Mattei collection they may well derive from the time when he was painting in the adjoining Palazzo Mattei di Giove, 1607–1608 and 1615 (Panofsky-Soergel, 1967–1968, Docs. XXI, XXIV, XXXII).

A *"presa di Cristo del Caravaggio"* is listed in an inventory of the possessions of Giovan Battista Mattei on 5 June 1624 (Frommel, 1971, p. 9, n. 31); hence it presumably had not been commissioned by his uncle Asdrubale (as Bellori believed, p. 207), who was still alive in 1624. Nevertheless Caravaggio could have been introduced to Ciriaco through Asdrubale, his younger brother, who began to employ Caravaggio's friend Prospero Orsi to paint in his palace in May 1600 (Panofsky-Soergel, p. 171, doc. VI). Baglione (p. 137) attributes Caravaggio's patronage by Ciriaco Mattei to Orsi's propaganda. This work appears in an inventory of the effects of Asdrubale Mattei in 1638, and it continued in the Mattei collection, occasionally attributed to Honthorst, until the early nineteenth century (Frommel).

The other Caravaggios surely owned by the Mattei family [42 and 96] date to c. 1600–1602, and the original of this work should perhaps be put near those dates. Bellori (p. 207), who saw it in the Palazzo Mattei, mentioned it after Giustiniani's *Amor* [98], which cannot date later than mid 1602. The painting Bellori described in great detail is so similar to this work that there can be no doubt that it reflects Caravaggio's original, if it is not indeed the Mattei painting. (Bellori wrongly identified the man fleeing at the left as St. John; see Mark 14: 46–52.)

For the Soviet picture, see S. Vsevolozhskaya & I. Linnik, *Caravaggio and his Followers* (Leningrad, 1975, plates 5–6), who call it "Caravaggio?" Another copy (*Mostra*, 1951, fig. 54) shows a bit more at the left. The so-called self-portrait, holding the lantern, does not appear to be in Caravaggio's mature style (shown in color detail in the Soviet publication). If it is a self-portrait, he seems younger than in the *Martyrdom*

of St. Matthew [66], dated 1600, where we also seem to see a different person. The man with the lantern appears again, painted in a demonstrably later manner, in the *St. Ursula* documented to 1610 [171], which may require a later dating for this work as well.

Nicolson described the painting as "?Lost" (1979, p. 22), assuming as most of us do that the Odessa version is only the best of a number of copies. I have not seen it. The boy running with his mouth open recalls the one in the *Martyrdom of St. Matthew* [56]. The crowding, the spatial ambiguity, and the facial features might point to a date no later than 1600. (Photo: Museum)

39. Cariani (Giovanni Busi), *The Road to Calvary*. Brescia, Pinacoteca Tosio Martinengo, no. 95. 195 × 100. Cariani (c. 1585/1590–1547/48) was born near Bergamo but was already established in Venice in 1517 and died there. He was closest to Palma Vecchio in style. This painting may be the one described by Michiel as in Bergamo: "*la meza figura del Christo che porta la croce in spalla*" (see E. Safarik, *Dizionario biografico degli italiani*, XV, 1972, p. 528). The painting is dated to the period 1510–1517. (Photo: Museum)

40. Giuseppe Cesari d'Arpino, *The Betrayal of Christ*. Galleria Borghese, no. 356. Oil on copper, 56 × 17. Discussed by Röttgen (1973, pp. 91–92, no. 18) and dated c. 1596/1597. It is thought to have been influential for Caravaggio's *Martyrdom of St. Matthew* of 1600 [56], but the sizes are wildly dissimilar. This was one of the paintings sequestered from Cesari by the Borghese in 1607 (see Note 4). (Photo: Arte Fotografica)

41. After Caravaggio (?), *Christ Crowned with Thorns*. Vienna, Kunsthistorisches Museum, no. 307. 127 × 165.5. (M.26: 1598.) A painting of this subject is mentioned by Bellori (p. 207) together with the *Amor* [98] and the *Doubting Thomas* [104], as having been painted for Giustiniani. The Giustiniani inventory of 1638 lists "*un quadro sopraporta con la Incoronatione de spine di Xpo Nostro Signore 4 mezze figure dipinto in tela alto palmi 5—largo palmi 7—di mano di Michelangelo da Caravaggio con sua cornice profilata, e rabe-*

scata di oro" (Salerno, 1960, p. 135, no. 3). I read the figures in the Giustiniani inventory as *palmi* 5½ × 7½, literally 123 × 168 cm, which is almost identical with the measurements of the Vienna painting (see Note 18). Although the Vienna picture was not part of the Giustiniani sale in Paris (see Salerno, 1960, pp. 26–27), its purchase in Rome in 1816 makes it possible that it came from that source, as Marini thought. It is the best candidate we have for that painting, even if it is only a copy. If it is a copy, the original presumably dated from the general time of the other Giustiniani paintings, which (from the known evidence) ranged from c. 1596/1597 [18, 27] to c. 1605 [188]. This work, to fit into that span, would presumably have to be put fairly close to the Contarelli Chapel, which is why I discuss it where I do in the text—but I am not convinced that it belongs there.

Nicolson was doubtful that this is autograph and followed Longhi in thinking that it might be a copy by Caracciolo (1979, p. 32). Indeed, the composition seems too concentrated and mature for Marini's date of 1598. Perhaps it was painted c. 1602–1603, or even later: a Neapolitan date has often been suggested. (Heinz, 1965, p. 32, no. 485, concluded that it was by an Emilian follower, which seems unlikely.) The figure in armor with his feathered hat has affinities with the *Crucifixion of St. Andrew* [144], a securely Neapolitan work. By comparison, this work is relatively hard and tightly modeled. Marini noted *pentimenti* and unfinished areas. The close similarity in dimensions and subject to the *Betrayal of Christ* [38] makes a pairing an attractive but ultimately unlikely hypothesis: the *Betrayal* seems considerably earlier in flavor.

It is possible that the composition of this work derives in some sense from Titian's great painting of the same subject, now in the Louvre but then in Santa Maria delle Grazie in Milan, where Caravaggio had surely seen it. (Photo: Museum)

An impressive painting now in Prato [178] (M.44: c. 1601), long considered to be a copy, has been published as an original by M. Gregori (*Burlington Magazine*, CXVIII, 1976, pp. 671–

178. *Christ Crowned with Thorns.* Prato, Cassa di Risparmi e Depositi. c. 1601.

680, with poor color reproductions; cf. *Progress,* II, 4, 1976, pp. 16–33, with better color plate and details. I am indebted to the officials of the Cassa di Risparmi e Depositi di Prato for their cordial welcome and for a copy of *Progress,* a house publication). I find the painting quite convincing, but it is dark, sunken, and hard to reproduce. It could be a damaged original of c. 1601–1602 (accepted by Nicolson, 1979, p. 32). One figure is almost identical with the man at upper left in the *Crucifixion of St. Peter* [82], and the Prato painting (or its hypothetical original) must be close to it in date. When compared, the *Crucifixion of St. Peter* is superior in condition and quality.

42. *The Supper at Emmaus.* London, National Gallery, no. 172. 141 × 196.2. (M.30: 1599.) Cataloged by Levey (1971, pp. 49 ff.) and discussed by H. Potterton, *The Supper at Emmaus by Caravaggio* (London, National Gallery, 1975: "Painting in Focus," 3). It can be followed from the Borghese collection (Manilli, 1650, p. 88) to its entry into the National Gallery in 1839. The "N.º 1" at the lower right is the Borghese inventory number. It cannot have been painted for Cardinal Scipione Borghese, as Bellori (and Röttgen, 1974, p. 60) believed, for Scipione Caffarelli was an obscure Sienese cleric until his elevation on 18 July 1605 by the new pope, Paul V Borghese—several years later than anyone thinks this picture was painted.

Celio saw such a painting *("Quella de Emaus")* in the Mattei collection. Since Celio was painting in the adjoining palace of Ciriaco's brother Asdrubale in 1607–1608 (see Note 38), his knowledge of the Mattei pictures may stem from that time (and Ciriaco also had a painting by Celio). It seems quite possible that this work soon entered the collection of the rapacious new cardinal-nephew, Scipione Borghese. Celio, writing of the Borghese collection, merely mentions paintings by Caravaggio (p. 137) without specifying them. Baglione, talking about people being duped by Caravaggio's rising reputation, wrote that he painted both this and a *Doubting Thomas* for Mattei (p. 137). Nevertheless no such paintings are mentioned in the inventory of Ciriaco Mattei's effects in 1613, or in those of his descendants (Frommel, 1971, p. 9, n. 31). The *Emmaus* could have been with Asdrubale, Ciriaco's brother, who died in 1638 and who, according to Bellori, commissioned the original of the *Betrayal* [38]; but the painting is not in Asdrubale's inventory (Frommel).

Levey (p. 52, n. 5) tried to show that the Mattei *Emmaus* could still have been in that collection in 1638 (Celio) and even in 1763 and hence claimed that it was not the Borghese-London painting. His reasoning is faulty: the Mattei *St. John,* for example, was already ceded to Cardinal Del Monte in 1624 and appears in his inventory (Note 96; cf. Note 38). Celio nevertheless records it in the Mattei collection. Thus Celio's book is perhaps valid for c. 1620, but not for 1638, as Levey assumed. Titi's guidebook of 1763 cites the *Betrayal of Christ* [cf. 38] and two unnamed Caravaggios in the Mattei collection. We know that the *St. John* was not one of them; the other was presumably not the *Emmaus,* the most impressive of the three, which presumably would have been mentioned. Bellori, too, cited only the *Betrayal* in the Mattei collection: the *Emmaus* was obviously no longer there.

The painting now in London was listed by Manilli in 1650 as being in the Villa Borghese (p. 88), and soon afterward it was cited by Scannelli (1657, pp. 198–199, in the "Palazzo Borghese"). Scannelli noted its *"tremenda naturalezza."* It seems reasonable to suppose that the outstanding painting mentioned by Baglione and Celio was indeed this work. Bellori, like Scannelli, saw and described the *Supper at Emmaus* in the Borghese collection, comparing it with [137], as we still do today (p. 208; see also Borea's note, her p. 231, n. 4).

Mahon (1952, p. 19) dated it to 1599/1600, toward the end of the period in which he placed the Contarelli paintings. The similarity he found was with the *Martyrdom* [56], and I tend to accept that date and reasoning: c. 1600, or just possibly 1600/1601, since the painting is rhetorically developed in a manner that connects it with the Cerasi Chapel [75, 82]. R. W. Bissell (*Art Bulletin,* LVI, 1974, p. 133) favored a date before 1600, linking this work with the *Doubting*

Thomas, which does not seem to me to be a convincing argument (see Note 104). Röttgen (1974, pp. 66–67) put the *Emmaus* together with the first *St. Matthew* of 1602 [87] and the *Amor* [98] as a coherent group. Levy and Potterton also date the painting c. 1602. Frommel (1971, p. 20), like Mahon, remarked on similarities with works of the late 1590s and dated the painting 1600/1601. Its affinities are perhaps more with the busy *Martyrdom of St. Matthew* [56] than with the more austere final versions of the Cerasi pictures; a date of c. 1600/1601 cannot be far off. Cinotti (1973, no. 32) dated it at the time of the Cerasi pictures.

The work is of interest technically because it shows few changes or *pentimenti* (Levey), and it has white tempera highlights added onto wet oil paint (also supposedly found in [33]: *Burlington Magazine,* CXVI, 1974, p. 571 and fig. 17; cf. Note 33). Dempsey writes that Caravaggio's use of pure color (reds, yellows, greens) here and elsewhere in the later Roman paintings "duplicates the pure hues used by Annibale—they are Bolognese hues, or, if you will, Lombard *colore* —and, even more important, they are located midway between *chiaro* and *scuro,* where Annibale located them, and the value relations are handled as Annibale handled them" (1977, pp. 85–86, n. 59). Nevertheless this is far darker in tonality than Annibale's paintings of c. 1600 [cf. 116, 81], and the analogy is not perfect.

The iconography is discussed ingeniously by C. Scribner III (*Art Bulletin,* LIX, 1977, pp. 375–382). Cf. Nadal (1593, text to plate 141/CXV). (Photo: Museum)

A *Christ on the Road to Emmaus* (M.27: 1598) is often cited as a possible candidate for the Mattei picture, even though the best version (Hampton Court) is regarded as a copy. Moreover, it may not be a *Road to Emmaus* at all but a *Christ with Sts. Peter and Andrew,* as Longhi and others have suggested. It does not look very Caravaggesque and may be Bolognese. The problem originated with Mancini (p. 225), who mentioned a *"Christ Who Goes to Emmaus"* as having been painted after Caravaggio fled Rome in 1606. I think that Mancini merely used this locu-

tion to describe our [137] (q.v.). Certainly the putative original of the Hampton Court painting would not fit that date, whereas [137] does, and it seems extreme to suppose that there was a third painting.

43. Studio of Paolo Veronese, *The Supper at Emmaus.* Dresden, Staatliche Kunstsammlungen, no. 233. 120 × 181. c. 1560? A variant of a more elaborate autograph painting in the Louvre (R. Marini, *L'Opera completa del Veronese,* Milan, 1968, p. 96, no. 51). The comparison with Caravaggio was made by Friedlaender (p. 164), who said that this work was in Rome until c. 1624— I do not know from what source. (Photo: Museum)

44. Marco d'Oggiono, *Salvator Mundi.* Galleria Borghese, no. 435. Oil on wood, 33 × 26. Della Pergola (I, 1955, p. 82, no. 146) notes that the painting, attributed to Leonardo da Vinci, was given to Scipione Borghese by the pope in 1611.

45. Michelangelo Buonarroti, *The Last Judgment:* detail of Christ. Vatican City, Sistine Chapel. Fresco, 1534–1541. Cf. Hibbard (1978/1979, p. 246) and Note 101.

46. Detail of [42]. (Photo: Museum)

47. *Still Life.* Milan, Pinacoteca Ambrosiana. 31 × 47. (M.19: 1596.) Apparently in the possession of Cardinal Federico Borromeo in 1607, and presumably he had it before he left Rome in June 1601; recorded first in a document of 1618 (A. Bellù in Falchetti, 1969, pp. 295 ff.). The *Still Life* is described there as *"Una cesta di frutti di Michel Angelo da Caravaggio, sopra la tela, larga un braccio, et alta tre quarti, senza cornice"* (p. 205). The illusionistic frame, still partially visible, was all that there was at the time. Cardinal Borromeo praised the picture: "of not little value is a basket ... with flowers [*sic*] in lively tints. It was made by Michelangelo da Caravaggio who acquired a great name in Rome. I would have liked to place another similar basket nearby, but no other having attained the beauty and incomparable excellence of this, it remained alone" (*Mvsaevm,* 1625, pp. 32–33; trans. Diamond, 1974, p. 252). Borromeo's word *flores* makes one wonder whether he had looked at the painting before writing, but

it must simply be a *lapsus calami.* Borromeo's paintings form the nucleus of the Pinacoteca Ambrosiana in Milan, which he founded. The inventory of 28 April 1618, renewing codicils to wills of 1607 and 1611, is published by Bellù (Falchetti, 1969, pp. 285 ff.). Borromeo's division of the paintings into categories is of interest: "A. Originals by major artists containing histories or portraits; B. Originals by less famous painters containing histories; C. Original landscapes; D. Good copies; E. Portraits by less famous painters; F. Copies of miniatures; G. Drawings." Bruegel's *Bouquet of Flowers* is listed under "C," as is Caravaggio's *Still Life* [47]; cf. Diamond (1974). For a comparison of Borromeo's collection with Del Monte's, which displayed similar tastes, see Calvesi (1975, pp. 81–82).

This work was dated to 1597 by Cinotti (1973, no. 13), after the Uffizi *Bacchus* [22], which she dates late, and just before what she calls the *"fase di studio"* of 1598/1599. Dated c. 1598/1600 by Frommel (1971, pp. 20, 51), before the London *Emmaus* [42], which he dated to 1600/1601. The picture, restored in Rome in the mid 1960s, was found to be painted over a cut-down canvas that had been previously painted with a grotesque decoration at one side, conceivably by Prospero Orsi, Caravaggio's friend (see Marini, 1974, p. 114, for a photograph of the X-ray).

For the history of still-life painting, see Sterling (1981). Although no other painting of still life of this period is similar, or approaches Caravaggio's in its low viewpoint and consequent monumentality, the Milanese painter Giovan Ambrogio Figino (1548–1608) painted still life with considerable concentration and mastery (Ciardi, 1968, p. 55 and plate II).

Almost every Renaissance poet wrote of time by invoking the ripening and decay of the world of nature; thus Shakespeare:

When I consider everything that grows
Holds in perfection but a little moment . . .
Where wasteful time debateth with decay
To change your day of youth to sullied night
(Sonnet 15)

Such sentiments were clichés, then as now.

Despite what Gombrich (see pp. 82–83) called "built in" symbolism, I suspect that the impressive displays in the *Boy with a Basket* [4], the Uffizi *Bacchus* [22], the *Supper at Emmaus* [42], and this *Still Life* were essentially tours de force by an artist who found still life easier to master than traditional figure painting. The pleasure that such pictures gave, and still give, is a product of their verisimilitude, which in this work becomes an exercise in *trompe l'oeil* because of its illusionistic frame and the apparent projection into our own space. (I am grateful to Phoebe Dent Weil for showing me the painting during its restoration in Rome in the mid 1960s.) (Photo: ICR 9608)

Caravaggio's fame as a still-life painter was such that various works have been incorrectly attributed to him (see Nicolson, 1979, p. 78, under "Pensionante del Saraceni"). One such example is presumably found in an inventory of the Patrizi collection in Rome, dated 1739: *"Due sopraporti in misura di sette, e cinque bassi rappresentanti frutti dipinti da Michel Angelo di Caravaggio con cornice negra filettata d'oro—scudi 40"* (Archivio Segreto Vaticano, *Famiglia Patrizi,* Tomo B 86, Prot. 7).

48. Detail of [42]. (Photo: Museum)

49. Vault of the Contarelli Chapel, San Luigi dei Francesi. Frescoes by Giuseppe Cesari d'Arpino: four *Prophets* (sides); *St. Matthew Resurrects the Daughter of the King of Ethiopia* (center) [cf. 71]. Commissioned 27 May 1591, final payment 4 June 1593 (Röttgen, 1974, chapter 1 and *passim;* the documents are reprinted by Cinotti, 1971, pp. 147–148, F 6–7, and by Marini, 1974, appendix I, pp. 482 ff.). For the chapel itself, see also Röttgen, chapter 3, and Hess (1967, pp. 302–303), who pointed out that the Hebrew on *Jeremiah's* scroll comes from the Breviary, which is therefore the probable source of the imagery, rather than the *Golden Legend.* For Contarelli (Cointrel), see Hess (pp. 222–223). (Photo: GFN E 41984)

50. Giuseppe Cesari d'Arpino, *The Calling of St. Matthew.* Vienna, Graphische Sammlungen Albertina, no. 612 (attributed to F. Zuccaro). Chalk on paper, 22.3 × 26.4. c. 1593? Published by Röttgen (1974, p. 23; 1973, p. 152, no. 87).

Color plate in Cinotti (1971, p. 100, fig. 87). (Photo: Museum)

51. Antonio Tempesta, *Map of Rome* (detail). Woodcut, 1593. Reproduced from the facsimile in F. Ehrle, *Roma al tempo di Clemente VIII . . .* (Vatican City, 1932). (1) San Luigi dei Francesi. (2) Piazza Navona. (3) Palazzo Madama (Cardinal Del Monte's residence c. 1600). (4) Palazzo Giustiniani. (5) Palazzo Crescenzi. (6) Pantheon. (7) Sant'Agostino. (8) Santa Maria in Vallicella (the Chiesa Nuova).

52. *The Calling of St. Matthew.* Contarelli Chapel, San Luigi dei Francesi. 322 × 340. 1599–1600. (M.35.) The documents, discovered by Michèle Schwager, were subsequently published by Röttgen (1974, chapter 2): contract of 23 July 1599; *saldo* of 4 July 1600. The frames were paid for in late December 1600, by which time the two paintings had been permanently installed on the side walls of the chapel, [52] at the left as we look at the altar, [56] at the right [see 64]. Caravaggio was to follow the directions given to Muziano and then to Cesari d'Arpino in 1591: "At the right [our left] of the altar . . . will be made a painting seventeen *palmi* high and fourteen wide in which is to be painted St. Matthew within a shop, or actually room [*salone*] used for customs with various things pertaining to that service [and] with a counter such as is used by customs officials with books, and money as if a certain sum had just been paid, or however seems best. St. Matthew, dressed as seems fitting for that post, rises from the counter with the desire of following Our Lord, who, passing along the street with his disciples, calls him to the apostolate; and in the actions of St. Matthew the painter is to show his craft, as in the rest" (Röttgen, 1974, pp. 20–21; my translation).

X-rays of the painting, first published by Lionello Venturi and reproduced by Marini (1974, p. 150), show that Christ originally had a different position and a more colloquial gesture, and that the Apostle in front of him was apparently an afterthought (see G. Urbani et al., *Bollettino dell'Istituto Centrale del Restauro,* 1966, pp. 37–76). Röttgen (pp. 102 ff.) has an important discussion of the painting, its sources and its

meaning. He demonstrated the relationship between it and a minor fresco of the same subject in the Palazzo Mattei-Caetani by Giuseppe Agellio, a follower of Roncalli (his figs. 71, 73). Agellio's fresco shows Christ in a similar position but striding to the right while turning back sharply to our left in a *maniera* pose that Caravaggio wholly transformed—while keeping the ambiguous position of his feet [cf. 54]. Agellio's Matthew, too, is related to Caravaggio's. (Because the fresco is undated, it is not altogether certain in which direction the influence went.) N. De Marco (*Isis*, 1, 1982, pp. 5–7) proposes that Levi is the boy at the left in Caravaggio's painting—I believe incorrectly.

The eyeglasses and other northern iconography are discussed by G. A. H. Vlam (*Art Bulletin,* XIX, 1977, pp. 560–570; and LX, 1978, p. 741); cf. Rembrandt's *Miser* (Bredius no. 420). In other contexts, glasses could symbolize learning, specifically pedantic learning, and there might be some such reference in Caravaggio's image too, with reference to Mark 2:16 (cf. Luke 5:30), as Robert Torchia pointed out to me.

Molina and Molinism, which could be represented by the man with the spectacles, is touched on briefly by Röttgen (pp. 219–220); cf. the summary by Parker (1968, pp. 67 ff.). For "Veni Creator Spiritus," see C. Seymour, Jr., *Michelangelo: The Sistine Ceiling* (New York, 1972, pp. 93–94). The "finger of God" is mentioned in Exodus (31:18) and Luke (11:20); for the concept in St. Augustine, see E. G. Dotson (*Art Bulletin,* LXI, 1979, p. 243 and n. 111). The concept could be particularly relevant here because the *Golden Legend* (p. 561) derived Matthew's name from *Manus Theos,* the hand of God.

The picture was praised for its religious content by Marzio Milesi, perhaps almost immediately after its unveiling, since the altarpiece seems not to be mentioned (Fulco, 1980, p. 88, no. 8; but see Bologna in Pacelli-Bologna, 1980, p. 43). I am grateful to Troy Thomas for calling my attention to the significance of this poem and its possible early date (see also Note 56). Baglione (pp. 136–137) wrote a famous passage on these paintings, concluding with disparaging remarks

supposedly made by Federico Zuccaro about this work that connect Caravaggio's style with Giorgione (see above, pp. 112–113, nn. 8–10). Cf. Bellori (p. 206) and Note 56. The most extravagant admirer was Scannelli (1657, pp. 197–198), who also commented on the darkness of the chapel. He considered the paintings to be easily Caravaggio's best and particularly admired the *Calling*.

The costumes are discussed on p. 23, n. 5. Despite Bologna's idea that the picture contradicts Paleotti's ideas (cf. p. 51, n. 1 above), Caravaggio has consciously distinguished between the sinful secular people in modern dress and the holy Christians in their robes.

The important works of conservation and restoration done in the 1960s are discussed by Urbani (1966, cit.). (Photo: ICR 9779)

53. Detail of [52]. (Photo: ICR 9780)

54. Detail of [52]. (Photo: ICR 9781)

55. Marinus van Reymerswaele, *The Calling of St. Matthew*. Villa Favorita, Castagnola (Lugano), Thyssen-Bornemisza Collection, no. 349. Oil on wood, 71 × 88. Heinemann (*Catalog*, 1975, p. 88). Cf. Vlam (cited in Note 52; her fig. 9). (Photo: Museum)

56. *The Martyrdom of St. Matthew* (companion to [52]). Contarelli Chapel, San Luigi dei Francesi. 323 × 343. 1599–1600. (M.33: first version; M.40: final version.) See the comments and citations in Note 52. The directions given to Cesari in 1591, which were to be followed by Caravaggio, requested a painting similar in size to the *Calling* and showing "a place wide and deep almost like a temple [*tempio*] and in the upper part an altar on an elevated dais with three, four, five, or more or less steps: there St. Matthew, celebrating Mass dressed in a manner that will convey that idea, is killed by the hand of soldiers —and we think that it will be best to show him in the act of being killed, either fallen after having received some wounds, or in the act of falling but not yet dead; and in that temple should be a large number of men and women, old and young and babies in variety, largely praying, and shown dressed according to their station and nobility, [seated] on benches with rugs and other

furnishings, with most of them horrified by the act, some showing abhorrence and others compassion" (Italian text in Röttgen, 1974, p. 21, immediately follows the passage quoted in Note 52). A great deal of what one sees, or tries to see, in the painting is explained by this prescription; the desire for *"banchi . . . et altri apparati"* may explain the odd nudes sprawled on the descending steps in the foreground. Since the figures were to be dressed according to their social station, the nudes are perhaps slaves or others seeking salvation.

Mahon (1953) gave a reasonable solution to the chronology of the version of this vis-à-vis [52]. For Baglione's comments, see Note 52. Bellori described the painting (p. 206) and mentioned that Caravaggio repainted it two times, emphasizing the darkness of the chapel. Hess (1967, p. 236) suggested that Bellori's information, which is more or less correct, came to him through his friend Poussin, who could have heard it from Marino, his patron in Paris. But perhaps it was well known that Caravaggio had been forced to begin all over again after having started the painting more than once in another manner.

Kirwin (1972, pp. 180 f.) has suggested that Roncalli may have guided Caravaggio to the *Battle of Constantine* in the Vatican *Stanze,* whose influence he sees in the final version. Calvesi (1954, p. 130) illustrated a *Christ Cleansing the Temple* attributed to Peterzano; the similarities with Caravaggio's composition can perhaps best be explained by assuming that both relied on Titian's *Death of St. Peter Martyr* [cf. 61], or one of the many versions of it. A perhaps contemporary appreciation of the religious content of the painting is found in rhymes by Marzio Milesi (Fulco, 1980, p. 88, no. 8), which also refer to *"odio"* and *"invidia."* The darkness of the painting seems to have prevented Sandrart from remembering its subject (see pp. 377–378): he called it *Christ Cleansing the Temple.* (Photo: ICR 977)

57. Girolamo Muziano, *The Martyrdom of St. Matthew.* Mattei Chapel, Santa Maria in Aracoeli. Oil (!), 1586/1589. See J. E. Heidemann

(*Burlington Magazine,* CXIX, 1977, pp. 686–694). Muziano was assisted by Cesare Nebbia (Röttgen, 1974, p. 260, n. 262). (Photo: GFN E 33490)

58. After Niccolò Circignani, *The Martyrdom of Blessed Edmund Campion and Other English Jesuits in 1583.* Engraving by G. B. Cavalieri from *Ecclesiae Anglicanae Tropaea* (Rome, 1584), recording a lost fresco in San Tomaso di Cantorbury in Rome. See Buser (1976, pp. 424–433).

59. *The Martyrdom of St. Matthew.* Outline of earlier attempts to paint [56] as recovered from X-rays, superimposed on a photograph of the painting (cf. Marini, 1974, p. 146). Cinotti (1971, pp. 108–109) reproduces the X-rays on a large scale. (Photo: ICR 5249)

60. Niccolò Circignani (Il Pomarancio), *The Massacre of the Innocents.* Second chapel left, Il Gesù. Fresco, late 1580s (?). See Hibbard (1972, p. 43). (Photo: GFN D 5660)

61. Titian, *The Death of St. Peter Martyr* (destroyed). Engraving by Martino Rota after a painting formerly in Venice, SS. Giovanni e Paolo. (Engraving reversed by me; the original composition is the reverse of what is shown here.) Titian's painting was completed in 1530; see Wethey (I, 1969, pp. 153–154, no. 133). There were many versions and copies, including one by Moretto in Bergamo (now Ambrosiana).

62. Girolamo Sicciolante da Sermoneta, *The Baptism of Clovis.* Fourth chapel right, San Luigi dei Francesi. Fresco, c. 1548/1549. See B. Davidson (*Art Bulletin,* XLVIII, 1966, pp. 61–62). (Photo: GFN E 28839)

63. Detail of [56]. (Photo: ICR 9533)

64. Contarelli Chapel, San Luigi dei Francesi. View showing parts of [56] and [93]. (Photo: Rigamonti 68/3)

65. Detail of [56]. (Photo: ICR 9777)

66. Detail of [56]. (Photo: ICR 9533)

67. Ottavio Leoni, *Michelangelo Merisi da Caravaggio.* Florence, Biblioteca Marucelliana. Graphite and color. See H.-W. Kruft (*Storia dell'arte,* 4, 1969, pp. 447–458).

68. Detail of [56]. (Photo: ICR 9774)

69. Detail of [56]. (Photo: ICR 9536)

70. Detail of [52]. See the discussion in Note 71. (Photo: GFN E 24584)

71. Giuseppe Cesari d'Arpino, *St. Matthew Resurrects the Daughter of the King of Ethiopia* (after restoration of 1966). Detail of [49]. The window at the upper right makes it likely that the window in [70] is seen from the outside, as is also shown by the deep shadow at the left of the scene [52], as if caused by the edge of a façade. Here we see that the window opened inward; the shutter, if any, would have to be outside, which was probably usual, especially for a ground-floor window such as that in [70], where the parchment or glass of the window would be protected from outside harm. (Photo: Bibliotheca Hertziana)

72. Ludovico Carracci, *The Calling of St. Matthew.* Bologna, Pinacoteca Comunale, no. 457. Painted for the Cappella de' Solaroli in Santa Maria della Pietà (Chiesa dei Mendicanti) in Bologna. Dated by Malvasia (I, pp. 321–322) after Annibale Carracci's death in 1609; hence c. 1610? Cf. D. Mahon (*Gazette des Beaux-Arts,* XLIX, 1957, p. 206, n. 21: 1606/1607). See also the discussion by Dempsey (1970, p. 325). I am grateful to Babette Bohn for discussing the date, which she believes to be c. 1610 rather than earlier. (Photo: Villani 24019)

73. Cerasi Chapel, Santa Maria del Popolo, showing [81] and [82]. Vault frescoes by Innocenzo Tacconi after designs by Annibale Carracci, c. 1600/1601 (see Note 81). (Photo: GFN E 42409)

74. *The Conversion of St. Paul.* Principe Guido Odescalchi, Palazzo Chigi-Odescalchi. Oil on cypress wood, 237 × 189. (M. 37: 1600.) The presumed first version of [75]. Mancini, saying that Caravaggio painted for private patrons, mentioned pictures for Cardinal Giacomo Sannesio, "which are copied and retouched after those in the Madonna del Popolo" (p. 225, n.), which is obviously not true of this work. Baglione called Sannesio's paintings rejected first versions: speaking of the two paintings now in the chapel [75 and 82], he wrote that "these two pictures had been painted in another style, but because they did not please the patron, Cardinal Sannesio took them" (p. 137; cf. Cinotti, 1971,

p. 66). Sannesio became cardinal on 9 June 1604, years after the paintings were finished in the chapel; he died 19 February 1621 (Eubel, IV, p. 8: I, 46). He and his family had a considerable collection of paintings (see Note 10 and Posner, 1971, II, nos. 129 and 141, n.), and the "Duchi Sanesii" patronized Caravaggio's friend, the architect Onorio Longhi (Baglione, p. 156). When Baglione was writing, the pictures in Sannesio's collection may have been unavailable (see Note 10), and perhaps his memory was wrong (cf. Moir, 1976, p. 160, n. 282, who did not accept this work). Bellori makes short shrift of Caravaggio's paintings in the Cerasi Chapel and mentions no first versions (see Note 75).

This was first published as a Caravaggio by A. Morassi in 1947 (cf. *Burlington Magazine,* XCIV, 1952, pp. 118–119, with an answer by Denis Mahon). Mahon pointed out affinities with the first *St. Matthew* [87] and the *Sacrifice of Abraham* [102], both of which were then dated to the 1590s but are now dated quite securely to 1602–1603. He correctly found the angel in the second *St. Matthew* [93] to be more advanced than the one here [74], not realizing that [93] must be dated 1602. Almost all writers now accept this work, which was called a Caravaggio in the will of F. M. Balbi in 1701 (Cinotti, 1971, pp. 116 and 189, nn. 317–318). A few still date it very early in Caravaggio's career (Argan, 1974, p. 22). Cf. Salerno (1957, pp. 121–122, n. 898), who also discussed the problem of the missing first version of the *Crucifixion of St. Peter* [82], for which see also Moir (1976, p. 145, n. 244). Both the support and the size of the work accord with the contract of September 1600 (see Note 75). The *maniera* aspects of the painting seem to reflect the lessons Caravaggio had forced himself to take in order to finish the *Martyrdom of St. Matthew* [56], as Salerno indicated. The angel resembles the boy with the plumed hat in the *Calling of St. Matthew* of 1600 [52] as well as the *Amor* [98], which was presumably painted c. 1601/1602.

The subject matter (Crucifixion of St. Peter; Conversion of St. Paul) automatically makes us think of the Cappella Paolina [83, 179], but Caravaggio's first effort at painting a *Conversion of St. Paul* owes even more to Raphael than it does to Michelangelo [77].

The painting is more convincing as a work by Caravaggio of 1600 than any photograph can reveal, and the few stylistic differences between it and the *Martyrdom of St. Matthew* [56] can be reconciled by invoking the poor state of preservation of [56] and the wooden support and consequently hard surface of this work. Here the features and details are much sharper and clearer than in the other paintings of this period that we have been discussing, in part because of excellent preservation. We see the teeth in Saul's open mouth, the precise features of the angel's face (similar to those of the angel in [87]), the bound tail of the horse, and other particulars of foliage and costume, all with almost preternatural clarity. (In proper light one also detects scoring in the priming on the right arm and back of Saul, a feature to be found in the Contarelli paintings of 1600 but not in many earlier paintings.) It may well be that Caravaggio finished the painting for a private patron, realizing that he would have to produce something simpler and clearer for the chapel. The larger size of this work, compared with [75], may have been caused by an enlargement. Even in the photograph one can see what looks like a border added all around, unlikely as that seemed to Mahon (cit., p. 119).

Steinberg (1975) has valuable discussions of the theme, the age of Paul in traditional representations, and the meaning and interpretation of the foreshortened Christ. These aspects of the work are like Raphael (and Michelangelo). In the sequel Caravaggio was, among other things, rejecting these precedents.

75. *The Conversion of St. Paul.* Cerasi Chapel, Santa Maria del Popolo. 230 × 175. (M.42.) The documents were discovered and published by Mahon (1951): contract of 24 September 1600 for two paintings on cypress wood, *palmi* 10 × 8 (233 × 179 cm), which were to be finished in eight months (24 May 1601). Final payment on 10 November 1601, after the patron's death in early May. The contract was printed in full by Cinotti (1971, p. 151, F 29) and Marini (1974,

pp. 292–293, appendix 2).

Mancini only named the Cerasi Chapel; Baglione discussed it (p. 137) as an example of Caravaggio's rise to fame, and it is he who mentions the "first versions" (see Note 74). Scannelli (1657, p. 197) lists the Cerasi paintings only after describing those that are "definitely the best" and then says nothing about them. Nor did Bellori trouble to describe the paintings; he wrote of the *Conversion of St. Paul* (p. 207) that "the history is completely without action" *(la quale istoria è affatto senza azzione)*. Argan (1956, p. 31) explained that "in modern terms, it means exactly the opposite: action without meaning, mere happening." Borea (Bellori, p. 222, n. 2) thought that Bellori meant that we do not see heroic mimesis, or *affetti,* which for him was a sign of non-art.

Despite their obvious differences, this work shares with [74] the sandals and tassels of Saul's costume, the foam at the horse's mouth, and other details. For the antique armor found in both paintings, see H. E. Wethey, *El Greco* ... (Princeton, 1962, I, p. 95, n. 162). The helmet at lower right, with a feather, reminds us of Caravaggio's earlier paintings, including [74], but the emphatic delineation of the earlier picture has given way to an overall darkness and color harmony that can be attributed only in part to the canvas support.

Mahon (1951, p. 227, n. 40) noted that even though this is a "second version," another composition is partially visible beneath the paint surface, one that is so diverse from the final painting that what shows through cannot be described merely as *pentimenti:* we should think rather of

179. Michelangelo, *Conversion of St. Paul.* Vatican, Cappella Paolina. 1542–45.

a different version underneath. Cf. Dell' Acqua-Cinotti (1971, plate XVII) for the double fingers and thumb, etc.

Further to the antecedents for the Cerasi Chapel paintings, see Friedlaender, chapter I. Steinberg (1959, pp. 183–190) noted that the paintings were conceived to be seen from the side, with an emphasis on diagonals, and that the light in the *Conversion of St. Paul* should be construed as coming from the vault of the vestibule of the chapel, on which the Dove of the Holy Spirit is painted. Wright (1978) disputes this, pointing out that afternoon sunlight pours onto the painting from the clerestory windows of the transept.

Caravaggio's youthful, beardless Paul is only one of a number of evidently deliberate changes away from the great Pauline exemplar by Michelangelo [179]. Pepper (1971, p. 334) assumes that Paul's outflung arms derive from the Virgin in Annibale's altarpiece [81]; but cf. also the *Supper at Emmaus* [42]. Röttgen (1974, pp. 122, n. 92, and 127) and Kirwin (1972, pp. 182 ff.) assumed that Caravaggio was influenced by Roncalli's *Resurrection* for San Giovanni degli Incurabili, begun in 1600 (Röttgen, fig. 74), even though a payment for it was made as late as mid 1603. If Caravaggio and Roncalli were indeed friendly c. 1600, the assumption may be correct; but I suspect that the painting was not delivered before 1603 and the influence may have gone the other way. (For Roncalli and Caravaggio, see also p. 159, n. 12.)

For the subject matter, see Note 74 and Steinberg (1975). Baronius (1590, p. 218) repeats the familiar story. For Grace, Justification, and "Evangelism," see O. M. T. Logan (*Journal of Ecclesiastical History*, XX, 1969, pp. 67–78). The passages quoted in the text from the *Golden Legend* are on pp. 126–127. For St. Augustine in the Renaissance, cf. E. G. Dotson (*Art Bulletin*, LXI, 1979, pp. 223 ff. and 405 ff.). (Photo: GFN E 48474)

76. Detail of [75]. See also [148]. (Photo: GFN E 24464)

77. After Raphael, *The Conversion of St. Paul*. Vatican City, Pinacoteca Vaticana. Tapestry.

Width (without side border) 557 cm. Part of a series for the Sistine Chapel. Based on a lost cartoon of c.1515 that was in Venice in 1521. See Dussler (1971, pp. 102–103, II.b).

78. Taddeo Zuccaro, *The Conversion of St. Paul.* Frangipane Chapel, San Marcello al Corso. c. 1563. See Freedberg (1975, pp. 490–491). (Photo: GFN E 58037)

79. Il Moretto da Brescia (Alessandro Buonvicino), *The Conversion of St. Paul.* Milan, Santa Maria presso San Celso, ambulatory (originally painted for the Mint). c. 1529–1530. See C. Boselli, *Il Moretto* (Brescia, 1964, pp. 88–89). Freedberg observed that Moretto's "nearly tangible duplicate in paint of un-idealized reality" was "an invention, invading a new reach of the possibilities of art" (1975, p. 368), a quality that must have affected Caravaggio.

80. View into the Cerasi Chapel, showing [75]; cf. [73]. (Photo: GFN E 42410)

81. Annibale Carracci, *The Assumption of the Virgin.* Cerasi Chapel, Santa Maria del Popolo. Oil on wood, 245 × 155. 1600/1601? See Posner (1971, I, chapter 11, and II, pp. 55–56, no. 126, with information on the chapel). (Photo: Villani 23679)

82. *The Crucifixion of St. Peter* (companion to [75]). Cerasi Chapel, Santa Maria del Popolo. 230 × 175. (M.41.) The painting, often copied, was enormously influential (cf. Moir, 1976, pp. 92 ff., no. 24, and 145, n. 244). Rubens's *Raising of the Cross* in Antwerp owes something to it, and his *Crucifixion of St. Peter* in Cologne is in a sense a commentary on it (Friedlaender, p. 186 and fig. 101). Among the copies is one signed by Francisco Ribalta (Moir, no. *24s), which in turn was copied in Spain.

When seen in a good light, the painting seems to show a rocky promontory in the background that declines from a high point at the left; perhaps it is a veiled reference to the supposed site of crucifixion on Montorio (Mons Aureus, the ancient Janiculum). The site was still considered a probable one in this period, and it was commemorated by Bramante's Tempietto on the supposed spot of martyrdom. Thus Baronius (1590, p. 339) asserted that Peter was crucified on the

Janiculum in AD 69, the same year that Paul met his martyrdom. Perhaps that spot was the one meant by Michelangelo in his representation of the scene [83]. For the site, see P. Fehl (*Art Bulletin,* LII, 1971, pp. 327 ff.) and especially Steinberg (1975). The big stone in the foreground surely recalls Peter's Latin name, Petrus (*petra* in Latin means rock); the same pun worked in the original Greek of the New Testament: "You are Peter, and on this rock I will build my church" (Matthew 16:18, a passage on which the authority of the papacy largely rests; it is inscribed in Latin inside the drum of the dome of St. Peter's).

If the action that is taking place in the painting were to be completed, the cross would then be out of the picture; this may have seemed radical to contemporary observers. The angle of view chosen by Caravaggio put the crossbar of the cross almost in line with the shaft, emphasizing the diagonal, as Friedlaender pointed out (cf. Steinberg, 1959). Although Peter appears to look at the nail in his left hand (Pepper, 1971, pp. 335 ff.), he is presumably supposed to be looking past it toward the altar [cf. 73], thus connecting him with salvation through his Roman Church. The light in the painting falls from a hypothetical source at the left, as in most of Caravaggio's paintings (but unlike [75]; see the discussion in Note 75). (Photo: GFN E 48473)

83. Michelangelo Buonarroti, *The Crucifixion of St. Peter* . Vatican City, Cappella Paolina. Fresco, 1545–1550. Companion to [179]. See Steinberg (1975). (Photo: GFN E 73624)

84. Detail of [82]. (Photo: GFN E 24466)

85. Pieter Bruegel, *The Conversion of St. Paul.* Vienna, Kunsthistorisches Museum, no. 3690. Oil on wood, 108 × 156. See W. S. Gibson, *Bruegel* (London, 1977, pp. 180 ff.). (Photo: Museum)

86. Photomontage of the Contarelli Chapel, San Luigi dei Francesi, with the statuary group by Jacob Cobaert (*St. Matthew,* 1587–1602) and Pompeo Ferrucci, now in SS. Trinità dei Pellegrini, right transept. See Röttgen (1974, pp. 54 ff.) and Baglione (p. 348 for Ferrucci; for Co-

baert, see pp. 91, 138, 146 above). Spezzaferro (1980, p. 52) has shown that the *St. Matthew* belonged to Francesco Contarelli after its rejection and was left to SS. Trinità dei Pellegrini together with his other possessions at his death in 1625. Thus the addition of Ferrucci's angel presumably postdates that year. (Ferrucci supposedly died in 1637.) (Photo: Rigamonti)

87. *The Inspiration of St. Matthew.* Formerly Berlin, Kaiser Friedrich Museum, no. 365 (destroyed 1945). 223 × 183 (originally larger? See below and Note 92). 1602. (M.45: 1602.) A contract of 7 February 1602 was discovered and published by Röttgen (1974, chapter 2). He assumed that the *saldo* of 22 September 1602 referred not to this but to its replacement, [93]. My opinion, expressed in the text, is also discussed in Hibbard (1982).

A *telaio* of wood, evidently to go underneath the stretcher and frame (and also "le cornice intorno a detto cuadro"), was made before 5 October 1602 (payment) in order to protect the painting from the wall behind (Cinotti, 1971, p. 153, F 42: *palmi* 13 × 9 or 290 × 201 cm). The measurements fit [93], not this, but Röttgen argued persuasively that this was originally the same size, to fit into the marble tabernacle that was already there [cf. 92]. Thus the measurements should not favor [93] as the picture finished in September 1602. Since a second *telaio* (without stated dimensions) was paid for in February 1603, the presumption must be that the frame paid for in October was for this work and the second one was for [93]—*pace* Röttgen (Cinotti, 1971, p. 153, F 43).

One might have hoped that Röttgen's documents and arguments had settled at least the question of the date of this work, but they have not. Bissell (1974, pp. 118 ff.), Moir (1976, pp. 90–91, no. 19), Borea (Bellori, 1976, p. 219, n. 2), and Nicolson (1979, p. 33: "Said to be after Feb. 1602, but probably *c.* two years earlier") all yearned for an earlier date. Nicolson no doubt followed Salerno (*Burlington Magazine,* CXVI, 1974, p. 587): "Caravaggio could have painted the first *St. Matthew* in the second half of 1600, immediately after the delivery of the lateral can-

vases, reckoning on the possible decisions of the patrons to substitute a picture by him for the statue," and Salerno then cited the "stylistically analogous" *St. Paul* [74]. But the stylistic analogies are rather with the Cerasi *St. Peter* [82], which was probably painted in mid 1601: the highly sculptural forms and the tendency to break through the picture plane that are characteristic of the first *St. Matthew* are found in the paintings of 1601 and not earlier. Likewise, the simplification of this work seems to be an achievement born of the Cerasi Chapel. Only then did Caravaggio begin to show "peasant" types as the Apostles. Moreover, it was unknown for a painter to create a major altarpiece without payment or contract.

Nevertheless the arguments for an earlier date do not cease. Spezzaferro (1980) argues that this work was produced for the consecration of the chapel in May 1599 and that it was never rejected because it was a temporary altarpiece and in a sense a trial run for the work now there. As such it seems to have attracted a great deal of adverse commentary, and one wonders why such a temporary altarpiece would have been infused with so much thoughtful and erudite learning. Moreover, since the painting existed and was a major effort on Caravaggio's part, the fact that another altarpiece was commissioned in 1602 (to follow Spezzaferro's argument) proves that this work was judged unsatisfactory. Spezzaferro's arguments against the offensiveness of the saint's foot were rightly dismissed by Bologna (Pacelli-Bologna, 1980, p. 43, n. 14), but I think Bologna is wrong in his attempt to find a reference to the altarpiece in a poem by Marzio Milesi (Fulco, 1980, p. 88, no. 8, lines 13 ff.).

In actual fact, until January 1602 the official altarpiece was the sculptural group by Cobaert, and only after it had been installed and refused in January was a contract drawn up with Caravaggio. The story of the rejection of [87] and Giustiniani's intervention is told by both Baglione and Bellori. Baglione (p. 137), after relating the story of Zuccaro's visit in 1600 (see Note 52), said that Giustiniani took the *St. Matthew* "which nobody liked" because of his mad infatuation with the *Amor* [98]. (Baglione blamed Prospero Orsi for propagandizing Caravaggio's work far beyond its merits, hinting that it was all a plot against the Cavalier d'Arpino.) Bellori was apparently better informed as well as less malicious (pp. 205–206; see my p. 144). His story has the ring of truth; it corresponds with the historical record so far as we have it and with the styles of the two altarpieces.

The Giustiniani inventory lists the painting first among Caravaggio's works and, according to my reading, as measuring *palmi* 10½ × 8½ *"in circa,"* or c. 235 × c. 190 cm, which is close to the measurements in the old Berlin catalogs. Salerno (1960, p. 135, no. 1) read the measurements as *palmi* 10— × 8—, or 224 × 179 cm, which is even closer, but I believe incorrect (cf. Note 18).

The Hebrew inscription and Matthew's "Socratic" appearance are discussed by I. Lavin (*Art Bulletin*, LVI, 1974, pp. 59–81, 590–591; LXII, 1980, pp. 113–114). I am indebted to the unpublished research of Adrienne von Lates on the subject of contemporary French stoicism and the cult of Socrates, which she plans to pursue. The problem with both the Socrates theory and the Hebrew lettering lies in their source, for Caravaggio was surely incapable of the conflation of Matthew with Socrates, and he was no Hebrew scholar. Hess (1967, p. 234) supposed that Matthew's Hebrew came from the "learned Monsignore Melchiorre Crescenzi." Spezzaferro (1980) proposed Del Monte, who was not a Hebrew scholar so far as we know. (For the use of Hebrew rather than Aramaic, see Baronio, 1590, p. 234.) If the Socrates theory is correct, the source of Caravaggio's image should probably be found among French intellectuals or clerics; San Luigi was officiated by the French. (Further to Socrates in this period, see *"Ecce Homo:* Socrates and Jesus," in A. Heller, *Renaissance Man,* trans. R. E. Allen, London, 1967, chapter 4 and *passim.*) The greatest appeal of the idea that this work predates the other paintings lies not in its style, which seems later, but in the appearance of Matthew, which is notably different from his physiognomy in the *Calling* [53].

Röttgen (1974, pp. 89 ff.) pointed out that the chapel directly opposite formerly had an altarpiece by Battista Naldini depicting St. John the Evangelist (his fig. 45). He pointed to similarities between the angel in [87] and Cesari d'Arpino's *St. Barbara* [91]. But Caravaggio's use of a *figura serpentinata* here, like the angel in the *Rest on the Flight* [29], is surely based on several sources. Even if [91] were the main inspiration, Caravaggio's use of the image would not indicate an earlier date for this work (*pace* Bissell), since his borrowings were somewhat capricious and ad hoc.

For Caravaggio's use of sources in Raphael and his circle, see the inadequate article by Argan (1974, pp. 19–28). (Photo: Museum 365)

88. Simone Peterzano, *The Inspiration of St. Matthew*. Milan, Certosa di Garegnano. Fresco, c. 1578–1582. Cf. Calvesi (1954, p. 124). The comparison was made by Friedlaender (pp. 98 ff.), who also pointed to related compositions in drawings by Ambrogio Figino, Peterzano's contemporary, and discussed the Lombard tradition of a humble St. Matthew that is most obvious in Romanino's image (his fig. 67, p. 99). (Photo: Archivio Fotografico del Castello Sforzesco, Milan)

89. Cherubino Alberti after Raphael, *Jupiter and Cupid*. Engraving (reversing the original), 1580; reissued by G. Orlandi, Rome, 1602. Painting, Villa Farnesina, c. 1518. This work and [90] were published in conjunction with [87] by E. Masetti (*Spazio*, V, 1951, pp. 9–14). Alberti was a favorite of Del Monte's (Spezzaferro, 1971, pp. 81–82) and, at least later, a friend of Caravaggio's (cf. Bertolotti, 1881, II, p. 71; the document is now lost: Cinotti, 1971, p. 176, n. 67).

90. Agostino Veneziano (Agostino De Musi), after Raphael, *The Inspiration of St. Matthew*. Engraving, 1518. Based on a group in Raphael's *School of Athens*, transposed and reversed. (See Note 89.)

91. Giuseppe Cesari d'Arpino, *St. Barbara*. First chapel right, Santa Maria in Traspontina. Röttgen (1973, pp. 93 ff., no. 20) shows that the painting was commissioned on 14 February 1594 and unveiled on 29 September 1597. (Photo: Arte Fotografica)

92. Photomontage of the Contarelli Chapel, San Luigi dei Francesi, with [87] inserted into the altar and enlarged to fit the frame by additions. See Röttgen (1974, pp. 77 ff.). (Photo: Rigamonti)

93. *The Inspiration of St. Matthew*. Contarelli Chapel, San Luigi dei Francesi. 296.5 × 195. 1602 (–1603?). (M.47: 1602.) Cf. Note 87 and the references to Röttgen and Lavin. Baglione only mentions this picture (p. 136). Bellori (p. 206), after telling the story quoted on p. 144, went on to describe [93].

Röttgen (1974, chapter 3) argued that a payment for a new *telaio* in February 1603 was not a symptom of a new altarpiece and insisted that the payments of September–October 1602 must have been for this. I have discussed the problem in Note 87.

This *St. Matthew* is notably different from [87]; the angel now flies. Hess (1967, p. 237) suggested that Caravaggio may have been helped in his effort to show flying figures by the consultation of Annibale Carracci's *Pan and Diana* and other frescoes on the vault of the Galleria Farnese, which had been unveiled by this time but was not generally visible until 1604. It is not immediately clear that the table on which the book rests carries on behind Matthew, with its foreshortened end above his heel. Just what the stool is meant to overhang in front is unclear; apparently Caravaggio tried to give the impression of a kind of stage with projections beyond the picture plane [cf. 42, 47]. Lavin (pp. 79–80) suggested a source in what he called the "backhanded" Annunciation type, in which the angel appears from above, making the Virgin look back and up over her shoulder. Perhaps all of them are based on a composition by Michelangelo (cf. [91], where something of the same movement is found). Argan (1974, pp. 19–20, 24–25) suggested a source in the Raphaelesque *St. Luke Painting the Virgin* in the Accademia di San Luca, but neither it nor his remarks on the reasons for the rejection of the first altarpiece are convincing. (Photo: ICR 9783)

94. Cesare da Sesto, *St. John the Baptist in the Wilderness.* Edinburgh, National Gallery of Scotland (Anonymous Loan). Oil on panel. Evolved from drawings by Leonardo such as one in Varese (See S. J. Freedberg, *Burlington Magazine*, CXXIV, 1982, p. 285). See also Lombard *Baptists* of later date, such as Antonio Campi's (G. Bora, *Disegni di manieristi lombardi,* Vicenza, 1971, fig. 46a). Bernardino Campi produced a clothed *Baptist* in an analogous pose (Bora, fig. 46). (Photo: Museum)

95. *St. John the Baptist in the Wilderness.* Galleria Borghese, no. 267. 159 × 124. (M.93: 1610.) Della Pergola (II, 1959, pp. 78–79, no. 113). Of uncertain date due to its poor condition. It could just conceivably be the picture that Caravaggio had with him when he died (see p. 255). Such a date might explain the painting's acquisition by Cardinal Borghese shortly thereafter: it was eulogized before July 1613 by Francucci (fols. 81v f., lines 260 ff.) as *"S. Giovanbattista del Caravaggio";* he calls Caravaggio *"Emulo a Rafaello . . ./Anzi emulo gentil de la natura,"* which was evidently conventional praise (but see Argan, 1974). Francucci, like others, did not notice that the "lamb" was a ram: *"Candido Agnel . . . Qual sia l'Agnello"* (Further to the lamb/ram, see Note 96.)

Scannelli (1657, p. 197) may even have seen two *Baptists* in the Borghese palace; he wrote of "a nude St. John the Baptist, and another similar in every respect of apparent truthfulness." Cinotti (1973, no. 72) puts the painting at the end of Caravaggio's life, after the *David* [173], but its date too is in doubt. Others have tended to date it to 1605/1606 (Della Pergola; Mahon, 1952, p. 19; cf. Note 173). Mahon wrote after the *Mostra* of 1951 that this was "presumably an original, but so damaged as to be practically inscrutable" (1951, p. 234, n. 122). There are no known copies (Moir, 1976, p. 98, no. 31). See also Note 126. (Photo: GFN E 59359)

96. *St. John the Baptist* (?). Pinacoteca Capitolina. 130.4 × 97.6. (M.36: 1600.) Rediscovered by Denis Mahon and later cataloged and discussed by him (*Artists in 17th Century Rome,* London, Wildenstein, 1955, 2nd ed., pp. 20–24,

no. 17: "Nude Youth with a Ram"). See also Salerno (1957, pp. 115–116, n. 891). Although the version in the Galleria Doria Pamphilj is still occasionally considered to be an autograph variant, it is an old copy of considerably lower quality. The date and subject are debated.

Mancini, writing of the early works done while Caravaggio stayed with Monsignor Fantin Petrignani, listed a *"S. Gio. Evangelista"* (cf. Note 12), which Salerno quite reasonably supposed to be an error for *"S. Gio. Battista"* since there are many paintings of the latter by or close to Caravaggio, and none of the former. Nevertheless a Patrizi inventory of 1739 lists a painting of that subject by Caravaggio (evaluated at 40 *scudi,* it is listed as being four *palmi* in height: Archivio Segreto Vaticano, *Famiglia Patrizi,* tomo B 86, prot. 7). The inventory of paintings in the Pio collection in 1749 also mentions a *St. John the Evangelist,* which was presumably an error for "Baptist," this work having been part of the Pio collection for many years (E. Battisti, *Commentari,* VI, 1955, p. 182). Cf. Cinotti (1971, pp. 103–104 and notes). If Mancini's painting were to be dated, we should naturally put it with its companions in his list, the *Fortuneteller* [12], etc., which is much too early for this. On the other hand, the next picture he mentions is the *Entombment* of 1603/1604 [107]—thus he was not following a serious chronology.

A painting of the size and description of this work was listed in Del Monte's inventory: *"Un S. Giovanni Battista di mano del Caravaggio con cornice negra rabescata di Palmi sei, et ¼,"* or literally 139.6 cm high (Frommel, 1971, p. 31). It was, however, not a "Del Monte picture" like [15, 18, 22, and 34]; it had been left to him by Giovan Battista Mattei in 1624 (wills of 1623 and 1624, in which he calls the cardinal *"unico mio padrone";* Frommel, p. 9, n. 31). Celio, who had seen the picture in the Mattei collection by 1620, called it a *"Pastor friso"* (1638, p. 134; ed. Zocca, pp. 41 and 102, n. 391; cf. Note 38). The Del Monte sales of 1628 list *"il Coridone e Zingara del Caravaggio"* (Kirwin, 1971, p. 55 and p. 53, n. 1). Kirwin assumes that this refers wholly to the *Fortuneteller,* but "Corydon" was a generic

shepherd's name in ancient and Renaissance literature and I assume that it here refers to [96], which would also account for both pictures remaining together until the present. Giovanni Battista Mattei's will called it *"il quadro di S. Giovanni Battista del Caravaggio,"* and further, *"Un quadro di S. Giovanni Battista con il suo agnello"* (Frommel, p. 9, n. 31). Despite the mistaken animal identification, these references show that, like [95], it was considered to be a *St. John the Baptist* by the family that had presumably owned it from the beginning and had probably commissioned it from the painter.

Old copies tended to make the identification more obvious by adding attributes of John the Baptist, with the notable exception of the Doria version, in which the genitals are obscured (Moir, 1976, pp. 87, no. 16, and 125–126, n. 188). The homosexual aspects of the image are dominant, whatever subject may have been in Caravaggio's mind. Frommel (1971a, pp. 49 ff.) tried to link the model for this *St. John,* the *Amor* [98], and other contemporary adolescent images to a *"Giovan Battista, che habita dietro ai Banchi,"* who, according to Mao Salini, was Caravaggio's (and Onorio Longhi's) *bardassa. Bardassa* could mean either catamite or no-good; the feminine ending is suggestive. If the former, it might explain the erotic aspects of this painting and the *Amor,* but it makes them more mysterious as commissions from married members of the Roman nobility. Caravaggio claimed not to know this Giovan Battista, which may well prove that Mao's meaning was sexual. See Cinotti (1971, pp. 153 ff., F 47 and 52) for the texts, which date from the trial of September 1603.

Both Scannelli and Bellori saw the painting in the collection of Cardinal Carlo Pio di Savoia (cardinal 1654–1683); Scannelli (1657, p. 197) linked it, significantly, with the *Amor* [98] as an example of utterly realistic flesh-painting. Bellori (p. 204) mentioned the painting after the *Luteplayer* [18] and *St. Catherine* [34].

Mahon (Wildenstein, 1955, p. 22) dated it 1598/1599; with the slightly later dates for the Contarelli Chapel that we now have, he might

well change that to 1599/1600 or even later, since some of his other comparative material now dates from the early 1600s. Dated by Röttgen to 1600/1601 (1974, p. 197). Cinotti (1973, no. 21a) puts it after the *Medusa* [37] and *Judith* [36], at the time of the first studies for the Contarelli Chapel (late 1599). Evidently of the same opinion, Spezzaferro (1971, pp. 88–89) pointed out that the painting "seems like an anthology (in the good sense, obviously) of all the motifs . . . that Caravaggio was developing in *casa* Del Monte." Nevertheless the model and even the handling associate the painting with works of 1602/1603: the angel in the second *St. Matthew* [93] and Isaac in the *Abraham* of 1603 [102]. Above all, it is close to the *Amor* [98] and must be quite near it in date. Since the original owner was presumably Ciriaco Mattei, it may also be possible to associate its purchase with that of the *Supper at Emmaus* [42], which I date 1600/1601.

Despite the evidence of the Mattei and Del Monte testaments, there are persistent and well-founded doubts about Caravaggio's intentions in this painting. L. Slatkes (*Actes du XXII^e Congrès International d'Histoire de l'Art,* 1969, Budapest, 1972, II, pp. 17–24, supplemented by a note in *Nederlands Kunsthistorisch Jaarboek* [*Festschrift H. Gerson*], 1972, pp. 1–6) has argued that the figure should be interpreted as the Sanguine Temperament, with connections with Phrixos (Celio) and implications of Aries and the month of March. The concept seems more northern than Italian. (What he took to be a bird at the upper left seems to be a weird branch formation.) Gertrude Wilmers, in an unpublished paper, associated the image with Giovan Battista Mattei and proposed that the elements pointing to March in the picture could refer to his birth, which might reconcile some of the seemingly disparate messages that the painting seems to send.

I do not believe that it has been pointed out in print that the little pile of stones at the lower left has on it a red color, different from the cloak, which presumably has to be interpreted as either blood or fire. If fire, it could be part of the traditional iconography of St. John in the wilderness; either blood or fire could point to a

sacrifice. Phrixos sacrificed a ram, but he was not a nude shepherd. A few people have suggested (orally) that the figure could be Isaac thanking the ram that had saved his life—an ingenious idea wholly without iconographic precedent (cf. Note 102). Salerno observed that the ram could also be a symbol of the cross and of redemption, and thus for him the image was a *St. John* with very specific Michelangelesque intent (1970, p. 243; cf. Röttgen, 1974, pp. 119–120, n. 66). But the ram is rarely a symbol of Christ outside the context of the Sacrifice of Isaac, which was commented on by Augustine and Paulinus of Nola (Migne, P. L., XXXVIII, 133; LXI, 318). Cf. Van Woerden (1961). (Photo: GFN E 38031)

97. Michelangelo Buonarroti, *Ignudo* from the Sistine Ceiling. Vatican City, Sistine Chapel. Fresco, c. 1509/1510. For this figure vis-à-vis [96], see Röttgen (1974, pp. 118–119, n. 66). Friedlaender (though he illustrated the wrong nude) connected the figure in [96] not only with this *ignudo* but with the sacrificial ram within the neighboring fresco of the *Sacrifice of Noah* (his p. 90, fig. 57). Cherubino Alberti's engraving of this nude is reproduced by Moir (1969, fig. 8). For the nudes in the context of the ceiling, cf. Hibbard (1978/1979).

98. *Amor Vincit Omnia (Victorious Cupid)*. Berlin, Staatliche Museen, no. 369. 154 × 110. (M.46: 1602.) Evidently painted for Marchese Vincenzo Giustiniani and listed in his inventory of 1638: *"Un quadro con un Amore ridente, in atto di dispregiar il mondo, che tiene sotto con diversi stromenti Corone, Scettri, et armature chiamato per fama il Cupido del Caravaggio dipinto in tela alta palmi 7, larga 5 con cornice di noce profilata e rabescata d'oro"* (Salerno, 1960, p. 135, no. 9). Baglione (p. 137) located it quite precisely in his discussion of the first *St. Matthew* for the Contarelli Chapel [87]. After reporting Federico Zuccaro's criticism of the *Calling of St. Matthew* (see Note 52), he stated that Caravaggio did "a seated Cupid from life, so exquisitely painted that thereafter Giustiniani admired Caravaggio beyond reason; and a certain picture of St. Matthew that he had first made for that altar in San Luigi, which pleased nobody, but because it was

by Michelangelo, Giustiniani took it for himself." Thus Baglione seems to imply that it was done not long before the first *St. Matthew,* and most writers now date it to c. 1601/1602.

The most particular information comes from Orazio Gentileschi's declaration in the trial of September 1603 (see pp. 160–163) that Baglione set up his own *Amor Divino* in front of Gentileschi's painting at San Giovanni dei Fiorentini (by which he presumably meant the public show at San Giovanni Decollato, where paintings were exhibited every August, and which was also a Florentine church; cf. Bissell, 1974). Baglione's painting (now Berlin, no. 381), Gentileschi tells us, was painted "in competition with an *Earthly Love* by Caravaggio; that *Divine Love* was dedicated by Baglione to Cardinal Giustiniani . . . although it was not as well received as the one by Caravaggio" (Cinotti, 1971, p. 156, F 54). Bissell claimed that [98] should be dated early because the exhibition at San Giovanni Decollato was probably that of 1601, or less probably of 1602. If a picture in an exhibition rivaled Caravaggio's *Amor,* the latter would have had to exist before the exhibition. Bissell then dates the *Amor* to 1598/1599, earlier than his argument warrants, but interwoven with other early datings (including especially that of the first *St. Matthew*) with which I am not in agreement (cf. Note 87). Bissell's argument rests in part on the fact that Cardinal Giustiniani was the patron of one of these summer exhibitions; but if Caravaggio's *Amor* was already owned by Vincenzo Giustiniani, that would be reason enough to dedicate a rival painting (of *Divine* Love) to his cardinal brother.

A golden necklace that Cardinal Giustiniani gave Baglione for his *Divine Love* was mentioned in the slanderous rhymes that led to the lawsuit of August–September 1603. The necklace is mentioned in much the same way in an undated letter from Gentileschi to Baglione that was sent earlier (Bertolotti, 1881, II, pp. 61–62). Thus Baglione could not have received the necklace as late as August 1603, and therefore—if the evidence we have is adequate—the *Amor* cannot be later than 1602 (cf. Bissell, 1981, pp. 13 and

83–84, nn. 13–14). In my opinion the testimony of the trial indicates that all of these events were nevertheless quite recent: Caravaggio's *Amor*, Baglione's *Amor*, and the resulting necklace are mentioned as problems that still festered, which would hardly have been the case had it all occurred in 1601 or earlier.

Friedlaender thought that [98] was painted with the aid of wings borrowed from Gentileschi and still not returned on 14 September 1603 (see Cinotti, 1971, p. 156, F 54). But Baglione says that the *Amor* prompted Giustiniani to purchase the *St. Matthew* [87], which was surely finished and available no later than September 1602, and according to other arguments even earlier. Thus the *Amor* could date very shortly before [87], even a year before, but—if we believe any of Baglione's argument—hardly much more (cf. Note 102). Nevertheless, comparing photographs (the originals are scattered), one sees that the head of Cupid is closest in type and manner to that of the angel in the second *St. Matthew* [93] and of Isaac in the *Abraham* [102], works securely dated to 1602–1603. Thus I should not date the *Amor* much before 1602.

Giustiniani's inventory indicates that the *Amor* was famous. Scannelli (1657, p. 199) linked it with the *St. John* [96], as we still do, writing of the Pio collection that there were several paintings by Caravaggio, most notably a nude *St. John the Baptist* that could not look more like real flesh if it were alive, "like the *Amoretto* in Prince Giustiniani's collection, which is probably the most worthy painting by Caravaggio in private hands." The *Amor* obviously had that reputation among a wide circle of connoisseurs. It was the subject of a celebrated description by Sandrart, who was in Rome c. 1629–1635, living at least part of the time in the Palazzo Giustiniani. Although his book, largely cribbed from various obvious sources and containing notable errors, was published only in 1675, his information on the *Amor* is unique (see Appendix II, pp. 378–379). He claimed that on his advice the painting was covered with a dark green silk curtain because, uncovered, it made all the other pictures in the great room look insignificant. (Today one

wonders whether there might have been an element of puritanism underlying his advice, for the painting hung near a number of religious works.) He went on to report that Giustiniani refused a princely sum for the *Amor*, saying that if the prospective buyer could help him to buy a painting of that quality, he would gladly pay twice the price he was being offered (p. 277). Bellori (p. 207) also mentioned this work as being among the Giustiniani paintings. Having cited the *Christ Crowned with Thorns* [41?] and *St. Thomas* [104], he wrote a description of the *Amor* without commenting on its quality. (He then mentioned the Mattei *Betrayal of Christ*; cf. Note 38.) According to Félibien, the picture was greatly disliked by Poussin: *"M. Poussin nous en parloit un jour avec grand mépris"*; but then Poussin supposedly said of Caravaggio, *"qu'il estoit venu au monde pour détruire la Peinture"* (A. Félibien, *Entretiens . . .* , II, Paris, 1688, pp. 12–13).

Gregori (1972, pp. 37 ff.), in the context of a larger and not wholly convincing discussion of Caravaggio and Giovanni da Udine—another north-Italian specialist in still life and genre details—pointed out that the objects, especially the musical instruments [99], are related to those at the feet of Raphael's *St. Cecilia* in Bologna, details that were painted by Giovanni.

Egan (1961) saw the objects trampled underfoot as symbols "of prevailing forms of concord —musical, mathematical, and military." Thus she would see the painting, presumably, as "Discordant Love." (Her argument is in the context of paintings illustrating Music, usually as harmony.) For A. P. de Mirimonde (*Gazette des Beaux-Arts*, LXIX, 1967, p. 320), the musical instruments refer to Venus, the arms to Mars, and the image is one of generation and destruction. Cf. Scherliess (1973, pp. 147–148, and 1972).

An attempt to connect the symbols trampled underfoot with Marchese Vincenzo Giustiniani was made by R. Enggass (*Palatino*, XI, 1967, pp. 13–20, with fascinating information on the marchese), but the erotic implications of the painting make his interpretation less than convincing. Giustiniani's learning was extraordinary and his

interests wide: he wrote treatises on gardening, music, sculpture, architecture, and other subjects (cf. Salerno, 1960, with bibliography). For his building activity, see Hibbard (1971, p. 116 and *passim*).

The picture was discussed by Frommel (1971a, pp. 47 ff.), who invoked Petrarch's "Triumph of Love" and emphasized its novelty and its possibly personal references to a *"bardassa"* of Caravaggio's mentioned in the trial of September 1603 (see Note 96). The picture was accurately characterized by Dempsey (1970, pp. 325–326), from which I quote (p. 158). But Dempsey's assertion that "The *Amor Victorious* . . . could only have been painted by a man of the most sophisticated literary knowledge and refined literary response" creates a Caravaggio who is otherwise unknown, either in the old descriptions or in modern opinion. What sophistication was necessary to conceive the image in the first place was surely Giustiniani's. Caravaggio's achievement was to do what Dempsey says he did. The *Amor* ultimately derives from Alciati's emblem, *Potentia Amoris* (Emblema CVI), which shows a seated nude boy with large wings, described as smiling (as Creighton Gilbert kindly reminded me). Cf. Alciati's *Vis Amoris* (CVII).

In an unpublished paper, Joseph Manca pointed out that all the symbols can be made to correspond with those of the Muses and that Giustiniani had a fresco of Parnassus at Bassano, where a section of his garden was called "Parnassus." If the two arrows held by Cupid are the gold and leaden arrows shot at Apollo and Daphne (*Metamorphoses*, I, 470 ff.), the iconography might be specifically Giustiniani's, despite Caravaggio's special qualities as a translator. The arrows are painted with red and black tips and bear similar bands on the shafts, as if to indicate some such conceit.

The cliché of triumphant Love had long been a tired one at the time Caravaggio painted his picture, as contemporary writers made abundantly clear. See for example the poem by Tommaso Campanella, "Against Cupid":

The world's been bowing for three thousand years
to a blind Love with quiver and with wings,

180. Michelangelo (?), *Ganymede*. Harvard University, Fogg Art Museum. Drawing.

who is now even deaf, and scorns to hear

(trans. J. Tusiani, *Italian Poets of the Renaissance*, Long Island City, 1971, p. 262); (see *Tommaso Campanella poesie*, ed. G. Gentile, Florence, 1939, p. 56, no. 27; from a volume published in Paris in 1621 but written earlier). See also the sheet of disparaging caricatures of famous ancient gods ("La Castissima Diana," etc.) by Martino Rota (Posner, 1971, I, fig. 66). Annibale Carracci's mocking use of the Eros-Anteros theme in the Galleria Farnese might be another example of the treatment such themes seemed to demand by c. 1600 (see Dempsey, *Art Bulletin*, L, 1968, pp. 363 ff.; for Eros-Anteros, pp. 364–365). Dempsey's thesis is that "the Gallery is a satire on the gods. It is funny" (p. 367). Thus connoisseurs in Rome seem to have welcomed satirical versions of these hoary themes. Caravaggio is always special, and his painting was chiefly a showpiece of still life and flesh painting, with mocking overtones of various kinds.

For a possible connection with an engraving by Agostino Carracci, see Calvesi (1971, p. 108); for the supposed relationship between this work and prints of Eros from the school of Raphael,

see S. Howard (*Art Quarterly,* II, 1979, pp. 160–163). Cupid is the subject of an extended commentary by Cartari (1571, pp. 494 ff.), which is the basic study of mythology in this period and is essential to an understanding of its treatment by artists.

The *Amor*'s homosexuality can also be related to Michelangelo's *Ganymede* [180], which Caravaggio, so to speak, unsublimated (see p. 157, n. 11).

A contemporary, Marzio Milesi, composed a distich on Caravaggio's *Amor*: "*Omnia vincit amor, tu pictor et omnia vincis/scilicet ille animos, corpora tuque animos*" (Petrucci, 1956, pp. 426–441; Cinotti, 1971, p. 162, F 93). Further to Milesi, see Note 52. For Murtola's poems, see below. (Photo: Museum)

Baglione (p. 136) wrote that Caravaggio "made a Divine Love who subjugated the Profane" for Cardinal Del Monte. It is not mentioned by other writers; it was not in the inventory of 1627; presumably it was a minor work or an error by Baglione, who painted a picture of the same subject (see above) and thus would have been unlikely to have made that particular error. Marini (1974, no. 10) illustrates a "copy" that Nicolson (1979) correctly called "not Caravaggesque."

In 1603 Gaspare Murtola published a series of verses, "L'Amore: Pittura del Caravaggio," but neither [98] nor the presumably lost *Amor Divino* seems to have been the subject of these madrigals, which invoke a figure now blindfolded, now sleeping (Bissell, p. 118; Salerno, 1966; the poems are reprinted by Cinotti, 1971, p. 164, F 110, and 1973, p. 51); however, see the comments by Frommel (1971a, pp. 49–50).

99. Michelangelo Buonarroti, *Victory*. Florence, Palazzo della Signoria. 1527–1530? Carved for the Tomb of Julius II but not used (see J. Wilde, *Michelangelo's "Victory,"* Oxford, 1954, Charlton Lectures on Art).

100. Detail of [98]. (Photo: Museum)

101. Michelangelo Buonarroti, *St. Bartholomew* (detail from the *Last Judgment*; cf. [45]). Vatican City, Sistine Chapel. Fresco, 1534–1541.

Discussed by L. Steinberg (*Critical Inquiry,* VI, 1980, pp. 423–436).

102. *The Sacrifice of Abraham.* Florence, Galleria degli Uffizi, no. 4659. 104 × 135. (M.49: c. 1603.) Long dated to the later 1590s on false analogy with the *Rest on the Flight* [29]. It is now almost universally assumed to have been the picture for Monsignor Maffeo Barberini for which three payments "*a conto*" (totaling 50 *scudi*) were registered between 20 May and 12 July 1603; a *saldo* of 60 *scudi* was recorded by the Barberini on 8 January 1604 (M. A. Lavin, *Burlington Magazine,* CIX, 1967, pp. 470–473). This final payment may represent a bookkeeping record, as Caravaggio seems to have been out of town (see p. 168); in any event the documents prove the date of the painting to be 1603.

The only other Barberini painting mentioned by the old writers is a portrait of Barberini (see Note 193); if it is indeed Caravaggio's painting, or a copy, the style is not of 1603 but rather of the late 1590s [cf. 27]. Moreover, Caravaggio's *Abraham* is continuously recorded in the Barberini inventories (M. Lavin, 1975, *passim*), but they never record a portrait by Caravaggio. The work subsequently passed to the Sciarra-Colonna and then to the Uffizi.

Mahon (1951, p. 226) noted connections between it, the *Amor* [98], and the second *St. Matthew* [93], and his stylistic observations still stand up, despite the later dates that we now accept. The golden-haired angel seems to usher in a new type, but he may have been the model for *St. John* [96]. Isaac seems to be an older version of the angel in the first *Conversion of St. Paul* [74], and he is almost identical with the *Amor* (see Note 98 and Frommel, 1971a, pp. 49 ff.).

The scoring in the priming around Isaac seems to be a characteristic of works done after c. 1600 (cf. Spear, 1971, p. 76 and n. 10). There is also a relative darkness that is obvious in the gallery, where it usually hangs beside the *Bacchus* [22]. This is an outdoor picture with a large and charming landscape, freely brushed in a style that must have strengthened Caravaggio's position as a colorist.

Bellori (p. 208) called the painting a commis-

sion from Cardinal Maffeo Barberini, and the documents seem to prove this; but since Barberini did not become cardinal until 11 September 1606, he should have been called "monsignore." Borea, annotating Bellori (1976, p. 224, n. 5), clung to the old date in the 1590s, repeated in the Uffizi catalog (Berti, 1979, P 359). But this painting is as securely dated as any in Caravaggio's *oeuvre* and just as authentic; its closest stylistic affinities are with the second *St. Matthew* [93], *St. John* [96], and *Amor* [98].

For the early iconography of this subject, which was taken to symbolize the crucifixion, see Van Woerden (1961). For the ram as a symbol of Christ, see Note 96.

A Caravaggesque *Sacrifice of Abraham,* not known in the original and not mentioned by the sources, is in Marini (M.24: 1597). The copy he illustrates may have connections with the *St. John* in Toledo, which is by an anonymous follower (cf. Note 126).

103. Detail of [93]. (Photo: ICR 9785)

104. *The Doubting Thomas.* Potsdam, Staatliche Schlösser und Gärten. 107 × 146. (M.31: 1599.) Occasionally thought to have been a pair to the *Supper at Emmaus* [42], but neither the sizes nor the dates are very close. Mentioned by Baglione (p. 137) among the pictures commissioned by Ciriaco Mattei following the notoriety caused by the *Amor* [98] and the propaganda of Caravaggio's friend Prospero Orsi (cf. Note 98), which might point to a date c. 1603. Yet there was no *Doubting Thomas* in Ciriaco Mattei's collection before he died in 1614, nor is one listed in the later inventories; it was not mentioned by Celio (cf. Notes 42 and 96; the inventories were cited by Frommel, 1971, p. 9, n. 31). On the other hand, we know that Vincenzo Giustiniani owned the painting by 1606, for Giustiniani's companion Bernardo Bizoni reported seeing a copy in Genoa in August 1606, when Giustiniani identified it as a version of his original (Banti, 1942, p. 200). There were also copies in Bologna at an early date (Malvasia, II, p. 217; cf. Moir, 1976, p. 127, n. 190). Scannelli cites one in the Ludovisi collection in Rome (1657, p. 199), but

he may have been mistaken—no such painting was listed in their inventories of 1623 or 1633 (cf. Cinotti, 1971, p. 193, n. 409).

The Giustiniani inventory of 1638 lists: *"un quadro sopraporto di mezze figure con l'Historia di S. Tomasso che tocca il Costato di Christo col dito depinto in tela alto palmi 5 largo palmi 6—di mano di Michelangelo da Caravaggio con cornice negra profilata e rabescata d'oro"* (Salerno, 1960, p. 135, no. 10; I read the measurements as *palmi* 5 × 6½, or 112 × 145 cm, which is closer to the actual width of the painting—see Note 18 for an explanation of the divergent readings). Bellori cited it among Caravaggio's notable paintings in the collection (p. 207). Del Monte owned one of the many copies (Frommel, 1971, p. 30). Although the painting was obviously popular, there is no reason to doubt that the original was Giustiniani's, which went to Berlin with many others [27, 87, 98, 188]. Nevertheless Cinotti (1973, no. 36) considered the original lost.

Sandrart thought the picture dated from the time of Ranuccio Tommasoni's murder (which was not for Sandrart the cause of Caravaggio's flight from Rome in mid 1606—see p. 377). Modern writers all date it earlier than 1606, sometimes too early (R. W. Bissell, *Art Bulletin,* LVI, 1974, p. 133; cf. Bissell, 1974). The highly concentrated and stylized composition seems impossible before the Cerasi paintings of 1601. It could be contemporary with their completion in later 1601. Although there are affinities with the *Emmaus* [42], which strikes me as earlier, and with the Contarelli altarpieces [87, 93], the picture shares many qualities with the *Entombment* [107], which may have been finished only in mid 1604. Apostles resemble both Abraham [102] and Nicodemus [107]. Hence a date c. 1602/1603 is probably correct.

For allusions to unconscious sexual implications in scenes of the Doubting Thomas, see M. Schapiro, "From Mozarabic to Romanesque in Silos," reprinted in *Romanesque Art* (New York, 1977), pp. 87–88, n. 123).

I have not seen this painting. (Photo: Museum)

105. Hendrick Terbrugghen, *St. Sebastian*

Tended by Irene. Oberlin, Ohio, Allen Memorial Art Museum, no. 53.256. 149.5 × 120. 1625. B. Nicolson, *Hendrick Terbrugghen* (London, 1958, no. A54). (Photo: Museum)

106. Scipione Pulzone, *Crucifixion with Saints.* Santa Maria in Vallicella. Hess (1967, pp. 363, 365) reports that the painting was mentioned in 1583, transferred to the new chapel, and restored in 1595/1598. F. Zeri, *Pittura e controriforma . . .* (Turin, 1957, pp. 79–80), dated it to 1585/1590; Freedberg (1975, fig. 299) dated it c. 1590, and it is manifestly close in style and physiognomy to the documented altarpiece of the *Pietà* formerly in the Gesù, dated 1591 (Hibbard, 1972, p. 44; payments of 1589–1590). Thus I suspect that this picture was painted for the new chapel, which was presumably finished c. 1588 (Hess, p. 357), and that Hess's reference was to a preceding altarpiece.

The composition is based on Titian (Zeri, fig. 84). Röttgen (1973, pp. 74 ff., no. 7) pointed out that Cesari d'Arpino's similar painting, begun in 1591, must have been based on Pulzone's. (Photo: GFN E 29822)

107. *The Entombment of Christ.* Vatican City, Pinacoteca Vaticana. 300 × 203. (M.48: 1602/1604.) Painted for the Vittrici Chapel, dedicated to the Pietà, in Santa Maria in Vallicella (the "Chiesa Nuova" of the Oratorian Fathers). For the early history of the church, see Ponnelle & Bordet (1929, pp. 265 ff.: chapels; p. 244: Vittrici and Neri), supplemented by Hess (1967, pp. 353 ff., 363, and 365). An excellent brief introduction is in J. Connors, *Borromini and the Roman Oratory* (New York, Cambridge, 1980, chapter 1). See also Zuccari (1981) for an extended discussion.

The date "1602–04," which is in a sense correct, was deduced by L. Lopresti (*L'Arte*, XXV, 1922, p. 116) on the basis of a passage in G. Calenzio (*La vita . . . del cardinale Cesare Baronio*, Rome, 1907, p. 630 [not 620]), who quoted a document of 9 January 1602. It reads: *"Che il P. Prometheo [Peregrini] tratti col signor Cardinal Baronio, che Nostro Signore ne dia licenza di dir la messa a uno altro altare, sin che s'accomoda il privilegiato"* (Archivio della Congregazione del-

l'Oratorio di Roma, C I 5, *Libro 4 dei Decreti 1599–1614,* fol. 15, no. 8)́. Cinotti (1971, p. 152, F 38) repeats Lopresti's version, which is not significantly different.

The meaning of the entry transcribed by Calenzio and interpreted by Lopresti is to be found in a later but still roughly contemporary compilation on the chapels in the Chiesa Nuova, which tells us that until 1602 Vittrici's original chapel remained intact because of its unique altar conferring a papal privilege. Thus long after the rest of the church had assumed its present form, Vittrici's old chapel occupied its place in what is now the right aisle. Then, the compilation tells us, *"Volendo li Padri l'anno 1602 sfondare detta Cappella per uguagliarla all'altre, et però dubitando, che non si perdesse il privilegio supplicorno Clemente 8.° volesse concedere detto Privilegio al novo altare, e fin che si fabricasse concederlo a qualche altro altare il tutto concesse il detto Pontefice"* (Archivio, cit., A V 14, fol. 19; I am grateful to Joseph Connors for leading me to this document and for checking the transcription afterward). The document states that in 1602 the Fathers wanted to build a new chapel like the others but were afraid that they would lose their papal privilege. Thus they begged Clement VIII to give the privilege to the new altar when it was finished, and the pope agreed.

Thanks to this discovery we see that Lopresti's report had nothing directly to do with Caravaggio's altarpiece; rather, it signaled the coming demolition of the old chapel and the eventual construction of a new one, all of which was surely the labor of several months. The painting in the old chapel, called a *Pietà,* was taken down, and money for a new painting by Caravaggio was extracted from Pietro Vittrici's unnamed nephew, who seems on the basis of further documents to have been a reluctant patron, for the chapel soon passed into other hands.

We do not know when Caravaggio was commissioned to paint his picture, perhaps not until late 1602 or even 1603. On 1 September 1604 (not 6 September, *pace* Lopresti) the Oratorians were prepared to give the old Pietà to Vittrici: *"Si dia al Nepote del signor Pietro Vittrici Il quadro*

della Pietà con il suo ornamento di legno, che dimanda, havendo di sua cortesia fatto fare Il quadro nuovo dal Caravaggio, al quale non serve il sopradetto ornamento di legno" (Archivio, cit., C I 5, *Libro 4 dei Decreti 1599–1614,* fol. 71, no. 3; cf. Lopresti, p. 116). The document is illustrated in Cinotti (1971, p. 117, fig. 108) but her transcription (F 60) repeats Lopresti's error. Given Caravaggio's other problems in late 1603 and early 1604 (see pp. 168–170 above), the *Entombment* may indeed have been quite *"nuovo"* in the summer of 1604; possibly it had only recently been consigned, thereby leading to Vittrici's request for the old altarpiece before September 1604.

We do not know the name of this Vittrici, but it seems possible that it was the same Alessandro who, c. 1620, owned Caravaggio's *Fortuneteller* (see Note 12). An Alessandro Vittrici was Marshall for the Regione Castelli in the *posesso* of Pope Leo XI in April 1605 (Hess, 1967, p. 288, n. 5). That short-lived pope, Alessandro de' Medici, had been associated with the Chiesa Nuova as a cardinal and had officiated at its consecration in 1599 (Pastor, XI, p. 681).

The chapel remained without further decoration until the stuccoing of the vault, which was finished in December 1611 (Archivio, cit., C I 5, fol. 281, no. 5, 15 December 1611: *"Che si dia qualche mancia alli stucchatori che hanno fatto la cappella della Pietà"*). The paintings in the vault are by Angelo Caroselli (see Hess, 1967, p. 365, and Passeri-Hess, p. 193). On fol. 299, no. 3, of the same document, dated 9 May 1612, we read that three men were deputed to change the inscription in the chapel because of a dispute between Vittrici and the new patron, named Mareri (Forcella, IV, pp. 152, no. 362, and 156, no. 371, has the garbled inscriptions). Nevertheless a Vittrici was buried in the chapel as late as 1650 (Hess, 1967, p. 288).

We cannot be sure how Caravaggio came to be commissioned to paint this work. We know that the Crescenzi and Giustiniani were closely involved with the Oratory; Girolamo Giustiniani, nephew of Cardinal Benedetto and of Marchese Vincenzo, had become an Oratorian in 1596 and rose to *Preposito* in 1623 (C. Gasbarri,

L'Oratorio romano . . ., Rome, 1963, p. 159; cf. Cinotti, 1971, pp. 67 ff., for these families).

The idea that Caravaggio himself was somehow affected by Oratorian ideals is unlikely: see Cozzi (1961), Röttgen (1974, pp. 175–176), and Bologna (1974, pp. 175–176), all of whom discount Friedlaender's hypothesis, as I do. Fagiolo (1968, pp. 41–42), however, accepted the idea. Zuccari (1981, pp. 92–103) tries to reaffirm Caravaggio's ties with the Oratory without substantial arguments.

For the old sources, see Baglione (p. 137), Scannelli (1657, p. 197), and Bellori (p. 207), all of whom say positive things about the painting. The idea that the painting is a normal group rotated to be seen from the right is in Röttgen (1974, pp. 94–95). For copies (some by artists who never went to Rome), see Friedlaender (pp. 187–188), Cinotti (1971, pp. 118–119), and Moir (1976, pp. 94–95, no. 25).

It is unlikely that the painting refers specifically to the stone of unction, despite the ingenious arguments of M. A. Graeve (*Art Bulletin,* XL, 1958, pp. 223–238; preliminary discussion by Friedlaender, p. 188). Nadal (1593, p. 133) shows Christ on a true stone of unction, at a distance from the sepulchre. For a more conventional *Pietà* implying unction, see Peterzano's painting [114], which has all the ingredients missing in Caravaggio's. Without them, the argument becomes irrelevant. The Friedlaender-Graeve idea that the painting should be seen within the context of the dedication of the chapel to the Pietà, and that it is therefore a combined *Pietà-Entombment,* is closer to the mark.

The jutting stone is presumably the covering or door to the tomb of Joseph of Arimathia, "who took the body, wrapped it in a clean linen sheet, and laid it in his own unused tomb, which he had cut out of the rock; he then rolled a large stone against the entrance" (Matthew 27:59). The powerfully projecting corner of that stone is stylistically related to the projecting foot of Matthew in [87] (and hence tends to affirm the later date for that painting argued above). The stone also conjures up ideas of Christ as the stone that

the builders rejected, which then became the cornerstone of the Church (Mark 12:1–11, elaborated in Luke 20:17–18, both quoting Psalm 118:22–23; cf. I Peter 2:4–8; cited by Friedlaender, pp. 127–128). We cannot be sure that Caravaggio had this reference in mind, for the slab performs a function similar to the projecting foot in the first *St. Matthew* [87] and the stool in the second [93]: it joins the painting with our own space. I am indebted to Wright (1978) for the idea that this is essentially a *Corpus Domini* image. Again, we should remember that the dedication of the chapel was to the Pietà, not to the Deposition, the Entombment, or Extreme Unction.

Mary frequently appears as a cowled nun in earlier northern art and is occasionally found in Italy, as in Moretto's "Cook" *Entombment* in the National Gallery, Washington (Venturi, *Storia,* IX, 4, p. 146, fig. 122), and in his last *Pietà,* in New York (ibid., p. 199, fig. 174; also in a sense an Entombment or "Last Farewell"). For the Mary with her hands raised, see the Orants in the catacombs (much studied at this time); El Greco's raised hands (R. Wittkower, *Allegory and the*

shows that they mean "enlightenment"); and the upraised hands of the grieving Magdalen in Mi-*Migration of Symbols,* London, 1977, pp. 147 ff., chelangelo's *Pietà* for Vittoria Colonna (Hibbard, 1978/1979, fig. 170). Caravaggio must have known the roughly analogous gesture at the right of Durante Alberti's pietistic *Adoration of the Shepherds* in the Chiesa Nuova (third chapel left; Venturi, *Storia,* IX, 6, p. 457, fig. 253; cf. Baglione, p. 118), which was presumably painted before c. 1585 (Hess, 1967, p. 363, states that it was transferred from the old chapel, which seems to have been decorated c. 1582 and afterward). (Photo: Archivio Fotografico, Musei Vaticani)

Cristofano Roncalli's *Entombment* [181] is a discursive painting of 1585–1586 that Caravaggio surely knew. It has all the ingredients missing in Caravaggio's own painting: the stone of unction, which seems to be the top of a sarcophagus, and the presumed tomb-cave behind (see Kirwin, 1972, pp. 75 ff.). Chapel transferred to Paolo Mattei in May 1585 (Kirwin, p. 70). Whether we prefer to interpret it as an Entombment, a kind of "Last Farewell," or as a combina-

181. Cristofano Roncalli, *Entombment.* S. M. in Aracoeli. 1585–86.

182. Federico Barocci, *Presentation of Mary in the Temple*. S. M. in Vallicella. 1603.

tion of these themes with Unction, it is obviously an Albertian *istoria* in a sense that Caravaggio's painting is not.

Barocci's painting [182] arrived in Rome in April 1603 (Emiliani, 1975, pp. 206 ff., no. 255). (See p. 178 above.) Installed in the left transept, perhaps while Caravaggio was being commissioned to paint the *Entombment,* it must have seemed wholly irrelevant to what he wanted painting to accomplish.

108. View of Vittrici Chapel (second right), Santa Maria in Vallicella, with copy of [107] over the altar. (Photo: David Wright)

109. Fragment of a Meleager Sarcophagus. Museo Capitolino, no. 619. 47 × 49. Restored. Mid or later Antonine, c. A.D. 150. G. Koch, *Die mythologischen Sarkophage* (Deutsches Archäologisches Instituts, *Die antiken Sarkophagreliefs,* ed. F. Matz & B. Andrae, XII), VI, (Ber-

lin, 1975, p. 113, no. 88). (Photo: Deutsches Archäologisches Instituts, Rome, no. 68.3477).

110. Michelangelo Buonarroti, *Pietà*. St. Peter's. 1497–1500. See Hibbard (1978/1979, pp. 43 ff.).

111. Raphael, *The Entombment of Christ*. Galleria Borghese, no. 369. Oil on wood, 184 × 176. 1507. In Perugia until 1608 but well known from copies and engravings. Della Pergola (II, 1959, pp. 116 ff., no. 170); Dussler (1971, pp. 23–24).

112. Ascribed to Girolamo Grandi or Gabriele Giolito of Ferrara, *The Entombment of Christ*. Woodcut, 1533 (?). One of a set of twelve (Passavant, VI, p. 228, no. 29). The last is inscribed *"stampata in Venetia per Nicolo di Aristotile deto Zopino M.D. XXXIII."* A tablet on the *Crowning with Thorns* is inscribed

.G.G.

F.

Passavant also illustrates a monogram that is not present in any of the six in the British Museum. (I am grateful to J. A. Gere for this information.)

113. Detail of [107]. (Photo: Archivio Fotografico, Musei Vaticani)

114. Simone Peterzano, *Pietà*. Milan, San Fedele. Signed. 1583/1584? Cited by Freedberg (1975, p. 599) as remembered by Caravaggio when he painted the *Entombment* [107]; cf. Calvesi (1954, pp. 124–125), who disputes the common dating of 1591. For the stone of unction, see Note 107. (Photo: M. Perotti, Milan, 6861)

115. Peter Paul Rubens, *The Entombment of Christ* (after Caravaggio). Ottawa, National Gallery of Canada. Oil on wood, 88.3 × 65.4. c. 1613/1615? The date is that customarily given (cf. *P. P. Rubens,* Antwerp, Royal Museum of Fine Arts, exhibition catalog, 1977, p. 87, no. 32). J. Held, *The Oil Sketches of Peter Paul Rubens* (Princeton, 1980, I, pp. 499 ff., no. 365), says it was "painted soon after his return from Italy" (late in 1608); he connects it with a drawing and, finally, an oil sketch in the Seilern collection (Held, II, plate 359) that develops the theme into a theatrical entombment with the body of Christ lowered into a subterranean vault. If all this has anything to do with Caravaggio's painting, it

shows that Rubens envisioned the body being lowered in front of the stone toward the altar. (Photo: Museum)

116. Annibale Carracci, *Pietà*. Naples, Museo Nazionale di Capodimonte. 156 × 149. c. 1599/1600. See Posner (1971, II, p. 52, no. 119). In the Farnese Palace in Rome until at least 1653. Often copied (old copy in the Galleria Doria-Pamphilj, no. 137). (Photo: Villani 23227)

117. Annibale Carracci, *Pietà (The Three Marys)*. London, National Gallery, no. 2923. c. 1604/1606. Posner (1971, II, pp. 73–74, no. 177). Cf. Levey (1971, pp. 70 ff.). (Photo: Museum)

118. *The Madonna of the Rosary (The Virgin Enthroned with Sts. Dominic and Peter Martyr)*. Vienna, Kunsthistorisches Museum, no. 147. 364 × 249. (M.64: 1607.) Heinz (1965, pp. 30–31, no. 483) has the later history. The picture was for sale in Naples in September 1607, after Caravaggio had left for Malta (cf. p. 226). A letter dated 25 September from a dealer in Naples, Frans Pourbus, to the Duke of Mantua states: "I have seen here two beautiful pictures by the hand of Michelangelo da Caravaggio: one is a Rosary and was made as an altarpiece and is 18 *palmi* high [402 cm]; they will not take less than 400 ducats for it. The other is a half-length painting of medium size of Holofernes with Judith, for which they want no less than 300 ducats. . . ." These paintings must be those mentioned by the duke's agent in a letter of 15 September: "there are some good things for sale by Michelangelo Caravaggio that he painted here" (Cinotti, 1971, p. 161, F 82–83).

The painting was purchased in Naples by Louis Finson, a Flemish painter-dealer (see Note 136) who was in Naples by 1604/1605 (Pacelli, in Pacelli-Bologna, 1980, p. 29, n. 4). Various authorities, including Longhi, Cinotti, and Marini, date it to 1607. Hess (1967, pp. 280–281) supposed that it was begun for the bankrupt Don Marzio Colonna, under whose protection Caravaggio stayed in Colonna and Zagarolo after the murder of 28 May 1606 forced him to flee Rome (see pp. 209–210), and was then finished in Naples. Hess pointed out that the subject conforms to a special worship of the Rosary in Zagarolo

(Confraternity founded in 1575 by Donna Orinzia Colonna, Don Marzio's mother) that was instigated by the Battle of Lepanto in 1571, in which Marcantonio Colonna, admiral of the papal fleet, defeated the Turks with the aid of a miracle of the Virgin. The column might thus be associated with the Colonna coat of arms as well as with the standard iconography of the Virgin. The donor, Hess thought, resembled Marzio Colonna (but cf. his note, p. 425). Calvesi (1975, p. 76, followed by Borea in Bellori, 1976, p. 225, n. 1) identified the Colonna with whom Caravaggio stayed in 1606 as Don Muzio Sforza Colonna, I think incorrectly (see p. 209, n. 2).

The painting is puzzling, and doubts have been cast on its entire authenticity (e.g., Friedlaender, p. 200, who thought that the Madonna's face, the curtain, and the donor were left unfinished and added by another hand). The models, such as that for the Virgin, are unlike those in the Roman works, as writers who favor a Neapolitan date have pointed out. The picture seems far too large and complex to be the painting of the *Madonna* begun for Modena for the relatively small sum of fifty or sixty *scudi* (see p. 180, and Cinotti, 1971, pp. 158–159, F 66 and 70). Possibly, as Causa suggested, the upper part was begun in Rome and the rest finished in Naples (1972, pp. 962–963, n. 4, citing a *"frattura interna";* the idea was also expressed by Wagner in 1958). The painting, described in 1607 as *"fatto per ancona,"* must have been commissioned.

The painting is apparently made up of three large vertical strips of canvas that occupy the lower half, three roughly square sections above that, and a narrow strip at the top. This description is based only on examination in the gallery, but the joins are obvious enough; one wonders whether the picture was not enlarged and changed drastically in the course of painting. If so, perhaps this is the Modena canvas, transformed for a different purpose, conceivably for a place in San Domenico Maggiore in Naples, for which he was painting a *Flagellation* for a private family chapel in 1607 (see Note 145). Bologna (1974, pp. 182–183) assumed that the painting had been refused by a patron before being put on

the market and believed that it was the Modena painting.

Although it is unlike any other by Caravaggio, this painting seems closer in style and handling to the *Madonna di Loreto* [120] than any other, as Roger Hinks pointed out. Bologna (pp. 182–183) found it to be *"identico"* in style with the *Death of the Virgin* [133], but it is dangerous to compare a clean and restored picture [118] with a filthy one. Mahon (1952, p. 19) also decided that this was a late Roman work. The case for a Neapolitan origin is summed up by Cinotti (1971, pp. 134–135), who sees similarities in the Madonna to the mother in the *Seven Works of Mercy* [141]; Longhi, followed by others, noticed similarities between the Madonna's head and the presumably late *Salome* in London [168]. Cf. Marini (1978, p. 34).

The column, whether it refers to the Colonna or not, was a standard element in the iconography of the Virgin [cf. 119], referring to her as the *columna novae legis* (cf. *Zeitschrift für Kunstgeschichte*, XXXI, 1968, p. 305). The tradition is also based to some degree on Ecclesiasticus 24:4: "My dwelling place was in high heaven, my throne was in a pillar of cloud" (*Et thronus meus in columna nubis;* cf. *Art Bulletin*, XXI, 1979, pp. 59–67). That column is specifically associated with the concept of the Immaculate Conception (not then Church dogma), which was supported especially by Franciscans and which the Dominicans tended to combat. Hence, perhaps, Hess was correct in emphasizing another meaning.

The legend of Mary's donation of the Rosary to St. Dominic (who lived into the thirteenth century and was canonized in 1234) postdates the *Golden Legend* and seems to have become popular only in the fifteenth century. The iconography was not standard; sometimes Dominic gets roses: see Cesari d'Arpino's painting begun c. 1592/1593 (Röttgen, 1973, pp. 105–106, no. 28). There too we see the populace below clamoring for roses, and this may be a distant source of Caravaggio's idea. Reni's painting, which dates from before 1600, is more traditional in showing the Madonna giving a rosary to St. Dominic without an audience (E. Baccheschi, *L'Opera*

completa di G. R., Milan, 1971, pp. 86–87, no. 12). (Photo: Museum)

119. Annibale Carracci, *Madonna and Child Enthroned with Saints (Madonna of St. Matthew).* Dresden, Staatliche Kunstsammlungen, no. 304. 384 × 255. 1588. Posner (1971, II, pp. 20–21, no. 35). Freely based on a painting by Veronese (Posner, I, fig. 42). (Photo: Museum)

120. *The Madonna di Loreto (La Madonna dei Pellegrini).* Cavalletti Chapel, Sant'Agostino. 260 × 150. (M.52: 1604/1605.) L. Lopresti published a notarial act of 4 September 1603 that granted the heirs of Ermete Cavalletti the chapel dedicated to Mary Magdalen in Sant'Agostino, with the provision that they erect an altar with a painting in honor of the most blessed Mary of Loreto (*L'Arte,* XXXV, 1922, p. 176; Cinotti, 1971, p. 154, F 48). The patron, "Ermes Cavalletti Bononiensis," died on 21 July 1602 (Biblioteca Vaticana, *Vat. lat.* 7875, fol. 33). He left 500 *scudi* to ornament the chapel with an altar and a painting of the Madonna di Loreto. A version of Lopresti's document, from Sant'Agostino, states that on 4 September 1603 the Fathers agreed to give the chapel of St. Mary Magdalen ("which is by the little door of our church") to Signora Orinzia de Rossi, widow of Ermes Cavalletti, "and to their children and descendants, namely Signor Pietro Paolo and Agostino Cavalletti, who agree to decorate the chapel with marble [*pietra nobilij*] and to spend more than 500 *scudi* on it" (Rome, Archivio di Stato, *Corporazioni religiose,* Agostiniani in S. Agostino, 3, Registro istromenti 1–3, no. 3: *Libro delle Proposte del 1587 al 1609,* fol 69v: "Adi 4 7bre 1603 fu proposto alli padri se si contentarano dare la cappella di santa Maria Madalena quale sta vicina alla porta piccola della nostra chiesa darla alla signora Orintia de Rossis già moglie del signore Ermes Cavaletti, at alli suoi figlioli, et descendenti cioè il signor Pietro Paolo, et Agostino Cavaletti quali s'obligarano farla di pietra nobilij et spenderci sopra cinquecento scudi. . . .").

Caravaggio's painting was installed before 2 March 1606, when Cardinal Scipione Borghese was given the *Pietà* formerly on the altar (Lopresti, 1922, p. 176, n. 2), which cannot now be

identified in the Borghese collection.

The *Madonna di Loreto* was described with some animosity by Baglione (p. 137); Bellori also disapproved (pp. 206–207) and then returned to the subject (p. 213), speaking of the "filthy feet of the pilgrims" among Caravaggio's breaches of decorum.

An eighteenth-century view of the Santa Casa at Loreto that shows pilgrims, including one kneeling on the projecting socle that runs around the Holy House, is in K. Weil-Garris, *The Santa Casa di Loreto* (New York, 1977, I, fig. 3). To what extent we are meant to believe that Caravaggio's painting represents the Santa Casa is in doubt; he made no attempt to conjure up that environment, let alone specify the nature of the Virgin's apparition. His painting has nothing to do with the type represented by the contemporary painting from Annibale Carracci's studio or by pictures of the subject by Sacchi and others (Posner, 1971, II, p. 68, no. 151: c. 1604/1605; for Sacchi's painting, see Sutherland Harris, 1977, p. 51, no. 7; plate 5). In these paintings the Madonna and Child are shown on the floating House. The relationship of this work with such images as [121] is more obvious. We should remember that pilgrims and pilgrimages were a commonplace in Rome: Delumeau estimated that some 30,000 pilgrims arrived every year (I, 1957, pp. 196 ff.).

A "Madonna di Loreto" was not a standard iconographic formula c. 1600. It could refer to the image of the Madonna at Loreto [cf. 121] or to the Litany of Loreto, which invoked the Virgin under various titles, followed by the request, "Pray for us." Perhaps that was essentially what Cavalletti had in mind (cf. L. Lüdicke-Kaute, "Lauretanische Litanei," *Lexikon der christlichen Ikonographie*, ed. E. Kirschbaum et al., III, Freiburg i. B., 1971, cols. 27 ff.). The Litany is intimately connected with the worship of Mary's Immaculate Conception. Loreto was the ultimate home of the Holy House where Mary was supposedly born, having been immaculately conceived in order to be the pure vessel for the birth of Jesus. Mary's pure conception, although not yet dogma, was widely accepted; it was taken as the logical symbolic solution to Eve's Fall. Thus man's Christian redemption was directly dependent on Mary's conception and birth. Someone who wished to be buried in a chapel dedicated to the Madonna would see that proximity as the best possible situation for the act of intercession in heaven for which Mary was especially renowned.

A "Madonna di Loreto" would emphasize Mary's purity as the Mother of God, which is symbolized in Caravaggio's painting by the presence of the Christ Child. With its supplicant pilgrims it became an image of pilgrimage, of intercession, and of man's redemption from sin through the Immaculate Conception. Yet little of this is apparent in Caravaggio's simple and direct painting, which is the first illustration in Emile Mâle's great book on art after the Council of Trent (1932, p. 6); he observes that Caravaggio *"avait senti plus profondément que personne que le christianisme avait été annoncé à des pauvres par des pauvres."*

In addition to Santi di Tito's image of the figures in a *Crucifixion* coming to life (see p. 188, n. 15), it is worth remembering the tradition of statues coming to life, which is less familiar. Another kind of apparition, cited by Longhi, is seen in Moretto's altarpiece in the pilgrimage church of Paitone (above Brescia), which shows the Virgin appearing to an impaired peasant boy (Venturi, *Storia*, IX, 4, p. 195, fig. 170). The image emphasizes the blessedness of the simple, poor, and meek, and in that sense it is like Caravaggio's. Cf. Gregori (1973, p. 34). See also Note 123.

Passeri's story of Caravaggio's model, whose suitor was a notary, is in Passeri-Hess (pp. 347 ff.); for the documents concerning Caravaggio's attack on a notary who was involved with the painter's friend Lena, see Hess (1967, pp. 77 ff. and esp. 275–277). A notary was a man of great dignity who would not be engaged to someone whose business or pleasure found her habitually "standing in Piazza Navona," as Lena was described in the lawsuit. Thus the notary of the document presumably did not want to marry Lena, and Passeri's story may have been garbled.

The coincidence of the presence of a notary in both stories is attractive, and the date of Caravaggio's altercation (July 1605) fits the presumed date of the painting perfectly (cf. Cinotti, 1971, p. 158, F 65). Nevertheless there is no proof that Lena was the model for this painting and Caravaggio was also involved with another young woman at this time (see p. 88, n. 28).

Old descriptions of the statue in Loreto mention that the Christ Child was large (see Note 121). Hess (pp. 276, 424) believed that the Madonna's pose was based on an antique statue, the "*Tusnelda*" now in the Loggia dei Lanzi in Florence but then in Rome in the Villa Medici. A print of 1580 (Hess, fig. 2) could have been the source. Nevertheless the resemblance of the idealized woman in [120] to that in the *Madonna dei Palafrenieri* [130] makes us believe that both were painted in some sense from life. The crossed legs and tightly pulled skirt may derive from the statue or another such source. (Photo: GFN E 35407)

An attractive *Madonna and Child* in the Corsini Gallery (M.R10), which may have been in some sense inspired by [120], was once attributed to Gentileschi but has since been attributed to Caravaggio by Longhi and accepted by both Mahon and Nicolson (1979, p. 32) but not by Spear (1979, p. 318) or by me: I find the attribution absurd. Bissell (1981, X–14) rejects the attribution to Gentileschi and considers it an old copy after Caravaggio.

121. Antonio Lafreri, *Santa Maria di Loreto.* Engraving of the Madonna of Loreto. Inscribed below the Virgin, ANT. LAFRERI SEQVANI FORMIS EXPRESSA ROMAE. Below the columns (left), SVCCVRRE MISERIS. IVVA. PVSILLANIMES., and (right), INTERCEDE PRO DEVOTO FEMINEO SEXV. At bottom, "*Sancta Maria di Loreto fatta rettrar per il R.^{mo} Cardinal di Augusta.*" That cardinal was presumably Otto Truchsess von Waldburg, cardinal "Augustanus" (of the emperor) from 1544 to 1573 (Eubel, III, p. 29: VI, 53). The wooden statue, supposedly carved by St. Luke, was described by a later writer as having a Child "*più grandicello di ciò in cotal età vedonsi i putti*" (P. V.

Martorelli, *Teatro istorico della santa casa . . . ,* Rome, 1732, pp. 305–306; kindly brought to my attention by Jaynie Anderson).

122. Cavalletti Chapel, Sant'Agostino, showing Caravaggio's altarpiece [120]. The chapel is decorated above with frescoes *(Annunciation, Coronation,* and *Birth of the Virgin).* Below, to left and right of the altarpiece, are *Mary Magdalen* and *St. William.* According to Baglione (p. 306), the frescoes are by Cristoforo Casolano, who worked in the 1620s; cf. Hess (1967, pp. 276, 424).

123. Giovanni Battista Moroni, *Gentleman in Adoration Before the Madonna.* Washington, National Gallery of Art, no. 225. 60 × 65. Dated c. 1560 by Shapley (1979, p. 338). She rejects the idea that the painting is a fragment, citing Moroni's half-length portraits and portraits with visionary scenes. The realistic portrait contrasts with the Madonna and Child, which is based on traditional images influenced by Northern art. See M. Gregori in *I pittori bergamaschi (Il Cinquecento,* III, Bergamo, 1979, pp. 311–312, no. 209), and for a related *Madonna,* see her no. 86 (pp. 248–249). (Photo: Museum)

124. Detail of [118]. (Photo: Museum)

125. Detail of [120]. (Photo: GFN E 35409)

126. *St. John the Baptist.* Kansas City, Nelson Gallery, no. 52–25. 172.5 × 134.5. (M.38: 1600.) Possibly the "*quadro con l'imagine di s. Gio. Batta. nel diserto fatto dall'istesso Caravaggio*" listed in the will of Ottavio Costa, 18 January 1639 (Spezzaferro, 1974, pp. 584–585; cf. 1975). Cataloged by Spear (1971, pp. 18–19, no. 17) and dated 1604/1605, with a photograph of the grooving (also in Marini, 1974, p. 160). For Costa and the copy of this in Conscente, near Albenga, see Spezzaferro (1974, p. 585); further to Costa and the church, see P. Matthiesen & S. Pepper *(Apollo,* XCLI, 1970, pp. 452–462). Caravaggio's trip to Genoa in the summer of 1605 (see p. 196) and the presence of a copy of this on an altar endowed by Costa conspire to make one imagine that this dates from that general period, as does the style (but cf. Marini, 1974, p. 387). The darkness of the painting, the deep, brilliant red of the mantle, and the han-

dling in general place it quite firmly in the last years of Caravaggio's Roman period. (Photo: Museum)

A related painting in the Corsini Gallery, no. 433 (M.57: 1606), has been in a windowless room for so long that I hesitate to pass judgment. Accepted by Nicolson (1979, p. 33), it was doubted by Spear (1979, p. 318). I suspect that it is a good picture by a follower; the lighting of the face is not what one expects from Caravaggio himself, nor is the physiognomy.

The *St. John* in Toledo (M.R11, pp. 300–301; Pérez Sánchez, 1973, no. 3) was accepted by Nicolson (he called it a "fine Caravaggio" in 1974; cf. 1979, p. 33) and others. But for me and a number of doubters it is quite unlike Caravaggio's authentic works. The relation of the figure to the unusually visible background with its effects of back-lighting is wholly unlike Caravaggio. Gregori (1975, p. 33) rejected a recent attribution to G. B. Crescenzi and considered it anonymous.

127. *St. Jerome in His Study*. Galleria Borghese, no. 56. 112 × 157. (M.59: 1606.) Della Pergola (II, 1959, pp. 80–81, no. 115). Occasionally doubted because the Borghese inventories from 1700 until Venturi's catalog of 1893 called it Ribera. It seems to have been painted quickly, in a bravura manner unlike that of other pictures of its size and presumed date. Marini considers it possibly unfinished. Scoring is visible along the extended arm (see *Burlington Magazine*, CXVI, 1974, p. 567, n. 6). Both arms show an interest in silhouetting that can be found in other works of the general period [102, 126].

The picture was mentioned by Manilli (1650, p. 85). Bellori, after discussing the Borghese *Supper at Emmaus* [42], wrote that this was painted for Cardinal Borghese (p. 208). Nevertheless it was not described by Francucci in 1613, and it was not necessarily painted for Borghese, who was made cardinal on 18 July 1605 (see Note 42). The conventional date of 1605/1606 is based on Bellori and may not be correct.

I am indebted to Eugene Rice for information on St. Jerome in the sixteenth century. (Photo:

GFN E 59258)

128. Detail of [127]. (Photo: GFN E 59257)

129. After (?) Caravaggio, *St. Jerome*. Montserrat (Spain), Monastery Museum. 110 × 81. (M.55: 1605.) Possibly the painting mentioned in the Giustiniani inventory of 1638: *"Un altro quadro simile* [to a *St. Augustine* now unknown], *di mezza figura, di San Gerolamo dipinto in tela alto palmi 5½ largo 4½ in circa di mano di Michelangelo da Caravaggio e con sua cornice negra"* (Salerno, 1960, p. 135, no. 5, with my corrections of his measurements, which he read as *palmi* 5 × 4: see Note 18). The actual measurements of the Montserrat picture correspond closely to those read by Salerno (112 × 89 cm). Mahon (1953, p. 213) found it "unmistakably authentic," though he noted that its condition "is not all that one could desire," and he said that among [126], [129], and the Corsini *St. John* (cited following Note 126) —all of which are attributions—the Montserrat picture was "the least satisfactory." In 1974 Nicolson wrote that "nobody would dispute the Montserrat St. Jerome" (*Burlington Magazine*, CXVI, p. 607). Nevertheless, after seeing it in 1980, I have to doubt it. The painting is crude, coarse, and obvious. The wrinkles are painted in a Caravaggesque manner unlike any original of that size that I know. The silhouetted arm is far less subtle than any other in his *oeuvre*, and the head appears to be merely a coarse version of the Borghese *Jerome* [127]. I agree with Friedlaender (p. 204) that it is a clever imitation. Whether it could be an early Ribera, as Arslan and now Moir suggest (1976, p. 161, n. 285), I cannot say.

130. *The Madonna and Child with St. Anne (La Madonna dei Palafrenieri)*. Galleria Borghese, no. 110. 292 × 211. (M.56.) Discussed by L. Spezzaferro, with new documents (*Colloquio*, 1974, pp. 125–137). The Compagnia dei Palafrenieri had once had an altar dedicated to St. Anne in the right transept of Old St. Peter's, one of seven privileged altars in the church. When the western part of the church was torn down in the early sixteenth century in order to build Pope Julius II's new church, the altar was transferred and joined to that of St. Anthony Abbot, just to the right of the central door of the nave upon enter-

ing (Spezzaferro, p. 127). On 31 October 1605 a meeting was held in which the transferral of the altar of St. Anne was discussed, the east end of St. Peter's being destined for destruction (see Hibbard, 1971, pp. 156, 168). The Dean of the Palafrenieri asked the members of his group to contribute to the expense of a new painting for their new altar (Spezzaferro, p. 126). Caravaggio was reported to have been commissioned for this task in a note of 28 November 1605, and on 1 December he was given a first payment of 25 *scudi* (Spezzaferro, p. 130). By 13 March 1606 the painting was almost finished. Caravaggio wrote a receipt for complete payment on 8 April —the only writing that we have in his hand. From a later document we learn that he had been paid only 75 *scudi* in all: the 25 *scudi* paid in December and two further payments. On 16 April men were paid for carrying the painting from St. Peter's (where it can have been exposed for only a few days) to the nearby church of Sant'Anna dei Palafrenieri. That the Palafrenieri had to change altars in St. Peter's does not explain the fate of Caravaggio's painting, for as late as 1618 an altar of St. Anne in the right transept bore another painting, then attributed to Perino del Vaga, which is now in the Sacristy (Spezzaferro, fig. IV).

Baglione reported in 1642 that Caravaggio's painting had been removed "by order of the cardinals of the *Fabbrica*" (pp. 137–138). If the cardinals rejected the painting, one of them was Benedetto Giustiniani. According to Bellori, the picture was rejected because the Virgin and nude Christ Child were shown in a low manner (*"vilmente"; p. 213*). The Palafrenieri did not give the picture to Cardinal Borghese as Baglione asserted; on 16 June 1606 they approved its sale to him for 100 *scudi,* a profit of one-third. For the Borghese history, see Della Pergola (II, 1959, pp. 81 ff., no. 116).

For the new technique visible here and in other paintings of the period and afterward, see D. Mahon (*Paragone,* 77, 1956, pp. 28–29).

The iconography is explained by a theological interpretation of the middle ages that translated God's curse on the serpent in the Vulgate version of Genesis (3:15) as "she shall crush [*ipsa conteret*] your head," referring *"ipsa"* to the Virgin Mary (Pelikan, 1978, pp. 71, 166). For the Renaissance tradition, see Spezzaferro (pp. 135 ff.). The painting by Figino with the same motif of Mother and Child stepping on the serpent is reproduced by Friedlaender (p. 193, fig. 106) and in color by Dell'Acqua-Cinotti (1971, p. 123, fig. 115). See also Gregori (1973, p. 35). (Photo: GFN E 42280)

131. Detail of [120]. (Photo: GFN E 35408)

132. Detail of [130]. (Photo: GFN E 42795)

133. *The Death of the Virgin.* Paris, Louvre, no. 54. 369 × 245. (M.60: 1606.) Painted for Laerzio Cherubini (died 1626), a papal lawyer who published collections of papal bulls and commentaries on legal aspects of theology. The church of Santa Maria della Scala, for which it was commissioned, was still incomplete when the nave chapels were ornamented. Cherubini's chapel decoration was under way in or before 1605, or so we assume. The dates are given by F. Fasolo, once as "1603–4" and elsewhere as "1602," without documentation (*L'Opera di H. e C. Rainaldi,* Rome, 1961, text fig. IV, opp. p. 33, and p. 105). Fasolo's only document is for another chapel (p. 279: 4 October 1604); E. Borsook pointed out that this adjoining chapel was being decorated by Rainaldi late in 1604 (*Burlington Magazine,* XCVI, 1954, p. 270). Whether or not Fasolo had more information is unknown. The chapel opposite Cherubini's was given a *Madonna with St. Hyacinth* by Antiveduto Grammatica between c. 1598 and 1602 (Salerno, 1957, p. 145, no. 1049, referring to Mancini, p. 245). Caravaggio's picture might have been commissioned somewhat earlier than is generally supposed, since the altarpiece for the adjoining Pandini Chapel was evidently painted by Roncalli between October 1604 and October 1605 (Borsook, p. 271; Kirwin, 1972, pp. 450 ff., no. XXX). Caravaggio was probably commissioned at about that time as well, for he could have done relatively little on it while he was painting the *Madonna dei Palafrenieri* (November 1605–April 1606; see Note 130), and perhaps could not have painted it completely in April–May 1606—but cf. Note 138.

Since the *Madonna di Loreto* [120] was definitely completed by March 1606, and quite probably by November 1605, when he began [130], the same arguments apply to [120] that apply to this work. On style, [120] can hardly be much earlier than 1605; this work must be put in the same general period and could have been commissioned as early as 1604, following [107].

Cinotti (1971, p. 80) presumed that the picture was painted in 1606 and refused only after Caravaggio left Rome on 31 May, since it was for sale early in 1607 (she supposed that such a painting would have been put on the market immediately and that it would soon have had a buyer). Spezzaferro (*Colloquio,* 1974, p. 135) thought that Cardinal Tolomeo Gallo, the builder of the church, might have been involved since he had been kept informed of the deliberations of the cardinals on the *Madonna dei Palafrenieri* (Note 130). Spezzaferro also assumed that the *Death of the Virgin* was rejected before [130], which I too tend to believe.

Mancini, who called it a *"bel quadro,"* relates in three different places that the picture was refused by the Fathers of Santa Maria della Scala because of Caravaggio's indecent portrayal of a whore—who he says was loved by Caravaggio (p. 132; cf. pp. 120, 224 and n.). Baglione (p. 138) also thought the picture had been refused because it was indecorous, the Virgin's legs being exposed. Bellori, after a critical passage in which he says that Caravaggio lacked most of the qualities of art (quoted on p. 372), wrote that it was removed because of the realistic imitation of a swollen dead woman (p. 213). Presumably these reports reflect the truth, yet there were other reasons for rejecting the painting. As Bellori hinted, and as Roger Hinks (*Caravaggio's Death of the Virgin,* Charlton Lectures on Art, Oxford, 1953), Cinotti (1971, p. 80; 1973, no. 48), and others have observed, there were theological objections. Caravaggio showed the Virgin dead instead of dying, and without a heavenly host to signify her translation to heaven, as was conventional in pietistic images of the scene [cf. 134]. Cf. also Hess (1967, p. 234, n. 1); and L. Schildkraut (*Apocrypha,* III, 1978,

pp. 35–42). Nevertheless, as Shirley Malone pointed out in an unpublished paper, Bartolomeo Cesi showed the Virgin dead and in sharp foreshortening, without a heavenly host, in a fresco of c. 1595 in Bologna, which was then a center of pietistic thought—and apparently no objection was raised (F. Arcangeli, *Maestri della pittura del seicento emiliano,* Bologna, 1959, pp. 50 ff. and plate 11). Moreover, Cesare Baronius had already admitted that the legend of the Apostles gathering for the Virgin's death was wholly apocryphal; for this, and for Molanus and other commentary, see Mâle (1932, pp. 359 ff.).

Rainaldi's altar with Saraceni's more conventional substitute picture is shown by Fasolo (text fig. IV, opp. p. 33).

134. *The Death of the Virgin,* from Geronimo Nadal, S.J., *Evangelicae Historiae Imagines . . .* (Antwerp, 1593, p. 150: *"Transitus Matris Dei";* other editions on different pages). Engraving by Jerome Wierix, based on a drawing by Bernardino Passeri. For Nadal, who prepared the book before his death in 1580, see Buser (1976, pp. 424–433). The iconographical content of the illustrations must therefore be earlier than the book, which was issued with different title pages and dates between 1593 and 1595.

135. Detail of [133]. (Photo: AGRACI, Paris)

136. Louis Finson, copy of Caravaggio's *St. Mary Magdalen in Ecstasy.* Marseilles, Musée Cantini, no. 90. 126 × 100. c. 1613? (M. 62 illustrates another version as the original.) Mancini wrote that when Caravaggio fled Rome he first went to Zagarolo, where he had secret dealings with Prince Colonna, and made there a *Magdalen* and a *Christ Going to Emmaus* (p. 225; cf. Note 137). Baglione wrote that the picture was painted in Palestrina (p. 138), but Bellori reverted to Zagarolo (p. 208) and again mentioned the *Emmaus,* which Baglione had omitted.

The picture painted in Zagarolo or Palestrina was presumably not the large *Magdalen* owned by Giustiniani, which was listed in the inventory of 1638 as *"Un quadro grande della Madalena figura intiera depinto in tela alto palmi 10 largo 7½ di mano di Michelangelo da Caravaggio con la cornice"*

(Salerno, 1960, p. 135, no. 7, with the measurements transcribed as *palmi* 10 × 7; see Note 18 above). Moir (1976, p. 148, n. 247) tried to show that the composition of [136] was known in Rome by c. 1610. Nevertheless most of the copies, like Finson's, seem to stem from Naples (cf. Note 118).

I illustrate Finson's copy because it is presumably just that. The impressive painting published by Marini (1974), with color detail opposite his p. 56, does not seem to me to be by Caravaggio, but I know only the reproductions.

The various copies and their types were first discussed by D. Bodart (*Palatino*, X, 1966, pp. 118–126; cf. Moir, no. 69: some twenty painted copies). The theme of death and solitude was connected by Cinotti (1973, no. 52) with the Borghese *Jerome* [127]. For the possible influence of [136] on Bernini, see Hibbard (1983).

Caravaggio would presumably have known a version of Annibale's *Landscape with St. Mary Magdalen* [183], which is a more conventional version of the theme of the nude penitent saint, though the extensive landscape is not always present. The contrast between [183] and this work is striking (cf. p. 53, n. 2). (Photo: Courtesy Richard Spear)

137. *The Supper at Emmaus.* Milan, Pinacoteca di Brera, no. 966. 175 × 141. (M.61: Rome? 1606.) In the Patrizi collection from at least 1624 until its sale to the Brera in 1939. This impressive picture, painted thinly on coarse canvas, is almost universally thought to date from the summer of 1606 because of its identification with a picture cited by Mancini and Bellori (see Note 136). Bellori described it as belonging to the Patrizi (p. 208); later he mentioned the Borghese picture [42] and compared them. But Bellori did not specifically identify this work as the one done in Zagarolo, which he called a *"Cristo in Emaus fra*

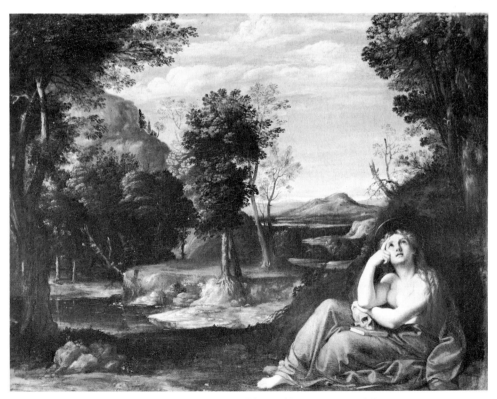

183. Annibale Carracci, *Landscape with St. Mary Magdalen*. Galleria Doria-Pamphilj. c. 1597.

li due apostoli" rather than *"Christo che va in Emaus"* as did Mancini. Probably he simply failed to mention that they were identical (see Note 42).

This painting has aspects that might make one want to date it later rather than earlier: the soft handling, the almost caricatured wrinkles, and the type of the old woman are found in later paintings [but cf. 130]. Nevertheless Cinotti (1973, no. 49; 1971, pp. 130–131), like Marini, thought that the picture was painted in Rome. The old woman looks like a version of Anne in [130], but the resemblance only tends to confirm that this work was painted soon afterward.

Mancini's statement that the *Emmaus* was purchased by Costa in Rome, together with his title for the painting, has caused confusion; there is no such painting in Costa's inventories (Spezzaferro, 1974, pp. 585–586, supposes that he may have owned a copy; cf. 1975, pp. 116–117). Costa seems to have been something of a dealer; he had contacts with Naples, where the picture could have been sold. (Photo: Soprintendenza alle Gallerie, Pinacoteca di Brera, Milano, 12906/L)

138. *The Seven Works of Mercy*. Naples, Pio Monte della Misericordia. 390 × 260. (M.63.) On 9 January 1607 Caravaggio was paid the final installment of a total of 400 *scudi* for the picture, *"che ha dipinto,"* which was to be the high altarpiece in a new church being completed by G. G. di Conforto (Cinotti, 1971, p. 160, F 78; R. Causa, *Opere d'arte nel Pio Monte della Misericordia a Napoli*, Naples, 1970, pp. 18–30). Described by Bellori (p. 209), who mentions only the parts in the lower right, which may have been most visible when he saw it—but later he decried the vulgar form of the man drinking (p. 213).

The meaning of the painting was investigated by Fagiolo (1968/1969). Cf. Bologna (1974, pp. 183–184). It was restored in 1962–1963 at Capodimonte and then exhibited at the Palazzo Reale (Scavizzi, 1963, p. 18, no. 5). X-rays show that the Christ Child was originally a third angel and that the Madonna was missing (Causa).

Although Caravaggio's painting is unique, the subject is known from northern versions, among them a populous picture by Frans Francken I (1542–1616) in St. George's Church, Antwerp (photo: R. K. D. Iconklapper C 7605). There are no points of contact between this (or other pictures known to me) and Caravaggio's stupendous work. For similarities with *Measure for Measure*, see Brooke (1977, p. 60). (Photo: GFN E 51918)

139. Detail of [138]. (Photo: GFN E 51920)

140. Detail of [138]. (Photo: GFN E 51928)

141. Detail of [138]. (Photo: GFN E 51929)

142. Antonio Campi, *The Empress Visits St. Catherine in Prison*. Milan, Sant'Angelo. 1585. See M. P. Rossi Pernier & M. Terenzi, *Dizionario biografico degli italiani* (XVIII, 1974, pp. 500 ff.). (Photo: Archivio Fotografico dei Civici Musei, Castel Sforzesco, Milan)

143. Detail of [138]. (Photo: GFN E 51923)

144. *The Crucifixion of St. Andrew*. Cleveland Museum of Art, no. 76.2. 202.5 × 152.7. (M.72: 1607; shows another version as original.) Painted for Don Juan Alonso Pimentel y Herrera, Count of Benavente, who was Viceroy of Naples from 1603 to July 1610. According to Bellori (p. 214), it was done for Benavente; he then mentions a *David* and a portrait done for the "conte Villa Mediana," neither of which is known.

Discussed in a thorough and convincing article by A. Tzeutschler Lurie with D. Mahon (*Bulletin of the Cleveland Museum of Art*, LXIV, 1, 1977, pp. 3–23). There is no doubt that this is the original; the evidence includes *pentimenti*, particularly on the woman's throat, which was originally covered by her clasped hands, as in [168]. The authors date the picture to 1607, before Caravaggio's voyage to Malta, on the basis of similarities with the *Flagellation* [145] and the Malta *St. Jerome* [150]. This date may well be correct, but there are "short-hand" passages in the painting (such as the breeches of the man on the ladder) and an almost phosphorescent aspect to some of the highlights that make it possible that it was finished later than 1607, as Mina Gregori had proposed (1975, p. 43; cf. Note 168). The figure with his mouth open to the right of Andrew is similar to the left tormentor in the *Flagellation* [149], which was certainly well

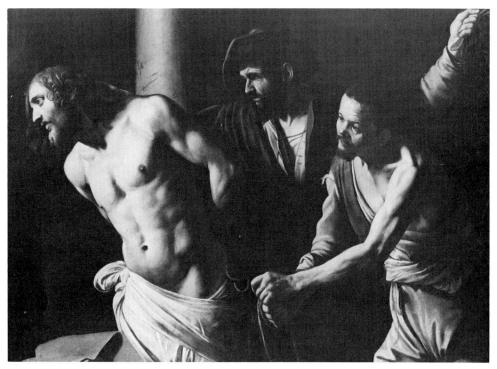

184. Caravaggio (?), *Flagellation of Christ.* Rouen, Musée.

under way by mid 1607. The old woman should be compared with one in the London *Salome* [168]. Goiters are found in Lombard paintings, e.g., Peterzano's *Adoration of the Shepherds* of 1578–1582 (Baccheschi, 1978, pp. 499, 527), where a shepherd is afflicted. (Photo: Museum)

145. *The Flagellation of Christ.* Naples, Museo Nazionale di Capodimonte. 286 × 213. (M.91: 1609/1610.) Painted on commission of Lorenzo de Franchis (Franchi) and eventually placed in the family chapel in San Domenico Maggiore in Naples. A payment of 100 ducats *"a compimento di ducati 250"* to Caravaggio on 11 May 1607 must have been for this picture; another payment of 40.09 ducats was made to him on 28 May, perhaps for incidental expenses (Pacelli, 1977, pp. 820–821, with a mistaken reading of 29 for 28 May). The first document does not specify the painting by name, but it says *"che li haverrà da consignare"* (which remains to be delivered). (The final payment on 11 May indicates completion.) This circumstantial evidence of a commis-

sion from Franchis in 1607 is sufficient to scotch the late date proposed by Longhi and once accepted by many. The painting was in the Franchis chapel until its recent removal.

The painting derives from an enormous repertory of models, not only Sebastiano's [146] but also north-Italian versions, including one in Rome that has been attributed to Peterzano (Calvesi, 1954, pp. 115 ff; fig. 12). (Photo: GFN E 51981)

Another painting of this subject is now in Rouen [184]. (M.65: 1607; Spear, 1971, pp. 76–77, no. 18: c. 1605/1607; Cinotti, 1973, no. 59.) It is sometimes dated very late (Röttgen, 1974, pp. 201–202; F. Bologna, in Pacelli-Bologna, 1980, p. 42, n. 8). The scoring in the paint (Spear) makes it seem authentic. Some doubts by others are listed in Spear (1975, p. 227). Gregori (1974, p. 599) seems to date it close to the Maltese paintings (1607–1608). I sympathize with Moir's doubts (1976, pp. 158 ff., no. 279) and find only the right-hand figure wholly convinc-

ing as Caravaggio's invention. Nevertheless this is in some sense a Caravaggio, puzzling though it is. Perhaps it is only a version of an original. Denis Mahon recently indicated to me that he still believes that the version he published (*Burlington Magazine,* XCVIII, 1956, pp. 225–228), then in a private Swiss collection, is more likely the original: "The problem for me," he writes of the Rouen painting, "is that its handling, etc., is in my opinion quite irreconcilable with that of the period which the presentation of the subject and the types of the *sbirri* so strongly suggest (about 1605–1607). But this problem does not pose itself with the rendering which I published, and which I believe to be an original of about that period. . . ."

A painting of this subject was in the Villa Borghese in 1650 and 1683 (M.25: 1598; cites another composition). The compositions that have been connected with that painting should show two ruffians flogging Christ, as one of the descriptions specifies, but the painting could also have been this one.

146. Sebastiano del Piombo, *The Flagellation of Christ.* San Pietro in Montorio. Oil on prepared wall, c. 1521, but based on earlier studies, including sketches by Michelangelo. See M. Hirst, *Sebastiano del Piombo* (Oxford, 1981, chapter 4).

147. Federico Zuccaro, *The Flagellation of Christ.* Oratorio del Gonfalone. Fresco, 1573. See A. Molfino, *L'Oratorio del Gonfalone* (Rome, 1964). (Photo: GFN E 47086)

148. Detail of [75]. (Photo: GFN E 24465)

149. Detail of [145]. (Photo: GFN E 51982)

150. *St. Jerome Writing.* Malta, Valletta, Cathedral Museum. 117 × 157. (M.76: 1608.) Formerly in the Italian Chapel of the Cathedral of St. John. It bears the Malaspina arms (Hess, 1967, p. 340). Presumably commissioned by Ippolito Malaspina, Prior of the Order of St. John in Naples, which would suggest that the commission antedated Caravaggio's voyage to Malta in June/July 1607. Malaspina was a relative and friend of Ottavio Costa's; Costa owned a portrait of Malaspina, and Costa's sons set up his tomb after his death (Hess; Spezzaferro, 1975, p. 107

and n. 22; portrait listed p. 118).

Since Caravaggio is known to have gone to Malta in mid 1607 (see p. 226), it seems possible that this was painted or at least finished there. Bellori saw it in the chapel and mistakenly thought that the accompanying painting of the Magdalen was also by Caravaggio; the pictures hung very high (p. 210; he also mentions a second *St. Jerome,* which is not known; cf. Note 166).

The precise painting of the figure and still life, different from that of the *Flagellation* [145; cf. 149], indicates that [150] was done with care, possibly as a kind of trial or example, and possibly for the private devotion of Malaspina, since the *Magdalen* with which it was paired in the chapel is evidently later. The skull, already seen in the Borghese *St. Jerome* [127], is prominent as a *vanitas* symbol [cf. also 163].

Although there are generic similarities between the head of Jerome and that of the grand master [151], there are also differences; perhaps the coincidence of working on portraits of Wignacourt at the same time made the resemblance so close (Gregori, 1974, p. 599). Nevertheless many writers have seen here a flattering portrait of the grand master as St. Jerome. (Photo: GFN E 38189)

151. *Portrait of Alof de Wignacourt, Grand Master of the Knights of Malta, with a Page.* Paris, Louvre. 195 × 134. (M.74: c. 1608.) In poor condition, often and poorly restored and repainted, and now, in the words of Pierre Rosenberg, "beyond restoration." A consciously traditional painting showing the grand master in old armor, conceivably La Valette's (cf. Marini, 1974, pp. 437–438), and holding a commander's baton. The armored portrait had been developed in Venice; Caravaggio's sources could have included several portraits by Titian, of which he may have known at least the *Pier Luigi Farnese* from the Palazzo Farnese in Rome (Wethey, II, 1971, no. 30; cf. no. 89). Friedlaender (p. 221) cited the *Allocution of Alfonso d'Avalos, Marquis of Vasto,* now in Madrid, in which there is an armored figure with a page holding his casque, as in this work (Wethey, no. 10).

Baglione wrote that a portrait had led to Caravaggio's knighthood (p. 138). Bellori, better informed from his own visit to Malta, cited it as one of two portraits by Caravaggio, the other showing the grand master seated (p. 209; for the lost seated portrait, see Gregori, 1974). We can assume that this painting and perhaps another were the cause of Caravaggio's knighthood.

It has been suggested that only the head of Wignacourt is by Caravaggio, and also that the head has been repainted. Yet he often painted armor [cf. 144, 38]. The page does not look authentic to me and may have been repainted or even finished by another hand, but for Gregori (1974, p. 598) it is the most Caravaggesque part of the picture. Since the canvas is divided vertically between Wignacourt's elbow and the boy, it is even possible that the page was an afterthought. Wignacourt looks off, as if toward battle. (Photo: AGRACI, Paris, 20474)

An attractive portrait of a Maltese knight with rosary and sword (Florence, Galleria Palatina, Palazzo Pitti; 72 × 105; M. 79: 1608) was published as a portrait of Wignacourt by Gregori (1974), who attributed the painting to Caravaggio. I have come to the conclusion that the painting is not of Wignacourt: assuming that [151] shows his face accurately, the features of the Pitti portrait have a different relationship to the head, despite some similarities. Bologna (Pacelli-Bologna, 1980, p. 42, n. 8) claims to have found an engraving of the painting that identified the sitter as Niccolò Caracciolo di San Vito, who supposedly died in 1689. If that identification is correct, the portrait must be much later than the period of Caravaggio's lifetime.

152. Callisto Piazza, *The Beheading of St. John the Baptist*. Venice, Galleria dell'Accademia, no. 919. Oil on wood, 119 × 93. 1526. From the convent of SS. Giovanni e Paolo in Venice. See Note 16.

153. *The Beheading of St. John the Baptist*. Malta, Cathedral of St. John, Oratory of the Knights. 361 × 520. Signed: "*F*[ra] *Michel A* [ngel . . .]" [cf. 156]. (M.75: 1608.) Caravaggio was knighted on 14 July 1608. Hence the signa-

ture, if nothing else, dates from after that time. Described with admiration and accuracy by Bellori (pp. 209–210). Considerably damaged and poorly restored in the past (cf. the old illustrations, e.g., Friedlaender, plate 51). It was excellently renewed in 1955 (R. Carità, *Bollettino dell'Istituto Centrale del Restauro,* 29/30, 1957, pp. 41–77), when it was found to have few *pentimenti* (Salome's ear shows one). (Photo: GFN E 38258)

154. Detail of [153]. (Photo: GFN E 38397)
155. Detail of [153]. (Photo: GFN E 38259)
156. Detail of [153]. (Photo: GFN E 38005)

157. Antonio Campi, *St. John the Baptist Awaiting Execution*. Milan, San Paolo. 1581. Painted a few years before *The Empress Visits St. Catherine in Prison* (see Note 142). (Photo: Mario Perotti, Milan, 128)

158. *The Burial of St. Lucy of Syracuse*. Syracuse, Santa Lucia al Sepolcro (temporarily? removed). 408 × 300. (M.80.) For some years the painting has been at the Istituto Centrale del Restauro in Rome, awaiting a decision on its destination in Syracuse: the church is damp and the painting in bad condition, but the recent restorations have removed a great deal of repainting and preserve the composition. Presumably it will be sent eventually to the Museo Nazionale di Palazzo Bellomo. I am grateful to the authorities at the Istituto Centrale del Restauro, particularly the chief restorer, Paolo Mora, and recently Michele Cordaro, for allowing me to examine the painting at length on various occasions over the years.

Evidently painted soon after Caravaggio's arrival from Malta in October 1608. Saccà (1907, p. 78), on the basis of records destroyed in the earthquake of 1908, thought that the painting was commissioned by "Bishop Orosco (1586)," who was bishop 1579–1602 (Eubel, III, p. 307). His successor was Giuseppe Saladino from Palermo (bishop 1605–1611; Eubel, IV, p. 325). Since a bishop is prominent in the painting as one-half of the forced dichotomy of temporal and spiritual action, it is quite possible that the bishop was involved in the commission and that Saccà's source simply named the wrong one—or

that Saccà added the name incorrectly. Susinno, in 1724, thought the commission came from the Senate of Syracuse through the offices of Caravaggio's old friend Mario Minnitti (1960, p. 10; cf. pp. 235–236 and p. 8, n. 15).

Caravaggio's new altarpiece seems to have been related to a modernization of the church that added a refurbished nave onto the Norman sanctuary. Late in the eighteenth century the painting was restored, and in 1821 it was partially repainted. At some time it was removed and, to judge from the creases, folded.

Originally Lucy held a lily and a palm, and other details can be reconstructed from old copies (Moir, 1976, figs. 110–111, are unclear). The face of the woman in profile above the head of the right gravedigger is an old repaint with nothing underneath, as is the bishop's eye. The head next right to the old woman, partially obscured in the crowd, has been called a self-portrait (see Marini, 1974, p. 253, for a larger reproduction; also Dell'Acqua-Cinotti, 1971, plate XLIV). The crosier of the bishop shows a *pentimento,* with the curve first going right instead of left. The deep red of the ecclesiastical figure above Lucy has been restored in order to make the head in front of it stand out, and there are many other losses, major and minor, all over the canvas, particularly at the bottom, where the shovels and other features are missing.

Röttgen (1974, p. 254, n. 179) sees here a new style of drapery that is typical of the latest works. See [138] and [144] for analogous passages in earlier paintings. The drapery on the loins of the man on the ladder in the *Crucifixion of St. Andrew* [144] is similar to that of the right gravedigger.

According to legend, Lucy was a victim of the Emperor Diocletian's persecution at Syracuse, where she died c. 303. Venerated at an early date, she is mentioned in the fourth-century canon of the Roman Mass. The tradition is that, after endless torments, she died from a sword thrust in her throat, as implied in this painting. Iconographically the painting is unusual: common representations show an iconic figure holding a plate with eyes, her attribute (*luce* [*lux*]: light). Antonio Tempesta's engraving of 1591 shows her

being beheaded (Bartsch, XVII, p. 138, nos. 390–462, no. 39).

I am indebted to an unpublished paper by Louise Rice in which she pointed out that Lucy's grave on the site of the church in Syracuse was especially venerated although the body was no longer there. Hence the subject of Caravaggio's painting is essentially unique, though a few cycles of paintings from previous centuries included Lucy's funeral or a related scene. For a more conventional funeral-burial scene, see Giulio Campi's *Burial of St. Agatha* (Cremona, S. Agata; Venturi, *Storia,* IX, 6, p. 85, fig. 516), which takes place with the saint on a sarcophagus within a church. (Photo: ICR 11737)

159. Detail of [158]. (Photo: ICR 11743)

160. Stefano Maderno, *St. Cecilia.* Santa Cecilia in Trastevere. 1600. See J. Pope-Hennessy, *Italian High Renaissance and Baroque Sculpture* (Phaidon, 1970, 2nd ed., pp. 91–92, 440). A body identified as St. Cecilia was discovered under the altar on 20 October 1599, causing a great stir. Maderno was paid for his work, including the reconstructed altar, on 16 December 1600.

161. Detail of [153]. (Photo: GFN E 38395)

162. Detail of [158]. (Photo: ICR 353)

163. *The Resurrection of Lazarus.* Messina, Museo Nazionale. 380 × 275. (M.82.) (John 11:1–44.) Commissioned by Giovanni Battista de Lazzari, who was originally Genoese, which could conceivably be the result of Caravaggio's other Genoese connections (Giustiniani; Costa; Prince Doria). Painted by 10 June 1609, according to a marginal note to a contract of 6 December 1608, which was for an altarpiece depicting the Madonna with St. John the Baptist and other saints, and which made no mention of Caravaggio. Whether he was in Messina and got this commission then is unknown. The marginal note of 10 June mentioned Mary and Martha and called Caravaggio *"militis Gerosolimitanus"* (Saccà, 1907, pp. 66–67; the document was destroyed in the earthquake of 1908). The story of a first version and its dramatic destruction is told by Susinno (1960, p. 111); cf. Röttgen (1974, p. 182). It is possible that Susinno's anecdote derives

from the memory that Caravaggio produced a first version, which could have been the painting described in the contract. Bellori (p. 210) mentions a man holding his nose who is not now visible (see Note 166).

Susinno (p. 112) reports that Caravaggio demanded the best room of the hospital at Lazzari's expense, where he insisted on having a newly disinterred corpse held up for him to paint. When the porters rebelled at the smell, he supposedly beat them and made them stay at the job.

The painting is in poor condition; it was heavily restored in 1908–1909. A strip of c. 30 cm at the bottom seems to be an addition or a replacement. The more recent conservation at the Istituto Centrale del Restauro has not been published.

The iconography was discussed by Spear (*Gazette des Beaux-Arts,* LXV, 1965, pp. 65–70), who discovered a possible source for the pose of Lazarus in a small picture by Cesari d'Arpino in the Galleria Nazionale di Palazzo Barberini. Röttgen (1974, pp. 213–214, and 1975, pp. 61–74) cites [164] and discusses the tension between life and death. As in [158], Caravaggio relies here on traditional Passion iconography for his formulas of grief. (Photo: ICR 5026)

164. Diana Scultori after Giulio Romano, *Achilles Bearing the Body of the Dead Patroclus.* Engraving, 24.7 × 40.1. (Bartsch, XV, 35.) Cf. Röttgen (1974, p. 213, and 1975, pp. 61–74). After a fresco in the Sala di Troia, Palazzo Ducale, Mantua.

165. Detail of [163]. (Photo: ICR 5025)

166. *The Adoration of the Shepherds.* Messina, Museo Nazionale. 314 × 211. (M.83.) Painted for the Capuchin church in Messina, Santa Maria degli Angeli *extra moenia,* according to Susinno at the behest of the Senate (pp. 113–114, with a description). It was mentioned in a local source of 1644 and described by Bellori (p. 210) along with [163] and a *St. Jerome Writing* that is unknown. Hackert's *Memorie de' pittori messinesi* (Naples, 1792), cited by Saccà (1907, pp. 70 ff.), is apparently only a version of Susinno's manuscript; it claimed that the *Adoration* was painted first: see Martinelli in Susinno (1960, pp. xlviii

ff.). "Hackert" reported that Caravaggio was in Messina for more than a year. Cf. Marini (1974, p. 448).

The subject, with Mary on the ground, is connected with the old theme of the Madonna of Humility: see M. Meiss, *Painting in Florence and Siena after the Black Death* (Princeton, 1951, chapter VI). (Photo: ICR 5058)

Susinno (p. 114), in addition to the *St. Jerome* cited by Bellori (p. 210), mentioned a second one with a skull; both were then in the collection of Count Adonnino in Messina (cf. Note 129). Saccà (p. 64) records a document concerning four paintings of Christ's Passion done for a Nicolao di Giacomo of Messina, of which at least one, *Christ Carrying the Cross,* was finished. All are now unknown.

167. *The Adoration of the Shepherds with Sts. Lawrence and Francis.* Formerly Palermo, Oratorio di San Lorenzo. 268 × 197. 1609. Stolen the night of 17–18 October 1969. (M.88.) Painted for the Compagnia di San Francesco, which together with the dedication of the Oratory accounts for the presence of the two saints. Discussed by Bellori (pp. 210–211). Denis Mahon kindly pointed out the Flemish character of the small child lying on the floor (cf. Hugo van der Goes's *Portinari Altarpiece* in the Uffizi).

Following the tendencies seen in [133] and [166], we look up at the rafters of the ceiling.

The painting was restored in 1951. I have never seen it. (Photo: ICR 5235)

168. *Salome Receiving the Head of St. John the Baptist.* London, National Gallery, no. 6389. 91.5 × 106.7. (M.67: Naples, 1607.) Cataloged by Levey (1971, pp. 53–56), who questioned the attribution, following Michael Kitson. The picture must be discussed together with the damaged and repainted [170] because one of them may be the painting described by Bellori (p. 211) as having been sent to Malta to placate the grand master after Caravaggio returned to Naples from Sicily. The old women here and in [170] are manifestly versions of the same model, and one could be a version or a copy of the other; the problem is complicated by uncertain dates and

attributions and the doubtful condition of [170]. Longhi and Kitson pointed out a generic similarity between this Salome and the Virgin in the *Madonna of the Rosary* [118], but the appearance and handling are not similar enough to force a date of c. 1607. I suspect that by c. 1606/1607 Caravaggio had developed a formula for various faces—old women, executioners, etc. —and that the dates have to be determined by other means. Thus the executioner here is similar to the tormentor at upper left in the *Flagellation* [145]. The old woman is related to the one in the *Crucifixion of St. Andrew* [144] and is even closer to the one in the *Beheading of St. John the Baptist* [153; cf. also 161, 162]. This series, roughly chronological, makes the obsessively wrinkled woman in [170] seem Caravaggesque rather than by Caravaggio; the same is true of the lovely, perhaps repainted Salome in that painting. The executioner, too, seems derivative and attractive, as opposed to Caravaggio's genuine productions of the late years. Marini (1978, p. 45, n. 180) suggested that the *"Judith"* mentioned in September 1607 as having been painted by Caravaggio in Naples (see Note 118) might have been a *Salome,* misidentified in the letter. The possibility is appealing; since treatments of both subjects normally include a younger woman accompanied by an older one, it is a possible mistake. Neither this work nor [170] would be mistaken in this manner, however, because of the presence of the executioner.

Bologna (Pacelli-Bologna, 1980, p. 41), following Longhi when he can, dated [168] to 1609/1610 and hinted that the *Flagellation* [145] might have been left unfinished when Caravaggio went to Malta in mid 1607; thus he reconciles what he sees to be the late style of that painting with its correspondences to this work. But the payments prove that the *Flagellation* was essentially finished in May 1607 (see Note 145).

The painting has a Neapolitan provenance, attested to by a copy in the Abbey of Montevergine that was "certainly" there from the beginning (Scavizzi, 1963, p. 21, no. 9: 92 × 105 cm, essentially identical with this). Longhi, Röttgen (1974, pp. 201–202), and Gregori (1975, p. 43)

believed that this was a late picture, but our idea of very late Caravaggio was then based in good part on Longhi's attribution of the *Flagellation* to 1609/1610. It is rather the *Martyrdom of St. Ursula* [171] that now gives us our touchstone for the latest style of Caravaggio, for it is securely documented to May 1610.

The condition of the painting, as described by Levey, is not good. The drapery on the executioner looks unfinished and unlike fabric, a quality that begins to be evident in the *Crucifixion of St. Andrew* [144]. Blood shows through John's hair over the ear. The hands of the old woman are merely drawn, and the paint is everywhere thin, with underpainting showing through. It is almost colorless: flesh tones, grays, off-whites.

The iconographic origins of this and [170] are found in Lombardy [cf. 169, 152]. The old woman, presumably not Herodias, is a handmaiden borrowed from the iconography of Judith [cf. 36]: E. Panofsky, *Problems in Titian . . .* (New York, 1969, p. 42). (Photo: Museum)

169. Bernardino Luini, *Salome Receiving the Head of St. John the Baptist.* Florence, Galleria degli Uffizi, no. 1454. Tempera on wood, 51 × 58. (Berti, 1979, P 939.) Many variants and copies known (in Prado no. 243 the handmaiden is omitted). Such a painting was in the Barberini collection in Rome, attributed to Leonardo: *"Erodiade con il Carnifice quale tiene in mano la Testa di S. Gio. Battista di mano di Leonardo da Vinci di Altezza di palmi 6"* (M. A. Lavin, 1975, p. 299, no. 162), but it was higher than it was wide. There is also a type by Solario showing only Salome with the head being placed on the charger by an arm (e.g., Metropolitan Museum of Art, no. 32.100.81). (Photo: Soprintendenza 252416)

170. After Caravaggio (?), *Salome Receiving the Head of St. John the Baptist.* Madrid, Palacio Real. 116 × 140. (M.84: Messina, 1609.) See Note 168 for discussion of both pictures. Pérez Sánchez (1973, no. 1) considers it very late. In Spain since before 1686; evidently damaged and reworked after a fire in the Alcázar in 1734. Its condition is questionable, and the problems that I and others have with the attribution may be the

result of rather extensive repainting. I have not been able to examine it at any length: it is difficult to view the picture apart from rather rushed guided tours.

Mahon dated it to 1607, between the Brera *Emmaus* [137] and the documented Neapolitan canvases of 1607 (1952, p. 19; in 1977 he told me that he thought it was earlier and less psychologically astute than [168]). Cinotti (1973, no. 69) considered it close to the Messina *Adoration* [166], and that was also Marini's opinion. Causa called it a "replica with variants, with some doubt as to its autograph status—very early Battistello [Caracciolo]?" (1972, p. 963, n. 5).

The composition is odd, perhaps because of damage and repainting; possibly it was cut down at the right, for the empty space at the left is unusual. The rich, deep colors are not characteristic of the very late Caravaggio but the surface we see today can hardly be his.

171. *The Martyrdom of St. Ursula.* Naples, Banca Commerciale Italiana. 154 × 178. Completed May 1610. Painted for Prince Marcantonio Doria of Genoa; in the Doria collections in Genoa and then in Naples until at least 1854. It reappeared after World War II in a villa of the Romano-Avezzana family near Eboli, where Ferdinando Bologna saw it; at that time it was identified as coming from the Doria D'Angri collection. It had been cited in a guidebook of 1845 as being in that collection, which went unnoticed until the painting's publication by Vincenzo Pacelli (Pacelli-Bologna, 1980).

First published as an allegorical scene by Mattia Preti (Scavizzi, 1963, pp. 53–54, no. 5 and fig. 6b). Acquired as a Preti by the present owners. Published as a possible Caravaggio by Gregori (1975, pp. 44–48 and fig. 21). That attribution was also maintained by Ferdinando Bologna. A strip has been added at top.

Documents located by Giorgio Fulco and Pacelli tell the story of the painting, which was still wet with varnish on 11 May 1610 when Lanfranco Massa, the agent of Prince Marcantonio Doria in Naples, wrote his patron about the painting (Pacelli, 1980). Massa relates that he wanted to send the *St. Ursula* to Genoa that week, and in order to dry it he had put it out in the sun on the previous afternoon, Caravaggio having applied the varnish quite thickly *("per darcela il Caravaggio assai grossa")*. Massa also proposed talking to Caravaggio about the painting in order to avoid damage in transit. He later mentions that Car[avaggio?] is "as I know, a friend" of the prince's, which seems to have been information from Caravaggio. It links up with the report of a loggia in Genoa (actually Sampierdarena) that Prince Doria had wanted Caravaggio to paint in 1605 (see p. 197, n. 20). Further, see Pacelli-Bologna (1980, esp. p. 27).

The canvas bears inscriptions on the back: *"M.A.D."* and *"Michelangelo di Caravaggio 1616"* (Bologna, 1980, p. 35 and figs. 10a, 10b). The painting appears in an inventory of 1620, without the painter's name, as *"Santa Orsola confitta dal Tiranno"* (Pacelli, p. 28). In Doria's will of 19 October 1651 the painting is mentioned as *"Sant'Orsola di Michel'Angelo da Caravaggio,"* and it is continuously documented in the Doria collections until 1854/55. (Photo: Courtesy Vincenzo Pacelli)

172. *Sleeping Cupid.* Florence, Galleria Palatina, Palazzo Pitti. 72 × 105. (M.77.) Painted on Malta in 1608, according to an old inscription on the back: *"Michelangelo Merisi de Caravaggio i*[n] *Malta 1608."* See S. Meloni Trkulja (*Paragone,* 331, 1977, pp. 46–50). The picture is very dark, with red highlights. The life-size child looks as much dead as asleep, its teeth showing like a *memento mori.*

173. *David with the Head of Goliath.* Galleria Borghese, no. 455. 125.5 × 99. (M.92: Naples, 1610.) A *David* by Caravaggio was being copied in Naples late in 1610 (Pacelli, 1977, p. 829, n. 35: two copies; he mentions a good replica still in Naples). In the Borghese collection by 1613 (Francucci, fol. 59v, lines 182 ff.; Della Pergola, II, 1959, pp. 79–80, no. 114: frame paid for in 1613, hence perhaps just acquired). Variously dated 1605/1606 or 1609/1610. Described in Manilli (1650, p. 67), who claims that in the head of Goliath, Caravaggio portrayed himself and that the David represents *"suo Caravaggino."* Bellori mentioned the painting among other works

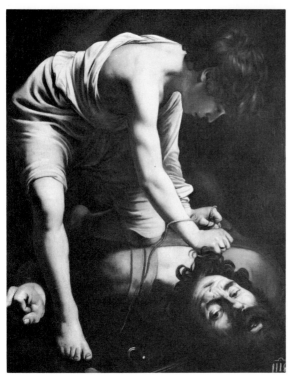

185. Caravaggio (?), *David*. Madrid, Prado.

it is in poor condition: David's right arm is invisible, as is the right side of his head; the ground shows through all over; folds of drapery can be seen through the sword at the bottom.

The identity of both figures has been debated: Röttgen (pp. 201–202) asserts that David is not *"il Caravaggino"* as Manilli had stated. Presumably Manilli did not mean Tommaso Donini, *"il Caravaggino"* (1601–1637), a minor painter whom Caravaggio could not have known (see F. D'Amico, *Bollettino d'arte,* LXIV, 3, 1979, p. 82). The self-portrait has also been doubted (De Logu). D. T. Kinkead (Salerno, 1966, p. 113) cited precedents in Solario and Lotto. Giorgione's *Self-Portrait as David* is mentioned by Vasari (ed. Milanesi, IV, pp. 93–94; ed. Barocchi, IV, 1, p. 43) and was known from engravings.

Enigmatic scratches on the upper blade of the sword have not been satisfactorily explained; readings of "H AS O" and "M AC O" have been proposed. Wagner interpreted the latter as a kind of signature (1958, p. 213, n. 517; cf. Marini, 1974, p. 459 H). Berenson and later writers compared the figure of David with a Lysippean or even earlier Greek type. (Photo: GFN E 59360)

Two other paintings of the subject have been ascribed to Caravaggio:

Prado, no. 65 [185]. 110 × 91. (M.34: 1599.) Cataloged by Spear as "Attributed to Caravaggio" (1971, p. 78, no. 19; cf. 1975, p. 227). Pérez Sánchez (1973, no. 3). See also the related *Narcissus* (Note 186). Moir (1976, pp. 138–139, n. 235) found the Prado painting to be closer to Caravaggio than the *Narcissus,* which he attributed to Manfredi. Cinotti (1973, no. 34) put the Prado picture just after the *Amor* [98]. For Gregori (1975, p. 30) the only question seems to be whether it is an original or a copy. I prefer to attribute it to a follower. Bissell (1981, nos. X–9 and X–18) tentatively attributes this to Orazio Gentileschi.

Vienna, Kunsthistorisches Museum, no. 482. Oil on wood, 95 × 165. (M.70: Naples, 1607.) Possibly to be equated with Bellori's citation of *"la mezza figura di Davide"* with the Conte di Villamediana (p. 214), which Moir (p. 138, n.

in the Borghese collection (p. 208, implying that Caravaggio had painted the pictures in 1605/1606 for the Borghese).

There are analogies with a number of earlier representations of David, Judith, Perseus, and even Michelangelo's *St. Bartholomew* [101]. Discussed by Röttgen (1974, pp. 201 ff., 210, 226–227) and dated by him 1609/1610. The drapery is of a type first evident in 1606 [130], and hence a Roman date is rather hard to sustain. But Frommel (1971a, pp. 52 ff.) dated it to 1605/1606 and considered the David the last in a series of portraits of a model used for the *St. John* [96], *Amor* [98], and other images of c. 1600/1603 and even later (see Notes 96, 98). Pacelli (1977, p. 829, n. 35), citing the copies made in Naples late in 1610, thought it was painted there during the first Neapolitan sojourn. He was contradicted by Bologna (Pacelli-Bologna, 1980, p. 41), who took the references to copies as evidence that the picture was new and about to be sent away.

235) interpreted as a reference to a copy, I think wrongly. Rejected by Mahon (1953, p. 213, n. 8). Accepted, oddly enough, by Nicolson (1979, p. 31) but doubted by Spear (1979, p. 318). A wholly unlikely original, beginning with the support, which has painted beneath the present surface a Mannerist *Venus and Mars:* Heinz, (1965, pp. 29–30). For Cinotti (1973, no. 56) a disconcerting work, perhaps *"à la manière de,"* and possibly by Gentileschi, as Wagner had also proposed. For Moir (p. 160, n. 280) a painting of high quality, not by Caravaggio, derived from [173]. Cinotti, Moir, and Spear all noted that it combines aspects of earlier and later works. I find it completely unacceptable; but Bologna (Pacelli-Bologna, 1980, p. 41) dates it to the first Neapolitan period without a qualm.

174. Michelangelo Buonarroti, *Pietà (The Deposition of Christ).* Florence, Museo dell'Opera del Duomo. c. 1547–1555. Discussed by Hibbard (1978/1979, pp. 280 ff.). See Liebert (1977, pp. 47–54).

175. Detail of [173]. (Photo: Arte Fotografica)

The following illustrations accompany the Notes to the Illustrations.

176. Giuseppe Cesari d'Arpino, Olgiati Chapel, Santa Prassede. Vault (detail). Fresco. Commissioned April 1587; painted c. 1593–1595 (Röttgen, 1973, pp. 29–30, 177). See p. 10. (Photo: GFN F 32336)

177. *Fortuneteller.* Pinacoteca Capitolina. See the note that follows Note 12, pp. 276–277. (Photo: GFN E 36606)

178. *Christ Crowned with Thorns.* Prato. 178 × 125. See Note 41, p. 291. (Photo: Courtesy Cassa di Risparmi e Depositi e Prato)

179. Michelangelo Buonarroti, *The Conversion of St. Paul.* Vatican City, Cappella Paolina. Fresco, 1542–1545. See p. 302 and Note 83.

180. Michelangelo Buonarroti (?), *Ganymede.* Fogg Art Museum, Harvard University, no. 1955.75. Black chalk on beige paper, 36.1 × 27.5. See p. 157 and Note 98). (Photo: Museum)

181. Cristofano Roncalli, *Entombment.* Chapel of Paolo Mattei, Santa Maria in Aracoeli. Fresco, 1585–1586. See Note 107, p. 314. (Photo: GFN E 48728)

182. Federico Barocci, *The Presentation of Mary in the Temple.* Santa Maria in Vallicella. 383 × 247. See Note 107, p. 315. (Photo: Villani 31527)

183. Annibale Carracci, *Landscape with St. Mary Magdalen.* Rome, Galleria Doria-Pamphilj. 51.5 × 67. Dated c. 1597 by Denis Mahon, and now by M. Jaffé on the basis of new evidence (*Burlington Magazine,* CXXIII, 1981, pp. 88–91). Cf. Posner (1971, II, p. 55, no. 125). (Photo: Villani 23699)

184. Caravaggio (?), *The Flagellation of Christ.* Rouen, Musée. 134.5 × 174.5. See Note 145, p. 325. (Photo: Courtesy Richard Spear)

185. Caravaggio (?), *David.* Madrid, Prado. See Note 173, p. 332. (Photo: Museum)

Appendix I

Other Paintings Attributed to Caravaggio

The following paintings, attributed to Caravaggio by Nicolson (1979, pp. 31 ff.), are not discussed in the text of this book. Paintings considered by Nicolson to be lost or wrongly attributed to Caravaggio are chiefly omitted; the order is Nicolson's.

186. *Narcissus.* Galleria Nazionale, Palazzo Corsini. 110 × 92(?). (M.39: 1600.) Already attributed to Caravaggio in a text of 1645. Called badly preserved and of uncertain attribution by Nicolson (see my remarks on the Corsini

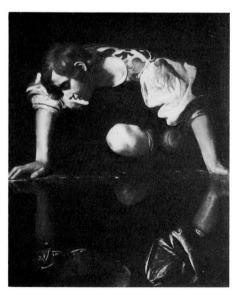

186. *Narcissus.* Galleria Corsini.

St. John in the note that follows Note 126, p. 320). Considered hard to judge by Cinotti (1973, no. 18), who dated it c. 1598/1599. Moir (1976, no. 116) tentatively suggested Manfredi (cf. his pp. 138–139, n. 235). He found similarities with the Prado *David* [185] (see the note that follows Note 173, p. 332), as had Spear (1971, p. 78, no. 19), who believed that the *David* "almost certainly is by the same hand as the *Narcissus* in Rome, but because that painting is equally problematic and in very bad condition, no attribution can rest on it." (Cf. Spear, 1975, p. 227.) The subject, supposedly autobiographical, has appealed to writers on Caravaggio despite the dubious condition of the canvas and its doubtful authorship. The painting has been almost impossible to see in recent years because of poor lighting conditions. Tentatively attributed to Gentileschi by Bissell (1981, X-19). (Photo: GFN E 34732)

187. *Jupiter, Neptune, and Pluto (The Sons of Chronos).* Casino Ludovisi (ex-Del Monte). Oil on plaster vault, 300 × 180. (M.R1: attributable to Antonio Pomarancio.) Cited by Bellori (pp. 214–215) toward the end of his *Life of Caravaggio* as a work attributed by some to Caravaggio. The iconography was discussed by N. C. Wallach

187. *Jupiter, Neptune, and Pluto.* Casino Ludovisi.

187a. Detail of [187].

188. *Agony of Christ in the Garden.* Destroyed.

(*Marsyas*, XVII, 1974–1975, pp. 12 ff.). The painting has affinities with Caravaggio's works of the mid or late 1590s and was accepted by Moir, Frommel (1971, p. 13), and Röttgen (1974, p. 198: to be dated after the *Luteplayer* [18] and before the *Boy Bitten* [25]). Nicolson labeled it "UU," or a wrong attribution, which is my own impression; but there are no secure points of comparison with other works because this is a ceiling painting.

The casino was sold by Del Monte to the Ludovisi in 1621 (Hibbard, 1971, p. 211).

(Photo: Courtesy Christoph Frommel)

David with the Head of Goliath [185]. See the note that follows Note 173, p. 332, and Note 186.

David with the Head of Goliath (Vienna). See pp. 332–333.

Christ with Sts. Peter and Andrew. See the note that follows Note 42, p. 294.

188. *The Agony of Christ in the Garden.* Formerly Berlin, Kaiser-Friedrich Museum, no. 359 (destroyed 1945). 154 × 222. (M.54: 1605.) From the Giustiniani collection (Salerno, 1960, p. 135: *palmi* 7 × 10, or 156.4 × 223.4 cm). Cinotti (1973, no. 40) dated it "c. 1603?" Moir (1976, no. 32; pp. 130–131, n. 213) placed it between the *Madonna dei Palafrenieri* [130] and the *Death of the Virgin* [133]. Difficult to accept with much enthusiasm from the photograph; it must nevertheless have been in some sense a Caravaggio of the later Roman period, perhaps drastically repainted. (Photo: Museum)

Christ Crowned with Thorns [178]. See the note that follows Note 41, p. 291.

189. *Ecce Homo.* Genoa, Palazzo Rosso. 128 × 103. (M.58: Rome, 1606.) G. B. Ciardi, Cigoli's nephew, wrote a biography of the painter that was sent to Baldinucci (published Florence, 1913; printed in Baldinucci, VII, pp. 40 ff.). Ciardi described a secret competition set up by a Monsignor Massimi between Passignano, Caravaggio, and Cigoli. Cigoli's picture pleased

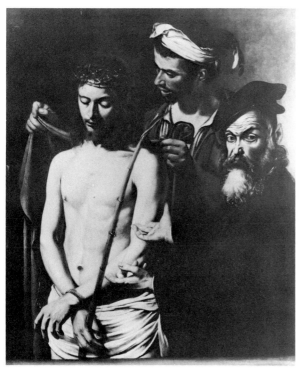

189. *Ecce Homo.* Genoa, Palazzo Rosso.

him most, and when Massimi went to Florence it was taken there and sold to the Severi (Baldinucci, VII, p. 56). That painting is still in Florence (Pitti; 175 × 135); the others are not necessarily recognizable (see *Mostra del Cigoli,* San Miniato, 1959, pp. 88–89, no. 33, *Tav. XXXII; others are illustrated on XXXIIa and b). Passignano's painting seems not to have survived, but M. L. Chappell (in Chappell et al., *Disegni dei toscani a Roma (1580–1620)*, Florence, 1979, pp. 175 ff.) cited a reference to a square *Ecce Homo* attributed to Passignano in the Barberini collection; its five and one-half *palmi* height made it the same height as this (cf. M. A. Lavin, 1975, p. 307, no. 319).

Bellori wrote (pp. 207–208) that Caravaggio's painting was taken to Spain; he mentioned it after the *Betrayal* [38] and before the Patrizi *Emmaus* [137] among the pictures done for private patrons. There is no reason to suppose that he knew it. A number of crude copies are or were in Sicily, which is perhaps where the painting was sent. This is presumably an original, for there are huge *pentimenti:* Christ's shoulder was originally higher and farther left; Pilate's left hand is greatly changed. (The right hand of the turbaned man is boneless.) Perhaps, however, it is merely extensively repainted by someone who tried to make a wreck into an acceptable picture (Pico Cellini's report on the restoration is in Marini, 1974, p. 413). Cinotti (1973, no. 51) and Marini give bibliography and opinions pro and con. Cinotti is dubious but thought that it was based on a prototype by Caravaggio of 1604/1605 (the three painters were together in Rome only in the spring and summer of 1604, though the commissions need not have been given out in person). Accepted by Moir (1976, no. 34 and pp. 131–132, n. 215). Called badly preserved and perhaps a copy by Nicolson. Spear (1979, p. 318) called it a "disagreeable painting" that could not be from the master's hand, which is my opinion.

The caricaturelike furrows on Pilate's forehead are like late Caravaggio; the hands and face are leathery, but the type itself is unknown in his *oeuvre.* Marini (p. 318, C 19) compared it to a portrait of Andrea Doria (illustrated). Since the painting, if by Caravaggio, would have to be dated c. 1605, and since he had dealings with Prince Marcantonio Doria when he was in Genoa in July/August of that year (see p. 196 and Note 171), the Doria "portrait" might be explained as a *jeu d'esprit* connected with that visit—but if so it makes no sense in a work for Monsignor Massimi. (Photo: Museum)

The Flagellation of Christ [184]. See the note that follows Note 145, p. 325.

190. *The Annunciation.* Nancy, Musée. 285 × 205. (M.86: Messina, 1609.) Supposedly a gift from Henry II of Lorraine (reigned 1608–1616). Cinotti (1973, no. 70) dated it to the end of Caravaggio's career, with the Borghese *David* [173]. The central part is grievously damaged (restored in Rome, 1969), and the present canvas is probably more than fifty percent restoration. Hence any attribution of this striking and appealing image is to be made with caution, and I have not seen it. I should like to attribute the original to Caravaggio in the late years. Moir (1976, no. 101 and p. 156, n. 272) suggested Valentin or a follower. Correspondence between Cardinal Federico Borromeo and the former Bishop of Toul (not of Nancy, which became a bishopric in 1777), discovered by Calvesi (1975, pp. 86 ff.), seems irrelevant. (Photo: ICR 10372)

Madonna and Child. Galleria Nazionale, Palazzo Corsini. 113 × 91. (M.R10, p. 300, attributed to Orazio Gentileschi.) See the note that follows Note 120, p. 319.

Holy Family. (Lost?) (M.71: Naples, 1607.) Cinotti (1973, no. 30: 1601) preferred the Berlin copy, Marini and Nicolson the version ex-Acquavella Galleries, New York. I am convinced that this attractive image does not derive from an original by Caravaggio. It was decisively rejected by Moir (1976, no. 104 and p. 157, n. 275): "The wistful sentimentality of the treatment of the subject suggests some not very stringent Caravaggist like Angelo Caroselli . . . ca. 1615."

191. *St. Francis in Meditation.* Formerly Carpineto Romano, San Pietro; now Palazzo Venezia. 123.8 × 93. See Note 30, p.287. A

190. *Annunciation.* Nancy, Musée.

191. *St. Francis in Meditation.* Palazzo Venezia.

better version of a painting in Santa Maria della Concezione (dei Cappucini). (M.89: Palermo? 1609, before 20 October.) Accepted by Nicolson; called "uneven" by Spear (1979, p. 318). I have not seen this version, but I doubt that the composition is by Caravaggio.

Penitent St. Francis. Cremona, Pinacoteca. (M.50: c.1603.) See Note 30. Treated with caution by Spear (1979, p. 318).

St. Isidore Agricola. (Lost?) (M.51: Ascoli Piceno? c. 1604.) A poor copy of a weak composition was connected by Marini with Caravaggio's brief sojourn in the Marches early in 1604 (see my p. 168). The attribution is based on a local legend, published in 1722, that concerns a lost painting in Ascoli. Yet Caravaggio went not to Ascoli but to Tolentino to paint a picture

for the Chiesa dei Cappuccini (del Crocefisso), which he evidently did not do. The *St. Isidore* has no apparent connection with him; since Isidore was canonized only in 1622, it is possible that the original image dates from that time rather than earlier, for he was not an Italian saint and local veneration in the Marches prior to his canonization is hardly likely.

St. John the Baptist Drinking at the Well. Valletta, heirs of V. Bonello. 100 × 73. (M.78: Malta, 1608.) Called "?Copy" by Nicolson, as well as "ruined." Spear (1979, p. 318) called it a disagreeable work, not by Caravaggio. I have not seen it, but I tend to agree.

St. John the Baptist. Toledo, Cathedral Sacristy. 169 × 112. (M.R11, pp. 300–301, attributed to B. Cavarozzi.) See the second note that follows Note 126, p. 320.

192. *Denial of St. Peter.* Switzerland, private collection.

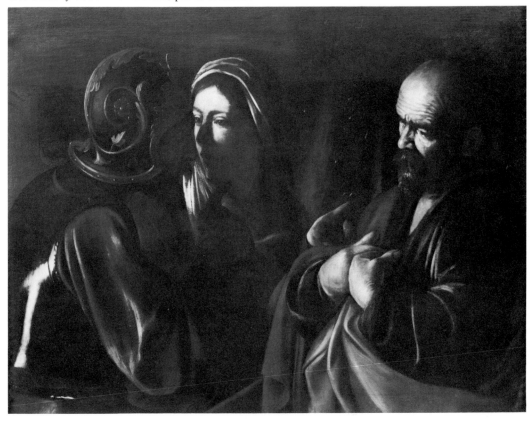

St. John the Baptist. Galleria Nazionale, Palazzo Corsini. 97 × 131.9. See Note 126, p. 320.

192. *The Denial of St. Peter.* Switzerland, private collection. 94 × 125.5. (M.66: Naples, 1607.) Bellori (p. 209) mentioned such a painting in Naples, but it was not this one, and the Naples picture is not by Caravaggio (cf. Moir, 1976, fig. 101 and pp. 48–49, n. 251). Gregori (1975, p. 47) wrote that the painting came from Naples. She placed it close in time to the *Annunciation* [190]. A painting of this subject was attributed to Caravaggio in a Medici inventory of 1624, listing works at Poggio Reale (Frommel, 1971, p. 9, n. 31). One such, 4 × 5 *palmi*, may have been in the Savelli collection in 1650 (Marini, 1978, p. 36, n. 4). Denis Mahon described the picture's restoration to me in 1977, speaking of it enthusiastically as a wonderful late work. Röttgen (1974, p. 202) thought that it was perhaps Caravaggio's last surviving painting. I accept the attribution; the date will now have to be judged by the dated *St. Ursula* of 1610 [171]. Since I have been unable to see either of them, I cannot comment. (Photo: Courtesy Herman Shickman)

Crucifixion of St. Peter. Leningrad, Hermitage. 232 × 201. (M.R2, p. 290, as Luca Saltarelli.) Sometimes thought to be the reflection or copy of a lost first version of [82]. See Cinotti (1971, p. 189, n. 315). A picture in the Giustiniani collection attributed to Saltarelli (Salerno, 1960, p. 94, no. 6), thought by Longhi and others to be the Leningrad picture, is not now believed to be identical with it. The genre-like treatment, more northern than Italian, and other disparities make it unlikely that this is even a reflection of the presumed first attempt at [82], if such a painting ever existed.

The Martyrdom of St. Sebastian. (Lost.) (M.69: Naples, 1607.) Cited by Bellori (p. 214) as one of Caravaggio's best works, taken to Paris. Sometimes identified with copies, one of which is illustrated by Marini; cf. Moir (1976, pp. 152–153, n. 257: possibly derived from a lost Saraceni).

193. *Portrait of Maffeo Barberini.* Florence, private collection.

193. *Portrait of Maffeo Barberini.* Florence, private collection. 124 × 90. (M.29: 1598/1599.) See p. 164. Called "?badly preserved" by Nicolson, "uncertain" by Spear (1979, p. 318). M. A. Lavin (*Burlington Magazine,* CIX, 1967, pp. 470–473) cited two portraits in a Barberini inventory of 1608, which may be paintings by Nicodemo Ferrucci; a payment for two portraits of Barberini by him, dating 3 July 1604, for a total of only 10 *scudi,* was published by C. D' Onofrio, *Roma vista da Roma* (Rome, 1967, pp. 61–62, and fig. 1). The portrait he illustrated is the one with the vase of flowers (cf. Note 18, p. 281). He assumes that the other one was this picture. But it seems unlikely that a painter (especially an unknown one) could produce two strikingly different portraits such as these; the payment should be compared with the 22 *scudi* that Mangone got for two painted copies in 1642 (Note 18). Presumably Ferrucci's two pictures were identical, and one was given away. Whether it was this one, or the one with the flowers, is impossible to guess. Cinotti (1973, no. 38) thought [93] not very Caravaggesque and possibly by Passignano. Frommel (1971, p. 20)

supported a date c. 1599; Lavin preferred 1598. Cf. Moir (1976, p. 155, n. 269). Mancini (p. 227, n.) added in the margin of his text: *"Fece ritratti per Barbarino,"* and he should have known, for he was physician to Urban VIII. Bellori's statement (p. 208) is quoted above, p. 164. I have not seen this painting. (Photo: Courtesy Francis Haskell)

Portrait of Sigismund Laire. Düsseldorf, Kunst-museum; formerly Berlin, Kaiser-Friedrich Museum, no. 354. 186 × 136. Attributed to Caravaggio in the Giustiniani inventory of 1638 (Salerno, 1960, p. 27 and fig. 30; p. 135, no. 6: *"Gismondo Todesco Pittore").* Moir (1976, p. 155, n. 265) calls the painting "clearly not by Caravaggio," which is what the reproductions proclaim. Attributed by Marini (1974, "appendix 4" insert) to the young Ribera.

Portrait of a Maltese Knight. Florence, Pitti. 72 × 105. (M.79 and plate IV.) See the note that follows Note 151, p. 327.

194. *Portrait of Pope Paul V.* Palazzo Borghese. 203 × 119. (M.53: 1605, after 16 May.) Bellori (p. 208) reported that after Cardinal Borghese began to patronize Caravaggio he introduced him to the pope, and Caravaggio painted him seated. A portrait of Paul V was attributed to Caravaggio by Manilli (1650, p. 77). Francucci (1613, fol. 137, lines 477 ff.) mentioned a portrait but not Caravaggio; the inventory of Marcantonio Borghese's effects in 1616 included two seated portraits, unattributed and without dimensions (Archivio Segreto Vaticano, *Fondo Borghese,* IV, 73 bis, fols. 122v and 125).

The painting in the Palazzo Borghese has often been doubted. Mahon (1953, p. 213, n. 8), judging from a reproduction, called it "far from easy to reconcile with Caravaggio's style . . . during the very short period when he was in a position to make such a portrait." I have not seen it since 1956. Marini's large details show a work of some quality but not necessarily by Caravaggio. Cinotti was also dubious (1973, no. 51). Moir (1976, pp. 155–156, n. 270) called it "rather inept" and possibly a replica of a lost original. But there is no reason for an original to have been lost, given the continuous history of the

194. *Portrait of Pope Paul V.* Palazzo Borghese.

family, the collection, and the palace. (Photo: GFN E 13950)

Gypsy Fortuneteller [177]. Pinacoteca Capitolina. See the note that follows Note 12, pp. 276–277.

The Tooth Extractor. Published by Gregori (1975, pp. 42 ff.) and dated c. 1607/1610. Nicolson called it "ruined" and of "uncertain attribution." The photographs show figures engaged in an animated genre scene that is wholly unlike any of Caravaggio's known works. The attribution gains what credence it has from Scannelli (1657, p. 199), who reported having seen such a painting years before in the Medici collection in Florence. Rejected, I think correctly, by Bologna (Pacelli-Bologna, 1980, p. 41).

Boy with a Carafe of Roses. (Lost?) (M.6: 1593.) See the note that follows Note 25, p. 284.

Appendix II

Old Reports About Caravaggio, in the Original and in Translation

The texts that follow are the basic early writings concerning Caravaggio, ranging from Van Mander's short notice published in 1604 to Susinno's manuscript *Life* dated 1724. (A few other references to Caravaggio from contemporary sources can be found in the footnotes and in the Notes to the Illustrations; they include Agucchi, Carducho, Pacheco, Bernini-Chantelou, etc.) The first important attempt to collect all these references was made by Roberto Longhi (1951). Cinotti (1971) printed many texts in Italian (pp. 164 ff., FF 109–130, including the poems based on paintings by Caravaggio by Murtola, Marino, and others). The translations are mine. I am indebted to Darma Beck for a great deal of help with those from Italian, and to J. W. Smit for helpful suggestions for translating Van Mander.

1. CAREL VAN MANDER

Van Mander (1548–1606), born in Flanders, was in Italy from 1573 to 1577 and settled in Haarlem in 1583. He was the first Netherlandish theoretician of art and made an effort to collect accurate biographical material about painters from his native land. He also wrote lives of Italian artists, including the earliest coherent notice of Caravaggio, in "Het Leven der Moderne oft dees-tejtsche doorluchtighe Italiaensche Schilders . . . Het tweedde Boeck van het Leven der Schilders," which forms Part III of *Het Schilder-Boeck* . . . (Haarlem, 1604, 191 r). Van Mander's manuscript is dated Alkmaar, 1603, which gives the latest date for his information. See Helen Noë, *Carel van Mander en Italië* (The Hague, 1954; Caravaggio's *Life* is on her pp. 292–294). The reference to paintings in San Lorenzo in Damaso by Giuseppe Cesari seems to be correct; but the story of Caravaggio's dwarf nearby is erroneous. It may signal a confusion with the frescoes by Cesari in the Contarelli Chapel, San Luigi dei Francesi, where Caravaggio added side paintings that were unveiled in July 1600.

Der is oock eenen *Michael Agnolo* van *Cara-* 191
vaggio, die te Room wonderlijcke dinghen doet:
hy is oock ghelijck den *Ioseph* voor verhaelt/ uyt
der armoede op gheclommen door vlijt/ cloeck
en stoutlijck alles aenvattende/ en aennemende/
ghelijck eenighe doen/ die niet en willen door
blooheyt oft cleenherticheyt t'onder blijven:
maer vrymoedigh/ en onbeschroemt hun selven
voort doen/ *en hun voordeel over al stoutlijck ver-*
soecken / t'welck doch alst eerlijck/ op taemlijcke
wijse/ met beleeftheyt toegaet/ niet te mis-
prijsen is: want t'gheluck wilt hem selven van
t'self ons dickwils so niet aenbieden/ het moet
somtijts van ons ghetenteert/ aengheport/ en
versocht wesen. Desen *Michael Agnolo* dan heeft
alree met zijn wercken groot gherucht/ eere/ en
naem gecreghen. Hy heeft ghedaen een Historie
tot *S. Laurens in Damas,* neffens die van *Iosepino,*
daer in zijn leven van verhaelt is: hier in heeft hy
gemaect een Naenken/ oft Reusken/ dat nae
Iosephs Historie toe siende de tongh uyt steeckt/
schijnende of hy aldus *Iosephs* werck wilde be-
spotten: want hy is een die van geen Meesters
dinghen veel houdt: doch sy selven niet opent-
lijck prijsende. Dan zijn segghen is/ dat alle
dinghen niet dan *Bagatelli,* kinderwerck/ oft
bueselinghen zijn/ t'zy wat/ oft van wien ghe-
schildert/ soo sy niet nae t'leven ghedaen/ en
gheschildert en zijn/ en datter niet goet/ oft
beter en can wesen/ dan de Natuere te volghen.
Alsoo dat hy niet eenen enckelen treck en dest/
oft hy en sittet vlack nae t'leven/ en copieert/
end' en schildert. Dit en is doch geene[n] quaden
wegh/ om tot goeden eyndt te comen: want nae
Teyckeninghe (of sy schoon nae t'leven comt) te
schilderen/ is so ghewis niet/ als t'leven voor
hebben/ en de Natuere met al haer verscheyden
verwen te volgen: doch behoefde men eerst so
verre gecomen te wesen in verstandt/ dat men t'
schoonste leven uyt t'schoon onderscheyde[n] en
uyt te kiesen wist. Nu isser neffens dit Cooren
weder dit Kaf/ dat hy niet stadigh hem ter studie
en begheeft/ maer hebbende een veerthien
daghen ghewrocht/ gaet hy der twee/ oft een
maendt teghen wandelen/ met t'Rapier op t'sij-
de/ met een knecht achter hem/ van d'een
Kaetsbaen in d'ander/ seer gheneghen tot

There is also a certain Michelangelo da Cara-
vaggio, who is doing extraordinary things in
Rome; like Giuseppe [Cesari d'Arpino] previ-
ously mentioned, he has climbed up from pov-
erty through hard work and by taking on every-
thing with foresight and courage, as some do
who will not be held back by faint-heartedness
or lack of courage, but who push themselves
forward boldly and fearlessly and who every-
where seek their advantage boldly. This enter-
prise deserves no blame if it is undertaken with
honest propriety and discretion, for Lady Luck
will rarely come to those who do not help them-
selves, and usually we must seek her out and prod
her on. This Michelangelo has already [overcome
adversity to] earn reputation, a good name, and
honor with his works. He painted a history in
San Lorenzo in Damaso, next to one by Giu-
seppe, as described in his Life. In it he painted
a dwarf or midget who sticks out his tongue at
Giuseppe's painting, making it seem as if in this
way he wanted to ridicule Giuseppe's work: he
is one who thinks little of the works of other
masters, but will not openly praise his own. His
belief is that all art is nothing but a bagatelle or
children's work, whatever it is and whoever it is
by, unless it is done after life, and that we can do
no better than to follow Nature. Therefore he
will not make a single brushstroke without the
close study of life, which he copies and paints.
This is surely no bad way of achieving a good
end: for to paint after drawing, however close it
may be to life, is not as good as following Nature
with all her various colors. Of course one should
have achieved a degree of understanding that
would allow one to distinguish the most beauti-
ful of life's beauties and select it. But one must
also take the chaff with the grain: thus, he does
not study his art constantly, so that after two
weeks of work he will sally forth for two
months together with his rapier at his side and his
servant-boy after him, going from one tennis
court to another, always ready to argue or fight,
so that he is impossible to get along with. This
is totally foreign to Art; for Mars and Minerva
have never been good friends. Yet as for his
painting, it is very delightful and an exception-

vechten en krackeelen wesende/ soo dat het seldtsaem met hem om te gaen is. Welcke dingen onse Const heel niet en gelijcke[n]: want *Mars* en *Minerva* zijn doch noyt de beste vrienden gheweest: dan soo veel zijn handelinghe belangt/ die is sulcx/ datse bevallijck seer is/ en een wonder fraey maniere/ om de Schilder-jeught nae te volgen/ Corrigenda: is mij qualijck bericht/ dat 300 Michel Agnolo Caravaggio door zijn gheschildert Reusken de dingen van Ioseppijn bespot.

ally beautiful style, one for our young artists to follow.

Appendix attached to a later edition: I have been misinformed that Michelangelo Caravaggio made fun of the work of Giuseppino by painting that dwarf.

2. VINCENZO GIUSTINIANI

Marchese Vincenzo Giustiniani, Letter to Teodoro [Dirck van] Amayden. Undated. First published 1675; republished in *Raccolta di lettere . . . ,* ed. G. Bottari (VI, Rome, 1768, pp. 248–253), and by Bottari & Ticozzi, *Raccolta di lettere . . .* (VI, Milan, 1822, pp. 121–129). For possible textual emendations, see Longhi (1951, p. 50, with earlier references). Translated by Enggass (Enggass-Brown, 1970, pp. 16 ff.). The letter is often dated c. 1620–1630 (Giustiniani died in 1637), but Haskell (1963; 1980, p. 94, n. 3) concluded that it dates from well before 1620. The only real clues are the citations of artists, and the more prominent artists of the 1620s are all omitted. The original versions (followed by Cinotti and Enggass) mention "Romanelli" (c. 1610–1662), who is wholly out of place. Longhi substituted "il Pomarancio," the nickname of Cristofano Roncalli; since Giustiniani traveled with him in 1606 (see Banti, 1942), his name makes good sense (though "Roncalli" seems a more likely correction for "Romanelli" than does "Pomarancio"). The names that date the letter latest are presumably those of Jusepe de Ribera, Hendrick Terbrugghen, Gerrit van Honthorst, and Dirck van Baburen, all Caravaggisti known in Rome in the period c. 1615. Terbrugghen, who was back in Utrecht in 1614, was not particularly known in Rome (he was not mentioned by Mancini), and his being mentioned by Giustiniani could point to a rather later date; Terbrugghen might have returned c. 1620/1621, but we do not know. Ribera was in Rome in 1615 and received loquacious notice from Mancini soon afterward (I, pp. 249–251). Giustiniani may have become an enthusiast by this time; his inventory of 1638 lists thirteen canvases by Ribera. Giustiniani also had paintings by Honthorst and Baburen, who were in Rome until 1620/1621. Honthorst became prominent c. 1617 and was well known to Mancini; Mancini also knew works in progress by Baburen but did not get his name. As these painters were only coming into prominence c. 1619–1620, it would be odd if Giustiniani knew much about them before that time. Thus a date of c. 1620 might be about right for his famous letter, and it seems unlikely that it was written many years before that.

Had it been written in the mid 1620s or later it seems inconceivable that the prominent new artists (not including Romanelli) would have been altogether omitted: Pietro da Cortona, Poussin, Andrea Sacchi. Nevertheless the letter is not an anthology of artists; Giustiniani omits Lanfranco, for example, who was already famous in the second decade.

Quinto [modo], il saper ritrarre fiori, ed altre cose minute . . . e sopra a tutto vi si ricerca straordinaria pazienza; ed il Caravaggio disse, che tanta manifattura gli era a fare un quadro buono di fiori, come di figure.

.

Duodecimo modo, è il più perfetto di tutti; perché è più difficile, l'unire il modo decimo con l' undecimo già detti, cioè dipingere di maniera, e con l'esempio avanti del naturale, che così dipinsero gli eccellenti pittori della prima classe, noti al mondo; ed a' tempi nostri il Caravaggio, i Caracci, il Guido Reni, ed altri, tra i quali taluno ha premute più nel naturale che nella maniera, e taluno più nella maniera che nel naturale, senza però discostarsi dall'uno, né dall'altro modo di dipignere, premendo nel buon disegno, e vero colorito, e con dare i lumi propri e veri. [Text from Longhi, 1951, p. 50.]

The fifth method is to know how to portray flowers and other small things . . . and above all it requires great patience. Caravaggio said that it was as difficult for him to make a good painting of flowers as one of figures.

.

The twelfth method is the most perfect of all because it is the most difficult: to combine the tenth with the eleventh just described, namely, to paint with style, and with nature in front of one, as did the most excellent painters of the first rank, famous all over the world. And in our time Caravaggio, the Carracci, Guido Reni, and others, among whom some stressed naturalism more than style, others style more than naturalism, without however neglecting the one or the other, as well as insisting on good design, true coloration, and appropriate and realistic lighting.

3. GIULIO MANCINI

Giulio Mancini, *Considerazioni sulla pittura*. Manuscript of c. 1617–1621 with additions and corrections, published with critical apparatus by A. Marucchi (I, Rome, 1956) and with art-historical commentary by L. Salerno (II, 1957). See above, pp. 5, 7–10 and esp. n. 12. The marginal numbers refer to the pages of Marucchi's edition. I have omitted variants, cited in her notes; for those affecting Caravaggio, see p. 5, n. 6, and pp. 9–10, nn. 17–18. The passages concerning Caravaggio are reordered here to give first his biography and a few bits of incidental information, then two versions of Mancini's attempt to characterize the schools of Roman painting.

Di Michelangelo Merisi da Caravaggio 223
Deve molto questa nostra età a Michelangelo da Caravaggio, per il colorir che ha introdotto, seguito adesso assai communemente.

Questo nacque in Caravaggio d'assai

On Michelangelo Merisi da Caravaggio
Our times owe much to Michelangelo da Caravaggio for the method of painting he introduced, which is now quite widely followed.

He was born in Caravaggio of honorable

honorati cittadini, poichè il padre fu mastro di casa et architetto del Marchese di Caravaggio; studiò da fanciulezza per 4 o 6 anni in Milano con diligenza, ancorchè di quando in quando facesse qualche stravanganza causata da quel calor e spirito così grande.

Doppo se ne passò a Roma d'età incirca 20 224 anni dove, essendo poco provisto di denari, stette con Pandolfo Pucci da Recanati, benefitiato di S. Pietro, dove le conveniva andar per la parte et altri servitij non convenienti all'esser suo e, quel ch'è peggio, se la passava la sera con un'insalata quale li serviva per antipasto, pasto e pospasto e, come dice il caporale, per companatico e per stecco. Donde dopo alcuni mesi partitosi con poca sodisfattione, chiamò poi questo benifatio suo padrone monsignor Insalata.

In questo tempo fece per esso alcune copie di devotione che sono in Recanati e, per vendere, un putto che piange per esser stato morso da un racano che tiene in mano, e dopo pur un putto che mondava una pera con il cortello, et il ritratto d'un hoste dove si ricoverava; et un ritratto di un. . . .

Fra tanto fu assalito da una malatia che, trovandolo senza denari, fu necessitato andarsene allo Spedal della Consolatione, dove nella convalescenza fece molti quadri per il priore che se li portò in Sivilia sua patria.

Doppo mi vien detto che stesse in casa del cavalier Giuseppe e di monsignor Fantin Petrignani che li dava commodità d'una stanza. Nel qual tempo fece molti quadri et in particolare una zingara che dà la bona ventura ad un giovanetto, la Madonna che va in Egitto, la Madalena Convertita, un S. Gio. Evangelista.

E dopo il Christo Deposto nella Chiesa Nova, li quadri di S. Luigi, la Morte della Madonna nella Scala, che l'ha adesso il Serenissimo di Mantova, fatta levar di detta chiesa da quei padri perchè in persona della Madonna havea ritratto una cortigiana, la Madonna di Loreto in S. Agostino, quella dell'altar de' Palafrenieri in S. Pietro, molti quadri che possiede l'illustrissimo Borghese, al Popolo la Cappella del Cerasi, molti 225

citizens since his father was majordomo and architect to the Marchese of Caravaggio. At a young age he studied diligently for four or six years in Milan, though now and again he would do some outrageous thing because of his hot nature and high spirits.

At the age of about twenty he moved to Rome where, since he had no money, he lived with Pandolfo Pucci from Recanati, a beneficiary of St. Peter's, because he was able to work for his room by doing unpleasant work. Worse, he was given nothing but salad to eat in the evening, which served as appetizer, entrée, and dessert—as the corporal says, as accompaniment and toothpick. After a few months he left with little recompense, calling his benefactor and master "Monsignor Salad."

During his stay he painted some copies of devotional images that are now in Recanati. He painted for sale a boy who cries out because he has been bitten by a lizard that he holds in his hand, and then he painted another boy who is peeling a pear with a knife, and a portrait of an innkeeper who had given him lodgings, and the portrait of [missing].

In the meantime he was struck by sickness and, being without money, was obliged to enter the hospital of the Consolazione, where during his convalescence he made many pictures for the prior, who brought them to Seville, his home.

Afterward, I have been told, he stayed with Cavalier Giuseppe [Cesari d'Arpino] and Monsignor Fantin Petrignani, who gave him the comfort of a room in which to live. During that period he painted many pictures, and in particular a Gypsy who tells a young man his fortune, the Flight into Egypt, the Penitent Magdalen, a St. John the Evangelist.

These were followed by the Deposition of Christ in the Chiesa Nuova, the pictures in San Luigi, the Death of the Virgin for Santa Maria della Scala, which the Duke of Mantua now has since the fathers of that church had it removed because Caravaggio portrayed a courtesan as the Virgin; the Madonna of Loreto in Sant'Agostino, and the Madonna for the altar of the Palafrenieri in St. Peter's. He also did many paintings now

quadri privati in casa Mattei, Giustiniani e Sennesio.

In ultimo, per alcuni eventi—che corse pericolo di vita che, per salvarsi, aiutato da Onorio Longo, ammazzò l'inimico—fu necessitato fuggirsi di Roma, e di primo salto fu in Zagarola, ivi trattenuto secretamente da quel Prencipe, dove fece una Madalena e Christo che va in Emaus che lo comprò in Roma il Costa.

Che con questi denari se ne passò a Napoli dove operò alcune cose.

E di lì se ne passò a Malta dove condusse alcune opere con gusto del Gran Mastro, che in segno di honore (come dicano), gli dette l'habito di sua religione. Donde partitosi con speranza di rimettersi, viene a Portercole dove, soprapreso da febre maligna, in colmo di sua gloria, che era d'età di 35 in 40 anni, morse di stento e senza cura et in un luogo ivi vicino fu sepellito.

Non si puol negare che per una figura sola, per le teste e colorito non sia arrivato ad un gran segno e che la profession di questo secolo non li sia molto obligata. Ma questo suo gran saper d'arte l'haveva accompagnato con una stravaganza de costumi, perchè haveva un unico fratello, sacerdote, huomo di lettere e bon costumi, qual, sentendo i gridi del fratello, gli venne voglia di vederlo, e mosso da fraterno amore se ne viene a Roma, e sapendo che era trattenuto in casa dell' illustrissimo cardinal Del Monte et il stravagante modo del fratello, pensò esser bene di far prima motto all'illustrissimo Cardinale et esporli il tutto come fece: hebbe bonissime parole, che tornasse fra tre giorni. Obbedisce. Fra tanto il Cardinale chiama Michelangelo, gli dimanda se ha parenti; gli risponde che no; nè potendo credere che quel sacerdote gli dicesse bugia in cosa che si poteva ritrovare e che non gli risultava utile, perciò fra tanto fa cercare fra paesani se Michelangelo havesse fratelli e chi, e trovò che la bestialità era da parte di Michelangelo. Torna il prete doppo i tre giorni, e trattenuto dal Car-

owned by the most illustrious [Cardinal Scipione] Borghese, the Cerasi Chapel in Santa Maria del Popolo, and many paintings privately owned by the Mattei, the Giustiniani, and the Sannesio.

Finally, as a result of certain events he almost lost his life, and in defending himself Caravaggio killed his foe with the help of his friend Onorio Longhi and was forced to leave Rome. He first reached Zagarolo where he was secretly housed by the Prince. There he painted a Magdalen and a Christ going to Emmaus, which was bought by Costa in Rome.

With these earnings he moved on to Naples, where he painted various works.

From there he went to Malta, where he did some paintings that pleased the Grand Master, who as a token of his appreciation (it is said) gave him the Cloak of his Order. Caravaggio left Malta with the hope of being pardoned, but at Port' Ercole he was stricken by a malignant fever and there, between thirty-five and forty years of age, at the height of his success, he died of privation without any help, and was buried nearby.

It cannot be denied that for single figures, heads, and coloration he attained a high point, and that the artists of our century are much indebted to him. But his great knowledge of art went together with extravagance of behavior. Caravaggio had an only brother, a priest, a man of letters and of high morals who, when he heard of his brother's fame, wanted to see him and, filled with brotherly love, arrived in Rome. He knew that his brother was staying with Cardinal Del Monte, and being aware of his brother's eccentricities, he thought it best to speak first to the Cardinal, and explain everything to him, 226 which he did. He was well received by the Cardinal, who asked him to return in three days. He did so. In the meantime, the Cardinal called Michelangelo and asked him if he had any relatives; he answered that he did not. Unwilling to believe that the priest would tell him a lie about a matter that could be checked, and that would do him no good, he asked among Caravaggio's compatriots whether he had brothers, and who they were, and so discovered that it was Cara-

dinale fa chiamar Michelangelo, e mostrandoli il fratello, disse che non lo conosceva nè essergli fratello. Onde il povero prete, intenerito, alla presenza del Cardinale, gli disse: "Fratello io son venuto tanto da lontano sol per vedervi, et havendovi visto ho ottenuto quello che desiderava, essendo io in stato, per gratia di Dio, come sapete, che non ho bisogno di voi nè per me nè per i miei figli, ma si ben per i vostri, se Dio m'havesse concesso gratia di farvi accompagnare e vedervi successione. Dio vi dia da far bene come io ne' miei sacrificij pregarò Sua Divina Maestà et il medesimo so che farà vostra sorella nelle sue pudiche e verginali orationi." Nè si movendo Michelangelo a queste parole di ardente e scintillante amore, si partì il buon sacerdote senza haver dal fratello un buon viaggio a Dio. Onde non si può negare che non fusse stravagantissimo, e con queste sue stravaganze non si sia tolto qualche dicina d'anni di vita et minuitasi in parte la gloria acquistata con la professione: e col viver si sarebbe agumentato con grand'utile de' studiosi di simil professione.

vaggio who had lied. After three days the priest returned and was received by the Cardinal, who sent for Michelangelo. At the sight of his brother he declared that he did not know him and that he was not his brother. So, in the presence of the Cardinal, the poor priest said tenderly: "Brother, I have come from far away to see you, and thus I have fulfilled my desire; as you know, in my situation, thank God, I do not need you for myself or for my children, but rather for your own children if God will give you the blessing of marriage and see to your succession. I hope God will do you good as I will pray to His Divine Majesty during my services, as will be done by your sister in her virginal and chaste prayers." But Michelangelo was not moved by his brother's ardent and stimulating words of love, and so the good priest left without even a goodbye. Thus one cannot deny that Caravaggio was a very odd person, and that his eccentricities served to shorten his life by at least ten years and somewhat diminished the fame he had acquired through his profession. Had he lived longer he would have grown, to the great benefit of students of art.

. . . come ancor un povero huomo a tempo 140 di suo bisogno vender una pittura a molto minor prezzo di quel che haveva trovato altre volte, lasciando la fama, come si vedde nel Caravaggio che vendè il Putto Morso dal Racano per quindici giulij, la Zingara per otto scudi. . . .

. . . when a poor painter needs to sell a picture at a lower price than he had done in previous times, he loses his reputation as indeed Caravaggio did when he sold the Boy Bitten by a Lizard for fifteen *giuli,* and the Gypsy for eight *scudi.* . . .

Et avanti che si vada più oltre, si deve 120 considerar il costume delle figure che habbin quell'esser proprio in effigie, affetto et operatione, con la quale vogliamo esprimere una persona che facci quella tal operatione. E di qui si puol vedere quanto che alcuni di moderni faccin male, quali, per descriver una Vergine e Nostra Donna, vanno retrahendo qualche meretrice sozza delli ortacci, come faceva Michelangelo da Caravaggio e fece nel Transito di Nostra Donna, in quel quadro della Madonna della Scala, che per tal rispetto quei buoni padri non lo volsero e forsi quel poverello patì tanti travagli di sua vita. . . .

Before going further, we must consider the aspects of figures in order that they look appropriate, with expression and movement such as will portray a person in a particular activity. As a result we can comprehend how poorly some modern artists paint. For example, when they wish to portray the Virgin Our Lady they depict some dirty prostitute from the Ortaccio, as Michelangelo da Caravaggio did when he portrayed the Death of the Virgin in the picture of the Madonna della Scala, which the good Fathers rejected for that reason and perhaps consequently Caravaggio suffered so much trouble during his lifetime. . . .

... essendo già venuti al secolo de' viventi, 108 per poterli meglio considerare si devon propor alcune cose che sono le seguenti, cioè:

Che questi viventi si reducono a quattro ordini, classe o ver vogliam dire schole, una delle quali è quella del Caravagio, assai seguita, camminando per essa con fine, diligentia e sapere Bartolomeo Manfredi, lo Spagnoletto, Francesco detto Cecco del Caravagio, lo Spadarino et in parte Carlo Venetiano. Proprio di questa schola è di lumeggiar con lume unito che venghi d'alto senza reflessi, come sarebbe in una stanza da una fenestra con le pariete colorite di negro, che così, havendo i chiari e l'ombre molto chiare e molto oscure, vengono a dar rilievo alla pittura, ma però con modo non naturale, nè fatto, nè pensato da altro secolo o pittori più antichi, come Raffaelo, Titiano, Correggio et altri. Questa schola in questo modo d'operare è molto osservante del vero, che sempre lo tien davanti mentre ch'opera; fa bene una figura sola, ma nella compositione dell'historia et esplicar affetto, pendendo questo dall'immagination e non dall'osservanza della cosa, per ritrar il vero che tengon sempre avanti, non mi par che vi vagliano, essendo impossibil di mettere in una stanza una moltitudine d'huomini 109 che rappresentin l'historia con quel lume d'una fenestra sola, et haver un che rida o pianga o faccia atto di camminare e stia fermo per lasciarsi copiare, e così poi le lor figure, ancorchè habbin forza, mancano di moto e d'affetti, di gratia, che sta in quell'atto d'operare come si dirà. E di questa schuola non credo forsi che se sia visto cosa con più gratia e affetto che quella zingara che dà la buona ventura a quel giovenetto, mano del Caravaggio, che possiede il signor Alessandro Vittrici, gentilhuomo qui di Roma, che, ancorchè sia per questa strada, nondimeno la zingaretta mostra la sua furbaria con un riso finto nel levar l'anello al giovanotto, et questo la sua semplicità et affetto di libidine verso la vaghezza della zingaretta che le dà la ventura e le leva l'anello.

... now that we have reached the century of living artists, I should like to propose the following ideas in order to examine them, namely:

That these living painters be divided into four categories or classes, or better, schools, one of which is that of Caravaggio, which had a wide following and was taken up with vigor and knowledge by Bartolomeo Manfredi, Spagnoletto [Giuseppe Ribera], Francesco called also Cecco del Caravaggio, Spadarino [Giacomo Galli], and partially by Carlo [Saraceni] Veneziano. A characteristic of this school is lighting from one source only, which beams down without reflections, as would occur in a very dark room with one window and the walls painted black, and thus with the light very strong and the shadows very deep, they give powerful relief to the painting, but in an unnatural way, something that was never thought of or done before by any other painter like Raphael, Titian, Correggio, or others. This school, working in this way, is closely tied to nature, which is always before their eyes as they work. It succeeds well with one figure alone, but in narrative compositions and in the interpretation of feelings, which are based on imagination and not direct observation of things, mere copying does not seem to me to be satisfactory, since it is impossible to put in one room a multitude of people acting out the story, with that light coming in from a single window, having to laugh or cry or pretending to walk while having to stay still in order to be copied. As a result the figures, though they look forceful, lack movement, expression, and grace, as is the case with this style, as we shall see. Of this school I do not think that I have seen a more graceful and expressive figure than the Gypsy who foretells good fortune to a young man, by Caravaggio, a picture owned by Signor Alessandro Vittrici, a gentleman of Rome. Here too, while using the same method, nonetheless he shows the Gypsy's slyness with a false smile as she takes the ring of the young man, who shows his naiveté and the effects of his amorous response to the beauty of the little Gypsy who tells his fortune and steals his ring.

(Le quattro scuole dei pittori viventi)

A questo secolo succede quello di modernissimi, quali mi pare si deva preferire al secolo che successe al perfetto per l'intelligenza, per il modo e forza del colorire, per i paesacci et per le prospettive. Et tutto questo secolo mi pare che si reduchi a quattro scuole, poichè in esso pare che si trovino quattro varietà di dipingere.

La prima diremo esser quella de' Caracci.

. . .

La seconda parmi che si deva metter quella 303 di Michelangelo da Caravaggio, il quale ha molta forza et è di bonissimo colorito. Di questo si vedono molte cose: il Deposto di Croce nella Chiesa Nuova, la Madonna dell'Horto in S. Agostino, la cappella di S. Matteo in San Luigi de' Franzesi, et molti quadri privati et in particolare in casa del signor marchese Giustiniano e del signor Alessandro Vitrice; nella Madonna della Scala quella a man dritta, et a Monte Cavallo molte cose nella sala avanti la cappella, con infiniti altri quadri particolari che sono in case particolari. Et questa in questo secolo è molto seguita et abbracciata et è proprio di questa una certa naturalità.

La terza è quella del cavalier Gioseppe.

. . .

302 *(The four schools of living painters)*

In the present century there followed the most modern painters, who it seems to me achieved perfection through intelligence, style, and force of coloring, in landscapes and in perspectives. Our century can be divided into four schools that represent four different styles of painting.

The first should be that of the Carracci.

. . .

The second school is that of Michelangelo da Caravaggio, which is forceful and excellently colored. There are many works by him: the Deposition from the Cross in the Chiesa Nuova, the Madonna dell'Horto [*sic*] in Sant'Agostino, the chapel of St. Matthew in the church of San Luigi dei Francesi, and many privately owned pictures, and in particular those in the house of Marchese Giustiniani and of Signor Alessandro Vittrici; on the right side in the church of the Madonna della Scala, and in Monte Cavallo there are many things in the room before the chapel [here he seems to be talking of paintings by Caravaggio's followers], and many other pictures in private houses. In this century it has been taken up and followed by many, and its characteristic is a certain naturalness.

The third school is that of Cavalier Gioseppe Cesari. . . .

4. GIOVANNI BAGLIONE

Giovanni Baglione, *Le vite de' pittori, scultori, et architetti* . . . (Rome, 1642, pp. 136–139). A photographic reprint (Rome, 1935, ed. V. Mariani) of a copy owned by Giovan Pietro Bellori shows his marginal notes *(postille)* as well as those by others, which are transcribed together with those from another annotated copy at the end of the book (cf. p. 113, n. 10 above). Baglione's final manuscript is apparently preserved in the Vatican Library (*Chig. G. VIII, 222*). It is written in a more direct way than the final printed version (cf. p. 170, n. 4, and p. 254, n. 14 above). The final version, according to Bellori's notes, was reworked by a literary man, Ottaviano Tronsarelli (pp. 1–2 of the reprint of 1935; for Tronsarelli, see reprint, p. ix ff., and Hibbard, 1971, p. 229).

A new edition of Baglione's *Lives* was projected by Jacob Hess in the 1930s and continued more recently by Herwarth Röttgen, so far with no result. Hess

postulated (1967, p. 231 and n. 1) that Baglione began writing his lives chronologically c. 1620, so that he got to Caravaggio c. 1625, but the internal evidence is not consistent (cf. my p. 55, n. 4; 163, n. 22; 272; and Notes 10 and 96).

La Vita di Michelagnolo da Caravaggio, Pittore 136 *The Life of Michelangelo da Caravaggio, Painter*

Nacque in Caravaggio di Lombardia Michelagnolo, e fu figliuolo d'un Maestro, che murava edificii, assai da bene, di casa Amerigi. Diedesi ad imparare la dipintura, e non havendo in Caravaggio, chi a suo modo gl'insegnasse, andò egli a Milano, & alcun tempo dimorovvi. Dapoi se ne venne à Roma con animo di apprender con diligenza questo virtuoso essercitio. E da principio si accomodò con un pittore Siciliano, che di opere grossolane tenea bottega.

Poi andò a stare in casa del Cavalier Gioseppe Cesari d'Arpino per alcuni mesi. Indi provò a stare da se stesso, e fece alcuni quadretti da lui nello specchio ritratti. Et il primo fu un Bacco con alcuni grappoli d'uve diverse, con gran diligenza fatte; ma di maniera un poco secca. Fece anche un fanciullo, che da una lucerta, la quale usciva da fiori, e da frutti, era morso; e parea quella testa veramente stridere, & il tutto con diligenza era lavorato. Pur non trovava a farne esito, e darli via, & a mal termine si ridusse senza danari, e pessimamente vestito sì, che alcuni galant'huomini della professione, per carità, l'andavano sollevando, infin che Maestro Valentino a s. Luigi de'Francesi rivenditore di quadri glie ne fece dar via alcuni; e con questa occasione fu conosciuto dal Cardinal del Monte, il quale per dilettarsi assai della pittura, se lo prese in casa, & havendo parte, e provisione pigliò animo, e credito, e dipinse per il Cardinale una musica di alcuni giovani ritratti dal naturale, assai bene; & anche un giovane, che sonava il Lauto, che vivo, e vero il tutto parea con una caraffa de fiori piena d'acqua, che dentro il reflesso d'una finestra eccellentemente si scorgeva con altri ripercotimenti di quella camera dentro l'acqua, e sopra quei fiori eravi una viva rugiada con ogni esquisita diligenza finta. E questo (disse) che fu il più bel pezzo, che facesse mai.[1]

Michelangelo, born in Caravaggio in Lombardy, was the son of a mason, quite well off, of the Merisi family. He decided to study painting and, because nobody was competent to teach him in Caravaggio, he moved to Milan and remained there for some time. Subsequently he went to Rome with the desire of learning this admirable discipline with diligence. In the beginning he settled down with a Sicilian painter who had a shop full of crude works of art.

Then he moved into the house of Cavalier Giuseppe Cesari d'Arpino for a few months. From there he tried to live by himself, and he painted some portraits of himself in the mirror. The first was a Bacchus with different bunches of grapes, painted with great care though a bit dry in style. He also painted a boy bitten by a lizard emerging from flowers and fruits; you could almost hear the boy scream, and it was all done meticulously.

Nevertheless he was unable to sell these works, and in a short time he found himself without money and poorly dressed. But some charitable gentlemen expert in the profession came to his aid, and finally Maestro Valentino, a dealer in paintings at San Luigi dei Francesi, managed to sell a few. This was the means by which he met Cardinal Del Monte, an art lover, who invited him to his home. In these quarters Michelangelo was given room and board, and soon he felt stimulated and confident. For Cardinal Del Monte he painted a Concert of Youths from nature, very well. He also painted a youth playing a lute, and everything seemed lively and real, such as the carafe of flowers filled with water, in which we see clearly the reflection of a window and other objects in the room, while on the petals of the flowers there are dewdrops imitated most exquisitely. And this picture (he said) was the best he had ever done.

Effigiò una Zinghera, che dava la ventura ad un giovane con bel colorito. Fece un'Amore divino, che sommetteva il profano. E parimente una testa di Medusa con capelli di vipere, assai spaventosa sopra una rotella rapportata, che dal Cardinale fu mandata in dono a Ferdinando gran Duca di Toscana.

Per opera del suo Cardinale hebbe in s. Luigi de'Francesi la cappella de'Contarelli, ove sopra l'altare fece il s. Mattheo con un'Angelo. A man diritta, quando l'Apostolo è chiamato dal Redentore, & a man manca, quando sù l'altare è 137 ferito dal carnefice con altre figure. La volta però della cappella è assai ben dipinta dal Cavalier Gioseppe Cesari d'Arpino.

Quest'opera, per havere alcune pitture del naturale, e per essere in compagnia d'altre fatte dal Cavalier Gioseppe, che con la sua virtù si haveva presso i professori qualche invidia acquistata, fece gioco alla fama del Caravaggio, & era da'maligni sommamente lodata.[2] Pur venendovi a vederla Federico Zucchero, mentre io era presente, disse, Che rumore è questo? e guardando il tutto diligentemente, soggiunse. Io non ci vedo altro, che il pensiero di Giorgione nella tavola del Santo, quando Christo il chiamò all'Apostolato; e sogghignando, e maravigliandosi di tanto rumore, voltò le spalle, & andossene con Dio.[3] Per il Marchese Vincenzo Giustiniani fece un Cupido a sedere dal naturale ritratto, ben colorito sì, che egli dell'opere del Caravaggio fuor de'termini invaghissi; & il quadro d'un certo s. Matteo, che prima havea fatto per quell'altare di s. Luigi, e non era a veruno piacciuto, egli per esser'opera di Michelagnolo, se'l prese; & in questa opinione entrò il Marchese per li gran schiamazzi, che del Caravaggio, da per tutto, faceva Prosperino delle grottesche, turcimanno di Michelagnolo, e mal'affetto co'l Cavalier Gioseppe. Anzi fe cadere al rumore anche il Signor Ciriaco Matthei, a cui il Caravaggio havea dipinto un s. Gio. Battista, e quando N. Signore andò in Emaus, & all'hora che s. Thomasso toccò co'l dito il costato del Salvadore; & intaccò quel Signore di molte centinaia di scudi.

Nella prima cappella della chiesa di s.

He portrayed a Gypsy predicting the future to a young man, with beautiful colors. He painted a Divine Love who subjugated the Profane. Similarly, he made a head of a terrifying Medusa with vipers for hair placed on a shield, which the Cardinal sent as a gift to Ferdinando, Grand Duke of Tuscany.

With the support of his Cardinal he got the commission for the Contarelli Chapel in San Luigi dei Francesi, where over the altar he painted St. Matthew with an angel. On the right side, the Calling of the Apostle by the Savior, and on the left the Saint is shown at the altar, wounded by the executioner, with other figures. The vault of the chapel, however, is quite well painted by Cavalier Giuseppe Cesari d'Arpino.

This commission with the paintings done after life, together with those of Cavalier Giuseppe, whose talent aroused a certain envy on the part of his colleagues, made Caravaggio famous, and the paintings were excessively praised by evil people. When Federico Zuccaro came to see this picture, while I was there, he exclaimed: "What is all the fuss about?" and, after having studied the entire work carefully, added: "I do not see anything here other than the style of Giorgione in the picture of the Saint when Christ calls him to the Apostolate"; and, sneering, astonished by such commotion, he turned his back and left. For Marchese Vincenzo Giustiniani he did a seated Cupid from life, so exquisitely painted that thereafter Giustiniani admired Caravaggio beyond reason; and a certain picture of St. Matthew, that he had first made for that altar in San Luigi, which pleased nobody, but because it was by Michelangelo, Giustiniani took it for himself. The Marchese had been put into this frame of mind as a result of the propaganda by Prosperino delle Grottesche, Caravaggio's henchman, who was hostile toward Cavalier Giuseppe. Moreover, Signor Ciriaco Mattei succumbed to the propaganda: for him Caravaggio had painted St. John the Baptist, the Lord going to Emmaus, and also St. Thomas who pokes his finger into the ribs of the Savior. Thus Caravaggio pocketed many hundred *scudi* from this gentleman.

In the first chapel on the left in the church

Agostino alla man manca fece una Madonna di Loreto ritratta dal naturale con due pellegrini, uno co'piedi fangosi, e l'altra con una cuffia sdrucita, e sudicia; e per queste leggierezze in riguardo delle parti, che una gran pittura haver dee, da popolani ne fu fatto estremo schiamazzo.

Nella Madonna del Popolo a man diritta dell'altar maggiore dentro la cappella de'Signori Cerasi sù i lati del muro sono di sua mano la Crocifissione di s. Pietro; E di rincontro ha la Conversione di s. Paolo. Questi quadri prima furono lavorati da lui in un'altra maniera, ma perche non piacquero al Padrone, se li prese il Cardinale Sannesio; e lo stesso Caravaggio vi fece questi, che hora si vedono, a olio dipinti, poiche egli non operava in altra maniera; e (per dir cosi) la Fortuna con la Fama il portava.

Nella Chiesa nuova alla man diritta v'è del suo nella seconda cappella il Christo morto, che lo vogliono sepellire con alcune figure, a olio lavorato; e questa dicono, che sia la migliore opera di lui.

Fece anch'egli in s. Pietro Vaticano una s. Anna con la Madonna, che ha il putto fra le sue gambe, che con il piede schiaccia la testa ad un serpe; opera da lui condotta per li Palafrenieri di palazzo; ma fu levata d'ordine de'Signori Cardinali della fabrica, e poi da'Palafrenieri donata al Cardinale Scipione Borghese.

Per la Madonna della Scala in Trastevere dipinse il transito di N. Donna, ma perche havea fatto con poco decoro la Madonna gonfia, e con gambe scoperte, fu levata via; e la comperò il Duca di Mantova, e la mise in Mantova nella sua nobilissima Galleria.

Colori una Giuditta, che taglia la testa ad Oloferne per li Signori Costi, e diversi quadri per altri, che per non stare in luoghi publici, io trapasso, e qualche cosa de'suoi costumi dispiego.

Michelagnolo Amerigi fu huomo Satirico, & altiero; ed usciva tal'hora a dir male di tutti li pittori passati, e presenti per insigni, che si fussero; poiche a lui parea d'haver solo con le sue opere avanzati tutti gli altri della sua profes-

of Sant'Agostino, he painted the Madonna of Loreto from life with two pilgrims; one of them has muddy feet and the other wears a soiled and torn cap; and because of this pettiness in the details of a grand painting the public made a great fuss over it.

In Santa Maria del Popolo on the right side of the high altar, in the chapel of the Cerasi family, above on the wall there are his Crucifixion of St. Peter and on the opposite side the Conversion of St. Paul. At first these two pictures had been painted in a different style, but because they did not please the patron, Cardinal Sannesio took them; in their place he painted the two oil paintings that can be seen there today, since he did not use any other medium. And—so to speak—Fortune and Fame carried him along.

In the Chiesa Nuova, on the right side in the second chapel, is his oil painting of the Dead Christ who is about to be buried, with other figures; and this work is said to be his best.

For St. Peter's in the Vatican, a St. Anne with the Madonna shows the Virgin holding the Child between her legs, with her foot crushing the serpent's head. This work was painted for the Grooms of the Palace; but it was removed on the orders of the Cardinals in charge of St. Peter's and subsequently given by the Palafrenieri to Cardinal Scipione Borghese.

For the Madonna della Scala in Trastevere Caravaggio painted the Death of the Virgin, but because he had portrayed the Virgin with little decorum, swollen and with bare legs, it was taken away; and the Duke of Mantua bought it and placed it in his noble Gallery.

For the Signori Costa he made a Judith who cuts off the head of Holofernes, and other pictures which I omit because they are not in public places, and instead I will discuss something about his habits.

Michelangelo Merisi was a satirical and proud man; at times he would speak badly of the painters of the past, and also of the present, no matter how distinguished they were, because he thought that he alone had surpassed all the other

sione. Anzi presso alcuni si stima, haver'esso rovinata la pittura; poiche molti giovani ad essempio di lui si danno ad imitare una testa del naturale, e non studiando ne'fondamenti del disegno, e della profondità dell'arte, solamente del colorito appagansi; onde non sanno mettere due figure insieme, nè tessere historia veruna, per non comprendere la bontà di sì nobil'arte.

Fu Michelagnolo, per soverchio ardimento di spiriti, un poco discolo, e tal'hora cercava occasione di fiaccarsi il collo, o di mettere a sbaraglio l'altrui vita. Pratticavano spesso in sua compagnia huomini anch'essi per natura brigosi: & ultimamente affrontatosi con Ranuccio Tomassoni giovane di molto garbo, per certa differenza di gioco di palla a corda, sfidaronsi, e venuti all'armi, caduto a terra Ranuccio, Michelagnolo gli tirò d'una punta, e nel pesce della coscia feritolo il diede a morte. Fuggirono tutti da Roma, e Michelagnolo andossene a Pelestrina, ove dipinse una s. Maria Maddalena. E d'indi giunse a Napoli, e quivi operò molte cose.

Poscia andossene a Malta, & introdotto a far riverenza al gran Maestro, fecegli il ritratto; onde quel Principe in segno di merito, dell'habito di s. Giovanni il regalò, e creollo Cavaliere di gratia. E quivi havendo non so che disparere con un Cavaliere di Giustitia, Michelagnolo gli fece non so che affronto, e però ne fu posto prigione, ma di notte tempo scalò le carceri, e se ne fuggi, & arrivato all'Isola di Sicilia operò alcune cose in Palermo; ma per esser perseguitato dal suo nemico, convennegli tornare alla Città di Napoli; e quivi ultimamente essendo da colui giunto, fu nel viso cosi fattamente ferito, che per li colpi quasi più non si riconosceva, e disperatosi della vendetta, con tutto che'egli vi si provasse, misesi in una felluca con alcune poche robe, per venirsene a Roma, tornando sotto la parola del Cardinal Gonzaga, che co'l Pontefice Paolo V. la sua rimissione trattava. Arrivato ch' egli fu nella spiaggia, fu in cambio fatto prigione, e posto dentro le carceri, ove per due giorni

artists in his profession. Moreover, some people thought that he had destroyed the art of painting; also, many young artists followed his example and painted heads from life, without studying the rudiments of design and the profundity of art, but were satisfied only with the colors; therefore these painters were not able to put two figures together, nor could they illustrate a history because they did not comprehend the value of so noble an art.

Because of his excessively fearless nature Michelangelo was quite a quarrelsome individual, and sometimes he looked for a chance to break his neck or jeopardize the life of another. Often he was found in the company of men who, like himself, were also belligerent. And finally he confronted Ranuccio Tomassoni, a very polite young man, over some disagreement about a tennis match. They argued and ended up fighting. Ranuccio fell to the ground after Michelangelo had wounded him in the thigh and then killed him. Everyone who was involved in this affair fled Rome and Michelangelo too went to Palestrina, where he painted a Mary Magdalen. From there he moved to Naples, where he also produced many paintings.

Then he went to Malta, where he was invited to pay his respects to the Grand Master and to make his portrait. Whereupon this Prince, as a sign of gratitude, presented him with the Mantle of St. John and made him a Cavaliere di Grazia. Here, following some sort of disagreement with the Cavaliere di Giustizia, Michelangelo was put into prison. But he managed to escape at night by means of a rope ladder and fled to the island of Sicily. In Palermo he painted some works. But since his enemies were chasing him, he decided to return to Naples. There they finally caught up with him, wounding him on his face with such severe slashes that he was almost unrecognizable. Despairing of revenge for this vindictive act and with all the agony he had experienced, he packed his few belongings and boarded a little boat in order to go to Rome, where Cardinal Gonzaga was negotiating with Pope Paul V for his pardon. On the beach where he arrived, he was mistakenly captured and held

Leone a veder, se poteva in mare ravvisare il ritenuto, e poi rilassato, più la felluca non ritrovava si, che postosi in furia, come disperato andava per quella spiaggia sotto la sferza del Sol vascello, che le sue robe portava. Ultimamente arrivato in un luogo della spiaggia misesi in letto con febre maligna; e senza aiuto humano tra pochi giorni mori malamente, come appunto male havea vivuto.[4]

Se Michelagnolo Amerigi non fusse morto sì presto, haveria fatto gran profitto nell'arte per la buona maniera, che presa havea nel colorire del naturale; benche egli nel rappresentar le cose non havesse molto giudicio di scieglere il buono, e lasciare il cattivo. Nondimeno acquistò gran credito, e più si pagavano le sue teste, che l'altrui historie, tanto importa l'aura popolare, che non giudica con gli occhi, ma guarda con l'orecchie. E nell'Accademia il suo ritratto è posto.

139

for two days in prison and when he was released, his boat was no longer to be found. This made him furious, and in desperation he started out along the beach under the fierce heat of the July sun, trying to catch sight of the vessel that had his belongings. Finally, he came to a place where he was put to bed with a raging fever; and so, without the aid of God or man, in a few days he died, as miserably as he had lived.

If Michelangelo Merisi had not died so soon, the art world would have profited greatly from his beautiful style, which consisted of painting from nature; although in his pictures he did not have much judgment in selecting the good and avoiding the bad, he nevertheless was able to earn great credit for himself, and he was paid more for his portraits than others obtained for their history pictures, such is the value of recognition by the people, who judge not with their eyes but look with their ears. His portrait was placed in the Academy.

[1]Marginal note by Bellori in a copy of Baglione in the Accademia dei Lincei, p. 136:

Macinava li colori in Milano, et apprese a colorire et per haver occiso un suo compagno fuggì dal paese in bottega di mess. Lorenzo siciliano ricoverò in Roma dove, essendo estremamente bisognoso et ignudo, faceva le teste per un grosso l'una et ne faceva tre il giorno, poi lavorò in casa di Antiveduto Gramatica mezze figure manco strapazzate. [canceled]

Michelangelo ritraheva tutte le sue figure da un lume medio et le faceva tutte ad un solo piano senza digradarle.

[2]Marginal notes:
Baglione
Bestia.

[3]Marginal note: Federico Zuchero era Pittore di . . . [canceled] è degno di grandissima lode il Caravaggio che solo si mise ad imitare la natura contro l'uso di tutti gli altri che imitavano gli altri artefici.
Fu di statura piccola e brutto di volto.

[4]Marginal note: Morì l'anno 1609.

5. FRANCESCO SCANNELLI

Francesco Scannelli, *Il microcosmo della pittura* . . . (Cesena, 1657). Scannelli, like Mancini, was a medical doctor and an amateur of painting. His home was in Forlì in the Romagna, and his point of view was influenced by the nearby school of Bologna. The book tries to discuss painters in order of merit, beginning with Raphael,

and it divides Italian painting into four schools: the Roman school of Raphael, the Venetian of Titian, the Lombard of Correggio, and the Bolognese of the Carracci.

E per essere il vero, et ultimo scopo del buon Pittore l'imitazione de' corpi naturali, e non altro in fatti il laudabil dipinto, che un'espressione del già ben concepito in ordine alla piena somiglianza de' migliori oggetti di natura, conseguentemente ne deriva, che quello, il quale mostra animare i colori con artificio più eccellente, venendo a sortire l'effetto del bramato intento, pare, che debba parimente raccogliere il frutto della maggior gloria, dove comparendo Michelangelo da Caravaggio nel teatro del Mondo, unico mostro di naturalezza, portato dal proprio istinto di natura all'imitazione del vero, e così ascendendo dalla copia de' fiori, e frutti, e da' corpi meno perfetti a più sublimi, e dopo gl'irrazionali a gli humani ritratti, e finalmente operando intiere figure, e anco talvolta componimenti d'historie con tal verità, forza, e rilievo, che bene spesso la natura, se non di fatto eguagliata, e vinta, apportando però confusione al riguardante con istupendo inganno, allettava, e rapiva l'humana vista, e però fu creduto da varij anco sopra d'ogni altro eccellentissimo.

Ma sia pur detto il tutto con pace de' gusti particolari, perché dalle premesse imperfette non si può dedurre, se non falsa la conclusione, avengache un soggetto tale non si dimostrò in effetto, che provisto di particolar genio, mediante il quale dava con l'opere a vedere una straordinaria, e veramente singolare immitatione del vero, e nel communicar forza, e rilievo al dipinto non inferiore, e forsi ad ogni altro supremo, privo però della necessaria base del buon disegno, si palesò poscia d'inventione mancante, e come del tutto ignudo di bella idea, gratia, decoro, Architettura, Prospettiva, ed altri simili convenevoli fondamenti, i quali rendono unitamente sufficienti, e degni i veri principali, e maggiori Maestri, ed egli quasi del tutto privo si dovrà anco credere in comparatione de' sopracitati primi capi di Pittura inferiore, ed imperfetto.

51 (Book I, Chapter VIII) And since the true and ultimate scope of the good painter is the imitation of natural forms, and an estimable painting being in fact nothing other than an already well-conceived expression put forward with full cognizance of the best elements of nature, consequently it follows that he who invigorates color with the most excellent artifice, bringing forth his longed-for objective, ought to gather the fruit of greater fame, just as Michelangelo da Caravaggio did when he appeared on the world's stage. He was a unique exponent of naturalism, nurtured by his own instinct to paint from nature, and in this fashion rising from imitations of flowers and fruits, from less perfect figures to the most sublime, from irrational to more human portraits, and finally by painting complete figures, and sometimes also narratives, with such truth, vigor, and relief that quite often nature, if not actually equaled and conquered, would nevertheless bring confusion to the viewer through his astonishing deceptions, which attracted and ravished human sight; and so he was regarded by many as being most excellent above all others.

But one must speak calmly about this particular style, because from imperfect premises one can deduce only false conclusions. And if, in fact, such an artist did not demonstrate that he was endowed with a particular talent, he gave his works an extraordinary and truly singular imitation of nature, and an injection of force and relief greater perhaps than any other. Nevertheless he lacked the necessary basis for good design, producing faulty creations without completely achieving a beautiful conception, gracefulness, decorum, architecture, perspective, or other similar and significant elements that together render sufficiently worthy the true principles of the greatest masters. And he, almost totally without these qualities, and in comparison to the abovementioned first masters of painting, must appear inferior and imperfect.

E se Federico Barocci palesò con gli effetti [197] dell'opere eccedere la virtù di Michelangelo da Caravaggio, ed altri consimili rari imitatori della più apparente naturalezza nel dissegno, decoro, e bella gratia; dimostrarono però gli altri ne' loro dipinti rilievo, e maggior verità, e dello stesso Michelangelo primo capo de' naturalisti stanno in publica vista della Città di Roma la maggior parte, ed anco le migliori del suo qualificato pennello, e la prima, e facilmente più eccellente d'ogni altra si vede nella Chiesa di S. Luigi della Natione Francese l'ultima Capella nell'entrare a mano sinistra con la Tavola, che dimostra S. Matteo con un'Angelo dalla parte di sopra, e alla parte destra l'historia pure del Santo quando fu chiamato da Christo all'Apostolato, veramente una delle più pastose, rilevate, e naturali operationi, che venga a dimostrare l'artificio della Pittura per immitatione di mera verità, essendo in [198] tal luogo, quasi del tutto mancante il lume, in modo che opera tale per disgratia de' virtuosi, e dello stesso Autore non si può vedere, che imperfettamente. Il dipinto della parte di sopra è del Cavaliere Gioseffo Cesare d'Arpino, il quale per ritrovarsi con maniera di prattica, e dal vero lontana in paragone dell'altro del tutto contrario riesce languido, e mancante, non essendo in fatti la Pittura, che adeguata imitatione de gli effetti di natura, e per ritrovarsi talento molto proportionato lo stesso Michelangelo, venne anco un tal particolar soggetto a dimostrare col mezo dell'opere un'inganno in effetto straordinario; e quando havesse aggiunto più fondato studio in ordine al puntual dissegno, havria facilmente palesato al più perfetto, e sublime grado la maggiormente vera, e bella naturalezza e, però in paragone de gli altrui dipinti saranno non poco laudabili le sue se bene particolari, nondimeno eccedenti qualità; mà però non affatto disprezzevoli quelle dell'altro d'Arpino. Di simile straordinaria eccellenza si ritrova egualmente la Tavola nella Chiesa Nuova, che dimostra quando portano Christo morto a sepellire, e queste sono al sicuro le migliori, che si manifestano in publico dell'Autore. Nella Chiesa di S. Agostino compare subito nell'entrare a mano sinistra nella prima Cappella una Tavola dove intese di rap-

(Book II, Chapter X) Even if Federico Barocci with the effects in his paintings appears to surpass the virtues of Michelangelo da Caravaggio and other similar and rare imitators of the most obvious naturalism in art, in decorum and gracefulness, the other painters on the contrary demonstrated in their works relief and greater realism. And the works of the same Michelangelo, the foremost exponent of naturalism, can largely be viewed publicly in the city of Rome: the first and also the best can be seen in the church of San Luigi dei Francesi in the last chapel on the left side, with the painting that depicts St. Matthew with an angel above; and on the right side there are the histories with the same Saint when Christ calls him to the Apostolate. This is truly one of the most luminous, sculptural, and natural works, which serves to demonstrate the artifice of painting when it imitates mere reality. It has been placed in almost complete darkness so that such works, to the sorrow of other artists, and of the painter himself, cannot be seen except imperfectly. The paintings above are by the Cavalier Giuseppe d'Arpino, whose facile style was remote from reality and quite different from Caravaggio's. Therefore the effect is languid and inadequate. In fact the art of painting is nothing but a good imitation of nature. Michelangelo, who was endowed with a proportionate talent, was able to depict a particular subject in his works to extraordinary effect with the help of deceptions; and if he had deepened his study, he could have been able more readily to reveal a more perfect and sublime level of deeper and truer beauty. However, in comparison to other paintings, his appear not a little praiseworthy though quite unusual, nor are they without excellent qualities. Nor are the works of Arpino without merit. Similar and extraordinary beauty can also be found in the panel in the Chiesa Nuova that depicts the Entombment of the dead Christ; and these are surely his best pictures among those displayed in public. In the church of Sant'Agostino, near the entrance, in the first chapel at the left, there is a painting that represents on its right side the standing Virgin holding the Holy Child to her neck; at the left side a

presentare dalla parte destra la B. Vergine in piedi col Santo Bambino in collo, e alla sinistra inginocchiati un Pellegrino insieme con una Vecchia in atto di divotione, e chi viene ad osservarli non può anco, se non confessare il lor' animo ben disposto, ed assai confirmato egualmente nella fede, come nella pura simplicità di cuore per orare ad immagine, che in vece di contenere il dovuto decoro, con gratia, e divotione si riconosce per ogni parte priva, havendo in fatti i soli primi capi, e maggiori Maestri dimostrato in un'epilogato a maraviglia il tutto. Nella Chiesa della Madonna del Popolo nella Capella della parte destra della Maggiore vi sono due Quadri dalle bande, l'uno coll'historia della Crocefissione di S. Pietro, e l'altro della Conversione di S. Paolo, essendo la Tavola di mezo d'Annibale Carracci. Si vedono ancora nelle Gallerie Quadri di tremenda naturalezza, ed in particolare nel Palazzo de' Borghesi uno assai grande, che dimostra Christo a tavola con i due [199] Pellegrini, et un'ignudo di S. Gio. Battista, et un'altro simile a tutti d'ogni parte di apparente verità; e nella Galleria de' Lodovisi il Quadro, che fà conoscere S. Tomaso quando mette il dito nel Costato di Christo, e altri quadri di meze figure molto rilevate, e simili al vivo; et appresso l'Eminentissimo Antonio Barberini si vede un Quadro di meze figure al naturale, che dimostrano giocare mirabilmente alle carte, inventione molto al di lui genio confacevole, e per conseguenza in tal particolare di rara bellezza; e nella Vigna Pamfilia fuori della Porta S. Pancratio il Quadro della Zingara, che dà ad un Giovane la buona ventura, et in un'altro Quadro una Maddalena, figura intera al naturale, e l'altro di meze figure, e nella Galeria dell'Eminentissimo Pio alcuni Quadretti, ed in particolare una figura di S. Gio. Battista ignudo, che non potria dimostrare più vera carne quando fosse vivo, sicome l'Amoretto che si ritrova appresso al Prencipe Giustiniani, che frà i dipinti privati di Michelangelo da Carravaggio sarà forsi il più degno. Viddi pure anni sono nelle stanze del Serenissimo Gran Duca di Toscana un Quadro di meze figure della solita naturalezza, che fà vedere quando un Ceretano cava ad un Contadino un dente, e se

pilgrim is kneeling with an old woman in the act of devotion; and whoever comes to view this cannot but admit that their spirit is well disposed, strengthened by their faith with the pure simplicity of the heart when worshipping the image. However, instead of showing a suitable decorum with grace and devotion, we find everywhere their lack. In fact, the major masters would have expressed their astonishment at all of it. In the chapel of the Madonna del Popolo, on the right side, there are two side paintings: the first illustrates the Crucifixion of St. Peter, the other the Conversion of St. Paul, the panel in the center being by Annibale Carracci. In the galleries one can admire pictures of terrible naturalism: in particular quite a big one in the Palazzo Borghese, which depicts Christ seated at table between two pilgrims, a nude St. John the Baptist, and another one painted with the same naturalistic appearance. In the gallery of the Ludovisi, St. Thomas when he pokes his finger into Christ's side, and other paintings of half-figures in strong relief, like life. In Cardinal Antonio Barberini's collection there is a painting of half-figures from life, who are shown marvelously playing cards, an invention tailored to his talent, and consequently in that detail particularly beautiful. In the Villa Pamphilj outside Porta San Pancrazio, the picture of the Gypsy who is shown predicting good fortune to a young man; also a Magdalen, a full figure from life, and another in half-figures. In the gallery of Cardinal Pio are some small paintings, in particular a St. John the Baptist, nude, which could not reveal truer flesh if he had been alive, like the *Amoretto* in Prince Giustiniani's collection, which is probably the most worthy painting by Michelangelo da Caravaggio in private hands. Some years ago in the room of his Most Serene Highness the Grand Duke of Tuscany, I also saw a painting with half-figures, of the usual naturalism, which depicts a dentist who is pulling a tooth from a peasant's mouth, and if this work were well preserved (it is in large part very dark, and ruined) it would be one of his best. In the extraordinary gallery of his Most Serene Highness the Duke of Modena, a painting of St. Augustine, in half-length, from life, turn-

questo Quadro fosse di buona conservatione, come si ritrova in buona parte oscuro, e rovinato, saria una delle più degne operationi, che havesse dipinto. Si possono però osservare continoamente nella straordinaria Galeria del Serenissimo Duca di Modana un Quadro d'un S. Agostino di meze figure al naturale, il quale sta rivolto con la penna in mano in atto spiritosissimo, che palesa vivezza, e verità veramente insolita, e rara, come un'altra meza figura, parimente di grandezza simile con S. Sebastiano ignudo, la quale dimostra oltre la solita forza, e rilievo della maniera, una tal gratia, delicatezza, e maggior decoro, che forsi non ha palesato in altro suo dipinto.

ing toward the viewer, holding a pen in a very spirited pose, revealing exuberance and an unusual and rare realism. The same qualities can be found in another half-figure painting of similar size of the nude St. Sebastian, which represents with the usual vigor and relief style a grace, delicacy, and greater decorum than he had perhaps ever displayed before in a painting.

Molti al certo hanno dipinto l'opere d'espressa naturalezza, e frà gli altri Michelangelo da Carravaggio nell'imitatione dell'opere piu vere della natura, pare che non riuscisse a nissuno inferiore. Nientedimeno se verremo ad osservare la figura della Maddalena citata nel primo Libro del medesimo da Carravaggio nella Galeria del Prencipe Pamfilio in paragone di questa espressa nel medesimo Quadro della pietà del Correggio, la quale oltre alla più bella verità si ritrova in atto addolorato, e proprio; e l'altra del Carravaggio non dimostra la naturalezza, che nella pura apparente superficie, perche non valendo in fatti per animarla, si ritrova priva dello spirito, gratia, e debita espressione, che si può dire per ogni parte morta.

277 (Book II, Chapter XX) Certainly many artists have painted their works with great naturalism, and among them Michelangelo da Caravaggio seems not to be inferior to anybody in imitation of works more true than nature. Nevertheless, if you observe the figure of Magdalen (cited in Book I), made by Caravaggio himself for the gallery of Prince Pamphilj, and compare this work with the same subject in the painting by Correggio, you see that, apart from the more beautiful truthfulness, it shows appropriate sadness. The work by Caravaggio is not natural, except on the purely superficial level, because he gives it no life, it is without spirit, grace, and appropriate expression, so that one could say that everything appears dead.

6. GIOVANNI PIETRO BELLORI

Giovanni Pietro Bellori, *Le vite de' pittori, scultori e architetti moderni* (Rome, 1672). The text printed here is that published by Evelina Borea (Turin, 1976) but with the original pagination, as shown in the margins of Borea's edition. For Bellori, who was the outstanding art critic and archaeological writer of his age, see the introduction to Borea's edition by Giovanni Previtali and their extensive bibliography on Bellori (pp. lxxiv ff.). Further, see above, pp. 5–10 and 48, n. 29.

Dicesi che Demetrio antico statuario fu tanto studioso della rassomiglianza che dilettossi piú dell'imitazione che della bellezza delle cose; lo stesso abbiamo veduto in Michelangelo Merigi, il quale non riconobbe altro maestro che il modello, e senza elezzione delle megliori forme naturali, quello che a dire è stupendo, pare che senz'arte emulasse l'arte. Dupplicò egli con la sua nascita la fama di Caravaggio, nobile castello di Lombardia, patria insieme di Polidoro celebre pittore; l'uno e l'altro di loro si esercitò da giovine nell'arte di murare e portò lo schifo della calce nelle fabriche; poiché impiegandosi Michele in Milano col padre, che era muratore, s'incontrò a far le colle ad alcuni pittori che dipingevano a fresco, e tirato dalla voglia di usare i colori accompagnossi con loro, applicandosi tutto alla pittura. Si avanzò per quattro o cinque anni facendo ritratti, e dopo, essendo egli d'ingegno torbido e contenzioso, per alcune discordie fuggitosene da Milano giunse in Venezia, ove si compiacque tanto del colorito di Giorgione che se lo propose per iscorta nell'imitazione. Per questo veggonsi l'opere sue prime dolci, schiette e senza quelle ombre ch'egli usò poi; e come di tutti li pittori veneziani eccellenti nel colorito fu Giorgione il piú puro e 'l piú semplice nel rappresentare con poche tinte le forme naturali, nel modo stesso portossi Michele, quando prima si fissò intento a riguardare la natura. Condottosi a Roma vi dimorò senza ricapito e senza provedimento, riuscendogli troppo dispendioso il modello, senza il quale non sapeva dipingere, né guadagnando tanto che potesse avanzarsi le spese. Siché Michele dalla necessità costretto andò a servire il cavalier Giuseppe d'Arpino, da cui fu applicato a dipinger fiori e frutti sí bene contrafatti che da lui vennero a frequentarsi a quella maggior vaghezza che tanto oggi diletta. Dipinse una caraffa di fiori con le trasparenze dell'acqua e del vetro e coi riflessi della fenestra d'una camera, sparsi li fiori di freschissime rugiade, ed altri quadri eccellentemente fece di simile imitazione. Ma esercitandosi egli di mala voglia in queste cose, e sentendo gran rammarico di vedersi tolto alle figure, incontrò l'oc-

It is said that the ancient sculptor Demetrios was such a student of life that he preferred imitation to the beauty of things; we saw the same thing in Michelangelo Merisi, who recognized no other master than the model, without selecting from the best forms of nature—and what is incredible, it seems that he imitated art without art. With his birth he doubled the fame of Caravaggio, a notable town of Lombardy, which had also been the home of the celebrated painter Polidoro. Both artists began as masons and carried hods of mortar for construction. Since Michele was employed in Milan with his father, a mason, it happened that he prepared glue for some painters who were painting frescoes and, led on by the desire to paint, he remained with them, applying himself totally to painting. He continued in this activity for four or five years, making portraits, and afterward, being disturbed and contentious, because of certain quarrels he fled from Milan to Venice, where he came to enjoy the colors of Giorgione, which he then imitated. For this reason his first works are agreeably sweet, direct, and without those shadows that he used later on; and since of all the Venetian colorists Giorgione was the purest and the simplest in representing natural forms with only a few tones, Michele painted in the same manner when he was first studying nature intently. He went to Rome, where he lived without lodgings and without provisions; since models, without which he did not know how to paint, were too expensive, he did not earn enough to pay his expenses. Michele was therefore forced by necessity to work for Cavalier Giuseppe d'Arpino, who had him paint flowers and fruit, which he imitated so well that from then on they began to attain that greater beauty that we love today. He painted a vase of flowers with the transparencies of the water and glass and the reflections of a window of the room, rendering flowers sprinkled with the freshest dewdrops; and he painted other excellent pictures of similar imitations. But he worked reluctantly at these things and felt deep regret at not being able to paint figures. When he met Prospero, a painter of grotesques,

casione di Prospero, pittore di grottesche, ed uscí di casa di Giuseppe per contrastargli la gloria del pennello. Datosi perciò egli a colorire secondo il suo proprio genio, non riguardando punto, anzi spregiando gli eccellentissimi marmi de gli antichi e le pitture tanto celebri di Rafaelle, si propose la sola natura per oggetto del suo pennello. Laonde, essendogli mostrate le statue piú famose di Fidia e di Glicone, accioché vi accommodasse lo studio, non diede altra risposta se non che distese la mano verso una moltitudine di uomini, accennando che la natura l'aveva a sufficienza proveduto di maestri. E per dare autorità alle sue parole, chiamò una zingara che passava a caso per istrada, e condottala all'albergo la ritrasse in atto di predire l'avventure, come sogliono queste donne di razza egizziana: fecevi un giovine, il quale posa la mano col guanto su la spada e porge l'altra scoperta a costei, che la tiene e la riguarda; ed in queste due mezze figure tradusse Michele sí puramente il vero che venne a confermare i suoi detti. Quasi un simil fatto si legge di Eupompo antico pittore; se bene ora non è tempo di considerare insino a quanto sia lodevole tale insegnamento. E perché egli aspirava all'unica lode del colore, siché paresse vera l'incarnazione, la pelle e 'l sangue e la superficie naturale, a questo solo volgeva intento l'occhio e l'industria, lasciando da parte gli altri pensieri dell'arte. Onde nel trovare e disporre le figure, quando incontravasi a vederne per la città alcuna che gli fosse piaciuta, egli si fermava a quella invenzione di natura, senza altrimente esercitare l'ingegno. Dipinse una fanciulla a sedere sopra una seggiola con le mani in seno in atto di asciugarsi li capelli, la ritrasse in una camera, ed aggiungendovi in terra un vasello d'unguenti, con monili e gemme, la finse per Madalena. Posa alquanto da un lato la faccia e s'imprime la guancia, il collo e 'l petto in una tinta pura, facile e vera, accompagnata dalla semplicità di tutta la figura, con le braccia in camicia e la veste gialla ritirata alle ginocchia dalla sottana bianca di damasco fiorato. Quella figura abbiamo descritta particolarmente per indicare li suoi modi naturali e l'imitazione in poche tinte sino alla verità del colore. Dipinse in un maggior quadro la Madonna che si riposa

203

he took the opportunity to leave Giuseppe in order to compete with him for the glory of painting. Then he began to paint according to his own inclinations; not only ignoring but even despising the superb statuary of antiquity and the famous paintings of Raphael, he considered nature to be the only subject fit for his brush. As a result, when he was shown the most famous statues of Phidias and Glykon in order that he might use them as models, his only answer was to point toward a crowd of people, saying that nature had given him an abundance of masters. And to give authority to his words, he called a Gypsy who happened to pass by in the street and, taking her to his lodgings, he portrayed her in the act of predicting the future, as is the custom of these Egyptian women. He painted a young man who places his gloved hand on his sword and offers the other hand bare to her, which she holds and examines; and in these two half-figures Michele captured the truth so purely as to confirm his beliefs. A similar story is told about the ancient painter Eupompos—though this is not the time to discuss to what extent such teachings are praiseworthy. Since Caravaggio aspired only to the glory of color, so that the complexion, skin, blood, and natural surfaces might appear real, he directed his eye and work solely to that end, leaving aside all the other aspects of art. Therefore, in order to find figure types and to compose them, when he came upon someone in town who pleased him he made no attempt to improve on the creations of nature. He painted a girl drying her hair, seated on a little chair with her hands in her lap. He portrayed her in a room, adding a small ointment jar, jewels and gems on the floor, pretending that she is the Magdalen. She holds her head a little to one side, and her cheek, neck, and breast are rendered in pure, simple, and true colors, enhanced by the simplicity of the whole figure, with her arms covered by a blouse and her yellow gown drawn up to her knees over a white underskirt of flowered damask. We have described this figure in detail in order to show his naturalistic style and the way in which he imitates truthful coloration by using only a few hues. On a bigger canvas he painted the Madonna

dalla fuga in Egitto: evvi un angelo in piedi che suona il violino, San Giuseppe sedente gli tiene avanti il libro delle note, e l'angelo è bellissimo, poiché volgendo la testa dolcemente in profilo va discoprendo le spalle alate e 'l resto dell'ignudo interrotto da un pannolino. Dall'altro lato siede la Madonna, e piegando il capo sembra dormire col bambino in seno. Veggonsi questi quadri nel palazzo del principe Pamphilio, ed un altro degno dell'istessa lode nelle camere del cardinale Antonio Barberini, disposto in tre mezze figure ad un giuoco di carte. Finsevi un giovinetto semplice con le carte in mano, ed è una testa ben ritratta dal vivo in abito oscuro, e di rincontro a lui si volge in profilo un giovine fraudolente, appoggiato con una mano su la tavola del giuoco, e con l'altra dietro si cava una carta falsa dalla cinta, mentre il terzo vicino al giovinetto guarda li punti delle carte, e con tre dita della mano li palesa al compagno, il quale nel piegarsi su 'l tavolino espone la spalla al lume in giubbone giallo listato di fascie nere, né finto è il colore nell'imitazione. Sono questi li primi tratti del pennello di Michele in quella schietta maniera di Giorgione, con oscuri temperati; e Prospero acclamando il nuovo stile di Michele accresceva la stima delle sue opere con util proprio fra le prime persone della corte. Il giuoco fu comprato dal cardinale del Monte, che per dilettarsi molto della pittura ridusse in buono stato Michele e lo sollevò, dandogli luogo onorato in casa fra' suoi gentiluomini. Dipinse per questo signore una musica di giovani ritratti dal naturale in mezze figure, una donna in camicia che suona il liuto con le note avanti, e Santa Caterina ginocchione appoggiata alla rota; li due ultimi sono ancora nelle medesime camere, ma riescono d'un colorito piú tinto, cominciando già Michele ad ingagliardire gli oscuri. Dipinse San Giovanni nel deserto, che è un giovinetto ignudo a sedere, il quale sporgendo la testa avanti abbraccia un agnello; e questo si vede nel palazzo del signor cardinal Pio. Ma il Caravaggio, che cosí egli già veniva da tutti col nome della patria chiamato, facevasi ogni giorno piú noto per lo colorito ch'egli andava introducendo, non come prima dolce e con poche tinte, ma tutto risentito di

204 resting in the Flight into Egypt: here there is a standing angel who plays the violin, and St. Joseph, seated, holds a book of music open for him; the angel is very beautiful, and by turning his head in sweet profile, displays his winged shoulders and the rest of his nude body, which is covered by a little drapery. On the other side sits the Madonna who, with her head inclined, seems asleep with her baby at her breast. These pictures are in the palace of Prince Pamphilj; and another one worthy of similar praise is in the rooms of Cardinal Antonio Barberini, which shows three half-figures playing cards. He showed a simple young man holding the cards, his head portrayed well from life and wearing dark clothes, and on the opposite side there is a dishonest youth in profile, who leans on the card table with one hand while with the other behind him he slips a false card from his belt; a third man close to the young one looks at his cards and with three fingers reveals them to his companion who, as he bends forward over the small table, exposes the shoulder of his heavy yellow coat striped with black to the light. The color is true to life. These are the first strokes from Michele's brush in the free manner of Giorgione, with tempered shadows. Prospero [Orsi, "delle grottesche"], by acclaiming the new style of Michele, increased the value of his works to his own advantage among the most important people of the court. The Cardsharps was bought by Cardinal Del Monte who, being a lover of paintings, set Michele up and gave him an honored place in his household. For this gentleman he painted the Concert of Youths portrayed from life in half-figures; a woman in a blouse playing a lute with the music sheets in front of her; a kneeling St. Catherine leaning on the wheel. The last two paintings are also in the same rooms but have a darker color, as Michele had already begun to darken the darks. He painted St. John in the desert, a naked young boy, seated, who thrusts his head forward embracing a lamb; this painting can be seen in the palace of Cardinal Pio. But Caravaggio (as he was called by everyone, with the name of his native town) was becoming more famous every day because the coloration he was introducing

oscuri gagliardi, servendosi assai del nero per dar rilievo alli corpi. E s'inoltrò egli tanto in questo suo modo di operare, che non faceva mai uscire all'aperto del sole alcuna delle sue figure, ma trovò una maniera di campirle entro l'aria bruna d'una camera rinchiusa, pigliando un lume alto che scendeva a piombo sopra la parte principale del corpo, e lasciando il rimanente in ombra a 205 fine di recar forza con veemenza di chiaro e di oscuro. Tanto che li pittori allora erano in Roma presi dalla novità, e particolarmente li giovini concorrevano a lui e celebravano lui solo come unico imitatore della natura, e come miracoli mirando l'opere sue lo seguitavano a gara, spogliando modelli ed alzando lumi; e senza piú attendere a studio ed insegnamenti, ciascuno trovava facilmente in piazza e per via il maestro e gli esempi nel copiare il naturale. La qual facilità tirando gli altri, solo i vecchi pittori assuefatti alla practica rimanevano sbigottiti per questo novello studio di natura; né cessavano di sgridare il Caravaggio e la sua maniera, divolgando ch'egli non sapeva uscir fuori dalle cantine, e che, povero d'invenzione e di disegno, senza decoro e senz'arte, coloriva tutte le sue figure ad un lume e sopra un piano senza degradarle: le quali accuse però non rallentavano il volo alla sua fama.

Aveva il Caravaggio fatto il ritratto del cavalier Marino, con premio di gloria tra gli uomini di lettere, venendo nell'Accademie cantato il nome del poeta e del pittore; sí come dal Marino stesso fu celebrata particolarmente la testa di Medusa di sua mano, che il cardinale Del Monte donò al granduca di Toscana. Tantoché il Marino, per una grandissima benevolenza e compiacimento dell'operare del Caravaggio, l'introdusse seco in casa di monsignor Melchiorre Crescenzi chierico di camera: colorí Michele il ritratto di questo dottissimo prelato e l'altro del signor Virgilio Crescenzi, il quale, restato erede del cardinale Contarelli, lo elesse a concorrenza di Giuseppino alle pitture della cappella in San Luigi de' Francesi. Cosí il Marino, che era amico di questi due pittori, consigliò che a Giuseppe,

was not as sweet and delicate as before, but became boldly dark and black, which he used abundantly to give relief to the forms. He went so far in this style that he never showed any of his figures in open daylight, but instead found a way to place them in the darkness of a closed room, placing a lamp high so that the light would fall straight down, revealing the principal part of the body and leaving the rest in shadow so as to produce a powerful contrast of light and dark. The painters then in Rome were greatly taken by this novelty, and the young ones particularly gathered around him, praised him as the unique imitator of nature, and looked on his work as miracles. They outdid each other in imitating his works, undressing their models and raising their lights. Without devoting themselves to study and instruction, each one easily found in the piazza and in the street their masters and the models for imitating nature. With this easy style attracting the others, only the older painters already set in their styles were dismayed by this new study of nature: they never stopped attacking Caravaggio and his style, saying that he did not know how to come out of the cellar and that, lacking *invenzione* and *disegno,* without decorum or art, he painted all his figures with a single source of light and on one plane without any diminution; but such accusations did not stop the flight of his fame.

Caravaggio painted the portrait of Cavalier Marino, with the reward of praise from literary men; the names of both the painter and the poet were sung in Academies; in fact Marino in particular so praised the head of Medusa by Caravaggio that Cardinal Del Monte gave it to the Grand Duke of Tuscany. Because of his kindness and his delight in Caravaggio's style, Marino introduced the painter into the house of Monsignor Melchiorre Crescenzi, clerk of the papal chamber. Michele painted the portrait of this most learned prelate and another one of Virgilio Crescenzi who, as heir of Cardinal Contarelli, chose him to compete with Giuseppino [Cesari d'Arpino] for the paintings in the chapel of San Luigi dei Francesi. Marino, who was the friend of both painters, suggested that Giuseppe, an ex-

pratichissimo del fresco, si distribuissero le figure di sopra nel muro ed a Michele li quadri ad olio. Qui avvenne cosa che pose in grandissimo disturbo e quasi fece disperare il Caravaggio in riguardo della sua riputazione; poiché, avendo egli terminato il quadro di mezzo di San Matteo e postolo su l'altare, fu tolto via da i preti con dire che quella figura non aveva decoro né aspetto di Santo, stando a sedere con le gambe incavalcate e co' piedi rozzamente esposti al popolo. Si disperava il Caravaggio per tale affronto nella prima opera da esso publicata in chiesa, quando il marchese Vincenzo Giustiniani si mosse a favorirlo e liberollo da questa pena; poiché, interpostosi con quei sacerdoti, si prese per sé il quadro e gliene fece fare un altro diverso, che è quello si vede ora su l'altare; e per onorare maggiormente il primo, portatolo a casa, l'accompagnò poi con gli altri tre Vangelisti di mano di Guido, di Domenichino e dell'Albano, tre li piú celebri pittori che in quel tempo avessero fama. Usò il Caravaggio ogni sforzo per riuscire in questo secondo quadro: e nell'accommodare al naturale la figura del Santo che scrive il Vangelo, egli la dispose con un ginocchio piegato sopra lo scabello e con le mani al tavolino, intingendo la penna nel calamaio sopra il libro. In questo atto volge la faccia dal lato sinistro verso l'angelo, il quale sospeso su l'ali in aria gli parla, e gli accenna, toccando con la destra l'indice della mano sinistra. Sembra l'angelo lontano da color finto, e sta sospeso su l'ali verso il Santo, ignude le braccia e 'l petto, con lo svolazzo d'un velo bianco che lo cinge nell'oscurità del campo. Dal lato destro l'altare vi è Cristo che chiama San Matteo all'apostolato, ritrattevi alcune teste al naturale, tra le quali il Santo lasciando di contar le monete, con una mano al petto, si volge al Signore; ed appresso un vecchio si pone gli occhiali al naso, riguardando un giovine che tira a sé quelle monete assiso nell'angolo della tavola. Dall'altro lato vi è il martirio del Santo istesso in abito sacerdotale disteso sopra una banca; e 'l manigoldo incontro brandisce la spada per ferirlo, figura ignuda, ed altre si ritirano con orrore. Il componimento e li moti però non sono sufficienti all'istoria, ancor-

206

pert fresco painter, be given the figures on the wall above and Michele the oil paintings. Here something happened that greatly upset Caravaggio with respect to his reputation. After he had finished the central picture of St. Matthew and installed it on the altar, the priests took it down, saying that the figure with its legs crossed and its feet rudely exposed to the public had neither decorum nor the appearance of a saint. Caravaggio was in despair at such an outrage over his first work in a church, when Marchese Vincenzo Giustiniani acted in his favor and freed him from this predicament. So, intervening with the priests, he took the painting for himself and had Caravaggio do a different one, which is now to be seen above the altar. And to honor the first painting more he took it to his house and later added the other three Evangelists by Guido [Reni], Domenichino, and Albani, three of the most famous painters of that time. Caravaggio used all his powers to succeed in his second picture; and in order to give a natural form to the saint writing the gospel, he showed him with a knee bent over the stool and his hands on the table, in the act of dipping his pen in the inkwell above the book. In so doing he turns his face from the left toward the angel who, suspended on his wings in air, talks to him and makes a sign by touching the index finger of his left hand with his right. The coloration makes the angel seem far away, suspended on his wings toward the saint, his arms and chest naked and the white fluttering veil surrounding him in the background darkness. Christ Calling St. Matthew to the Apostolate is on the right side of the altar. He portrayed several heads from life, among them the saint's, who, stopping to count the coins, with one hand on his chest turns toward the Lord. Close to him an old man is putting his eyeglasses on his nose, looking at a young man seated at the corner of the table who draws the coins to himself. On the other side there is the Martyrdom of the Saint himself, who is dressed in priestly garments stretched out on a bench. The nude figure of the executioner is brandishing his sword in the act of wounding him while the others withdraw in horror. The composition and

ché egli la rifacesse due volte; e l'oscurità della cappella e del colore tolgono questi due quadri alla vista. Seguitò a dipingere nella Chiesa di Santo Agostino l'altro quadro della cappella de' signori Cavalletti, la Madonna in piedi col fanciullo fra le braccia in atto di benedire: s'inginocchiano avanti due pellegrini con le mani giunte, e 'l primo di loro è un povero scalzo li piedi e le gambe, con la mozzetta di cuoio e 'l bordone appoggiato alla spalla, ed è accompagnato da una vecchia con la cuffia in capo. 207

Ben tra le megliori opere che uscissero dal pennello di Michele si tiene meritamente in istima la Deposizione di Cristo nella Chiesa Nuova de' Padri dell'Oratorio; situate le figure sopra una pietra nell'apertura del sepolcro. Vedesi in mezzo il sacro corpo, lo regge Nicodemo da piedi, abbracciandolo sotto le ginocchia, e nell'abbassarsi le coscie escono in fuori le gambe. Di là San Giovanni sottopone un braccio alla spalla del Redentore, e resta supina la faccia e 'l petto pallido a morte, pendendo il braccio col lenzuolo; e tutto l'ignudo è ritratto con forza della più esatta imitazione. Dietro Nicodemo si veggono alquanto le Marie dolenti, l'una con le braccia sollevate, l'altra col velo a gli occhi, e la terza riguarda il Signore. Nella Chiesa della Madonna del Popolo, entro la cappella dell'Assunta dipinta da Annibale Carracci, sono di mano del Caravaggio li due quadri laterali, la Crocifissione di San Pietro e la Conversione di San Paolo, la quale istoria è affatto senza azzione. Seguitava egli nel favore del marchese Vincenzo Giustiniani, che l'impiegò in alcuni quadri, l'Incoronazione di spine e San Tomaso che pone il dito nella piaga del costato del Signore, il quale gli accosta la mano e si svela il petto da un lenzuolo, discostandolo dalla poppa. Appresso le quali mezze figure colorí un Amore vincitore, che con la destra solleva lo strale, ed a' suoi piedi giacciono in terra armi, libri ed altri stromenti per trofeo. Concorsero al diletto del suo pennello altri signori romani, e tra questi il marchese Asdrubale Mattei gli fece dipingere la Presa di Cristo all'orto, parimente in mezze figure. Tiene

movements in the painting, however, are insufficient for the narrative, though he did it over twice. These two paintings are difficult to see because of the darkness in the chapel and because of their color. He then painted the picture of the Cavalletti Chapel in the church of Sant'Agostino, with the standing Madonna holding the Child in her arms in the act of giving benediction: two pilgrims with clasped hands are kneeling before her, the first one a poor man with feet and legs bare, with a leather cape and a staff resting on his shoulder. He is accompanied by an old woman with a cap on her head.

People correctly hold in great esteem the Deposition of Christ in the Chiesa Nuova of the Oratorians, one of the finest works of Michele's brush. The figures are located on a slab at the opening of the sepulchre. In the middle we see the holy body. The standing Nicodemus holds it under the knees; in lowering the hips the legs jut out. On the other side St. John holds one arm under the Redeemer's shoulder, whose face is turned up and his chest deadly pale as one arm hangs down with the sheet: the nude parts are portrayed with the force of the most exacting naturalism. Behind Nicodemus we see the mourning Marys; one has her arms raised, another has a veil over her eyes, and the third looks at the Lord. In the church of the Madonna del Popolo, inside the chapel of the Assumption, painted by Annibale Carracci, the two pictures on the sides are by Caravaggio: the Crucifixion of St. Peter and the Conversion of St. Paul, in which the history is completely without action. He continued to be favored by Marchese Vincenzo Giustiniani, who commissioned various pictures such as the Crowning with Thorns and St. Thomas putting his finger into the wound in the Lord's side. Christ holds St. Thomas's hand and exposes his chest from the shroud. In addition to these half-figures he painted the Victorious Love with an arrow raised in his right hand while arms, books, and various trophies lie about on the ground at his feet. Other Roman gentlemen vied with each other in admiring his works, and among them, Marchese Asdrubale Mattei, for whom he painted the Taking of Christ in the

Giuda la mano alla spalla del Maestro, dopo il bacio; intanto un soldato tutto armato stende il braccio e la mano di ferro al petto del Signore, il quale si arresta paziente ed umile con le mani incrocicchiate avanti, fuggendo dietro San Giovanni con le braccia aperte. Imitò l'armatura rugginosa di quel soldato, coperto il capo e 'l volto dall'elmo, uscendo alquanto fuori il profilo; e dietro s'inalza una lanterna, seguitando due altre teste d'armati. Alli signori Massimi colorí un *Ecce Homo* che fu portato in Ispagna, ed al marchese Patrizi la Cena in Emaus, nella quale vi è Cristo in mezzo che benedice il pane, ed uno de gli apostoli a sedere nel riconoscerlo apre le braccia, e l'altro ferma le mani su la mensa e lo riguarda con maraviglia: evvi dietro l'oste con la cuffia in capo ed una vecchia che porta le vivande. Un'altra di queste invenzioni dipinse per lo cardinale Scipione Borghese, alquanto differente; la prima piú tinta, e l'una e l'altra alla lode dell'imitazione del colore naturale; se bene mancano nella parte del decoro, degenerando spesso Michele nelle forme umili e vulgari. Per lo medesimo cardinale dipinse San Girolamo, che scrivendo attentamente distende la mano e la penna al calamaio, e l'altra mezza figura di Davide, il quale tiene per li capelli la testa di Golia, che è il suo proprio ritratto, impugnando la spada: lo figurò da un giovine discoperto con una spalla fuori della camicia, colorito con fondi ed ombre fierissime, delle quali soleva valersi per dar forza alle sue figure e componimenti. Si compiacque il cardinale di queste e di altre opere che gli fece il Caravaggio, e l'introdusse avanti il pontefice Paolo V, il quale da lui fu ritratto a sedere, e da quel signore ne fu ben rimunerato. Al cardinale Maffeo Barberini, che fu poi Urbano VIII sommo pontefice, oltre il ritratto, fece il Sacrificio di Abramo, il quale tiene il ferro presso la gola del figliuolo che grida e cade.

Non però il Caravaggio con le occupazioni della pittura rimetteva punto le sue inquiete inclinazioni; e dopo ch'egli aveva dipinto alcune ore del giorno, compariva per la città con la

Garden, also in half-figures. Judas is shown after the kiss with his hand on the Lord's shoulder; a soldier in full armor extends his arms and his ironclad hand toward the chest of the Lord, who stands still, patiently and humbly, his hands crossed before him, as John runs away behind with outstretched arms. Caravaggio rendered the rusty armor of the soldier accurately with head and face covered by a helmet, his profile partially visible. Behind him a lantern is raised and we see the heads of two other armed men. For the Massimi he painted an Ecce Homo that was taken to Spain; for the Marchese Patrizi he painted the Supper at Emmaus, with Christ in the center in the act of blessing the bread: one of the two seated Apostles extends his arms as he recognizes the Lord and the other one places his hands on the table and looks at him with astonishment. Behind are the innkeeper with a cap on his head and an old woman who brings food. He painted a quite different version for Cardinal Scipione Borghese; the first one is darker, but both are to be praised for their natural colors even though they lack decorum, since Michele's work often degenerated into common and vulgar forms. For the same cardinal Caravaggio painted St. Jerome, who is shown writing attentively and extending his hand to dip his pen into an inkwell; and another painting, the half-figure of David, who holds the head of Goliath by the hair, which is his own portrait. He holds the sword and is shown as a bareheaded youth with one shoulder emerging from his shirt; it is painted with the deep dark shadows that Caravaggio liked to use in order to give strength to his figures and compositions. The cardinal, pleased with these and other works, introduced Caravaggio to Pope Paul V, whom he portrayed seated and by whom he was well rewarded. For Cardinal Maffeo Barberini, who became Pope Urban VIII, in addition to a portrait, he painted the Sacrifice of Abraham, in which Abraham holds a knife to the throat of his son, who screams and falls.

But Caravaggio's preoccupation with painting did not calm his restless nature. After having painted for a few hours in the day he used to go out on the town with his sword at his side,

spada al fianco e faceva professione d'armi, mostrando di attendere ad ogn'altra cosa fuori che alla pittura. Venuto però a rissa nel giuoco di palla a corda con un giovine suo amico, battutisi con le racchette e prese l'armi, uccise il giovine, restando anch'egli ferito. Fuggitosene di Roma, senza denari e perseguitato ricoverò in Zagarolo nella benevolenza del duca don Marzio Colonna, dove colorí il quadro di Cristo in Emaus fra li due apostoli ed un'altra mezza figura di Madalena. Prese dopo il camino per Napoli, nella qual città trovò subito impiego, essendovi già conosciuta la maniera e 'l suo nome. Per la Chiesa di San Domenico maggiore gli fu data a fare nella cappella de' signori di Franco la Flagellazione di Cristo alla colonna, ed in Santa Anna de' Lombardi la Risurrezione. Si tiene in Napoli fra' suoi quadri megliori la Negazione di San Pietro nella Sagrestia di San Martino, figuratovi l'ancella che addita Pietro, il quale volgesi con le mani aperte, in atto di negar Cristo; ed è colorito a lume notturno, con altre figure che si scaldano al fuoco. Nella medesima città per la Chiesa della Misericordia dipinse le Sette Opere in un quadro lungo circa dieci palmi; vedesi la testa di un vecchio che sporge fuori dalla ferrata della prigione suggendo il latte d'una donna che a lui si piega con la mammella ignuda. Fra l'altre figure vi appariscono li piedi e le gambe di un morto portato alla sepoltura; e dal lume della torcia di uno che sostenta il cadavero si spargono i raggi sopra il sacerdote con la cotta bianca, e s'illumina il colore, dando spirito al componimento.

Era il Caravaggio desideroso di ricevere la croce di Malta, solita darsi per grazia ad uomini riguardevoli per merito e per virtú; fece però risoluzione di trasferirsi in quell'isola, dove giunto fu introdotto avanti il Gran Maestro Vignacourt, signore francese. Lo ritrasse in piedi armato ed a sedere disarmato nell'abito di Gran Maestro, conservandosi il primo ritratto nell'armeria di Malta. Laonde questo signore gli donò in premio la croce; e per la Chiesa di San Giovanni gli fece dipingere la Decollazione del Santo caduto a terra, mentre il carnefice, quasi

like a professional swordsman, seeming to do anything but paint. And during a tennis match with a young friend of his, they began hitting each other with their rackets. At the end he drew his sword, killed the young man, and was also wounded himself. Fleeing from Rome, without money and being followed, he found refuge in Zagarolo under the protection of Duke Marzio Colonna, where he painted Christ in Emmaus between the Apostles and another half-figure of Magdalen. Afterward he went to Naples, where he immediately found employment, since his style and reputation were already known there. He was commissioned to do the Flagellation of Christ at the column in the Di Franco Chapel of the church of San Domenico Maggiore. In Sant-'Anna de' Lombardi he painted the Resurrection. In Naples, the Denial of St. Peter for the Sacristy of San Marino is thought to be among his finest works. It shows a servant girl pointing at Peter, who turns around with open hands in the act of denying Christ; it is a nocturnal scene with other figures warming themselves at the fire. In the same city for the church of the Misericordia he painted the Seven Acts of Mercy, a picture about ten *palmi* high; one sees the head of an old man sticking out through the bars of a prison, sucking milk from the bare breast of a woman bending down toward him. Among the other figures you can distinguish the feet and legs of a corpse carried to burial; and the rays from the light of the torch held by one of the men who bears the body spread over the priest with a white surplice, revealing the color and giving life to the composition.

Caravaggio was eager to receive the Cross of Malta, which is usually given *per grazia* to honored men for their merit and virtue. He decided to go to that island, where he was introduced to the Grand Master Wignacourt, a French gentleman. He painted him standing dressed in armor and seated without armor, in the habit of Grand Master; the first is in the Armory of Malta. The Master rewarded Caravaggio with the Cross. In the church of San Giovanni he was ordered to paint the Beheading of St. John, who has fallen to the ground while the executioner,

209



non l'abbia colpito alla prima con la spada, prende il coltello dal fianco, afferrandolo ne' capelli per distaccargli la testa dal busto. Riguarda intenta Erodiade, ed una vecchia seco inorridisce allo spettacolo, mentre il guardiano della prigione in abito turco addita l'atroce scempio. In quest'opera il Caravaggio usò ogni potere del suo pennello, avendovi lavorato con tanta fierezza che lasciò in mezze tinte l'imprimitura della tela: sí che, oltre l'onore della croce, il Gran Maestro gli pose al collo una ricca collana d'oro e gli fece dono di due schiavi, con altre dimostrazioni della stima e compiacimento dell'operar suo. Per la Chiesa medesima di San Giovanni, entro la cappella della nazione Italiana dipinse due mezze figure sopra due porte, la Madalena e San Girolamo che scrive; e fece un altro San Girolamo con un teschio nella meditazione della morte, il quale tuttavia resta nel palazzo. Il Caravaggio riputavasi felicissimo con l'onore della croce e nelle lodi della pittura, vivendo in Malta con decoro della sua persona ed abbondante di ogni bene. Ma in un subito il suo torbido ingegno lo fece cadere da quel prospero stato e dalla benevolenza del Gran Maestro, poiché venuto egli importunamente a contesa con un cavaliere nobilissimo, fu ristretto in carcere e ridotto a mal termine di strappazzo e di timore. Onde per liberarsi si espose a gravissimo pericolo, ed iscavalcata di notte la prigione fuggí sconosciuto in Sicilia, cosí presto che non poté essere raggiunto. Pervenuto in Siracusa fece il quadro per la Chiesa di Santa Lucia che sta fuori alla Marina: dipinse la Santa morta col vescovo che la benedice; e vi sono due che scavano la terra con la pala per sepelirla. Passando egli dopo a Messina, colorí a' Cappuccini il quadro della Natività, figuratavi la Vergine col Bambino fuori la capanna rotta e disfatta d'assi e di travi; e vi è San Giuseppe appoggiato al bastone con alcuni pastori in adorazione. Per li medesimi Padri dipinse San Girolamo che sta scrivendo sopra il libro, e nella Chiesa de' Ministri de gl'infermi, nella cappella de' signori Lazzari, la Risurrezzione di Lazzaro, il quale sostentato fuori del sepolcro, apre le braccia alla voce di Cristo che lo chiama e stende verso di lui la mano.

210

almost as if he had not killed him with his sword, takes his knife from his side, seizing the saint by his hair in order to cut off his head. Herodias looks on intently, and an old woman is horrified by the spectacle, while the prison warden, dressed in a Turkish garment, points to the atrocious slaughter. In this work Caravaggio put all the force of his brush to use, working with such intensity that he let the priming of the canvas show through the half-tones. As a reward, besides the honor of the Cross, the Grand Master put a gold chain around Caravaggio's neck and made him a gift of two slaves, along with other signs of esteem and appreciation for his work. For the same church of San Giovanni, in the Italian Chapel, he painted two half-figures over two doors, the Magdalen and St. Jerome in the act of writing. He painted another St. Jerome with a skull, in meditation on death, which is still in the palace. Caravaggio was very happy to have been honored with the Cross and for the praise received for his painting. He lived in Malta in dignity and abundance. But suddenly, because of his tormented nature, he lost his prosperity and the support of the Grand Master. On account of an ill-considered quarrel with a noble knight, he was jailed and reduced to a state of misery and fear. In order to free himself he was exposed to grave danger, but he managed to scale the prison walls at night and to flee unrecognized to Sicily, with such speed that no one could catch him. In Syracuse he painted the altarpiece for the church of Santa Lucia in the port outside the city. He painted the dead St. Lucy blessed by the bishop; there are also two men who dig her grave with shovels. He then went to Messina, where he painted the Nativity for the Capuchin Fathers. It represents the Virgin and Child before a broken-down shack with its boards and rafters apart. St. Joseph leans on his staff, with some shepherds in adoration. For the same Fathers he painted St. Jerome, who is writing in a book, and in the Lazzari Chapel, in the church of the Ministri degl'Infermi, he painted the Resurrection of Lazarus who, being raised from the sepulchre, opens his arms as he hears the voice of Christ who calls him and extends his hand toward him.

Piange Marta e si maraviglia Madalena, e vi è uno che si pone la mano al naso per ripararsi dal fetore del cadavero. Il quadro è grande, e le figure hanno il campo d'una grotta, col maggior lume sopra l'ignudo di Lazzaro e di quelli che lo reggono, ed è sommamente in istima per la forza dell'imitazione. Ma la disgrazia di Michele non l'abbandonava, e 'l timore lo scacciava di luogo in luogo; tantoché, scorrendo egli la Sicilia, di Messina si trasferí a Palermo, dove per l'Oratorio della Compagnia di San Lorenzo fece un'altra 211 Natività; la Vergine che contempla il nato Bambino, con San Francesco e San Lorenzo, vi è San Giuseppe a sedere ed un angelo in aria, diffondendosi nella notte i lumi fra l'ombre.

Dopo quest'opera, non si assicurando di fermarsi piú lungamente in Sicilia, uscí fuori dell'isola e navigò di nuovo a Napoli, dov'egli pensava trattenersi fin tanto che avesse ricevuto la nuova della grazia della sua remissione per poter tornare a Roma; e cercando insieme di placare il Gran Maestro, gli mandò in dono una mezza figura di Erodiade con la testa di San Giovanni nel bacino. Non gli giovarono queste sue diligenze; perché, fermatosi egli un giorno su la porta dell'osteria del Ciriglio, preso in mezzo da alcuni con l'armi, fu da essi mal trattato e ferito nel viso. Ond'egli, quanto prima gli fu possibile montato sopra una feluca, pieno d'acerbissimo dolore s'inviò a Roma, avendo già con l'intercessione del card. Gonzaga ottenuto dal papa la sua liberazione. Pervenuto alla spiaggia, la guardia spagnuola, che attendeva un altro cavaliere, l'arrestò in cambio e lo ritenne prigione. E se bene fu egli tosto rilasciato in libertà, non però rivide piú la sua feluca che con le robbe lo conduceva. Onde agitato miseramente da affanno e da cordoglio, scorrendo il lido al piú caldo del sole estivo, giunto a Porto Ercole si abbandonò, e sorpreso da febbre maligna morí in pochi giorni, circa gli anni quaranta di sua vita, nel 1609, anno funesto per la pittura, avendoci tolto insieme Annibale Carracci e Federico Zuccheri. Cosí il Caravaggio si ridusse a chiuder la vita e l'ossa in una spiaggia deserta, ed allora che in Roma attendevasi il suo ritorno, giunse la

Martha is crying and Magdalen appears astonished, and there is a figure who puts his hand to his nose to protect himself from the stink of the corpse. The painting is huge, and the figures are in a grotto with brilliant light on the nude body of Lazarus and those who support him. This painting is very highly esteemed for its powerful realism. But misfortune did not abandon Michele, and fear hunted him from place to place. Consequently he hurried across Sicily and from Messina went to Palermo, wherehe painted another Nativity for the Oratorio of San Lorenzo. The Virgin is shown adoring her newborn child, with St. Francis, St. Lawrence, the seated St. Joseph, and above an angel in the air. The lights are diffused among shadows in the darkness.

After this he no longer felt safe in Sicily, and so he departed the island and sailed back to Naples, where he thought he would stay until he got word of his pardon allowing him to return to Rome. And hoping to placate the Grand Master, Caravaggio sent to him as a present a half-figure of Herodias with the head of St. John the Baptist in a basin. These efforts did not succeed. Indeed, one day at the doorway of the Osteria del Ciriglio he was surrounded by armed men who attacked him and wounded him in the face. Thus, as soon as possible, although suffering the fiercest pain, he boarded a *felucca* and headed for Rome, having by then obtained his freedom from the pope through the intercession of Cardinal Gonzaga. Upon his arrival ashore, a Spanish guard, who was waiting for another knight, arrested him by mistake, holding him prisoner. And when he was finally released he never again saw his *felucca* or his possessions. Thus, in a miserable state of anxiety and desperation, he ran along the beach in the heat of the summer sun. Arriving at Porto Ercole, he collapsed and was seized by a malignant fever that killed him in a few days, at about forty years of age, in 1609. This was a sad year for painting, since Annibale Carracci and Federico Zuccaro also died. Thus Caravaggio ended his life on a deserted beach while in Rome people were enthusiastically waiting for his return. But the unexpected news of his death arrived in Rome and saddened ev-

novella inaspettata della sua morte, che dispiacque universalmente; e 'l cavalier Marino suo amicissimo se ne dolse ed adornò il mortorio con li seguenti versi:

Fecer crudel congiura
Michele a' danni tuoi Morte e Natura;
Questa restar temea
Da la tua mano in ogni imagin vinta,
Ch'era da te creata, e non dipinta;
Quella di sdegno ardea,
Perché con larga usura,
Quante la falce sua genti struggea,
Tante il pennello tuo ne rifacea.

Giovò senza dubbio il Caravaggio alla pittura, venuto in tempo che, non essendo molto in uso il naturale, si fingevano le figure di pratica e di maniera, e sodisfacevasi piú al senso della vaghezza che della verità. Laonde costui, togliendo ogni belletto e vanità al colore, rinvigorí le tinte e restituí ad esse il sangue e l'incarnazione, ricordando a' pittori l'imitazione. Non si trova però che egli usasse cinabri né azzurri nelle sue figure; e se pure tal volta li avesse adoperati, li ammorzava, dicendo ch'erano il veleno delle tinte; non dirò dell'aria turchina e chiara, che egli non colorí mai nell'istorie, anzi usò sempre il campo e 'l fondo nero; e 'l nero nelle carni, restringendo in poche parti la forza del lume. Professavasi egli inoltre tanto ubbidiente al modello che non si faceva propria né meno una pennellata, la quale diceva non essere sua ma della natura; e sdegnando ogn'altro precetto, riputava sommo artificio il non essere obligato all'arte. Con la quale novità ebbe tanto applauso che a seguitarlo sforzò alcuni ingegni piú elevati e nutriti nelle megliori scuole, come fece Guido Reni, che allora si piegò alquanto alla maniera di esso, e si mostrò naturalista, riconoscendosi nella Crocifissione di San Pietro alle Tre Fontane, e cosí dopo Gio. Francesco da Cento. Per le quali lodi il Caravaggio non apprezzava altri che se stesso, chiamandosi egli fido, unico imitatore della natura; contuttociò molte e le megliori parti gli mancavano, perché non erano in lui né invenzione né decoro né disegno né scienza alcuna della pittura mentre tolto da gli occhi suoi il modello restavano vacui la mano e l'ingegno.

eryone. His very good friend, Cavalier Marino, mourned his death and honored his funeral with the following verses:

Death and Nature made a cruel plot against you, Michele;
Nature was afraid
Your hand would surpass it in every image
You created, not painted.
212 Death burned with indignation,
Because however many more
His scythe would cut down in life,
Your brush recreated even more.

Without doubt Caravaggio advanced the art of painting, for he lived at a time when realism was not much in vogue and figures were made according to convention and *maniera,* satisfying more a taste for beauty than for truth. Thus by avoiding all pettiness and falsity in his color, he strengthened his hues, giving them blood and flesh again, thereby reminding painters to work from nature. Consequently, Caravaggio did not use cinnabar reds or azure blues in his figures; and if he occasionally did use them, he toned them down, saying that they were poisonous colors. He never used clear blue atmosphere in his pictures; indeed, he always used a black ground, and black in his flesh tones, limiting the highlights to a few areas. Moreover, he claimed that he imitated his models so closely that he never made a single brushstroke that he called his own, but said rather that it was nature's. Repudiating all other rules, he considered the highest achievement not to be bound to art. For this innovation he was greatly acclaimed, and many talented and educated artists seemed compelled to follow him, as is the case of Guido Reni, who adopted much of his manner and demonstrated himself a realist, as we see in the Crucifixion of St. Peter in the church of the Tre Fontane; and so did also Giovan Francesco [Guercino] da Cento. Such praise caused Caravaggio to appreciate himself alone, and he claimed to be the only faithful imitator of nature. Nevertheless he lacked *invenzione,* decorum, *disegno,* or any knowledge of the science of painting. The moment the model was taken from him, his hand and his mind became empty.

Molti nondimeno, invaghiti della sua maniera, l'abbracciavano volentieri, poiché senz'altro studio e fatica si facilitavano la via al copiare il naturale, seguitando li corpi vulgari e senza bellezza. Così sottoposta dal Caravaggio la maestà dell'arte, ciascuno si prese licenza, e ne seguí il dispregio delle cose belle, tolta ogni autorità all'antico ed a Rafaelle, dove per la commodità de' modelli e di condurre una testa dal naturale, lasciando costoro l'uso dell'istorie che sono proprie de' pittori, si diedero alle mezze figure, che avanti erano poco in uso. Allora cominciò l'imitazione delle cose vili, ricercandosi le sozzure e le deformità, come sogliono fare alcuni ansiosamente: se essi hanno a dipingere un'armatura, eleggono la piú rugginosa, se un vaso, non lo fanno intiero, ma sboccato e rotto. Sono gli abiti loro calze, brache e berrettoni, e così nell'imitare li corpi si fermano con tutto lo studio sopra le rughe e i difetti della pelle e dintorni, formano le dita nodose, le membra alterate da morbi.

Per li quali modi il Caravaggio incontrò dispiaceri, essendogli tolti li quadri da gli altari, come in San Luigi abbiamo raccontato. La medesima sorte ebbe il Transito della Madonna nella Chiesa della Scala, rimosso per avervi troppo imitato una donna morta gonfia. L'altro quadro di Santa Anna fu tolto ancora da uno de' minori altari della Basilica Vaticana, ritratti in esso vilmente la Vergine con Giesú fanciullo ignudo, come si vede nella Villa Borghese. In Santo Agostino si offeriscono le sozzure de' piedi del pellegrino; ed in Napoli fra le sette Opere della Misericordia vi è uno che alzando il fiasco beve con la bocca aperta, lasciandovi cadere sconciamente il vino. Nella Cena in Emaus, oltre le forme rustiche delli due apostoli e del Signore figurato giovine senza barba, vi assiste l'oste con la cuffia in capo, e nella mensa vi è un piatto d'uve, fichi, melagrane fuori di stagione. Sí come dunque alcune erbe producono medicamenti salutiferi e veleni perniciosissimi, così il Caravaggio, se bene giovò in parte, fu nondimeno molto dannoso e mise sottosopra ogni ornamento e buon costume della pittura. E veramente li

213

Nonetheless many artists were taken by his style and gladly embraced it, since without any kind of effort it opened the way to easy copying, imitating common forms lacking beauty. Thus, as Caravaggio suppressed the dignity of art, everybody did as he pleased, and what followed was contempt for beautiful things, the authority of antiquity and Raphael destroyed. Since it was easy to find models and to paint heads from life, giving up the history painting appropriate for artists, these people made half-figures, which were previously uncommon. Now began the imitation of common and vulgar things, seeking out filth and deformity, as some popular artists do assiduously. So if they have to paint armor, they choose to reproduce the rustiest; if a vase, they would not complete it except to show it broken and without a spout. The costumes they paint consist of stockings, breeches, and big caps, and in their figures they pay attention only to wrinkles, defects of the skin and exterior, depicting knotted fingers and limbs disfigured by disease.

Because of his style Caravaggio encountered dissatisfaction, and some of his paintings were taken down from their altars, as we saw in the case of San Luigi. The same thing happened to his Death of the Virgin in the Chiesa della Scala, which was removed because he had shown the swollen body of a dead woman too realistically. The other picture, of St. Anne, was also removed from one of the minor altars of St. Peter's because of the offensive portrayal of the Virgin with the nude Christ child, as we can see in the Villa Borghese. In Sant'Agostino we are presented with the filthy feet of the pilgrim; in Naples, in the picture of the Seven Works of Mercy, a man is depicted raising his flask in the act of drinking, with his mouth wide open as the wine flows coarsely into it. In the Supper at Emmaus, in addition to the vulgar conception of the two Apostles and of the Lord who is shown young and without a beard, the innkeeper wears a cap, and on the table is a dish of grapes, figs, and pomegranates out of season. Just as certain herbs produce both beneficial medicine and most pernicious poison, in the same way, though he

pittori, sviati dalla naturale imitazione, avevano bisogno di uno che li rimettesse nel buon sentiero; ma come facilmente, per fuggire uno estremo, s'incorre nell'altro, così nell'allontanarsi dalla maniera, per seguitar troppo il naturale, si scostarono affatto dall'arte, restando ne gli errori e nelle tenebre; finché Annibale Carracci venne ad illuminare le menti ed a restituire la bellezza all'imitazione.

Tali modi del Caravaggio acconsentivano alla sua fisonomia ed aspetto: era egli di color fosco, ed aveva foschi gli occhi, nere le ciglia ed i capelli; e tale riuscì ancora naturalmente nel suo dipingere. La prima maniera dolce e pura di colorire fu la megliore, essendosi avanzato in essa al supremo merito e mostratosi con gran lode ottimo coloritore lombardo. Ma egli trascorse poi nell'altra oscura, tiratovi dal proprio temperamento, come ne' costumi ancora era torbido e contenzioso; gli convenne però lasciar prima Milano e la patria; dopo fu costretto fuggir di Roma e di Malta, ascondersi per la Sicilia, pericolare in Napoli, e morire disgraziatamente in una spiaggia. Non lascieremo di annotare li modi stessi nel portamento e vestir suo, usando egli drappi e velluti nobili per adornarsi; ma quando poi si era messo un abito, mai lo tralasciava finché non gli cadeva in cenci. Era negligentissimo nel pulirsi; mangiò molti anni sopra la tela di un ritratto, servendosene per tovaglio mattina e sera. Sono pregiati li suoi colori dovunque è in conto la pittura; fu portata in Parigi la figura di San Sebastiano con due ministri che gli legano le mani di dietro: opera delle sue megliori. Il conte di Benavente, che fu viceré di Napoli, portò ancora in Ispagna la Crocifissione di Santo Andrea, e 'l conte di Villa Mediana ebbe la mezza figura di Davide e 'l ritratto di un giovine con un fiore di melarancio in mano. Si conserva in Anversa, nella Chiesa de' Domenicani, il quadro del Rosario, ed è opera che apporta gran fama al suo pennello. Tiensi ancora in Roma essere di sua mano Giove, Nettunno e Plutone nel Giardino Ludovisi a Porta

214

produced some good, Caravaggio has been most harmful and wrought havoc with every ornament and good tradition of painting. It is true that painters who strayed too far from nature needed someone to set them on the right path again—but how easy it is to fall into one extreme while fleeing from another. By departing from the *maniera* in order to follow nature too closely, they moved away from art altogether and remained in error and darkness until Annibale Carracci came to enlighten their minds and restore beauty to the imitation of nature.

Caravaggio's style corresponded to his physiognomy and appearance; he had a dark complexion and dark eyes, and his eyebrows and hair were black; this coloring was naturally reflected in his paintings. His first style, sweet and pure in color, was his best; he made a great achievement in it and proved that he was a most excellent Lombard colorist. But afterward, driven by his own nature, he retreated to the dark style that is connected to his disturbed and contentious temperament. At first he had to flee Milan and his homeland; then he was compelled to flee from Rome and Malta, to hide in Sicily, to be in danger in Naples, and finally to die miserably on a beach. We cannot fail to mention his behavior and his choice of clothes, since he wore only the finest materials and princely velvets; but once he put on a suit of clothes he changed only when it had fallen into rags. He was very negligent in washing himself; for years he used the canvas of a portrait for a tablecloth, morning and evening. Caravaggio's colors are prized wherever art is valued. The painting of St. Sebastian with his hands tied behind his back by two executioners, one of his best works, was taken to Paris. The Count of Benevento, who was Viceroy of Naples, took the Crucifixion of St. Andrew to Spain; the Count of Villamediana owned the half-figure of David and the portrait of a Youth with an Orange Blossom in his hand. In the church of the Dominicans in Antwerp is the painting of the Rosary, which brought great praise to Caravaggio. In Rome in the Ludovisi Gardens near the Porta Pinciana, they attribute to Caravaggio the Jupiter, Neptune, and Pluto in

Pinciana, nel casino che fu del cardinale Del Monte, il quale essendo studioso di medicamenti chimici, vi adornò il camerino della sua distilleria, appropiando questi dei a gli elementi col globo del mondo nel mezzo di loro. Dicesi che il Caravaggio, sentendosi biasimare di non intendere né piani né prospettiva, tanto si aiutò collocando li corpi in veduta dal sotto in su che volle contrastare gli scorti piú difficili. È ben vero che questi dei non ritengono le loro proprie forme e sono coloriti ad olio nella volta, non avendo Michele mai toccato pennello a fresco, come li suoi seguaci insieme ricorrono sempre alla commodità del colore ad olio per ritrarre il modello. Molti furono quelli che imitarono la sua maniera nel colorire dal naturale, chiamati perciò naturalisti; e tra essi annoteremo alcuni che hanno maggior nome. . . .

the casino of Cardinal Del Monte, who was interested in chemical medicines and adorned the small room of his laboratory, associating those gods with the elements with the globe of the world placed in their midst. It has been said that Caravaggio, reproached for not understanding either planes or perspective, placed the figures in such a position that they appear to be seen from sharply below, so as to vie with the most difficult foreshortenings. It is indeed true that those gods do not retain their proper forms, and are painted in oil on the vault, since Michele had never painted in fresco; just as all his followers prefer the easy way of oil painting when portraying the model. Many were those who imitated his style of painting from nature and were therefore called naturalists. And among them we shall note some who gained a great name. [There follow brief biographies of Bartolomeo Manfredi, Carlo Saraceni, Giuseppe Ribera, Valentin, and Gerrit van Honthorst.]

7. LUIGI SCARAMUCCIA

Luigi Scaramuccia, *Le finezze de' pennelli italiani* (Pavia, 1674), is an old-fashioned dialogue about painting from an idealist position, between "Girupeno" (Perugino; Scaramuccia was from Perugia) and the genius of Raphael ("Genio"). His information about Caravaggio is of no importance apart from the report about a painting, now lost, in Sant'Anna dei Lombardi in Naples.

In questo mezzo Aniello venne in parere di far noto alli due Forestieri alcune cose di Michel'Angelo da Caravaggio, che con occasione del suo passaggio à Malta (trattenendosi alcun tempo in Napoli) lasciò del suo Pennello, ed' una di queste si fù una Tavola d'Altare situata nella Chiesa di S. Anna de Lombardi, ov'è la Resurettione di Christo, come altresì un'altra nel Tempio della Misericordia sopra l'Altar Maggiore, nella cui per appunto vi espresse le Sette Opere della Misericordia con modo pittoresco, ed' in tutto bizzarro; doppo ciò haver veduto si tragittarono di bel nuovo nella sodetta Chiesa di S. Anna à rimirar più curiosamente l'altra, e quando osservarono il Christo, non come d'ordinario far si

In this way Aniello came by comparison to show the two foreigners some works that Michelangelo da Caravaggio, who at the time of his trip to Malta (he had stayed for a time in Naples) had made with his brush; and one of these was the altarpiece for the church of Sant'Anna dei Lombardi, with the Resurrection of Christ, as well as another one in the church of the Misericordia over the high altar in which he indeed had depicted the Seven Acts of Mercy in a very picturesque and bizarre fashion. Afterward they went again to the above-mentioned church of Sant' Anna to admire the other work more carefully, seeing not the usual Christ who appears quite agile and triumphant in the air. Rather, with his

suole, agile, e trionfante per l'aria; mà con quella sua fierissima maniera di colorire, con un Piede dentro, e l'altro fuori del Sepolcro posando in terra, restarono per simile stravaganza con qualche apprensione, tanto che richiese Girupeno al Genio suo Maestro se potea immiaginarsi per che ciò havesse fatto il Caravaggio. A che rispose il Genio. Quantunque questo Pittore habbi dato in tal bizzaria, e che per essa ne sia stato gradito, piacendo ad ogn'uno la novità dell'inventioni, non resta però ch'ei non ne possa venirne (da coloro, che sanno) alquanto biasimato, essendo uscito assai da quel decoro, che si conviene alla Persona di Christo Signor Nostro. Per finirla è stato quest'Huomo un gran Soggetto, mà non Ideale, che vuol dire non saper fare cosa alcuna senza il naturale avanti. . . .

bold manner of painting, he showed him with one foot inside and the other outside the tomb on the ground, and because of such extravagance they remained apprehensive—so much so that Girupeno asked Genio, his teacher, if he could imagine why Caravaggio had produced those images. Genio answered: Although this painter abandoned himself to such oddities, nevertheless people were grateful for them, because they were pleased by the novelty of his creations; at the same time it was possible for him to be criticized (by those who knew) because here he abandoned the decorum appropriate to the portrayal of Christ our Lord. And, to conclude the question, as a matter of fact, this man was great at subjects but not at ideals, which means that he did not know how to make anything without the actual model before his eyes.

8. JOACHIM VON SANDRART

Joachim von Sandrarts Academie der Bau-, Bild- und Mahlerey-Künste von 1675 (ed. A. R. Peltzer, Munich, 1925, pp. 275–277). The *Life of Caravaggio* appears in the *"Zweiten Buch des Zweiten Teiles"* of the first published volume of Sandrart's massive publication, which appeared in Nuremberg in 1675. The edition by Peltzer is abridged —it lacks most of the fine engravings that ornament the original—but it is complete where Caravaggio's life is concerned and is much the more convenient to consult. Sandrart makes obvious use of his predecessors, despite his own knowledge derived from residence in Rome in the Palazzo Giustiniani between 1629 and 1635, when he illustrated the massive volumes commemorating Giustiniani's collections of antiquities, the *Galleria Giustiniana*. Thus he repeats nonsense from Van Mander and makes other mistakes that betray the late date of his writing (cf. p. 209, n. 1).

LXXXII. Michael Angelo, gebürtig von Caravaggio, einen Ort in Langobardia unweit Mailand gelegen, ware zwar von guten Eltern des Adelichen Geschlechts Amarigi, aber durch große Begierde zu der edlen Mahlkunst merklich aufgestiegen, wie er dann zu Rom viele bewunderungswürdige Werke gefärtiget. Es ware dieser Caravaggio unter allen Italienern der erste, welcher seine Studien von denen angewöhnten alten Manieren ab und auf die einfältige Ausbil-

275 Michelangelo, born in Caravaggio in Lombardy, not far from Milan, was from a good family of the noble line of Amarigi, but rose markedly through his great passion for painting. It was Caravaggio who among all the Italians first gave up the customary Mannerism and took up the study of nature. Consequently he was determined not to make a brushstroke that was not from life, and to that end he placed the model before him in his room in order to copy it as well

dung der Natur, nach dem Leben zoge. Dannen-
hero beflisse er sich, keinen Strich anderst als nach
dem Leben zu thun und stellte sich zu dem Ende
dasjenige, so er abbilden wolte, in seinem Zim-
mer so lang in der Natur vor, biß er solcher nach
Genüge in seiner Arbeit nachgefolget. Damit er
aber auch die vollkommene Rondirung und
natürliche Erhebung desto bäßer herfür bringen
möchte, bediente er sich fleißig dunkler Ge-
wölber oder anderer finsterer Zimmer, die von
oben her ein einiges kleines Liecht hatten, damit
die Finsterniß dem auf das model fallenden
Liecht durch starke Schatten seine Macht lassen
und darmit eine hocherhobene Rundierung
verursachen möchte.

So verachtete er nun alles, was nicht nach
dem Leben gemacht war, nannte es Bagatell,
Kinder- und Bossen-Werk, weil nichts bässers
seyn könte, als was der Natur am ähnlichsten.
Und zwar ist auch solches kein übel Weg, zur
Vollkommenheit zu gelangen, weilen nach den
Zeichnungen und Gemälde niemals so gut als die
Natur selbst seyn können, sie seyen auch so
schön, als sie immer wollen. Dannenhero folgten
seiner Manier fast durchgehends alle Italienische
Mahler nach, bereiteten sich auch Mahlzimmer
nach seiner Art, und ist hernach diese Manier
auch in Hoch- und Nieder-Teutschland nach-
geahmet worden.

Obwol er nun wegen seiner großen Kunst
hohen Ruhms würdig geachtet, auch von männig-
lich gelobet wurde, so ware doch sehr übel mit
ihm umzugehen, weil er nicht allein von keines
einigen Meisters Arbeit sehr viel hielte (wiewol
er seine eigne auch nicht offentlich rühmte)
sondern darbey auch sehr zänkisch und seltsam
ware und gerne Raufhändel suchte. Von dieser
seiner bösen Gewonheit angetrieben, kam er auch
mit dem damals florirenden Mahler Josepho
d'Arpin in Händel, welcher sonst wegen seiner
Kunst, Höflichkeit und großen Reichtum hoch-
gehalten wurde. Diesen griffe unser Künstler
nicht allein mit spitzfindigen Stichelreden an, 276
sondern mahlte ihm auch zu trutz und Spott eine
Historie zu S. Lorenzo in Damas, neben die, so
gemeldter Joseph dahin gemacht: In selbiger bil-
dete er einen nackenden Riesen, der über Josephs

as he could. And in order to bring out better
those effects of relief and natural roundness, he
used dark vaults or other shadowed rooms with
one small light above, so that the light falling on
the model made strong shadows in the darkness
and so emphasized the effect of relief.

He despised anything that was not done
from life, calling it bagatelles, child's play, and
rustic work, because nothing could be better than
the closest imitation of nature. And indeed, that
is no bad way to achieve perfection, since draw-
ings and paintings can never be as good as nature,
be they ever so beautiful. Henceforth his style
was imitated by almost all the Italian painters,
and now it is also imitated in southern and north-
ern Germany.

Although his art gained him great fame
and was praised highly by all and sundry, it was
nevertheless very difficult to get along with him.
Not only did he hold the work of other masters
in slight esteem (though he did not praise his
own works openly either), but he was quarrel-
some and odd and gladly looked for fights.
Owing to these bad habits, he got into trouble
with Giuseppe d'Arpino, then a prominent
painter who was held in high esteem because of
his art, cultivation, and great wealth. Our artist
not only attacked Arpino with pointed epithets
but next to his painting in San Lorenzo in
Damaso he painted a giant who sticks out his
tongue in order to ridicule it. In the beginning
he painted many portraits and half-lengths in a
hard, dry manner, in one of which is a child with
a basket full of flowers and fruits, out of which

Werk die Zunge ausstreckte, als ob er dasselbe verspotten wolte. Im Anfang mahlte er auf scharfe truckene Manier, bildete viel Angesichter und halbe Bildere, deren eins ein Kindlein mit einem Kretzen voll Blumen und Obst gehalten, woraus ein Eydex das Kind in die Hand gebissen, deßwegen solches bitterlich scheinte zu weinen, daß es vortreflich zu sehen, wormit sein Lob durch Rom merklich gewachsen. Und weil Arpino meistens große Werke in fresco gemacht, selbige aber vor sich selbst nimmermehr in Colorit noch Stärke oder eigentlichen Wahrheit den Oelfarben gleichen, hingegen Caravaggio in diesen Stucken ganz verwunderlich ware, forderte er den Joseph und andere mehrere in einen Wettstreit heraus, wordurch endlich Händel entstanden und sie zu den Degen gegriffen auch ein Jüngling, genannt Ranuccio Tomassino, darunter todt geblieben, weßhalben Caravaggio weichen und sich in den Palast unsers Marches Justinians, als Protectors aller Virtuosen, retiriren muste, der seine Arbeit hoch geachtet, auch von selbigen zum meisten gehabt, die doch sonst schwerlich zu bekommen waren.

In wärender Zeit nun, da er sich so verstecken muste, mahlte er in gedachten Palast, wie Christus des Thomas Finger in Gegenwart der andern Aposteln in seine heiligen Wunden steckt. Da bildete er nun in aller Anwesenden Angesichtern durch gutes mahlen und rundiren eine solche Verwunderung und Natürlichkeit an Haut und Fleisch aus, daß meist alle andere Gemälde dabey nur als illuminirt Papier scheinen. Ingleichen mahlte er den Evangelisten Matthaeus, welchem ein Engel in weißem Kleid das Buch vorhält, darin er schreibt, und noch andere Figuren sehr groß; dann seine meiste Profession ware Lebensgroße, halb und ganze Bilder dem Leben gleich zu machen. Er mahlte auch für La Madonna Dal populo, in einer Capelle, die Creutzigung S. Peters, auch wie S. Paulus von dem Pferd fallend aufgehoben wird; das Pferd ist ein Scheck und scheint lebendig zu seyn.

Wiederum mahlte er zwey große Blätter zu S. Luigi di Francesci, bey Prinz Justinians Palast über. Das erste war, wie Christus, unser Seeligmacher, die Juden, Käuffer und Zöllner

a lizard bites him on the hand, making him seem to cry bitterly, which is wonderful to see and made his reputation grow notably all over Rome. And because Arpino worked mainly in fresco, which never has the same strength of coloration or the inherent truth of oil colors, in which Caravaggio was marvelous, he laid down a challenge to Giuseppe and others that led finally to quarrels and drawn swords, and a youth, called Ranuccio Tomassino, whom Caravaggio killed, died of it. Caravaggio had to hide in the palace of Marchese Giustiniani, the protector of all virtuosi, who prized his works and had the largest quantity of them, though they were usually difficult to come by.

During that time of hiding he painted in the aforesaid palace the Thomas putting his finger in Christ's holy wound in the presence of other Apostles. In it he represented the faces of all those present through such good painting and modeling of face and flesh that it makes most other pictures look like colored paper. Similarly, he painted Matthew the Evangelist writing in a book held by an angel in a white garment, and other very large figures; for most of his work contained life-size, half-, and full-length figures, like life. He also painted for the Madonna del Popolo, in a chapel, the Crucifixion of St. Peter and also how St. Paul was picked up after falling off his horse; the horse is piebald and seems alive.

He also painted two large works for San Luigi dei Francesi, near Prince Giustiniani's palace. The first shows Christ, our Redeemer, driving the Jews, Merchants, and Customs men from

samt ihren Krämen und Kaufftischen über Hauffen wirft und sie aus dem Tempel treibet; noch verwunderlicher aber ist das ander Blat, worinnen vorgestellt, wie Christus in ein finster Zimmer mit zween der seinen eingetreten und den Zöllner Matthaeum bey einer Rott Spitzbuben mit Karten und Würflen spielend und trinkend sitzen findet. Matthaeus, als furchtsam, verbirgt, die Karten in der einen Hand, die andre legt er auf seine Brust und gibt in seinem Angesicht den Schrecken und die Schamhaftigkeit zu erkennen, die er darüber gefast, daß er als unwürdig von Christo zum Apostelamt beruffen wird; einer streicht mit der einen Hand sein Geld vom Tisch in die andere und machet sich ganz schamhaft davon, welches alles dem Leben und der Natur selbst gleichet. Mehr ist von seiner Hand in Rom zu sehen, alla Chiesa Nova die Grablegung Christi, wovon ich eine gute Copia zeigen kan; Al Santo Augustino unser liebe Frau mit dem Kindlein Jesus, das von zweyen knienden Pilgramen angebetet wird. Zu Antorf ist in der Dominicaner-Kirch ein großes Blat, wie S. Domenico den Andächtigen den Rosenkranz austheilet, und ferner ebendaselbst unser lieben Frauen Verscheidung in beyseyn der meisten Aposteln, so gleichfalls ein sehr großes Werk ist.

Nachmalen mahlte er für unsere Kunst Vatter Marches Justinian einen Cupido in Lebensgrösse nach Gestalt eines ohngefehr zwölffjährigen Jünglings, sitzend auf der Weltkugel und in der Rechten seinen Bogen über sich haltend, zur Linken allerley Kunstinstrumenta, auch Bücher zu Studien und ein Lorbeerkranz auf den Büchern; Cupido hatte nach seiner Gestalt große braune Adlersflügel, alles zusammen in Corectura gezeichnet, mit starker colorit, Sauberheit und solcher Rundirung, daß es dem Leben wenig nachgegeben. Dieses Stuck ware neben andern hundert und zwanzigen, von den fürtreflichsten Künstlern gemacht, in einem Zimmer und offentlich zu sehen, aber es wurde auf mein Einrahten mit einem dunkelgrün seidenen Vorhang bedeket und erst, wann alles andere zu Genüge gesehen worden, zuletzt gezeigt, weil es sonsten alle andere Raritäten unansehentlich gemacht, so daß es mit guten Fug eine Verfinsterung aller

the Temple, their stalls and counters all over-turned; but even more marvelous is the other piece, in which Christ, with two followers, enters a dark room where the tax collector Matthew is shown seated with a bunch of rogues playing cards and throwing dice and drinking. Matthew, as if afraid, hides the cards in one hand and lays the other on his chest, and his face reveals the shock and shame that he feels because he is unworthy of being called by Christ to the apostolate. One of them moves his money from the table with one hand into the other hand and looks shamefaced, all of which seems to imitate life and nature. There is more to be seen by his hand in Rome; in the Chiesa Nuova the Entombment of Christ, of which I can show a good copy; in Sant'Agostino Our Lady with the Christ child, worshipped by two kneeling pilgrims. In Antwerp in the Dominican church a large canvas, showing St. Dominic distributing rosaries to the pious, and also by him is Our Lady's Death in the presence of most of the Apostles, also a very great work.

In addition he painted for our art patron, Marchese Giustiniani, a life-size Cupid after a boy of about twelve years of age, sitting on the globe and holding his bow in the right hand. In his left are all kinds of instruments, also bound books and a crown of laurel on the books. Cupid has large brown eagle's wings, all drawn correctly, with such powerful coloration, clarity, and relief that it comes to life. This piece was shown publicly in a room together with another 120 paintings by the most outstanding artists; but at my suggestion it was given a dark green silk covering, and only when all the others had been seen properly, was it finally exhibited, because it made all the other rarities seem insignificant, so that with good reason it could be said to eclipse all other paintings. A prominent nobleman liked it so much that he offered as much as 1000 *pistole* for it. But when I brought this offer to our patron, who had an income of 80,000 or 90,000

Gemälden mag genennet werden. Dernthalben beliebte es auch einem fürnehmen Cavallier so wol, daß er in Beyseyn unserer vieler 1000 Pistoleten dafür offerirt. Aber unser Patron, welcher jährlich in die 80 biß 90000 Cronen mehr Einkommens gehabt, als was er jährlich (da doch an Kunstsachen grosse Summen aufgegangen) verzehrt hat, wie ich ihme dieses Erbieten, indeme er am Podagra krank gelegen, vorgetragen und eine Antwort begehrt, [hat] darüber gelächelt und gesprochen: Dite â questo Corteggio Cavallier, che se egli mi puol far acquistar un altro quadro di questa sostanza, gli ne pagerò il doppia cioè 2000 Pistole. Blieb also der Kauf zurück und das Lob der verlangten Kunst-Vollkommenheit bey diesem so hoch berühmten Cupido des Marchesen Justinian. Er brachte auch durch dieses Werk zuwegen, daß ihm wieder erlaubt wurde, frey auf den Straßen zu handeln und zu wandeln, dessen er sich dann gleich mit seinen jungen Leuten, meist keker herzhafter Gesellen, Mahler und Fechter, die sich wol des Sprichworts nec spe, nec metu, ohne Hoffnung und Furcht, bedient.

Bald darauf geschahe es, daß Joseph d'Arpin zu Pferd nach Hof geritten und ihme Michael Angelo da Caravaggio begegnet, der ihn dann alsobald anredte und zuschrie: Es wäre nun eben die rechte Zeit, ihren alten Streit mit dem Degen gegeneinander auszumachen, weil sie beede mit Gewehr versehen, er solte nur fein bald von Pferd heruntersteigen, und machte sich also zum rauffen färtig. Joseph aber antwortete, daß ihme, als vom Papst gemachten Cavalier, nicht gezieme, sich in Streit einzulassen gegen einem, der kein Cavalier seye, mit welchem höflichen Streich und Antwort er den Caravaggio mehrer verwundt als mit seinem Degen geschehen mögen, indeme solche Rede Caravaggio also bestürzt und verirrt gemacht, daß er alsobald (weil er nicht auszusetzen gedacht) alles das Seinige den Juden um paar Geld verkaufft und sich nacher Malta zu dem Großmeister begeben, mit dem Vornehmen, auch bald Ritter und Cavalier zu werden; massen er generos wider den Türken seine Caracannen vollbracht, auch allda die Enthauptung des H. Johannis Baptistae, die daselbst

277 crowns over and above his expenditures (including huge sums for art), who was then suffering from gout, he laughed and said: "Tell that courteous gentleman that if he can help me acquire another painting of that quality, I will pay him double the sum, or 2000 *pistole.*" Thus the sale was off, and the glory of artistic perfection of this most famous Cupid remained Marchese Giustiniani's. Through this work Caravaggio also got permission to go freely in the streets, which he then did with his young friends, mainly lusty fellows, painters and swordsmen, who had as their motto *nec spe, nec metu*—without hope or fear.

Soon afterward it happened that Giuseppe d'Arpino, riding to court on horseback, met Michelangelo da Caravaggio, who accosted him and said: "This is the time to settle our quarrel, since we are both armed," and told him to get off his horse and prepare to fight. Giuseppe, however, answered that as a papal knight he could not deign to fight with one who was not of that rank. This courtly answer wounded Caravaggio more deeply than a sword-thrust might have, and it so upset and maddened him that he immediately (because he had no intention of delaying) sold all his possessions to the Jews for cash and set out for Malta to have the Grand Master make him a knight and *cavaliere*. He generously outfitted a man-of-war to fight against the Turks, and he painted the Beheading of St. John the Baptist in the church at Malta, which is marvelous because of its truth to nature, as well as some other paintings. Since he had now been dubbed a knight, he set off at once for Rome in order to settle his score with Arpino. However, his haste produced a high fever, and it was precisely in

zu Malta in der Kirche steht, und sehr verwunderlich ist, weil selbige die wahre Natürlichkeit scheint, mit noch wenig andern Gemälden gemacht. Als er nun zum Ritter geschlagen worden, hat er gleich darauf nacher Rom stark zugeeilt, um vorhabenden seinen Rauffhandel mit dem von Arpin auszumachen. Diese Eile aber hat ihm ein hitziges Fieber verursacht, und ist er eben zu Arpin, wo sein Widersacher geboren, der sich auch deshalben von selbigem Ort schreibet, erkranket ankommen und gestorben. Sein End wurde von allen fürnehmen Häuptern in Rom beklaget, weil er noch viel Gutes in dieser Kunst hätte mögen an Tag bringen. Sein Contrafät ist in der Kupferblatte S zu finden und hat er von Discipeln die in unserer Beschreibung nachfolgende hinterlassen.

Arpino, where his enemy was born and called himself after that place, that he became ill and died. His end was mourned by all the highplaced gentlemen of Rome because he might still have done much of worth in his art.

9. FRANCESCO SUSINNO

Francesco Susinno, *Le vite de' pittori messinesi.* Manuscript dated 1724. First published by Valentino Martinelli (Florence, 1960). Susinno was called "Susino" by early writers; his opinions were known through extracts and versions of his manuscript and were the basis of Filippo Hackert's *Memorie de' pittori messinesi* (Naples, 1792). Susinno, who called himself *"pittore"* on the title page of his manuscript, was a priest who had studied in Rome and had studied painting in Naples. His *Lives* are unique for their local lore, and for that reason his stories about Caravaggio and Caravaggio's friend Mario Minnitti of Syracuse are of interest, if not necessarily reliable. In the excerpt that follows, the marginal numbers are the pages of Martinelli's edition, which cites the manuscript pages from the source in the Basel Kunstmuseum (Kupferstichkabinett). I have omitted some extraneous material that shows Susinno to be both garrulous and credulous.

. . . poscia andossene a Malta. In quell'isola fu dal gran maestro Vignacourt, signore di nazione francese, accolto amorevolmente, perché del Caravaggio ammiravasi da per tutto la perizia del suo pennello e se ne ambivano le opere. Non indugiò quell'eminenza impiegarlo al Martirio di S. Giovanni, opera di gran valore per la quale fu riconosciuto dal sudetto gran maestro con una collana d'oro, dui schiavi ed altre ricompense

109 . . . he then went to Malta. On that island Caravaggio was warmly welcomed by the Grand Master Wignacourt, a French nobleman, because the skills of Caravaggio's brush were greatly appreciated and his works highly desired. His Eminence did not delay in commissioning the Martyrdom of St. John, a work of art of immense value for which the Grand Master honored him with a gold necklace, two slaves, and other re-

degne della liberalità di un tal signore. Ritrasse lo stesso gran maestro in pie' armato. Formò un altro ritratto del medesimo signore vestito in abito signorile di pompa; per le quali belle opere fu dichiarato cavaliere dell'abito.

Tutto che si vedesse Michelagnolo colla croce in petto, non solo non lasciò la torbidezza del suo naturale, anzi vié più lasciò acciecarsi dalla pazzia di stimarsi cavaliere nato. La marca de' cavalieri non ostentasi con l'orgoglio, ma rendesi commendabile colla piacevolezza. Divenne egli però così ardito che ardì un giorno competerla con alcuni cavalieri, ed affrontatone uno di giustizia, fu astretto il medesimo Vignacourt serrarlo in un castello. Ma di notte tempo, scalati i muri fuggì in Sicilia, e ricovratosi nella città di Siracusa fu ivi accolto dall'amico suo e collega nello studio di pittura, Mario Minnitti pittore siracusano, da cui ricevette tutta la compitezza che poté farle la civiltà di un tal galantuomo. Lo stesso supplicò quel senato della città acciò impiegasse il Caravaggio in qualche lavoro, e così potesse aver campo di godere per qualche tempo l'amico ed altresì osservarsi a qual grado di altezza erasi portato Michelagnolo, mentre se ne udiva grande il rumore e ch'egli fosse in Italia il primo dipintore.

L'autorità di quel magistrato non pose in non cale l'occasione, ed insubito l'impiegò nella fattura di una gran tela della vergine e martire S. Lucia siciliana. Oggi giorno ammirasi nella chiesa de' Padri Riformati di S. Francesco, dedicata alla stessa gloriosa santa, fuori le mura della medesima città. In questa gran tela il dipintore fece il cadavere della martire disteso in terra, mentre il vescovo con il popolo viene per sepellirlo e due facchini, figure principali dell'opera, una di una parte ed una dall'altra, con pale in azzione che fanno un fosso acciò in esso lo collochino.

Riuscì di tal gradimento questa gran tela che comunemente vien celebrata, ed è tale di questa dipintura il meritato concetto che in Messina ed altresì in tutte le città del regno se ne veggono molte copie.

wards worthy of the magnanimity of this gentleman. Caravaggio painted the portrait of the Grand Master standing in armor and another of the same gentleman dressed in ceremonial garments. For these two works Caravaggio was named *Cavaliere dell'abito*.

Michelangelo with the Cross on his chest did not abandon his natural belligerence but let himself be blinded by the madness of thinking himself to be a nobleman born. The mark of knighthood is not manifested by presumptuous action; the knight must render himself commendable by pleasantness. Nevertheless he became so daring that one day he had the courage to compete with some other swordsmen and to affront the Cavaliere of Justice. Wignacourt was forced to imprison him in a castle. But one night Caravaggio scaled the wall and fled to Sicily, arriving in the city of Syracuse, where he was welcomed by his friend and colleague in the study of painting, Mario Minnitti, a painter from Syracuse, from whom he received all the kindnesses that such a gentleman could extend to him. Minnitti himself implored the Senate of that city to employ Caravaggio in some way so that he could have the chance to enjoy his friend for some time and be able to evaluate the greatness of Michelangelo, for he had heard that people considered him to be the best painter in Italy.

Through its authority, the Senate gave Caravaggio the commission for a large canvas of the virgin and martyr St. Lucy of Sicily. Today one can still admire this painting, which was dedicated to that glorious saint in the Franciscan church outside the walls of the city of Syracuse. In this large canvas the painter depicted the dead body of the martyr stretched out on the ground while the bishop and the people come to bury her, and two handymen with shovels, who are the largest figures in this work, one on one side and the other on the other, dig a grave in which to lay the body to rest.

This big canvas came out so well that it became famous; the idea behind it was so good that there are many copies in Messina and in other cities of the Regno.

L'inquietissimo cervello di Michelagnolo, amando vagare pel mondo, lasciò gli agi della casa dell'amico Minnitti. Portossi alla città di Messina: e perché da per tutto ogni novità basta sola per oscurare qualunque bello e vago, ancorché invecchiato, di facile sortì attirarsi l'attenzione e la maraviglia con la novità. In que' tempi fiorivano Cattalani l'Antico, il Cumandeo, pittori molto celebri, ed altri. La nuova fama del Caravaggio, giungendosi al genio simpatico de' messinesi molto inchinanti a' forastieri, e l'effettivo merito di un tal uomo ferono che restasse nella medesima città e quivi fusse impiegato per alcuni lavori.

Dovendosi da certi signori ricchi di casa Lazzaro erger una nuova cappella nell'altare maggiore della Chiesa de' Padri Crociferi, pensarono commettere la gran tela a questo virtuoso, con cui si aggiustarono pel prezzo di mille scudi. Il pittore ideossi la Resurrezione di Lazzaro, pensiero allusivo al loro casato. N'ebbero i predetti signori molto gradimento, imperoché aveva l'artefice aperto campo da potervi felicemente condurre la sua ideata fantasia. Ragionevol cosa si è che i grand'ingegni si lascino operare a loro bell'aggio, giacché quasi legate sono amendue le mani a que' pittori, allorché vengono richiesti di qualche opera in tale o tal maniera, o in tal forma. Soleva fra Mattia Preti calabrese (Cara- 111 vaggio del secolo passato, e detto volgarmente il cavalier Mattia) tutte le volte che gli veniva commessa qualche pittura colla strettezza di tale e tale figura, allorché alla sua perfezione l'aveva portata, stupirsi come avesse potuto terminare colle mani tra' ceppi tal cosa. Portatasi alfine dal Caravaggio la gran tela rappresentante la Resurrezione di Lazzaro, come dianzi si è detto, opera così sospirata da coloro che l'aveano commessa, sempre tenuta secreta dall'autore nell'andarla perfezionando, ammirossene il compimento. E perché della facoltà pittrice ognuno ardisce e prosume discorrere secondo il costume, tra la comitiva fuvvi chi ne facesse qualche picciolo motivo, non già per criticare la perizia del Caravaggio, ma per così parergli. Michelagnolo colla solita impatienza sguainò il pugnale che in ogni tempo al fianco portar soleva; gli die' tanti

The unquiet nature of Michelangelo, which loved to wander the earth, soon after led him to leave the home of his friend Minnitti. He then went to Messina; and since novelty prevails everywhere over beauty and grace, even when it is old, it becomes easy to attract attention and astonishment with novelty. In those days such painters flourished as Catalano l'Antico, Cumandeo, and others, very famous. The new reputation of Caravaggio appealed to the sympathetic nature of the people of Messina, who always favored strangers, and the impressive excellence of such a man was such that they wanted him to stay, and they gave him commissions.

When some wealthy members of the house of Lazzaro wished to build a new chapel for the high altar of the church of the Padri Crociferi, they commissioned Caravaggio to paint a large canvas and agreed to pay the sum of 1000 scudi. Caravaggio conceived the Resurrection of Lazarus, alluding to their family. Those noblemen were greatly satisfied, and the artist was given free rein to fulfill his creative fantasy. It is commendable to give liberty to great artists to operate at their own will, instead of tying both their hands when they are ordered to execute a certain work in this or that manner or form. Fra Mattia Preti of Calabria (another Caravaggio of the past century, commonly called the Cavalier Mattia), every time he was commissioned to make a painting with such restrictions on the execution of this or that figure, would be astonished to see perfection in his creations even though he had had to work, so to speak, with his hands tied. When Caravaggio finally finished the great canvas representing the Resurrection of Lazarus, as we have said, it was much awaited by those who commissioned it because it was kept secret while Caravaggio painted it. It was astonishing once it was unveiled. And because everyone is proud of his own insights about art and presumes to be able to discuss art, as is customary, among this group there were those who had some small observations, not meaning to criticize Caravaggio's judgment but in order to seem informed. Michelangelo, with his usual impatience, drew his

infuriati colpi che ne restò miseramente squarciata quell'ammirabile pittura. E dopo aver in tal guisa sfogata la colera su quell'innocente lavoro, coll'animo all'apparenza sedato, rincorò que' smarriti galantuomini che non si attristassero mentre fra brieve tempo gliene darebbe un' altra secondo il loro gusto e più perfettamente compiuta.

Né ci dobbiamo maravigliare in udire sì fatte sciocchezze, perché se ne leggono molte di uomini assai più sensati del Caravaggio. . . .

L'essere il Caravaggio devenuto ad una azzione cotanto barbara e bestiale, fu effetto della sua natura impaziente ed invidiosa. L'udire qualche encomio convenevole de' pittori messinesi struggevalo e particolarmente lo trafiggeva il concetto del Cattalani l'Antico, la cui dote speciale fu una gentilezza di colore ed una grazia di belle idee ridenti, sul fare di Federico Barocci di Urbino suo maestro. Tale fu l'astio che aveva contro questo suo rivale che un giorno andò a visitare li quadri che sono nella basilica di S. Maria di Gesù, fra quali osservandone alcuni del prenarrato Cattalani, colla solita satira diessi a celebrare una tela fra quelle di Filippo Paladino fiorentino e pittore raffaellesco, come di sopra si è detto. In essa si rappresenta la Vergine in gloria con al di sotto S. Antonio di Padova e S. Caterina vergine e martire, figure amendue in piedi. La satirica lode fu questa: Or questo è quadro e l'altre tele son carte da giuoco, intendendo così rovesciare la vaghezza del Cattalani, perché il Caravaggio valevasi di quell'ombre gagliarde che nel Cattalani non s'osservano, essendo un altro stile oppostissimo: uno troppo delicato e dolce, e l'altro troppo aspro e fiero.

Dee dunque sapersi che prima che dasse principio all'opera de' sudetti signori di Lazzaro, volle questo mentecatto pittore procurata una stanza per mezzo degli stessi nello spedale. Per secondare il suo capriccioso volere e per vieppiù contentarlo, ebbe il migliore salone. Dato di mano all'opra fece nella parte destra il Salvatore

dagger, which he kept always at his side, and thrust many infuriated blows at that admirable painting, so that it was cut up miserably. And after having vented his anger on that innocent work, with his spirit apparently calmed, Caravaggio relaxed those concerned gentlemen and told them not to grieve because in a very short time he would make another picture for them that would satisfy their taste and be even more beautiful.

Nor should one be too shocked in hearing of such idiocy because one can read even worse things about people much more sensible than Caravaggio. . . .

Caravaggio acted in such a barbaric and brutal manner as a result of his impatient and envious nature. He was tormented when he heard the praise of the people for the painters of Messina, in particular the praise for Catalano l'Antico, whose special talent was the delicate color and gracefulness of his lovely creations, in the style of Federico Barocci of Urbino, his master. Such was his anger toward his rival that one day, on his way to visit the paintings in the Basilica of Santa Maria di Gesù, as he was observing works by Catalano, in his usual satirical manner he began to praise one of the canvases of the Florentine Filippo Paladino, a Raphaelesque painter, as mentioned above. This painting represents the Virgin in glory with St. Anthony of Padua, and St. Catherine, virgin and martyr, both figures standing below. The sarcastic eulogy went as follows: "This one is a true picture while the other canvases look like mere playing cards"; in such a way he meant to undermine the beauty of Catalano's work, because Caravaggio used forceful shadows that were absent in Catalano's paintings, his style being totally opposite, the one too delicate and sweet, the other too harsh and bold.

It should be understood that before Caravaggio began to work for the Lazzari, this crazy artist requested from them a room in the hospital. In order to support his capricious wish and to please him, Caravaggio was given the best room. He began his work by depicting on the right side the Savior with his back turned and the Apostles

112

voltato di schiena, con gli apostoli in atto di chiamare nel defonto e quattriduano Lazzaro lo spirito già partito, e nel mezo sonovi due facchini che alzano una gran lapide. Il cadavero di Lazzaro vedesi in braccio ad un altro facchino, e sembra come volesse svegliarsi. Da capo del Lazzaro nella parte sinistra, vi sono le sorelle che istupidite osservano il fratello che si sveglia. Ne' visaggi delle sorelle Michele rappresentò le più belle idee della bellezza, e per condurre la principal figura del Lazzaro, e di gusto naturalesco, fe' dissepellire un cadavero già puzzolente di alcuni giorni, e poselo in braccio ai facchini, che non potendo resistere al fetore, volevano abbandonare quell' atto. Ma questi colla solita ira impugnato il suo pugnale, l'atterrì avventandosi su di loro, finché gli infelici proseguirono per forza l'azione, ed ebbero quasi a morire al pari di que' miseri condannati dall'empio Mezzentio a perire ligati co' cadaveri. Altresì la stanza pittoresca del Caravaggio poteva in qualche modo dirsi la carnificina dello stesso tiranno.

Né mi sarebbe parsa verisimile una tale barbarie, se non l'avessi rincontrato nel morale Seneca. . . .

Dicesi altresì di Michelagnolo Bonarota (io son di parere che fosse favola) aver conficcato con veri chiodi un pover'uomo ad un legno ed avergli quindi trapassato il cuore con una lancia, per dipignere un crocifisso.

Inoltrossi vieppiù del Caravaggio il concetto, colla sperienza del suo ben operare, di modo che il senato di Messina gli commise una gran tela per l'altare maggiore della Chiesa de' Padri Capuccini della medesima città. In questa tela sta figurato il Natale di Nostro Signore, con figure al naturale, e tra le opere sue a mio credere questa si è la migliore, perché in esse questo gran naturalista fuggì quel tingere di macchia, furbesco, ma rimostrossi naturale senza quella fierezza d'ombre. Il sentire celebrare la dolcezza del Cattalani l'Antico lo fece rientrare in se stesso. Questa sola grand'opera l'averebbe reso memorabile ne' secoli avvenire, come lontana affatto dalle seccaggini e dagli oscuri cotanto gagliardi. Vedesi quivi nel piano terreno una sporta con

in the act of calling upon the dead and wealthy Lazarus whose soul had already departed, and in the center are two workmen who lift a large tombstone. The body of Lazarus is in the arms of another workman, and seems to want to wake up. On the left side, near the head of Lazarus, his two stunned sisters observe their brother awakening. In the faces of his sisters Michele depicted the most splendid expression of beauty, and in order to give the central figure of Lazarus a naturalistic flavor he asked to have a corpse dug up that was already in a state of decomposition, and had it placed in the arms of the workmen who, however, were unable to stand the foul odor and wanted to give up their work. Caravaggio, with his usual fury, raised his dagger and jumped on them, and as a result those unlucky men were forced to continue their job and nearly die, like those miserable creatures who were condemned by the impious Maxentius to die tied to corpses. Likewise, Caravaggio's picturesque room could in some fashion be called the slaughterhouse of the same tyrant.

Such barbarism would not appear likely, if I had not encountered it already in the ethical Seneca. . . .

It is also said that Michelangelo Buonarroti (I myself think it is only a fable) nailed a poor man to a wooden board and then pierced his heart with a lance, in order to paint a crucifixion.

The reputation of Caravaggio increased, and with knowledge of his good performance the Senate of Messina commissioned a large canvas for the high altar of the church of the Capuchin Fathers of the same city. In this canvas he represented the Nativity with life-size figures, and this in my opinion is the best of all his paintings, because here this great naturalist abandoned his sketchy, allusive style and demonstrated his naturalism once more without the use of bold shadows. The praise he had heard of the sweet touch in Catalano l'Antico's pictures helped him to find his own qualities. This one great work of art would have been enough for Caravaggio's glory for centuries to come, because here he removed himself completely from

113

strumenti di falegname alludenti a S. Giuseppe, nel secondo nella parte destra si vede distesa a terra la Vergine che vagheggia il pargoletto Gesù involto tra panni, facendogli vezzi. Ella sta appoggiata ad un fenile, dietro cui gli animali che vi pascono; nella sinistra parte, a pie' della Vergine, vi sta S. Giuseppe sedente pensoso in vaga panneggiatura ed in appresso li tre pastori che adorano il nato bambino, il primo con bastone in mano vestito di panno bianco, il secondo in atto adorante colle mani giunte, con una spalla ignuda che rassembra di viva carne; e per fine il terzo ammirativo, con testa calva, ch'è miracolosa. Il rimanente di questa tela consiste in campo nero con legni rustici che compongono la capanna: anzi il campo era più alto e ne fu tagliato un gran pezzo per potersi incastrare nella cappella.

In diversi tempi vari principi si sono invaghiti dell' accennato Presepe ed hanno cercato involarlo, ma non gli è riuscito perché li padri capuccini ne fecero ricorso al senato, in que' tempi che più fioriva, e colla solita autorità li fecero consapevoli che que' religiosi ne son semplicemente custodi. In tal guisa è restata in Messina e posso con verità affermare esser questa l'unica e più maestrevole pittura del Caravaggio.

Appresso al signor conte Adonnino sonovi dello stesso pittore due mezze figure in tele d'imperadori, rappresentanti amendue S. Girolamo, uno del buon gusto, che sta in atto di scrivere colla penna in mano, in profilo assai naturale; l'altro di maniera secca, che tiene nelle mani e medita un teschio di morte. Nel discernere di queste tele del Caravaggio il valore, vedesi la varietà della sua maniera, sempre diversa, mentre una è secca e l'altra buona senza quelle ombre.

Potrebbesi far ricordanza di altre belle opere sue private, che per brevità tralascio. Avendosi adunque il nostro dipintore acquistato una gran fama, guadagnossi altresì molti quatrini che dissipava in valenterie ed in bagordi: faceva il rompicollo ed il contenzioso, e quel ch'è peggio, mostravasi poco pio. Un giorno entrato con certi

dryness and from exceedingly dark tones. Instead, on the ground is a basket with carpentry tools alluding to St. Joseph's trade. Above, on the right, the Virgin is seen stretched out on the ground, looking at the Christ child wrapped in cloth and caressing him. She is leaning on a haystack, behind which those animals are grazing; on the left side, at the foot of the Virgin, St. Joseph is seated in attractive drapery, deep in thought. Nearby the three shepherds adore the newborn child; the first one has a staff in his hand and is dressed in a white garment, the second with his two hands joined in prayer shows a bare shoulder that looks like living flesh, and finally the third one looks on admiringly, his bold head painted marvelously. The rest of the canvas consists of a black background with rough wood that constitutes the shed. Indeed, the background was higher, and it was necessary to cut off a large section in order to fit the canvas into the chapel.

At various times princes have been attracted by this Nativity and have sought to take it away, but they were unable to do so because the Capuchin Fathers made an appeal to the Senate, which in those days was more important, and its authority made them realize that those Fathers were the only custodians. As a result the picture remained in Messina, and I can affirm in truth that this unique work is the most masterly painting by Caravaggio.

Count Adonnino has two large half-figures by Caravaggio, both representing St. Jerome; the first one is gracefully rendered, shown in the act of writing with pen in hand, with a realistic profile; the second one, in a dry manner, shows him concentrating on a skull in his hands. In defining the merits of these two canvases by Caravaggio, one should notice the diversity of his style, always different, one dry, the other good, without those shadows.

One could recall many other beautiful pictures by Caravaggio, which I must omit for the sake of brevity. Since Caravaggio gained great fame, he earned much money, which he then squandered in adventures and revelries. One day, entering the church of the Madonna del Pilero with some gentlemen, one of them, most

galantuomini nella chiesa della Madonna del Pilero, fattosi infra questi innanzi il più civile per apprestargli l'acqua benedetta, egli domandatogli a che ciò servisse, gli fu risposto per cancellare i peccati veniali: Non occorre ! dissegli, perché i miei son tutti mortali.

L'aver voluto altresì fuor della sua professione andar questionando le cose della nostra sacrosanta religione, gli dà taccia di miscredente, quando che gli stessi Gentili hanno mostrato una gran modestia ne' misteri di essa . . . Fu uomo inoltre astratto, inquieto, poco accorto sulla sua vita, e molte volte andava a letto vestito e col pugnale al fianco che mai lasciava; per l'inquietitudini dell'animo suo più agitato che non è il mare di Messina colle sue precipitose correnti che or salgono, or scendono. Vestiva mediocremente, armato sempre, che più tosto sembrava uno sgherro che un pittore. Soleva mangiare su di un cartone per tovaglia, e per lo più sopra una vecchia tela di ritratto: era così scimunito e pazzo che non può dirsi di più; sempre portava con esso lui un cane nero, che avvezzatolo avea a far vari giuochi, di che egli molto trastullavasi. Andava perduto nei giorni festivi appresso a un certo maestro di grammatica detto don Carlo Pepe: guidava questi li suoi scolaj a divertimento verso l'arsenale: ivi fabbricavansi le galee, oggi giorno ridotto ne' magazini di Portofranco. In tal luogo Michele andava osservando gli atteggiamenti di que' ragazzi scherzanti per formarne le sue fantasie. Insospettitosi di ciò sinistramente quel maestro, ispiava perché sempre gli era di attorno. Questa domanda disgustò fieramente il pittore, e quindi in tal ira e furore trascorse che, per non perdere il nome di folle, die' a quell'uomo dabbene una ferita in testa; per il che viddesi suo malgrado forzato partir da Messina. Insomma ove andava, stampava l'orme del suo forsennato cervello.

Fugiasco se ne passò in Palermo ed in quella città lasciò altresì opere lodevoli; di lì poi di novo andò in Napoli ed ivi inseguito dal suo antagonista offeso, fu malamente ferito nel viso e disperando di potersene vendicare, frappose l'autorità del cardinal Gonzaga, ottenne la grazia

cultivated, stepped forward in order to give him some holy water; Caravaggio asked him what was the purpose of it, and the answer was that it would erase any venial sin. "It is not necessary," he replied, "since all my sins are mortal."

Apart from his profession, Caravaggio also went about questioning our holy religion, for which he was accused of being a disbeliever, even though the pagans themselves expressed great humility toward its mysteries Caravaggio was very distracted, restless, indifferent to his own existence: many a time he would go to bed fully dressed, with his dagger (from which he was never separated) at his side. Because of his curious nature, his spirit was more disturbed than the sea of Messina with its raging currents that sometimes rise and sometimes fall. Even when dressed ordinarily he was always armed, so he looked more like a swordsman than a painter. He used to have his meal on a slab of wood, and instead of using a tablecloth, most of the time he would eat on an old portrait canvas; he was foolish and crazy, and more cannot be said. He used to be accompanied by a black dog that was trained to play various tricks, which he enjoyed immensely. He used to disappear during holy days to follow a certain grammar teacher called Don Carlo Pepe, who escorted his pupils for recreation to the arsenal. There galleys used to be built; today the arsenal has become the warehouse of Portofranco. Michele went to observe the positions of those playful boys and to form his inventions. But the teacher became suspicious and wanted to know why he was always around. That question so disturbed the painter, and he became so irate and furious (so as not to lose the name of crazy man), that he wounded the poor man on the head. For this action he was forced to leave Messina. In short, wherever he went he would leave the mark of his madness.

The fugitive arrived in Palermo, and in that city he also left excellent works of art. From there he moved again to Naples, chased there by his angered antagonist, and was badly wounded on the face. As a result he gave up the idea of revenge, and with the powerful intervention of

115

dal pontefice Paolo V acciò potesse ritornarsene in Roma. . . .

Se il Caravaggio non fusse sì tosto morto, avria fatto gran profitto all'arte, per la buona maniera che presa avea nel colorire dal naturale, bench'egli nel rappresentare le cose non avesse molto giudizio di scegliere il buono e lasciare il cattivo. Valevasi del naturale colle sue mancanze: lo sprezzare ch'egli fece in sul principio l'antichità de' marmi fecelo restare un semplice naturalista mancante di maniera. La maniera altro sì non è se non quella graziosità e gentilezza che dassi al naturale, il quale viene per essa spogliato da tutte le rusticità nella pittura. Acquistò non di meno gran credito, e più si pagavano le sue teste che le altrui storie. O quanto importa l'aura populare, che non fa giudizio con gli occhi, ma guarda coll'orecchie. Tale fu il concetto in che salì questo pittore, che da per tutto cercarono molti di approfittarsi sulla vivacità delle sue dipinture. . . .

Cardinal Gonzaga he was able to obtain from Pope Paul V permission to return to Rome. . . .

If Caravaggio had not died so soon he would have given great advancement to art, for his style in painting from nature was good, though he did not use much judgment in choosing between good and bad things. He availed himself of nature to overcome his shortcomings; his low regard for ancient sculpture kept him from being anything more than a mere naturalist, lacking style, which is the grace and refinement derived from nature, stripped of all its roughness. Nevertheless he acquired considerable fame, and his portraits were more expensive than history pictures by others. Yet popular praise is not important, for it does not judge with its eyes but looks with its ears. Such was the consideration given to this painter, and many sought to take advantage of the exuberance of his paintings. . . .

116

Bibliography

NOTE: This list includes works cited in the footnotes to the text, or cited frequently in the Notes. It is not meant to be a complete bibliography. I have added a few recent publications that came out too late to be considered (Marini, 1981; Whitfield and Martineau, 1982). Other citations are found, complete, in the Notes.

A documented monograph on Caravaggio by Mia Cinotti, with a catalog, will appear in the series *I pittori bergamaschi,* presumably in the course of 1983. It will have all of the documents so far discovered concerning Caravaggio's family, together with much other material cited here from Cinotti (1971) and her later publications.

Abromson, Morton, *Painting in Rome During the Papacy of Clement VIII (1592–1605) . . . ,* New York, 1981.

Alberti, Leon Battista, *De Pictura,* trans. and ed. C. Grayson, London, 1972.

Alciati, Andrea, *Emblemata . . . ,* Leiden, 1591 (many editions).

Arasse, D., "Extases et visions béatifiques à l'apogée de la Renaissance: quatre images de Raphaël," *Mélanges de l'École Française de Rome. Moyen-age, Temps moderne,* LXXXIV, 1972, pp. 403–492.

Argan, Giulio Carlo, "Il 'realismo' nella poetica del Caravaggio," *Scritti di storia dell'arte in onore di Lionello Venturi,* II, 1956, pp. 25–41.

———, "Caravaggio e Raffaello," *Colloquio,* 1974 (q.v.), pp. 19–28.

Armenini, Giovanni Battista, *On the True Precepts of the Art of Painting,* trans. and ed. E. J. Olszewski, New York, 1977 (original ed. 1586).

Ashford, Faith, "Caravaggio's Stay in Malta," *Burlington Magazine,* LXVII, 1935, pp. 168–174.

Askew, Pamela, "Ferdinando Gonzaga's Patronage of the Pictorial Arts . . . ," *Art Bulletin,* LX, 1978, pp. 274–296.

Azzopardi, John, "Caravaggio in Malta: An Unpublished Document," *The Church of St. John in Valletta 1578–1978* (exhibition catalog), Valletta, 1978, pp. 16–20.

Baccheschi, Edi, "Simone Peterzano," *I pittori bergamaschi . . . , Il Cinquecento,* IV, Bergamo, 1978, pp. 473–557 (with a "Studio critico" by Maurizio Calvesi, pp. 483–489).

Baglione, Giovanni, *Le vite de' pittori, scultori et architetti . . . ,* Rome, 1642 (facsimile ed. V. Mariani, Rome, 1935, with marginal notations by G. P. Bellori and others).

Baldinucci, Filippo, *Notizie dei professori del disegno da Cimabue in qua . . . ,* Florence, 1846–1847, 5 vols. (facsimile

ed. P. Barocchi, Florence, 1975, with critical notes, supplements, and index as vols. VI–VII). First ed. 1681–1728.

Banti, Anna [Lucia Longhi-Lopresti], ed., *Europa mille seicentosei. Diario di viaggio di Bernardo Bizoni,* Milan, Rome, 1942.

Barocchi, Paola, *Scritti d'arte del cinquecento,* Milan, Naples, I, 1971; II, 1973; III, 1977.

———, *Trattati d'arte del cinquecento fra manierismo e controriforma,* Bari, 1960–1962, 3 vols.

Baronius [Baronio], Cesare, *Il compendio de gli annali ecclesiastici del Padre Cesare Baronio,* trans., Rome, 1590.

Battisti, Eugenio, *Rinascimento e barocco,* Turin, 1960.

Baxandall, Michael, *Painting and Experience in Fifteenth Century Italy . . . ,* Oxford, 1974.

Beck, James, *Masaccio: The Documents,* New York, 1978.

Begni Redona, Pier Virgilio, "La pittura manieristica," *Storia di Brescia,* III, Brescia, 1964, VIII, pp. 527–588.

Bellori, Giovanni Pietro, *Le vite de' pittori, scultori e architetti moderni,* Rome, 1672; ed. cited, ed. E. Borea, Turin, 1976 (with old pagination as well as new; I cite the original pages when quoting from the *Lives* of 1672).

Berenson, Bernard, *Del Caravaggio: delle sue incongruenze e della sua fama,* Florence, 1951.

[Berti, Luciano, et al.], *Gli Uffizi. Catalogo generale.* Florence, 1979. (Entries for Caravaggio by E. Borea.)

Bertolotti, Antonino, *Artisti lombardi a Roma nei secoli XV, XVI, XVII,* Milan, 1881, 2 vols.

———, *Artisti in relazione coi Gonzaga duchi di Mantova nei secoli XVI e XVII,* Modena, 1885.

Bialostocki, Jan, "The Renaissance Concept of Nature and Antiquity," *Studies in Western Art,* II: *The Renaissance and Mannerism* (Acts of the Twentieth International Congress of the History of Art), Princeton, 1963, pp. 19–30.

Bissell, Ward, "Concerning the Date of Caravaggio's *Amore Vincitore*," *Hortus Imaginum* . . . (Festschrift Harold Wethey; University of Kansas Publications; Humanistic Studies, 45), Lawrence, 1974, pp. 113–123.

————, *Orazio Gentileschi* . . . , Pennsylvania State University Press, 1981.

Bizoni, *see* Banti.

Blunt, Anthony, *Artistic Theory in Italy 1450–1600*, 2nd ed., Oxford, 1956.

Blunt, Wilfred, and Sandra Raphael, *The Illustrated Herbal*, London, n.d. (1980?).

Bologna, Ferdinando, "Il Caravaggio nella cultura e nella società del suo tempo," *Colloquio*, 1974 (q.v.), pp. 149–187.

————, (cf. "Pacelli-Bologna"), "Caravaggio, 1610: la 'Sant'Orsola confitta dal Tiranno' per Marcantonio Doria, 2. L'Identificazione del dipinto (e i rapporti artistici fra Genova e Napoli nei primi decenni del Seicento)," *Prospettiva*, XXIII, 1980, pp. 30–44.

Borea, Evelina, *see* Bellori; Berti.

Borromeo, Federico, *Mvsaevm*, Milan, 1925; reprinted in Diamond, 1974 (q.v.).

Boschloo, A. W. A., *Annibale Carracci in Bologna* . . . (Kunsthistorische Studiën van het Nederlands Instituut te Rome, III), The Hague, 1974, 2 vols.

Bosio, Antonio, *Roma sotterranea* . . . , Rome, 1632.

Bossaglia, Rossana, " La pittura bresciana del Cinquecento . . . ," *Storia di Brescia*, II, Brescia, 1963, VII, pp. 1011–1101.

Bradford, Ernle, *The Shield and the Sword. The Knights of Malta*, London, 1972.

Brandi, Cesare, "L''Epistème' caravaggesca," in *Colloquio* 1974 (q.v.), pp. 9–17.

Brooke, Nicholas, "Shakespeare and Baroque Art," *Proceedings of the British Academy*, LXIII, 1977, pp. 53–69.

Buser, Thomas, "Jerome Nadal and Early Jesuit Art in Rome," *Art Bulletin*, LVIII, 1976, pp. 424–433.

Calvesi, Maurizio, "Simone Peterzano, maestro del Caravaggio," *Bollettino d'arte*, XXXIX, 1954, pp. 114–133.

————, "Caravaggio o la ricerca della salvazione," *Storia dell'arte*, 9/10, 1971, pp. 93–141.

————, "Letture iconologiche del Caravaggio, *Novità*, 1975 (q.v.), pp. 75–102.

Cartari, Vincenzo, *Le imagini de i dei de gli antichi* . . . , Venice, 1571.

Causa, Raffaello, "La pittura del seicento a Napoli dal naturalismo al barocco," *Storia di Napoli*, V, 2, Naples, Cava de'Tirreni, 1972, pp. 915–994.

Celio, Gaspare, *Memoria delli nomi dell'artefici delle pitture che sono in alcune chiese, facciate, e palazzi di Roma*, Naples, 1638; ed. cit., ed. E. Zocca, Milan, 1967.

Chantelou, Paul Fréart, sieur de, *Journal du voyage du Cavalier Bernin en France*, ed. L. Lalanne, Paris, 1885.

Chappell, Miles, and W. Chandler Kirwin, "A Petrine Triumph: The Decoration of the Navi Piccole in San Pietro Under Clement VIII," *Storia dell'arte*, XXI, 1974, pp. 119–170.

Ciardi, Roberto Paolo, *Giovan Ambrogio Figino*, Florence, 1968.

Cinotti, Mia, 1971, *see* Dell'Acqua and Cinotti.

————, *Immagine del Caravaggio*, catalogue (with G. A. dell'Acqua, et al.), Milan, 1973.

————, "La giovinezza del Caravaggio. Ricerche e scoperti," *Novità*, 1975 (q.v.), pp. 183–214.

————, *Caravaggio (I pittori bergamaschi* . . . , *Il Cinquecento)*, Bergamo, 1983?

Cochrane, Eric, ed., *The Late Italian Renaissance, 1525–1630*, London, 1970.

Colloquio sul tema Caravaggio e i Caravaggeschi, organizzato d'intesa con le Accademie di Spagna e di Olanda (Roma, 12–14 febbraio 1973), Rome, 1974 (Accademia Nazionale dei Lincei, CCCLXXI, Quaderno N. 205, *Problemi attuali di scienza e di cultura*). *See* Argan; Bologna; Brandi.

Coppa, Simonetta, "Federico Borromeo teorico d'arte," *Arte lombarda*, XV, 1, 1970, pp. 65–70.

Cordaro, Michele, "Indagine radiografica sulla 'Buona Ventura' dei Musei Capitolini," *Ricerche di storia dell'arte*, X, 1980, pp. 101–106.

Costello, Jane, "Caravaggio, Lizard, and Fruit," *Art the Ape of Nature. Studies in Honor of H. W. Janson*, ed. M. Barash and L. Freeman Sandler, New York, 1981, pp. 375–385.

Cozzi, Gaetano, "Intorno al cardinale Ottavio Paravicino, a monsignor Paolo Gualdo e a Michelangelo da Caravaggio," *Rivista storica italiana*, LXXIII, 1, 1961, pp. 36–68.

Cuzin, Jean-Pierre, "Pour Valentin," *Revue de l'art*, 28, 1975, pp. 53–61.

D'Ancona, Mirella Levi, *The Garden of the Renaissance*, Florence, 1977.

Dell'Acqua, Gian Alberto, "La pittura a Milano dalla metà del XVI secolo al 1630," *Storia di Milano*, X, 1957, pp. 671–782.

————, and Mia Cinotti, *Il Caravaggio e le sue grandi opere da San Luigi dei Francesi*, Milan, 1971. Chiefly cited as "Cinotti, 1971," when referring to the catalogue material, documents, etc.

Della Pergola, Paola, *Galleria Borghese. I dipinti*, Rome, I, 1955; II, 1959.

Delumeau, Jean, *Vie économique et sociale de Rome dans la seconde moitié du XVIe siècle* (Bibliotheque des Écoles Françaises d'Athènes et de Rome, 184), Paris, I, 1957; II, 1959.

Dempsey, Charles, review of A. Moir, *The Italian Followers of Caravaggio, Art Bulletin*, LII, 1970, pp. 324–326.

————, *Annibale Carracci and the Beginnings of Baroque Style*, Glückstadt, 1977. (Reviewed by D. Posner, *Burlington Magazine*, CXXI, 1979, pp. 44–45.)

De Rinaldis, Aldo, "Documenti inediti per la storia della R. Galleria Borghese in Roma. Le opere sequestrate al Cavalier d'Arpino," *Archivi [d'Italia]*, III, 1936, pp. 110–118.

Diamond, Arlene J., *Cardinal Federico Borromeo as a Patron of the Arts and His* Mvsaevm *of 1625,* Ann Arbor, University Microfilms, Ph.D. dissertation, UCLA, 1974.

Dorati, Maria Cristina, "Gli scultori della Cappella Paolina di Santa Maria Maggiore," *Commentari,* XVIII, 1967, pp. 231–260.

Dussler, Luitpold, *Raphael. A Critical Catalogue of His Pictures, Wall-Paintings and Tapestries,* London, New York, 1971.

Edgerton, Samuel Y., Jr., *"Maniera* and the *Mannaia:* Decorum and Decapitation in the Sixteenth Century," *The Meaning of Mannerism,* ed. F. W. Robinson and S. G. Nichols, Jr., Hanover, N.H., 1972, pp. 67–103.

Egan, Patricia, " 'Concert' Scenes in Musical Paintings of the Italian Renaissance," *Journal of the American Musicological Society,* XIV, 1961, pp. 184–195.

Einstein, Alfred, *The Italian Madrigal,* Princeton, 1949, 3 vols.

Eisenstein, Elizabeth L., *The Printing Press as an Agent of Change,* Cambridge, 1980. 2 vols. in 1.

Emiliani, Andrea, *Mostra di Federico Barocci,* Bologna, 1975.

Enggass, Robert, and Jonathan Brown, *Italy and Spain 1600–1750. Sources and Documents.* Englewood Cliffs, N.J., 1970.

Ertz, Klaus, *Jan Brueghel de Altere: die Gemälde,* Cologne, 1979.

Eubel, Conrad, et al., *Hierarchia Catholica Medii et Recentioris Aevi . . . ,* III, 1503–1592, Münster, 1923; IV, 1592–1667, Münster, 1935 (reprinted 1960); VI, 1730–1799, 1958.

Evennett, H. Outram, *The Spirit of the Counter-Reformation,* ed. J. Bossy, Notre Dame, London, 1970 (first pub., Cambridge Univ. Press, 1968).

Fagiolo dell'Arco, Maurizio, "Le 'Opere di Misericordia,' contributo alla poetica del Caravaggio," *L'Arte,* I, 1, 1968, pp. 37–61. Republished separately, Milan, 1969.

Falchetti, Antonia, *La Pinacoteca Ambrosiana,* Vicenza, 1969.

Forcella, Vincenzo, *Iscrizioni delle chiese di Roma . . . ,* Rome, 1869–1884, 14 vols.

Francucci, Scipione, "La Galleria dell'Illustris. S.re Reverendis. Cardinale Borghese . . . ," Archivio Segreto Vaticano, *Fondo Borghese,* IV, 102 (not 103). Dated, fol. 8v: 16 July 1613. Published separately, Arezzo, 1647.

Freedberg, David, "The Hidden God: Image and Interdiction in the Netherlands in the Sixteenth Century," *Art History,* V, 1982, pp. 133–153.

Freedberg, Sydney, *Painting in Italy: 1500–1600,* Pelican History of Art, rev. ed., 1975.

Freud, Sigmund, "Medusa's Head," trans. J. Strachey, *The Standard Edition of the Complete Psychological Works of Sigmund Freud,* XVIII, London, 1955, pp. 273–274. (ms. dated 1922.)

Friedlaender, Walter, *Caravaggio Studies,* Princeton, 1955 (cited as "Friedlaender").

———, *Mannerism and Anti-Mannerism in Italian Painting,* New York, 1957.

Frommel, Christoph L., "Caravaggios Frühwerk und der Kardinal Francesco Maria del Monte," *Storia dell'arte,* 9/10, 1971, pp. 5–49.

———, "Caravaggio und seine Modelle," *Castrum Peregrini,* XCVI, 1971, pp. 21–56 (cited as "Frommel, 1971a").

———, *Der römische Palastbau der Hochrenaissance,* Tübingen, 1973, 3 vols.

Fulco, Giorgio, " 'Ammirate l'altissimo pittore': Caravaggio nelle rime inedite di Marzio Milesi," *Ricerche di storia dell'arte,* X, 1980, pp. 65–89.

Gabrieli, G., "Federico Borromeo a Roma," *Archivio della Società Romana di Storia Patria,* LVI–LVII, 1933–1934, pp. 157–217.

Golden Legend: Jacobus de Voragine, *Legenda Sanctorum,* trans., adopted, and ed. G. Ryan and H. Ripperger, New York, 1941.

Gombrich, Ernst, "Tradition and Expression in Western Still Life" (review of Charles Sterling, q.v.), *Meditations on a Hobby Horse . . . ,* London, 1963, pp. 95–105.

Gould, Cecil, *The Paintings of Correggio,* Ithaca, 1976.

Green, Otis H., with Denis Mahon, "Caravaggio's Death: A New Document," *Burlington Magazine,* XCIII, 1951, 1. The Document, pp. 202–203; 2. Commentary, by D. Mahon, pp. 203–204.

Greenslade, S. L., ed., *The Cambridge History of the Bible,* Cambridge, 1963.

Gregori, Mina, "Caravaggio dopo la mostra di Cleveland," *Paragone,* 263, 1972, pp. 23–49.

———, "Note storiche sulla lombardia tra cinque e seicento," *Il Seicento lombardo,* I, Milan, 1973, pp. 19–46.

———, "A New Painting and Some Observations on Caravaggio's Journey to Malta," *Burlington Magazine,* CXVI, 1974, pp. 594–603.

———, "Significato delle mostre caravaggesche dal 1951 a oggi," *Novità,* 1975 (q.v.), pp. 27–60.

Harris, Ann, *see* Sutherland Harris.

Haskell, Francis, "Art Exhibitions in XVII Century Rome," *Studi seicenteschi,* ed. C. Jannaco and U. Limentani, Florence, 1961, pp. 107–121.

———, *Patrons and Painters,* Yale, 1980 (1st ed. London, 1963).

———, and Nicholas Penny, *Taste and the Antique . . . ,* Yale, 1981.

[Heinz, Günther, and Friderike Klauner], *Katalog der Gemäldegalerie, I: Italiener, Spanier, Franzosen, Engländer,* Vienna, 1965 (Führer durch das Kunsthistorische Museum, Nr. 3, 2 ed.); (cited as "Heinz, 1965").

Held, Julius S., "Flora, Goddess and Courtesan," *De Artibus Opuscula XL: Essays in Honor of Erwin Panofsky,* New York, 1961, pp. 201–218.

Hess, Jacob, *Kunstgeschichtliche Studien zu Renaissance und Barock,* Rome, 1967, 2 vols. Contains the following articles, cited by pages only: 77–79: "Contributo alla vita del Caravaggio" (*Bollettino d'arte,* 1932–1933, pp. 42–44); 221–239: "The Chronology of the Contarelli Chapel" (*Burlington Magazine,* 1951, pp. 186–201);

275–288: "Modelle e modelli del Caravaggio" (*Commentari*, 1954, pp. 271–289); 301–308: "Caravaggio, D'Arpino und Guido Reni" (*Zeitschrift für Kunstwissenschaft*, 1956, pp. 57–71); 339–342: "Caravaggio's Paintings in Malta" (*The Connoisseur*, November 1958, pp. 142–147); 353–367: "Contributi alla storia della Chiesa Nuova . . ." (*Scritti di storia dell'arte in onore di Mario Salmi*, Rome, 1963, pp. 215–238); 385 ff.: *Nachtrag*.

———, "Note manciniane," *Münchner Jahrbuch der bildenden Kunst*, XIX, 1968, pp. 103–120.

———, see Passeri-Hess.

Hibbard, Howard, *Carlo Maderno and Roman Architecture, 1580–1630*, London, 1971.

———, "*Ut picturae sermones*: The First Painted Decorations of the Gesù," *Baroque Art: The Jesuit Contribution*, ed. R. Wittkower and I. B. Jaffe, New York, 1972, pp. 29–49.

———, *Michelangelo*, Penguin, 1978; New York, 1979 (1st ed. 1974).

———, "Caravaggio's two *St. Matthews*," *Römisches Jahrbuch für Kunstgeschichte*, XX (Festschrift Wolfgang Lotz), in press (cited as "Hibbard, 1982").

———, "Bernini and Caravaggio," *The Art and Influence of Gianlorenzo Bernini (1598–1680). Colloquium, American Academy in Rome, May 8–9, 1980*, in press (cited as "Hibbard, 1983").

Hinks, Roger, *Michelangelo Merisi da Caravaggio. His Life—His Legend—His Works*. London, 1953.

Jacobus de Voragine, see *Golden Legend*.

Kinkead, see Salerno (1966).

Kirwin, W. Chandler, "Addendum to Cardinal Francesco Maria del Monte's Inventory: The Date of Sale of Various Notable Paintings," *Storia dell'arte*, 9/10, 1971, pp. 53–56.

———, *Christofano Roncalli (1551/2–1626), an Exponent of the Proto-Baroque: His Activity Through 1605*, Ann Arbor, University Microfilms, 1972, Ph.D. dissertation, Stanford.

Kitson, Michael, *The Complete Paintings of Caravaggio*, New York, 1969 (?); partially based on *L'Opera completa del Caravaggio* by A. Ottino della Chiesa, Milan, 1967.

Krautheimer, Richard, "A Christian Triumph in 1597," *Essays in the History of Art Presented to Rudolf Wittkower*, London, 1967, pp. 174–178.

Kris, Ernst, and Otto Kurz, *Legend, Myth, and Magic in the Image of the Artist*, Yale, 1979 (1st ed., Vienna, 1934).

Lavin, Irving, *Bernini and the Unity of the Visual Arts*, New York, London, 1980, 2 vols.

Lavin, Marilyn A., *Seventeenth-Century Barberini Documents and Inventories of Art*, New York, 1975.

Lee, Rensselaer W., *Ut Pictura Poesis. The Humanistic Theory of Painting*, New York, 1967 (reprinted from *Art Bulletin*, XXII, 1940, pp. 197–269).

Levey, Michael, *The Seventeenth and Eighteenth Century Schools* (National Gallery Catalogues), London, 1971.

Liebert, Robert S., M.D., "Michelangelo's Mutilation of the Florence Pietà: a Psychoanalytic Inquiry," *Art Bulletin*, LIX, 1977, pp. 47–54.

Lomazzo, Giovanni Paolo, *Idea del tempio della pittura*, Milan, 1590; ed. cit.: Bologna, 1785, reprinted Rome, 1947.

Longhi, Roberto, "Quesiti caravaggeschi" (1929), reprinted in *'Me Pinxit' e Quesiti caravaggeschi, 1928–1934* (Edizione delle opere complete di Roberto Longhi, IV), Florence, 1968.

———, "Alcuni pezzi rari nell'antologia della critica caravaggesca," *Paragone*, 17, 1951, pp. 44–62; 19, 1951, pp. 61–63.

———, see *Mostra*, 1951.

MacDougall, Elizabeth B., "The Villa Mattei and the Development of the Roman Garden Style," Ph.D. dissertation, Harvard University, 1970.

Mack Smith, Denis, *A History of Sicily*, London, 1968, 2 vols. (I: *Medieval Sicily, 800–1713*).

Macrae, Desmond, "Observations on the Sword in Caravaggio," *Burlington Magazine*, CVI, 1964, pp. 412–416.

Magurn, Ruth S., trans. and ed., *The Letters of Peter Paul Rubens*, Harvard, 1955.

Mahon, Denis, *Studies in Seicento Art and Theory*, London, 1947.

———, "Egregius in Urbe Pictor: Caravaggio Revisited," *Burlington Magazine*, XCIII, 1951, pp. 223–234.

———, "Addenda to Caravaggio," *Burlington Magazine*, XCIV, 1952, pp. 3–23.

———, "Contrasts in Art-Historical Method: Two Recent Approaches to Caravaggio," *Burlington Magazine*, XCV, 1953, pp. 212–220.

———, (and Denys Sutton), *Artists in 17th Century Rome*, 2nd ed., revised, London, Wildenstein, 1955.

———, see Green

Mâle, Émile, *L'Art religieux de la fin du XVI^e siècle, du XVII^e siècle et du XVIII^e siècle. Étude sur l'iconographie après le Concile de Trente . . .* , 2nd ed., Paris, 1932; reprinted 1951.

Malvasia, Carlo Cesare, *Felsina pittrice. Vite de' pittori bolognesi*, Bologna, 1841, 2 vols., reprinted Bologna, 1967. First ed. 1778.

———, *The Life of Guido Reni*, trans. and intro. C. and R. Enggass, Pennsylvania State University Press, 1980.

Mancini, Giulio, *Considerazioni sulla pittura . . .* , I, ed. A. Marucchi, Rome, 1956; II, see Salerno, 1957.

Mander, see Van Mander.

Manilli, Giacomo, *Villa Borghese . . . descritta . . .* , Rome, 1650.

Marini, Maurizio, *Io Michelangelo da Caravaggio*, Rome, 2nd ed., 1974. Reviewed by Nicolson, 1974.

———, "*Michael Angelus Caravaggio Romanus*," Rome, 1978.

———, "Caravaggio e il naturalismo internazionale," (with

an introduction by Marini and F. Zeri), *Storia dell'arte italiana*, VI: *Dal Cinquecento all'Ottocento, 1. Cinquecento e Seicento*, Turin, 1981, pp. 347–445. (Arrived too late to be cited.)

Masetti Zannini, Gian Ludovico, "Un dipinto del Caravaggio," *Commentari*, XXII, 1971, pp. 184–186.

McNeill, William H., *Plagues and Peoples*, New York, 1976.

Migne, Jean Paul, ed., *Patrologia Cursus Completus . . . Latina*, Paris, 1878–1890, many vols. (P. L.)

Mirollo, James V., *The Poet of the Marvellous, Giovanni Battista Marino*, New York, London, 1963.

Möbius, Hans, "Die ältesten Erwähnung der Portlandvase," in "Bemerken zu Kameën und Kameogläsern," *Kölner Jahrbuch für Vor- und Frühgeschichte*, IX, 1967/1968, pp. 25–27.

Moir, Alfred, "Did Caravaggio Draw?" *Art Quarterly*, XXXII, 1969, pp. 354–372.

————, *Caravaggio and His Copyists*, New York, 1976 [1978].

Monssen, Leif H., *"Rex Gloriose Martyrum:* A Contribution to Jesuit Iconography," *Art Bulletin*, LXII, 1981, pp. 130–137.

Moroni Lumbroso, Matizia, and Antonio Martini, *Le confraternite romane nelle loro chiese*, Rome, 1963.

Mostra del Caravaggio e dei Caravaggeschi, Florence, 1951. (Exhibition catalog by Roberto Longhi.)

Nadal, Geronimo, *Evangelicae Historiae Imagines . . .* , Antwerp, 1593 (cf. Buser).

Nicolson, Benedict, "Recent Caravaggio Studies," *Burlington Magazine*, CXVI, 1974, pp. 624–625.

————, *The International Caravaggesque Movement . . .* , Oxford, 1979, reviewed by Spear, 1979.

Norman, A. V. B., *The Rapier and Small-Sword*, London, 1980.

Novità sul Caravaggio, Saggi e contributi, Regione Lombarda, 1975. See Calvesi; Cinotti; Gregori; Röttgen; Salerno; Spezzaferro.

O'Connell, Marvin R., *The Counter Reformation, 1559–1610*, New York, 1974.

Orbaan, J. A. F., "Virtuosi al Pantheon . . . ," *Repertorium für Kunstwissenschaft*, XXXVII, 1915, pp. 17–52.

————, *Documenti sul barocco in Roma*, Rome, 1920.

Pacelli, Vincenzo, "New Documents Concerning Caravaggio in Naples," *Burlington Magazine*, CXIX, 1977, pp. 819–829.

———— ("Pacelli-Bologna"), "Caravaggio, 1610: la 'Sant' Orsola confitta dal Tiranno' per Marcantonio Doria. 1. Le evidenze documentarie . . . ," *Prospettiva*, XXIII, 1980, pp. 24–30. See Bologna.

Pacheco, Francisco, *Arte de la pintura . . .*, ed., F. J. Sanchez Canton, Madrid, I, 1956.

Panofsky, Erwin, *Idea*, New York, 1968.

Panofsky-Soergel, Gerda, "Zur Geschichte des Palazzo Mattei di Giove," *Römisches Jahrbuch für Kunstgeschichte*, XI, 1967/1968, pp. 109–188.

Parker, T. M., "The Papacy, Catholic Reform, and Christian Missions," *The New Cambridge Modern History*, III, *The Counter-Reformation and Price Revolution, 1559–1610*, Cambridge, 1968, pp. 44–71.

Parronchi, Alessandro, "La 'camera ombrosa' del Caravaggio," *Michelangelo*, V, 18, 1976, pp. 33–47.

Partner, Peter, *Renaissance Rome, 1500–1559*, Berkeley, 1976.

Paschini, Pio, *Cinquecento romano e riforma cattolica*, Rome, 1958.

Passeri-Hess: *Die Künstlerbiographien von Giovanni Battista Passeri . . .*, ed. J. Hess, Leipzig, Vienna, 1934.

Pastor, Ludwig von, *Geschichte der Päpste . . .*, rev. ed., Freiburg i. B., 1927–1933, many vols. The volumes I cite are: V: Paul III; VI: Julius III, Marcellus II, Paul IV; XI: Clement VIII.

Pecchiai, Pio, *Roma nel Cinquecento*, Bologna, 1948.

Pelikan, Jaroslav, *The Growth of Medieval Theology (600–1300)*, (The Christian Tradition . . ., III), Chicago, 1978.

Pepper, D. Stephen, "Caravaggio and Guido Reni: Constrasts in Attitudes," *Art Quarterly*, XXXIV, 1971, pp. 325–344.

Pérez Sánchez, Alfonso E., *Caravaggio y el naturalismo español*, Seville, 1973 (exhibition catalog).

Petrocchi, M., *Roma nel seicento*, Bologna, 1970.

Petrucci, Alfredo, "Amici del Caravaggio a Roma: Marzio Milesi," *Studi romani*, IV, 1956, pp. 426–441, 578–580.

Pierce, Stella M., "Costumes in Caravaggio's Painting," *Magazine of Art*, XLVI, 1953, pp. 147–154.

Pollitt, J. J., *The Art of Greece, 1400–31 BC: Sources and Documents*, Englewood Cliffs, N.J., 1965.

————, *The Art of Rome, c. 753 BC–337 AD. Sources and Documents*, Englewood Cliffs, N.J., 1966.

Ponnelle, Louis, and Louis Bordet, *Saint Philippe Néri et la société romaine de son temps (1515–1595)*, 3rd ed., Paris, 1929.

Posner, Donald, *Annibale Carracci*, London, New York, 1971, 2 vols.

————, "Caravaggio's Homo-Erotic Early Works," *Art Quarterly*, XXXIV, 1971, pp. 301–324 (cited as "Posner, 1971a").

————, see also Weil Garris Posner

Praz, Mario, "Caravaggio," *Il giardino dei sensi . . .* , Turin, 1975, pp. 264–275 (also in J. Slaski, ed., *Barocco fra Italia e Polonia*, Warsaw, 1977, pp. 79–87).

Prodi, Paolo, "Ricerche sulla teorica delle arti figurative nella riforma cattolica," *Archivio italiano per la storia della pietà*, IV, 1965, pp. 121–212.

Pullapilly, Cyriac K., *Caesar Baronius, Counter-Reformation Historian*, Notre Dame, London, 1975.

Ridolfi, Carlo, *Le maraviglie dell'arte . . .*, ed. D. von Hadeln, Berlin, 1914–1924, I (original ed. 1648).

Ripa, Cesare, *Iconologia*, Rome, 1593.

Rosand, David, " 'Troyes Painted Woes' . . . ," *Hebrew University Studies in Literature*, VIII, 1, 1980, pp. 77–97.

Röttgen, Herwarth, "Repräsentationsstil und Historienbild in der römischen Malerei um 1600," *Beiträge für H. G. Evers (Darmstädter Schriften, XXII),* 1968, pp. 71–82.

———, *Il Cavalier D'Arpino,* Rome, 1973 (exhibition catalog).

———, *Il Caravaggio: ricerche e interpretazioni,* Rome, 1974. Includes translations of German articles with new commentary, as well as a new essay. The original articles appeared as follows: pp. 11–41, (*Zeitschrift für Kunstgeschichte,* XXVII, 1964); 47–74, (*Zeitschrift für Kunstgeschichte,* XXVIII, 1965); 79–123, (*Münchner Jahrbuch der bildenden Kunst,* XX, 1969); 131–143, (*Neue Zürcher Zeitung,* 18 Dec. 1966); 147 ff. comprise a previously unpublished essay: "Riflessioni sul rapporto tra la personalità del Caravaggio e la sua opera."

———, "La 'Resurrezione di Lazzaro' del Caravaggio," *Novità,* 1975 (q.v.), pp. 61–74.

Rycroft, Charles, *The Innocence of Dreams,* New York, 1979.

Saccà, Virgilio, "Michelangelo da Caravaggio pittore. Studi e ricerche," IV, *Archivio storico messinese,* VIII, 1907, pp. 41–79.

Salerno, Luigi, *Commento alle opere del Mancini* (q.v.), Rome, 1957.

———, "The Picture Gallery of Vincenzo Giustiniani," *Burlington Magazine,* CII, 1960, pp. 21–27, 93–104, 135–148 (index, p. 148).

———, "Poesia e simboli nel Caravaggio. I dipinti emblematici," *Palatino,* X, 2, 1966, pp. 106–112; followed by Duncan T. Kinkead, "Temi religiosi," pp. 112–115, etc.

———, "Caravaggio e i caravaggeschi," *Storia dell'arte,* 7/8, 1970, pp. 234–248.

———, "The Art-Historical Implications of the Detroit 'Magdalen,'" *Burlington Magazine,* CXVI, 1974, pp. 586–593.

———, "Caravaggio e la cultura nel suo tempo," *Novità,* 1975 (q.v.), pp. 17–26.

Samek Ludovici, Sergio, *Vita del Caravaggio dalle testimonianze del suo tempo,* Milan, 1956 (largely superseded by Cinotti, 1971).

Sammut, Edward, "The Trial of Caravaggio," *The Church of St. John in Malta,* ed. Azzopardi, 1978, pp. 21–27.

Sandrart, Joachim von, *Academie der Bau-Bild- und Mahlerey-Künste von 1675,* ed. A. R. Peltzer, Munich, 1925.

Scannelli, Francesco, *Il microcosmo della pittura,* Cesena, 1657.

Scaramuccia, Luigi, *Le finezze de' pennelli italiani,* Pavia, 1674.

Scavizzi, Giuseppe, *Caravaggio e caravaggeschi,* Naples, 1963 (exhibition catalog).

Scherliess, Volker, *Musikalische Noten auf Kunstwerken . . .,* (Hamburger Beiträge zur Musikwissenschaft, VIII), Hamburg, 1972.

———, "Zu Caravaggios 'Musica,'" *Mitteilungen des Kunsthistorischen Institutes in Florenz,* XVII, 1973, pp. 141–148.

Schneider, Laurie, "Donatello and Caravaggio: The Iconography of Decapitation," *American Imago,* XXXIII, 1976, pp. 77–91.

Shapley, Fern R., *Catalogue of the Italian Paintings,* Washington, National Gallery, I, 1979.

Shearman, John, *Mannerism,* Penguin, 1967; reprinted 1977.

Spalding, Jack J., *Santi di Tito,* Ann Arbor, University Microfilms, Ph.D. dissertation, Princeton, 1976; New York, 1980.

Spear, Richard S., *Caravaggio and His Followers,* Cleveland Museum of Art, 1971 (exhibition catalog); rev. ed., New York, 1975.

———, Review of Nicolson (1979), *Burlington Magazine,* CXXI, 1979, pp. 317–322.

Spezzaferro, Luigi, "La cultura del Cardinal del Monte e il primo tempo del Caravaggio," *Storia dell'arte,* 9/10, 1971, pp. 57–92.

———, "Detroit's 'Conversion of the Magdalen' (The Alzaga Caravaggio), 4. The Documentary Findings," *Burlington Magazine,* CXVI, 1974, pp. 579–586.

———, "Ottavio Costa e Caravaggio: certezze e problemi," *Novità,* 1975 (q.v.), pp. 103–118.

———, "Caravaggio rifiutato? . . .," *Ricerche di storia dell'arte,* 10, 1980, pp. 49–64.

Spike, John, "'The Church of St. John in Valletta, 1578–1978' and the Earliest Record of Caravaggio in Malta: an Exhibition and its Catalogue," *Burlington Magazine,* CXX, 1978, pp. 626–628.

Steinberg, Leo, "Observations in the Cerasi Chapel," *Art Bulletin,* XLI, 1959, pp. 183–190.

———, *Michelangelo's Last Paintings,* New York, Oxford, 1975.

Sterling, Charles, *Still Life Painting,* 2nd rev. ed., New York, 1981.

Storia di Milano, X: *L'Età della riforma cattolica (1559–1630),* Milan, 1957.

Storia di Napoli, V, Naples, Cava dei Tirreni, 1972.

Strinati, Claudio, "Roma nell'anno 1600. Studio di pittura," *Ricerche di storia dell'arte,* 10, 1980, pp. 15–48.

Summers, David, "Contrapposto: Style and Meaning in Renaissance Art," *Art Bulletin,* LIX, 1977, pp. 336–361.

———, *Michelangelo and the Language of Art,* Princeton, 1981.

Susinno, Francesco, *Le vite di' pittori messinesi,* ed. V. Martinelli, Florence, 1960 (ms. dated 1724).

Sutherland Harris, Ann, *Andrea Sacchi,* Princeton, 1977.

Trevor-Roper, H. R., "Religion, the Reformation and Social Change," reprinted in *The European Witch-Craze of the Sixteenth and Seventeenth Centuries and other Essays,* New York, 1969, pp. 1–45.

Van Mander, Carel, *Het Schilder-Boeck . . . ,* Haarlem, 1604.

Van Woerden, Isabel Speyart, "The Iconography of the Sac-

Bibliography

rifice of Abraham," *Vigilae Christianae*, XV, 1961, pp. 214–255.

Vasari, Giorgio, *Le vite . . .*, cited in two editions: for the lives through Valerio Vicentino: Giorgio Vasari, *Le vite . . ., nelle redazioni del 1550 e 1568*, ed. R. Bettarini, commentary P. Barocchi (cited as "Vasari-Barocchi"), Florence, 1966– (in progress). Also: *Le opere*, ed. G. Milanesi, Florence, 1878–1889, 9 vols. (cited as "Vasari-Milanesi").

Venturi, Adolfo, *Storia dell'arte italiana*, IX, 4, 6, Milan, 1929, 1933.

Vey, Horst, "Later Mannerism: Painting in the Netherlands," in Gert von der Osten and H. Vey, *Painting and Sculpture in Germany and the Netherlands: 1500–1600*, Pelican History of Art, 1969, Ch. 39.

Viola, Gianni E., *Il verso di Narciso—tre tesi sulla poetica di Giovan Battista Marino*, Rome, 1978.

Wagner, Hugo, *Michelangelo da Caravaggio*, Bern, 1958.

Weil, Mark S., "The Devotion of the Forty Hours and Roman Baroque Illusions," *Journal of the Warburg and Courtauld Institutes*, XXXVII, 1974, pp. 218–248.

Weil Garris Posner, Kathleen, *Leonardo and Central Italian Art: 1515–1550*, New York, 1974.

Wethey, Harold E., *The Paintings of Titian*, London, 1969–1975, 3 vols.

Whitfield, C., and J. Martineau, eds., *Painting in Naples, 1606–1705: from Caravaggio to Giordano;* exhibition catalog, Royal Academy of Arts, London, 1982 (entries for Caravaggio, including *Martyrdom of St. Ursula* and *Denial of St. Peter*, by M. Gregori). (Arrived too late to be cited.)

Wittkower, Rudolf, *Art and Architecture in Italy: 1600–1750*, Pelican History of Art, 3rd ed., 1980.

———, and Margot Wittkower, *Born Under Saturn*, New York, 1969.

Wright, Georgia, "Caravaggio's Entombment Considered *in Situ*," *Art Bulletin*, LX, 1978, pp. 35–42.

Zampetti, Pietro, ed., *I pittori bergamaschi. Il Cinquecento*, Bergamo, 1975–(in progress).

Zeri, Federico, "Sull'esecuzione di 'nature morte' nella bottega del Cavalier d'Arpino e sulla presenza ivi del giovane Caravaggio," *Diari di lavoro*, 2, Turin, 1976, pp. 92–103.

———, and Elizabeth E. Gardner, *Italian Paintings. A Catalogue of the Collection of The Metropolitan Museum of Art. Venetian School*, New York, 1973.

Zuccari, Alessandro, "La politica culturale dell'Oratorio romano nella seconda metà del Cinquecento," *Storia dell'arte*, 41, 1981, pp. 77–112.

Acknowledgments

Author and publisher gratefully acknowledge permission to publish photographs from the following sources: Staatliche Museen Preussischer Kulturbesitz, West Berlin; Staatliche Museen zu Berlin—Bodemuseum, East Berlin; Isabella Stewart Gardner Museum, Boston; Fogg Art Museum, Harvard University, Cambridge; The Cleveland Museum of Art; The Detroit Institute of Arts; Staatliche Kunstsammlungen, Dresden; Scottish National Portrait Gallery, Edinburgh; Biblioteca Marucelliana, Florence; Direzione Belle Arti del Comune di Genova; Wadsworth Atheneum, Hartford; William Rockhill Nelson Gallery, Kansas City; The Hermitage Museum, Leningrad; Trustees of the British Museum, London; Trustees of the National Gallery, London; Thyssen-Bornemisza Collection, Villa Favorita, Castagnola (Lugano); Museo del Prado, Madrid; Musée Cantini, Marseilles; The Metropolitan Museum of Art, New York; Allen Memorial Art Museum, Oberlin College, Oberlin, Ohio; Museum of Western and Eastern Art, Odessa; National Gallery of Canada, Ottawa; Musée du Louvre, Paris; Philadelphia Museum of Art, Johnson Collection; Cassa di Risparmi e Depositi, Prato; Museum of Art, Rhode Island School of Design, Providence; Istituto Centrale per il Catalogo e la Documentazione, Rome; Istituto Centrale del Restauro, Rome; Kunsthistorisches Museum, Vienna; The National Gallery of Art, Washington, D.C.

Index

NOTE: Illustrations are shown within brackets, viz. [23], which is also the number of the Note to that illustration (not otherwise cited here). An asterisk following a citation indicates a quotation. Unless specified, works of art are by Caravaggio or attributed to him.

Index

Index